THE SEA
Day by Day

PHILIP PLISSON ⚓

CAPTIONS BY Sophie Furlaud, Anne Jankeliowitch, AND Sandrine Pierrefeu

TRANSLATED FROM THE FRENCH BY
Alexandra Bonfante-Warren AND Laurel Hirsch

Harry N. Abrams, Inc., Publishers

WELCOME ABOARD!

This is an invitation from Pêcheur d'Images to experience 365 days on board, between sky and sea, and sentimental memories of time spent along our iodated horizons.

Photographically yours,
PHILIP PLISSON ⚓

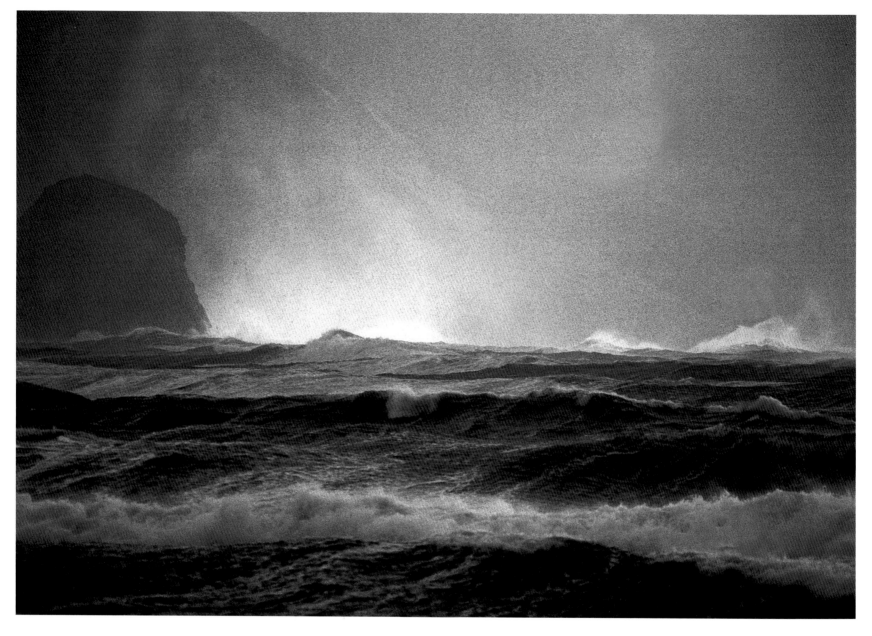

IRELAND. AT ACHILL ISLAND, A DELICATE TOUCH OF LIGHT
ILLUMINATES THE BAY IN TURNERESQUE FASHION.

The ocean seems to insinuate itself everywhere in Ireland, whose west coast opens to it in a series of deep,
narrow coves. With some 1,875 miles (3,000 km) of indented shoreline, Ireland boasts impressive landscapes,
most often with the sea at center stage. Achill Island rises a few miles to the west, not far from Europe's high-
est cliffs at Slieve League, which raises ramparts almost 2,000 feet (600 m) high against the Atlantic's swells.
The wind on the surface of the sea creates undulations that eventually turn into waves, if the conditions are
maintained. A misleading effect makes it appear that these are units of water that move, whereas in fact they
are waves that are propagated. When the waves go beyond the area where the wind formed them, they gradu-
ally turn into swells. But not only do swells and waves not necessarily go in the same direction, they may even
cross if a wind from the opposite direction raises new waves against a swell that has come from far away.

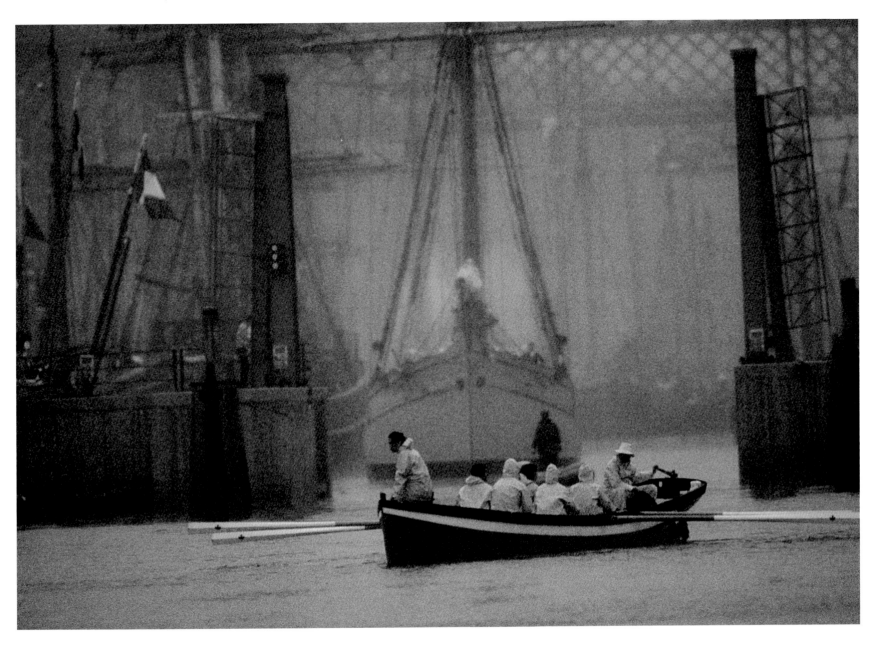

DOUARNENEZ. THE 1996 BREST ARMADA LEAVES PORT-RHU EARLY IN THE MORNING IN A HEAVY DOWNPOUR. THE CREW OF THE CANADIAN SKIFF AT ITS HEAD IS PROTECTED BY YELLOW OILSKINS.

To capture the armada sailing out of Douarnenez early in the morning, you have to anchor across from the starting point the day before and spend the night there. This is the only way to be in the front row the following morning to witness the priceless collection of tall ships gathered for the occasion. The desire to preserve, restore, and launch these pieces of naval history first emerged in the Anglo-Saxon countries in the 1960s, followed by France ten years later. Many ships were saved from oblivion when a handful of enthusiasts freed them from the mud on the French coast and dusted off plans to rebuild them. Through such acts and in the course of reviving know-how, associations were formed, the owners of old sailing ships met, passions were shared, and, from Brittany to the Côte d'Azur, local celebrations such as Concarneau's Les Vieilles Coques—"The Old Ships"— multiplied. But the ultimate event, the one that brings the whole world together around the most varied collection of the old ships for the sheer pleasure of it, is Brest.

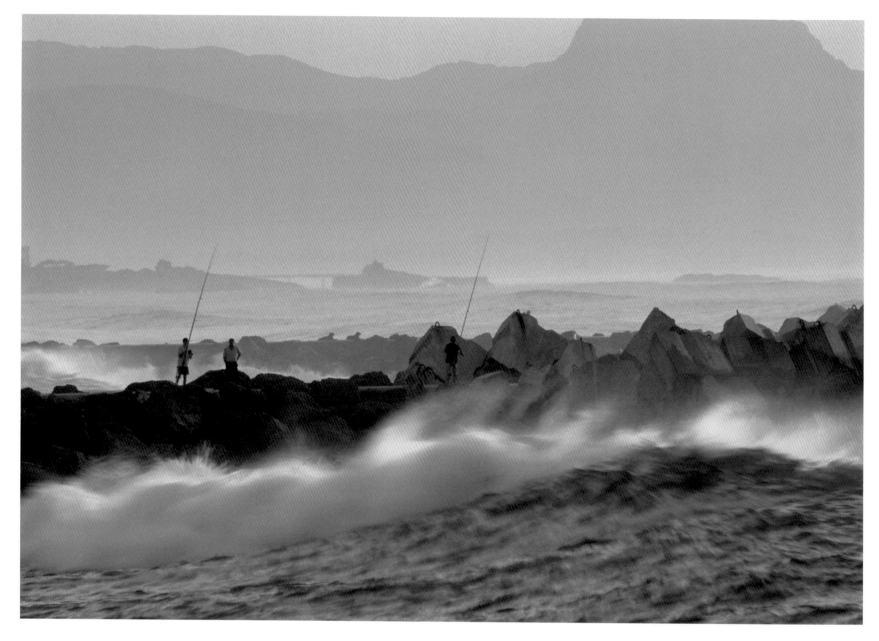

BIARRITZ. HERE, THE SWELLS OUT AT SEA ARE PART OF THE LANDSCAPE AND THE CULTURE. THE PEOPLE PLAY WITH THEM AND MAKE THEIR LIVING FROM THEM.

The people who live by the sea have imitated the natural reefs that appear all along the shoreline, creating their own breakwaters that can pacify the most powerful waves. A whole range of barriers—sloping, with rock fill or coffers, or floating—make it possible to adjust for the strength of the waves and currents, the configuration of the site, and the purpose of the construction. These jetties are built out into the water to protect delicate places, contain certain types of erosion, and shelter ports or create channels at the mouths of rivers. The longest breakwater—its granite seawall extends outward almost 7 miles (11 km)—is in Galveston, Texas. This more modestly proportioned jetty, across from the Rock of the Virgin at Biarritz, is ideally designed for anglers, who go out into waves kept level by the cement structure, surrounded by eddies of foam, in pursuit of fishing's ineffable pleasures.

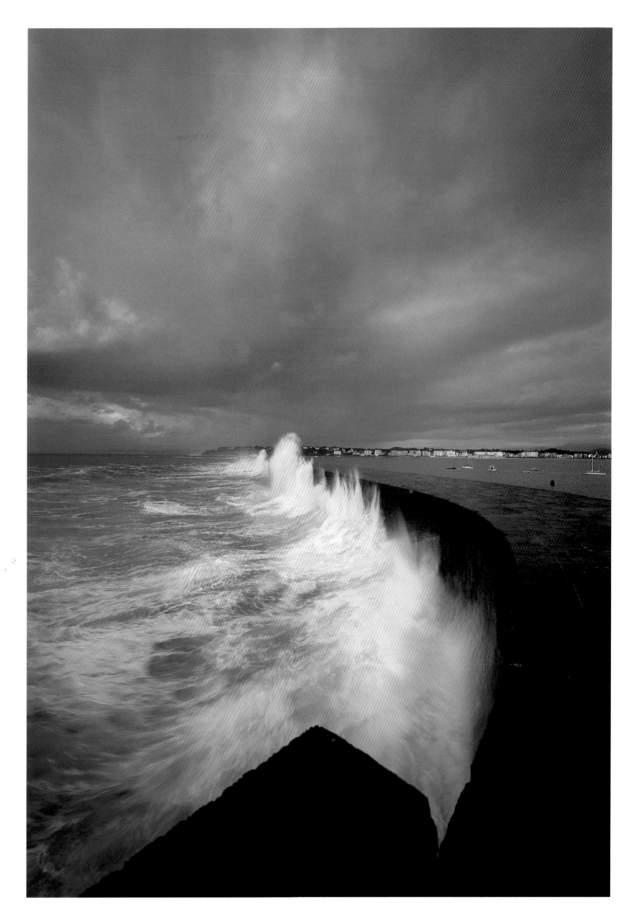

SAINT-JEAN-DE-LUZ, FROM
WHERE BASQUE SEAMEN
WOULD SET OFF ON A WHALE
HUNT THAT COULD REACH TO
THE CANADIAN COAST.

Accustomed to the currents and
violent winds that strike the
Gulf of Gascony, Basques have
always been known for their
seamanship. Ever since the
Middle Ages, they hunted
whales far from their shores.
Then, following the routes of
the great navigators, they
pushed their vessels all the way
to the Canadian shores, even
lending their name to a variety
of large aquatic mammals—such
as the Biscayan right whale—
which primarily lives in the Bay
of Fundy off New Brunswick.
The Saint-Jean-de-Luz whalers,
like those of Biarritz, have long
since laid their harpoons to
rest, but the whales have had
difficulty recovering from this
intensive hunt that spanned all
the oceans of the globe. Thanks
to protective measures, some
species, like the Mediterranean
fine whale and the California
gray whale, seem to be on the
road to return. On the other
hand, the blue whale and
the northern right whale are
near extinction.

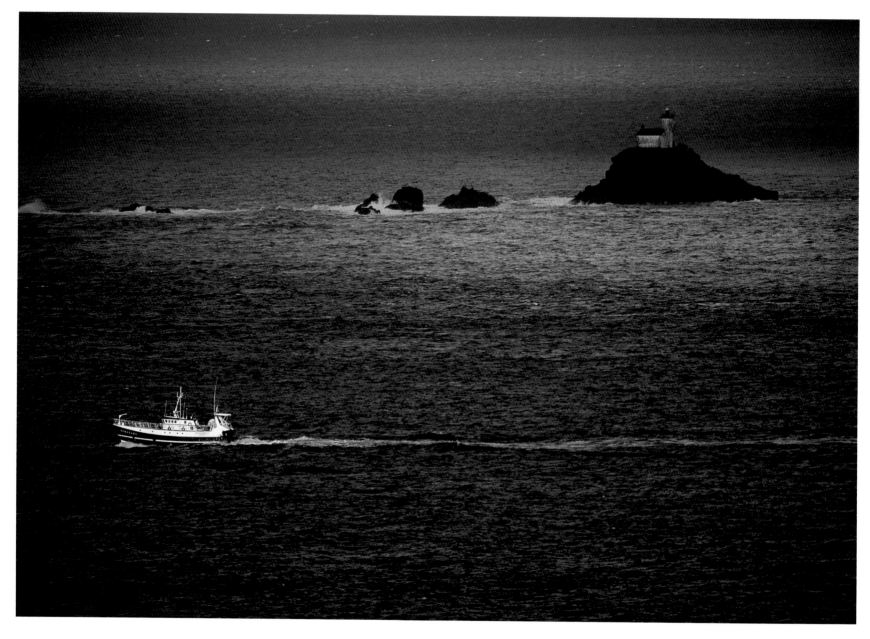

UNDERWAY. THIS TRAWLER IS LEAVING CONCARNEAU AT DUSK
FOR TWO WEEKS IN THE FISHING GROUNDS OF THE IRISH SEA.

The sea's abundance is such that it seems able to satisfy the needs of everyone everywhere in the world. People dive in it, float on it, study it, install platforms off its shores, lay cable in it, take sand from it, carry goods over it, raise lighthouses beside it, and help themselves to its fish. We do all this as if the sea belonged to everyone. But whom, in fact, does it belong to? In 1982, the Exclusive Economic Zones (EEZ) were established on the principle that coastal nations have sovereign rights over their territorial waters, with border zones that extend 200 miles (320 km) from shore. The measure limits people's freedom to exploit marine resources and allows them to be better managed. The continental plates are the areas richest in fish. The EEZ apply to 90 percent of the world's fishing grounds. In order to make the most of this space, shipowners buy fishing rights from the coastal countries. The common fishing grounds, however, are still a matter of contention, and migrating species such as tuna or salmon are not covered by the agreements.

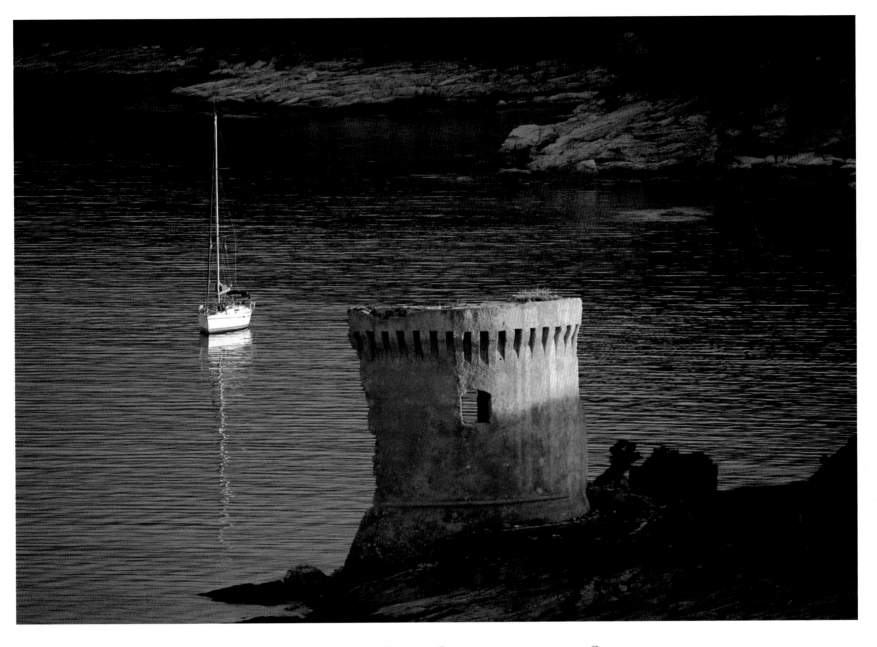

CORSICA. DROPPING ANCHOR FOR THE NIGHT IN SAINT-FLORENT BAY, AT THE FOOT OF THE GENOESE TOWER.

The pleasingly plump shape of the Genoese towers, characteristic features of this beautiful island, dot capes and promontories all along the Corsican coast. These watchtowers that overlook the sea were built in the sixteenth and seventeenth centuries, when the island belonged to the Republic of Genoa. Five keepers—the *torregiani*—kept a lookout from these stone sentinels that rise 32 to 49 feet high (10 to 15 m) and measure almost the same across. Upon sighting a suspicious vessel, the *torregiani* lit a fire on top of the tower, or sounded a horn. Every watchtower was visible from the other two nearest, so warnings were quickly transmitted to help fend off pirate attacks. The *torregiani* were also responsible for protecting the inland with cannon and harquebus fire and for commercial and health inspections of all incoming ships; the latter practice saved Corsica from the ravages of the plague. Of the one hundred or so towers built, more than sixty are still standing, some thirty of them on the jagged coast of Cap Corse, east of Saint-Florent Bay. These survivors bring to the restorative calm of the Corsican anchorages a faraway note of history that has entered this yachtman's dreams.

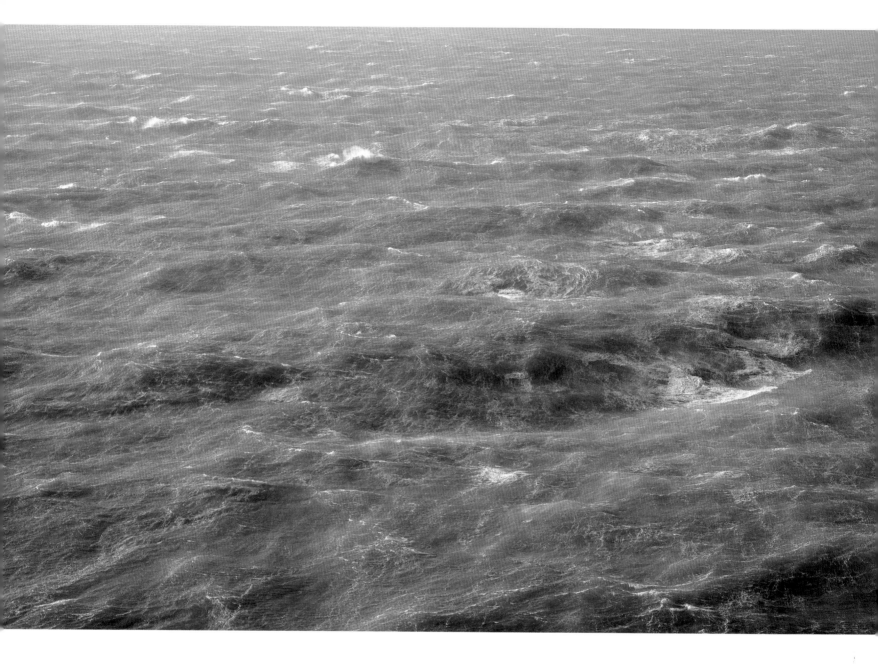

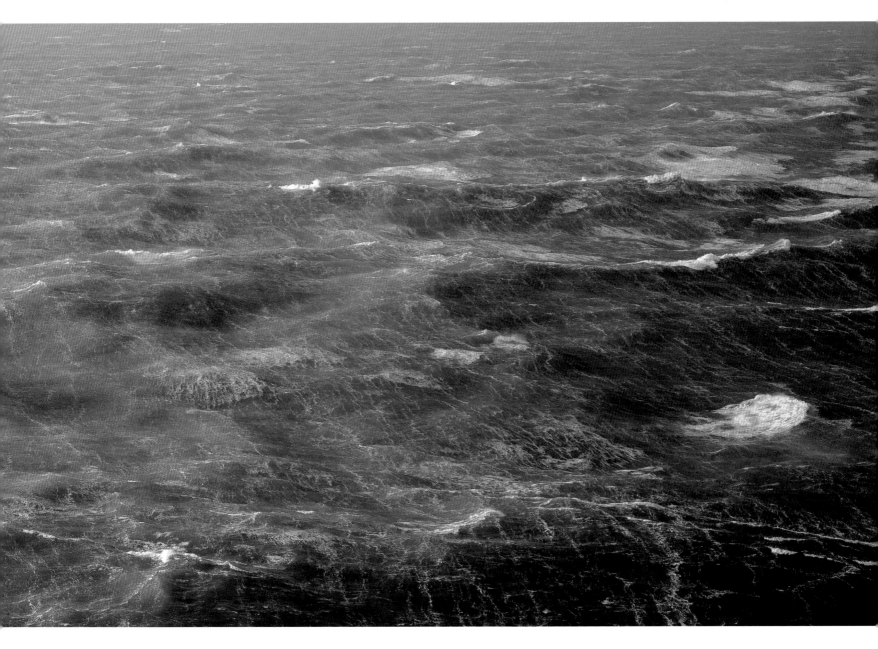

CAPE HORN. VIOLENT TROUGHS STRUNG TOGETHER LIKE A NECKLACE
OF BEADS MAINTAIN A PERPETUAL LINE OF SWELLS.

For man, the sea can only be measured on a human scale, compared to a boat or house, for example. Where there are no people, the sea no longer has dimension, its waves no height, its dangers no breadth. The limitless ocean is alone in its grandeur. It covers three quarters of the globe, inspiring the astronauts—the first to see it whole—to call ours the Blue Planet. This liquid universe contains 40 quadrillion tons of salt, which comes from continental erosion, supplying 3.6 billion tons a year. Were the oceans to suddenly evaporate, the world would be covered with a layer of salt nearly 114 feet (35 m) thick. But the ocean is more than just a lot of salt water. The tiniest drop of water contains more than 10 million protozoa, bacteria, and invisible viruses. The ocean supplies 90 percent of the bromine and 60 percent of the magnesium used in industry worldwide. It also holds silver, cobalt, titanium, nickel, copper, zinc, and uranium—not to mention 10 billion tons of completely unrecoverable gold.

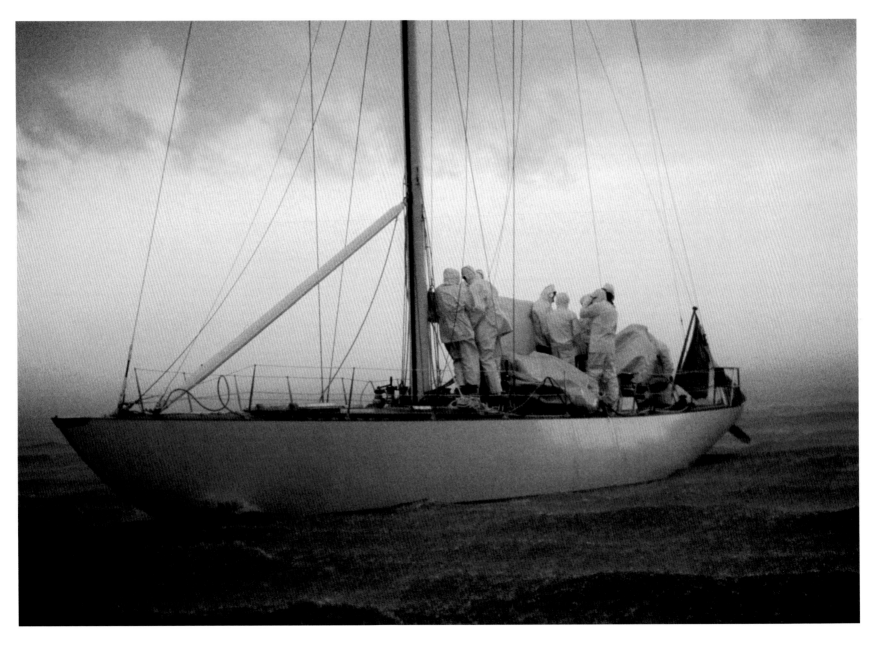

SPRING SHOWERS GREET THE 12-METER JI COLUMBIA, WINNER IN 1958 OF THE FIRST POSTWAR AMERICA'S CUP, IN CHARENTE-MARITIME, ON ITS FIRST OUTING IN EUROPE.

An unexpected downpour catches the *Columbia* and its crew as they prepare to hoist the sail. This onetime winner of the prestigious America's Cup, bought by a Frenchman who restored it, sailed in the 12-meter category. The yachts that participate in the cup race are built to specifications that have developed over time. The superb J-Class of the first races, ineffably luxurious floating palaces sponsored by millionaires, were almost 130 feet (40 m) long. World War II interrupted the regattas, which resumed in 1958 with the lighter and more affordable 12-meter JIs, about 65 feet (20 m) long. Since the 1992 race in San Diego, contestants for the cup have been Americas Class, state-of-the-art craft some 71 1/2 feet (22 m) long, with monumental sails. These vessels, handled by impeccably trained crews with access to sophisticated equipment, are a far cry from the giant, opulently comfortable yachts that battled for the first cups. Today, the competition is between the technologies of the participating countries as much as between the crews.

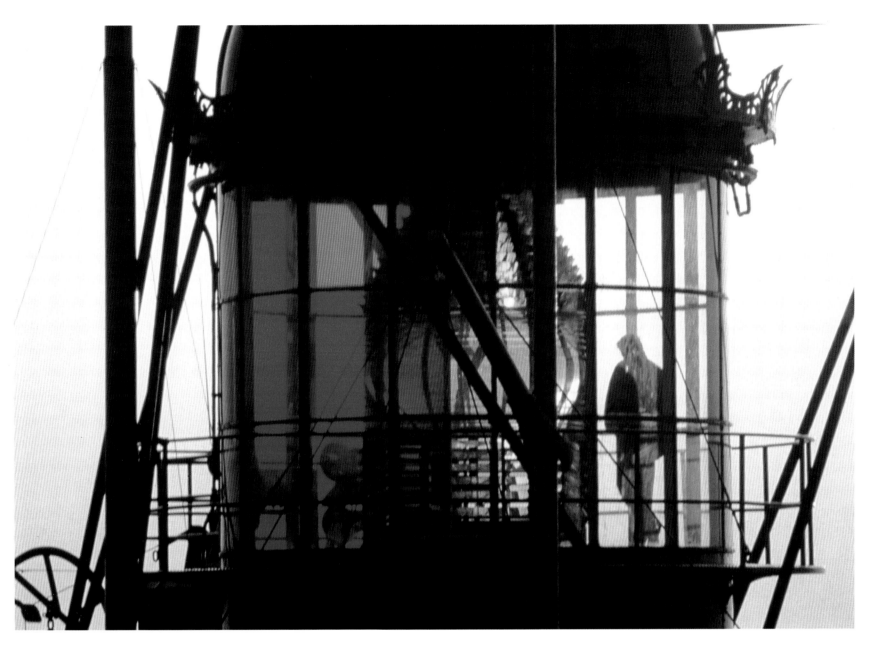

KÉRÉON LIGHTHOUSE. IN THE LANTERN, THÉODORE MALGORN
CHECKS THE LENS BEFORE TURNING ON THE LIGHT AT DUSK.

Théodore Malgorn, one of the last lamplighters on the seas, checks the Kéréon beam, which has been pulsing
around Île d'Ouessant since 1916. Lighting, dousing, and maintaining the lamp comprises an immutable ritual,
a lifebuoy in an ocean of solitude that makes up the routine of the lighthouse keeper. Reading, cooking, do-it-
yourself—everyone has a hobby to keep the boredom at bay. As Malgorn points out, "Being a lighthouse keeper
isn't a job, it's a life." Automation, long a subject of discussion, is becoming the rule, either to put an end to the
keepers' harsh exile, to reduce the number of employees, or to maintain signals on uninhabitable rocks. Kéréon
is one of the last three occupied ocean lighthouses. For most of the 152 lights that mark the coast, electronics
have eliminated the need for keepers. Who will maintain the lighthouses abandoned to the carelessness of sea
and humidity? Can this heritage be kept alive? Among this general indifference, the partial collapse of the roof
on the lighthouse of the Triagoz is not a good sign.

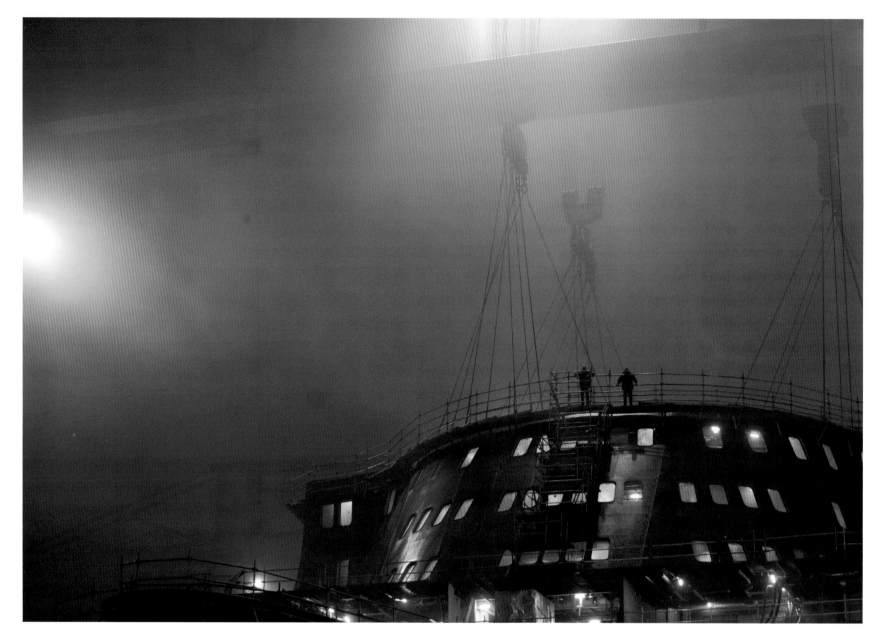

IN THE PRIVACY OF THE SHIPYARD, LAMPS ARE FORGED,
IRON IS CRUNCHED, AND SHEET METAL IS PRODUCED.

The night is calm. Following long months of preparation and after final verifications have been made, the bridge of the *Queen Mary II* is set in place. To make this cruise ship, the largest ever to be built, three hundred thousand pieces of steel will be cut and soldered in the surrounding workshops. In total, ninety-four blocks—some weighing 600 tons—will be assembled to form a hull that will weigh 50,000 tons. This construction will require 930 miles (1,500 km) of solder. The fittings will include 1,555 miles (2,500 km) of electric cables, the painters will cover 5,382,000 square feet (500,000 m²) with paint, and the carpet maker will install 2,691,000 square feet (250,000 m²) of carpet. It will have 2,000 bathrooms, 34,445 square feet (3,200 m²) of kitchen space, 5,000 staircase steps to accommodate in the finest fashion the 1,250-member staff and the 3,000 passengers who will stay in the 1,310 cabins, three-quarters of which will have private balconies.

THE BIRTH OF THE QUEEN MARY II. SOON IT WILL CROSS THE ATLANTIC.

The flagship of the Cunard fleet, a British company founded in 1839 and known for its transatlantic lines, the *Queen Mary II* will be launched in January 2004. Designed to resume the previous passenger service between Europe and the United States, it will make the crossing in six days and will replace the Cunard's other jewel, the *Queen Elizabeth II*. Conceived in the spirit of cruise ships of another era, it will be endowed with a principal dining room capable of serving 1,350 guests, and will extend the entire width of the ship. A monumental staircase will serve the four stories of its height. With five swimming pools, a spa, a fitness center, 19,400 square feet (1,800 m²) of sports installations, entertainment halls, a library, a multimedia center, and an education center, the *Queen Mary II* will be both the most luxurious liner and the most expensive to build. It will cost the company some 538 million pounds, more than 885 million dollars.

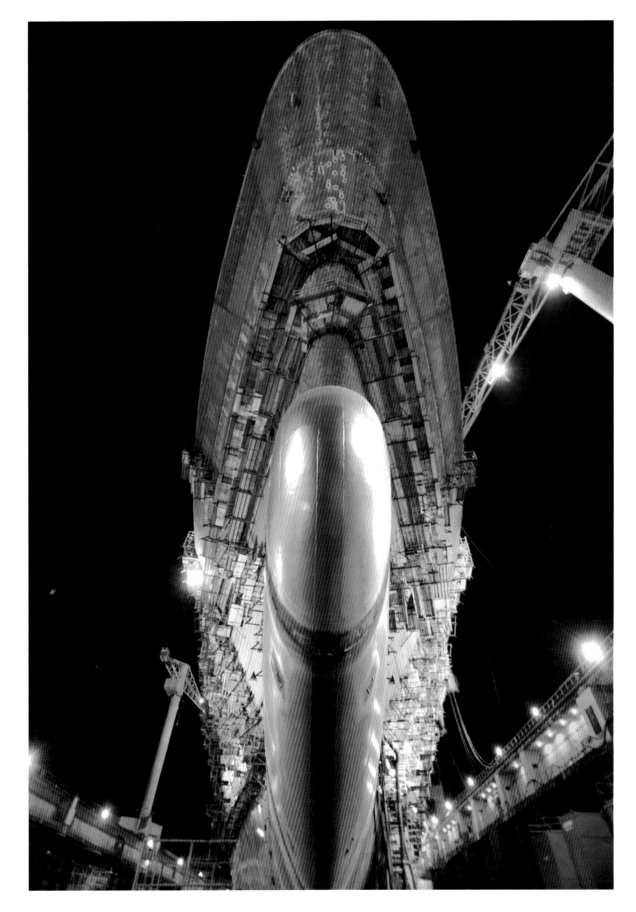

LES ROCHES DOUVRES. THE LIGHTHOUSE FARTHEST FROM THE FRENCH MAINLAND.

At the mouth of the Trieux River, off Côtes d'Armor, the Roches Douvres lighthouse reigns supreme over a tiny island of granite. A sturdy edifice—in looks, a little like a Fort Boyard outbuilding—it provides a solid foundation for the lamp that crowns the structure at 195 feet (60 m). Rebuilt in 1945, the lighthouse was supposed to enjoy the luxury of an elevator, according to the plans of the engineers of the Department of Civil Engineering. But because of a lack of funds, the elevator was never installed, so on every floor there is a gate that opens onto a terminally vacant shaft. The signature spiral stairway of the French towers occupies the space that the British have designated as the keepers' quarters. Europe's tallest lighthouse is Île Vièrge, with its 250-foot (77-m) tower and the 397 steps leading to the top. Keepers of French lighthouses lived at the bottom of these staircases; they did not envy their counterparts across the Channel, who lived in vertical tubes with ladders. The last keeper left the Roches Douvres in 2000.

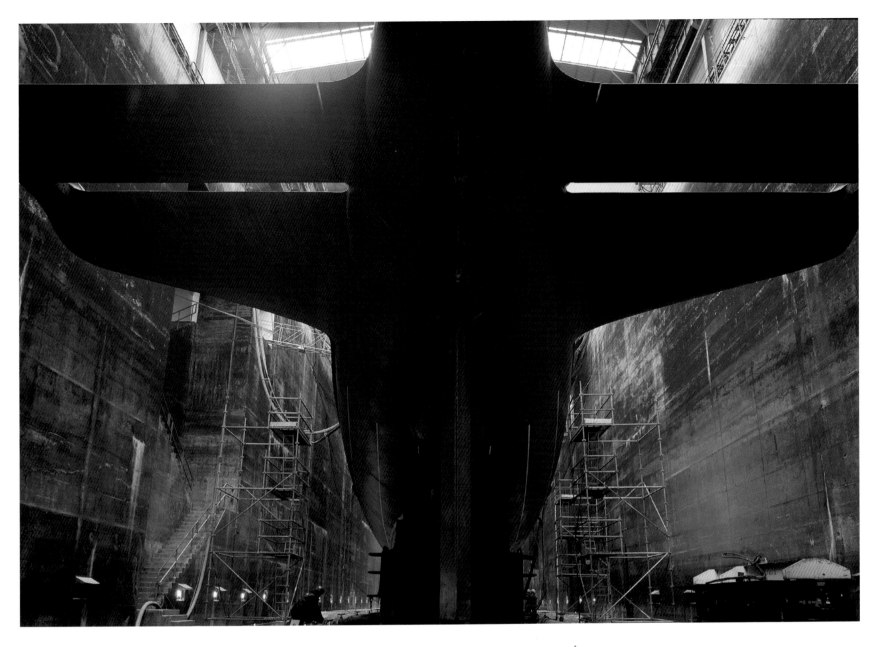

Brest. A nuclear missile-launching submarine in "hyper"—major overhaul—at Île Longue. This site is the most sensitive of all those harboring deterrance forces.

It is unusual to spot a submarine, and extraordinary to see one out of the water. Dry-docked for careening, with dwarfed, hard-hatted workers busy on the hull, this one reveals its titanic dimensions. Île Longue, in the Brest vicinity, is, with Toulon and Cherbourg, one of three French military ports; since 1968 it has been the base for the SNLEs, or nuclear missile-launching submarines. The first, aptly named *Le Redoutable*, left Cherbourg in 1967. A thick hull capable of resisting pressure, and ballast tanks that regulate the air within make it possible for the submarine to reach great depths. The diving planes, which can be clearly seen here, act as rudders, providing stability. The nuclear propulsion guarantees unlimited independence. The sailors aboard this metal tube—which can dive to 975 feet (300 m) for sixty days—cannot communicate with their loved ones on land from this self-sufficient vessel, which constantly purifies air by removing carbon dioxide and adding oxygen, and desalinates sea water for all onboard purposes.

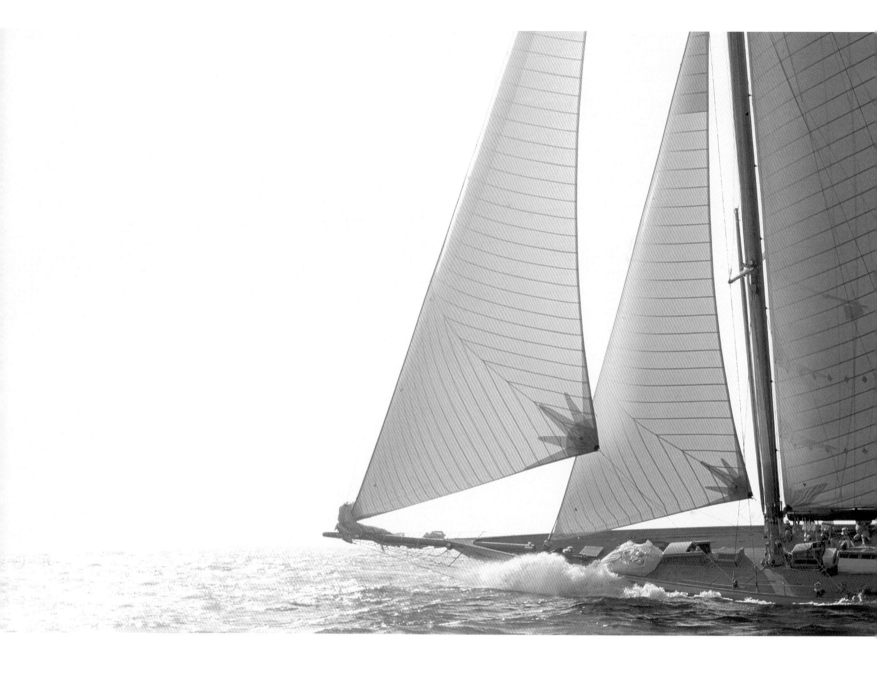

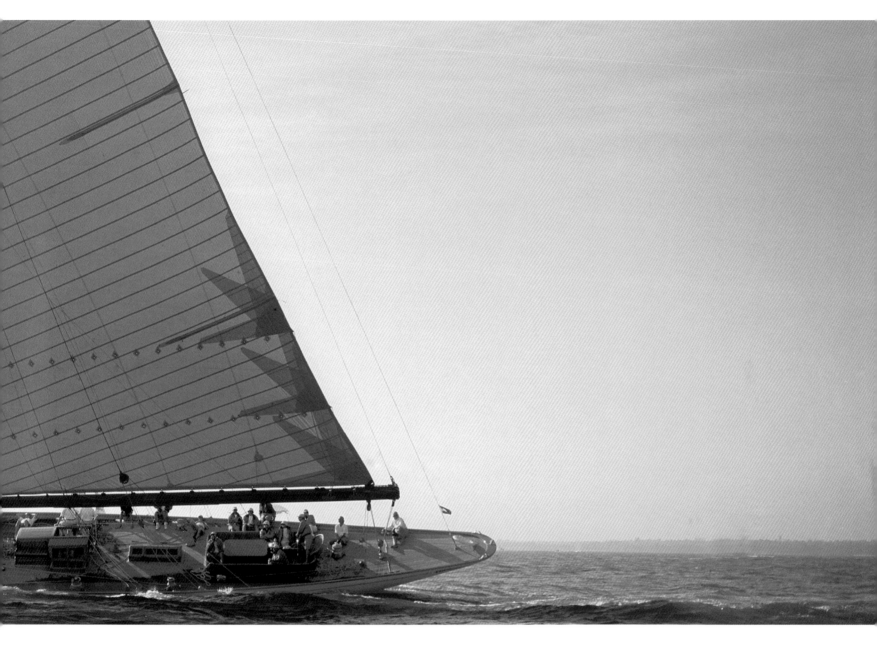

J-CLASS. BALANCED AND ELEGANT, THE SAILS ARE PERFECTLY TRIMMED.

As the crew rushes about on the starboard side, the boat on a hard keel with its sails well outside, the elegant schooner glides over an iridescent sea. It was during the 1930s, the finest time of the America's Cup, that the J-Class yachts first appeared, an immediate and stately presentation of the new constructions. The waterline had to be limited to between 76 and 87 feet (23.15 and 26.50 m) for a total length of less than 130 feet (40 m). The year 1931 was key, as it was then that the first transatlantic race between Newport and Plymouth was held. J-Class competitions continued for several years, with yacht clubs rivaling one another with their ingenuity in order to capture the America's Cup. Marine architects from many countries would test new designs of hulls, keels, and riggings. All the while, the cup race remained in Newport. World War II marked the end of the J-Class, which abruptly disappeared from the shipyards, only to later reappear as restorations. A handful remains as evidence of the luxury and elegance of an age, and to cross paths with one on the sea is to fall captive to a feeling of both nostalgia and admiration.

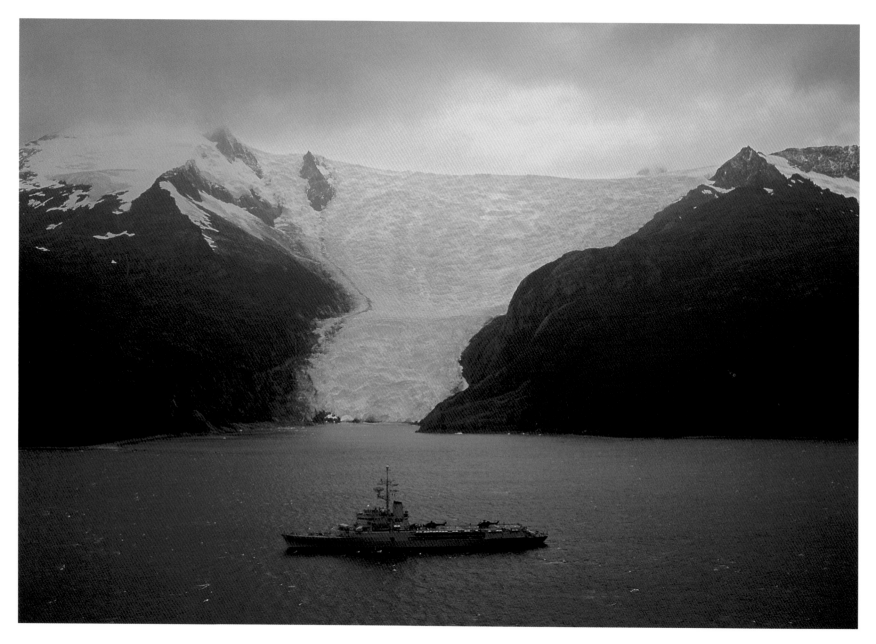

PATAGONIA. THE ITALIAN GLACIER IS THE MOST SPECTACULAR OF THE FROZEN WATERFALLS IN PATAGONIA'S PASSAGES. THE JEANNE GIVES AN EXCELLENT SENSE OF THE SCALE OF THE VIEW.

The Naval Officers' Training School, founded in 1864, has been aboard the helicopter carrier *La Jeanne d'Arc* since 1964. Some fifteen ships preceded it in this capacity; the first, which served until 1868, was the *Jean Bart*, an eighty-gun sailing ship. At the end of the initial training stage, approximately 150 cadets, including some twenty women, board the *Jeanne*, joining the 550-member crew of the training ship for a six-month around-the-world tour of duty. This practical course gives them a better understanding of the diversity of the world's coastlines and the activities of a navy out at sea. At the antipodes of Brest, its home port, *La Jeanne d'Arc* rounded Cape Horn and sailed into Patagonia's passages. Its 169-foot (52-m), radar-studded mast and 592-foot (182-m) bridge look tiny in front of the great tongue of ice. Yet the bridge is so long that the cadets go jogging on it.

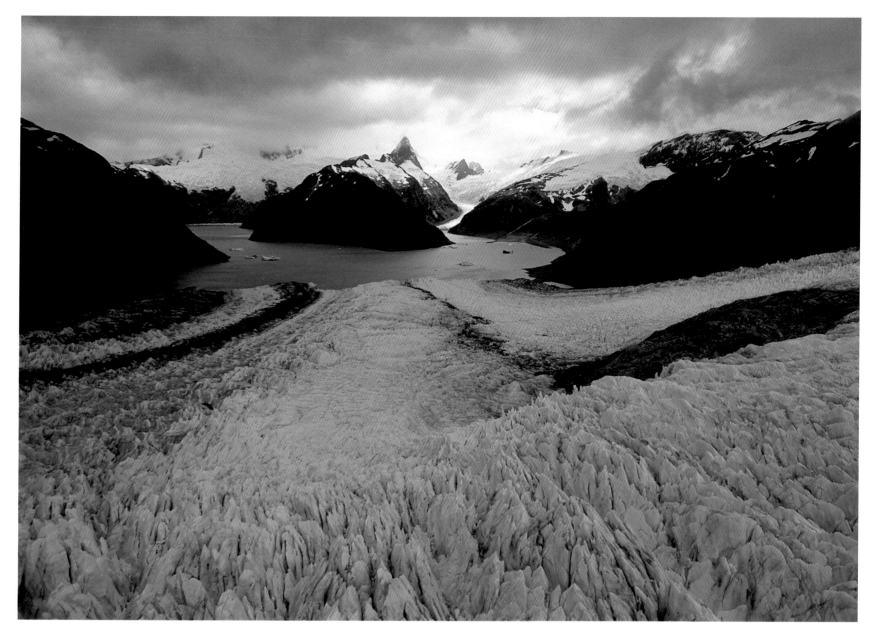

PATAGONIA. AN AVENUE OF GLACIERS AND THE FJORDS ON THE BEAGLE CANAL.
A UNIVERSE BETWEEN ICE AND WATER.

Navigation is dangerous at the extreme south of Chile on the Beagle Canal, a sliver of a passage from the
Atlantic toward the Pacific, between the large island detached from the continent and the islands of Hoste and
Navarino. It is a polar setting of jagged coastlines cut up into fjords, at the bottom of which glaciers become
engulfed in shades of lapis lazuli, the last vestige of the Andean cordillera before it disappears into the sea.
Before making its port of call in front of some of the most impressive glaciers in the world, it travels a sinuous
route inundated with obstacles in the form of growlers, or small icebergs. Shrouded in the ice floe, prior wrecks
and sunken ships lend this expedition the sinister impression of being in the middle of a sailors' cemetery. The
fearsome cracking of the ice floes rings out like an earthquake. Avalanches of ice add to the scene, as do the roar
of the polar winds coming up from Cape Horn—the legendary cape so dreaded by sailors where the terrible,
howling fiftieth parallels reign supreme.

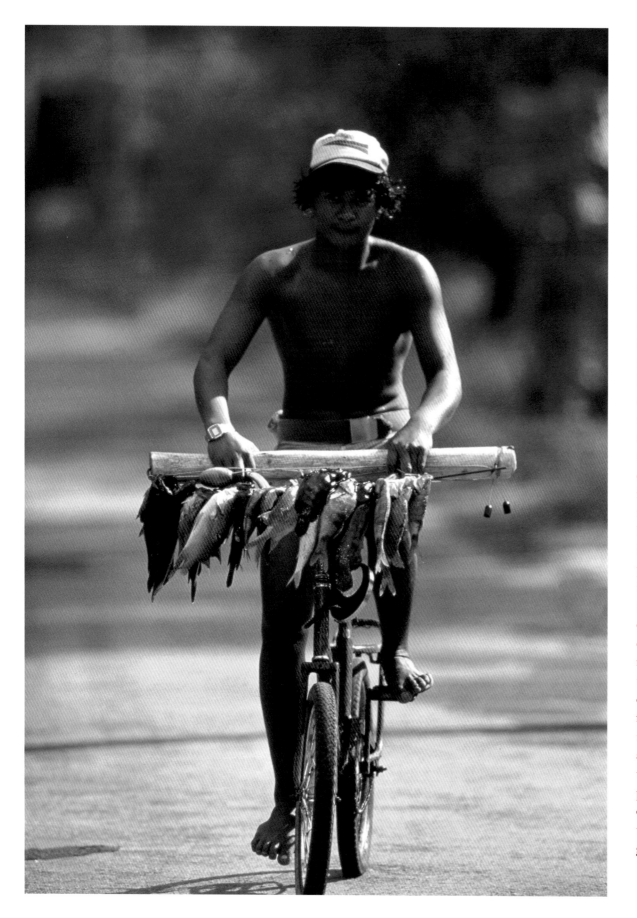

POLYNESIA. AFTER MAKING THE CATCH, FISHERMEN WASTE NO TIME IN GETTING BACK TO THE PORT TO SELL THE FRESH FISH.

Somewhat unsteady, this Polynesian boy on a bicycle works his way up the hills with his haul of fish from the atoll. If he looks determined in his efforts, that is because he is on his way to cash in his catch. While their fish is considered to be blander than those caught in the ocean, Polynesian divers have been fishing in the lagoon since the beginning of time. A mask, an arrow, and a line are all the equipment needed by these athletes of the deep. It is even said that underwater fishing was invented here in the middle of the Pacific Ocean. Fishing in the lagoon is divided into two categories: the first is practiced on the surface by inspecting the reefs that break through the water, while the other, which is much more demanding, is done in the channels that link the lagoon with the ocean. The water there is deeper and the fish more plentiful. It is through these openings in the coral that the fish enter and leave the atoll. In these waters napoleon fish, jacks, parrotfish, and rays fight each other in the silence of the deep, while waiting for an even bigger fish to come and catch them.

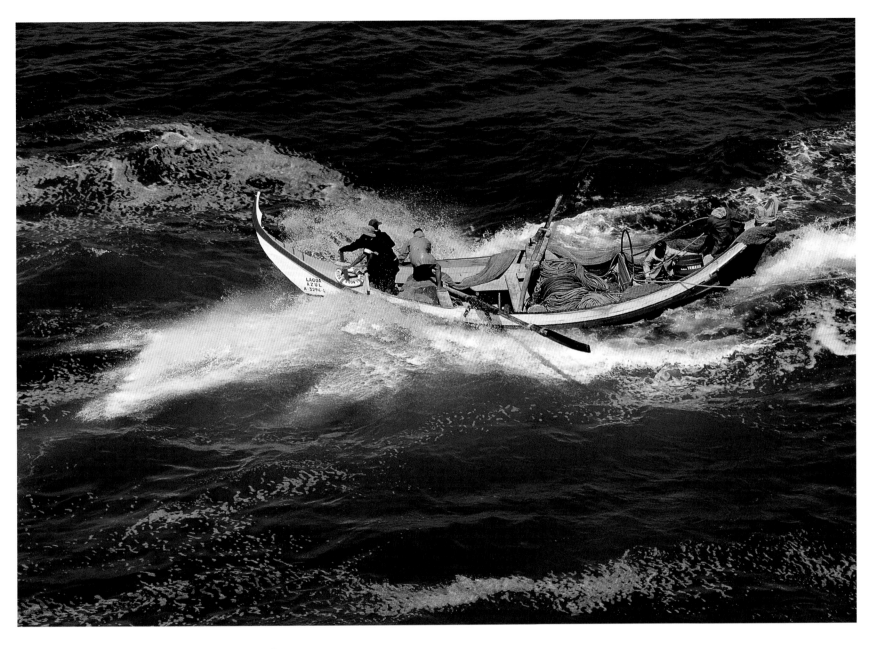

PORTUGAL. GOING FISHING ON THE BEIRA COAST.
OXEN STILL PULL THESE TRADITIONAL CRAFT ASHORE.

Aboard their narrow wooden motorboats, the Portuguese of the Beira coast practice fishing on a scale that is
unlikely to jeopardize the Atlantic's coastal resources. Their nets are painstakingly mended, and the cattle are
put to work hauling the boats out of the water. Millions of boats around the world are dedicated to small-scale
fishing. The crew, just a handful of men, goes out to sea for a few hours and usually stays close to the home port,
though occasionally they will be out on the water for several days. Such forays are enough to bring back sole,
turbot, skate, rock lobster, and others of the finest species, at their freshest. At the other end of the wide range
of the various kinds of fishing are the industrial trawlers, which first appeared in the 1950s. These take their
floating factories and outsize nets, which can catch 100 tons of fish in an hour—as much as a sixteenth-century
fishing boat caught in an entire season—into the open sea. But, as in most things, quantity rarely equals quality.

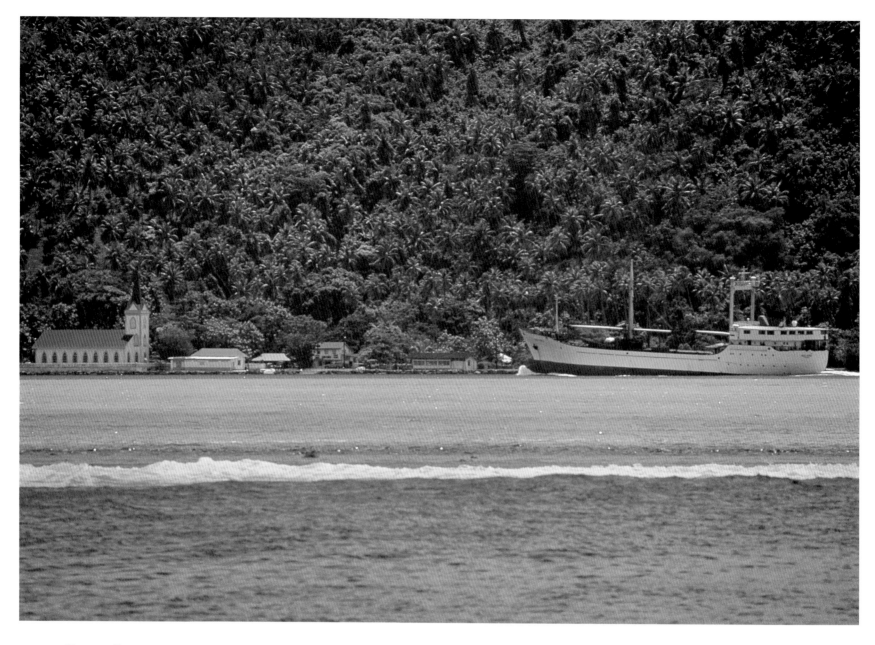

TAHAA. THE WEEKLY WHALER *VAEANU* HAS JUST MANEUVERED INTO POSITION AT QUAYSIDE, WHERE IT WILL DISEMBARK THE PASSENGERS AND PROVISIONS IT TOOK ON IN PAPEETE.

What miracle made it possible for the intrepid Maoris in their tiny dugouts to land on the Polynesian pebbles strewn about the heart of the Pacific Ocean? These bold seafarers left Southeast Asia around the middle of the third millennium BC. with only their daring and their knowledge of the stars, guided by their intuitive observation of waves, clouds, and birds. The Polynesian diaspora reached its peak around the eighth century, and those migrations were already ancient history when the Europeans first landed on the legendary islands of the South Seas. Even though today's media break down the boundaries between these various worlds, the islands' isolation is still very evident. In these small, distant, and deprived places, the arrival of the supply boat carrying its many goods from Tahiti is a major event in the life of these islanders. Their ancestors' legacy also includes the outrigger canoes that permeate the Polynesian way of life. They have become the national sport and a symbol of the region.

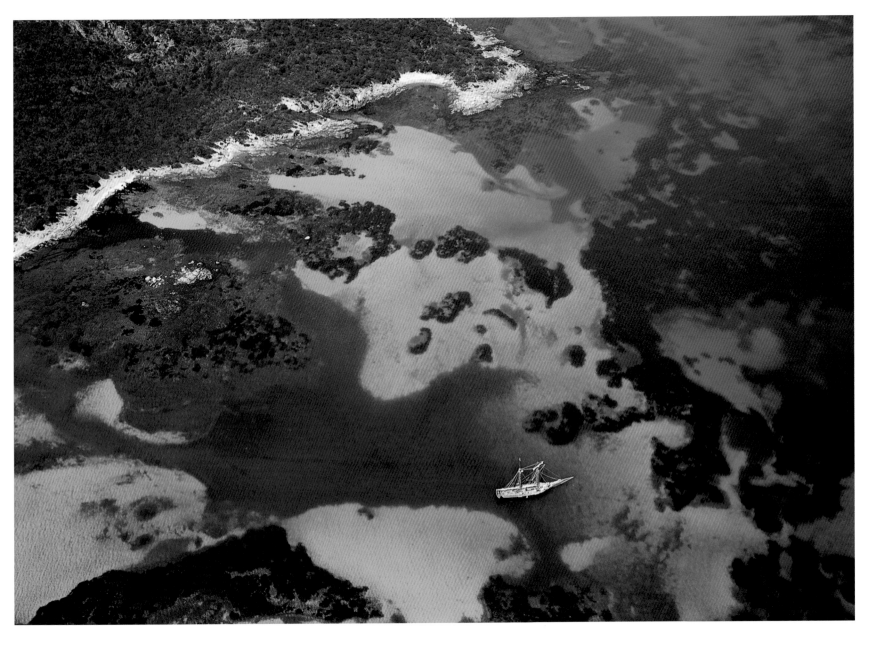

CORSICA. PARADISE FOR DIVERS AND UNDERWATER FISHERMAN.

With its cliffs that plunge straight into the sea, etched stone coves, translucent water, and temperate climate, Corsica is an extraordinary trove of rockfish and other Mediterranean varieties. Underwater fishing is strictly regulated and catching crustaceans such as lobsters, spider crabs, slipper lobsters, and prawns, among other species, is forbidden. On the other hand, the aficionado can fish unrestricted from the shore or a boat and have the makings for the local bouillabaisse—bass, scorpion fish, red mullets, and dorados. Corsica is a scuba diver's paradise. A descent of just a number of feet is enough to discover flora and fauna of a magical beauty and unbelievable diversity. The underwater sites off the Île de Lavezzi, south of Bonifacio, are the most populous and have been nicknamed *Mérouville* ("Grouperville").

19|20

J F M A M J J A S O N D

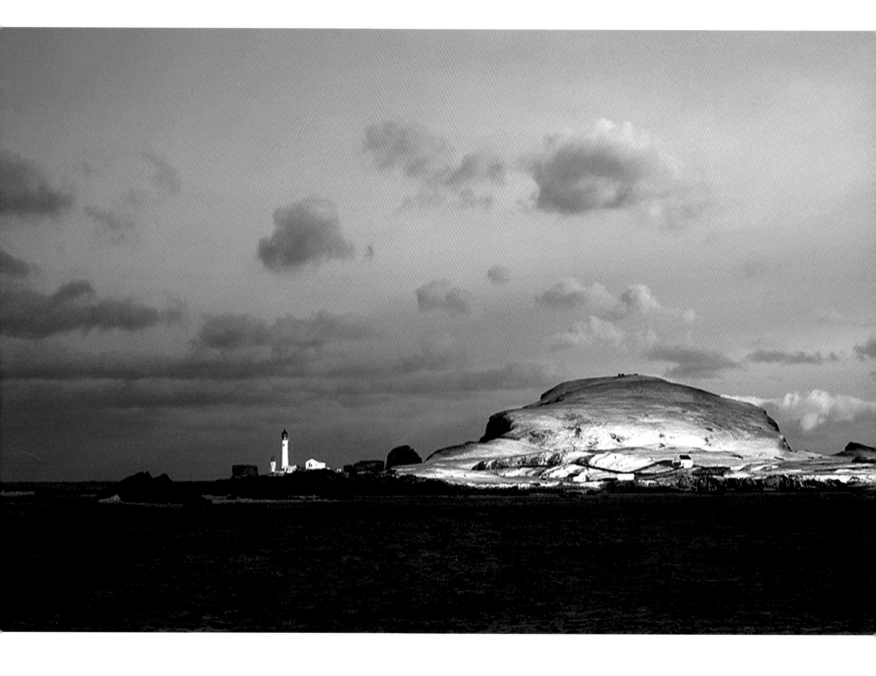

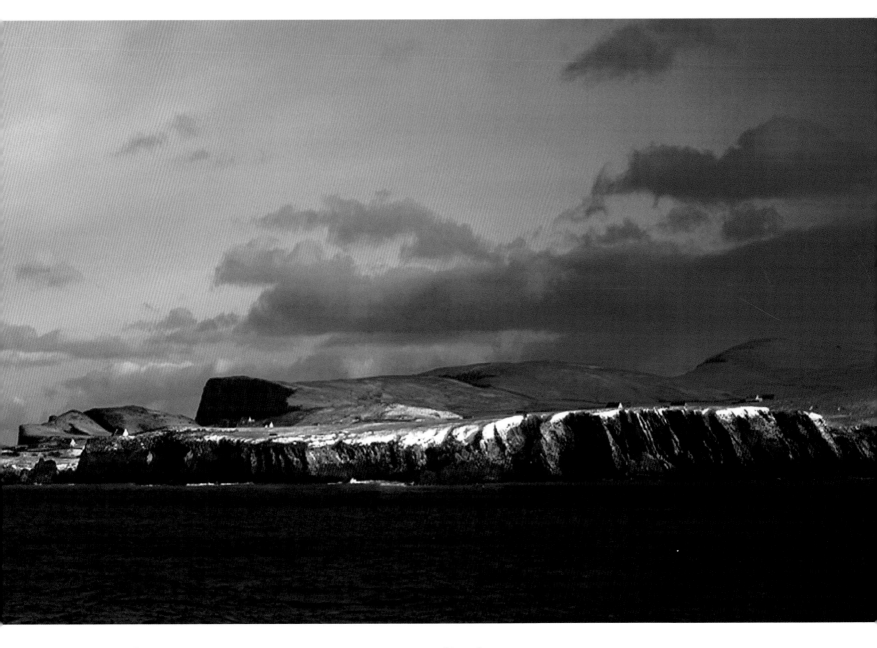

SCOTLAND. PUFFS OF CLOUDS ROLL THROUGH THE WINTER SKY OF FAIR ISLE.

The seventy residents of this tiny islet of the Shetland Islands benefit from the special attention bestowed upon their island by the authorities on the Continent. In fact, although Fair Isle is only 4.3 miles (7 km) long and 1.9 miles (3 km) wide, it is nonetheless an extremely important bird sanctuary in northern Scotland. The researchers call it Bird Island because of the 250,000 seabirds that regularly flock to its cliffs and hillsides. In total, there are more than eighteen different species that cohabit and nest on this harsh land swept by snow and winds. Auks, terns, petrels, puffins, and seagulls share the skies and a sea filled with fish under the watchful gaze of scientists and the few adventurous tourists. Several sea mammals roam these waters, including killer whales, other types of whales, dolphins, and seals. First meetings usually take place while on the boat coming to the island, and the welcome is exceptional. On rare occasions, which call to mind the ancient tales, one can spot the sharp point of the narwhal— that cetacean also known as a "sea unicorn," whose strange tusk can grow to 10 feet (3 m) long.

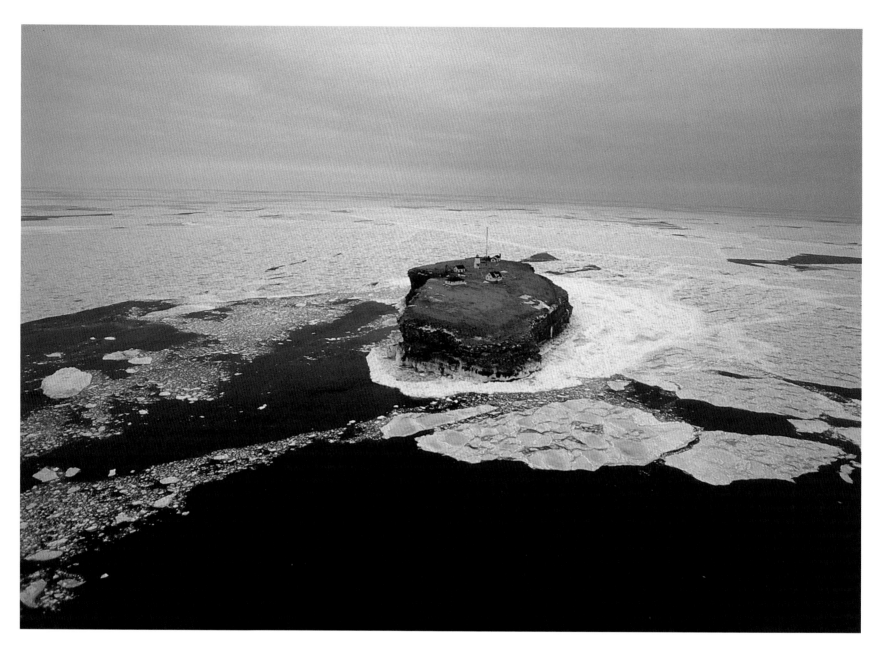

THE LIGHTHOUSE OF THE ROCHER AUX OISEAUX: A FLAME IN THE SAINT-LAURENT ICE.

Four signal-beacons, one antenna, and a beam of light. Here is the realm of the keepers of the Rocher aux Oiseaux lighthouse as the photographer found it in 1984. Three men worked in rotation 365 days a year seeing to the maintenance and watch of the beacon, one of the easternmost in Saint-Laurent, along with those of Saint Pierre-Miquelon and Terre Neuve. One hundred twenty-five miles (200 km) east of the Gaspé peninsula, the Madeleine Islands extend some 37 miles (60 km) and offer, according to locals, one of the most temperate climates in Canada—despite the fact that they remain covered in ice in the winter. When a storm would strike the area, the keepers of Rocher aux Oiseaux would not venture out without their wooden shields, as the wind would send stone flying. Today, the shields have been stowed away and the lighthouse automated.

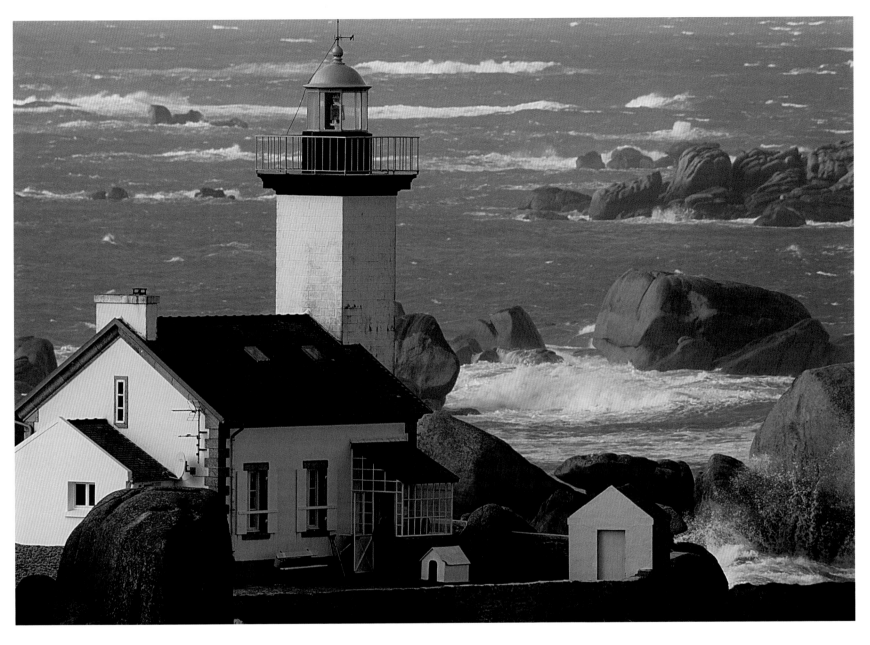

BRIGNOGAN. A DOLL'S HOUSE SET IN THE ROCKS,
THE RAIN SALTY WITH THE SPRAY OF THE SEA, AND AN INTENSE STORM.

At first glance, one sees only the lighthouse. Built in 1869, squat and sober, it is equipped with a small beacon with a typical low-beamed chimney. Upon closer look, one notices the lantern room and the extension of the house, then the sloping roof and the recess, all with pitched roofs and white walls like the tower. More than just a house, this assemblage of buildings resembles a village of prim dollhouses between the blocks of granite, with its surrounding walls that straddle the rocks. Hidden in the back is a small garden where the early fruit and vegetables have a taste for salt and are devilishly early sprouters, like on the Île de Batz. Plump paving stones pop up everywhere in these parts, making not the slightest concession to where the currents and shoals intermingle. A storm garden over which reigns the Pontusval lighthouse and its keeper, a Madame Le Guen, who keeps guard over this sea-foam paradise.

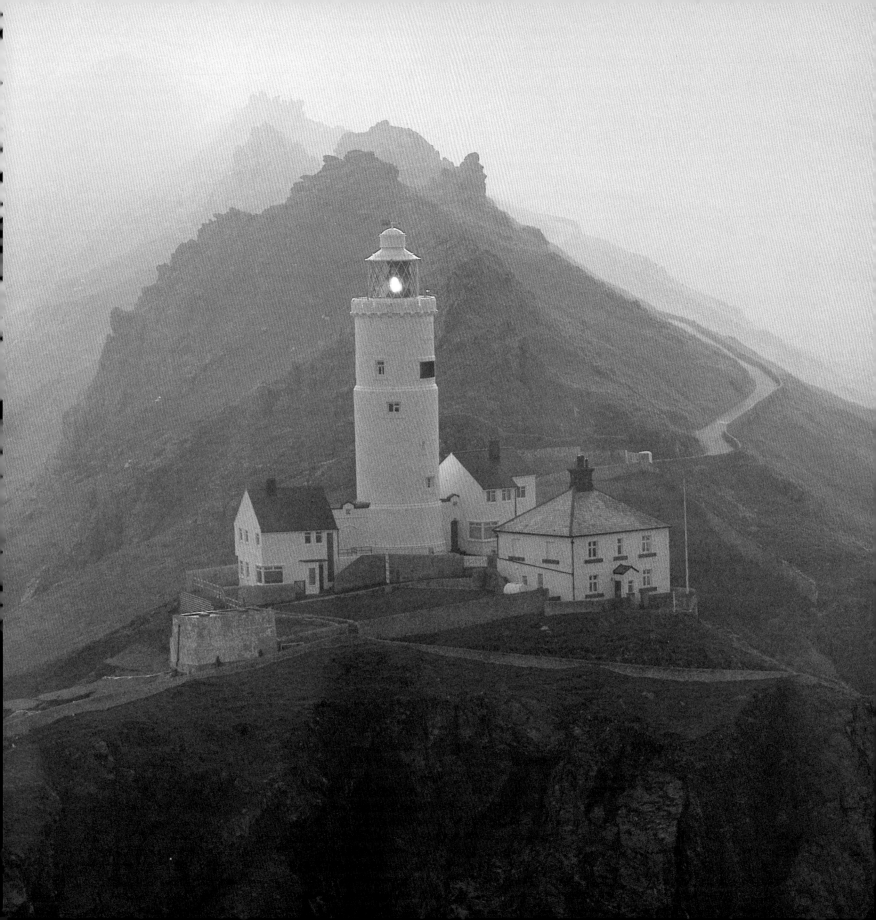

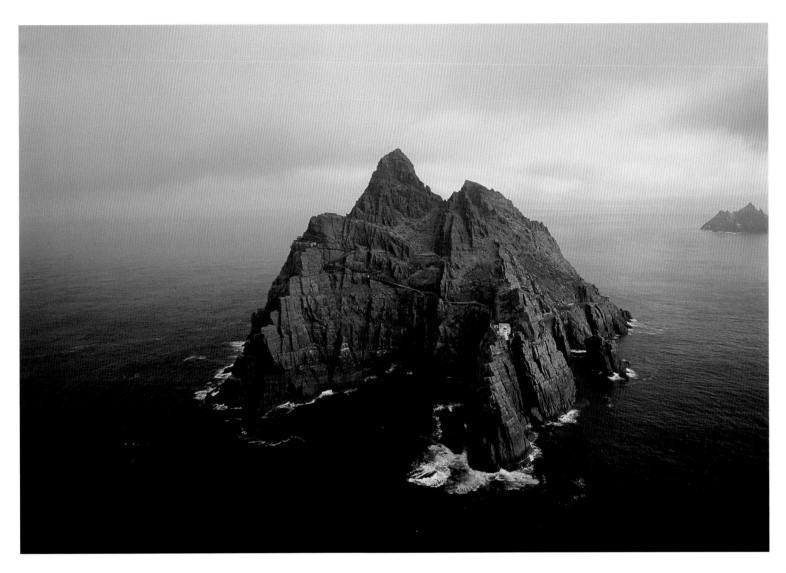

THE ENGLISH CHANNEL. CORNWALL'S START POINT FACES LA JUMENT IN THE IROISE SEA, ON THE OTHER SIDE OF THE CHANNEL. The lighthouse at Start Point, in southwest Great Britain, and its French counterpart, La Jument, in the Iroise Sea, flank the entrances to the English Channel. From Plymouth to Dover and from Roscoff to Dunkerque, countless French and British flashing lights escort the pleasure craft, fishing boats, ferries, freighters, and oil tankers that jostle one another on this, the largest of marine highways. More than 250 boats take to the Channel every day, with the traffic over the course of a year adding up to ninety thousand ships. Innumerable vessels carry a total of some 100 million tons of hydrocarbons and 28 million tons of various dangerous materials. This intense traffic traveling the length of the Channel is intersected by a dozen maritime routes that connect France and England. Every day, the 130 daily crossings ferry 63,000 passengers. A vast system watches over this marine activity. For this sharp-eyed sentry, every day is code red.

SKELLIG, IN COUNTY KERRY, IRELAND. In southwest Ireland, a half-dozen miles (10 km) from the coast, three impregnable sentries stand at outposts of the Atlantic Ocean: Inishtearaght, Bull Rock, and Skellig. Their conquest illustrates the human determination to solve the problems that arise in the course of impossible endeavors. The Skellig lighthouse, nesting like a gull in its huge cliff, is the most precipitously placed in Ireland. Its monumental, rocky stump, which shoots up to 700 feet (215 m) above the ocean, also protects the invincible sixth-century monastery that perches there at 585 feet (180 m). On the cliff's left-hand arête, at the end of the path that zigzags to the crest, the ruins of the first lighthouse, which was finished in 1826, are exposed to the wind. Farther down, a steep path leads to the foliated peak that bears the present lighthouse. Built in 1967, it stands 170 feet (53 m) above the void. The keeper at Skellig had better not suffer from a fear of heights! The automation of the lighthouse in 1987 put an end to the issue once and for all.

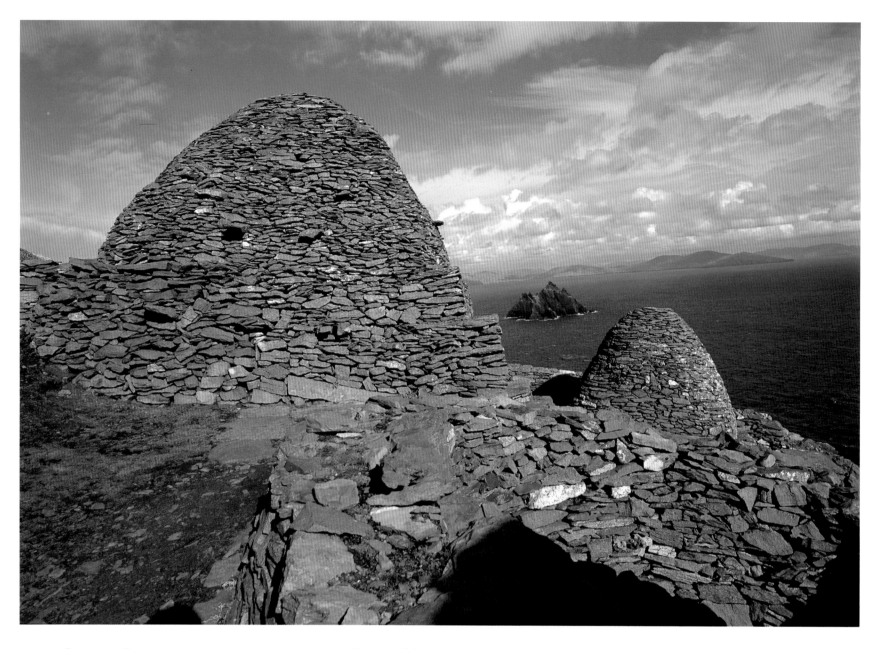

IRELAND. ROCK HUTS PERCHED ON THE ISLAND OF SKELLIG MICHAEL,
ANCIENT RETREATS OF MONKS. A LITTLE CLOSER TO THE SEA THAN THE HEAVENS.

The island of Skellig Michael projects from the sea off the coast of County Kerry in the south of Ireland. The perfectly aligned shelters stand out at the edge of the cliffs. Many believe this island shelters on its summits the vestiges of one of the first Irish Christian monasteries, founded in the sixth century. Construction would have been a colossal effort for these eremite monks, **who** would have had to flatten the island's summit and then carve out of the split rocks a snaking staircase of more **than** five hundred steps. Only faith could have propelled one to mount the peak and reach the monastery with arms **laden** with food and spiritual nourishment. A few miles off in the distance emerges the silhouette of Little Skellig, where it is impossible for boats to drop anchor. In the distance is neither monastery nor ancient stones, just birds meditating on the sea.

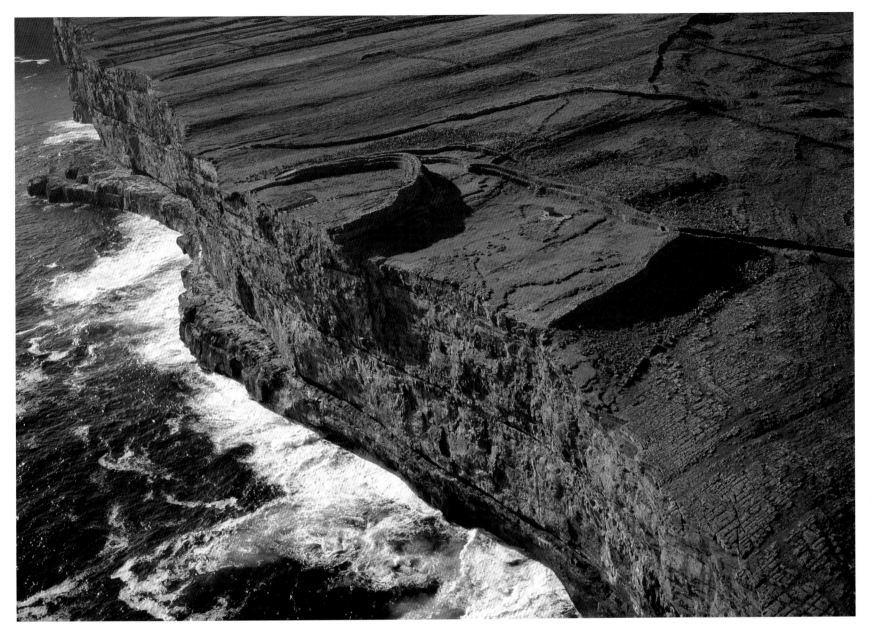

IRELAND. THE ISLE OF INISHMORE, ONE OF THE THREE ARAN ISLANDS. THE REMAINS OF THE DUN
AENGUS FORT ON THE DIZZYING CLIFFS OF INISHMORE, ALONE, FACE THE ATLANTIC.

The entry to the Bay of Galway is protected by the string of Aran Islands—Inishmore, Inishmaan, and Inisheer.
Inishmore is the largest, its Dun Aengus fort, which doesn't seem to mind heights, hangs over the sheer drop of
the cliffs. The remains and their thick walls extend out into the void, a few hundred feet separating them from
the waves that wash against the base of the island. Violent winds and assaults from the Atlantic hold sway.
Arriving by ferry, aficionados of Celtic mythology regularly come to meander along the rocky paths around the
small walls, the only human traces in this hostile landscape. There are miles upon miles of rock walls, 7,450 miles
(12,000 km) in total. For centuries, the residents of Inishmore have fertilized the land by digging out grooves in
the rock and filling them with a combination of sand and seaweed. Arable land was still not possible when these
windbreak walls were constructed, striating the landscape and giving it the appearance of a stone puzzle.

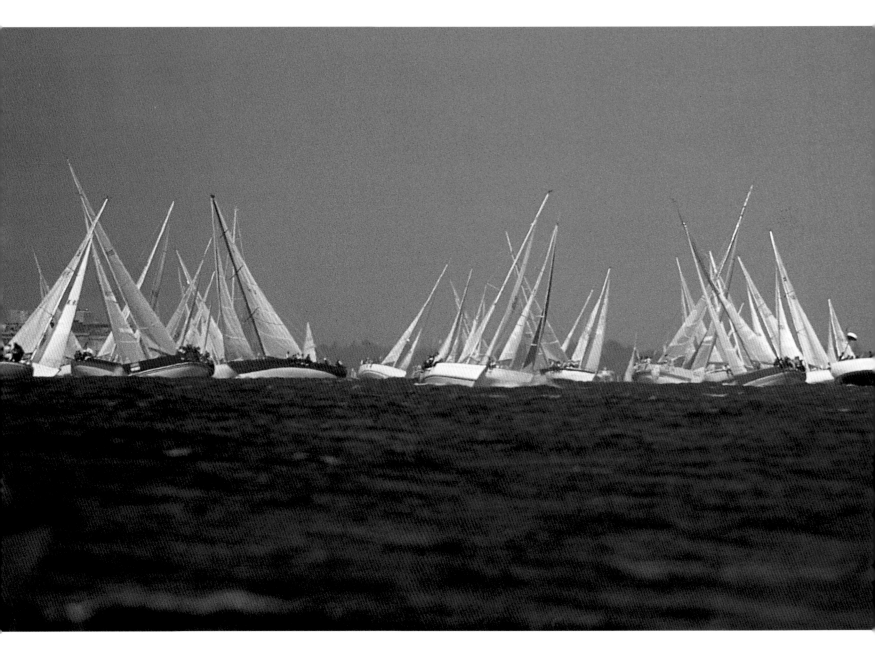

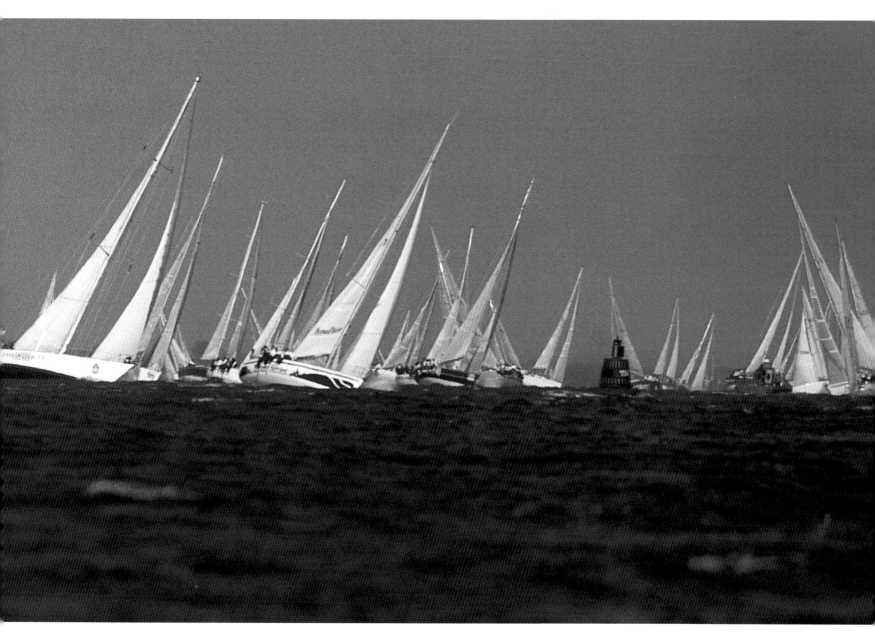

A REGATTA IN THE BAY OF QUIBERON. A NAVAL BATTLE TO ROUND THE BUOY.

The Bay of Quiberon, protected from Atlantic currents by sand dunes and the rocks of the peninsula, presents an exceptional stretch of smooth sea to yachters along the south coast of Brittany. The French National Sailing Academy, established in Beg-Rohu in 1966, has an international reputation for producing some of the best skippers in the world. During regattas, the most spectacular moments are those in which the yachts round the buoys. The yachts sail amain, gunwale to gunwale, their sails filled, all with the same objective: to make the shortest pass, to close in tightest against the buoy, and to gain a few precious seconds over one's competitors. The maneuver demands such precision that even if executed a thousand times before, the expertise could be rendered null at any time by a mischievous gust of wind.

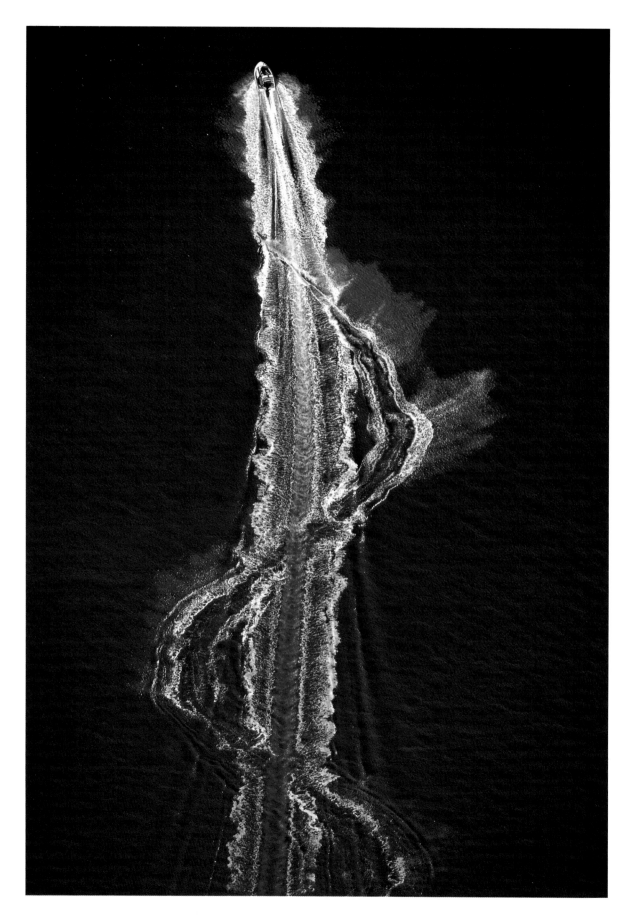

WATER-SKIING IN THE
GULF OF MORBIHAN,
ON AN ATLANTIC OCEAN
AS SMOOTH AS GLASS.

It is difficult to imagine that these deep blue waters, as calm as a mountain lake, are separated from the fury of the ocean merely by the Port Navalo barrier. South of Brittany, the Gulf of Morbihan forms a 115-square-mile (300-square-kilometer) internal sea that is more of a lagoon than a conventional seaside. In foggy weather, the rivers, wetlands, forests, islands, and rocks create an imprecise landscape that wavers between terra firma and the open sea. The residents of the gulf, however, are resolutely bound to the water. Although the children of this region may no longer join the French navy or work on fishing and commercial vessels, the local economy has gotten a second wind through tourism and pleasure sailing. As on the Île aux Moines and the Île d'Arz, and in the ports of Séné, Bono, and Arradon, one house in three is now a second residence.

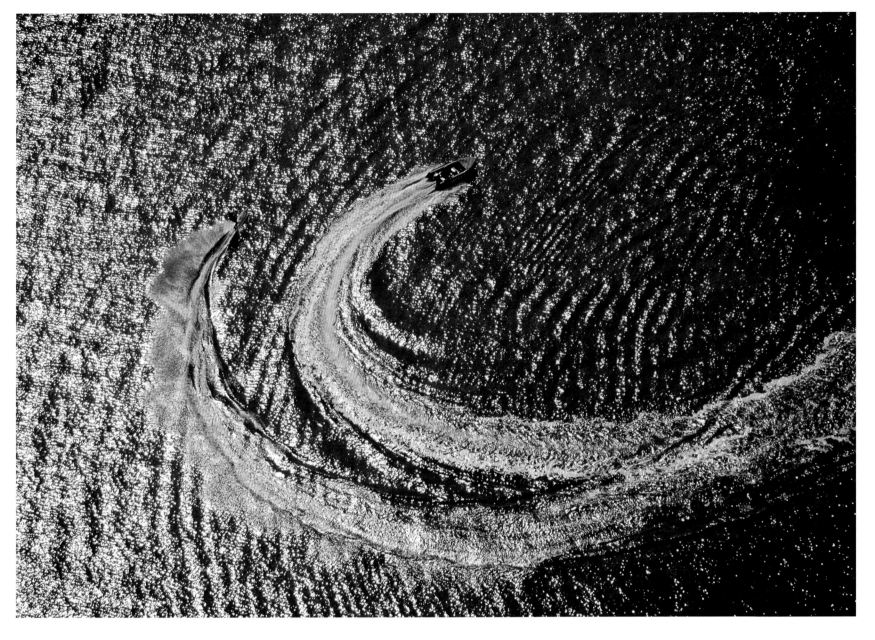

SAILING. TO EACH THEIR OWN.

Yachting, whether with motor or sails, is a pleasure. This leisure activity varies widely, from the charm of coastal sailing up the calm, deep creeks of the Mediterranean and the river mouths, to setting offshore speed records. Sailboats of every size and age, roaring motors on yachts, surfing and sea kayaking, windsurfing and water-skiing, deep-sea diving and deep-sea fishing, the sea makes no distinctions, lending its waves and winds to every one of these human inventions. A sparkling wave exercises an irresistible attraction, and inspires continual innovations. The most recent incarnation of water-skiing, the wakeboard, created by surfers around 1970, is ridden standing up while being pulled by a motorboat.

LIGHT AND SHADOW. THE SHADOWS OF THE RIGGING MAKE THE SEA CHANGE SAILS.

The life of the sea began in Earth's infancy, 3.9 billion years ago, but its common history with humanity began only yesterday. The first chapters were probably written between the third and second millennium BC. Through all those centuries, how many lives has the sea erased without a trace? How many of the drakkars, galleons, and caravels that have sailed through the history books has it quietly digested? The icy end of the *Titanic* and its 1,513 victims in 1912; the drama of the *Lusitania* and its 1,200 passengers, sunk by a German torpedo in 1915; the 118 people trapped in the *Kursk* at the bottom of the Barents Sea in 2000—the sea washed its impassive waves over all these tragic episodes. And yet if one looks carefully at its surface, a fleeting apparition may slip by, the specter of some ship that has evaded the ocean's memory, a caress from eternity.

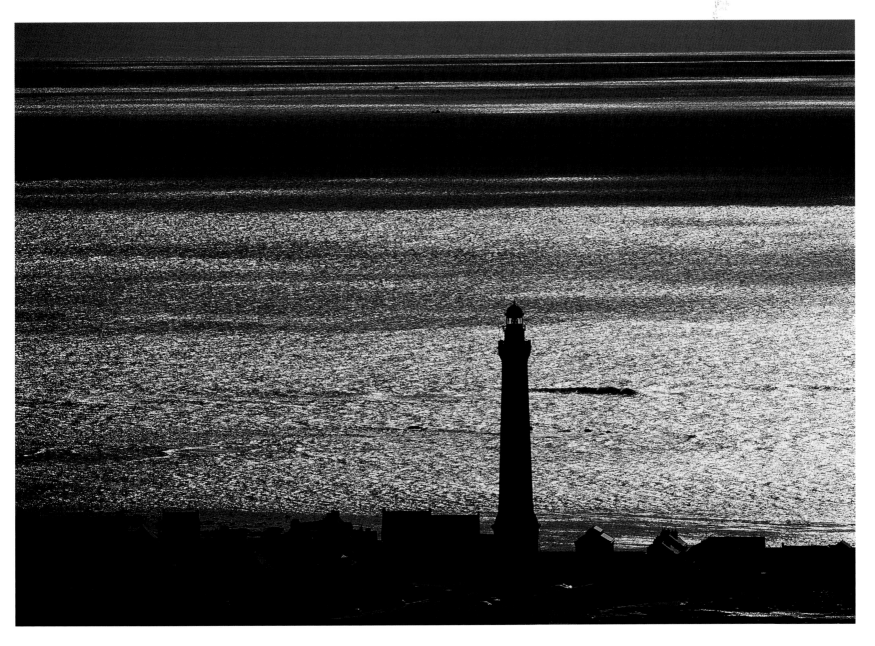

PENMARC'H, SOUTHERN FINISTÈRE. THE IMPRESSIVE ECKMÜHL LIGHTHOUSE.

When, in 1809, Louis-Nicolas Davout, one of Napoleon's marshals, thrashed the Austrians, he was renamed in glory after the Bavarian village where his military feat took place—Eggmühl. When Adélaïde-Louise Davout, marquise of Blocqueville and daughter of the prince of Eckmühl, passed away eighty years later, she bequeathed 300,000 francs and her wish that a lighthouse be erected worthy of the name it was to bear. Five years after her death, the Eckmühl lighthouse was lit at Penmarc'h, in Bigouden, amid clamorous festivities and the sound of the Breton bagpipes known as *biniou*. The lighthouse's centennial was joyously celebrated not long ago. A bust of the eponymous prince greets anyone brave enough to climb the 307 steps to the wrought-iron balcony more than 200 feet (65 m) farther up to be kissed by the pitch-scented spindrifts. Strolling around the foot of the steps, visitors can touch the Kersanton granite with which the land lighthouses are made; with the noble lighthouses of the sea, on the other hand, only the waves enjoy this privilege. Whether they are on land or at sea, their raison d'être is the same. As the marquise had hoped, "the tears shed for the casualties of war will thus be redeemed by the lives saved from the storm."

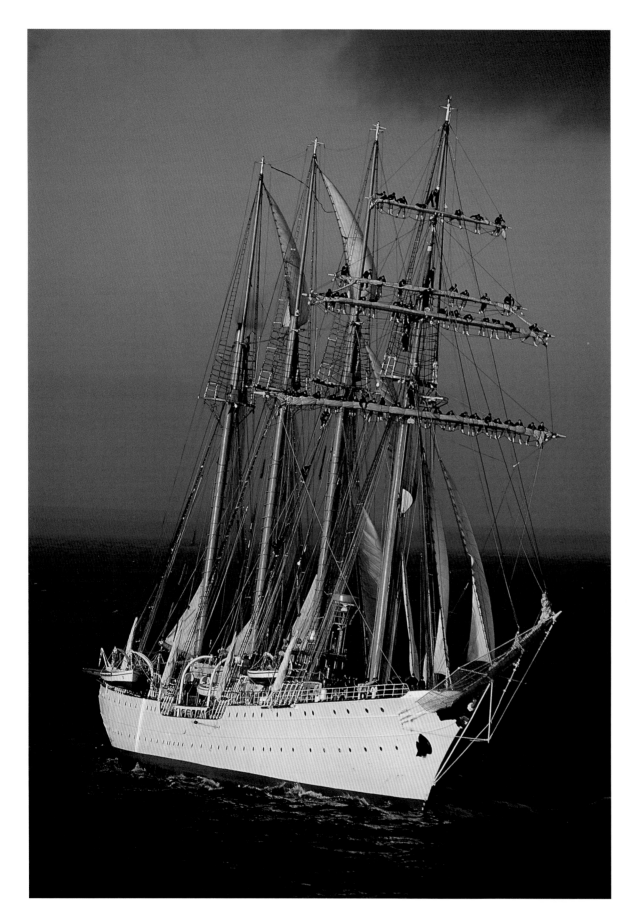

RIGGING. GREAT MANEUVERS
AND KEEPING THE WIND
IN THE CANVAS OF THE
ESMÉRALDA.

When a sailboat has several
masts, they are named according
to their position. The foremast—
as the name implies—is at the
front of the ship. Behind the
foremast is the mainmast, and
behind that, aft, is the mizzen-
mast. The diagonal spar that
extends the prow is called the
bowsprit. Each mast can be
divided into sections, each with
its own name. If a mast is all of
a piece, it is a pole mast, but an
assembled mast will be made up
of a lower mast, above which
are one or more upper masts—
the lower and upper topmasts,
the topgallant, the royal mast...
a veritable forest of masts! To
create one of the great four- or
five-masted tall ships, all you
have to do is add one or two
mainmasts that are distinguished
by their position, fore mainmast
and aft mainmast. This profusion
of masts, emblems of the great
sailing ships in the collective
imagination, has broken records.
Sailboats have been built with
as many as six and seven masts.

A WAVE OF MELANCHOLY.

Sometimes the glimmering sea suffers a wave of melancholy. Overwhelmed by nostalgia for years gone by, some-
times even this great expanse feels a touch of weariness in its seemingly eternal existence. The oceans began to
form 44 billion years ago. Earth, then in its earliest youth, was hit by storms of meteorites that released carbon
dioxide upon disintegration, thus creating the water vapor that would be necessary for the eventual creation
of these immense bodies of water, from condensation. The seas must have had a chaotic "childhood," given the
young Earth's unstable conditions. Vaporization may have caused them to appear and disappear several times, as
a result of multiple periods of warming produced by asteroid showers. After the bombardments of celestial pro-
jectiles ceased—3.9 billion years ago—the oceans finally stabilized. In time, simple life forms would emerge,
first in the form of bacteria, then, 3 billion years later, as sponges, shipworms, and jellyfish.

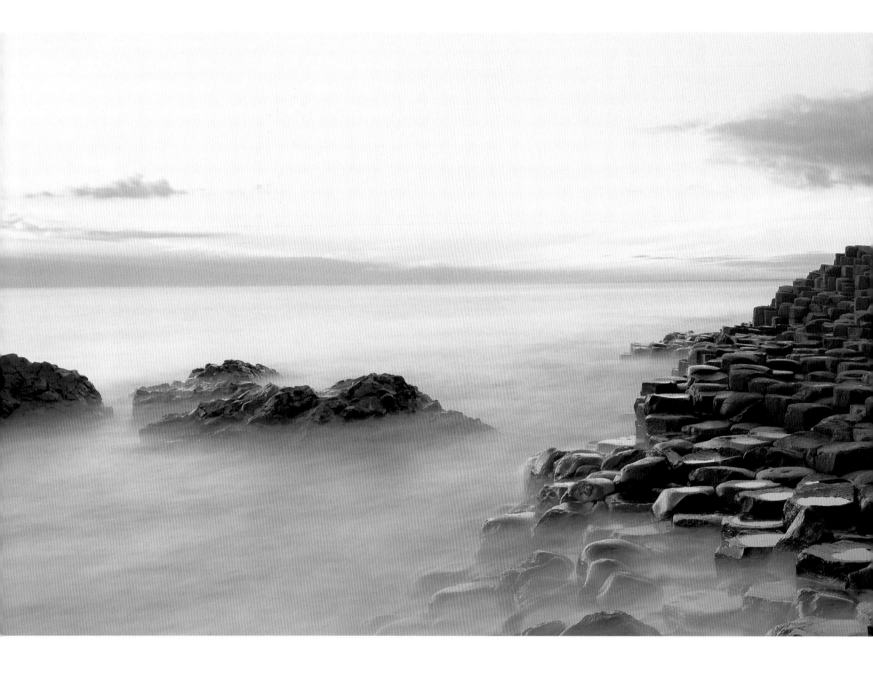

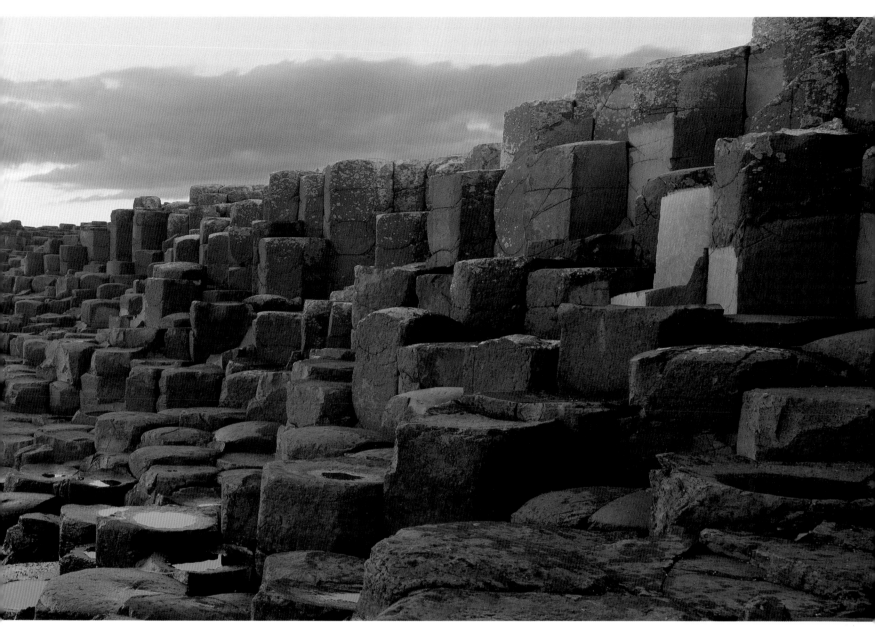

NORTHERN IRELAND. GIANT'S CAUSEWAY, NEAR BUSHMILLS.

Gaelic legend has it that when Northern Ireland was inhabited by giants, they used a paved causeway of enormous proportions to reach the shores of Scotland, located a Herculean stone's throw away. At the time, depending on the version of the story, they crossed the Irish Sea for love—seeking a tryst with some colossal sweetheart—or else to pick a fight with the rival titans who lived on the other side of the sound. More prosaically, the Giant's Causeway, which extends along the foot of the cliffs that edge Northern Ireland's Antrim plateau, is a natural wonder created by the cooling of the basaltic lava issued from volcanic activity 50 to 60 million years ago. The result of this geological convulsion was some forty thousand polygonal columns, partly leveled by the surf, which descend in a gentle incline into the waves. The geometric perfection of this group of tightly overlapping vertical prisms, forming something that looks like an immense honeycomb, has kept the attention of geologists for three centuries. In 1986, it also earned the Giant's Causeway a place as a UNESCO World Heritage Site.

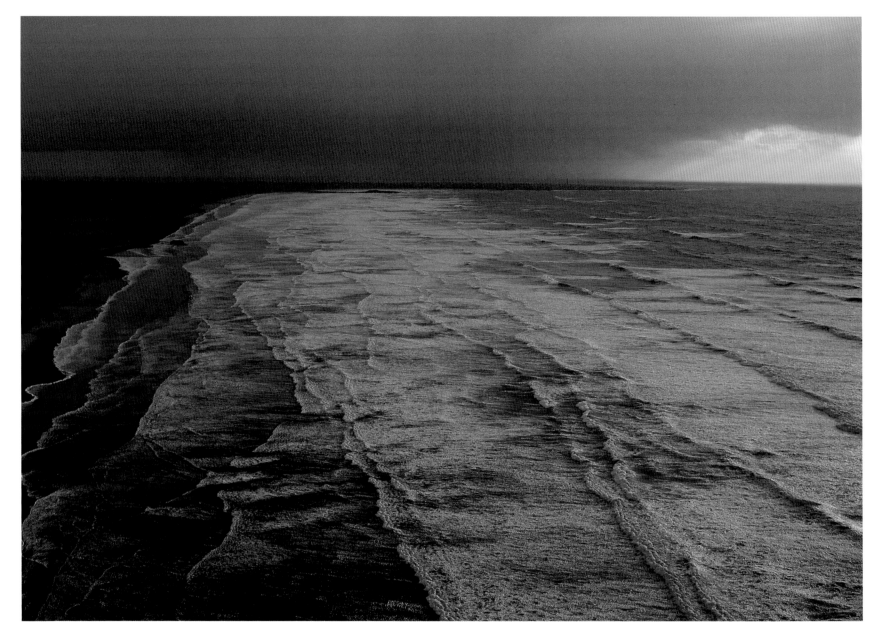

BAY. THE BAY OF AUDIERNE PRESENTS A SINGULAR JUXTAPOSITION OF SHALLOW MARSHES AND LAGOONS, SEPARATED FROM THE OCEAN BY A LINE OF SHIFTING DUNES. THREE HUNDRED SPECIES OF BIRDS EITHER NEST HERE OR STOP HERE IN THEIR MIGRATIONS.

Bounded on the south by Penmarc'h Point, visible from far away, and on the north by the headland of Sizun, the bay of Audierne opens onto the Finistère's southwest. It rolls out a 6-mile (10-km) dune-edged beach on the Atlantic Ocean; because of that exposure, the beach is very vulnerable to erosion. The waves, which usually curl out sideways, create a littoral drift that tears away huge quantities of material. The winter storms and their powerful breakers only aggravate the erosion on this sandy shoreline. In 1997, at Tuvalu in the Pacific, violent hurricanes hit a small island and, whirling the sand off its beaches, wiped it off the map. In just a century, the La Coubre lighthouse, in Charente-Maritime, has seen the distance between itself and the sea shrink from a mile (1,500 m) to 813 feet (250 m). Planetwide, it is estimated that 10 percent of the beaches are growing, and 20 percent are remaining stable. The remaining 70 percent are tending to shrink—like the bay of Audierne, as evidenced by the World War II pillboxes built along the shore that today are buried in sand and flooded at high tide.

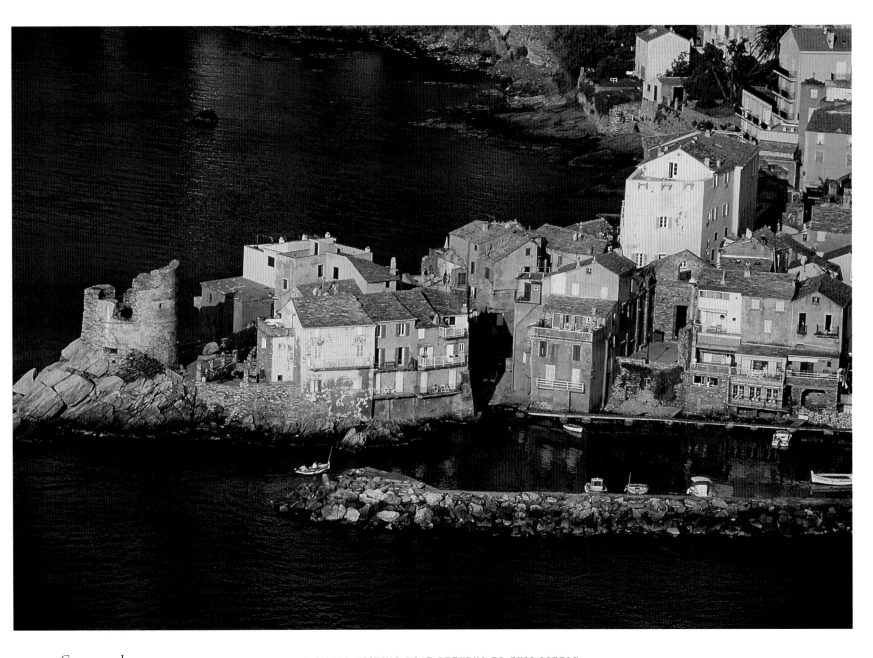

CORSICA. IN THE EARLY MORNING LIGHT, A SMALL FISHING BOAT RETURNS TO THIS LITTLE HARBOR ON CAP CORSE, NORTH OF BASTIA. THE WIND IS RESERVED FOR THE LOCALS FIRST.

Fishing in the Mediterranean accounts for only 1.5 percent of world production. Every year, 1.5 million tons of fish are caught in the Mediterranean, principally by fishermen from Turkey, Italy, and Greece. This ancient tradition is alive and well among the people who live near the Mediterranean. Unlike in the North Atlantic, the activity is carried out on a small scale. It is a major source of food, employment, and revenue; it also plays an important social, cultural, and economic role. The makeup of the fleet—85 percent small coastal fishing boats, 10 percent trawlers, and 3 percent seiners—confirms the dimensions of the sector. More than 40 percent of the catches are sardines and anchovies. Other species, particularly hake, sole, bass, and monkfish, are fished beyond their natural ability to replace themselves. Recent international agreements prove that efforts are being made to improve joint management of the Mediterranean's resources.

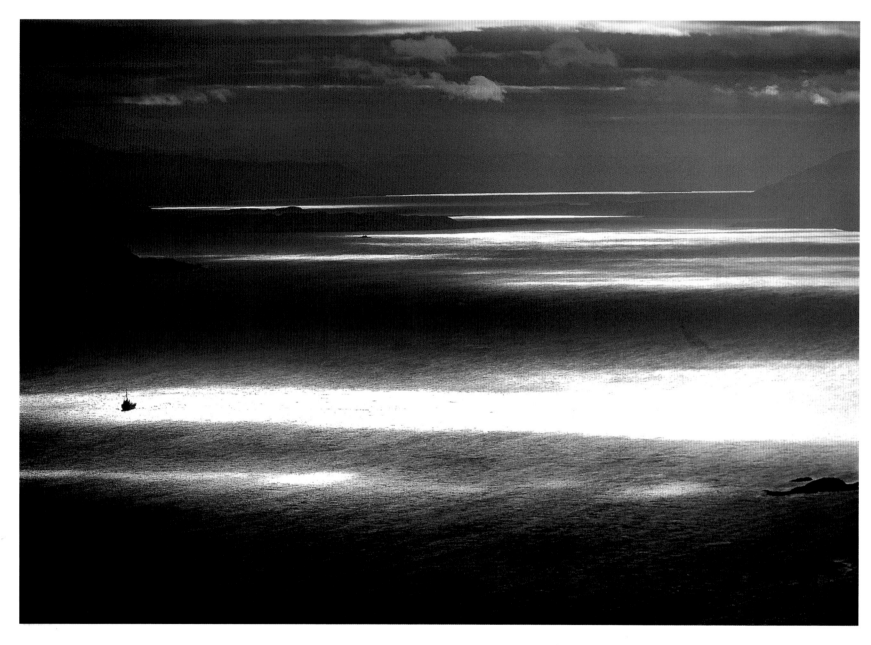

PATAGONIA. A BREAK IN THE SERIES OF STORMS THAT RAGE IN SOUTHERN CHILE
ALLOWS PALE SUNLIGHT TO SHINE ON THE BEAGLE CHANNEL.

Hurling themselves from the west down the thousands of miles of the high Andes, the great winds and ocean
plunge in a whirling rage through the opening they find at the ragged tip of the continent of South America.
This is the region of Patagonia's wild and windswept passages, and of the terrifying cape called the Horn. This
rocky island, whose promontories reach as high as 1,460 feet (450 m), is prey to the tempests' fury 300 days a
year. Historically, the dreaded cape has caused the loss of some 800 ships and more than 10,000 human lives.
As the cyclonic depressions pass, the cloud cover breaks apart. Those wispy shreds cast moving patches of
shadow onto the sea, and the dark straits of Tierra del Fuego come alive with shimmering light. In the wake of
the famous Cape-Horners—the great sailing ships that took on the perilous but unavoidable passage to the
Pacific—a solitary vessel takes advantage of a precious lull to cross this magnificent end of the world.

LORIENT. THE GROIX tuna
fleet decays in the tides
of the Blavet estuary.
Dozens of wrecks rest in the
ships' graveyard at Kerhervy,
nestled in the hollow of the last
meander. Here, the Blavet River
slows before it joins the Scorff
at Lorient, their common mouth.
The oldest are the tuna ships
from the Île de Groix, a few
miles offshore; they have lain in
this cove since the 1920s and
are sinking inexorably into the
mud. *L'Ouragan*, a trawler out
of Port-Louis, was the last to
arrive, in January 2001. Here,
in its last moorage, it joined
the eternally charming dundees
stranded in the Blavet estuary.
Innumerable ships sail the
world's seas with not a thought
of retirement. More than
40 percent of the world's ships
are more than fifteen years old,
and these are involved in a
disproportionate 80 percent of
accidental shipwrecks. A ship's
age is not the determining factor
of its seaworthiness; however,
owners generally tend to try to
save money on the oldest boats,
spending less for both materials
and expenses associated with
the crews (living and working
conditions as well as training).
At the same time, it's human
error—rather than structural
or mechanical defect—that
is responsible for 80 percent
of shipwrecks.

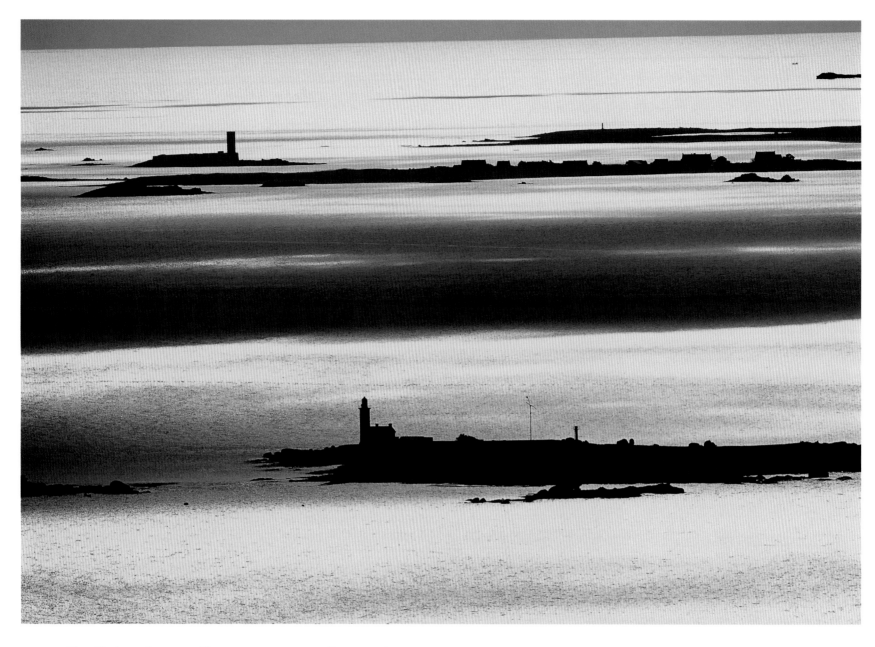

The Glénan Islands. This archipelago is Brittany's very own atoll.

The skyline of the Glénan archipelago is silhouetted against the late afternoon light, including the recognizable cylinder of Fort Cigogne and the lighthouse and keeper's lodge on Île aux Moutons. Off Concarneau about 12.5 miles (20 km), this Breton gem is a scattering of a dozen islets strewn in the crystalline Atlantic shallows, home since 1951 to the renowned Glénans sailing school. The famous Quémérés lived in the Île aux Moutons lighthouse, built in 1878. First assigned to the Eckmühl lighthouse in 1900, the couple moved to the infernal stone of Tévennec. This was the lighthouse that drove people mad, but it left Marie and Louis Quéméré's growing tribe unscathed. In 1906, they moved from their rock to a 15-acre (6-ha) piece of land, the Île aux Moutons, in the more forgiving climate of the Glénan archipelago. The couple soon occupied the larger space along with eleven children, three cows, sheep, ducks, geese, chickens, and rabbits. The Quémérés clung to their lighthouse for twenty-six years, filling the tiny islet with teeming life.

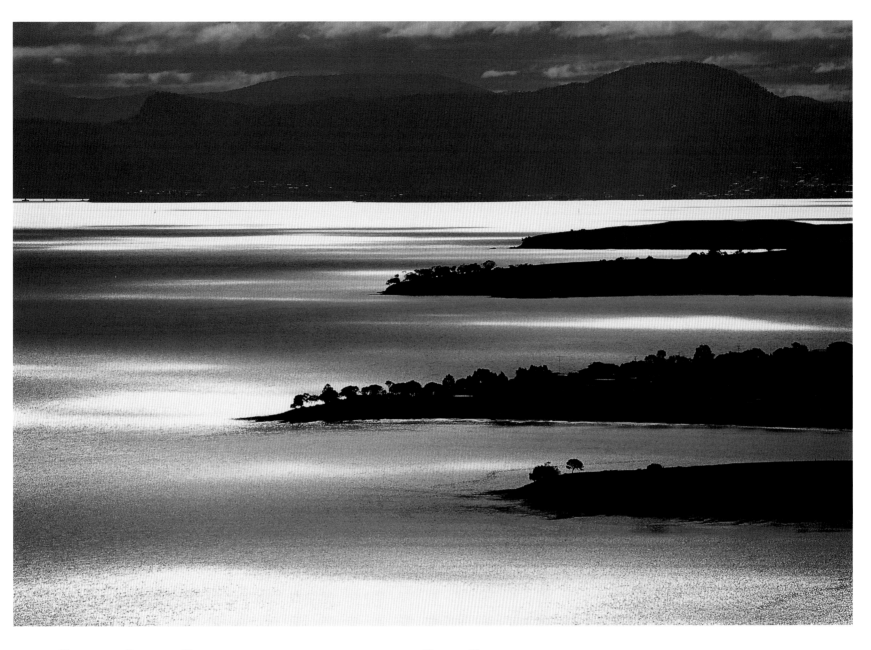

TASMANIA. SULLIVAN BAY, WHICH ANNOUNCES THE ENTRANCE TO HOBART HARBOR, IS CUT DRAMATICALLY INTO CAPES AND FJORDS. THIS IS WHERE THE FAMOUS SYDNEY–HOBART YACHT RACE FINISHES EVERY YEAR IN LATE DECEMBER.

In southern Tasmania, the coastline's deep indentations gradually fade into the sea. But beyond the surface of that mirror, does the land correspond to the mountains on land? People once tended to imagine the ocean floor as a vast, monotonous desert plain. The explorations of the ocean depths that began in the early nineteenth century, however, have disproved this hypothesis; around 1950, they began to reveal the variety of the landscapes of the abyss that were concealed beneath the mysterious liquid expanse. To about 650 feet (200 m), the continental plateau extends down at a gentle angle from the emergent land masses. These margins take up less than 8 percent of the ocean floor. Next comes the steeper continental slope, which rolls down into the abyssal plains. At an average depth of more than 2 miles (3,700 m) are the ocean ridges and their foothills, the volcanoes with their pointed cones, and the dizzying trenches, such as the Pacific's Mariana, the deepest of them all, plunging almost 7 miles (11 km) down. Although it represents more than 60 percent of our planet's surface, the universe of the ocean depths is beyond our reach. We know the surface of Mars better.

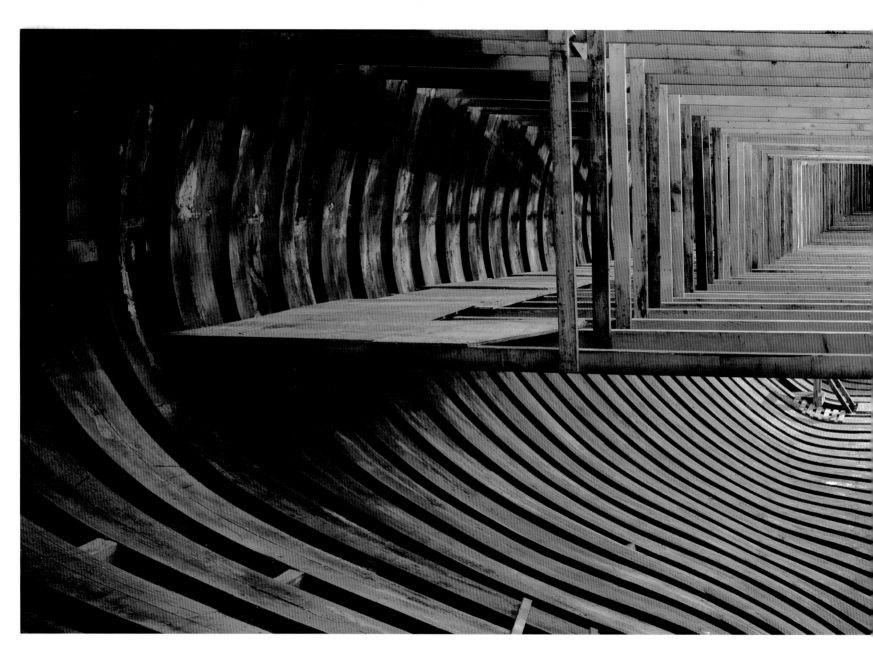

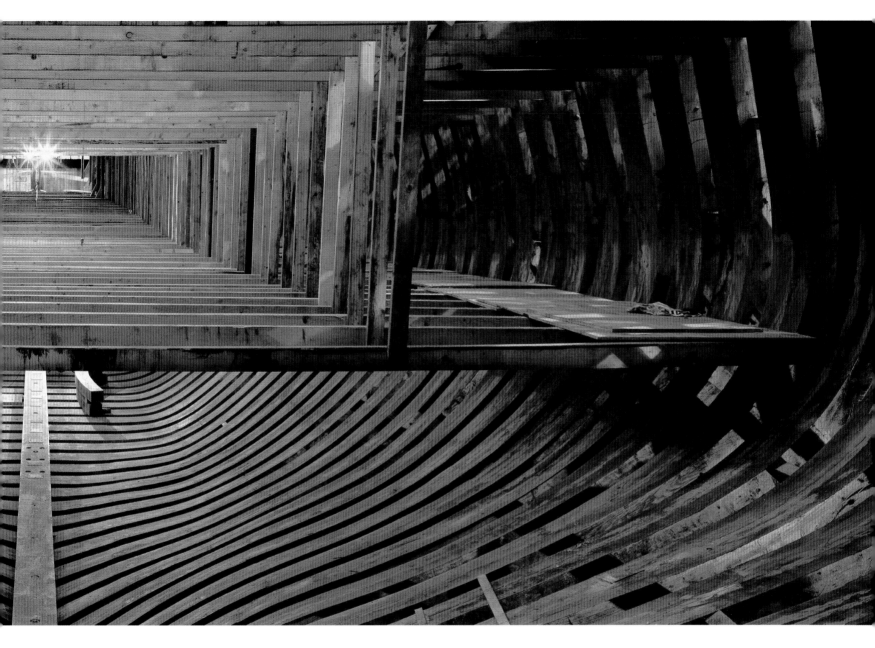

ROCHEFORT-SUR-MER. SKELETON OF THE FRIGATE HERMIONE.

In the eighteenth century, the Brest, Toulon, and Rochefort dockyards supplied ships to the French navy. Just the hull of these giants required nearly a year's work. The master shipbuilders, who kept their lore secret, used oak for the hulls—a seventy-four-gun vessel required some 2,800 century-old oaks—and suppler and lighter pine wood for the masts. The building began with the frame, the lengths of timber that make up the section of the hull that is fitted perpendicularly to the keel. Next, the ceiling and the plating (the inside and outside lining of the hull) were laid on, then the bridges; the portholes were cut out, and the caulked ship went to a registry pier. Thus the *Hermione* was born in Rochefort after eleven months' gestation time. In 1780, this light, three-masted frigate 211 feet (65 m) long carried the marquis de La Fayette to join the American insurgents fighting for independence. Since 1997, the Hermione–La Fayette Association has been pursuing their dream of reconstructing the frigate. In 2007, the *Hermione* will be launched into the wake of its illustrious ancestor.

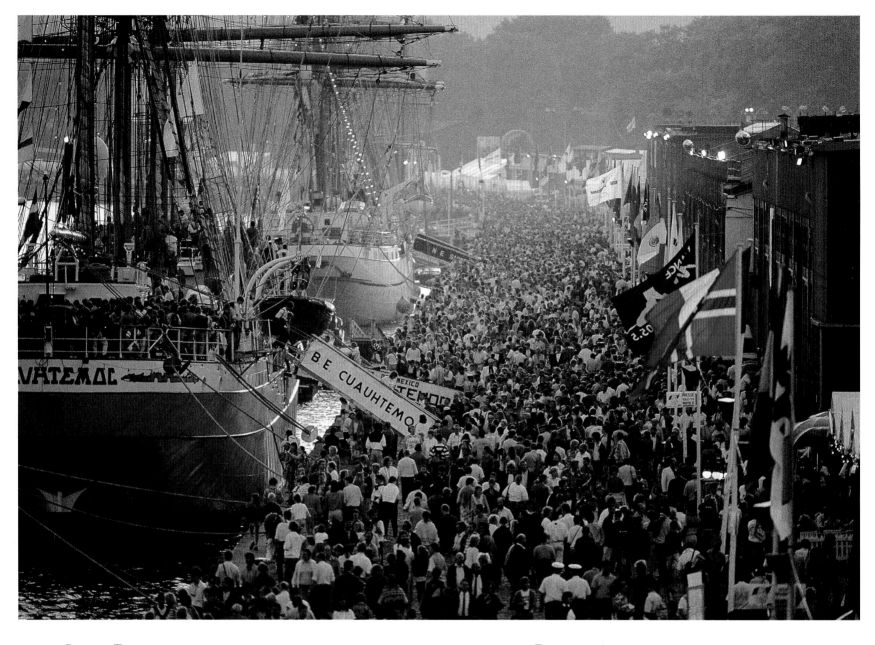

ROUEN. THE GREAT POPULAR ARMADAS ORGANIZED ON ITS SHORES ARE ALLOWING FRANCE
TO CONNECT WITH ITS NAUTICAL TRADITIONS TO SOME DEGREE.

We can read astonishment in the eyes of the public that crowds around the *Cuauhtemoc*, a 293-foot (90-m) three-masted bark
that serves as a training ship for the Mexican merchant marine. As they stroll up and down the port of Rouen's 5 miles (8 km) of
docks, visitors are entranced by these gigantic ships from a bygone age that lower their gangplanks and invite them to explore
their inner selves. Rouen's Voiles de la Liberté—"Freedom Sails"—celebrating the bicentennial of the French Revolution, was
the city's first festival of tall ships. The Armada de la Liberté—"Freedom Armada"—followed in 1994, on the fiftieth anniversary
of the Normandy landing. In 1999, the ten-day festivities of the Armada du Siècle—the Armada of the Century—attracted some
10 million curious people and about sixty sailing ships, warships, and riverboats from thirty countries. The finale of this spectacular
event was the Parade de la Seine, and its concluding show of the vessels setting sail amid the applause of their entranced audience,
massed along the 75 miles (120 km) between Rouen and the English Channel. The fourth Rouen Armada took place in July 2003.

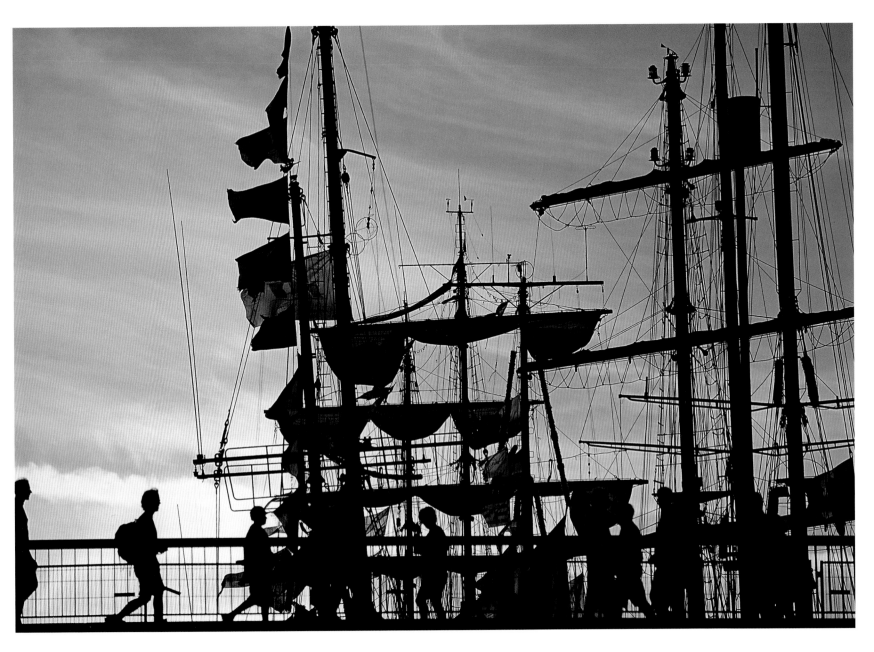

FOR THE ANNIVERSARY OF THE FRENCH REVOLUTION,
ROUEN PUT ON A CELEBRATION: THE SAILS OF LIBERTY.

In celebration of the bicentennial of the French Revolution, the association of Sails of Freedom gathered eigh-
teen tall ships in Rouen—a city blessed with one of the longest docks in the world. Included were the *Amerigo
Vespucci* (built in 1930 and more than 330 feet/100 m long), the *Libertad* (launched in 1956, 338 feet/103 m), the
Sagres II (1937, 292 feet/89 m), the *Belem* (1896, 190 feet/58 m) and the *Statsraad Lehmkühl* (1914, 322 feet/98 m).
There were immense masts, gleaming brass, unknown uniforms, square beacons, and wooden pulleys—a feast
of colors, shapes, and materials one would have thought long lost. To convince themselves that they were not
dreaming and to spend a few hours outside of time, tens of thousands of spectators showed up. Then hundreds
of thousands. Ultimately, a human wave of 3 million people came to view the parade of tall ships that sailed
between Rouen and the mouth of the Seine at Honfleur. A revelation.

AN EXERCISE ABOARD THE *SURCOUF*. THE PANTHER WILL SOON BE SPIC AND SPAN.

The second stealth frigate to leave the Lorient shipyards in the south of Brittany was named for the Breton ship owner known for his exploits in the Trades War—the pirate from Saint-Malo, Robert Surcouf (1773–1827). Launched in 1993 and brought into active service in 1997, this 410-foot (125-m) vessel stands apart for its acoustic discretion and its low radar detection. Designed to listen without being seen, it is equipped with combat apparatus such as Exocet MM40 surface-to-surface missiles, a Crotale CN2 surface-to-air missile system, and guns. In addition, the *Surcouf* is equipped with a medium-weight Panther helicopter, able to be rigged with a missile launcher. The La Fayette-class stealth frigates have a stabilizing system that keeps them level, even in cross swells, up to Beaufort force 5 to 6. These helicopters can both land and take off from the deck, even in stormy weather.

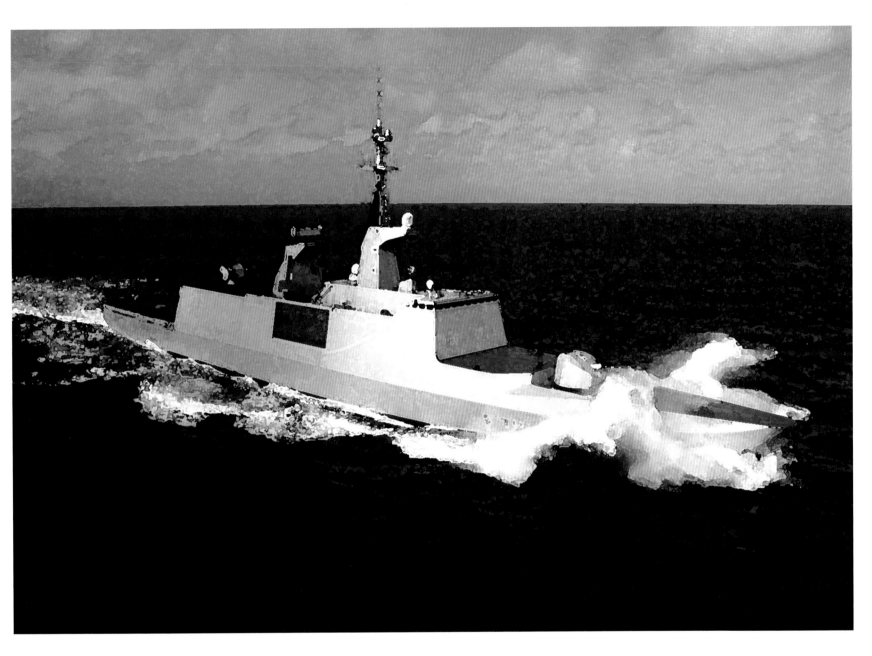

STEALTHILY, THE FRIGATE GLIDES WITHOUT CHURNING.

Designed to pass imperceptibly through enemy radar, the La Fayette stealth frigates look like futuristic constructions. The first five ships of this series were built in Lorient and launched in the 1990s. Aboard, everything has been designed to reduce the radar and acoustic signatures. The surfaces have been coated with a radar-absorbent paint, the foredeck and the quarterdeck covered, the lifeboats fitted into a superstructure and concealed behind railings. All the materials used help to reduce detection, special helices reduce vibrations, and the engines have been mounted on absorbent contacts. This underwater technology has been perfected so as to help carry out information-gathering and surveillance missions.

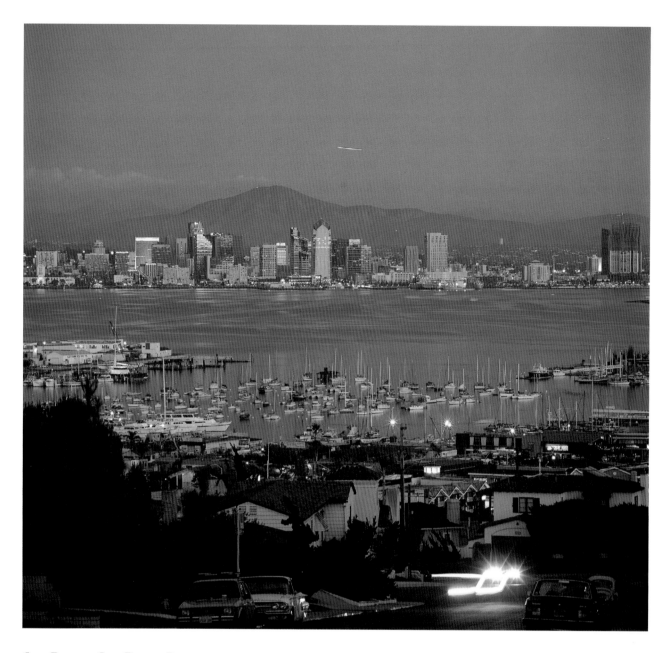

SAN DIEGO. SAN DIEGO BAY LIGHTS UP AS NIGHT FALLS, THE MASTS OF
THE PLEASURE YACHTS POINTING SKYWARD, AWAITING THE FIRST STARS.

The buildings of downtown stand in contrast to the hills beyond. The city of San Diego, with its 2.5 million residents, is the fifth-largest city in the United States. This urban center is undoubtedly oriented toward the sea, as is the vast majority of its tourist industry. The port is quite pretty and even moving, differing from other large city ports. There are a number of attractions in this zone of 22 square miles (57 km²), but the undisputed epicenter of San Diego is Mission Bay Park, the largest municipal aquatic park in the world. This recreational universe measuring 4,600 acres (1,860 ha) incorporates several islands, lagoons and 27 miles (43 km) of sandy beach. But above all, there is the famous Sea World, a marine park home to the largest colony of penguins in captivity and known for its performances with dolphins, seals, and the famously intelligent killer whales. There are also vast aquaria with roving sharks, moray eels, and barracudas, among other sea life.

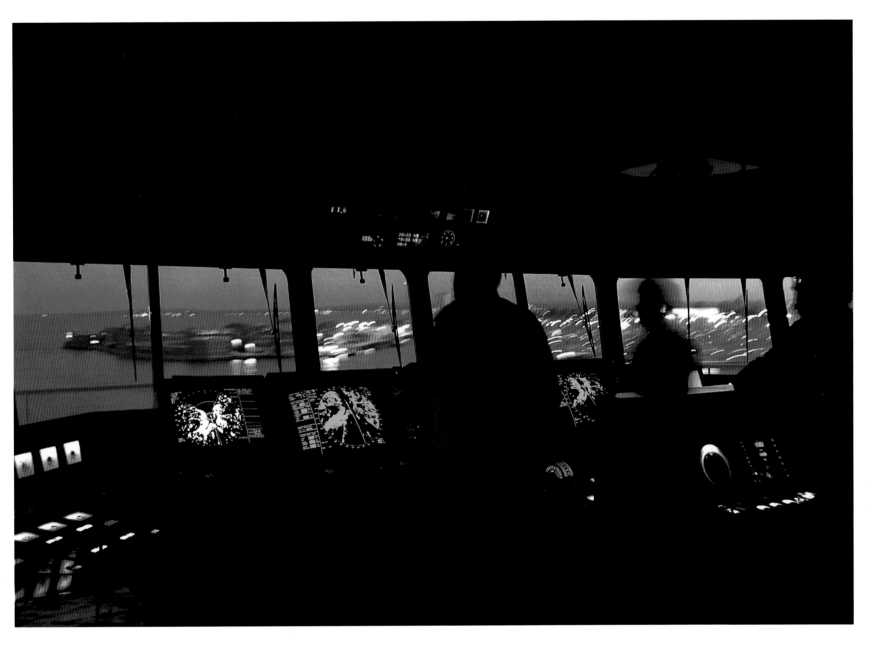

Three men on the gangway—the skipper pilots an unfamiliar ship through a familiar port. The captain, assisted
by his second, perfectly controls *his* ship but seems to be completely unaware of his surroundings. The three
men complement one another. Few words are exchanged, and when they are it is most often in English and
always in keeping with the strict etiquette of mutual respect that sailors maintain. The radar screens reveal the
contours of the port, along with the ship's speed and course, and a map of the surrounding area to be compared
with the charts. The anonymous lights of the city will slowly recede. Istanbul, Hong Kong, Helsinki, or Nantes
will soon be nothing more than a memory. Night will fall and the port pilot will climb down the rope ladder
that extends the length of the hull to the pier. It will be the crew's last contact with dry land until its next
entry, when the rope gangway welcomes aboard a new pilot from another port with equally anonymous lights.

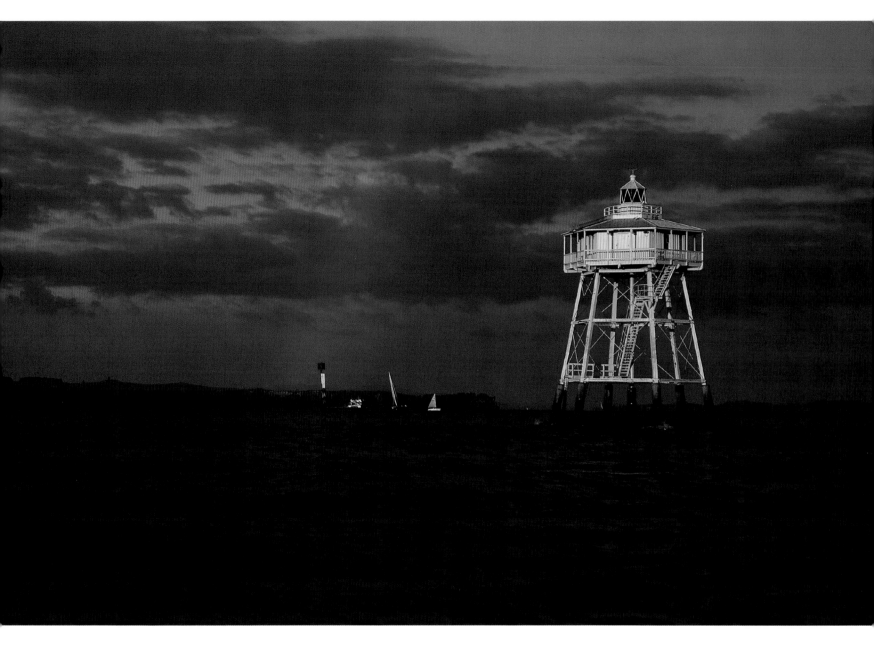

NEW ZEALAND. IN THE VAST BAY OF AUCKLAND,
BEACONS GUIDE CARGO VESSELS AND PLEASURE YACHTS.

The port of Auckland seems to stretch out to infinity, and in the wind thousands of sheets clack as they slap against thousands of white masts. In this city, everyone owns a boat, or knows somebody who does. In short, everyone here is a something of a sailor. On the welcoming billboards that adorn the boulevards is the slogan "The City of Sails Welcomes You." The New Zealander Peter Blake's victory in the America's Cup only served to reinforce this city's sea-loving identity. Since then, the regattas held in the Hauraki Gulf have proliferated, with crafts of carbon and Kevlar rounding the beacons in the bay at remarkable speeds, while avoiding the routes of the ferries and cargo ships omnipresent in the gulf. Returning to land, one has the lingering impression that the city of Auckland is an island unto itself. Many small natural ports are hidden in its jagged coastline, harbors that can take several hours to reach by car but only a few minutes by boat.

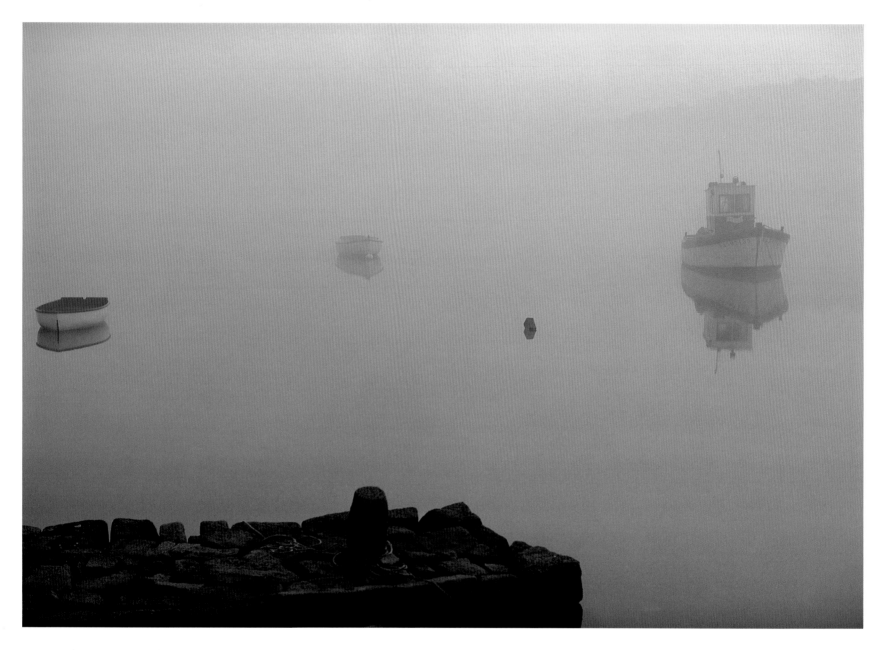

ANCHOR BUOY. AMONG BRITTANY'S CHARMS ARE THESE ANCHOR BUOYS IN BAYS AND RIVERS,
WHERE TENDERS PATIENTLY AWAIT THE RETURN OF THEIR OWNERS.

Boats on the lookout peer into the misty silence, at the mercy of the mischievous goblins that live in the nearby woods. You never know what could emerge from this thick cottony air or break through the watery mirror that shows a world in reverse. Once upon a time, popular belief of many cultures held that the ocean harbored not only gods such as Poseidon and Mannanan, but that it had the power to create sacred things such as the *amrita* that the Hindu gods drank and that it was also home to a host of sirens and other amphibian spirits, both good and bad. The depths also concealed lands such as Atlantis and the city of Ys. Marine creatures have inhabited all the seas—the Loch Ness monster has relatives everywhere. These fabulous figures, which reflect the peoples who invented them, played key roles in the world of the living. Sometimes they guided sailors from one shore to another, while at others they showed the way to the next world—the sailor's last crossing. The legendary creatures that once adorned the prows of ships today reside in children's tales. But sometimes, on a gloomy night or in impenetrable fog, they return, more real than ever, to our imaginations.

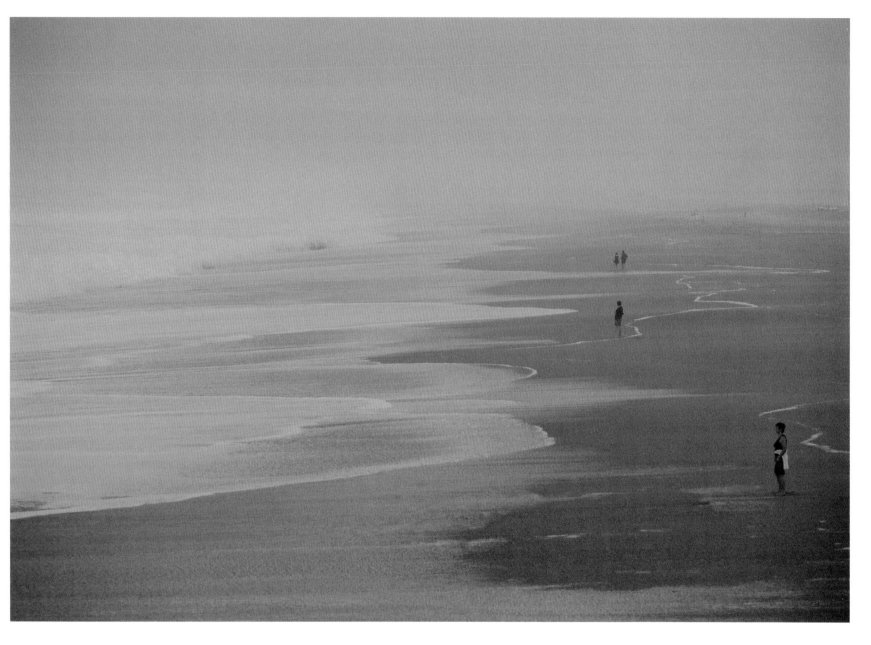

BAYONNE. EUROPE'S LARGEST BEACH, WHERE THE WAVES OF THE BAY OF BISCAY COME TO DIE
AFTER CROSSING THE NORTH ATLANTIC. THE END OF AN OCTOBER DAY.

The coasts are alive with the constant exchanges of material between land and ocean that give the shoreline its shape. The sand of the beaches (which represent 20 percent of the world's coastlines) comes mainly from the land. Rivers carry it, tearing 13.5 billion tons of sediment from the land, which they deposit at their mouths. The coastal currents take up the material and distribute it along the shoreline. On coasts exposed to currents and winds, there is a negative exchange rate—the shorelines recede. By contrast, material accumulates in the sheltered stretches. Disturbances created in this movement of materials by ports, jetties, dams, and the extraction of sand can result in increased erosion in nearby areas. The planting of sea bent, a grasslike plant that sinks its roots deep into the dunes, and various measures limiting human access, including enclosure and antierosion coverings, are helping to stabilize some of the receding beaches, such as those along the coast of the Gironde.

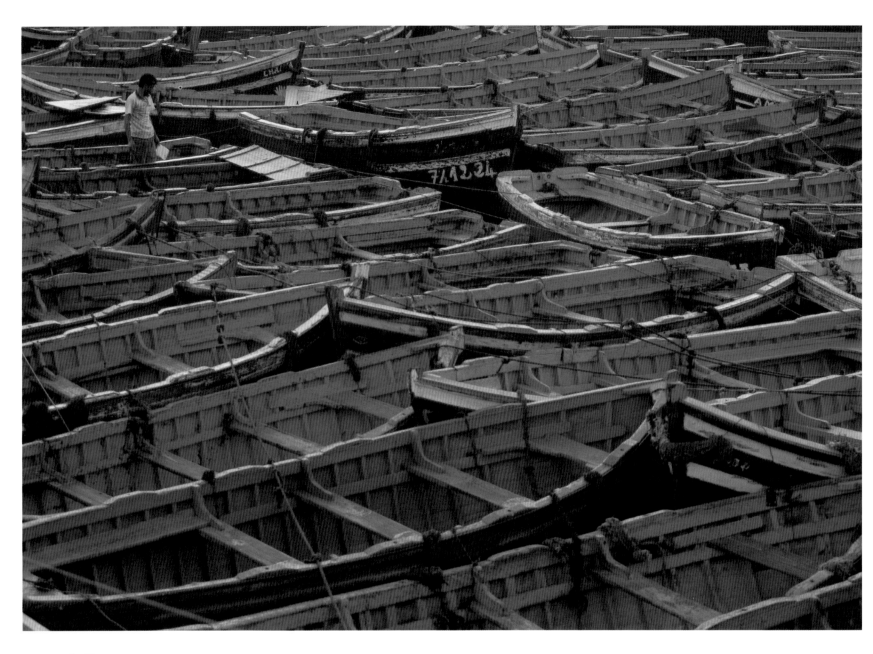

IN ESSAOUIRA, THE FISHERMEN KNOW ALL THE SUBTLE PLOYS TO HELP THEM CATCH SARDINES.

In this area, which was once known as Mogador, all the boats are painted blue so as to better trick the schools of silvery fish. In Brittany, a very fine blue is used to dye the nets that catch the fish. The *Sardina pilchardus* (pilchard)—a pelagic fish some 8 inches (20 cm) long that swims in dense schools—abandoned the western French waters during the mid-1960s and relocated to Morocco. Since then, it has lived a seasonal rhythm of migration along the 2,175-mile (3,500-km) Moroccan coastline. In the evening, the port of Essaouira is aglow with charcoal grills, fish scales glistening on the ground, and people feasting on fish caught earlier in the day. Packaging plants have sprung up all along the coast and Morocco has become the world's largest processor of sardines. Its small blue boats, assisted by an armada of more modern ones, bring in half of the world's pilchard.

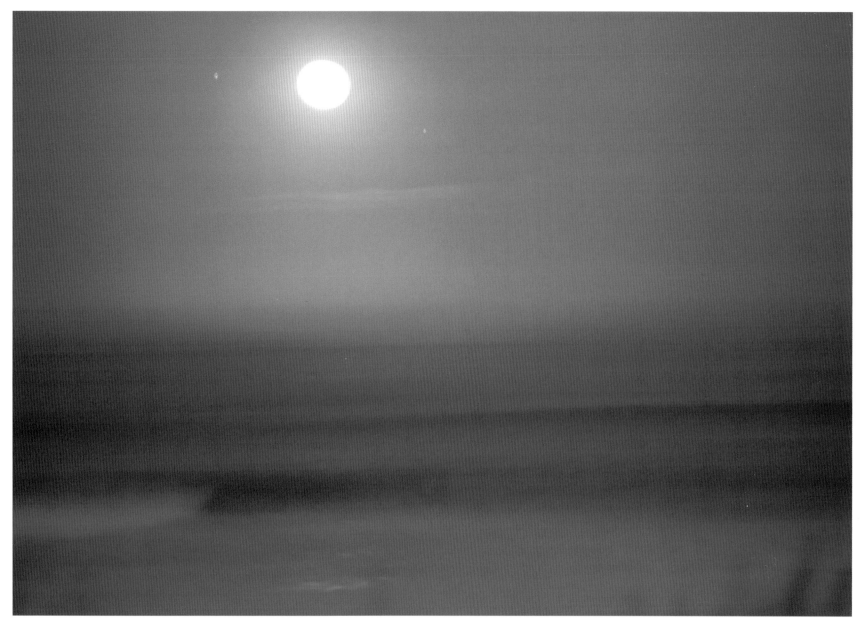

AQUITAINE. THE MOON SETTING OVER THE COAST,
BETWEEN THE SAND OF LES LANDES AND THE ATLANTIC OCEAN.

Haloed by dawn's subtle light, the moon melts delicately into the nascent day. This magical moment, touched with softness and attenuated shades, reveals nothing of the powerful forces that connect sea and moon, as is visible through the tides. Known for more than two thousand years, the nature of the tides—closely observed by the Greeks, who noticed that their size depended on the phases of the moon—was explained in the seventeenth century, when it was shown that they are produced by the gravitational pull of the moon and sun. When the position of these bodies forms a right angle with Earth (in the first and last quarters), the gravitational forces are opposed, leading to neap tides. When the moon and the sun are aligned with Earth, their gravitational pull merges: this is the period of spring tides, which reach their peak at the equinoxes. During this period the tide levels are at their highest every two weeks or so, during the new moon and the full moon, and yet so peaceful.

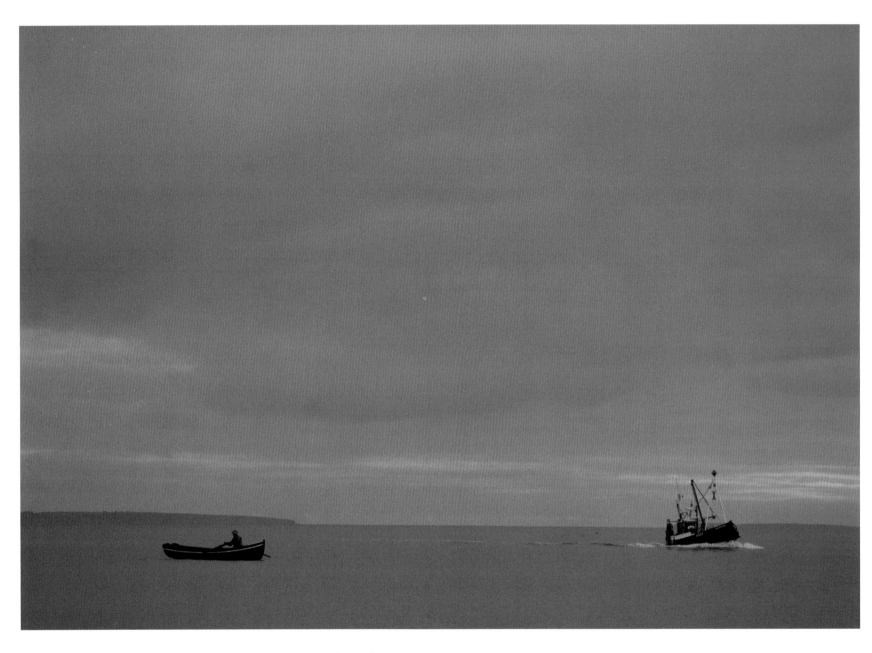

CONNEMARA. AGAINST THE BACKDROP OF THE ARAN ISLANDS,
FISHING BOATS RETURN TO THE SMALL HARBOR AT ROSSAVEEL ON A NOVEMBER EVENING.

There is always a reason that the sky looks the way it does. It expresses complex atmospheric phenomena and the eventful life of air masses. Clouds are kinetic works of art that encode whole meteorological tomes, revealing to those who can read them the secrets of the winds. The ancients complemented their interpretation of heavenly activity with insightful observations of subtle details (animal behavior, smells, the perception of distance, and so on). Although today we have lost this ability, satellites and computers deliver invaluable forecasts that are indispensable to anyone going out to sea for even a few hours. By watching the sky—a rich and easily accessible source of information—and keeping an eye on the barometer, sailors can, over time, hone and refine the data supplied by the weather report. The great book of the sky tells a different story every day.

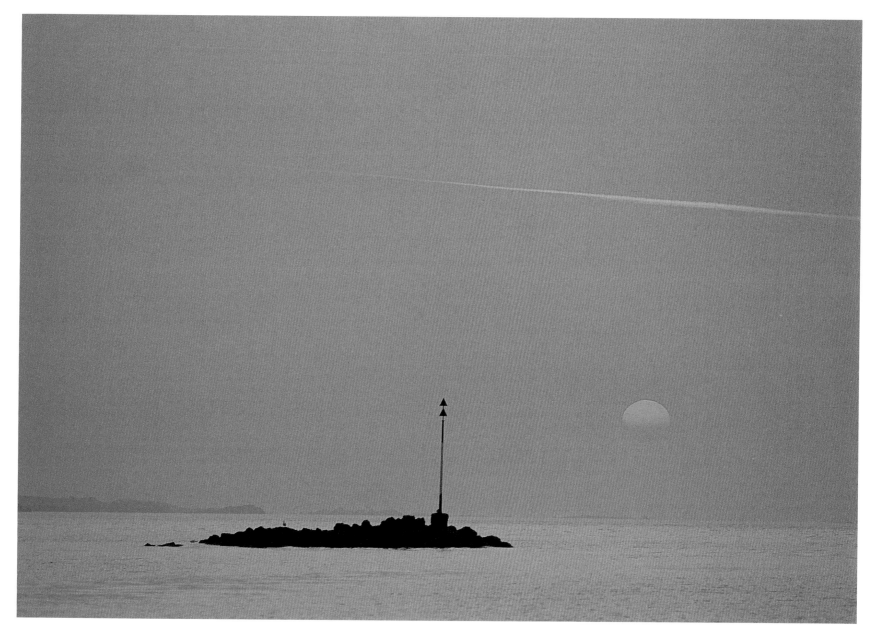

CARDINAL NORTH.

Whether stuck into their rocks or rocking on the end of a chain, skinny poles or squat little turrets, buoys are the Lilliputian cousins to the lighthouse. They line the entrances to ports and the sides of channels (lateral buoys), show where the clear waters are, and mark the reefs (cardinal buoys, indicating one or more cardinal points of a given danger). When the mist shrouds them, they ring bells and blow whistles and trumpets as reminders. Invented by seafarers to mark the dangers of coastal navigation, their colors and shapes, their signals of light and sound, are words in an international visual language established as a unified code in 1982. In 1976, there were more than thirty different systems of buoyage worldwide.

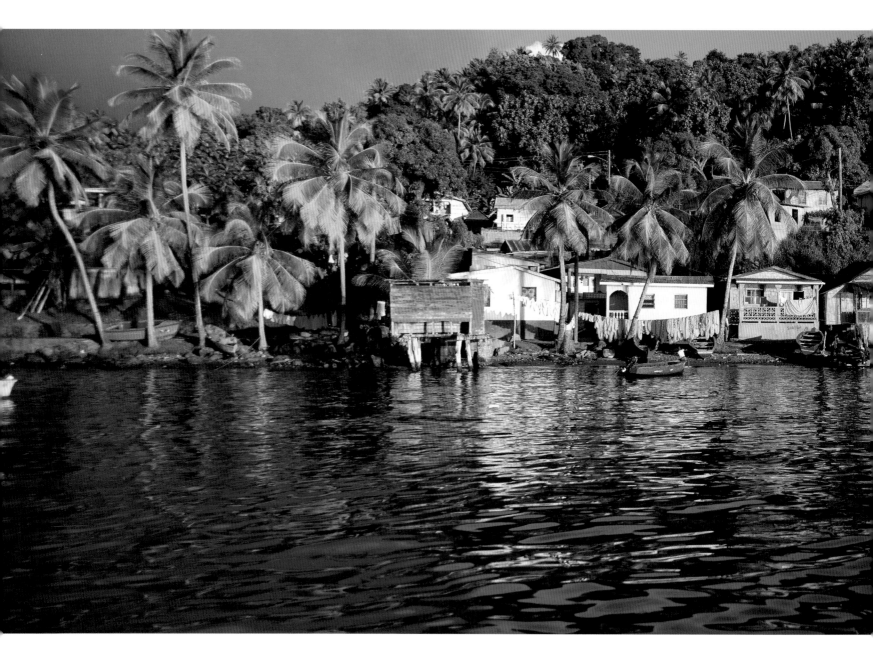

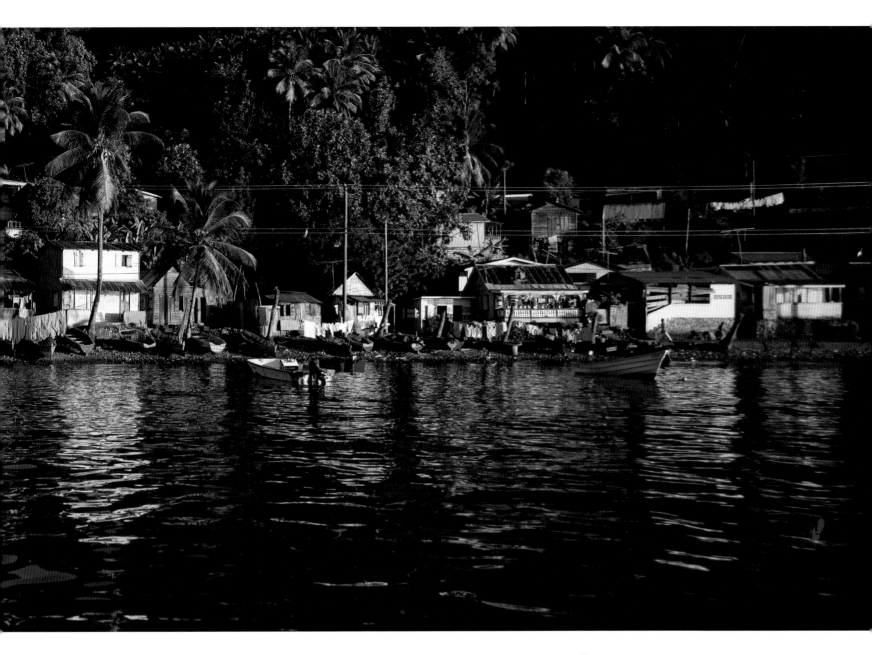

St. Lucia. This former British colony, visible from Martinique, retains a genuine Caribbean identity.
Its back to the Atlantic, the Antillean archipelago braces itself against the Caribbean Sea. St. Lucia, south of Martinique, displays a brilliant, authentic natural beauty around two volcanic peaks. Despite its small size (238 square miles, or 616 km) and small population (150,000 inhabitants), St. Lucia has been independent since 1979. This island is a member of the British Commonwealth and has produced two Nobel laureates. The object of colonial battles between France and England in the eighteenth century, St. Lucia passed back and forth fourteen times from one to the other until it became a British colony in 1814. Its Creole culture, a legacy of the French influence, is alive and well, and the island's patois is still spoken alongside English, the official language. The British ascendancy in the region and the country's developing tourism sector are threatening these roots. St. Lucia is determined to evolve a tourism respectful of the environment by encouraging visitors to behave civilly and inviting them to witness the island's culture firsthand. We can only hope that these initiatives become generalized beyond St. Lucia, to someday become the norm in tourism.

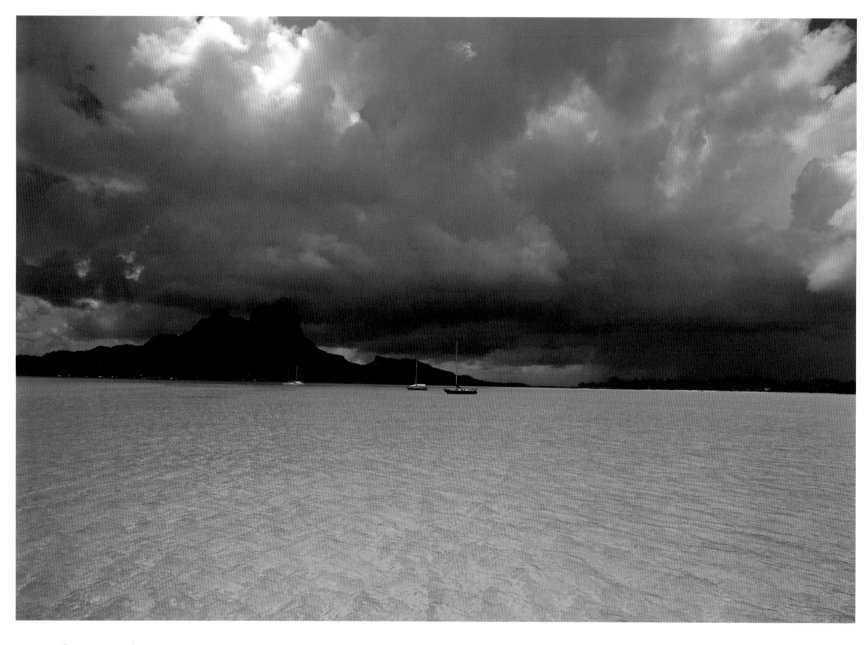

POLYNESIA. JUST BEFORE THE SKIES OPEN UP, THE PEOPLE OF THE SMALL ISLAND
OF BORA BORA LEAVE THEIR BOATS FOR DRY LAND.

Bora Bora translates as "first born," and it is possible that it was the first of the Polynesian islands to surface
from the sea a few million years ago. Located some 170 miles (270 km) from Tahiti, this mountainous massif
surrounded by a lagoon and a coral barrier is only 16 square miles (42 km²) and was born from volcanic activity.
Starting from beneath the ocean, a volcano erupted, shooting a mass of magma through the air, which then
cooled, forming an island. Over the course of time, Bora Bora has been carved by erosion and conquered by flora.
The island is home to lizards and geckoes, while the air above is filled with frigate birds, terns, petrels, and
other gannets. In this part of the Pacific, the landmasses are either "high islands" (volcanic) or "low islands"
(coral), the second being born from the disappearance of the first. While on occasion tropical hurricanes rage
through southern Polynesia, these encroaching black clouds over the turquoise waters of Bora Bora will bring
nothing more than a small storm.

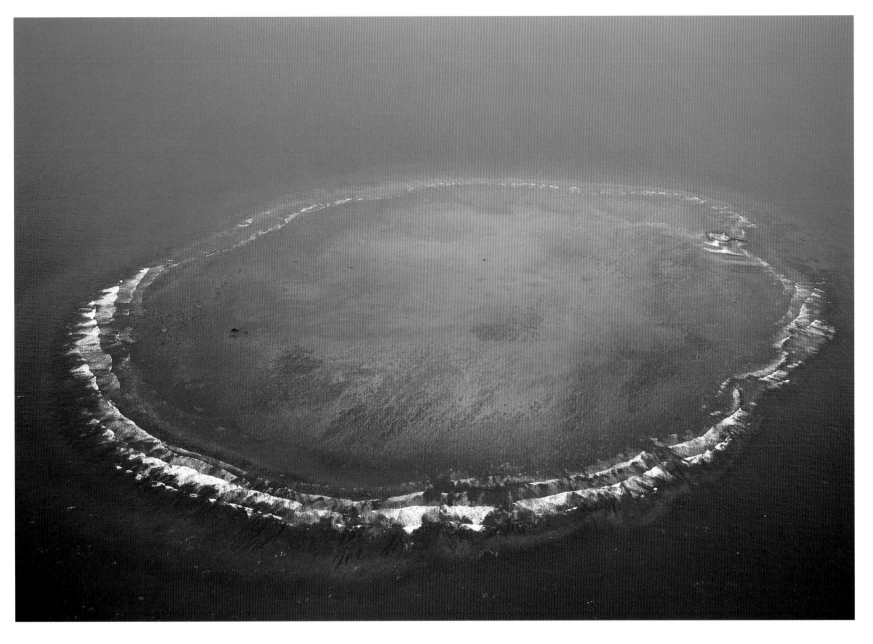

This outcropping of coral off the Japanese coast studies the skies with its Cyclopean eye. Perhaps it is watching for early signs
of the downpour that could submerge it as they have the other atolls in the Maldives or Polynesia that stand just 3 feet (1 m)
above sea level. For now, the greatest threat comes from global warming, which could raise the level of the oceans 4 to 35 inches
(10 to 90 cm) before the end of the century. It would not be the first such change. Another occurred at the end of the last ice age,
7,000 years ago, when the ocean rose 390 feet (120 m), spectacularly washing over the Bering Strait between Asia and America.
For the last ten years, the sea level has been rising at a rate of about a tenth of an inch (2.5 mm) a year, faster than at any time over
the last six millennia. As it warms, the ocean expands—the chief cause of the rise of the sea level. Melting glaciers play a relatively
small part in it. At present, human populations and activities are concentrated in coastal areas and so are particularly vulnerable to
even a slight variation in the sea level.

St. Lucia, in the Caribbean. All is well atop the coconut palms.

A slender palm tree that reaches heights of 100 feet (30 m), the coconut palm thrives at tropical latitudes. Symbolic of exotic beaches, it is a precious resource that often appears on islands where other natural resources are lacking. The long leaves are woven to make mats, hats, baskets, fish traps, and even roofs. The trunks are used to build permanent walls, or are carved into furniture, utensils, and dishes. And of course the fruit itself is enjoyed. Coconut milk straight from a pierced nut is delicious. A thicker milk derived by pressing the meat is used in East Indian and Caribbean cooking. Different cultures have found myriad uses for the oil. In Polynesia, for example, it is scented with the *tiaré*, or frangipani flower, and then called *monoï*. For ages Tahitians have used it to cover their skin and hair.

A PEACEFUL "FRIDAY." A STRAW HAT, BRIGHT COLORS, AND SOME *GOMMIERS*.

The shell will glide on the logs, the oars will extend, and the sails will be hoisted in order to place some nets and set a few traps in a Z formation. The Antillean elders have always known how to weave these baskets in *bois mirette*. When making these pretty traps, they use the same method they use to make their large straw hats. But today's traps are often woven out of wire, and the new *gommiers*, or small boats dug out of a gum tree, are motor-powered. Fiberglass boats are lighter, less fragile, and faster than the old canoes, and the red snapper, saury, jack, and king mackerel generally associated with seasonal fishermen have become too expensive when compared with the frozen fish available in supermarkets. In order to compete with the Japanese and South American ship-factories, the local fishermen have had to regroup and buy modern trawlers, travel farther out to sea, stay there longer, and fish deeper—even if many would prefer the simpler life of a *gommier* and the freedom it affords.

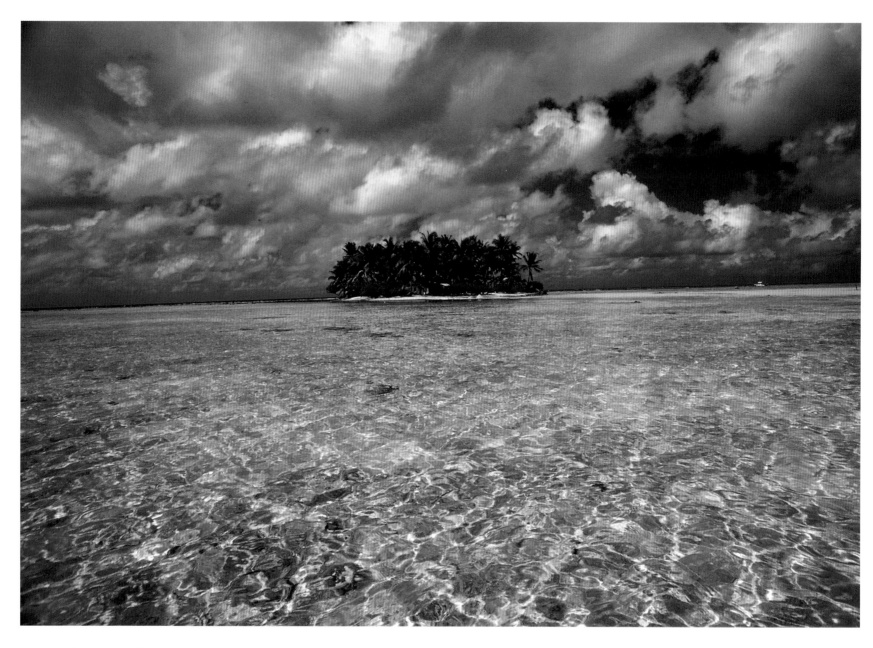

RANGIROA. FRENCH POLYNESIA.

Somewhere in the atoll of Rangiroa, lost between a light and dark gray sky, an islet seems to be drifting along with the current. A ribbon of sand, cabins made of boards and sheet metal, fishing boats, and a ring of coconut trees at the edge of the beach, leaning over the water as if something has caught their curiosity. What do they see? A school of exotic fish heading toward the coral reef? Some conch or dozens of other iridescent shellfish? A small, stray shark as non-threatening as a starfish? The water is so perfectly clear that it appears shallow, but in reality the bottom is a good 16 ½ feet (5 meters) deep. When the trade winds blow in their mix of clouds and sun, the water temperature and air temperature become almost the same. In this tropical setting, the alerted fishermen take heed and make for the port before the first drop falls.

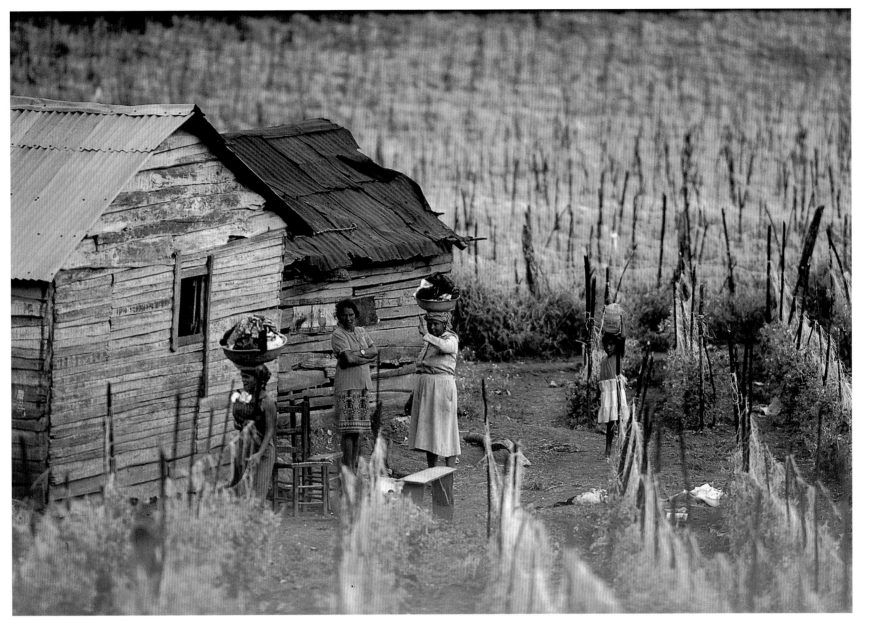

WOMEN IN A FIELD, NEAR A SMALL HOUSE. SANTO DOMINGO.

Women returning with the laundry in Santo Domingo. In the vast plains of the Dominican Republic, with its fields of cotton, sugarcane, bananas, and cocoa plantations, the women return with the laundry. Mothers, wives, young girls—in most cultures it is they who see to the family's hygiene and domestic needs—travel miles each day to reach wells and rivers with their gourds of laundry and water bottles. Here, water is everywhere. The Caribbean island with the highest elevations, Hispaniola's cordillera reaches almost 10,000 feet (more than 3,000 m) and generously waters the land. Everything grows on its slopes, even rice, and the 2.5 million people who make a living through farming—30 percent of the population—have kitchens brimming with abundance. Almost 250 miles (400 km) long, the island that is shared by the Dominican Republic and Haiti pays a high price for this luxury: occasionally, as in 1979, a hurricane destroys roads, houses, and plantations, leaving everyone to start over from scratch.

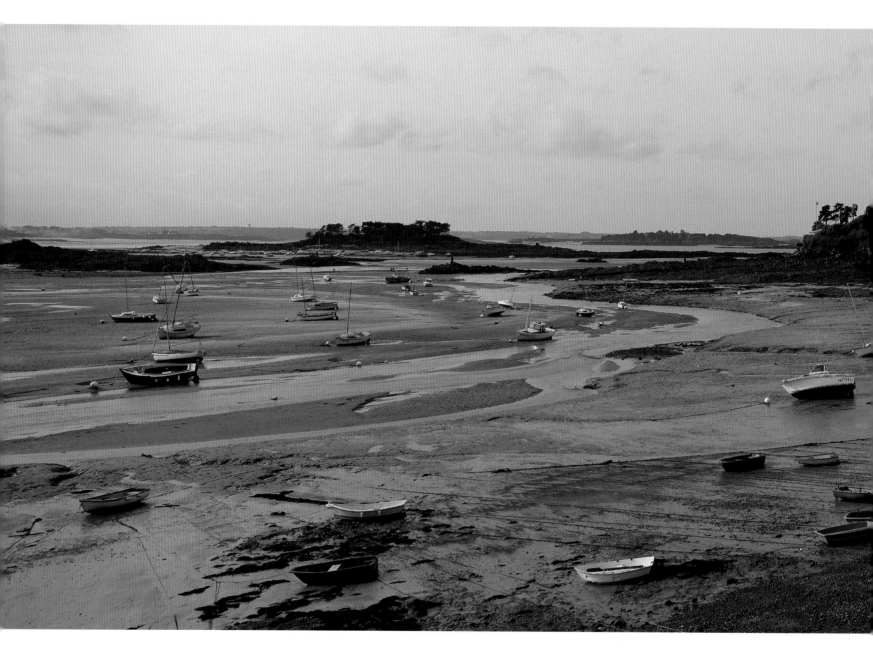

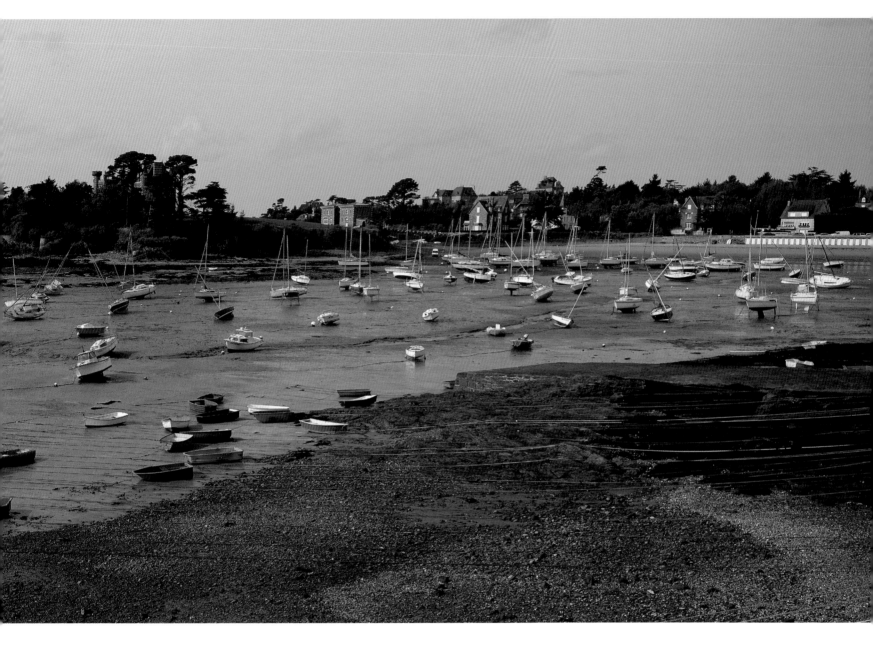

TIDES. HIGH TIDE AND LOW TIDE AT SAINT-BRIAC, WHERE THE 700 BOATS
MOORED CAN RISE AND FALL 42 FEET (13 M) WITH THE TIDES.

The phenomenon of the tides, the perpetual succession of high and low waters about every six hours, is caused by the attraction exerted by astral bodies on Earth's masses of water. However, a high tide in one part of the globe does not necessarily imply a low tide elsewhere. Usually, the variations in sea level are insignificant in the Mediterranean (no more than 16 inches, or 40 cm), but they are considerable on France's Atlantic coast as well as in the English Channel, where they are greater than 39 feet (12 m). A few hours can transform a landscape, which is thus forever changing. The lives of the people who live by the seashore, from swimmers to fishermen, follow the endless rhythm of the tides. When the tide is out in the Saint-Briac bay, the boats lie helplessly on their sides, like children's stranded toys. The Frémur, reduced to a puny trickle, wanders in a muddy bed that has become too big for it. The tide has ebbed, exposing the strand—that alternate universe balancing, undecided, between the worlds of air and sea.

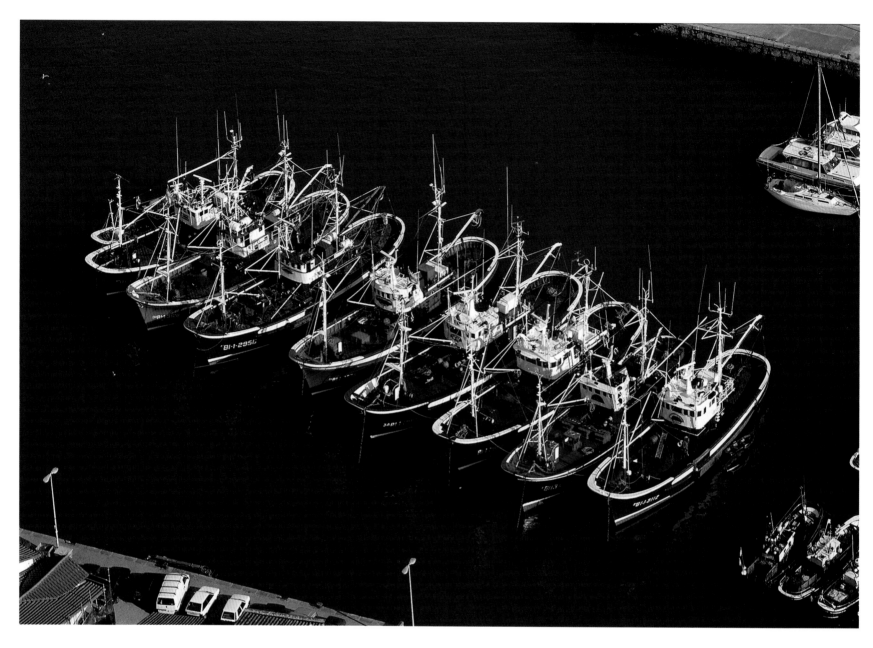

SAINT-JEAN-DE-LUZ. FISHING BOATS LINED UP AS IF ON PARADE.

If whaling may remain only in the local myths and Herman Melville's *Moby Dick*, the sailors of Saint-Jean-de-Luz
do still continue to take to the sea. Their little multicolored trawlers, primarily blue, white, and red, are
proudly lined up in the port at the foot of the Maison de l'Infante, the majestic brick and white stone residence
that in 1660 welcomed Marie-Thérèse, the daughter of the king of Spain, who had come to marry the young
Louis XIV. In 2002, Luzian fishermen hauled in 203 tons of sardines, 271 tons of anchovies, and 2,543 tons of
red and white tuna, ranking Saint-Jean-de-Luz as the sixteenth largest French port. Since Spain's entry into the
European Common Market, the gulf of Gascony is regularly the site of incidents between Basque sailors and
their Iberian neighbors, who argue about the size of fishing nets, among other subjects.

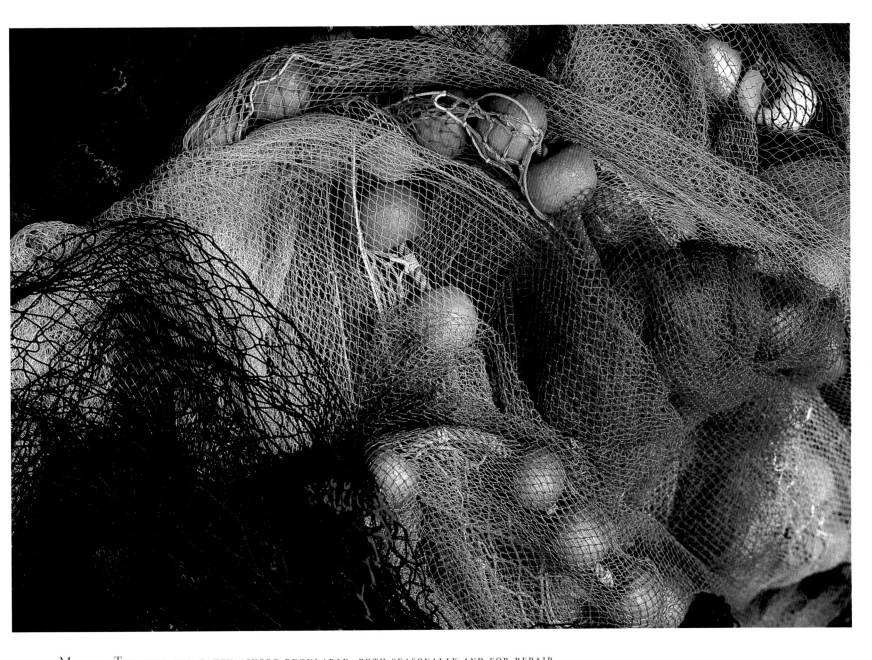

MESHES. THE NETS ARE TAKEN ASHORE REGULARLY, BOTH SEASONALLY AND FOR REPAIR.

Like hunting, in the domain of fishing all human ingenuity is brought to bear. The broad category of nets includes the classic trawls, or dragnets; fixed or drift gillnets (in effect, walls in which the fish's gills become fatally stuck); beach seines, and swivel seines. The latter are immense scoops that can be almost a mile (1,500 m) long and that are used as far down as 390 feet (120 m); once they've enveloped a school of fish, they are pulled closed at the base. Fishermen also use lines and live bait or lures. To capture crustaceans, human beings invented pots—crab pots and lobster pots—and devised dredges to scrape along the sea bottom. Other inventions are the ingenious eel pots, trap-nets, and harpoons. The more radical—and destructive—techniques involve the use of dynamite or cyanide. These are currently practiced on some of the Asian coasts, where they cause irreparable damage. Radar, satellites, and planes are used to locate schools of tuna deep in the oceans. Alongside all these tools are the countless local artisanal devices, born of the timeless experience of coastal communities the world over.

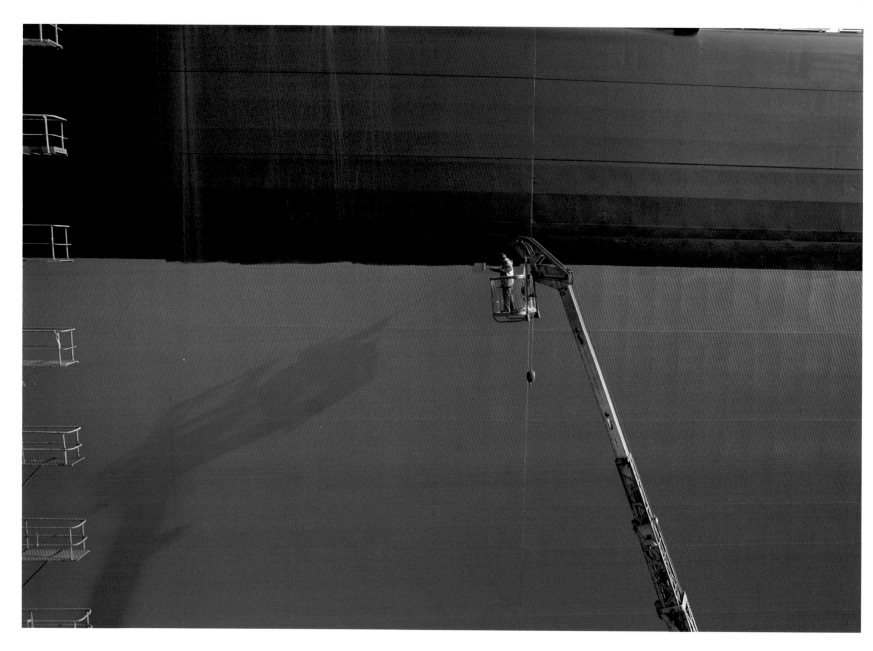

QUICK WORKS. THE CAREENING IS FINISHED ON THIS DRY-DOCKED SUPERTANKER. THERE IS ONLY TWO TIMES 800 FEET (250 M) OF WATER LINE TO BE ALIGNED BEFORE THE SHIP RETURNS INTO THE WATER.

On a ship, the phrase "quick works" applies to everything below the water line; even though this section is out of sight, it comprises vital parts of the ship. The fittings and everything above the water are known as "dead works." Dry-docked for maintenance, this supertanker, over 800 feet (250 m) in length, has just been completely repainted. In order to keep damaging mollusks, algae, and crustaceans from attaching themselves to the part of the hull that is under water, ship bottoms are treated with special paints. These coatings used to contain tributyl tin (TBT). In 1976, a marked decrease in production among the oysters of the Bassin d'Arcachon suggested that this substance was harmful, but not until 1981 did researchers confirm that it was the TBT coating on the ship bottoms that was causing the damage. Emergency measures saved the oysters of Arcachon. A total ban on TBT, sponsored by the International Maritime Organization, will go into effect in 2003, with full compliance required by 2007.

WHEN THE SEA IS
THE ARTIST.

Gray beneath a leaden sky as
the storm approaches, it
becomes white with foam along
the sheer coasts, turns turquoise
on the rocky shallows, then
takes on its emerald tint in a
peaceful lagoon. It will be yel-
low above a sand bank, beige in
an estuary, ocher at a river's
mouth. Muffled in opal in the
polar regions, it drapes itself in
the black of oil. It is rose-colored
when krill invades the surface,
delicate green or burgundy
when toxic algae proliferate in
its polluted waters, and multi-
colored and loud in summer
along its crowded beaches. It
flames red when a freighter
passes and adorns itself with
the motley hues of the fishing
boats as they rock at anchor. It
gleams with gold in the night-
time wake of a ship, reflects the
moon in a silver trail, and,
when the beach seine returns
home, it roils with a thousand
flashes of metallic gray. What
is it? The blue, blue sea.

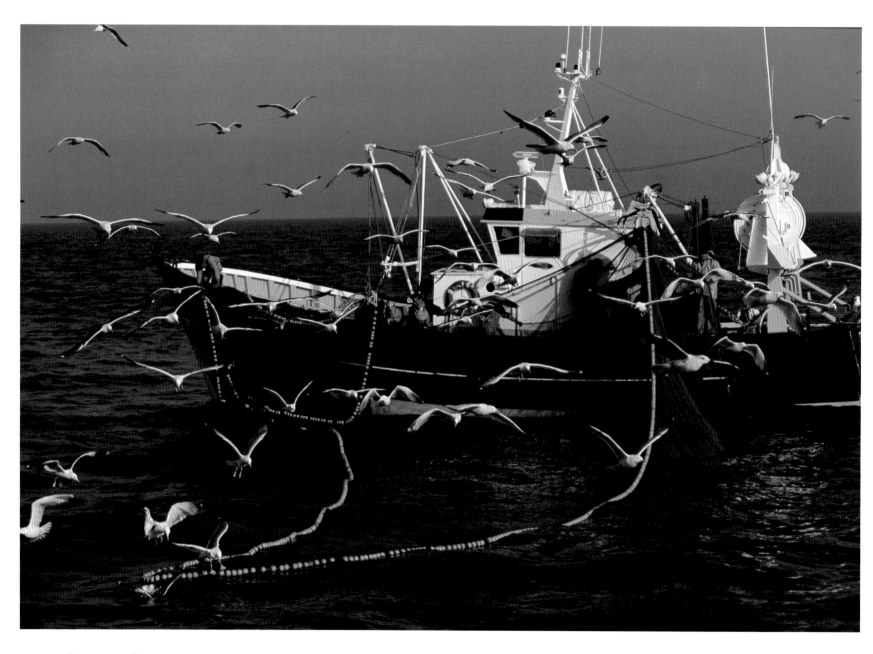

SARDINES. SEINE FISHING IS STILL PRACTICED BY THE FLEETS OF QUIBERON
AND LA TURBALLE, AS WELL AS HERE, OFF BELLE-ÎLE.

Off Belle-Île, a trawler maneuvers its swivel seine, a large vertical net that is held on the surface with floats.
When the school of sardines is surrounded, the net is pulled closed by a rope at the bottom. A cloud of gulls on
the lookout for easy pickings bickers directly overhead. Gulls are perfectly adapted for life at sea, as demon-
strated by their webbed feet, which are set back on the underside of their bodies to give them more stability
when they float. They feast on fish, mollusks, and crustaceans, but feed on garbage, too. A larger species of gull
(20 to 30 inches, or 50 to 80 cm) gleans the odd scrap from the rubbish, follows in the wake of tractors as well
as trawlers, and is even at home in the city. This opportunist species is growing at the expense of more fragile
ones such as the Atlantic puffin, whose eggs and chicks the gulls destroy.

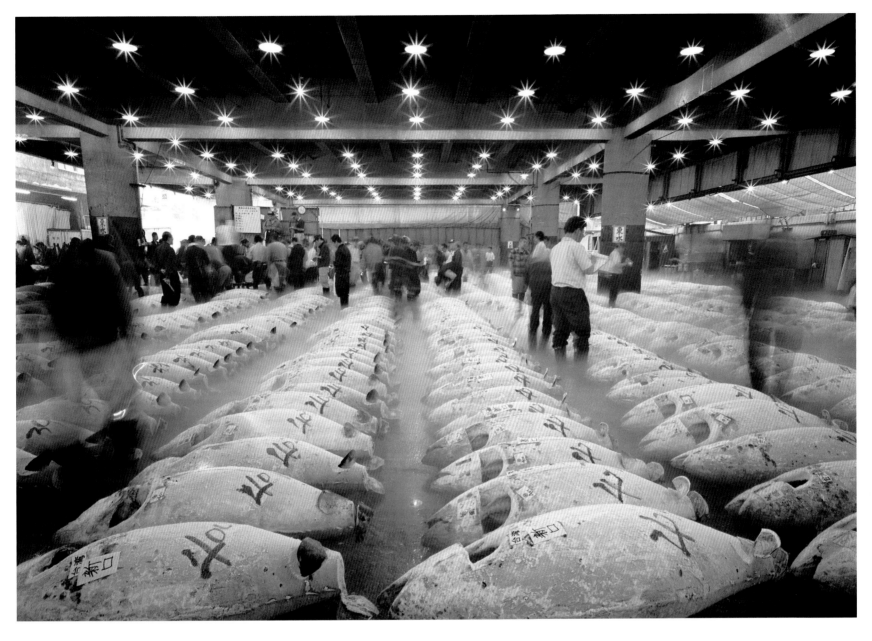

JAPAN. THE WORLD'S LARGEST FISH MARKET IS TOKYO'S TSUKIJI ICHIBA.
More than 2,500 tons of fish are handled every day except Sunday. The tuna auction begins at 4:00 in the morning. By 5:30, everything has been sold. Over the course of the twentieth century, technological progress and increasing demand multiplied the worldwide production of fish twenty-fold. It has doubled since 1970, and is now at 125 million tons. One third of the supply comes from aquiculture, which has experienced a spectacular growth in the last two decades. Catch fishing is tending to peak, since most of the fishing areas and stocks are fully exploited. One quarter of the world's production is made into meal and oil for animal feed, while about 90 million tons go to supply human consumption. Japan, in particular, whose consumption of seafood is among the world's highest, buys up 1 million tons of tuna per year. Its annual production is more than 5 million tons, the world's second largest, after China (17 million tons). Japan and Norway are the only two countries that still practice whaling, despite the international moratorium.

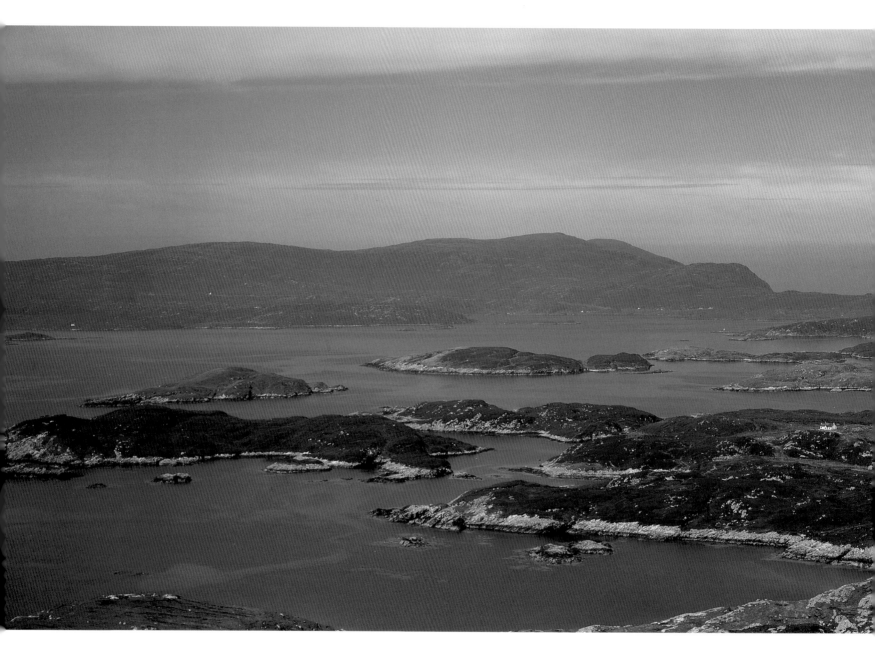

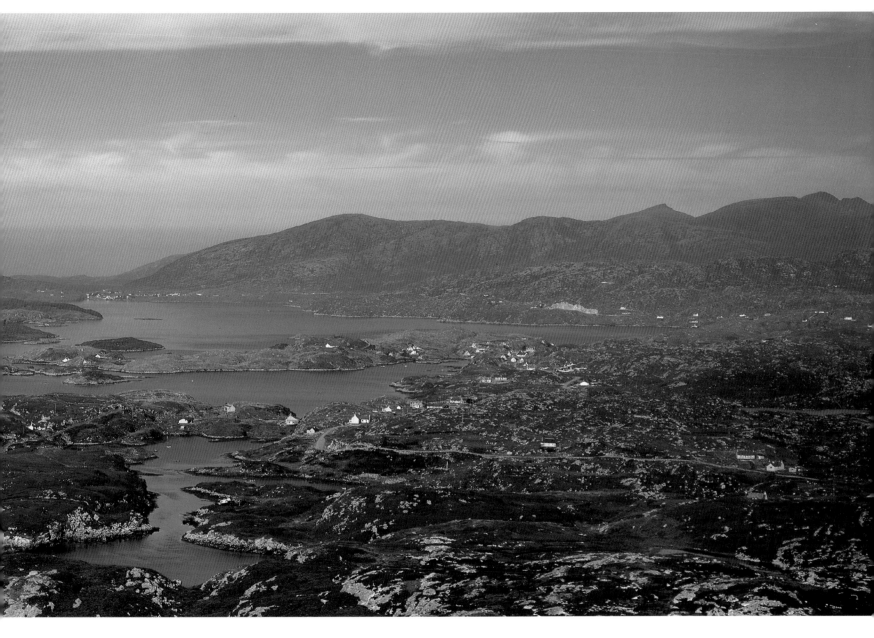

The chain of seventy islets, looking like a floating puzzle, counts no more than twenty thousand souls. While the official language is English, local dialects hearken back to Old Norwegian. (The Sea of Norway is not far away.) The Scandinavians made landfall in this region during the seventh century, but in 1472, the Orkney Islands realigned with Scotland. During both World War I and World War II, the British government established important naval bases in these natural shelters. This green land is, nevertheless, devoid of trees and a harsh climate with Arctic accents help to make daily life difficult in these parts. In the Orkneys, you make your living through fishing, tourism, and whiskey, or any combination of these. The distilleries in the capital of Kirkwall are esteemed throughout the country. The little white houses scattered in the remote areas serve as confirmation both of an obstinacy and a perseverance—man against, and with, the elements.

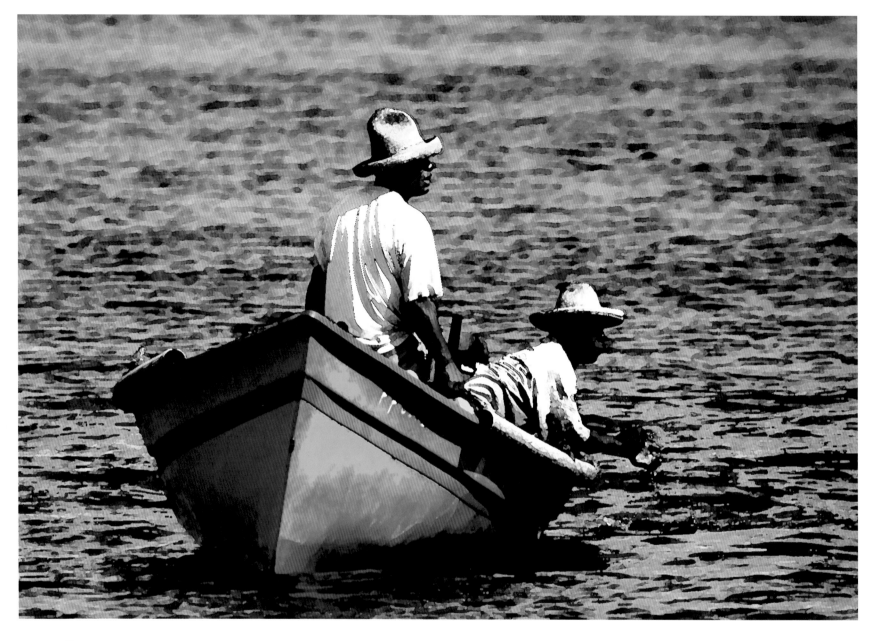

TWO FISHERMEN LOLL ON A GLASSY SEA.

In the calm waters of the Caribbean, two fishermen carry on with their traditions. Aboard their blue *gommier*, they vary their many techniques, which include *"Miquelon* fishing." This entails using a troll line to catch large fish, sometimes even swordfish. Another technique, one used by their ancestors since the time of their arrival in the Caribbean, is a form of trap fishing. A pot filled with fish or coconut meat as bait is sunk to the bottom of the sea to attract Atlantic bonitos, *capitaines*, or hogfish, and rock lobsters. Fishermen from small Martinique villages continue to go net fishing, a joint effort that requires several boats drawing a net out to sea. They keep it relatively shallow and then swing the tail end of the net back to shore. The whole village helps to drag the heavy, laden net back onto the beach. Here in the tropics time passes peaceably. Far from the deep-sea trawlers, in the tempo of the currents, the *gommiers* keep their four-stroke engines at a putter.

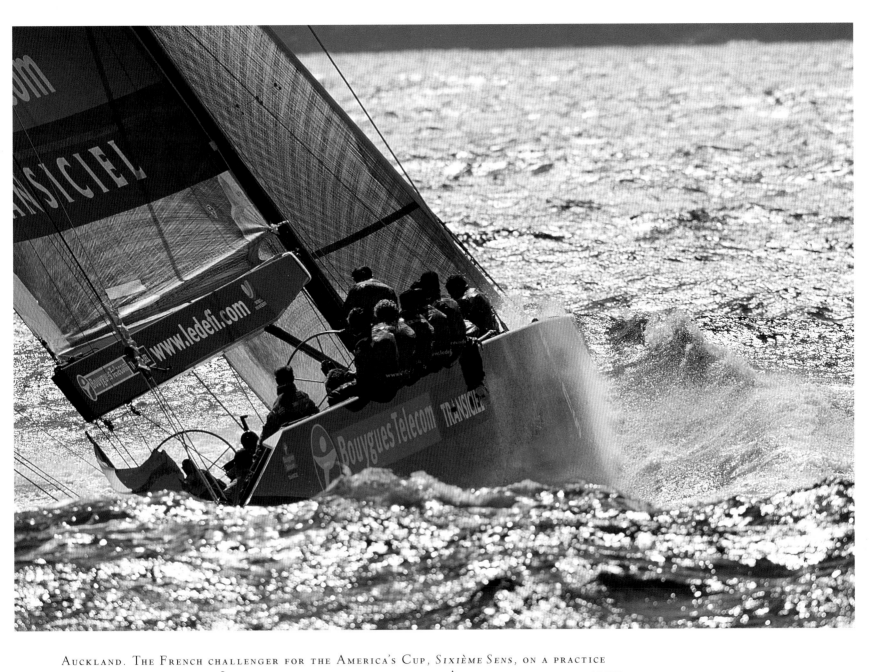

AUCKLAND. THE FRENCH CHALLENGER FOR THE AMERICA'S CUP, *SIXIÈME SENS*, ON A PRACTICE RUN OFF ITS HOME BASE AT LORIENT, BEFORE TAKING OFF FOR THE ANTIPODES TO JOIN THE OTHER ELEVEN ENTRANTS IN THE LOUIS VUITTON CUP 2000 IN NEW ZEALAND'S HAURAKI GULF.

In 1970, Baron Bich, inventor of the ballpoint pen, was the French challenger to America's possession of the famous trophy. France has competed in every America's Cup since then, despite difficulties in finding financing. In 2002, *Le Défi Areva* represented France's tenth entry in the history of the America's Cup. The French America Class, with Philippe Presti as helmsman and Luc Pillot as tactician, required a $20-million outlay. It lost in the quarterfinals, during the eliminatory Louis Vuitton Cup, in which a dozen challengers take each other on in a series of duels. At the end of these preliminary races, which can take several months and require tremendous logistics, the winner, declared the challenger, tries to take the cup from the defender in a number of rounds. If the challenger succeeds, his or her yacht club hosts the next race.

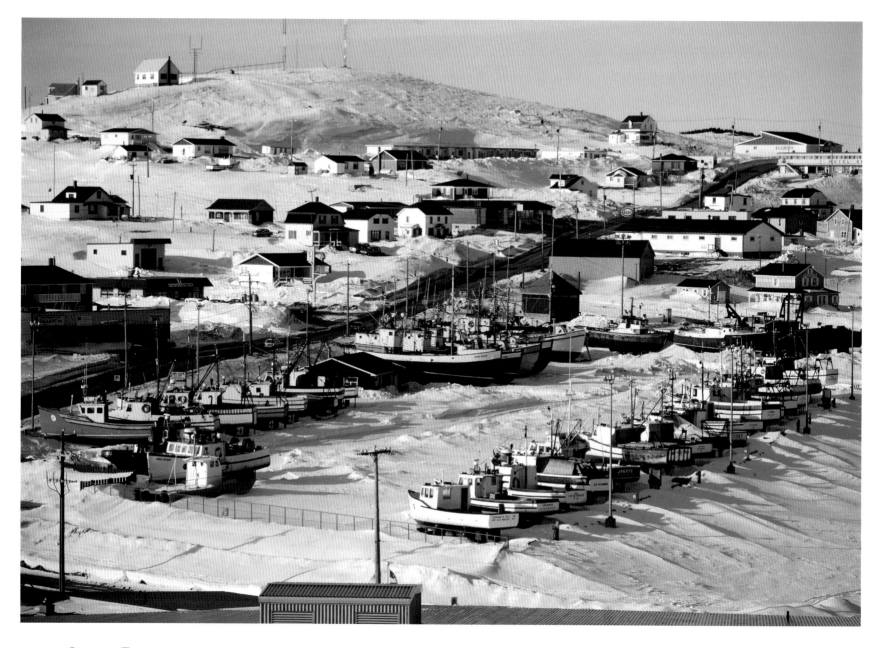

QUEBEC. THE LOBSTER-FISHING FLEET WINTERS IN THE MAGDALEN ISLANDS, SAFE FROM THE ICE FLOES OF THE ST. LAWRENCE RIVER.

The Magdalen Islands rise in the middle of the Gulf of St. Lawrence, west of Quebec. The "Madelinots" fish for lobster, using special equipment that they keep ashore in the winter, off the ice, but covered with snow. Winter is the season for seal hunting, which the indigenous people have practiced for centuries in order to feed, clothe, and warm themselves. Today, the six species of seal that live on the barrier ice are killed for their fur and their oil. Commercial seal hunting, which is regulated with quotas, has caused decades of irreconcilable disagreement. Some feel the hunting is too intensive, diminishing the seal populations in the Gulf of St. Lawrence at an unacceptable rate, while others see no negative impact. After centuries of a sustainable exploitation of the herds, perfectly in keeping with the resources of the natural environment, the system may be out of balance. This unsoluable controversy is another example of nature held hostage by divergent political and economic interests.

A TRUNCHEON AND A KNIFE. AN INUIT HUNTING SEALS.

When the Magdalen Islands become trapped in the St. Lawrence ice, the residents of this small archipelago, known for the quality of its lobster, set off on the seal hunt. The *whites*—newborns whose fur blends in with the snow—and young ones are particularly desirable. This traditional practice has been the subject of worldwide protests for four decades. Notably championed by Brigitte Bardot, the protests have become widespread, leading to fewer outlets for furriers who deal in baby seal, a reduction in hunting, and a collapse in the market, as sales are now far less profitable. Baby seal hunting is still practiced on the St. Lawrence islands at birthing time in March. Today, encouraged by the Canadian authorities, the hunting is permitted as a method of controlling the burgeoning seal population that presents a problem for fishermen.

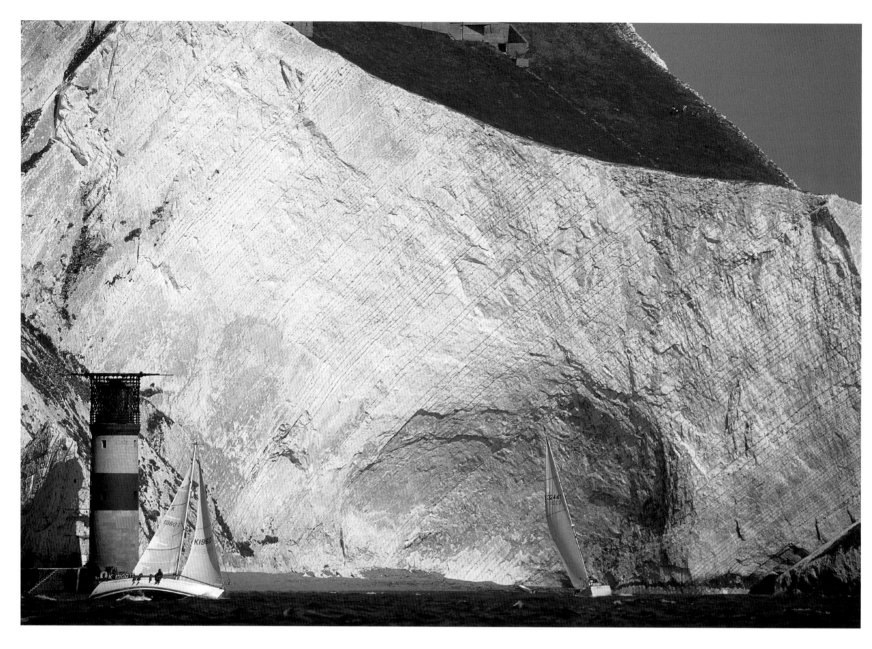

RACING AROUND THE NEEDLES BENEATH THE CLIFFS OF THE ISLE OF WIGHT.

How many have tacked around the lighthouse of the Needles? When the first beam was lit beneath these chalk slopes in 1786, the Isle of Wight still remembered the French fleets that had invaded it in the preceding centuries. Commercial vessels and the three-masted ships from Southampton, a major commercial port dating back to the Middle Ages, cross paths every day in the Solent and Spithead currents, the narrows that separate the island from Continental Europe. The present-day tower, erected in 1859, saw the disappearance of the tall ships, the advent of pleasure boats, and the very first races around "White" Island. Cowes, at the far north of the island, is one of the cradles of British yachting. The Royal Yacht Squadron, established in 1815, has organized regattas there for close to two hundred years. Cowes Week and the Fastnet Race attract crews from around the world. It was also here, in 1851, where the America's Cup began.

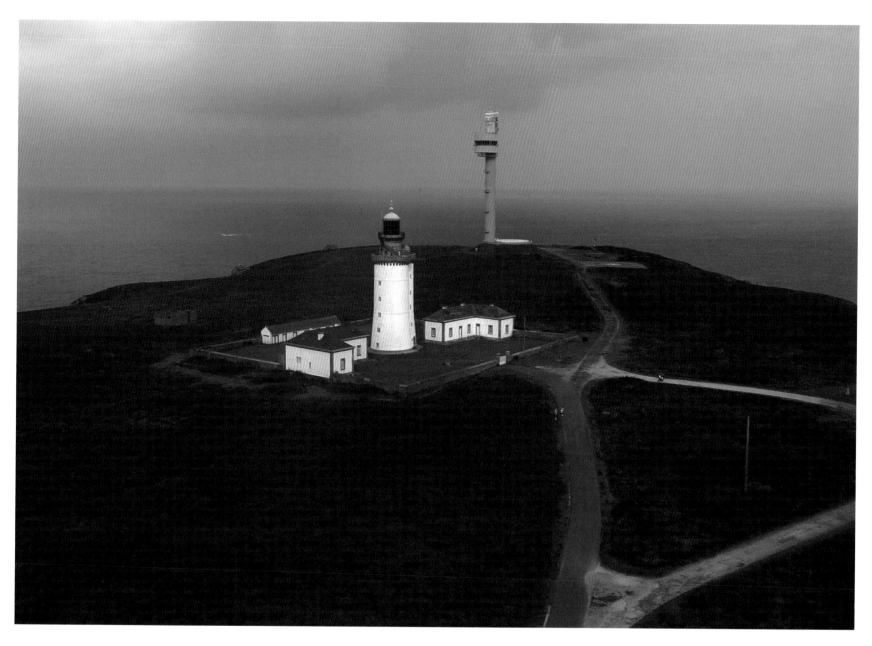

RADAR TOWER AND STIFF LIGHTHOUSE. FROM THE HEIGHT OF THESE KEEPS,
THREE CENTURIES OF MARITIME SIGNALING LOOKS DOWN UPON YOU.

This promontory of a reddish-brown moor is the end point of Ouessant, along one of the busiest sea-lanes in
the world. Every day, 150 to 200 vessels travel past the island. In the seventeenth century, Ouessant defined
the entry to Brest, the French Navy's large port, and to secure this approach, the Stiff lighthouse was inaugu-
rated in 1700. Three hundred years later, the maritime signaling system of the Finistère point is largely fitted
out. All the same, large commercial ships continue to run aground. The sinking of the Olympic *Bravery* in 1976
and the Amoco *Cadiz* in 1978 proved the need for a new surveillance and assistance system for ships. In 1978,
the Ouessant navigational corridor was created and the Stiff tower was erected beside the old lighthouse. From
the tower's panoramic observation hall, both men and radar keep watch over the traffic.

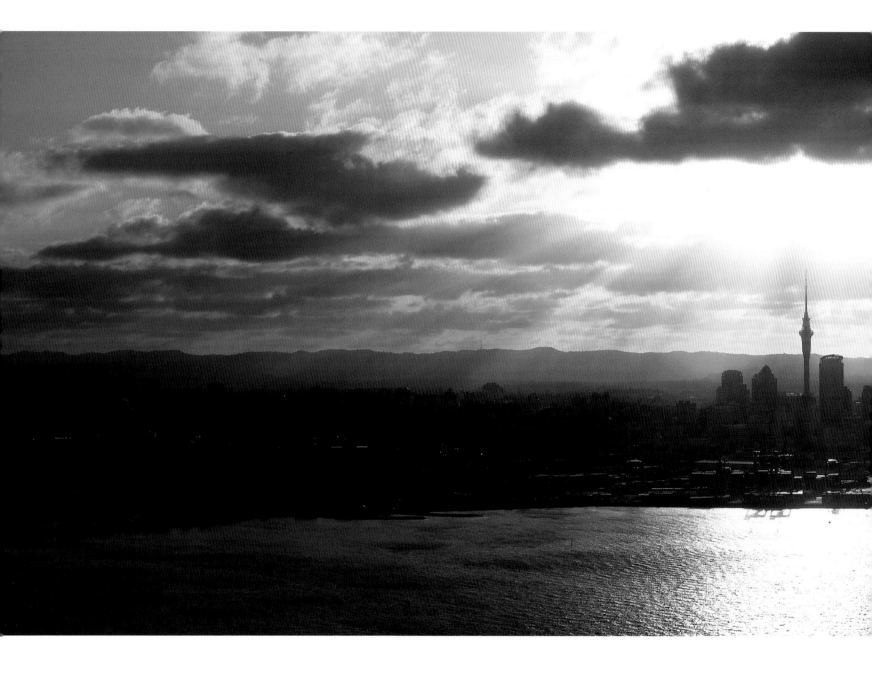

NEW ZEALAND. SHADOWS AND LIGHT ON THE BAY OF AUCKLAND.

A ball of fire radiates over the city of Auckland while the underground fire of the volcanoes that cover the region lies dormant. The silhouettes of the buildings stand like a far-off metropolis in this hemisphere where the sea prevails over the land. From a distance, an impression of calm floats over this vast industrial landscape. Once the capital of New Zealand, Auckland relinquished its role to Wellington, located at the southernmost point of the North Island (Smoking Island). The capital faces South Island, also known as Jade Island. From the vol-cano named One Tree Hill, the panoramic view of Auckland is without equal—in total, forty-eight live volca-noes surround the city. Here one is never far from the sea and beaches such as Kohimarama and Mission Bay, which open onto the Hauraki Gulf, and when the wind permits, sailboats dot the waters. Here the last rays of the sun break through the clouds, while Auckland's skyscrapers seem to point out the source of the light.

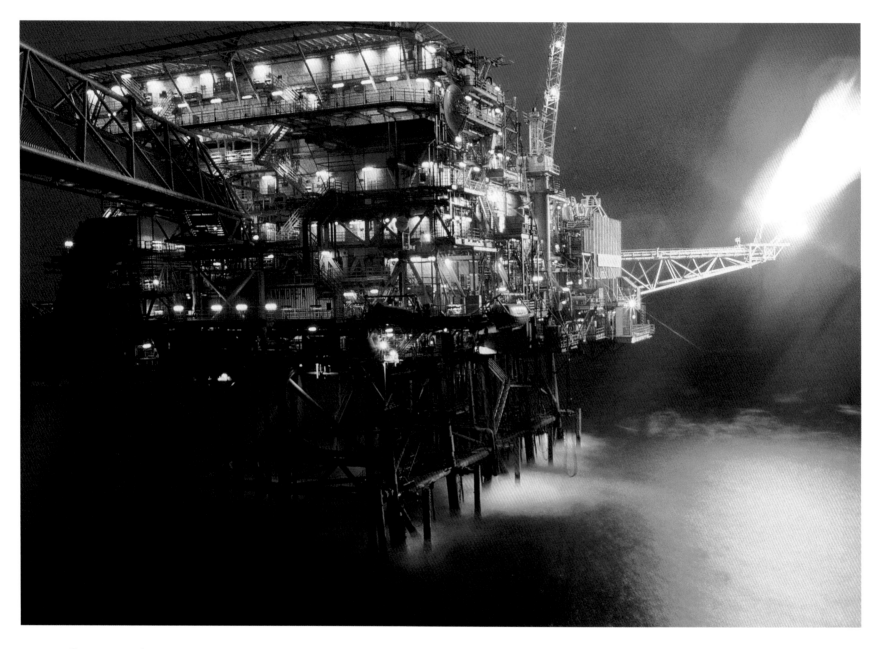

CLAYMORE. A WINTER STORM ON THE CLAYMORE PIPER PLATFORM
("THE SABER") OFF ABERDEEN, IN THE NORTH SEA.

The oil-bearing layers trapped among the planet's rocks are found at sea as well as on land. In order to exploit the oil that geologists have found in the ocean depths, companies have built platforms that allow vertical galleries to be dug into the ocean floor by means of an enormous drill. Tubes screwed into the back of the drill allow the oil to be pumped as soon as the deposit is reached, leading to royalties being paid to the coastal countries. Most offshore wells reach depths of less than 650 feet (200 m), but the legs of the largest rig, sunk off New Orleans, go down to 1,014 feet (312 m). The tragic fire of July 1977 on the Piper Alfa platform in the North Sea cost the lives of 167 people and remains the greatest catastrophe in the history of offshore drilling. To reduce the risks, today's installations separate the facilities dedicated to extraction and those given over to production and the living quarters, where some one hundred workers live together, carrying out tasks as varied as their national origins.

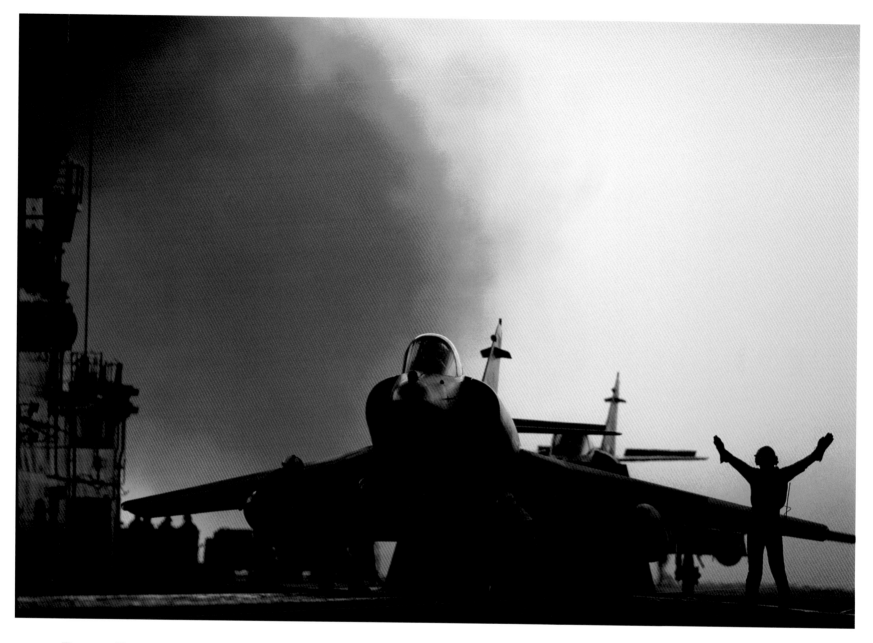

TOULON. THE LAST CATAPULT LAUNCHES OFF A STRIKE BOMBER FROM THE CLÉMENCEAU, AN AIRCRAFT CARRIER
RETIRED FROM ACTIVE SERVICE AFTER MORE THAN THIRTY YEARS ON THE WORLD'S SEAS.

An aircraft carrier is a major component of a nation's military fleet. The *Clémenceau* was such a one for France, from its launching in
1957 until its last time out, on July 16, 1997, after which it was replaced by the *Charles de Gaulle*. Weighing more than 32,000
tons—including 1,300 tons of ammunition—and capable of carrying two thousand crew members and thirty-nine aircraft, including
fifteen strike bombers, these craft are truly floating airports. The *Clémenceau* sailed more than 1 million nautical miles, the equiva-
lent of fifty times around the globe, in the course of some three thousand days of navigation over all the world's oceans. More than
seventy thousand aircraft landings and as many catapult-launchings took place on it. Here, a strike bomber prepares to take off amid
a plume of black smoke emitted by the ship under full power. Under the flight deck, which boasts a length of 845 feet (260 m),
the steam-powered catapult prepares to launch a plane at a speed of nearly 170 miles per hour (270 kph), by means of a sabot that
slides on a rail. The *Clémenceau*'s rudder, which had twenty-seven captains at its helm over the years, is on display at the Naval
Museum in Toulon, its former home port.

SPAIN. THE THREAT TO SHELLFISH FARMING IN GALICIA.

Sheltered from the wind, these perfectly aligned *bateas*, or wooden rafts, laid throughout the rias of Galicia remain the traditional way of harvesting mussels in Spain. These structures, half-submerged by the movement of the sea, could call to mind a streaming flotilla of boats, or even an array of underwater wrecks. But now, after the sinking of the oil tanker *Prestige* and the death of the sea in that region, no one has the heart to make jokes. Spain, the world's largest producer of farmed shellfish with its 250,000 tons of mussels each year, is poised to see its production levels plummet. Fear is mounting in the Baixas rias, a veritable breeding ground for mollusks and the economic lifeline of the region, as shellfish farming is Galicia's primary resource. This being added to the continual threat of hydrocarbons. One can look out for the currents and keep an eye on the wind, but what to do about the layers of hydrocarbons that spread across thousands of square miles, endangering coastlines as far away as in the Basque country, Brittany, and the Charente region of France. In Galicia, everyone is well aware that the hull of the sunken oil tanker can withstand the assaults of the elements for just so long. All know that a catastrophe is in the offing. All that one dares to hope is that the storage tanks will be pumped out.

Scotland. Saint Kilda, an islet in the Hebrides.

A meteor in the vast black infinity of the universe? The remains of a disintegrated planet within a galaxy of stars? No, it is a tiny islet in the Hebrides, a lost rock in the middle of the ocean that serves as a refuge for puffins, petrels, and gannets. What may look like stars is, in fact, the reflective plumage of the birds of this North Atlantic region that stretches between Iceland and Scotland. Despite its harsh appearance, for quite a long time, Saint Kilda was an inhabited island. Its population ultimately acquiesced to the monolithic island and, in 1930, requested permanent relocation to continental Scotland. Living on Saint Kilda had become a paradox of survival, as the residents had primarily fed themselves with the fish that they caught, then supplemented their diet with gannets, puffins, and birds' eggs, species that are now highly endangered. Nevertheless, Saint Kilda remains a sanctuary for these sea birds and whole colonies carpet the barren crags. Penetrating therein presents quite a challenge, as it is known that the petrels keep watch and discharge a fetid oil upon intruders. It is decidedly impossible to live on Saint Kilda.

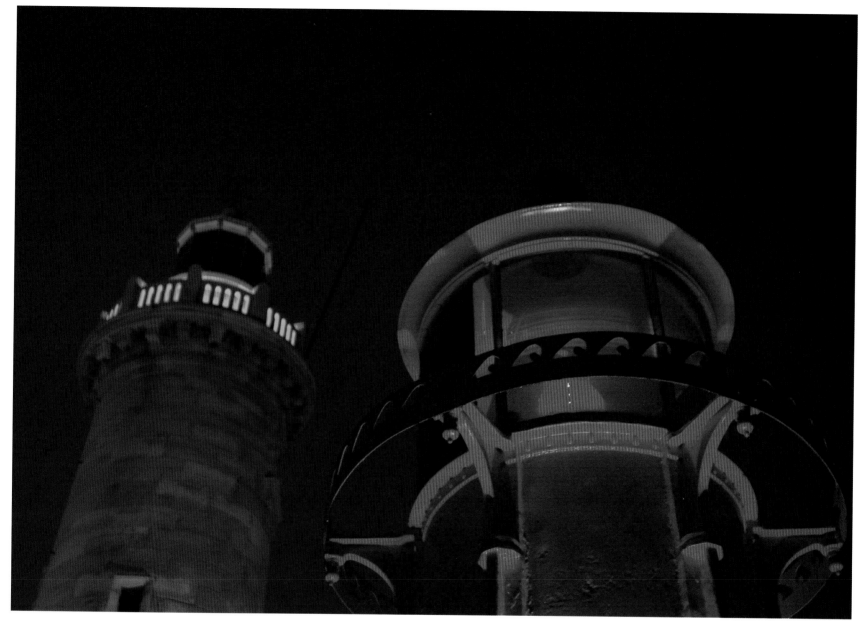

MARSEILLE. AN OLD FATE FOR AN ALL-NEW FUTURE.
CARTHAGE'S ANCIENT RIVAL NEVER CEASES TO BE REBORN.

One is blue, its battlements illuminated but the light extinguished. This is the Sainte-Marie Tower. The other is a vibrant blood red, and marks the entry to the port of Marseille. These marker buoys symbolize the evolution of Massilia. Caesar compared the Phoenician city to Carthage in terms of the power of its citadel and the size of its trade. Almost two thousand years later, the people of Marseille have preserved their heritage and continue to be prosperous. After Rotterdam and Hamburg, this autonomous port remains one of the premier ports of Europe. A hub for merchandise shipped through the Mediterranean, the docks of Marseille see almost 100 million tons of diverse goods every year. The old neighborhoods of La Joliette, Saint-Charles, Porte d'Aix, Belle de Mai, and Saint-Jean are far from antiquated. They comprise the heart of a mission to champion the ports of France as logistical and technical models for the twenty-first century and beyond.

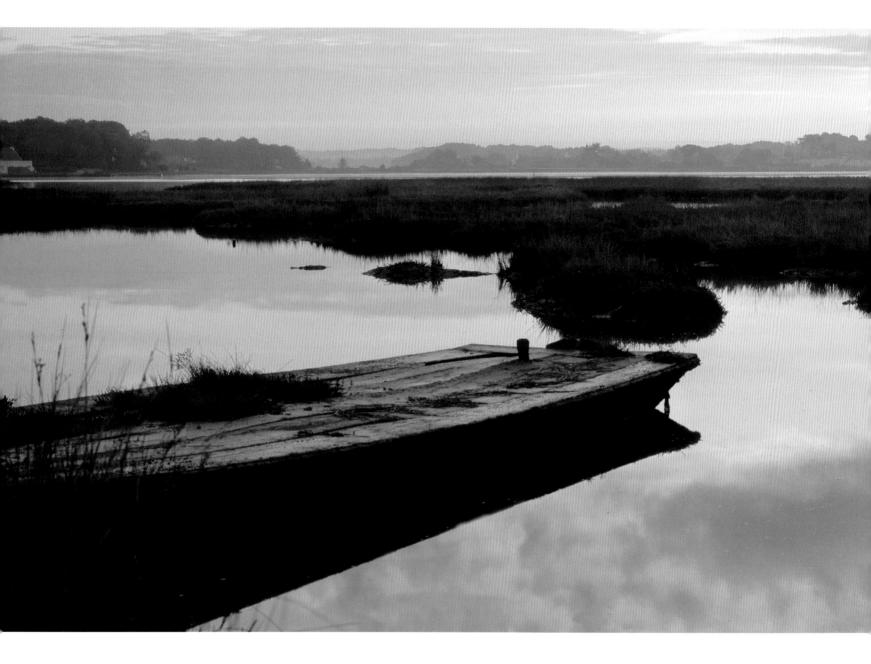

THE ETEL RIVER, A HAVEN OF TRANQUILITY TWO STEPS FROM THE OCEAN.

As the crow flies, the Etel River, which empties into the Atlantic between Lorient and the Quiberon peninsula, is only some 10 miles (15 km) long. But its lazy current meanders through the marshlands, twists around the islets with their chapels and fountains, and threads through the thickets so that its calm waters design a jagged bank that totals more than 60 miles (100 km). This Breton ria, rich in fish and shellfish, is the delight of fishermen who travel its waters in flat-bottomed boats. The region is protected from the ocean's assaults by a formidable gully. The meeting of fresh water and the sea over shifting sandbanks creates a barrier that makes navigation difficult, even in pleasant weather. The solo navigator Alain Bombard came here in 1958 to test his life raft, and the effort ended tragically. His shipwreck cost the lives of nine rescuers who tried to bring him to safety.

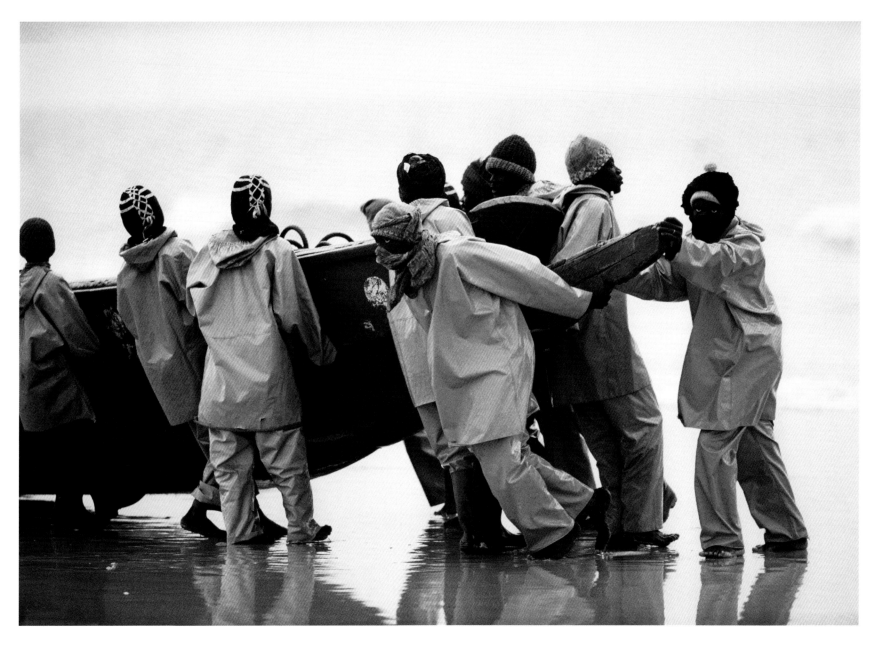

SENEGAL. RETURNING FROM FISHING EACH AFTERNOON ON THE BEACH AT DAKAR.

Thanks to alternating currents that supply nutrient-rich waters, Senegal's coast, extending nearly 450 miles (700 km) along the Atlantic, is rich in ocean life. This accessible wealth fuels coastal fishing, 80 percent of which is conducted by private individuals aboard pirogues of baobab or kapok wood, using lines or nets. It also attracts European industrial trawlers, who catch the quantities allowed by international agreements, then intensively fish the resources, thus depriving the lands along the rivers. With an annual production of nearly 40,000 tons, fishing remains Senegal's principal economic activity, with most of the catch sold locally. As soon as the pirogues return, women sell the tuna, sardines, and hake right on the beach, in a whirlwind of shouts, songs, and colors. As in any fishing scene anywhere on the planet, the yellow of the ubiquitous oilskins is the dominant color.

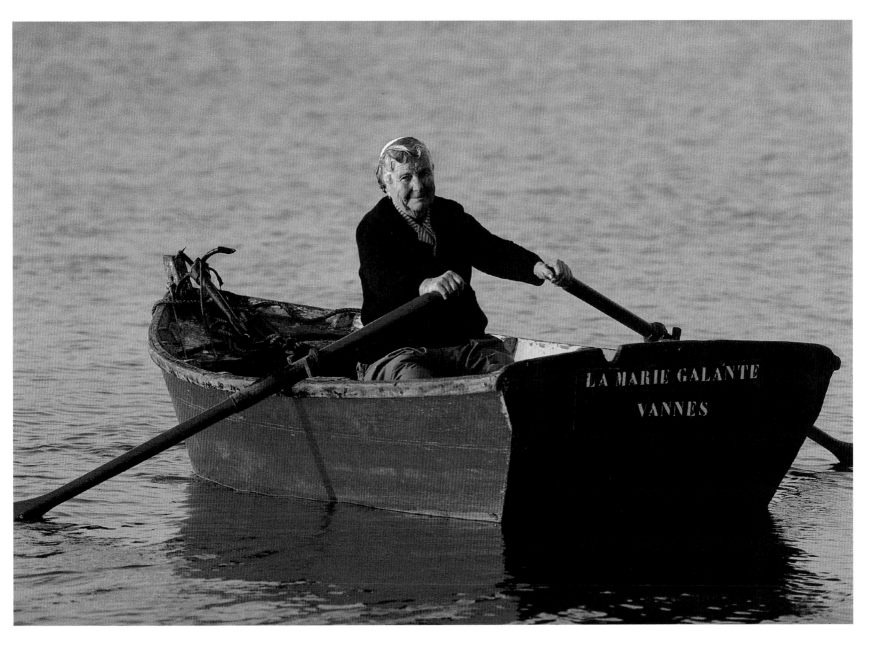

An homage to Ernestine and La Marie Galante of the "Little Sea,"
the queen of clams and quahogs.

Ernestine was one of the greatest fisherwomen at the foot of the Gulf of Morbihan, the little sea in the south
of Brittany. Armed with oars, her loyal red punt, and her short worker's haircut, she rowed for miles to reach
the islets of the lower sea, where she combed through the tidelands in search of clams, quahogs, and cockles.
Some crabs clinging under the rocks and some prawns trapped in pools complete the crop of the Madame de
Sinagote. Once the fishing was done, she loaded her catch into her wheelbarrow and set off on foot to the mar-
ket at Vannes, or even the one in Arrandon, which was more than 15 miles (25 km) from her home. In 2001,
Ernestine parted eternally from these terrestrial shores, leaving La Marie Galante an orphan. If there are tides in
heaven, there is no doubt that the Grande Dame of Séné has not wasted any time.

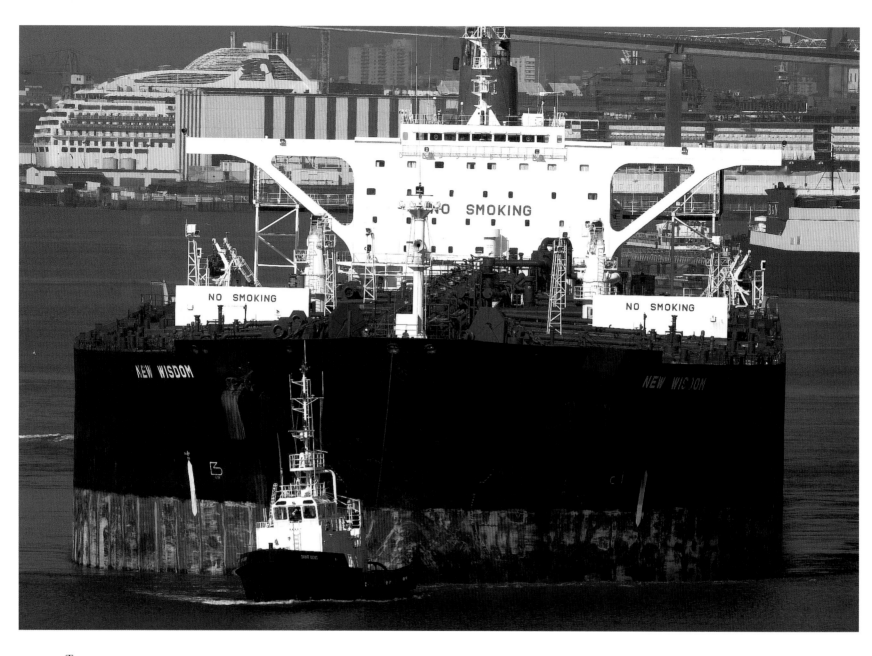

TOWED BY A MINUSCULE TUGBOAT, THE SUPER TANKER GETS READY FOR THE OPEN SEAS.

The *New Wisdom* is towed away from the Donge oil refinery. Passing by the Atlantic shipyards where cruise liners are being built, the vessel makes for the open sea, heading toward the Persian Gulf. Over the past fifty years, consumption has increased, as has the relocation of production. The amount of goods exchanged continues to increase unabated, and almost 90 percent of this movement is done through sea transport. Today, some ports handle more than 200 million containers per year and 300,000 tons of crude oil sail the seas. In order to make a profit, ship owners and leasers do not hesitate to circumvent regulations and take risks. Despite ever more stringent rules and the improvement of navigational instruments, three hundred large vessels sink every year. Human error and poor maintenance are the principal causes.

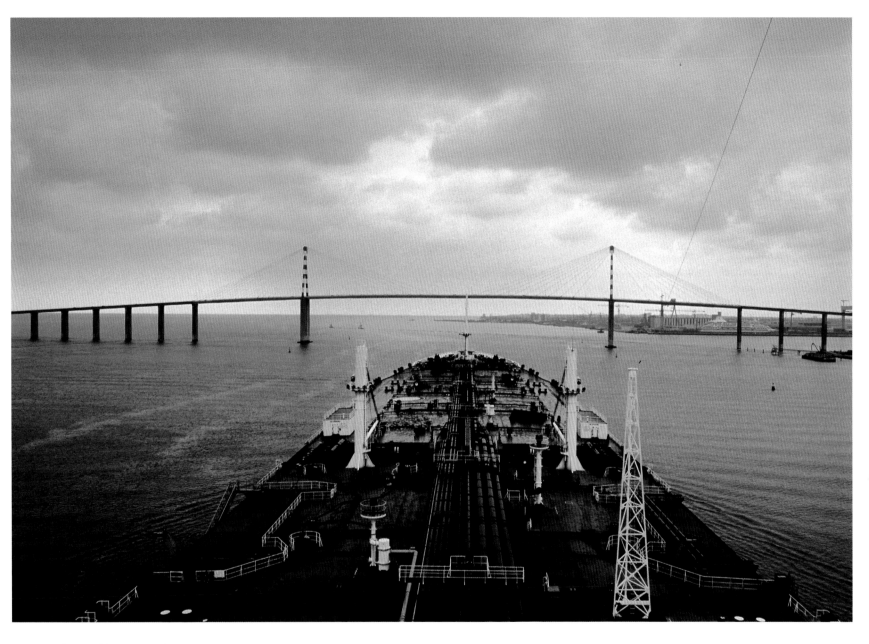

SAINT-NAZAIRE. A SUPERTANKER LEAVES THE TERMINAL
OF AN OIL REFINERY AFTER UNLOADING ITS CARGO.

The days are over when clippers and steamships crowded richly scented ports, unloading coffee from the
Americas, spices and tea from the Orient, and cotton and fruit from Africa. Today's merchant marines pack
everything into standardized containers, and the largest of the commercial vessels can carry up to 6,000 of these.
For freight that doesn't go in boxes, the commercial fleet has available to it a plethora of specialized freighters:
dry-bulk ships (for grains, wood, or cement in bulk); ore ships; chemical tankers with anticorrosion walls;
methane tankers whose vats, kept at –258 °F (–161 °C), keep the gas liquid; liners; and oil tankers. Today's
merchant marine, which began to grow in the 1960s and now dominates the global maritime traffic, are more
necessary than ever: 85 percent of all goods that travel between continents are transported by ship. Because a
ship is much more expensive docked than at sea, these largely automated freighters load and unload very quickly.
The great ports have become places of transit, where ships spend as little time as possible.

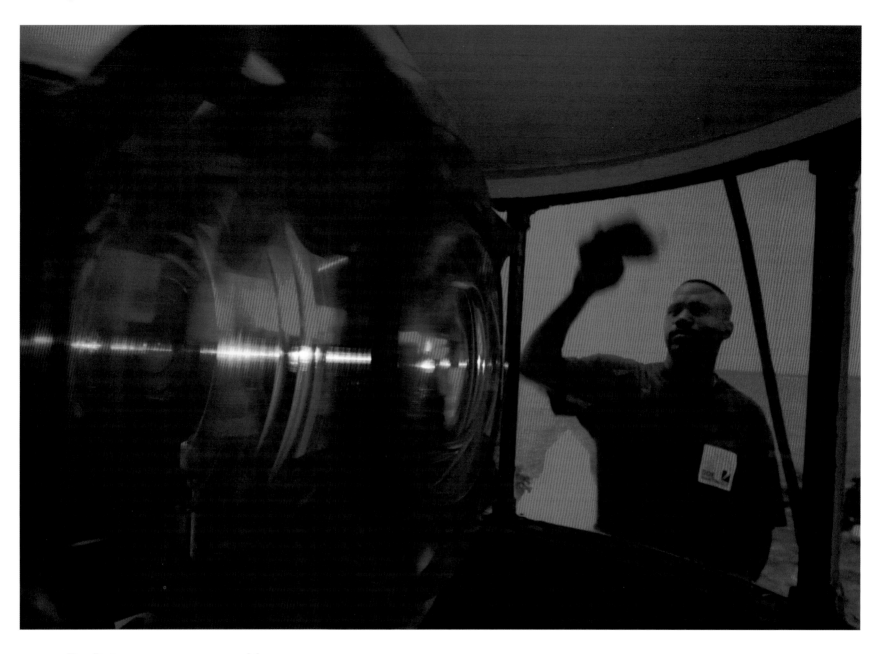

If he had the chance to come back to the world for a few hours, Augustin Fresnel would be proud of his invention—nearly all of the lighthouses around the globe are equipped with lenses similar to the one he first introduced in 1823 in Cordouan. To this day, no other system has dethroned the optical device invented two centuries ago by this engineer from the department of civil engineering. A polytechnician at sixteen years of age, the researcher came upon diffraction as a way to broadly diffuse light. The reflection of a light source gains power when amplified by blades of glass, enabling it to reach all the way to the horizon. This is the Fresnel "miracle" that had the residents of Cordouan, on that first night when the new lighthouse was lit, thinking a fire raged throughout the region. After centuries of wood fires, coal hearths, oil burners, and parabolic reflectors, this lens revolutionized maritime signal systems and continues to guide ships safely to port.

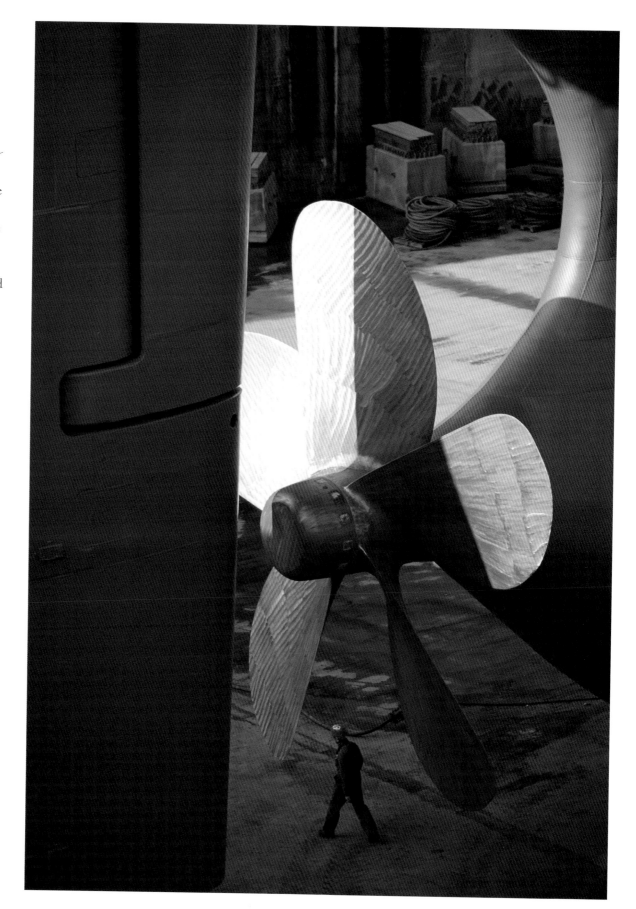

SAINT-NAZAIRE, FRANCE.
THE ATLANTIQUE-ALSTOM
SHIPYARDS, TOP BUILDER
OF LUXURY LINERS IN
THE WORLD.

Carnival Corporation, the company that owns the celebrated Cunard Line, commissioned the Atlantique-Alstom shipyards in November 2000 to build the largest and most expensive transatlantic liner of all time, the *Queen Mary II*, to be delivered in late 2003. Its design will have taken a year's work, 1 million hours of research, and more than 10,000 plans. Its hull, requiring the assembly of 300,000 metal pieces with 938 miles (1,500 kilometers) of soldering, weighs 50,000 tons. The *Queen Mary II* represents a new generation of ocean liners. The ship's energy consumptions will be the same as a city of 200,000, all provided by gas turbines, and a special system will treat wastewater before it is disposed of at sea. This floating city, more than 1,100 feet (345 meters) long and 130 feet (41 meters) wide, will cross the Atlantic at more than thirty knots, with a crew of a thousand. To its almost 3,000 passengers, the ship will have available 2,000 bathrooms, 3,000 telephones, a 1,350-seat dining room, a 1,100-seat theater, an 800-seat planetarium, four swimming pools, a kennel, and a hospital—and the list goes on.

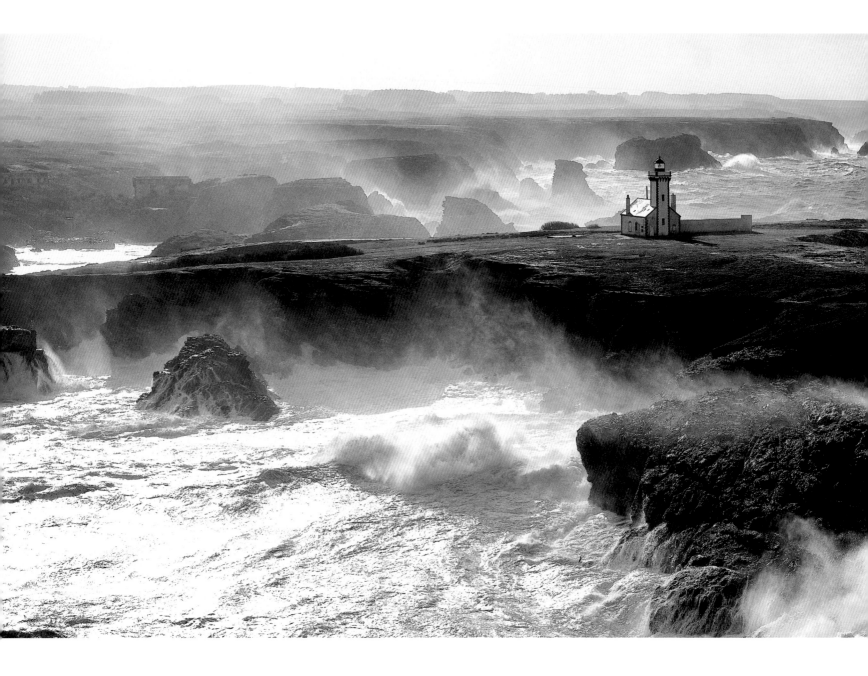

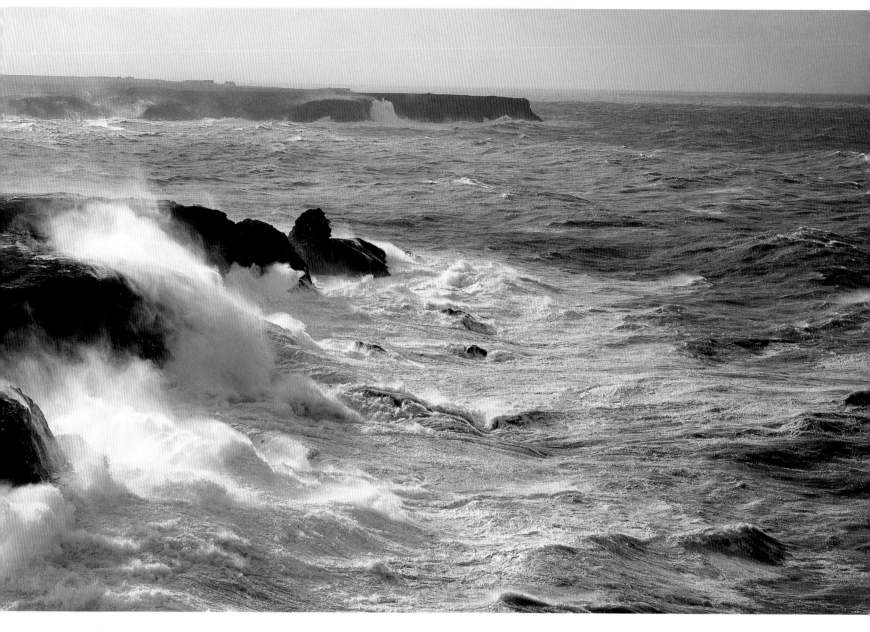

BELLE-ÎLE-EN-MER. GALE WARNING AT THE POINTE DES POULAINS. IT IS NOON
ON NOVEMBER 26, 1996; THE WIND IS BLOWING AT 80 MILES PER HOUR (130 KPH).
A SINGLE CLICK OF THE SHUTTER KNOWN AROUND THE WORLD.

At the western tip of Belle-Île, off the Morbihan coast, the tiny island of Poulains is an outpost in a tumult of
rocks. A lighthouse has been braving gusts and spindrifts on this scrap of cliff since 1899. But on this day in
1996, in this wild and magnificent setting, the furious squalls that blow around Pointe des Poulains are not the
usual ones. They seem to reveal a touch of magic that will deeply touch many people. Reproduced more than six
hundred thousand times, this photograph will know an extraordinary success all over the world, undoubtedly
because it vibrates with our eternal fascination with the sea. It reveals a scene that we feel we have seen before.
This fleeting, elusive moment is captured in an image that we may revisit at our leisure. Or perhaps it will be
the picture tenderly cherished by a distant relative.

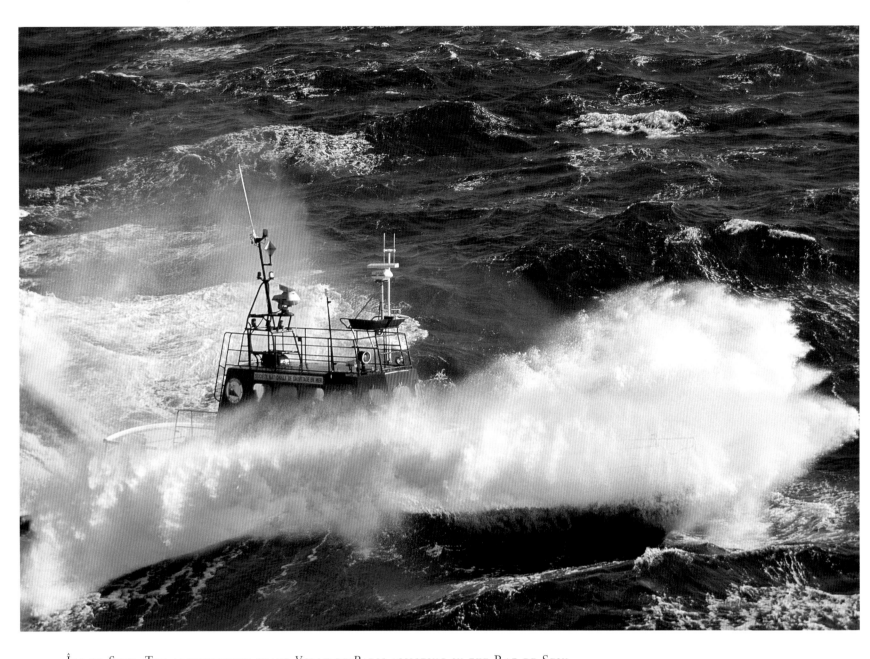

Île de Sein. The all-weather craft *Ville-de-Paris* assisting in the Raz de Sein.

Only the top of the launch toward Île de Sein escapes the avalanche of sea foam. Its red cover shows the four redeeming letters of the national society of sea rescue, an association that provides human sea rescue missions, free and voluntary according to its tradition. Present on all the coasts of France, it has scattered around 255 permanent or seasonal stations and 164 boats, ready to cast off within fifteen minutes of an alert. If only these all-weather craft could actually venture out onto the most raging waters, but they are only effective close to the coasts. They leave those rescue missions to helicopters and high-sea towboats. It is their ease in the reef areas, their capacity to operate in winds of 50 knots when a helicopter would have to give in, their size adequate enough for rescuing small boats, and their increasing performance that make them irreplaceable guardian angels every time. Techniques develop but that which makes a voluntary rescue worker will never change: a feel for the sea, experience, and devotion.

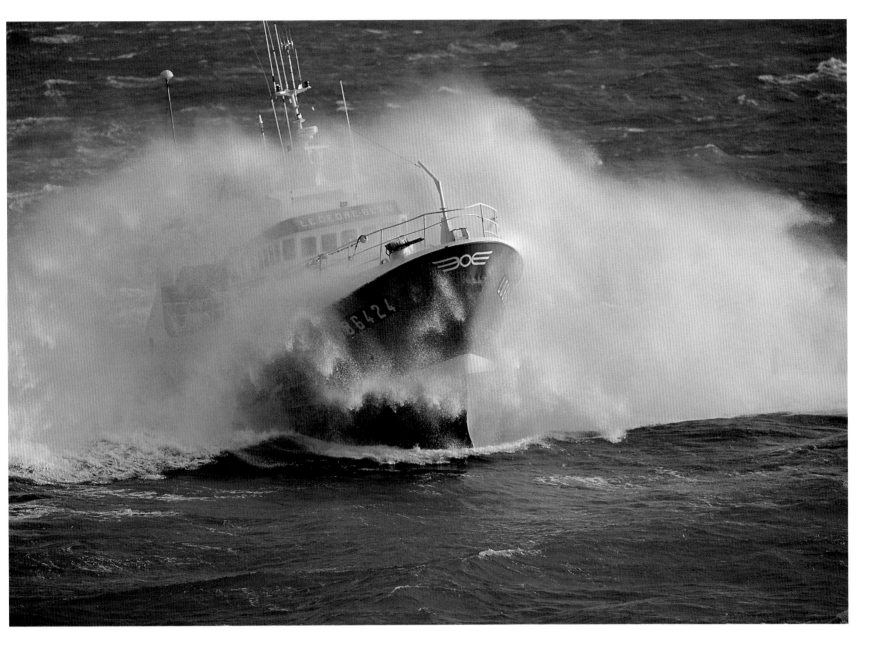

HEADING FOR THE FISH. A TRAWLER FROM LORIENT COVERS ITS FISHING GROUNDS.

Bundled in a shawl of sea spray, this trawler heads for its fishing grounds. These days, many areas are overfished, and stocks are dwindling. As a corollary, the fishing grounds are both fewer and farther out, and the commercial crews' journeys out increasingly longer. In order to assure the survival of the most sought-after species—and of fishing itself—regulations have been established that constitute the first steps toward a global management of fishing. Quotas, minimum permitted sizes, limitation of the periods and areas of fishing, and more selective nets are the chief measures taken to limit the depopulation of the oceans and reduce the numbers of fish thrown away annually (currently in the millions of tons). However, the will to genuinely implement these regulations is often absent. If every country scrupulously observed all of the rules, the age of sustainable and equitable fishing would already be here.

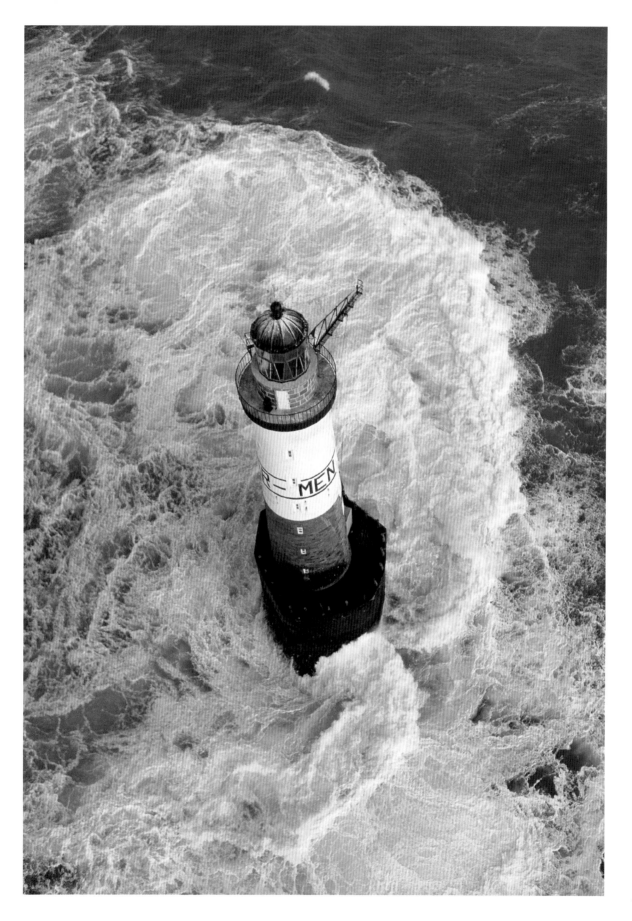

LIGHTS AT SEA. THE BLACK
ROCKS, AR-MEN, LA JUMENT,
AND KÉRÉON ARE THE LIGHT-
HOUSES THAT CAST THEIR
BEAMS OVER THE IROISE SEA,
IN WESTERNMOST BRITTANY,
WHERE THE LAND ENDS.

At the edges of the world's oceans,
some twenty-five thousand light-
houses trace a string of light,
pulsing at the tips of dangerous
headlands, revealing unsuspected
shoals, and framing ports. Each has
its own story. In Great Britain,
the lighthouse at Eddystone Rocks
has been rebuilt three times. It took
fourteen years to raise Ar-Men on
its underwater rock, where the
current can reach eight knots.
When the Black Rocks lighthouse
had a keeper, the changing of the
guard took place by means of a
hanging basket—the 260-foot
(80-m) ride up, over thrashing
waves, could take ten long minutes.
La Jument, constructed in just seven
years to benefit from the legacy of
a Mr. Potron, was then shored up
over the next twenty years, and
still wobbles. In 1861, the ocean
flooded Eagle Island, an Irish light-
house perched atop a 195-foot
(60-m) cliff. And Hercules's Tower
has been lighting La Coruña in
Spain since the second century. The
mother of all lighthouses, raised on
the Egyptian island of Pharos,
across from Alexandria, was con-
sidered one of the seven wonders of
the world, and at nearly 440 feet
(135 m), was the tallest lighthouse
of all time.

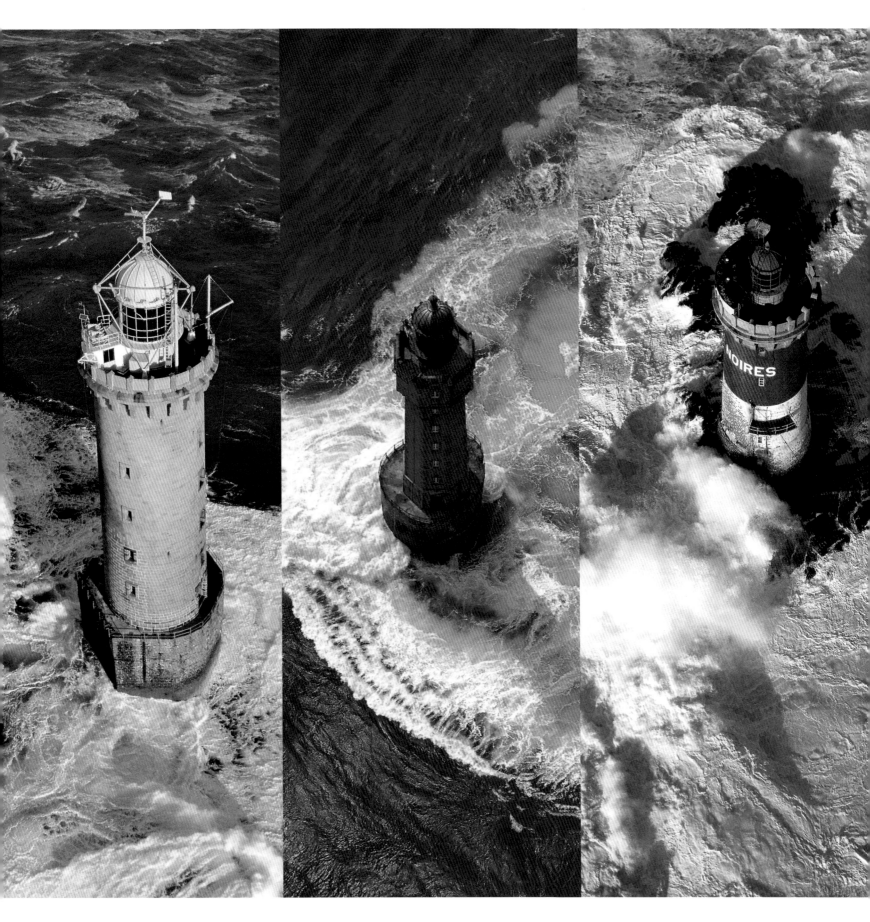

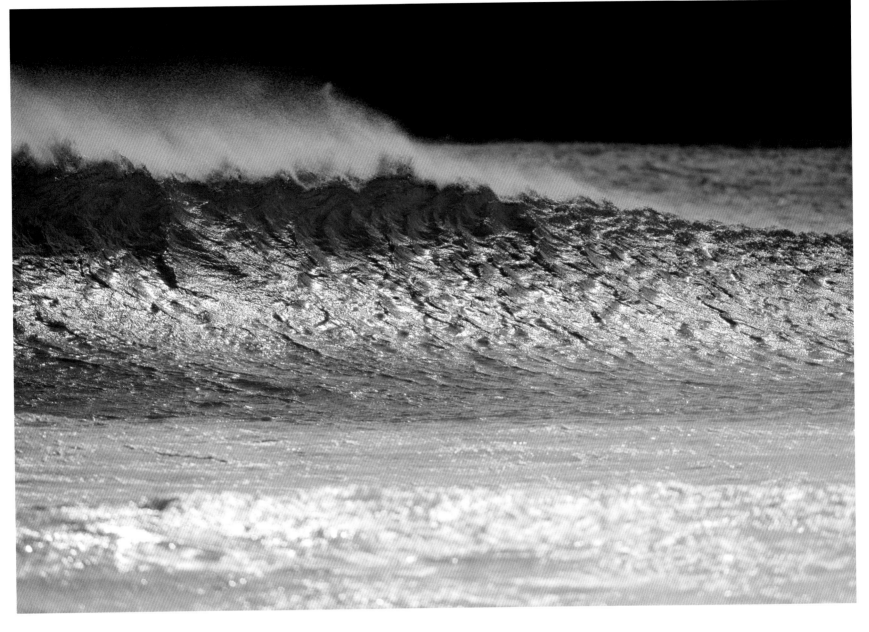

THE WIND HAS CHANGED. THE ONCOMING WAVES,
BUFFETED BY THE GUSTS, SEND UP CLOUDS OF SPRAY.

The swell rolls in from the open sea, colliding with the wind, which has turned. The opposing gust collides
with the wave and knocks off its crest, carrying away its plume. The exchanges between the ocean and the
atmosphere at the global level are important and complex, and people are working to understand these processes.
The great ocean currents, governed by salinity and temperature, reach across the world's waters, regulating the
planet's climate like a thermostat. The ocean moderates the climate of coastal regions, which often enjoy more
temperate climates than the interiors. We also know that every year almost 100,000 cubic miles (400,000 km^3)
of sea water evaporate into the atmosphere, where it will turn into rainwater, and that the ocean absorbs one
quarter of the carbon dioxide—the principal gas involved in global warming—given off by human activities.
What remains to be ascertained are the consequences of disturbing this system. Global warming, the urgent
topic of the day, only underscores our ignorance about the major player in it—the ocean.

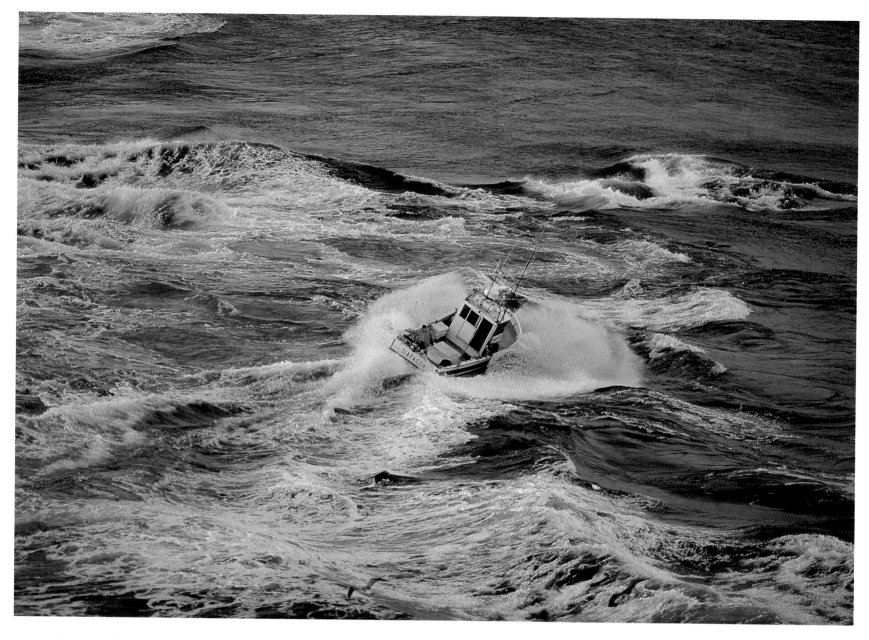

RAZ DE SEIN. FISHING FOR BASS IN THE CURRENTS BY LA VIEILLE LIGHTHOUSE.

The ocean is more than an inert mass glistening with tiny waves on its surface and edged with tumultuous eddies on the coasts. It is also spanned, across its immensity, by great currents that affect the planet's climate. This global circulation of masses of water in the depths and on the surface, determined by the temperature and salinity in the various ocean depressions, is like a gigantic rolling carpet. The lighter masses of water (high temperature, low salinity) circulate on the surface. When they reach the poles, they cool, and this causes them to become denser, which in turn causes them to sink. On the ocean floor, the deeper currents slip along very slowly, at a rate of no more than 12 feet (3.6 m) per hour. It would take a whole century for the masses of water around Greenland to reach the Atlantic. A complete tour of all the ocean's depressions would stretch out over almost a thousand years.

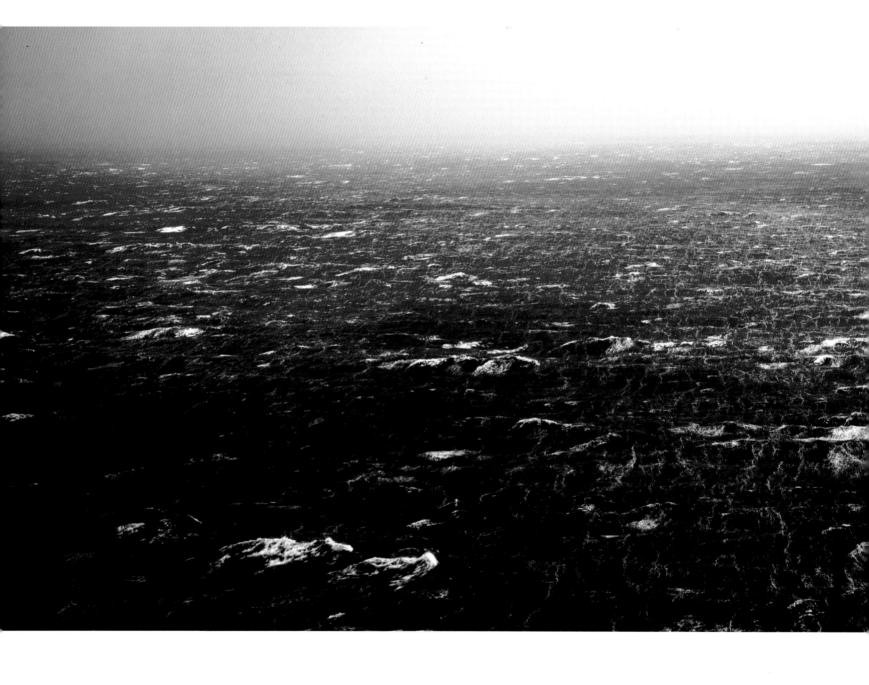

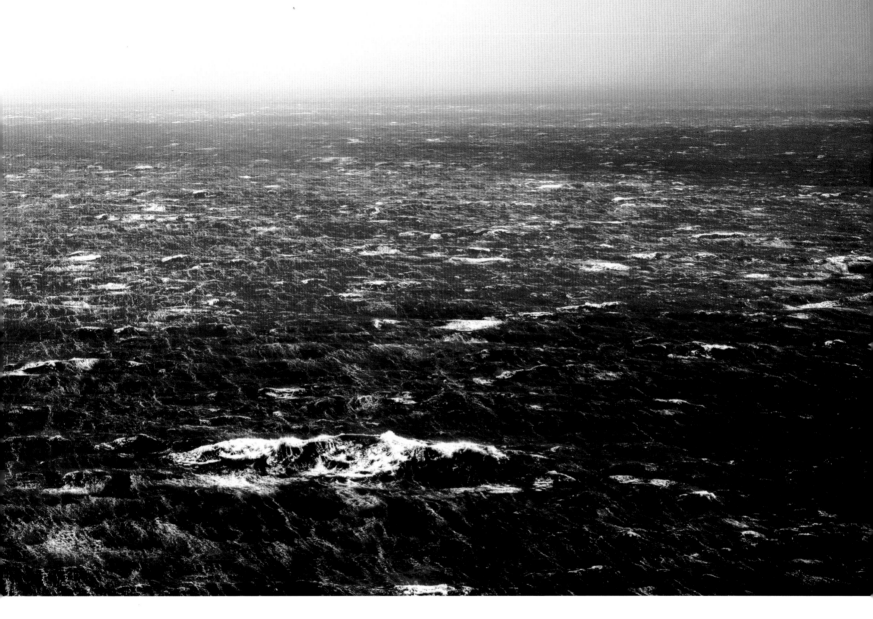

CHERBOURG. WHITE SEA ON THE ENGLISH CHANNEL.

Warning of a great chill on the English Channel. The sea is white, froth is everywhere, the wind gauge is stuck at Beaufort 7, with a few spikes up to 8. Here is Cherbourg, its boats huddling next to one another in the shelter of the port. The birds have disappeared, lying low with their feathers ruffled amid some granite rocks. The surrounding moor is a landscape of heather, gorse, and broom that gathers behind the low walls, modest constructions by men of the land. There, across on the horizon of Cherbourg's docks, emerges the "shipping lane" of men of the sea. In this zone a few miles wide, full cargo vessels cross paths with oil tankers of all sizes headed for the North Sea. The traffic is intense, and this sea-lane is one of the most heavily watched-over in the world. In this wind-whipped stretch the formidable nuclear-powered submarines from the base at Cherbourg pass in the silence of the depths. Nothing appears to disrupt the elements, despite this vessel that plunges headlong beneath the sea, and whose alluvial deposits at the Hague shipyards throw the Geiger counters into a frenzy.

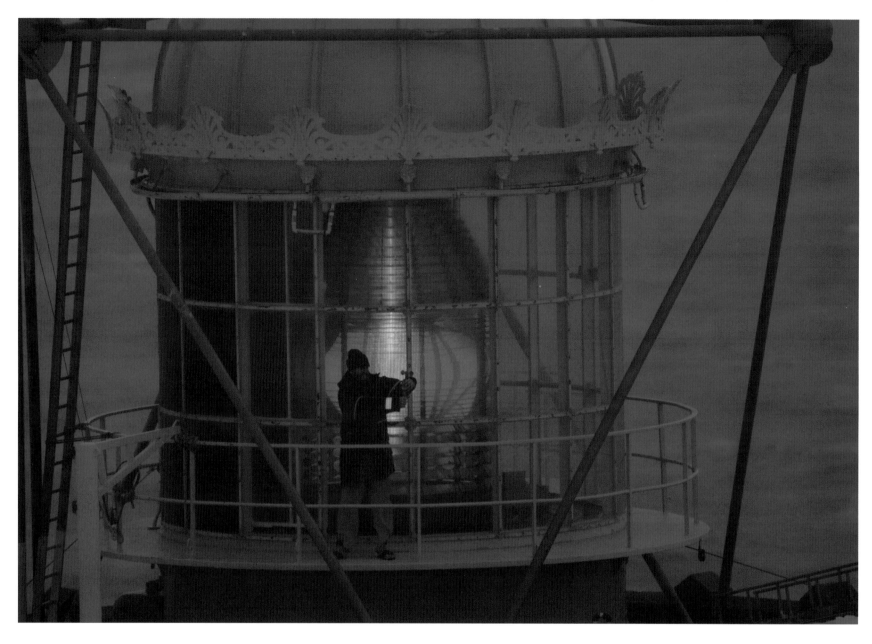

PERCHED ATOP AN IRON BALCONY, 150 FEET (45 M) OVER THE WAVES,
THE KEEPER OF THE KÉRÉON LIGHTHOUSE MEASURES THE WIND VELOCITY.

Reporting the weather conditions of the zone in his watch, verifying the working order of the buoys and bea-
cons in his sector, taking care of the upkeep and the running of the his own lighthouse, these are the tasks of the
last keepers of the high seas. At Kéréon, between the islands of Ouessant and Molène, the watchman goes out
on the balcony in his slippers to take the wind measurements by hand. Averaging more than 37 miles per hour
(60 kph) one day in three, the Brittany coast is often quite windy and receives head-on depressions that gather
in the north Atlantic. Born of clashes between the warm air masses over the Azores and the cold polar air over
Iceland, these disturbances roil in the intermediate latitudes and regularly strike the regions between the 40th
and 60th parallels.

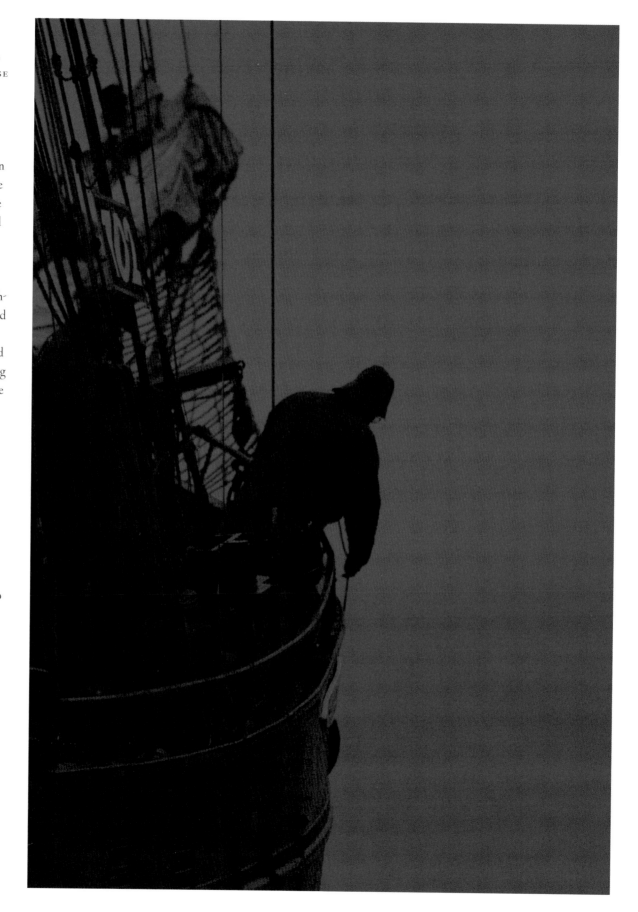

TRADITION. THE GHOST OF GOOD SMELLS OF HEMP AND CAULKING WAFT ABOUT THESE "OLD LADIES" OF THE SEA. Standing on the bridge astern, this sailor is busy with a line. In this pose, he looks like an old-time lookout, leaning down from his perch at the top of the mainmast to bend over the side of the crow's nest and be heard by the crew below. The lookouts on the great sailing ships of yesteryear were overseers who were responsible for watching out for the ship. They sailed aloft, isolated on narrow platforms, exposed to the wind and thrown off balance by the listing and pitching of the ship, whose movements were amplified by their high distance from the deck. Scrutinizing the horizon, they searched for suspicious sails that might suggest pirates or for a dark shape that would elicit the cry "Land ho!" Over time, modern navigational devices, radar, and the Global Positioning System (GPS) have allowed the sailors on watch to come down from their roosts. There are other elements as well—once essential to the grand sailing ships of bygone days—that no longer exist on their present-day descendants. The poop decks, those superstructures built astern on the bridge, have gone out of style, while the stems have lost the slender figureheads that the owners used to pick out specially to give every ship an individual identity.

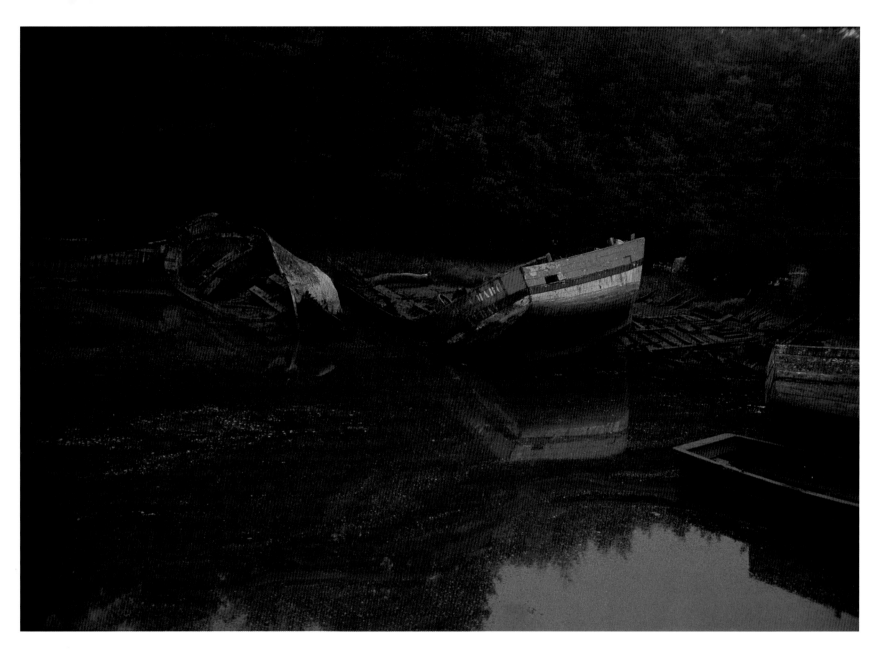

MORBIHAN. THE SHIPS' GRAVEYARD AT BONO, WHERE THE PIRATE SHIPS OF THE GULF CAME TO DIE.
Rafts, those most basic of boats, the most summary of skiffs, are made of logs. Wood was once the material of
every vessel, including the great four- and five-masters that vanished after World War I, their place usurped by
the steamship. Iron and steel made their first appearance in naval construction in the nineteenth century, gradu-
ally replacing wood in the building of the larger ships. Wood and steel, whether their end is natural or by
accident, eventually dissolve into the sea, eroded by the waves. Individual wrecks and ships' graveyards collect
these gutted or merely exhausted craft, which are slowly worn down in the mud of estuaries. Plastic, more
durable than wood and tougher than metal, after making a stunning entrance into the pleasure-craft shipyards in
the 1970s, does not decompose. Where will all those white ships go to die, after they have been abandoned?
No one knows that yet, but no other final resting place could ever evoke the emotion and poetry of the ships'
graveyard at Bono.

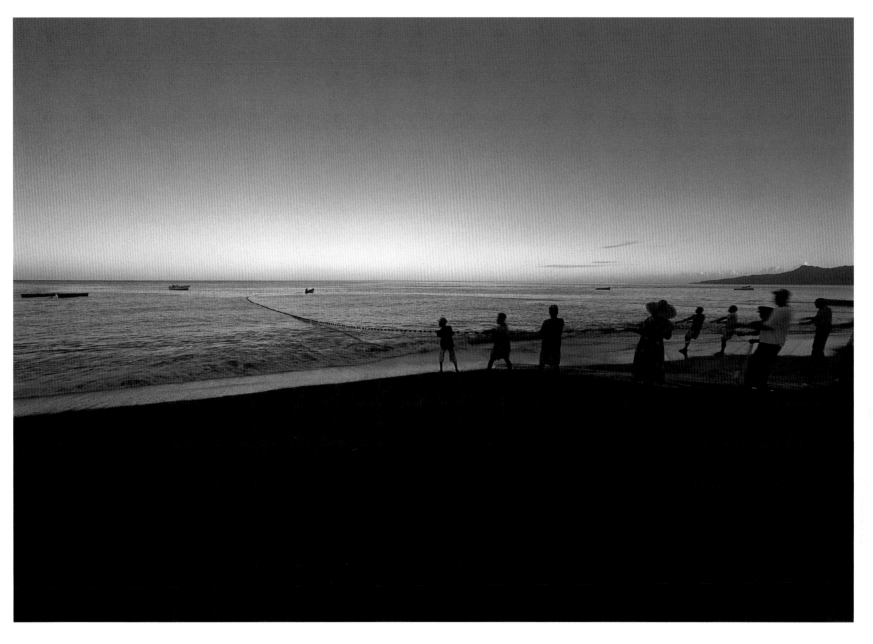

HAULING IN THE NETS AT DAWN. A TIME FOR FISHERMEN TO GET TOGETHER.

More than a tradition, it is a ritual. At sunrise and sunset in the villages on Martinique's west coast, the most sheltered part of the island, people come to do some net fishing. A very long net is carried out to the open waters by a *gommier*, which makes a huge circle before the wooden boat heads back to shore. The fishermen, abetted by countless volunteers, then drag the heavy pouch onto the sand, trapping the fish that had the misfortune to be swimming in the bay at that moment. From time immemorial, this fishing expedition, punctuated by the rhythm of chants and drums, has brought food to the poorest residents. Anyone who helps gather in the net is paid in fish. Widows of fishermen and women too old to drag the net lend a hand by singing. There is always someone who will garnish the top of their calabash with a few pieces of fresh fish.

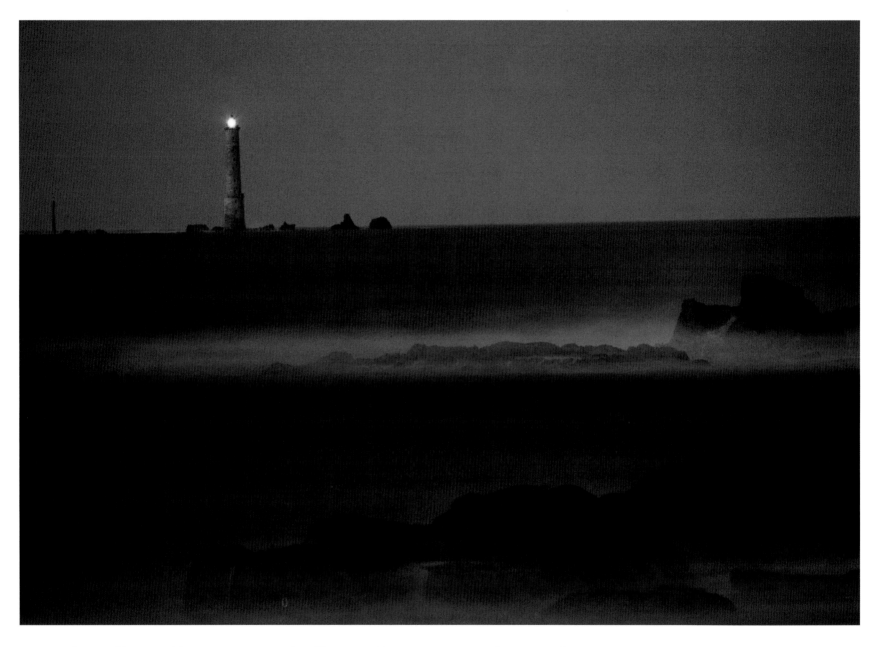

CÔTES-D'ARMOR. THE LIGHTHOUSE AT LES HÉAUX DE BRÉHAT, SEEN FROM PLOUMANAC'H.

Hovering at night off Côtes-d'Armor, a firefly glimmers atop Les Héaux de Bréhat. Since 1840, the lighthouse, which is 156 feet (48 m) high, has been signaling the Epées de Tréguier, a sword-shape outcropping of rocks in the northwest part of the island of Bréhat. It did not escape the wave of automation, which caught up with it in 1982. When the keepers went, so did any regular refueling—the lighthouses that once used gas, kerosene, or oil have had to plug into other energy sources. This has proved to be a boon for renewable forms of energy because the conditions are ideal for making the most of the ecological and economic advantages of wind power and solar energy, which are abundantly available in such locations. Windmills rise beside lighthouses such as Les Roches Douvres and Penfret, and solar panels have been providing energy since 1980. The lighthouse at Les Héaux de Bréhat shares its tiny world with this delicate windmill.

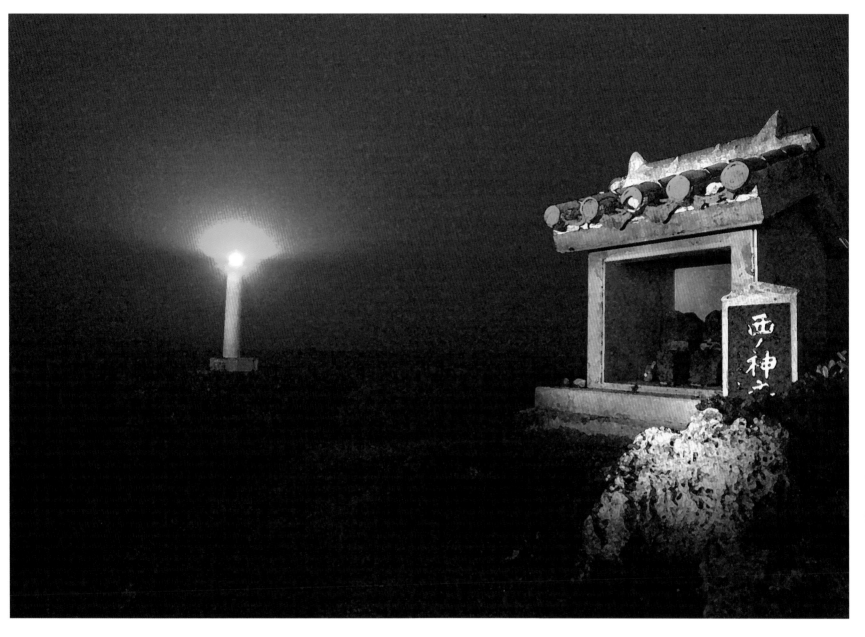

ARCHIPELAGO OF KYOTO. WITH THE COMPLICITY OF THE SHINTO GODS,
THE ZANPA MIWAKI LIGHTHOUSE STANDS GUARD OVER THE SEA OF JAPAN.

In the jet-black night, the large lighthouse at Zanpa Miwaki guards one of the capes of this archipelago of thousands of islands. Because of its fragmented configuration, this small country of 145,500 square miles (377,000 km²) has an enormous coastline of some 15,535 miles (25,000 km). Illuminating the Sea of Japan, this beacon is of tremendous importance to Japan's commercial fleet of seven thousand cargo vessels—one of the largest in the world—eliminating the danger of navigating among the islands and the return to the principal ports. At the foot of the tower stands a Shinto temple in honor of the Japanese gods and their spirits, the *kami*. Heavenly bodies, mountains, capes, rivers, and oceans are all deities in the ancient Japanese religion. The emperor and deceased friends and relatives are also considered spirits upon whom honors are bestowed through offerings of food, sake, paper strips, and pine branches.

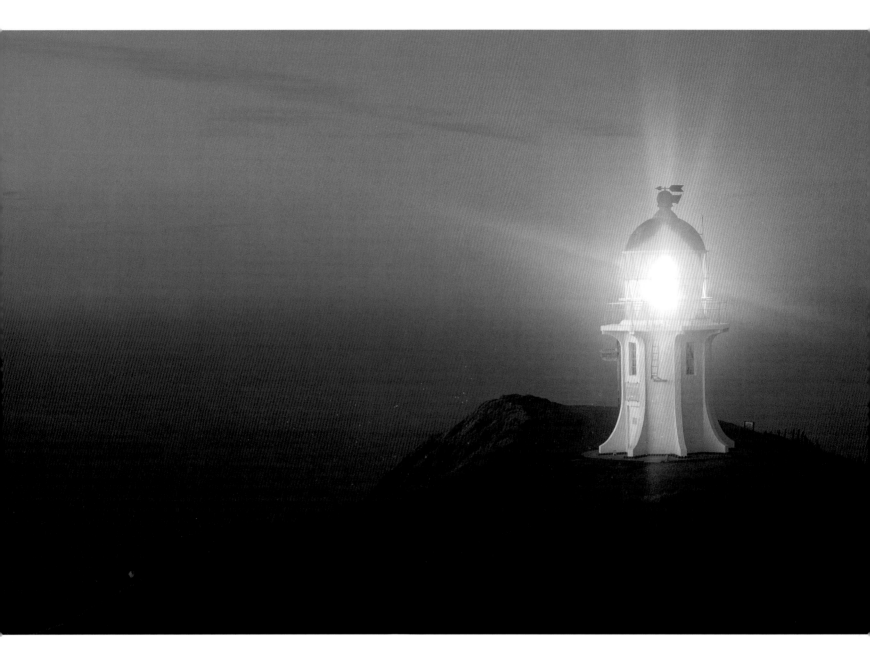

NEW ZEALAND. THE LIGHTHOUSE AT CAPE REINGA MARKS FOR THE SEAFARER THE NORTHERNMOST LANDFALL
IN A PLACE WHERE NATURE IS STILL IN CHARGE.

Rounding a cape is meaningful to any seafarer, who thereby changes scenery—sometimes even universe. Leaving an intimate cove to discover its neighbor, the sailor emerges from one ocean only to take on the next. Cape Reinga lighthouse, a landmark at the end of the world, signals entry into the Pacific Ocean. Two legendary capes, famous for their fearsome storms, rewrote the geography of the oceans. In 1488, Bartolomeu Dias came upon the Cape of Good Hope (formerly the Cape of Storms), where Africa ends, and which Vasco da Gama rounded en route to the Indies. In the seventeenth century, Dutchmen Willem Schouten and Jakob Le Maire, rounding Cape Horn from east to west in 1616, discovered the tip of South America, while their fellow countrymen reached Australia. Beyond all of these end points stretch the waters surrounding the mysterious austral landmass so passionately sought in the eighteenth century and which Fabian von Bellingshausen finally sighted in 1820: Antarctica, the pole of the most extreme cold, the most powerful winds, the greatest distances, the southernmost of all places.

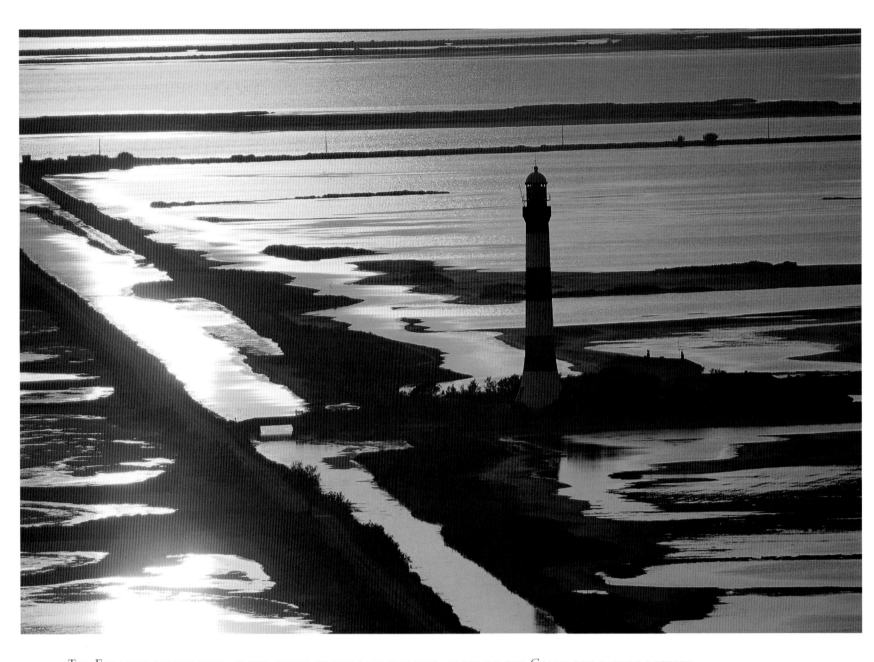

THE FARAMAN LIGHTHOUSE, IN THE HEART OF THE SALT MARSHES, CLOSE TO THE CAMARGUE NATURE RESERVE.

Arriving in the Bouches-du-Rhône, the Rhône opens two arms wide, joyful at reaching the sea. This emotional embrace forms the Camargue, a vast, damp, triangular area of 230 square miles (600 km²), half of which is ponds and fens. A diverse array of birds—including the emblematic pink flamingo—has taken refuge in this extraordinary environment, where nature fluctuates between sea and land. People grow rice and grapes in the northern area of the delta, while the swampy southern part is reserved for the *manades*—the herds of horses and bulls typical of the Camargue—and the exploitation of some 40 square miles (100 km²) of salt marshes. Near Salin-de-Giraud, west of the salt marshes, rises the black-and-white-clad Faraman lighthouse, overlooking the surrounding vastness from its height of 150 feet (47 m) and 110 years of age, celebrated in 2002. A restoration between 1947 and 1950 erased the stigmata the lighthouse received in World War II; now it sends a beam that can be seen more than 30 miles (50 km) out on the Mediterranean horizon. The lighthouse also watches over the abundant but vulnerable natural environment below: the Camargue would, in fact, be one of the first areas to be swamped if the level of the sea were to rise.

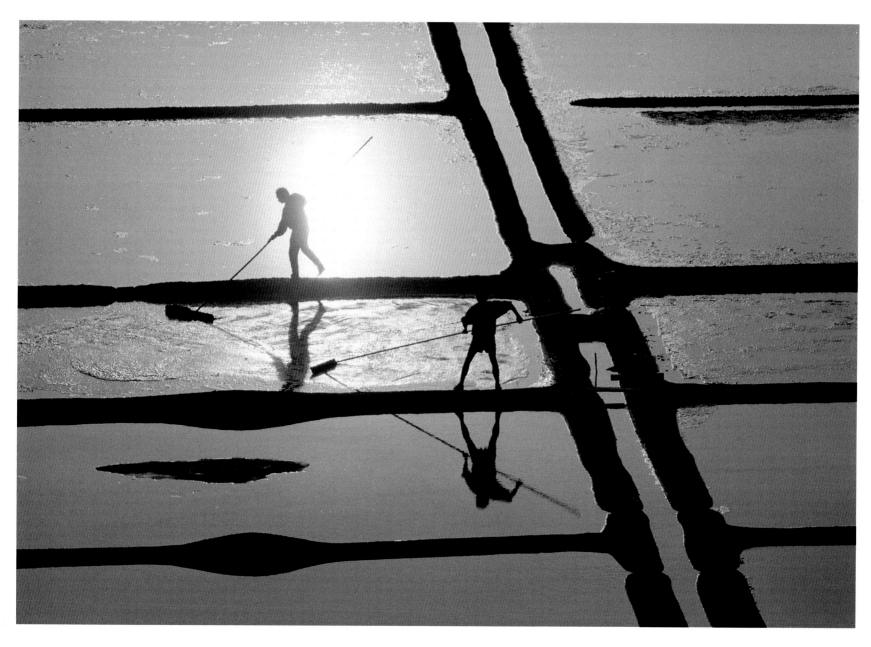

GUÉRANDE. IN SUMMER, AT THE END OF THE DAY, WORKERS IN THE SALT MARSHES
USE THE LAS TO HARVEST THE SALT THAT HAS CRYSTALLIZED IN THE SUN.

The summer sun and wind have labored all day on the 5,000 acres (2,000 ha) of salt marshes on the Guérand peninsula in the Loire-Atlantique region. The salt-marsh workers enter the scene in the furnace of late afternoon. Standing on the levees that contain the areas of water, they maneuver their *las*, the traditional long-handled wooden shovels, to collect the crystallized salt with centuries-old skill. People have exploited this salt-producing site on a small scale for more than a thousand years. They have shaped the clay soil into a maze of basins in which the seawater washed in by the spring tides circulates. The water gradually evaporates as it crosses the mosaic of the salt marsh, from the ocean to the evaporating pans at the end. In the 7,820 evaporating pans in use—which create this incandescent stained-glass effect each evening—the concentration of salt reaches 2 $^1/_2$ pounds per gallon (compared with 4 ounces per gallon of seawater). This is the first step on the way to the saltcellar. One-third of the world's salt is extracted from seawater, with the rest coming from salt mines, which also originated in the sea. The chemical industry and the deicing of roads account for three-quarters of all the salt produced.

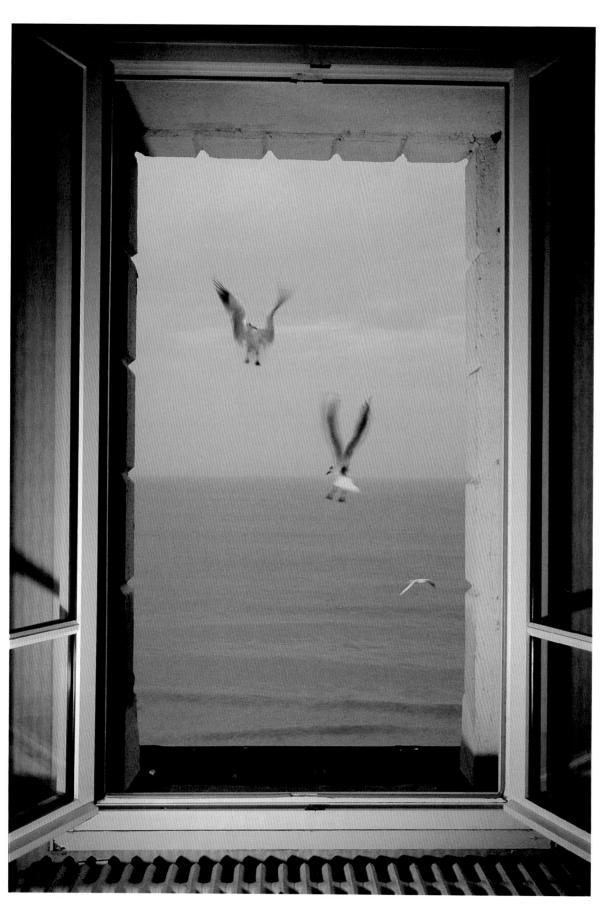

FLIGHT. ÎLE VIÈRGE
LIGHTHOUSE.

The lighthouses of the French
coastline display a wide variety
of architectural styles. La
Jument stands like a donjon of a
fortress, Tévennec resembles a
chapel, the lighthouse of Les
Héaux de Bréhat boasts intimi-
dating battlements, and the
great tower on the island of Yeu
is in the style of Art Déco.
Cordouan, a seaside Versailles,
with a chapel and royal apart-
ments, illustrates the architec-
tural whimsy of the French
lighthouses, which are, in effect,
monuments. They all feature
elaborate decorative details—
elegant balconies, refined
wrought-iron balustrades, or
corbelling ornamenting their
slender shafts. If the lighthouses
were built to signal reefs, why
make them so beautiful? Who
is there to be seduced by so
much splendor? The only visi-
tors who can freely admire the
myriad exteriors of the light-
houses are perhaps the seabirds,
unquestionably the most at
home in the towers' vertical,
aerial world.

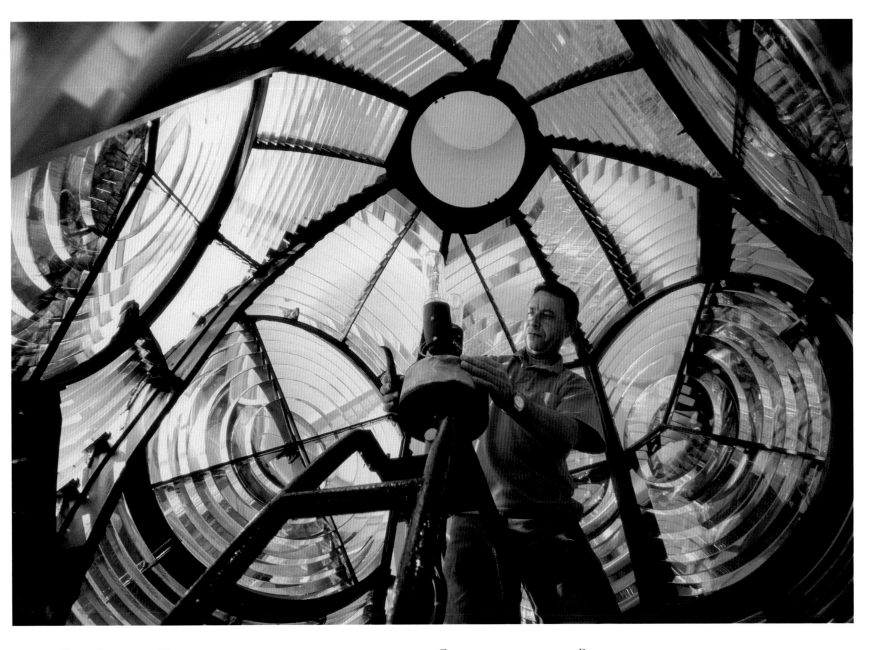

CABO SILLEIRO. THIS LIGHTHOUSE MARKS THE BORDER BETWEEN GALICIA AND NORTHERN PORTUGAL.
THE KEEPER, MANUEL EXPOSITO ALVAREZ, LOVINGLY MAINTAINS ITS GIANT FRESNEL LENS.

As ships head south, away from the Iberian peninsula, the last Spanish beams to shine their way over the Atlantic Ocean come from the desert promontory that has been home to the Cabo Silleiro lighthouse since 1925. This little palace of light, with its 98-foot (30-m) turret, perches some 276 feet (85 m) above the waves. It is equipped with Augustin-Jean Fresnel's revolutionary invention, patented in 1823: a stepped lens that focuses rays horizontally. Bonfires blazed on Cabo Silleiro's ancient stones until the late sixteenth century, when coal replaced wood as lighthouse fuel. At the time, a lighthouse could devour as much as 200 tons of coal a year—4 tons in a single stormy night. Tallow candles, the rule in lighthouses out on the reefs, could be dangerous: Eddystone II, on the English coast, burned to the ground in 1755. Oil lamps took over in the late eighteenth century and were soon surrounded by reflectors; this system gave way to oil and a powerful acetylene flame. The twentieth century brought electrification and automation to the lighthouses, the latter changing even the barred lamps.

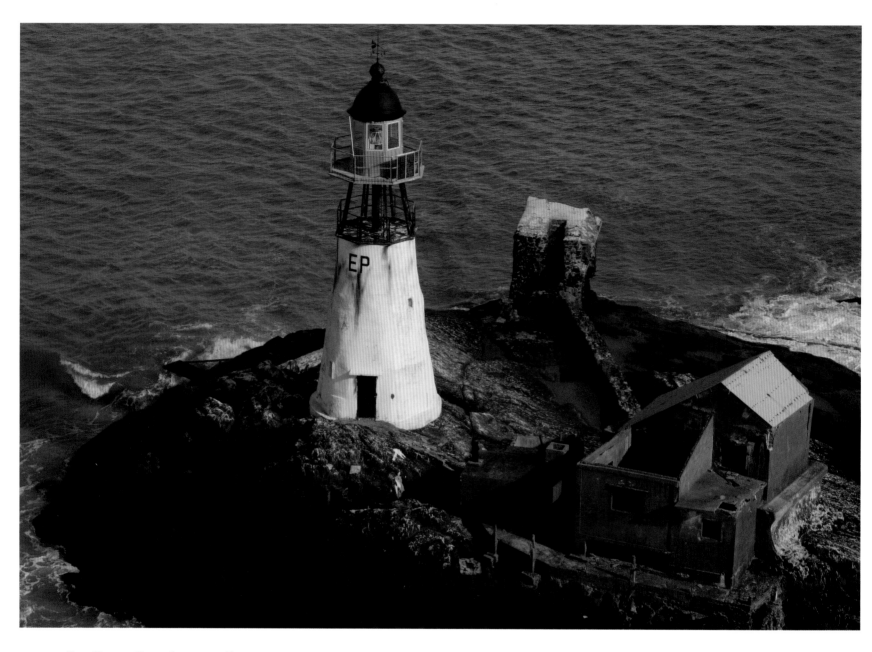

The "Lost Child" of the Guyana penal colony.

The length of the Guyanese coast is dotted with islets, one of which sports this iron beacon marked with the letters EP—Enfant Perdu, or Lost Child. The surrounding formations have been named Father, Mother, Two Breasts (renamed Two Daughters), and Sickly One. Legend has it that one day these islands went for a walk as a family, when a tidal wave took them by surprise and the youngest was lost. The lost child, carried off by the current, only returned to the coast much later. This name has great resonance with a dark page of Guyanese history—a page in the story of the penitentiary. Dating back to 1789, political prisoners who had escaped the guillotine were deposited in the forests of this Amazonian colony. By 1852, the deportation had become a systematic method to rid the French prisons of their six thousand condemned who idled about there in the "freshness of the Empire." Through 1946, the penal colonies of Cayenne and the surrounding islands accommodated thousands of prisoners, most of whom never set foot on French soil again.

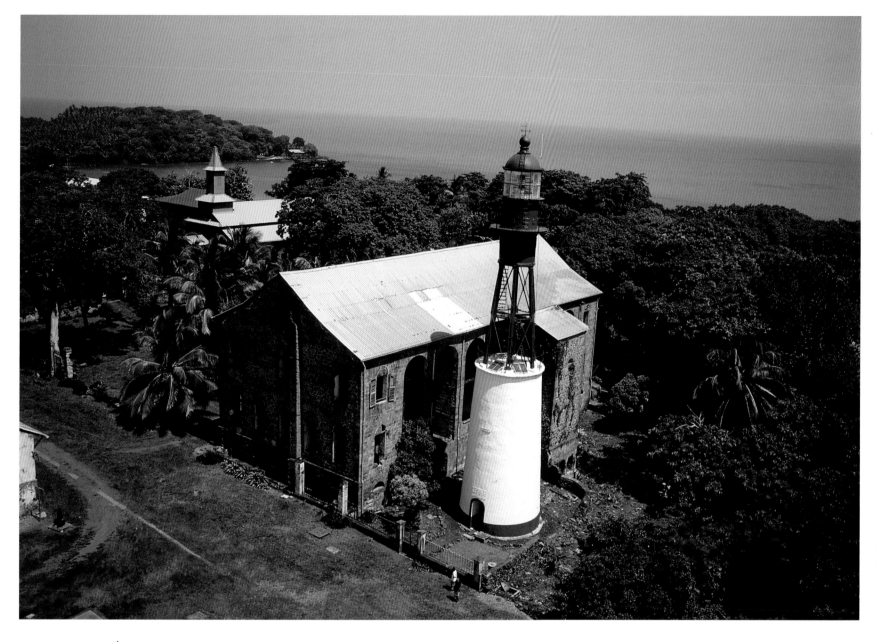

ON THE ÎLES DU SALUT. IN THE HOVERING SHADOW OF DREYFUS AND SEZNEC,
"ISLANDS OF SAFETY" SEEMS A MISNOMER.

Jutting up out of the Atlantic off Kourou in French Guyana, the three Îles du Salut present an idyllic image
of the tropics, complete with palm trees reflecting in turquoise waters. One can forget that for a century
(approximately from 1850 to 1950) the Île Royale, Île Saint-Joseph, and Île du Diable comprised the nucleus of
the French penal colony in Cayenne. France sent its political prisoners, including Dreyfus, Seznec, and others
less famous, as well as common criminals, there. In addition to strict security, the further threat of sharks circling
the shores made escape impossible. The lighthouse was built at the summit of the largest island, the Île Royale,
next to the convicts' hospital. The beacon offers a glimpse of humanity amid this great desolation where thou-
sands of convicts perished, cut off forever from their homeland and families.

IN THE GULF OF FOS, THE REFINED ARCHITECTURE
OF THE AUTONOMOUS PORT OF MARSEILLE ADORNS THE COAST.

With numerous sites along the Provençal coastline, astride the Berre-l'Etang on the Gulf of Fos, the autonomous port of Marseille has set many records: first port of France and the Mediterranean; third-largest port of Europe; 90 million tons of freight annually, with a turnover of $165 million (140 million euros) and some 1,500 employees. Two hundred regular sea-lanes link Marseille with 320 foreign ports dispersed through 120 countries around the world. Whereas since the end of World War I the flames of oil refineries have burned in La Mède, Lavéra, and Berre-l'Étang, Fos-sur-Mer, shown here, has remained a port for ore carriers.

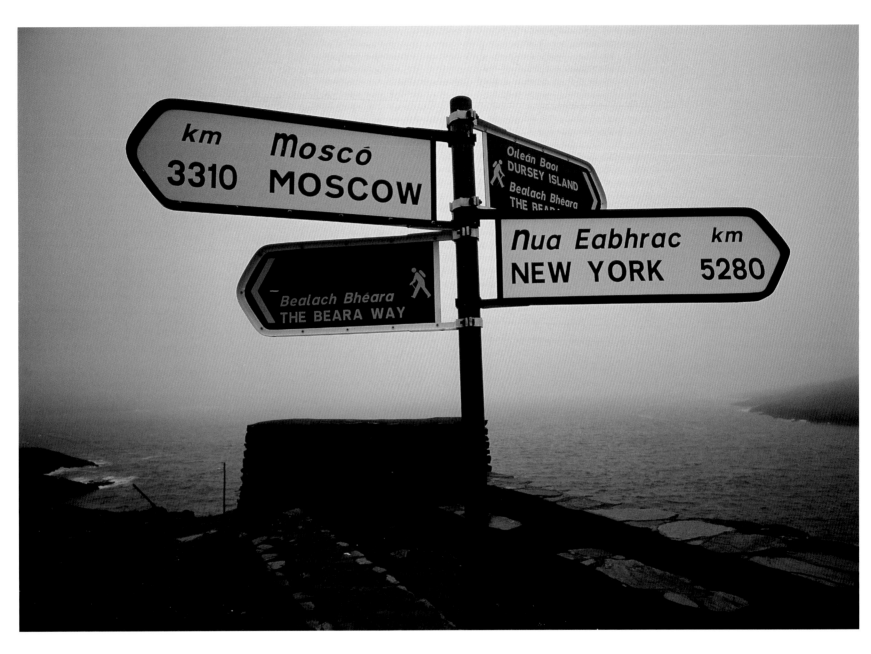

AMER. THE SOUTHWESTERNMOST TIP OF IRELAND, JUST BEYOND BANTRY BAY,
A TIP OF THE HAT TO THE MEMORY OF EMIGRATION.

Bantry Bay's deep channel, in southwest Ireland, boasts this signpost. The next one to be found lies far to the west, planted in American soil. Between the two stretches the Atlantic Ocean, which Christopher Columbus crossed in 1492 seeking the Far East—though he landed on an island in the Bahamas. With 41 million square miles (106 million km²), the Atlantic is half the size of the Pacific, but just as long, extending over some 7,200 miles (11,500 km), from Greenland to the South Pacific. Down the middle rises the underwater Mid-Atlantic ridge, the area of fracture in Earth's crust where the emerging magma is causing the Atlantic Ocean to widen by about 1 inch (2.5 cm) a year. This means Europe and North America are growing farther apart, and eventually the distances marked on this sign will be wrong. Other areas on the planet present subduction faults; here, the ocean's crust, subsiding below that of the landmass, sinks back into Earth's magma, compensating for the growth elsewhere.

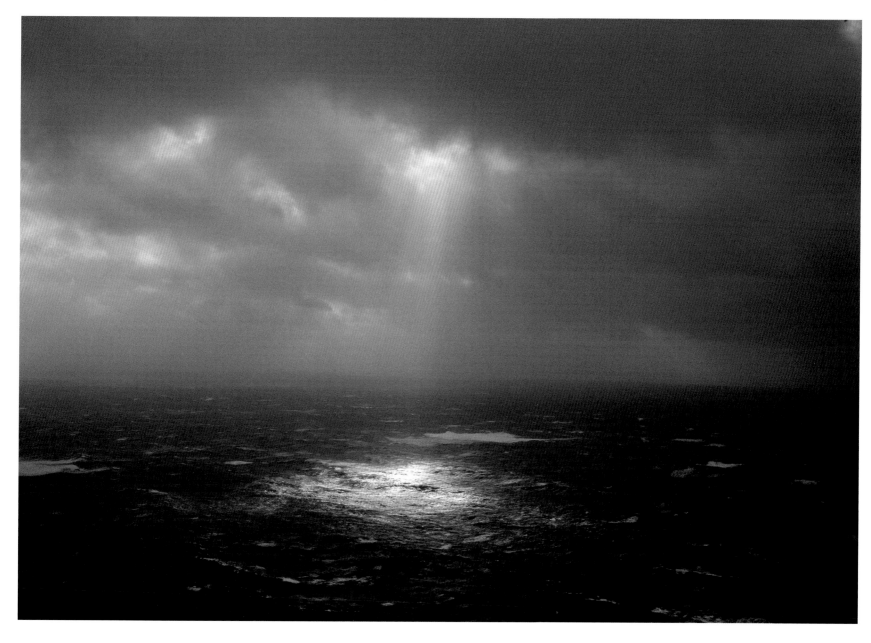

LIGHT. THE SUN BREAKS THROUGH THE CLOUD COVER ON AN OVERCAST SKY.

As the wind rips the layer of clouds, the sun sends a beam of light over a gloomy ocean, laying down a splash of silver. Below the opaque surface lies a shadowy domain, long inhabited by fearsome, voracious monsters born of the popular imagination and of the unbounded fear arising from a lack of information about the great ocean depths. In 1872, the British ship *Challenger* set out on a four-year mission, returning with unexpected proof— the result of much dredging—that life exists at depths of nearly 17,000 feet (5,200 m), thus shedding light on the mysterious fauna of the abyss. Since then, human explorers in bathyscaphes have observed that thousands of diverse and unique species (including a 55-foot [17-m] squid and a 2,000-pound [900-kg] jellyfish) reside in the hostile depths, adapted to the endless night, icy waters, enormous pressure, and scarce food. Yet even today, this realm of extremes is little known.

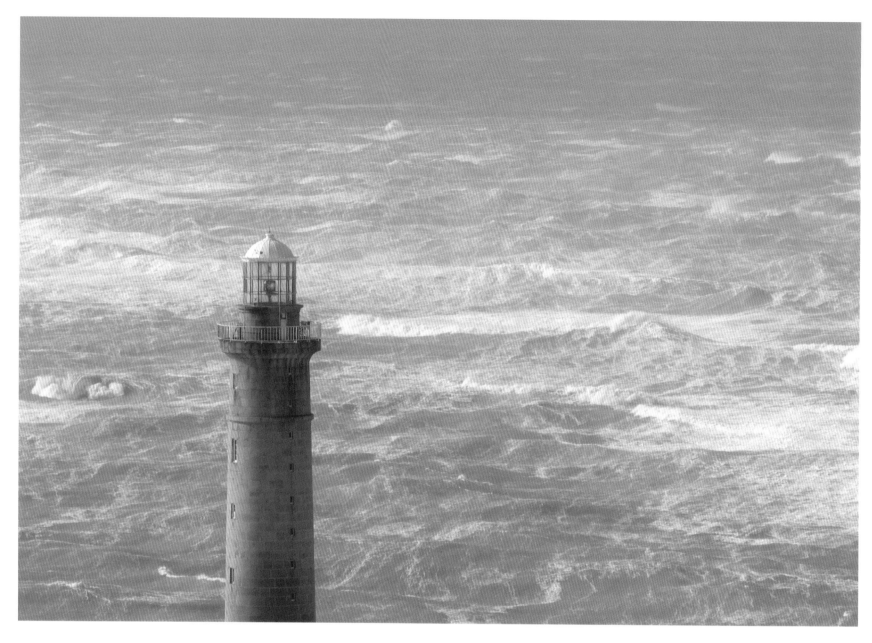

THE HAGUE LIGHTHOUSE. KEEPING WATCH OVER THE WELL-NAMED RAZ BLANCHARD.

"Never before had the Raz Blanchard lived up to its name as it did on this day. The sea wasn't blue, green, or even gray. It was white with the foam," recalls the photographer who was drawn to these brutal shores by a stormy-weather report one winter Sunday. When this photograph was taken, the storm winds had reached 20 miles per hour (30 kph). The surrounding airports had been closed to air traffic and thus the helicopter had to cross the Channel to refuel in England and then continue its flight. One hundred and seventy feet (52 m) tall, the lantern room houses a four-paneled lens and a 250-watt wind-resistant halogen bulb. Built in 1837, the granite tower was lived in year-round until 1990. Since then, the pale glimmers into the Blanchard do very well under the favorable auspices of the keepers. The beacon is remote controlled from Cherbourg and has a range of some 23 nautical miles (26.5 miles/42.5 km) in good weather.

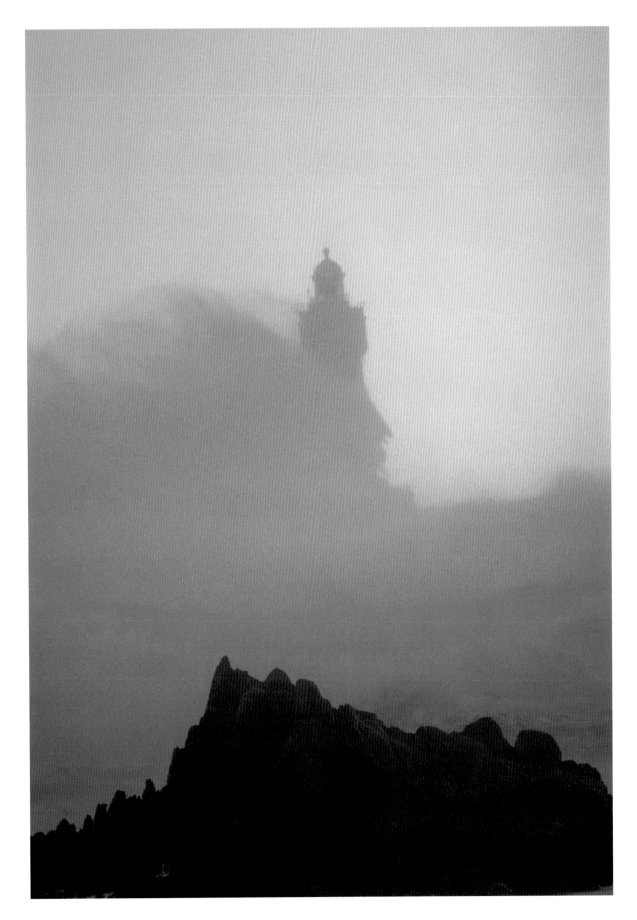

TWO LIGHTHOUSES FACE
EACH OTHER ACROSS THE
ENGLISH CHANNEL: START
POINT, IN CORNWALL,
AND, HERE, LA JUMENT,
IN THE IROISE SEA.

A certain Mr. Potron, a gentle-
man of independent means and
member of the Société de
Géographie, was miraculously
rescued from a shipwreck off
Île d'Ouessant in 1878. In
1904, he bequeathed four hun-
dred thousand gold francs for
the construction of a lighthouse,
specifying that it must be lit
within seven years. The chal-
lenge was accepted, and work
began immediately on the per-
ilous reef known as Ar Gazek-
Koz—Breton for "the old
mare"—which is in a place that
powerful currents make difficult
to reach. Nevertheless, in
1911, La Jument, an octagonal
tower, raised its light more
than 150 feet (47 m) up, shin-
ing its red beams onto Le
Fromveur passage. The bet was
won . . . almost. For no sooner
was it finished, than the granite
building began to shake on its
rock. The work to shore it up
continued until 1940, and the
tower was anchored to its rock
by four cables. The lighthouse
was automated in 1991. Now
and again, a window breaks, a
metal bar becomes twisted, and
the walls may vibrate . . . but
for La Jument it's nothing to be
concerned about.

MORBIHAN BAY. BOËDIC ISLAND, AT THE MOUTH OF THE VANNES RIVER,
IS ONE OF THE 365 ISLANDS THAT, LEGEND HAS IT, ARE VISIBLE AT LOW TIDE.
THE OWNER, AN OYSTER FARMER, RETURNS TO SHORE.

Everywhere, on all the world's oceans, people are busy with a repertoire of tasks. The continuous choreography of their activities on the sea's great stage makes the sea both more familiar and more attractive. People perform an endless array of jobs, all of them centered on the same single common point, the sea: ocean, river, and harbor pilots; fishermen; oceanographers; rescue workers; lighthouse keepers; those working on offshore rigs; high-sea rovers; workers in salt marshes; those laying ocean cables; oyster farmers; sailing instructors and captains. So many men and women live on, in, and from the sea. Some of them are wondering what effect technical, economic, and social developments will have on their professions. Some marine trades will gently disappear as new ones emerge. However different their ways of life, their futures, and their musings, the people of every country by the sea share a universal feeling—a humble deference toward the sea that provides them with their living.

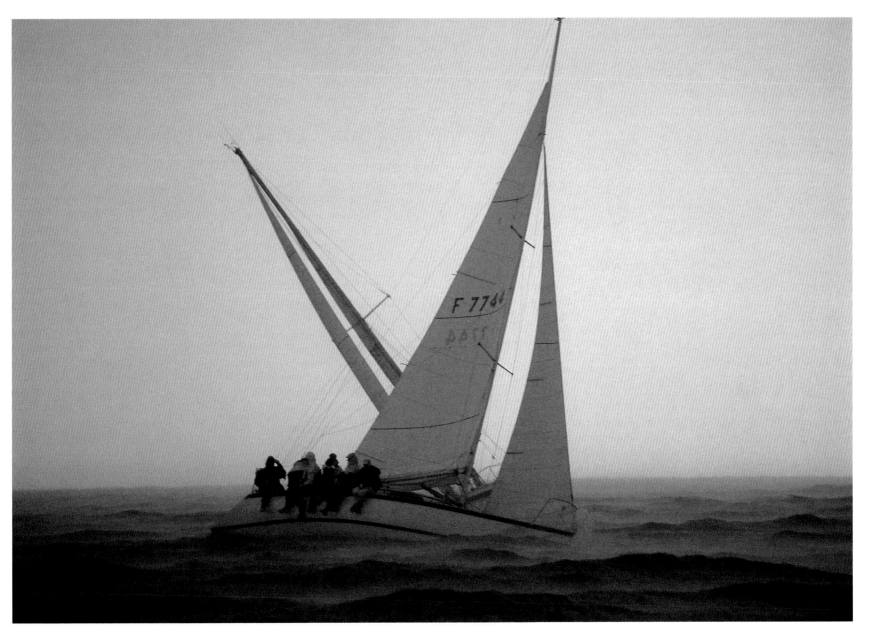

DRIZZLE. IN AUTUMN, WHEN DRIZZLING RAIN SHROUDS
A FLOTILLA OF RACERS, IT'S POINTILLIST POETRY.

Offshore or on the high seas, single-handed or crewed, pint-size Optimists or outsize multihulls, there are
infinite variations on sailboat races, the scenes of wonderful feats and unforgettable tragedies. The Route du Rhum
and the British Transatlantic, the most famous of the transatlantic races, share their ocean with, among others,
the Mini-Transat, with its 21-foot (6.5-m) sailboats. The illustrious solo around-the-world races—such as the
BOC Challenge (heir to the only Golden Globe, in 1968), the Vendée Globe, and the recent Around Alone—all
share the limelight with the prestigious Whitbread, which is run crewed. Amazing regattas such as the Multihull
Championship, classics like the Figaro race, and legends like the Admiral's Cup bring excitement to the coasts,
while the America's Cup and the Fastnet, which rounds the eponymous lighthouse in southwest Ireland, are run
at sea. Finally, there are the Jules Verne Trophy and the Race, awarded to the swiftest on the planet.

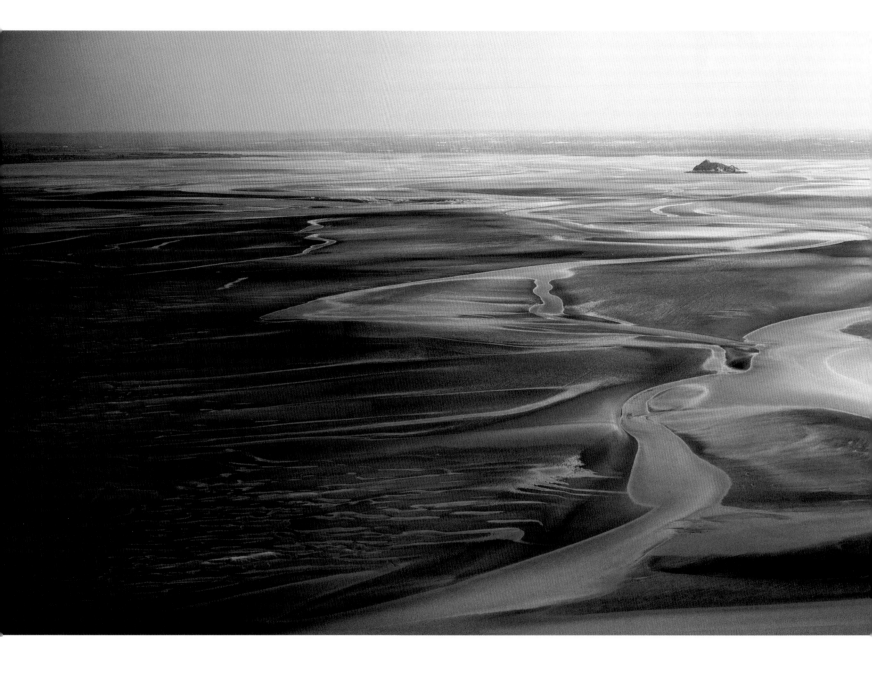

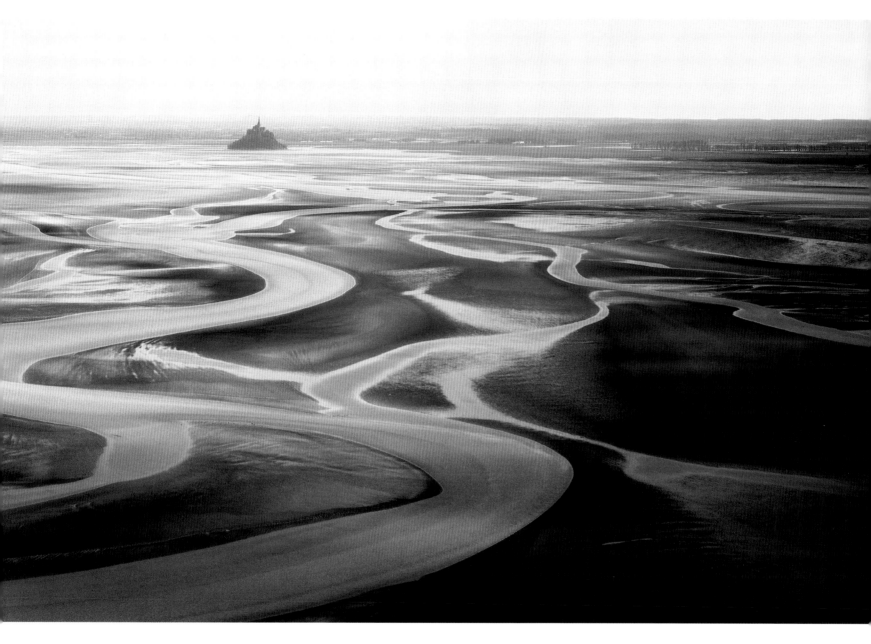

MONT-SAINT-MICHEL. LOW TIDE ON THIS BAY OF GREAT TIDES. AFTER NOVA SCOTIA'S BAY OF FUNDY,
THIS SITE BOASTS THE WORLD'S STRONGEST TIDE LEVEL.

Nestled in a bay so vast it touches both Brittany and Normandy, Mont-Saint-Michel bears the slender spire of the Benedictine abbey founded in 966 on this solitary rock, which is alternately surrounded by the sea and an expanse of sludge. A causeway built in 1879 connects it with the mainland, enabling the flood of visitors—up to seven hundred thousand in summer—to reach this tourist destination even at high tide. The difference between the level of the sea at high and low tides can be as much as 48 feet 9 inches (15 m). (The record of 52 feet [16 m] was registered in the Bay of Fundy.) Earlier plans for exploiting the colossal and inexhaustible power of the tides in both these places have been revised, owing to the effects on the ecology that have been observed around an installation at a similar site, the tidal power station at Rance, in Brittany. The great height of the tides in the Mont-Saint-Michel bay is caused by the shape of the coastline and the shallowness of the sea bottom (less than 114 feet [35 m]). At low tide, the sea disappears completely, leaving this incongruous, silver-beribboned pyramid. What if it never returned?

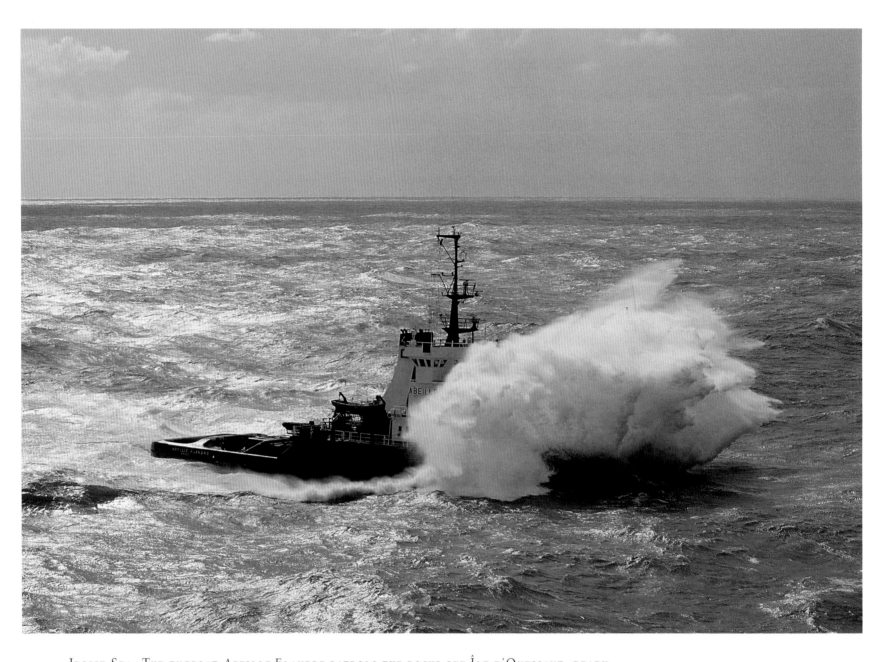

IROISE SEA. THE TUGBOAT *ABEILLE FLANDRE* PATROLS THE ROCKS OFF ÎLE D'OUESSANT, READY
TO COME TO THE RESCUE AND AVERT, IF AT ALL POSSIBLE, DISASTERS LIKE THOSE OF THE PAST.

Like its sister, the Cherbourg-based *Abeille Languedoc*, the *Abeille Flandre*, chartered since 1979 by the Marine
National Française in the aftermath of the Amoco *Cadiz* oil spill, belongs to the Abeille International shipping
company. This small high-seas tug, which measures 205 feet (63 m) long, devotes its Herculean 23,000-horse
power—it can tow a supertanker or an aircraft carrier—to aiding and rescuing ships in distress. When the
wind blows at more than 25 knots, it sails out of Brest to the rocks at Île d'Ouessant, warding off danger on
that most crowded and dangerous of the sea highways. It sees some 850,000 tons of oil pass by every day, the
equivalent of twenty *Erikas*. By January 1, 2000, the *Abeille Flandre* had conducted nearly eight hundred rescues
off Île d'Ouessant. In many cases, its efforts averted catastrophe and saved lives. The *Abeille Flandre*, that
faithful watchdog, is always ready to sail to the rescue.

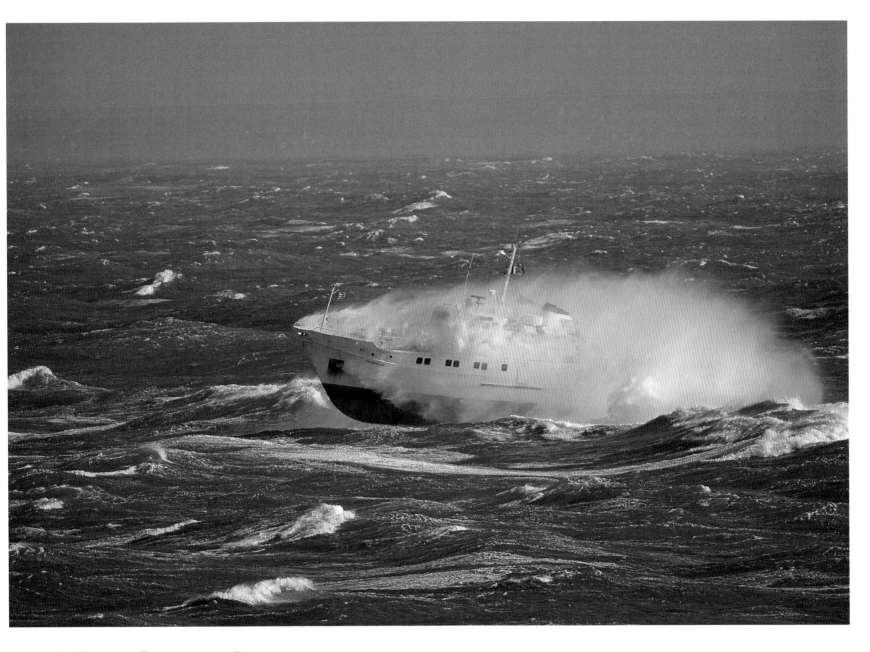

LE CONQUET. THE MAIL BOAT *FROMVEUR* CALLS DAILY IN NEARLY ALL WEATHER.

In all weather—or nearly—the Penn Ar Bed company provides service between Brest and Le Conquet, on the mainland of France, and the Molène island and Île d'Ouessant. This daily connection is known as the mail boat, and its first name, *Fromveur*, is that of the dangerous passage between the islands, where whirlpools swallow countless wrecks. Built in 1977, the *Fromveur*, 130 feet (40 m) long, was beginning to show its age after twenty-three years of daily service. Plans were made to replace it, but its sturdiness and seaworthiness argued for keeping it in the Finistère fleet. It was given a costly stint in dry dock to bring it up to standard: in April 2000, it left Concarneau rejuvenated and spruced up, ready for many more tours. The crossing to reach these tiny islands takes about three hours. Even though the Finist'air plane provides a quick round trip, and in summer other boats make the trip in thirty minutes, the people of Île d'Ouessant and their neighbors on Molène will always be islanders. The way to an island is by sea, and the sea has its moods.

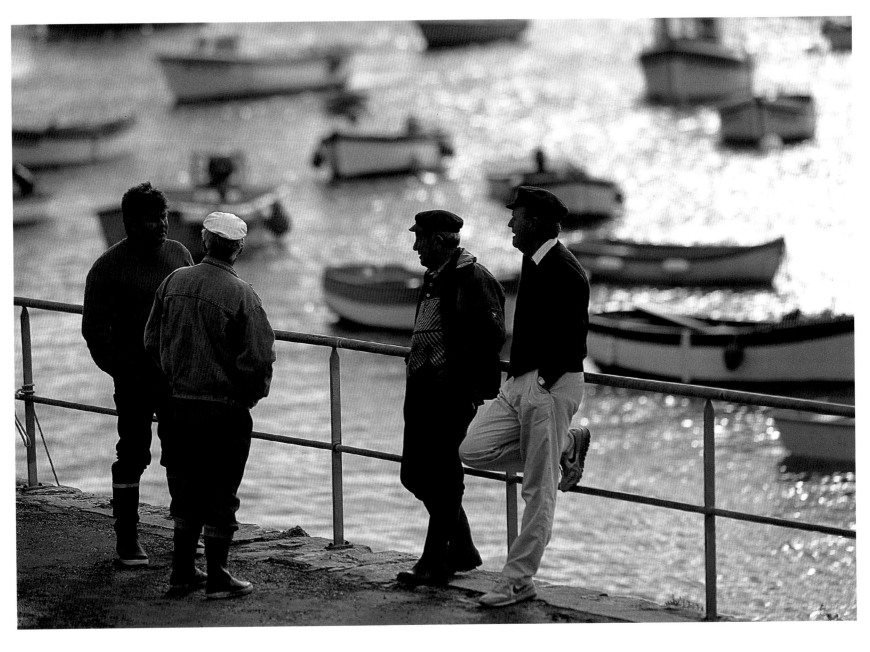

LIFE ON THE ISLANDS IS TRANQUIL, MOST OF THE TIME.

Just over 1 mile (2 km) long, 2,625 feet (800 m) wide, and 5 feet (1.5 m) high, Sein is a minute land mass
anchored at the prow of Finistère. Armed with thick seawalls, it resists storms as best it can. Sometimes, as
happened in 1830, 1868, and 1897, it becomes submerged. Taking refuge on their roofs, the people of the Île de
Sein saw their land remain sunken for several hours until the tide changed. On other occasions, it has been ship-
wrecks that have moved the population to take great risks. Legend has it that they were "ship wreckers" who
did not hesitate to set fires in order to confuse ships, only to then steal from them. In reality, however, for many
centuries the Sein fishermen have given assistance to those struck by the calamities of the sea. In October 1777,
they saved the *Magnifique* and its crew of five hundred; in 1780, the thirty-five seamen of the *Charmante* were
rescued; and in 1796, seven hundred people were given refuge on the island, taken care of and housed despite
a raging famine. The Sea of Iroise is not always kind, but when it offers a moment of respite, the locals relax.

MOLÈNE. EVEN WHEN ON SHORE, THE SAILOR'S EYES ARE ALWAYS TURNED TO THE SEA.

On islands such as Molène, the arrival of the mail—that ephemeral connection with the mainland—is the event of the day. The delivery boat draws alongside the dock, setting off an effusion of life: people approach, unload, stare, embark, welcome with open arms, oversee, exchange news, say emotional goodbyes, and observe in silence. The old sailors never miss a single one of these animated shows, which are also sources of conversation. Everything will be commented upon or noted mentally in the old-timers' vigorous memories, which contain the archives of the island's life: who arrived, who left, what's been delivered and for whom. The scene plays out by the sea, just as the entire existence of these silent witnesses has taken place on the sea, this forbidding water that has seeped into them, and now lives within them. This man's posture recalls the canvases of Roger Lucien Dufour, the photographer's uncle, who in the 1960s filled his Pont-Aven gallery with paintings of sailors seen from behind. Perhaps because from the back they seem to say more.

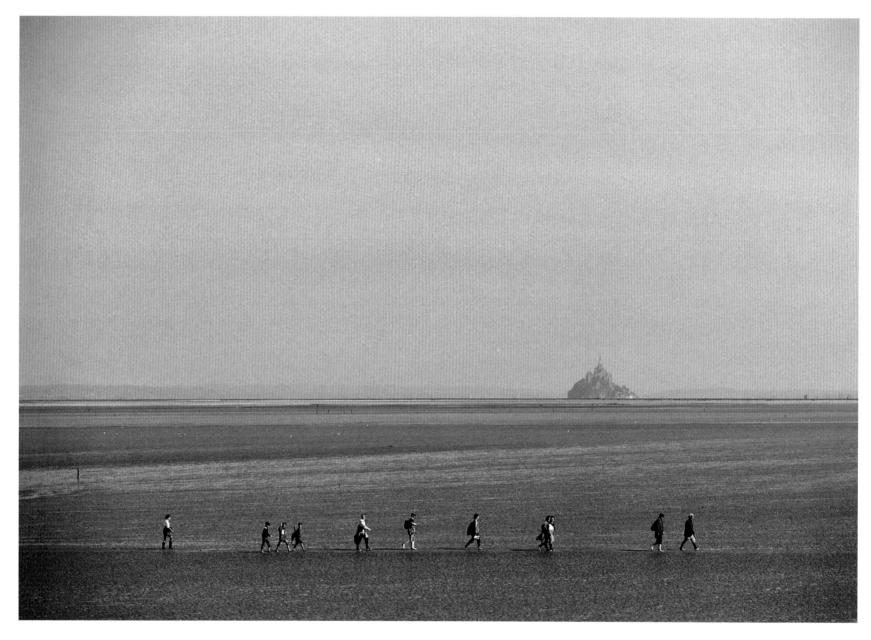

WALKING ON THE BAY IN MONT-SAINT-MICHEL, BETWEEN THE SAND AND THE CLOUDS.

Since the eleventh century, the abbey clock tower has served as a seamark for boats and a rallying point for pilgrims. The gilded archangel crowning its point, however, was added in 1897. Mont-Saint-Michel, the "wonder of the west," shoots up from a granite islet that is surrounded by sand and is linked to the mainland by a man-made seawall. The bay, bordered to the west by the Pointe du Grouin (in Brittany) and to the east by the port of Granville (in Normandy), concurrently holds some records. With a 46-foot (14-m) variation between low and high tides, its range is the largest in France. When the tide recedes, the channel uncovers the sandy banks, which extend over 9 miles (15 km) from shore, creating a veritable paradise for lovers of cockles, clams, and razor clams. Legend has it that the waves rise "with the speed of a horse at full gallop." Farther out, the currents that accompany the mounting tide are fearsome and more like a careless person who allows himself to be taken by surprise.

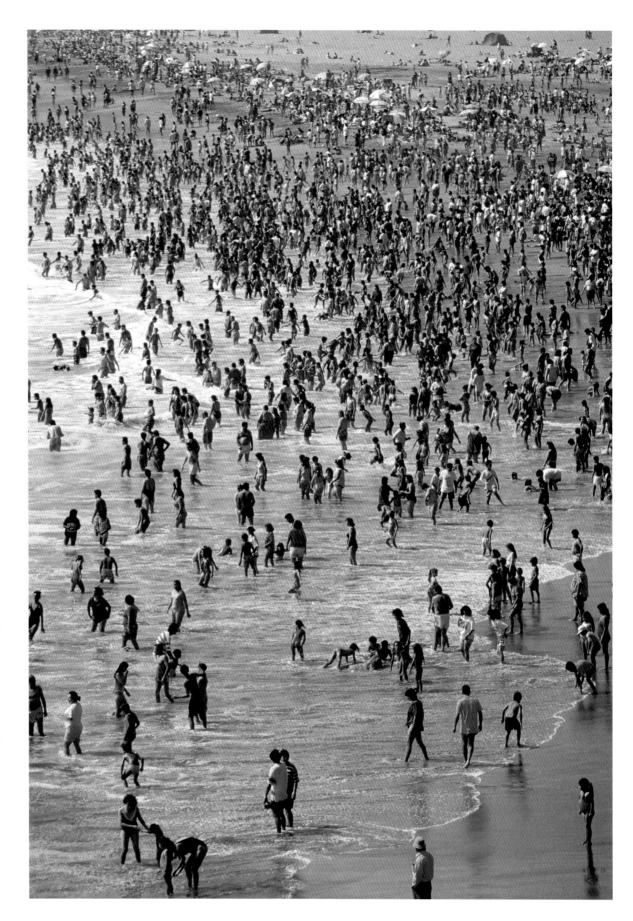

BEACH GAMES.
VALPARAISO, CHILE.

When the fashion for sea
bathing originated in the 1840s
in Trouville in northern France,
it was for therapeutic and
hygienic reasons. Then the duc
de Morny started a trend in
Deauville. Since then, innumer-
able beach resorts, worthy heirs
of these Norman pioneers, have
flourished along the world's
coastlines. Once a privilege
reserved for the urban elite, sea-
side tourism has become wildly
popular. But not all such resorts
are picturesque coastal towns.
Charmless, overbuilt cities have
risen behind many beaches,
erecting their concrete sky-
scrapers across from the sea, as
at Benidorm in Spain or Cancún
in Mexico. In the high season,
these coastal megalopolises ded-
icated to mass tourism can
attain surprising densities of
gregarious vacationers, a motley
human tide bristling with
beach umbrellas, that washes
over the waves.

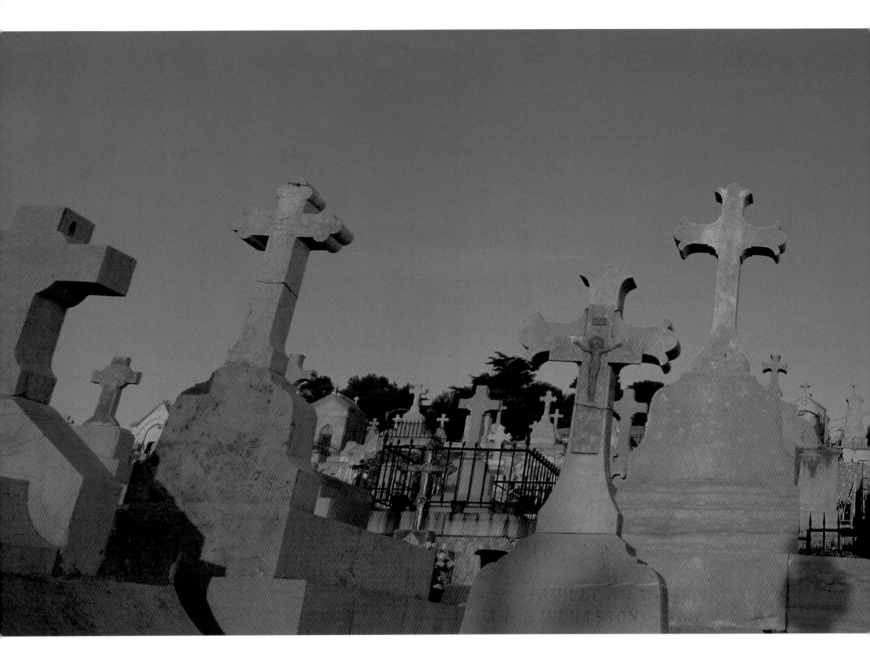

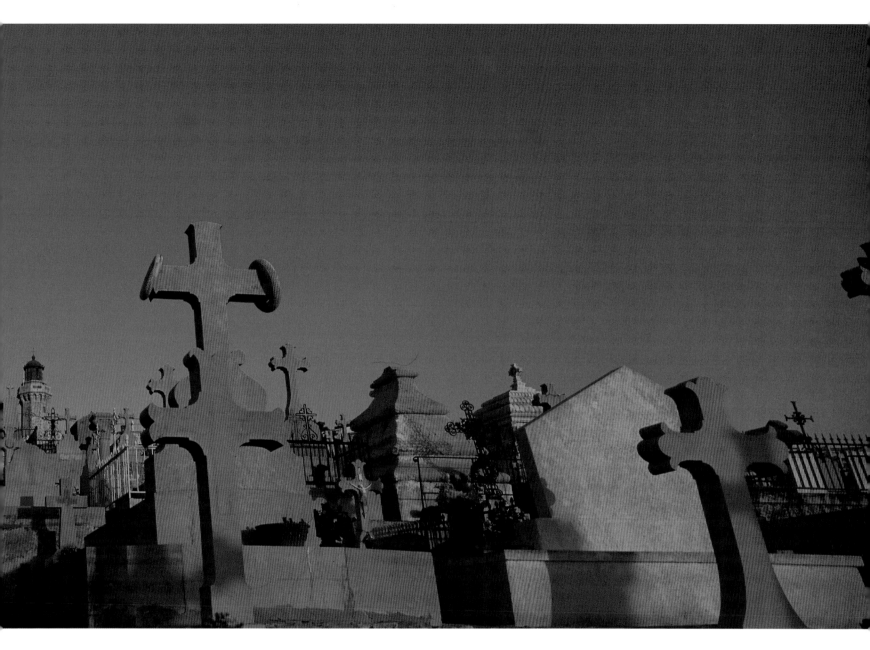

IN SÈTE, BETWEEN SKY AND SEA, STONE CROSSES IN THE MARITIME CEMETERY.

Death is the seaman's natural companion. Each time he sets sail he knows that beginnings of the slightest storm
may lead to an ominous shipwreck. Since time immemorial, seamen have called upon ancient superstitions to
ward off death, and they have filled churches with ex-votos as thanks to the heavens for having allowed escape.
While many seamen rest in the waters that take them, those who die on dry land have rights to the cemeteries
that are eternally swept by sea winds. "Of gold, stone and somber trees / Where so much marble trembles
beneath so much shadow / The loyal sea sleeps upon my grave," as Paul Valéry wrote in his celebrated poem
"Le Cimetière Marin." The old cemetery at Sète, where Valéry is buried, stands over the Mediterranean Sea
and the port, which seems blessed by these crosses, is pink with the light of the setting sun.

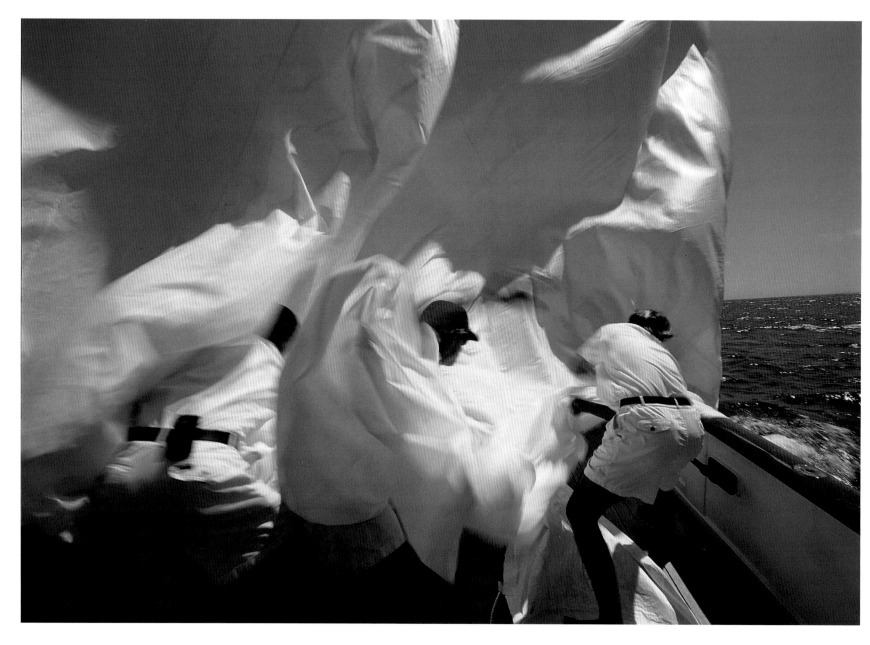

HAULING. EXACTING MOMENTS. THE CREW RUSHES TO BRING IN THE SAILS.

On the teak deck, the orders rain down and the crew rushes about. With bare hands and bare feet, caps tight on their heads, the technicians of the sail plunge toward the meticulously sewn cloth. Their energetic arms thrash out any remaining pockets of air while the rustling drowns out their calls of encouragement. They knead the sail without thinking, sure of their technique and dexterity. Suntanned skin contrasts with the white of the sails but blends with the varnished wooden railings. Everyone knows their position for the operation, which has been repeated countless times. Once the sail is brought down it is folded, and when all its mass has been swallowed up the crew is back in position, already on to the next task. The boat changes speed while always maintaining its course toward the azure of the horizon. On board, the crew is proud to carry on with its navigation.

AMERICA'S CUP CLASS.
A DIFFERENT SAILING
DIMENSION.

The rules governing the
America's Cup have been
revised several times over the
course of the race's long and
epic history. Just as cotton sails
have been replaced by synthetic
ones, the hulls have gotten
sharper and computers have
climbed aboard. Technology
has also changed the ships'
looks as well as their perfor-
mance. Far from taking any-
thing away from the thrill this
international sailing event
offers, these changes renew the
excitement each time—every
technological innovation further
hones the crews' skills, so the
show is always state-of-the-art.
The America's Cup Classes that
have succeeded the 12-meter
JI are 20 percent longer and
33 percent lighter, but most
significantly spread 66 percent
more sail than their predecessors.
The public can only admire the
display of the arithmetically
precise maneuvers required to
unfurl a capricious, 5,375-
square-foot (500-square-meter)
spinnaker in a matter of seconds,
and of the arabesques of the
crew, a graceful ballerina hang-
ing onto the heart of this huge,
still rumpled poppy.

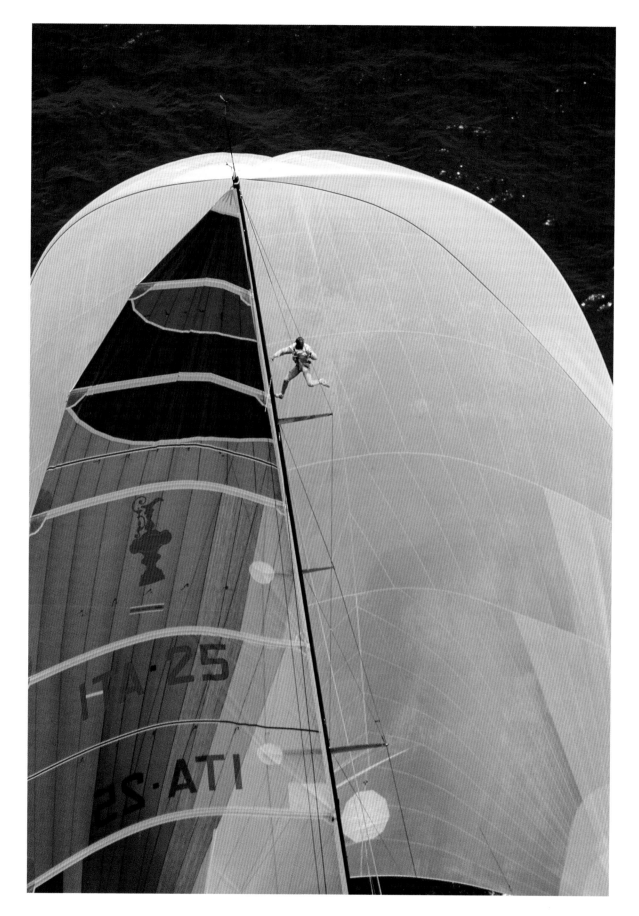

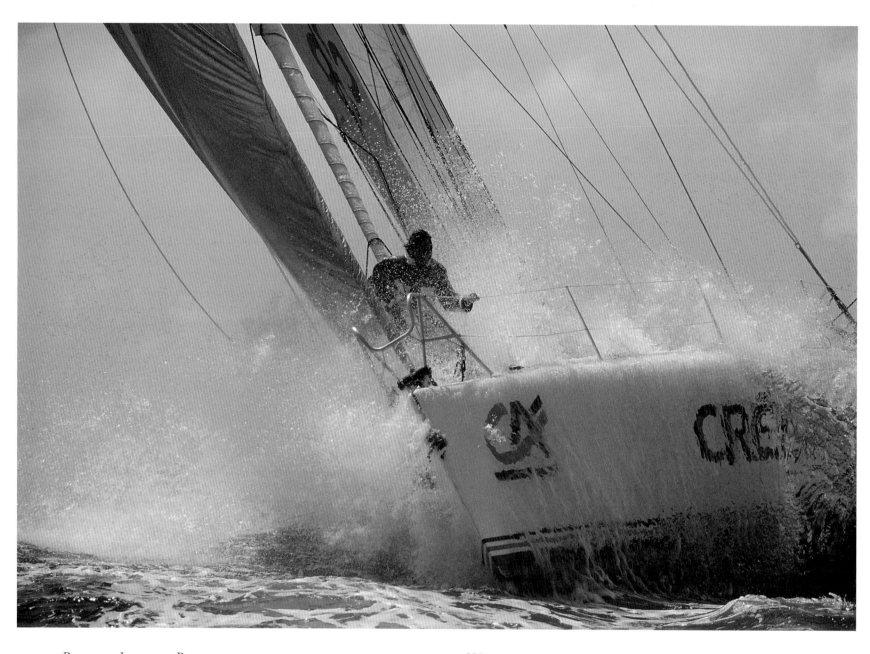

PHILIPPE JEANTOT. ROUND-THE-WORLD RACING HAS BECOME HIS LIFE. WHEN THE VENDÉE GLOBE WAS INAUGURATED, IN 1989, HE ORGANIZED THE RACE—THEN SAILED IT—ABOARD HIS YACHT, CRÉDIT AGRICOLE, THE FOURTH BY THAT NAME.

Joshua Slocum, who went around the world in 1895, and Alain Gerbault, who sailed off on a six-year world tour in 1930, were both leisurely pioneers of the round-the-world sailing routes. The Golden Globe, the first single-handed, nonstop, around-the world race, took place exactly once, in 1968. The four-leg BOC Challenge made its debut in 1982. Philippe Jeantot surprised everyone by winning the first two challenges. All he had to do to fulfill his ultimate dream was lose the stopovers and crew. In 1989, he inaugurated the Vendée Globe, a race to the end of the world—and to a sailor's personal limits. This extreme test (26,875 miles, or 43,000 kilometers, ocean to ocean, in a monohull) several times shadowed by tragedy, has become a hit with the public; 750,000 spectators watched at the finish line in 2000. It has made heroes like Titouan Lamazou, Alain Gautier, Christophe Auguin, and Michel Desjoyeaux. The fifth of these extraordinary physical and technical challenges, reserved for the most experienced racers, will take place in 2004.

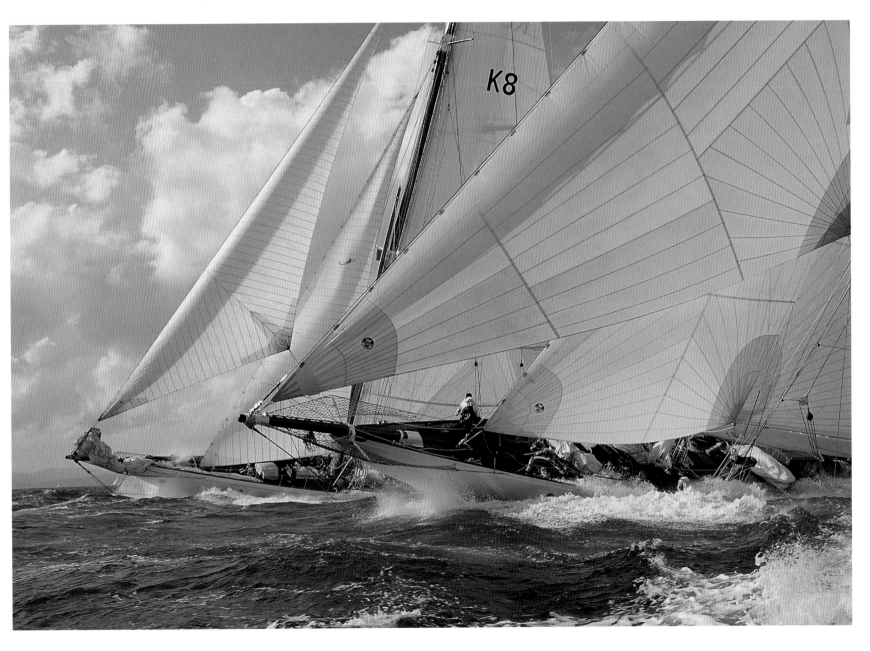

FOR TWELVE YEARS, THE BAY OF SAINT-TROPEZ WAS THE STAGE FOR THE NIOULARGUE,
MUCH TO THE DELIGHT OF PHOTOGRAPHERS—SINCE THERE ARE NO OFFSHORE BLEACHERS FOR THE PUBLIC.
THANKS TO PATRICE DE COLMONT AND HIS FRIENDS FOR STAGING THESE AUTUMN REUNIONS.

The Mediterranean is still the darling of fishermen and of the luxury yachtsmen, who cross from the Gulf of Genoa to Saint-Tropez. One of the most beautiful reunions of classic and modern sailboats has taken place there every year since 1981, when a bet between two sailors was played out around the Nioulargue shallows, 5 miles (8 km) off Pampelonne. One of the spectators, Patrice de Colmont, an enthusiast, decided to make this a regular event, and La Nioulargue became immediately popular. Year after year, the nautical festivities in October attracted increasing numbers of modern and racing boats, as well as prestigious traditional yachts, in a breathtaking series of regattas. Beginning in 1998, Les Voiles de Saint-Tropez replaced La Nioulargue. Orchestrated by the Société Nautique de Saint-Tropez, this event goes all out to perpetuate the festive spirit of wonder that made La Nioulargue so successful. In 2002, more than 160 modern boats and some 100 classic yachts put on an unforgettable show in the bay of Saint-Tropez.

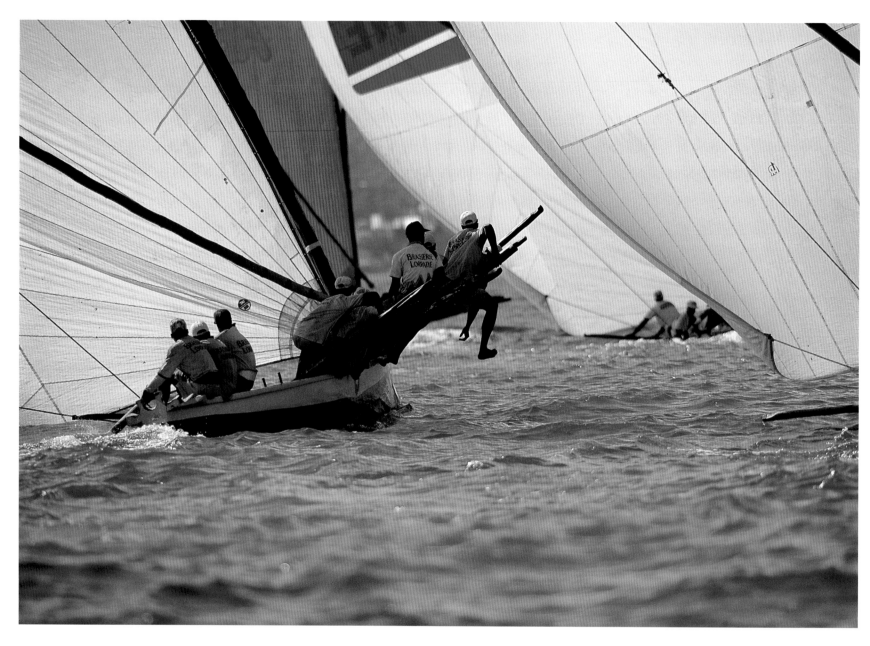

MARTINIQUE. THE "ROUND YAWL" RACES PROVIDE A COLORFUL SHOW—
ON LAND AS WELL AS AT SEA. THE SPECTATORS BET ON THE CREWS' ACROBATICS.

The word "yawl," from the Norwegian *jol*, meaning "open boat," describes any long, narrow, light craft with a shallow draft that is propelled by oar by several rowers. The West Indian version of the yawl, with sails, is used for fishing. Quick and easy to handle, it has replaced the traditional canoe made of a simple hollowed-out tree trunk. The first sporting competitions were held among just a few professional fishermen, but gradually the contests attracted the attention of all the coastal communities of Martinique, eventually becoming in effect a national sport. Like the boats in regattas, the yawls are constantly being improved; they often bear evocative—and tongue-in-cheek—names such as *Cyclone*, *Whirlwind*, *Electron*, and *Ariadne*. The crews match skills in contests in which sponsors (towns or commercial brands) vie in color and visibility. The most famous of the races, a circuit around the island, draws an ever-increasing audience.

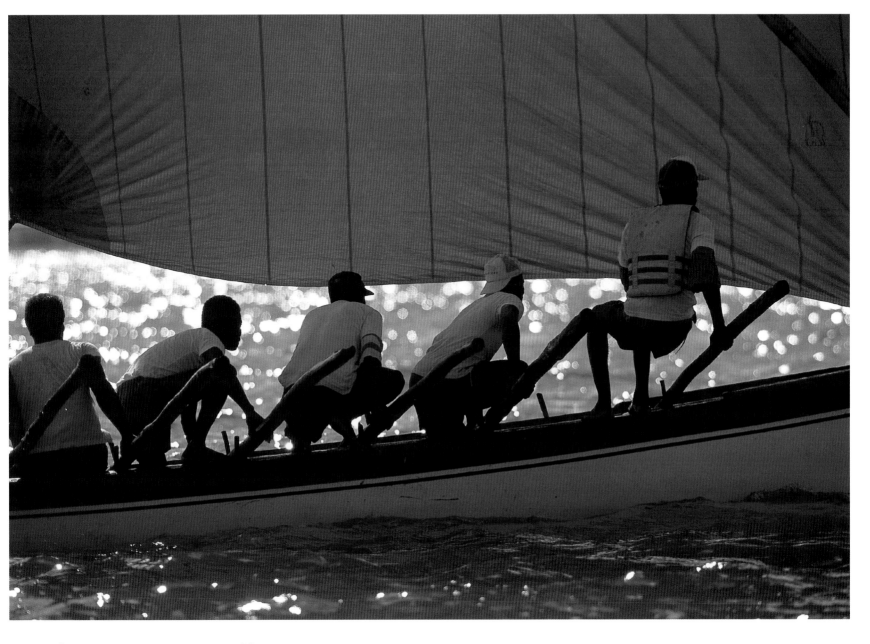

SKIFF REGATTA, A WEEKEND IN MARTINIQUE.

Robert, François, Macouba, Basse Pointe, and Prêcheur, but also Sainte-Anne, Sainte-Luce, and almost all the
ports on Martinique each host a skiff regatta in turn. These distinctive, 40-foot (12-m) shells have replaced the
old-time *gommiers*—boats made from the wood of gum trees—but the tradition of the Sunday race remains a
great excuse for a grand celebration. People come from all four corners of the island to follow the twists and
turns of the boats, all the while munching on *accras* (codfish croquettes) and Antillean blood sausages and drink-
ing Lorraines, the Martinique beer. A few miles off shore, the sails are swelled, the bows smash the sea, and
the crews do a tightrope act, teasing these long pirogues with their outsize sails. Without a keel and with sails
measuring 750 square feet (70 m²), it is only the repositioning of the crew, who balance on the wooden poles,
that keeps the boat from capsizing. It is a risky feat that requires unwavering attention, particularly when the
wind is changeable and the sea rough.

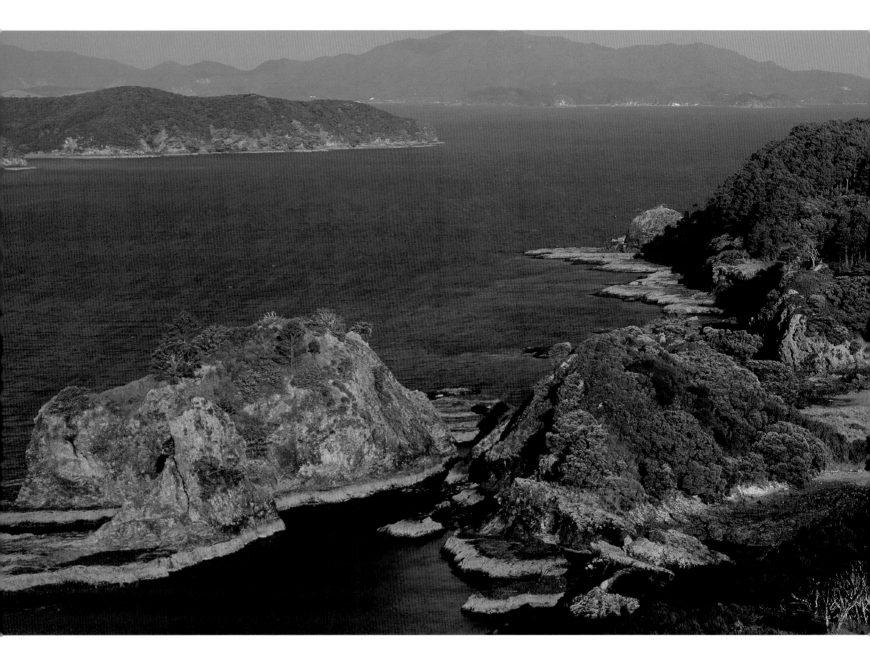

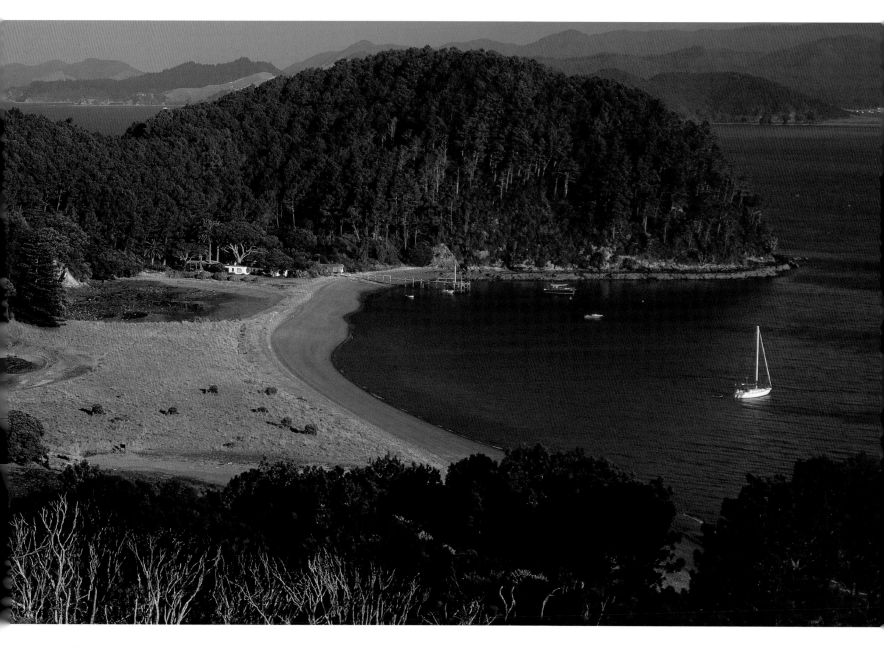

New Zealand. Bay of Islands off Smoking Island, the volcanic island of the North.

A stone's throw away from the gulf at whose end the city of Auckland sparkles, a myriad of small islands are scattered in strange formations. They lie on the shallows of the Pacific, like languid salamanders in the sun, and a handful of sea lovers decided to make it their home. With this sailboat mooring in the cove of sheltered inlet, it floats with an air of vacation, hinting at the everyday. Those who live here made that choice. Isolation has become an adventure, and to visit their neighbors, only one rule applies: you must follow the sea. Other islands that are less isolated such as Rangitoto, Great Barrier, and Waiheke also offer lodging. The feeling of virgin territory still has an effect, it's in that area where all the magic exists. The vegetation climbs along steep slopes, sea birds come here to nest, in the middle of the island a number of seal colonies laze around, and whales sometimes make a stopover here.

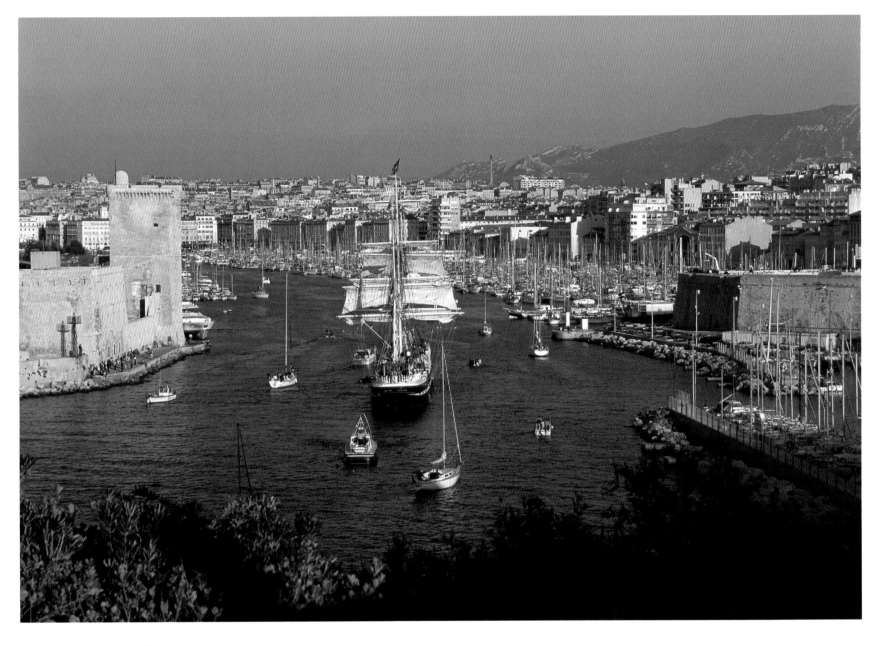

MARSEILLE. THE MAJESTIC BELEM, A NINTEENTH-CENTURY THREE-MASTER,
AS IT VENTURES INTO THE HEART OF THE PHOENICIAN CITY.

Launched in Nantes on June 10, 1896, one month later the *Belem* set sail for its first port of call, the Brazilian city of Belem. It then started its second career transporting cacao, sugar, and rum on a route between Europe, the Antilles, and Brazil. In 1902, the *Belem* survived a close call. Moored on the other side of the island because there was no space in Saint-Pierre's Bay, it just barely escaped the eruption of Mount Pelée in Martinique while other boats and their crews perished in an avalanche of ash and lava. Later, after thirty-three Antilles trips, the great sailboat would be replaced by a fleet of steamships. Then, in 1914 the *Belem* was converted into a training ship. With its 12,915 square feet (1,200 m²) of sails and 14,765 feet (4,500 m) of lines, the young tars lacked nothing in the pursuit of their education. This elegant vessel, however, is not the most maneuverable, and plea-sure yachts that dare to come too close ought to be forewarned, as this giant is rather slow to react.

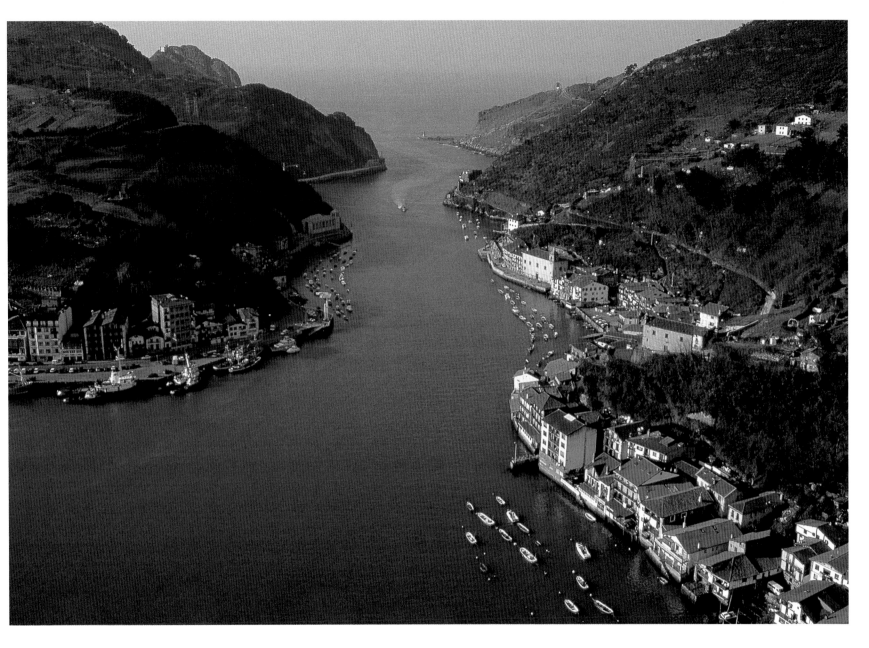

PASAJES. AN UNEXPECTED HARBOR AT THE END OF A NARROW CHANNEL. OF ALL THE SEAFARING PEOPLES, ONLY THE BASQUES OF SPAIN COULD HAVE DEVELOPED SUCH A HIGH-TRAFFIC SPOT IN SUCH AN UNLIKELY AMOUNT OF SPACE.

Hidden at the end of a sheltered neck that cuts into the Spanish coast 16 miles (25 km) from the French border, this harbor can accommodate ships of 650 feet (200 m) in length, drawing up to 33 feet (10 m) of water, on 3 miles (5 km) of docks. The closely built houses on either side of the natural channel remind us that the density of the population along the world's coastlines continues to increase steadily. Entire stretches of the Mediterranean coast have not only been urbanized, but have suffered decades of political neglect. French law now protects the most notable of the shoreline zones, but other countries on the Mediterranean have neither the laws nor the political will necessary to prevent the sudden development of buildings that are either constructed without codes or abandoned before completion. For example, some parts of the Lebanese and Turkish coastlines are completely buried under concrete. At the same time, pressure from demographic growth is only becoming progressively greater: the population of the countries around the Mediterranean is expected to double—and tourism to triple—over the next thirty years.

A STRETCH OF COASTLINE. Many, many human beings have settled by the ocean. Today, 80 percent of the world's population is concentrated on a coastal band 62 miles (100 kilometers) wide that represents just 15 percent of the world's dry land. In addition, of the planet's nineteen cities that have more than 10 million inhabitants, thirteen are coastal agglomerations. The globe's shores are becoming increasingly densely populated; twenty years from now, 75 percent of the planet's inhabitants will crowd the coasts, and new skyscrapers will rise along the waterfront of megalopolises such as Bangkok, Buenos Aires, Cairo, Jakarta, Lagos, New York, Shanghai, and Tokyo. The coastal population is increasing faster than we can develop ways to treat wastewater: only one city in ten has a water-purification plant, and the growing urban pressure on the shores will endanger the world's oceans proportionately. So far, these considerations do not appear to overly concern the residents of this tranquil home.

NEW YORK. ON THE HUDSON RIVER THE GLORY DAYS OF THE TRANSATLANTIC PIERS LASTED UNTIL WELL INTO THE 1960S. TODAY, THEY ARE ATTRACTING THE ATTENTION OF INVESTORS, WHO MAY GIVE THEM A NEW LIFE.

In 1626, Dutch traders bought a trading post at the southern tip of the island of Manhattan and called it New Amsterdam. A mere four centuries later, New York, one of the planet's largest megalopolises, rises on this site. Its port activity, which European immigrants developed beginning in the late seventeenth century, caused the city to flourish. In addition, in the days before airplanes came to predominate, New York received the great ocean liners arriving from Europe. In the background, Manhattan stretches out its vertical glass and concrete skyline; in the foreground, the piers advance into Upper New York Bay, at the mouth of the Hudson River, recalling the golden age of the transatlantic ships. We would not be a bit surprised to see the reappearance of the French *Normandie*, launched in 1935, or its British contemporary the *Queen Mary*. In the wake of these legendary aristocrats of the sea, vying in luxury to entice their cosmopolitan clientele, the *Queen Elizabeth II* was launched in 1969; the *Queen Mary II*, largest, fastest, and most expensive ship ever built, is scheduled for her inaugural voyage in early 2004. In our hyperrushed society, creator of the Concorde that put New York and Paris just two hours apart, isn't it true luxury to have five days to travel by ship?

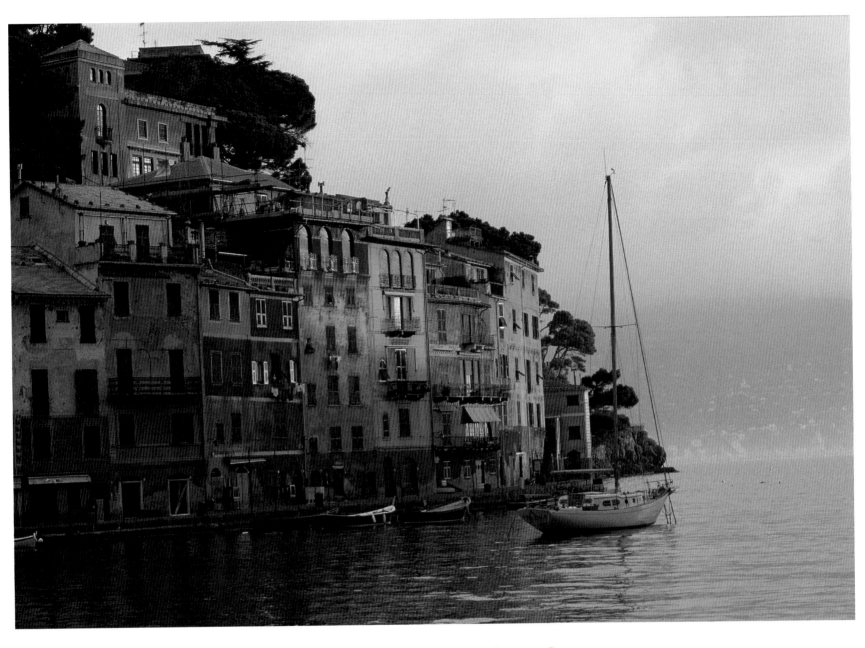

PORTOFINO. HANDS DOWN THE MOST SOPHISTICATED PORT OF CALL ON THE GULF OF GENOA.
IT IS NO SURPRISE THAT ITALIAN YACHTSMEN SELECTED THIS GEM FOR HOSTING A GATHERING OF
THE MOST BEAUTIFUL OF THE TRADITIONAL SAILBOATS.

The exquisite Gulf of Genoa opens onto the Ligurian Sea. This uniquely wondrous and hospitable bight hides in a bend of the Mediterranean. The delicate lace of its coastline, the many islets scattered in its waters, and its people, seafarers for millennia—all these make the Mediterranean one of the best places in the world for yachting. Only by boat is it possible to reach the wild and scented deep creeks and coves distributed along the shores of the Balearic Islands, Corsica, Sardinia, Sicily, and its Lipari Islands, the cradle of Aeolus, god of the winds, bathed by the Tyrrhenian Sea. Farther on, the Croatian coast tumbles into the Adriatic Sea, and Greece strews its 2,000 islands—including the illustrious Cyclades—into the Aegean. Huddled into their masses of rocks, the famous white houses with their sky-blue roofs look across to the Turkish shore, rich with history and carrying its tinge of Asia. To the south, the shores of the African continent stretch from the Strait of Gibraltar to Alexandria. The Mediterranean is all this, and more.

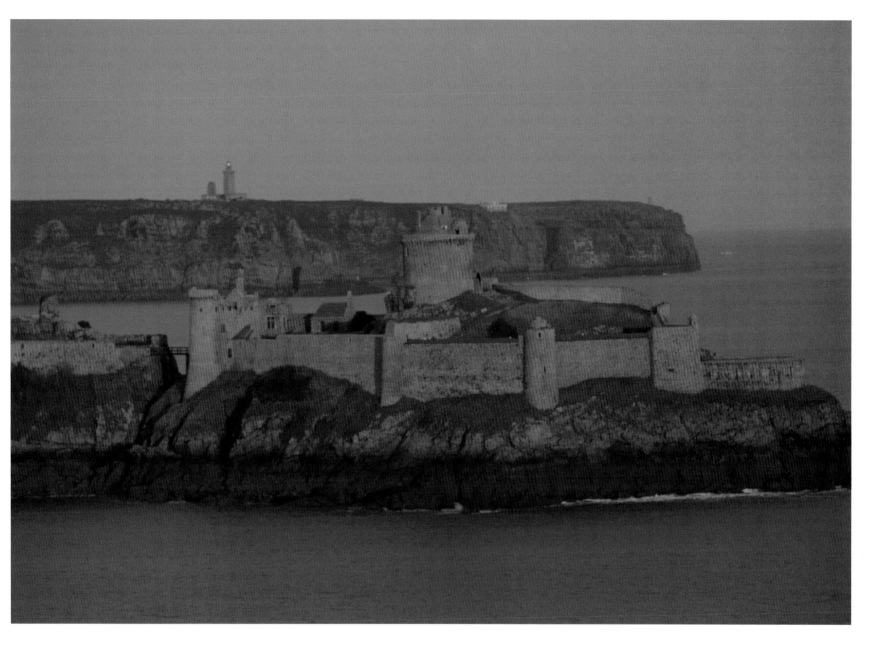

THE WALLS OF FRÉHEL. THE CRENELLATIONS OF FORT LA LATTE
MIMIC THE PINK SANDSTONE OF THE CLIFFS.

Perched 330 feet (100 m) over the sea, the lighthouse looks upon the tower designed by Vauban during the time of Louis XIV. As the Cap Fréhel is difficult to negotiate by sea because of its violent currents and changeable winds, it is of limited maritime importance. For the last three hundred years, its sheer drops have been lit by beacon signals. The original keep, which had fallen into disrepair, was replaced in 1847, then later destroyed by the Germans during World War II. The existing tower dates from July 1950. One of the first promontories in France to benefit from a signaling system, it doubled as a fortress. Modified numerous times since the fifteenth century, Fort La Latte both controlled maritime traffic and protected the region around Saint-Malo, the city of pirates. Many a boat lies at rest in its coves, a silent testament to a tumultuous past. In one instance, a single buoy and a dead signal caused the grounding of the frigate *Laplace* in Fresnaie Bay.

ALONG THE COAST OF THE LAND OF THE LONG WHITE CLOUD, BY THE NEEDLES OF CAPE BRETT.
When the Maori reached New Zealand for the first time, the island appeared to be wreathed in fog, and they
soon named their new world *Aotearoa*, Land of the Long White Cloud. They were then to discover a vast, com-
plex land of seven hundred islands, 9,320 miles (15,000 km) of coastline that extends over ten degrees of lati-
tude. The North Island has active volcanoes and forests rich with the enormous Kauri trees. The South Island is
crossed by a tall mountain chain that peaks with the 12,316-foot (3,754-m) Mount Cook, which continues to
grow several inches each year. The archipelago inhabited by the Maoris a thousand years ago was devoid of
mammals. Thus, there was not a single predator that threatened the birds, some of which could not fly. Moas,
the large ostriches that had flourished here, were among the creatures soon decimated by the new arrivals.

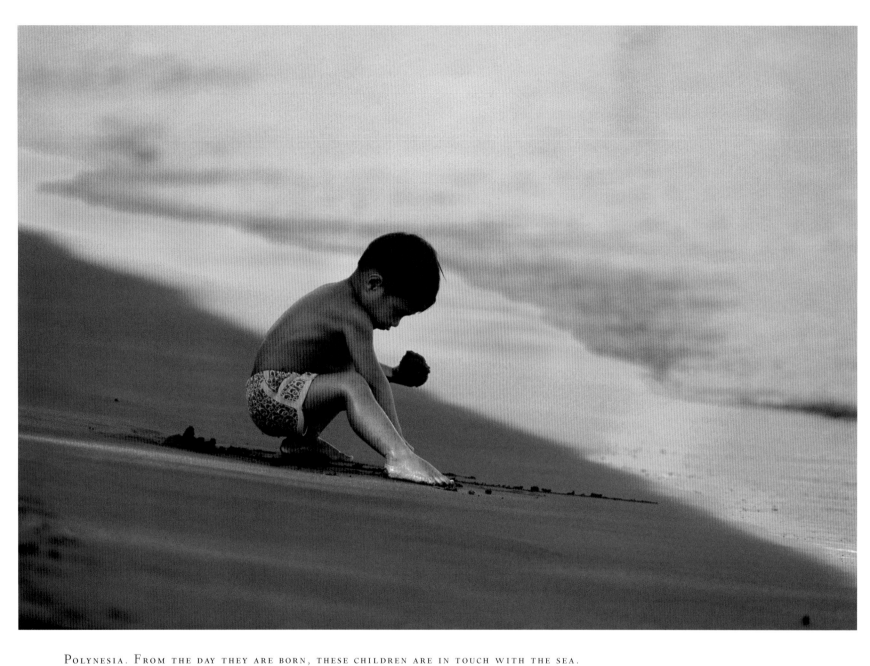

POLYNESIA. FROM THE DAY THEY ARE BORN, THESE CHILDREN ARE IN TOUCH WITH THE SEA.

The Pacific, the ocean of oceans, contains half the world's water and covers one third of the planet, or 70 million square miles (180 million km²), the equivalent of the area of dry land on Earth. It possesses many volcanoes, which gave birth to its myriad beautiful archipelagoes, symbols of the fantasy South Pacific, such as Polynesia and its jewel, Tahiti. Its black sand beach reveals the volcanic origin of this island and its fellows. Produced by a hot spot beneath the Earth's crust, these islands step away from it westward, in single file, the oldest island first. Attached to the ocean floor, it is pushed upward by the magmatic activity of the East Pacific ridge at a record speed of 4 3/4 to 6 inches (12 to 15 cm) a year. Between these extinct, ruiniform volcanoes—now islands and atolls—the ocean plunges to dizzying depths of 13,000 feet (4,000 m). The ocean floor, which is being constantly renewed, is relatively young: the oldest areas of the western Pacific are only 175 million years old, as opposed to the oldest rocks on land, which are some 3.7 billion years old.

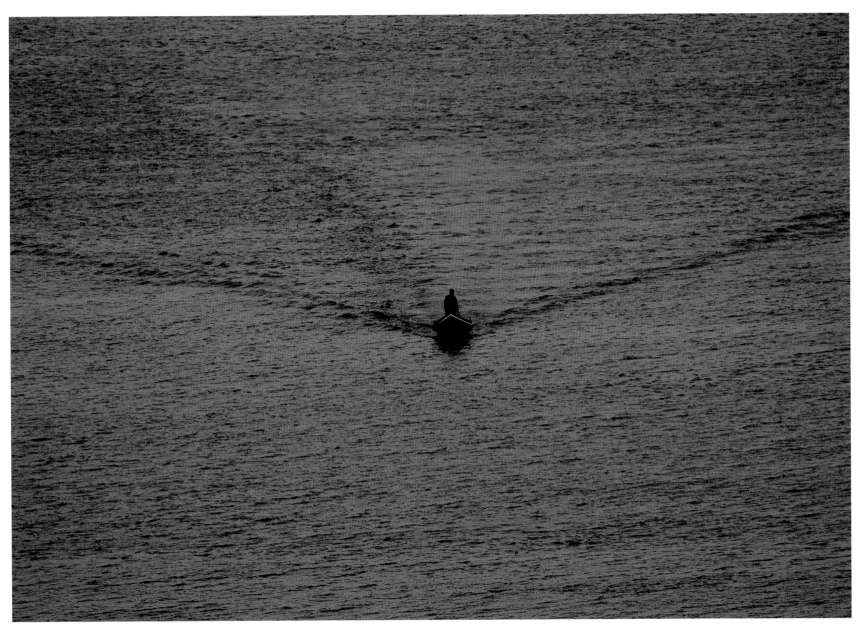

WAKE. FOR DECADES, THE BRITISH CROWN FORBADE FISHING ON THE IRISH COAST.
TODAY, THE CATCHES MADE THERE ARE EXPORTED AS FAR AS FRANCE AND SPAIN.

Ever since human beings first set foot on a beach and gazed out at the water's vast and unfathomable expanse, they have been prey to mixed emotions. It is hard to know exactly what first moved us to set out to sea—but we imagine it was something like attraction combined with rejection, and fascination tinged with terror. Someone had to be brave enough to go out on the water, to trace that first timid, ephemeral wake, satisfying—at long last—the ungovernable desire to *go* and *see*. Between the third and second millennium BC, the Maoris, for example, ventured out in canoes upon the living universe of the Pacific, while during that same period the Egyptians were launching their first vessels onto the waters of the Mediterranean. They, in turn, were followed by some of history's great seafaring peoples, such as the Phoenicians, Carthaginians, Romans, and Vikings. In the fifteenth century, the caravel made possible the great European journeys of discovery across all the world's seas. It would take Christopher Columbus, Vasco da Gama, Ferdinand Magellan, and many other explorers years of traveling the unknown waters of the globe in every direction, before, little by little, the oceans let their faces be known.

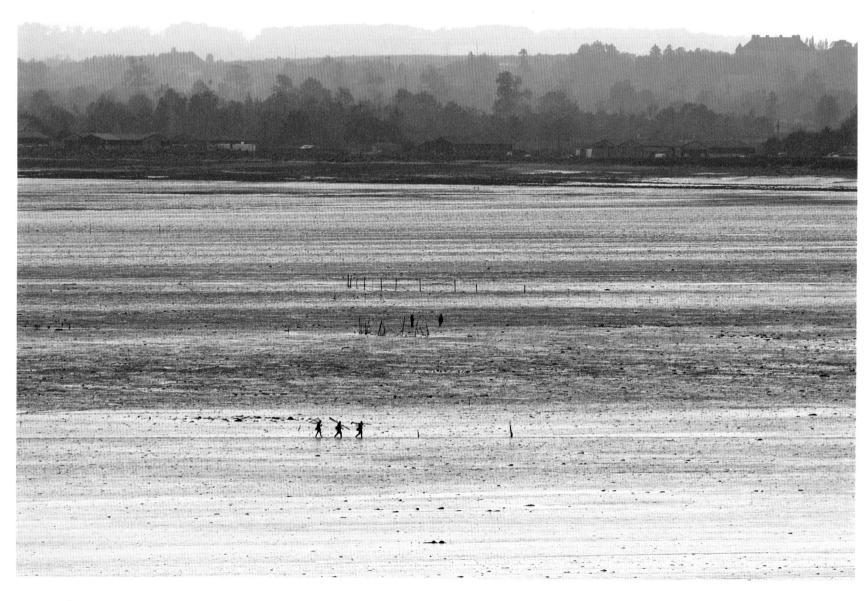

CRABBING. A POPULAR PASTIME IN THE BAY OF CANCALE.

Between Cancale and Le-Vivier-sur-Mer, on days when the tide goes far out, crabbing is a sure crowd-pleaser. As it withdraws, the sea leaves bare, damp algae-covered rocks, timid under their regained weightlessness, and a muddy desert with glimmering tide pools. For a few hours, the sea carelessly abandons its treasures to the attack of nets, sticks, spoons, knives, pails, and bags—any tool good for poking, digging, shifting, detaching, scratching. Time is counting down until the sea, huddled at ebb tide, changes its mind and returns to close the door on this cave of riches. The visions of plenty that stirred yesterday's impatient dreams now energize the day's hunt. Shrimp and crabs dislodged from beneath stones, clams dug up from the sand, periwinkles and limpets wrenched from the rocks, or mysterious cuttlefish bones, pieces of polished glass, sea urchin husks, and other second-hand wonders—what are these three cohorts bringing back, chased by the incoming tide?

IN CANCALE, THE OYSTER REMAINS QUEEN.

Seen at low tide, the oyster beds make an odd geometric patchwork of the beach that is heightened by the tracks of dark green kelp. Ever since the mysterious epidemic that decimated the bay in 1920, the Cancale oyster farmers have cultivated spats brought from Auray, in the Gulf of Morbihan. If the Cancale oyster retains a unique taste for the palate of the aficionado, it is due to the plankton-rich water of the Mont-Saint-Michel Bay that irrigates the farms. When the weather is fine, an old boat with a black hull and outsize, old-fashioned sails can sometimes be spotted off shore. The *Cancalaise*, a flat-bottomed *bisquine*, had been used by oyster farmers up until the beginning of the twentieth century. Nowadays, after having been refitted for tourists, the *bisquine* takes vacationers onto the bay, over which that celebrated silhouette of Mont-Saint-Michel stands tall.

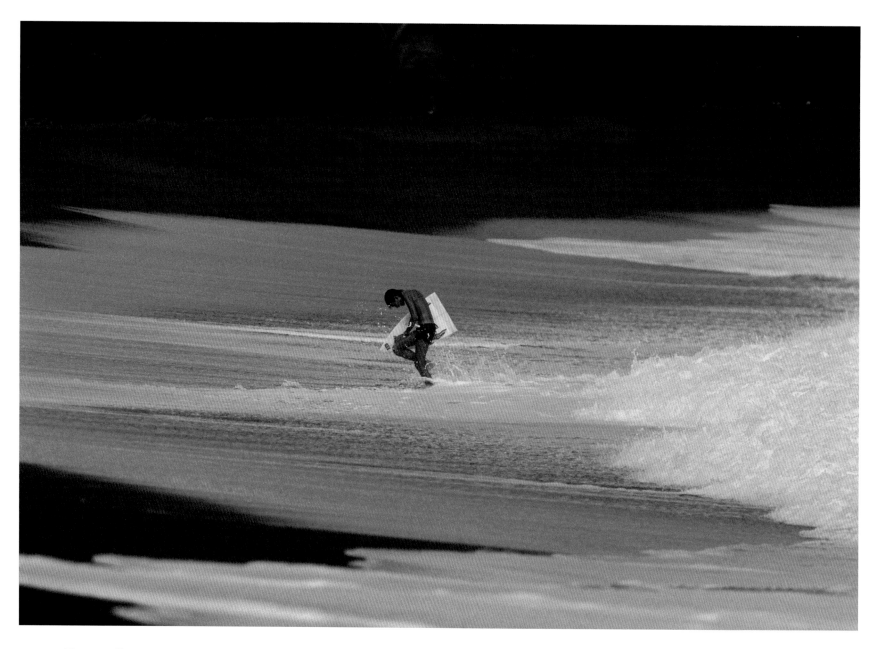

TAHITI. THIS SURFER ON TAMATA BEACH IS EMERGING FROM THE WAVES—AFTER SURVIVING THEM.

Captain James Cook, returning from one of his voyages of discovery in the Pacific, was the first to describe surfing. In 1778, reporting on his discovery of the Sandwich Islands—today, Hawaii—he told of a festive indigenous practice that consisted of rushing the breakers balanced on a long wooden board. Much later, this ritual became a sport—more of a craze, in fact, in California in the 1960s, where surfing became a way of life. Beginning around 1980, it became very popular in Brazil as well. Hawaiian surfers have inspired followers from the Fiji Islands to the French Basque beaches, from Indonesia to South Africa, in every one of the world's so-called spots, that is, places where the waves are large enough to ride inside. Tahiti, in Polynesia, is one of the preferred spots, but the surf there is very challenging, as evidenced by this young surfer, who has reason to look dejected: a violent wave has just broken his board in two.

A FEW DANCE STEPS AMID THE SEA AND FOAM, AT THE EDGE OF THE WORLD.

The blue dawn unveils this woman dancing on a beach in Bayonne. Walking barefoot in the foam, as if on a wire, following an ever moving, ever emotive path. Since the beginning of time, people have been attracted to this edge of the world that lies between land and water. Europeans are lucky in this way—they are never more than 220 miles (350 km) away from a coast. It is the good fortune of the land, seaboard par excellence, to have been willed the ocean at the birth of the Continent. The fashion of bathing in the sea only started in the middle of the nineteenth century for Europeans, but others did not wait so long to form their fascination with the waters. In the Sandwich Islands, later renamed Hawaii, surfing was an art of the gods and a sport of kings. In all Polynesian cultures, ritual bathing plays an important part in marking each of the great stages in life.

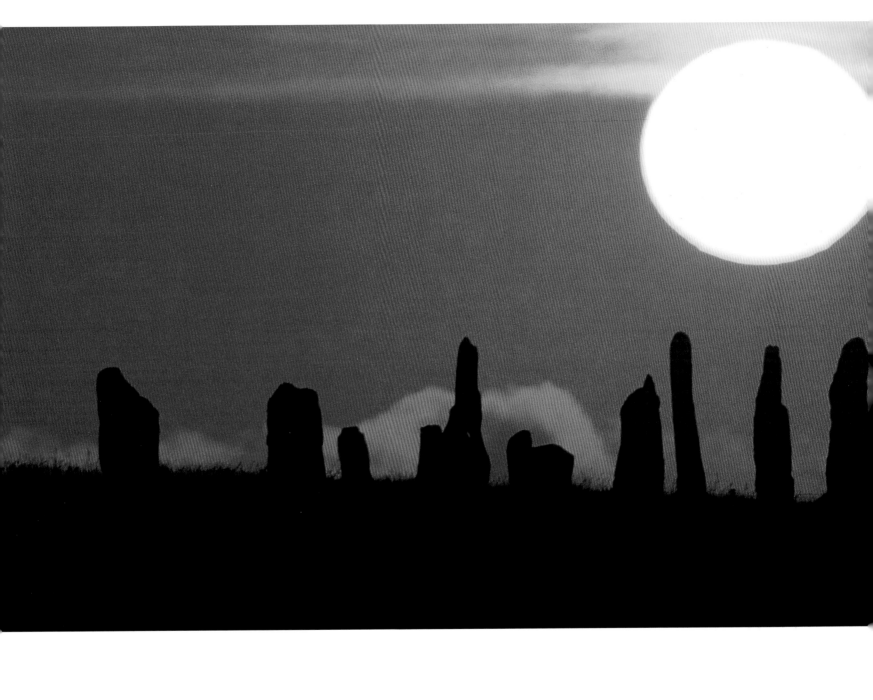

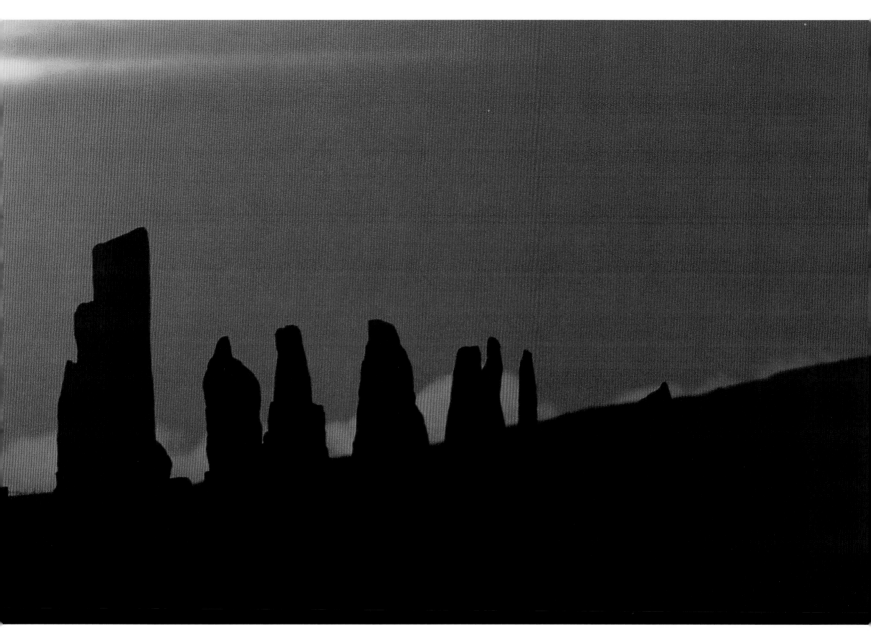

ISLE OF LEWIS, SCOTLAND. THE CALLANISH STONES,
A FIELD OF STANDING ROCKS IN THE SETTING ORANGE SUN.

When the setting sun or the full moon lights up the Callanish Stones, they seem to come alive beneath the red
light of a sacred halo. The Callanish Stones, also known as the Rocks of Wonder, form an almost perfect circle,
like a cromlech. The prehistoric monuments of the Isle of Lewis in the Hebrides Archipelago attract visitors
who may see figures or other visions in these chipped and eroded monoliths. Judiciously arranged around an
enormous central block, nineteen stones remain standing, while others seem to have disappeared over the course
of the centuries. The stones seem to be precisely oriented toward the sun. For some five thousand years, they
have kept their secret well guarded. Today the site remains a symbolic place for those practicing modern rituals.
Festivals celebrating the summer solstice and the passing of the century—the millennium in particular—cast a
singular resonance over this field of rocks that no one can take away.

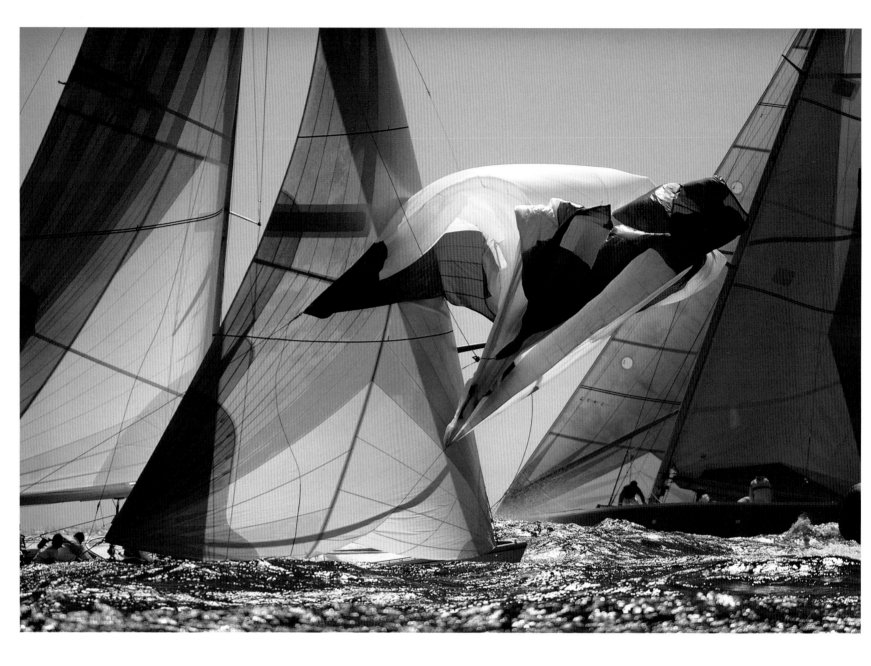

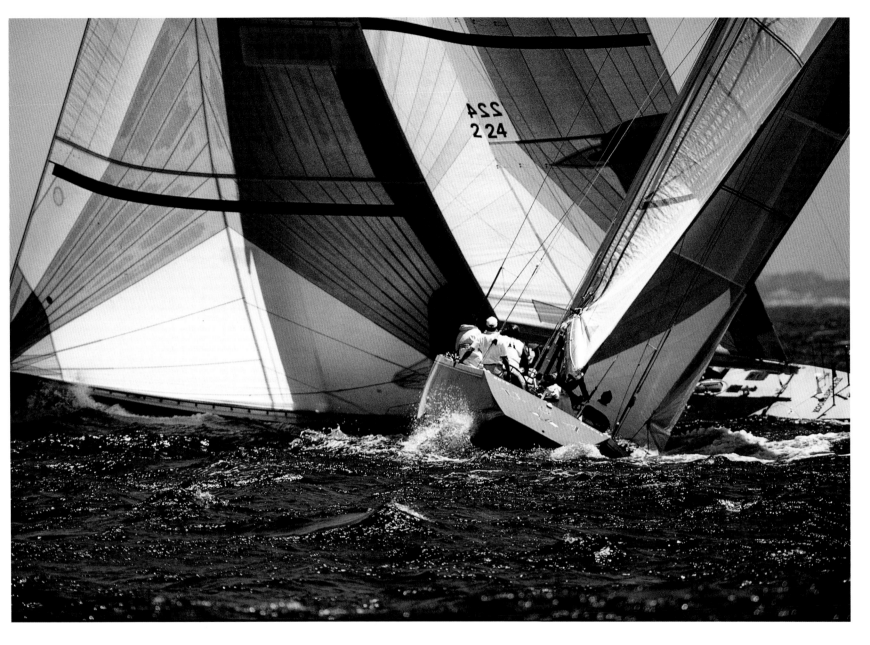

FINAL OF THE 1987 LOUIS VUITTON CUP.
A HISTORIC DUEL BETWEEN *STARS AND STRIPES* AND *KIWI MAGIC.*

The two boats took off at the starting gun, and then stayed neck-and-neck for the remainder of the race, some-
times following one another, sometimes skimming past. Such is the heart of match racing, this nautical jousting
between rivals that requires a perfect command of the sea and a highly focused strategy and set of tactics. The
great majesty of the America's Cup, a contest born off the Isle of Wight in 1851, is fond of the crisscrossing of
its giants. For almost 150 years, the race has been set as a duel. Challengers in the nautical "Holy Grail" face
one another in twos and cover a course of 22 miles (35 kilometers) during which they often must undertake a
series of rapid-fire maneuvers. A single heat comprises five passes around the buoys and three tight tacks. For
the millions of people who follow this widely covered sporting event (it comes in third after the Olympics and
the soccer World Cup), the drama is breathtaking and the suspense real. For the crews, it has the intensity of
both a boxing match and a game of chess.

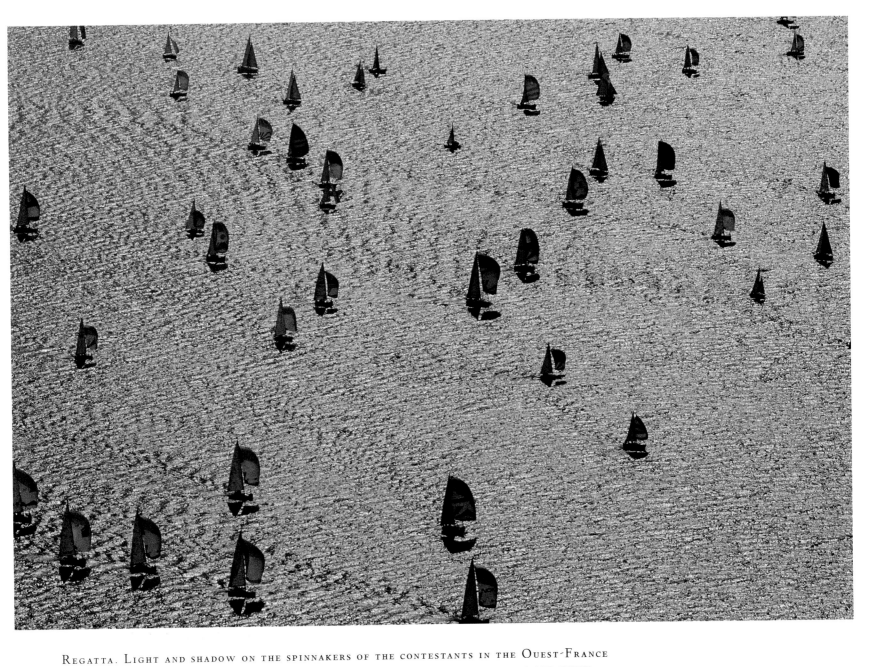

REGATTA. LIGHT AND SHADOW ON THE SPINNAKERS OF THE CONTESTANTS IN THE OUEST-FRANCE ON EASTER WEEKEND. FOR TWENTY-FIVE YEARS, MORE THAN FIVE HUNDRED BOATS AND THEIR CREWS HAVE GATHERED AT LA TRINITÉ FOR THE ULTIMATE EVENT OF AMATEUR SAILING.

Derived from the Italian word *regata*, or challenge, the word "regatta" now means a competition with rules, in which a number of sailboats race over a course marked by buoys or natural obstacles. These events have been attracting increasingly larger audiences, eliciting greater media coverage of the races—crossroads of wind, sport, and sea. The public shares the pleasure the crews take in taming the wind in the sails and thrills to the spinnakers blossoming on the sea, itself transformed into a prairie in springtime, where a thousand living corollas sway, swollen by the breeze astern. The spinnaker, a large foresail of light cloth hoisted and trimmed for the best lift, conceals a skittish personality beneath an easygoing manner. Every maneuver must be smartly executed, allowing it no slack. But what it can do when its spirit is harnessed!

BEACH GAMES.
TORCHE, IN BIGOUDEN.

The furthest tip of Torche, at
the southern end of the bay at
Audierne, in Finistère—"the
end of the earth"—is a popular
place for sailboard competi-
tions, offering the combination
of wind and waves favored by
windsurfers. The first sailboard
was made in the early 1960s in
the United States by its inven-
tor, Newman Darby. This
hugely successful novelty crossed
the Atlantic and arrived in
France on a surge of enthusiasm
in the mid-1970s. The elements
and materials used continue to
evolve, making possible new
achievements. The French
windsurfer Fréderic Beauchêne
doubled Cape Horn in 1980,
and Thierry Bielak set the
windsurfing speed record of
52.5 miles per hour (84 kph)
in 1993. The sportier "fun-
boards"—which are shorter—
enhance the pleasure of
windsurfing. And for the speed
demons, there are sails made of
monofilm, a light, transparent
material that is rapidly becom-
ing the new favorite.

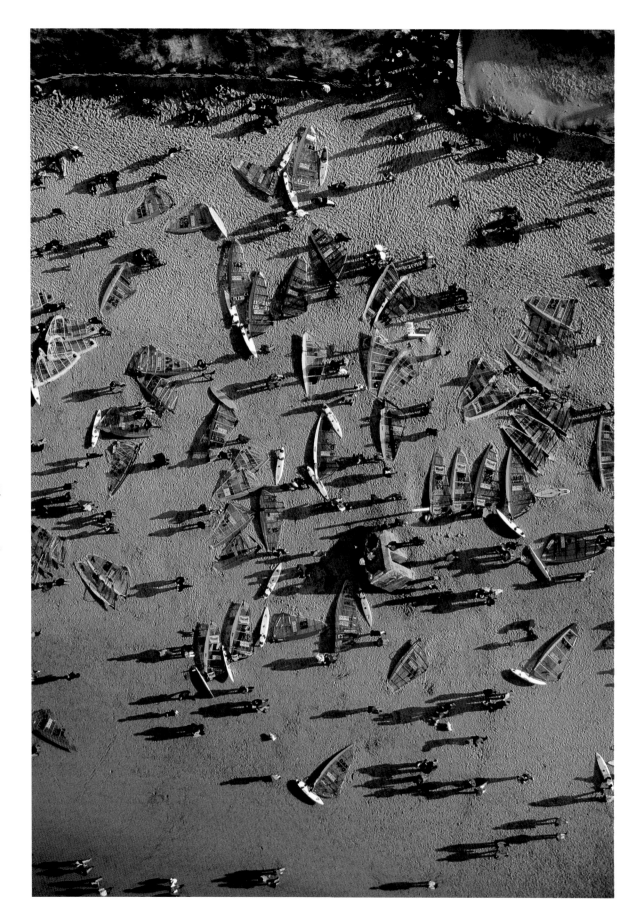

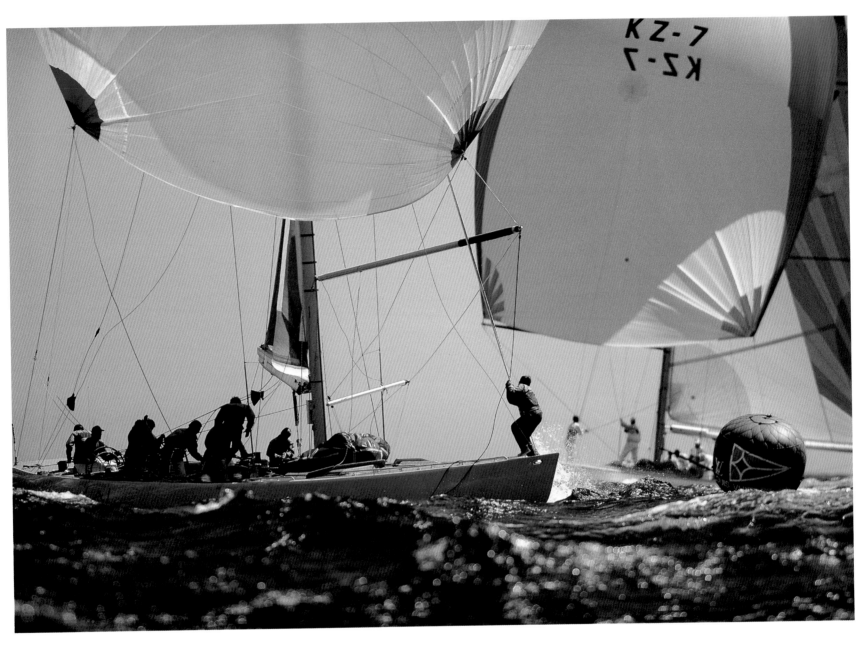

AUSTRALIA. THE 1987 AMERICA'S CUP WAS THE DEBUT OF MARC PAJOT
AND HIS 39-FOOT (12-M) FRENCH KISS. PERTH'S OCEAN REMAINS THE MOST
PHOTOGENIC IN THE HISTORY OF THE AMERICA'S CUP.

After a 150-year epic interrupted only by world wars, the globe's oldest trophy was up for grabs again, for the thirty-first time, in February 2003, in Auckland. The defender—New Zealand. The splendid Hauraki Gulf, an arena worthy of this planet-class sailing event, welcomed the regattas. Once again, Cup fever was spreading, mobilizing energies, spurring the most extreme expense. The America's Cup, a matter of egos and national pride, provokes a fierceness like no other. The participants spend tens of millions of dollars to position an America Class at the starting line. Today, as yesterday, fortunes are poured out to try to snatch the cup, to build championship vessels designed by the most brilliant architects, assembled at the most highly regarded yards, and handled by the best crews, all for the race of races—the most beautiful of all regattas.

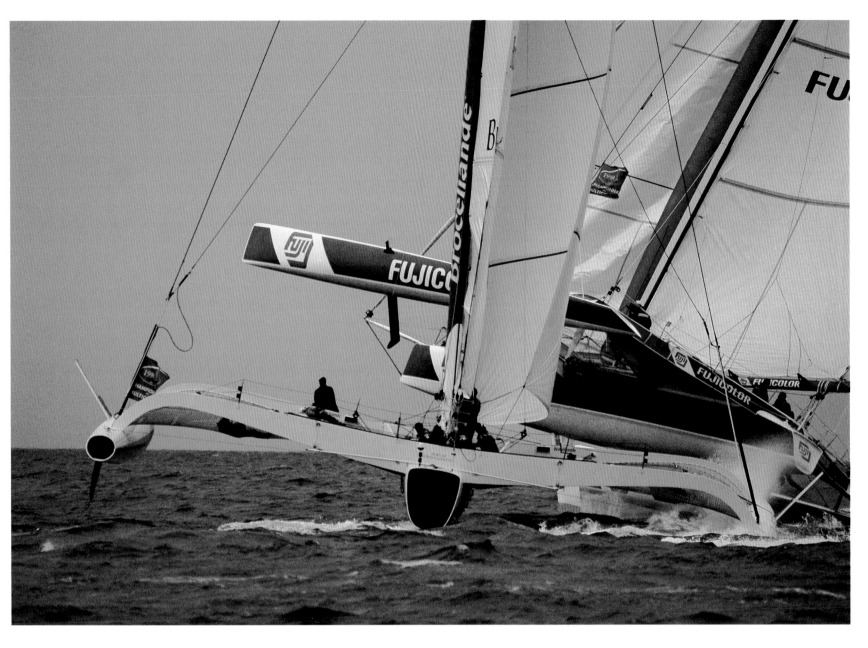

GRAND PRIX. OCEAN-GOING MULTIHULLS SPEED ACROSS THE ATLANTIC IN BLUE-RIBBON EVENTS, BUT THEY ALSO
GET TOGETHER UNDER THE AUSPICES OF ORMA (THE OCEAN RACING MULTIHULL ASSOCIATION) FOR REGATTAS,
IN WHICH THEY RACE AROUND THREE BUOYS LIKE STORM SPANKERS. A BREATHTAKING SIGHT.

ORMA, the governing organization behind the class of 60-foot (18-m) ocean-going multihulls, launched an annual championship
in which these giants of the sea face off. After the first race, in 1996, and its little-publicized beginnings, the competition became
well enough known to attract a substantial sponsor. In 2002, it became the ORMA 9 Telecom Championship, now recognized as
the official world championship. A series of grands prix for crewed racing (the Grand Prix of Lorient, of Belgium, and of Fécamp,
and the Course des Phares, or Lighthouse Race) and ocean racing, including the peak Route du Rhum in November, allow a sea-
son's winner to be declared on the basis of the total points won in each event. The contact regattas between the trimarans demand
the undivided attention of skipper and crew; these enthralling one-on-one sails around buoys combine speed and acrobatics in a
staggering spectacle. You never tire of seeing these great 60-foot (18-m) spiders of the sea give themselves over to such joyful play.

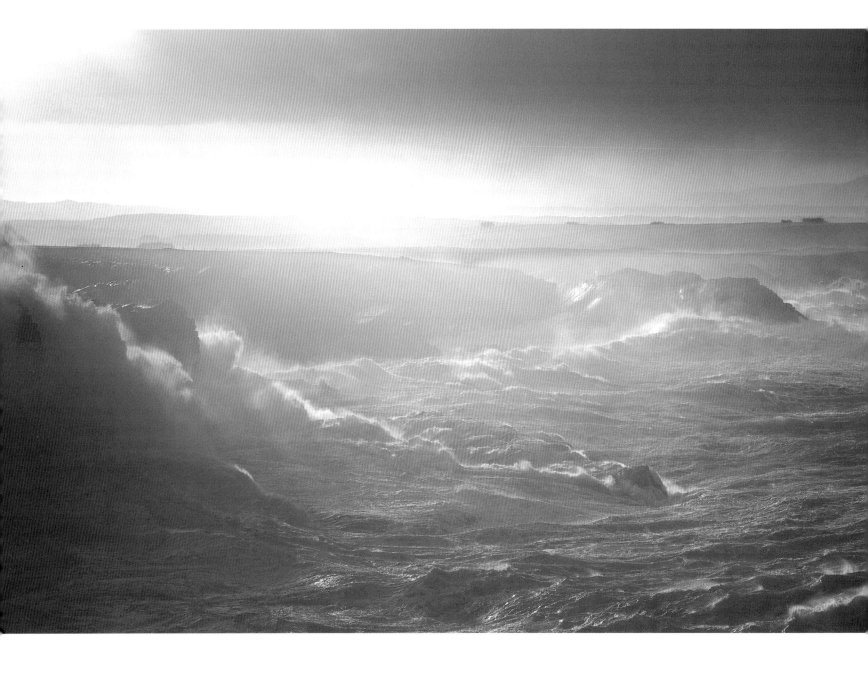

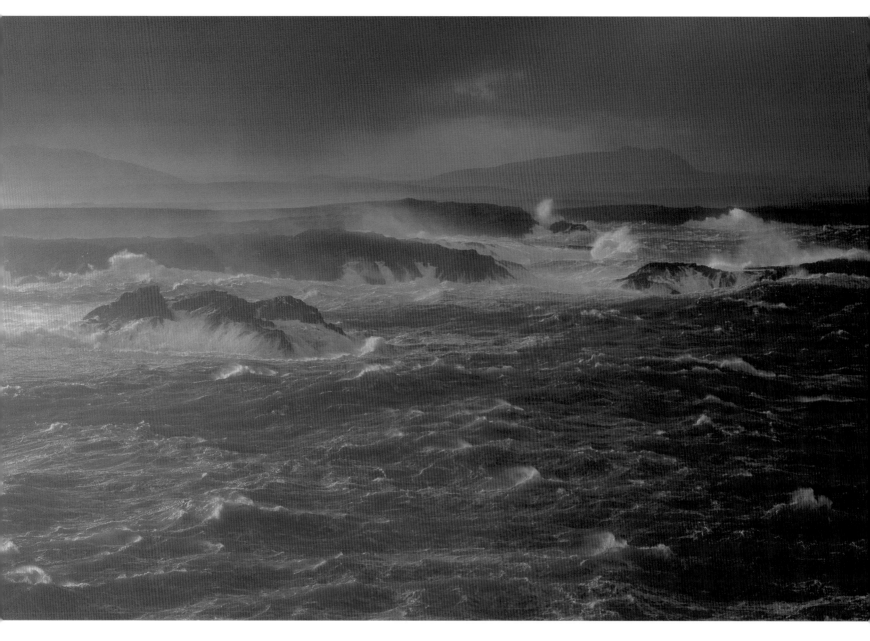

IRELAND. STORM WARNING FOR THE MULLET PENINSULA IN COUNTY KERRY.
GIVEN THE WIND CONDITIONS, FEW PEOPLE ARE PRESENT TO APPRECIATE
THE FURY OF THE ELEMENTS ON THIS DATE, JANUARY 17, 1999.

Only a passionate photographer would brave the outdoors in the face of such tumult, to capture this towering elemental mood swing. The sea, visibly vexed, hurls itself against the pitifully inadequate walls, above which stretches a landscape of salt, beaten by powerful air currents that not a single tree dares to defy. The ceaseless beating of the waves has created a tormented silhouette of coves and points along these rocky coasts. Elsewhere, as on the Channel strand, huge pieces of the crumbling chalk cliffs—formed long ago by accumulated sediments— are falling off. The sea ruthlessly undermines them, isolating the peaks and arches that are the pride of Étretat but that eat away at the nearby farmers' fields. Sea birds have found a refuge from predators in these vertical realms that allow them to live near their fishing grounds and establish whole colonies. Exposed to the ocean's crashing blows, this erosion continues along most of the coastal cliffs.

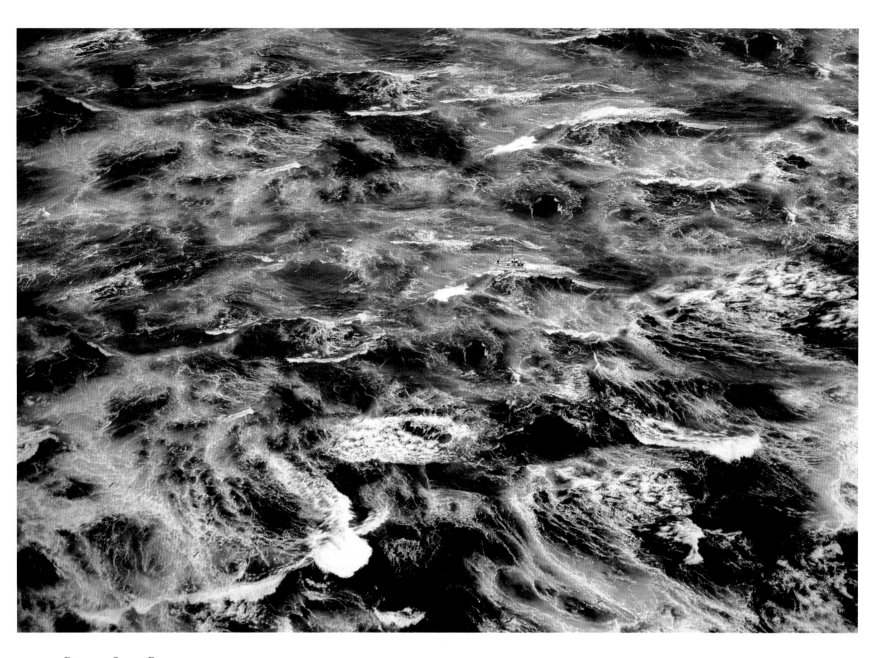

RAZ DE SEIN. PROFESSIONAL FISHERMEN RISK THEIR LIVES IN THE BREAKERS SKIMMING FOR BASS.

Bass love crashing waves and powerful eddies. In this roiling seawater, the impetuous bass spin with excitement as they feed on the abundant plankton. Raz de Sein, in the Iroise Sea, is a foaming cauldron where the currents that pound the rocky shoals create the tumult in which the species thrives. The more turbulent the waves, the better the bass like it—and the greater the danger for those who pursue this noble fish. Industrial fishing boats using trawls account for 80 percent of all catches. Their professional confreres, fishing more selectively with rod and reel, bring in another 10 percent, while the rest goes to retired fishermen and a few passionate amateurs. In order to assure the survival of the species, regulations set the smallest size that may be kept at 15 3/4 in. (40 cm), which corresponds to an eight-year-old bass weighing about 2 1/2 pounds (1.2 kg). The Atlantic bass, however (the twin of the Mediterranean sea perch), can live for thirty years and grow to more than 26 pounds (12 kg) if it is skillful and lucky enough to elude the nets and the lines.

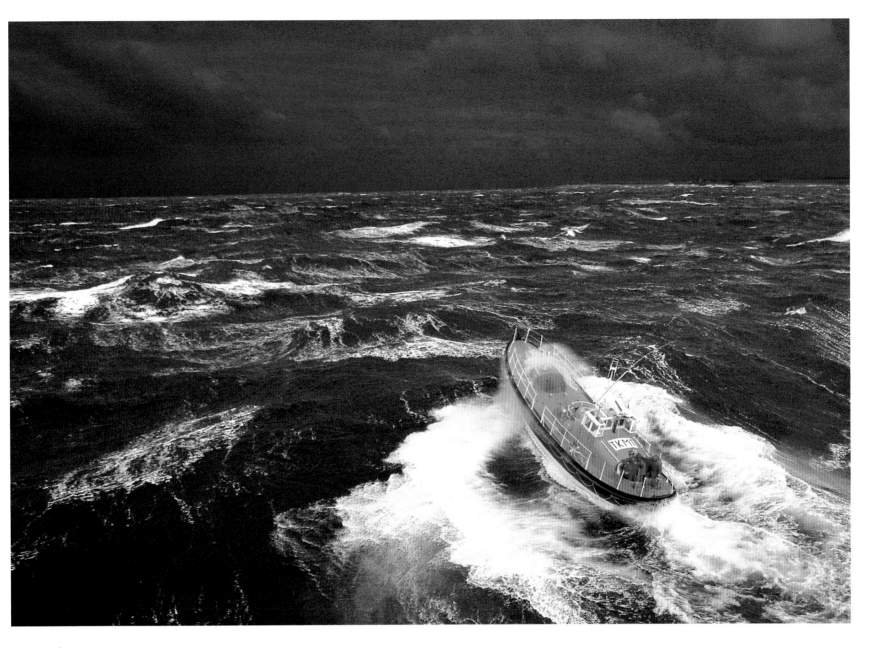

ÎLE D'OUESSANT. THE ALL-WEATHER CRAFT *PATRON FRANÇOIS MORIN* BRAVES THE WATERS
BEYOND PERN POINT. A PERFECT OUTING FOR A PHOTOGRAPHER.

The violent currents, fog, and wind that are the torturous order of the day in the waters around Pern Point,
the westernmost headland on Île d'Ouessant, make it a fearsome place. Lifeboats such as *Anaïs*, a small rowboat
some 30 feet (10 m) long, have been active around Île d'Ouessant since 1866. In 1937, the *Ville-de-Paris* went
into service; although it is diesel-fueled, it was designed like a rowboat, with no shelter for either the cast-
aways or the crew. The *Patron François Morin*, a wooden boat 45 ½ feet (14 m) long, was christened in honor of
the captain of its predecessor, the *Ville-de-Paris*, which it resembles. After thirty-six years of service, it was
replaced in 1995 by the *Île d'Ouessant*, a powerful, self-righting motorboat nearly 50 feet (15 m) long, which is
more reliable and easier to handle. But on this gloomy February morning in 1991, this is the boat that is head-
ing out to sea. Has some imprudent sailor in distress forced the rescuers to face this hostile ocean? Not at all.
They are doing this to please the photographer, for whom they are proud to let the *Patron François Morin* pose.

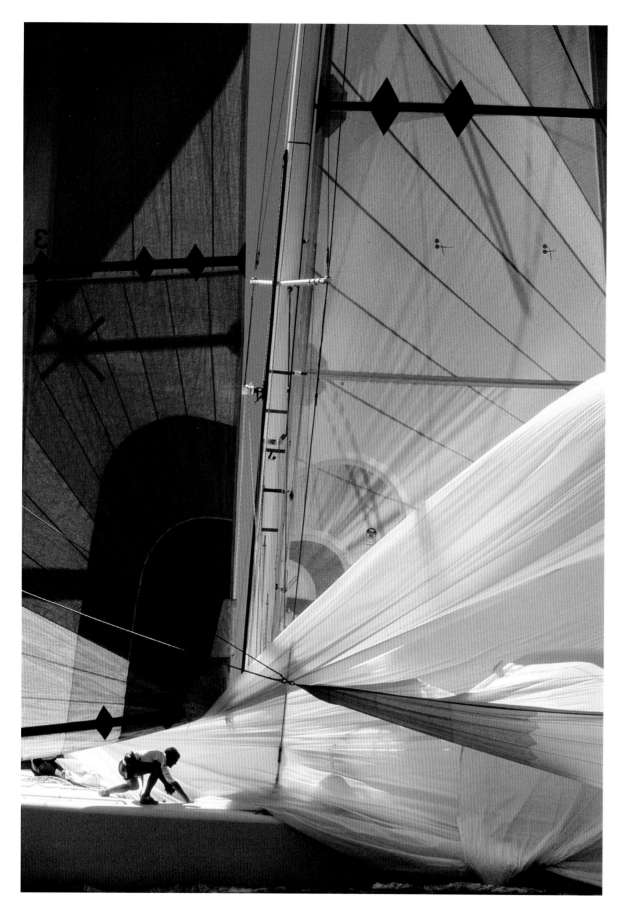

AMERICA'S CUP CLASS.
WHEN THE AMERICA'S CUP
CLASS REPLACED THE FAMOUS
12-METER CLASS IN 1990,
CREWS HAD TO REACCUSTOM
THEMSELVES TO HANDLING
MONUMENTAL SAILS.

The ships of the America's Cup Class take a long time to join the other challengers at the starting line of the elimination rounds of the America's Cup. The building of such a boat begins with a whole collective of world-class experts, with costs reaching up to $6 million (40 million euros). The team includes specialists in fluid dynamics, naval architects, designers—an Areopagus is called to the drawing board, tries out dozens of models, fiddles with the carbon mold, muses on the results of ship-testing tank and wind tunnel, invents extremely specific pieces, and scrupulously over-sees construction of the future racing animal to ensure that no mistakes of any kind occur. After several months in the yards, a gleaming red America's Cup Class ship some 65 feet (20 meters) long emerges from the shed, only to take on a crew to undergo months of training. Only about ten yards in the world can build an America's Cup Class ship.

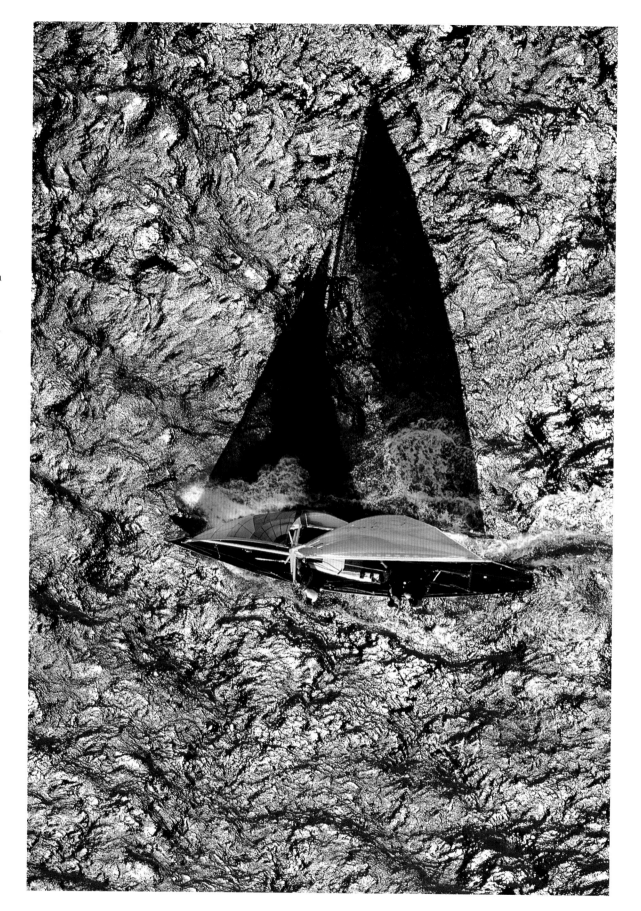

THE 8-METER JI IS UNQUESTIONABLY THE MOST ELEGANT MEMBER OF THE INTERNATIONAL-CLASS FAMILY. HERE, THE WIND KISSES THE SAILS OF THE *HISPANIA IV*, FORMERLY OWNED BY THE KING OF SPAIN.

Of the 450 8-meter JI international-class ships built over the course of the twentieth century, 180 are still sailing today. Every year, some compete in championships, the most recent of which was held at La Trinité-sur-Mer in 2003. The 8-meter JIs race in three categories: the "moderns," that is, boats built after 1960 to standard; the "vintage" boats, built before 1960, or restored to those specifications; and the "classics," older boats whose rigging has been updated. The *Hispania IV* is one of the last class. It was built in Bilbao in 1927 for Alfonso XIII, King of Spain, who had been seduced by the splendid 50-foot (15-meter) monohulls that ruled the waves after World War I. A first infatuation brought the *Hispania IV* into the world, but it would take a second to restore the ship to health. Bought by an enthusiast who rescued it from the mud, the *Hispania IV* was intensively rebuilt. After ten long years, it returned to sea and to racing, so elegant it might have come to life from a dream.

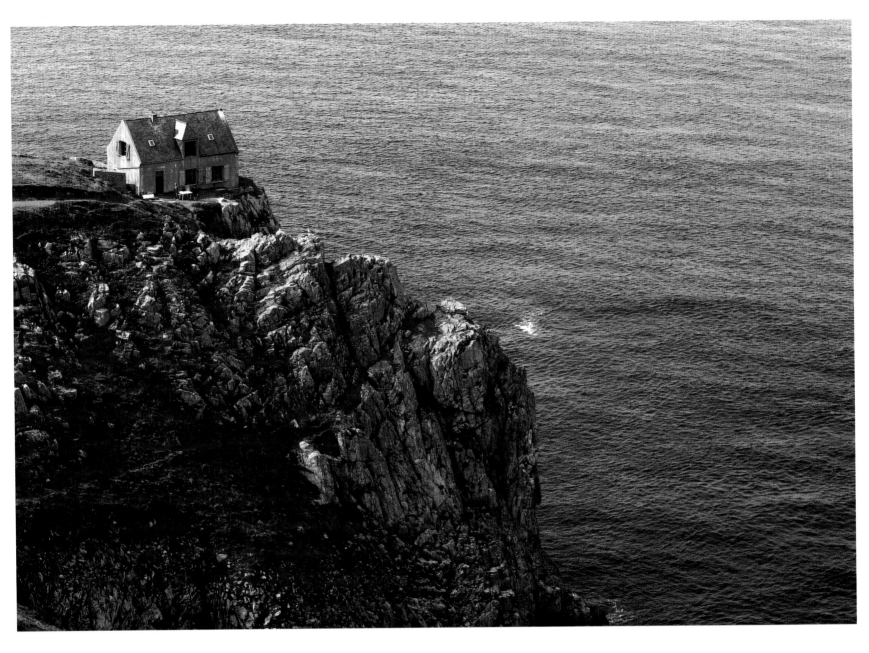

As on a ship, the sea house vanishes into thin air.

Hidden away in Ouessant, this small house, built with the stones taken from the cliffs, would be perfectly ordinary except that it hovers just steps from the abyss. But here, near the Stiff lighthouse, it holds the promise of mountains and wonders. One can just imagine daybreak from the upper bedroom, reclining and listening to the wind. If you hear nothing, that's a good sign. With just a hint of drizzle or fog, you would not even see your feet. When the forecast is for fine weather, there's no time to lose—make the most of it. And just to be sure, throw open the green shutters onto the vast, blue sky. Far down below, the surf swells in the grottoes and the sea reaches out in all directions. No different from the bedroom upstairs, the table in the garden exists in a perpetual state of vertigo, a constant, dizzying show. Here, the edge of the world is a footstep away.

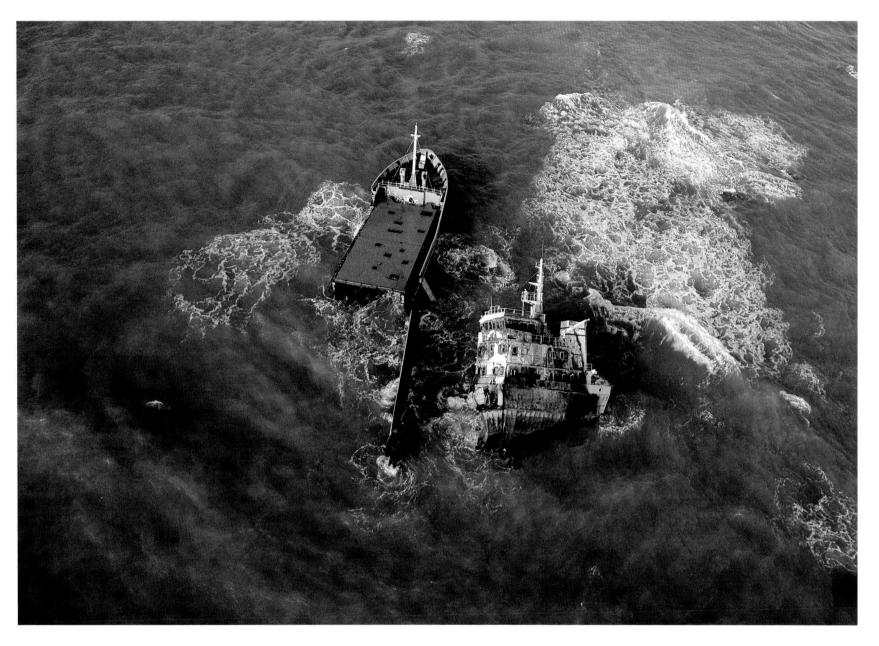

Prudence requires that, if a ship is to avoid meeting the same end as this rusty, broken wreck, its position must never be taken for granted, but constantly recalculated, taking new factors into account. When dealing with the sea and the wind it is better to check three times than make one educated guess. Doubt and skepticism, not laxness or a casual attitude, are the only things that work. Navigation is not a matter of approximations, and respect for regulations and attention to weather forecasts and safety equipment is nonnegotiable. While technical advances make possible better weather forecasts and radio communications and rescue efforts are more effective, none of these can prevent the sea from exacting its heavy toll: each week, on average two large vessels carrying more than 300 tons of cargo are shipwrecked.

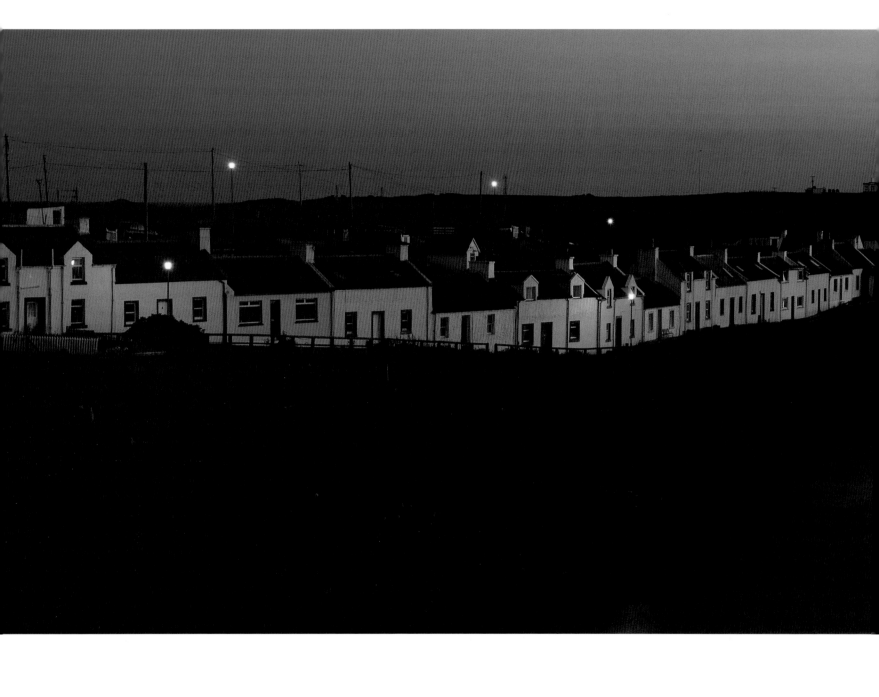

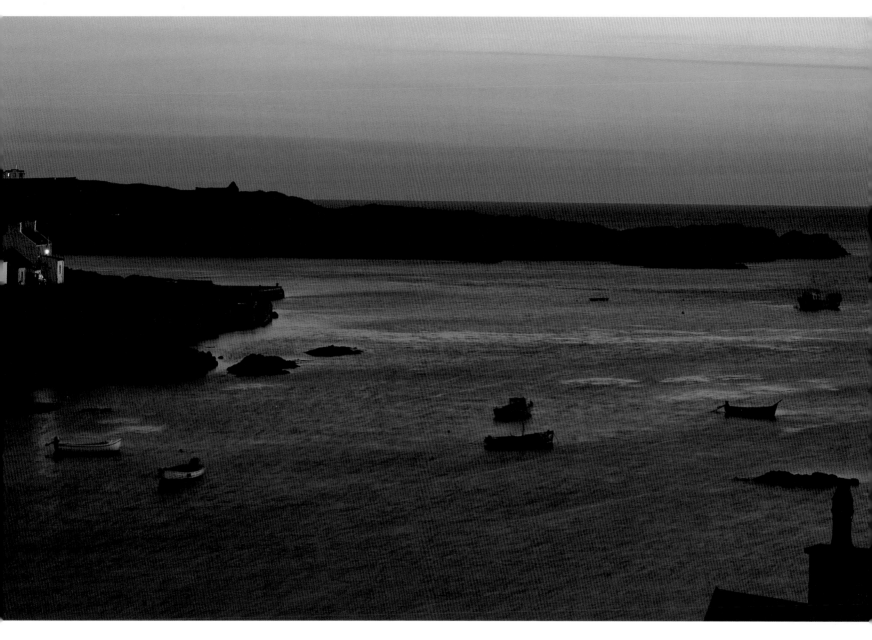

ISLAY. THIS ISLAND AT SCOTLAND'S SOUTHWESTERN TIP IS HOME TO NINE DISTILLERIES, MAKING IT THE PURE-MALT CAPITAL OF THE WORLD.

It has been strategically important during periods of blockade, but Scotland's Atlantic coast also watches all the maritime traffic between northern Europe and North America go by—which explains its sixty lighthouses. Islay, in southwest Scotland, for example, has one that dates from 1825; its beam, revolving 94 feet (29 m) up, can be seen from the Giant's Causeway in Northern Ireland. Today, behind the windows of the buildings snuggling at its feet, the light is probably out: Islay's Rhinns was automated on February 19, 1998. The tower is one of sixteen built by Robert Stevenson, the first in a great line of lighthouse builders. Three generations of Stevensons built almost all the Scottish lighthouses. The nineteenth century's grand saga of the construction of these towers of light has other heroes, including the Halpins, who from father to son illuminated the Irish coast, and the dynasty of the Douglasses, who brought light to the shores of England.

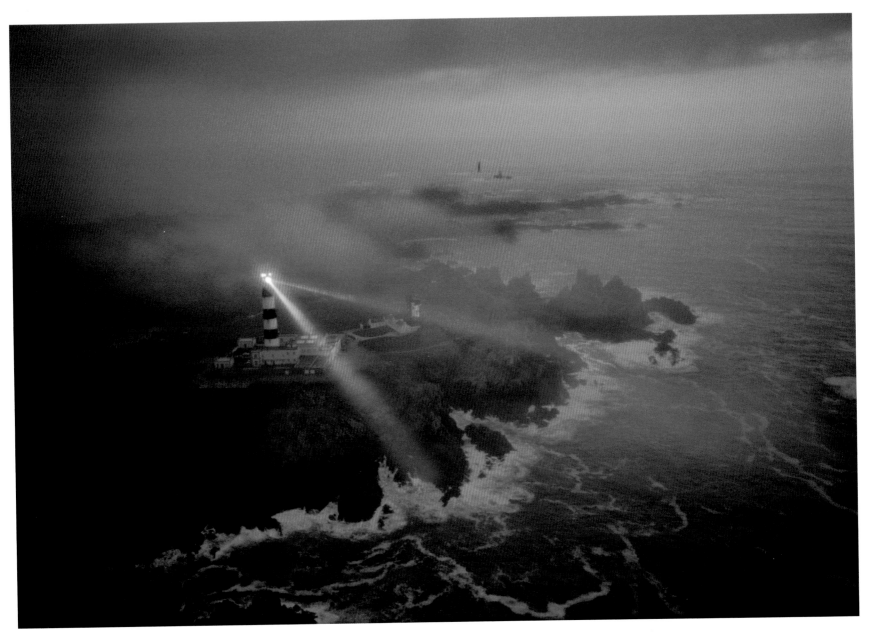

LE CRÉAC'H LIGHTHOUSE, ONE OF THE MOST POWERFUL IN THE WORLD, RISES ON ÎLE D'OUESSANT. IN CLEAR WEATHER, ITS BEAM MARKS THE HORIZON FOR MORE THAN 40 MILES (70 KM).

The advent of electronics will never diminish the emotion sailors experience when they come home from the open sea, first see the lighthouse's glow, and revel in their deliverance from the endless liquid dawns that have punctuated their crossing. Le Créac'h is one such landing light, because it marks the appearance of the Old World as one arrives from the Atlantic. Its powerful projector sweeps the darkness, piercing the night with two white flashes every ten seconds. When the thick and frequent fogs prevent Le Créac'h from pulsing out its shining phrase, its siren takes over. Standing since 1863 on a rocky rise on Île d'Ouessant's northwest point, La Créac'h signals, from its towering 179 feet (55 m), to the Atlantic Ocean's most heavily trafficked sea-lanes. At its base, the halls of the former electric plant have been home since 1988 to the Lighthouse and Beacon Museum, whose unique collection of lanterns, lenses, buoys, and beacons permits visitors to follow the saga of maritime signaling from antiquity onward.

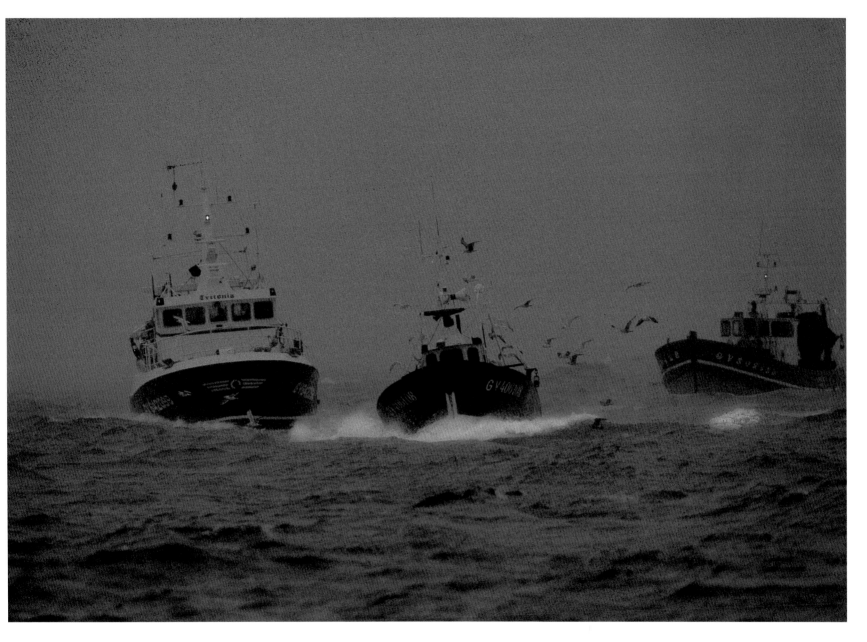

LE GUILVINEC. THE FISHING FLEET RETURNS TO PORT EVERY AFTERNOON AROUND FIVE O'CLOCK
TO AUCTION OFF THE CATCH: THE LEGENDARY LANGOUSTINES OF BIGOUDEN.

Every year, the planet's seas and oceans wash 4 million tons of Alaskan pollack, 2.4 million tons of Atlantic her-
ring, and 2 million tons each of Japanese anchovies, Chilean horse mackerel, and Spanish mackerel into fishing
nets. The langoustines of Bigouden, in southern Finistère, are not one of the world's most fished species—the
volume of the catches remains relatively small—but they are very popular with the locals and with gourmets. As
the trawlers out of Guilvinec return from the sea, escorted by gulls, these connoisseurs pace the docks waiting
to intercept a few pounds of the delectable crustaceans, before they vanish quickly at the nearby auction. In
December 2002, a fishing boat out of Guilvinec did not return from the sea. Fishing is a particularly dangerous
trade: around the globe at least sixty-five fishing boats disappear at sea daily.

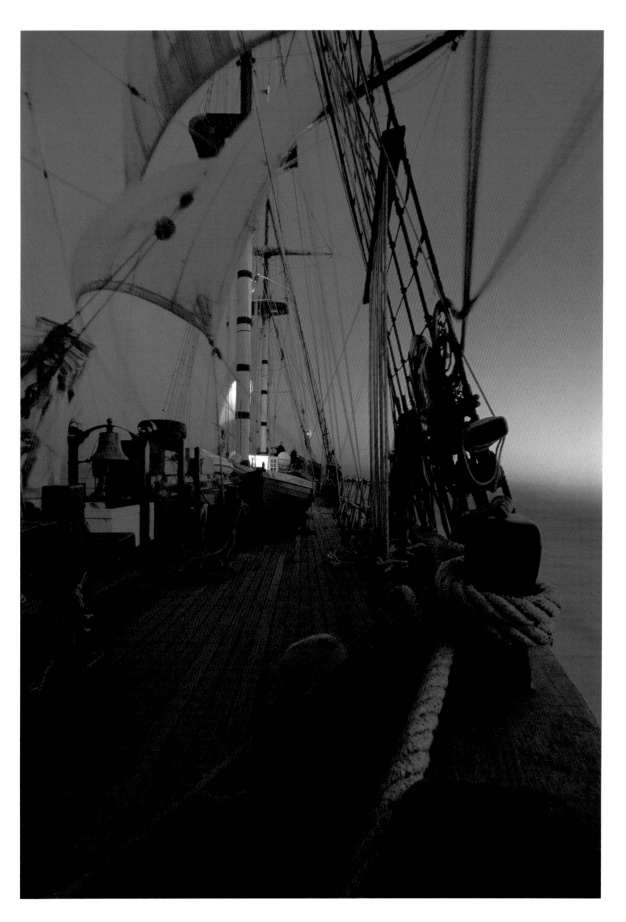

HMS Rose. Crossing.
Just minutes before dawn.
A boat is in the greatest danger
when it is closest to shore.
Therefore, it would seem logical
that it runs fewer risks out at
sea, where it can be alone for
tens of miles around. The sea,
however, is never really
entirely safe. During sea cross-
ings, when a ship is far from
the coast, or at night, when
there is less activity aboard,
the chief danger onboard is a
collision with another ship.
From freighters, those cities of
light visible from far away, to
a trafficker's craft slipping
through the night with all its
lights out, encounters are always
possible, but not all are desir-
able. The other principal danger,
especially at night, is man
overboard. Effective security
measures mean that the crew
can take precautions against
these hazards. The vast majority
of the time, these measures
mean that night crossings take
place without incident, con-
cluding calmly and peacefully,
as here, where the horizon's
pastel pink summons the coming
of the day.

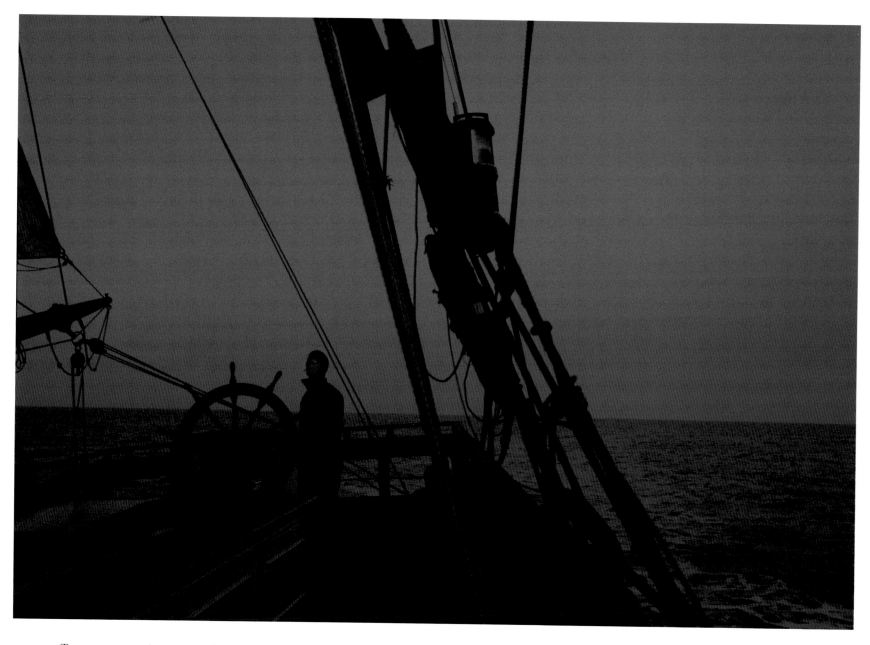

THE HELMSMAN'S WATCH. AT THE END OF THE NIGHT WATCH, THE SCENTS OF COFFEE AND FRESH-BAKED BREAD DRIFT UP TO THE BRIDGE, SIGNALING RELIEF.

A ship at sea is alive night and day. A rotation of the crew lets some rest while others take care of the navigation, the watches, and the daily chores. The watches are turns of four hours each. Until the late nineteenth century, the shifts on the bridge or in the engine room, known as "quarters," were six hours long, thus dividing the twenty-four-hour day into four parts. Today, however, the watches are shorter. Between 4:00 and 8:00 AM, the ship emerges from the long, dark hours. The crew member on watch will have spent them noting the lapping caress of water on the hull, the wake's phosphorescent spangles, the myriad galaxies hovering above the timid spark of a distant freighter, or the call of a life-saving lighthouse. In the torpor of early dawn, when the muffled activity of the relief disturbs a solitary meditation, the kettle's song announces that the day is beginning—and that the watch is over.

The Mediterranean. A storm on board the *Belem* between Corsica and the Continent.

On the bow of the *Belem*, two cigarettes light up a stormy night with their incandescent twisting. The crew takes turns watching, maintaining the sails and course, checking the logbook, sometimes responding to a distress call, or honoring the principle of absolute solidarity that prevails on the sea. So, on a ship, night is not necessarily made for sleeping. What's more, everything moves, the humidity is treacherous, given the enormity of the environment, you find yourself secluded in a tiny space. A boat leads a separate life, disconnected from landmarks. Negligence and disorder are forbidden there and anything that isn't steady falls, breaks, gets wet, or disappears. You try to invent another life there, rhythmic dotting punctuated by watches that are made up of demanding rules and rituals, of respect for others and the natural environment. This indispensable knowledge of the sea, this true key to the pleasure of the cruise, only allows through the constraints of this shaky life the happiness being at sea to be revealed. A feeling of liberation, perhaps.

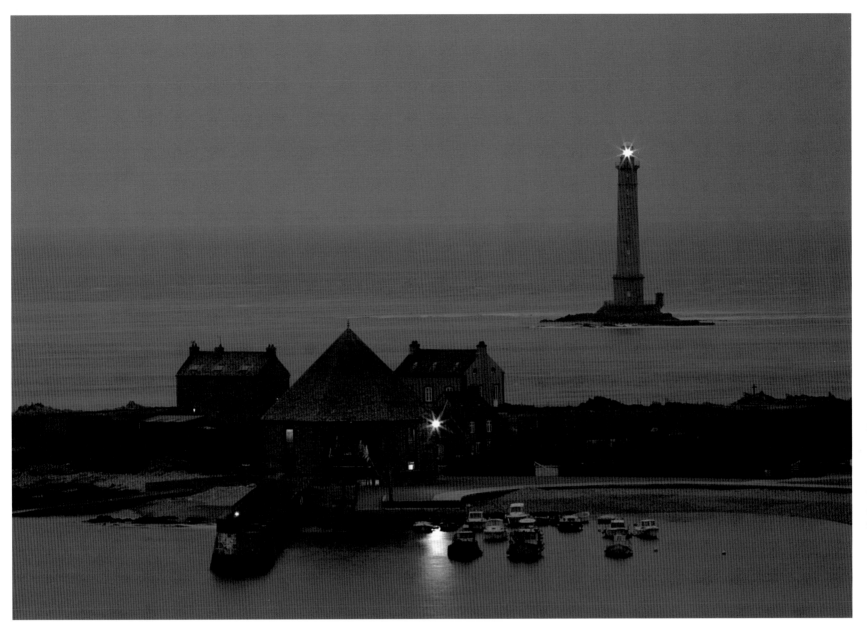

A GLASSY SEA ON THE RAZ BLANCHARD, INNOCENT AS AN IMAGE.
ABOVE ALL, DON'T TRUST IT.

To the extreme west of Cotentin, the Raz Blanchard is one of the trickiest passages in the English Channel.
The twice-daily tides of the North Sea first thrash this peninsula, and then surge between the coast and the
Anglo-French Normandy islands, the ebb and flow creating vertiginous eddies that move at more than 10 knots
(almost 13 miles per hour, or 20 kilometers per hour), forming some of the most violent currents in Europe.
Dreaded by sports enthusiasts and professionals alike, the Cap de la Hague has double protection. Its lighthouse
alerts ships and encourages them to consult the tide tables and nautical advisories long before committing to a
passage. The volunteers at the Goury rescue station are prepared to assist a vessel in distress regardless of
weather conditions. Their lifeboat—its engine running on the launch ramp—is one of the last ones that can
still cast off in inclement weather.

ARRAN, IN THE FIRTH OF CLYDE, EPITOMIZES ALL THINGS SCOTTISH.

West of the Scottish mainland, dawn leaves Arran, taking with it the mysteries of this green, windswept island where the titans of the Giant's Causeway, across the North Channel, came to enjoy a beach with outsized grains of sand. In full daylight, they are again only stones that the sea has rolled and rounded for millennia. The shore, at the mercy of both material from land and the sea's erosive power, is constantly changing. Here a cliff withstands, there a dune beats a retreat. A familiar stretch of coastline is only immutable within the brief span of human time—over the course of geological ages, it may recede or advance hundreds of miles. The level of the oceans fluctuates as well. It rose 390 feet (120 m) at the end of the last ice age, some 7,000 years ago. In 1990, the Cosquer Cave was discovered near Marseilles, at a depth of 120 feet (937 m). Its walls were decorated with rock art made more than 19,000 years ago, when the entrance to the cave was in the open air.

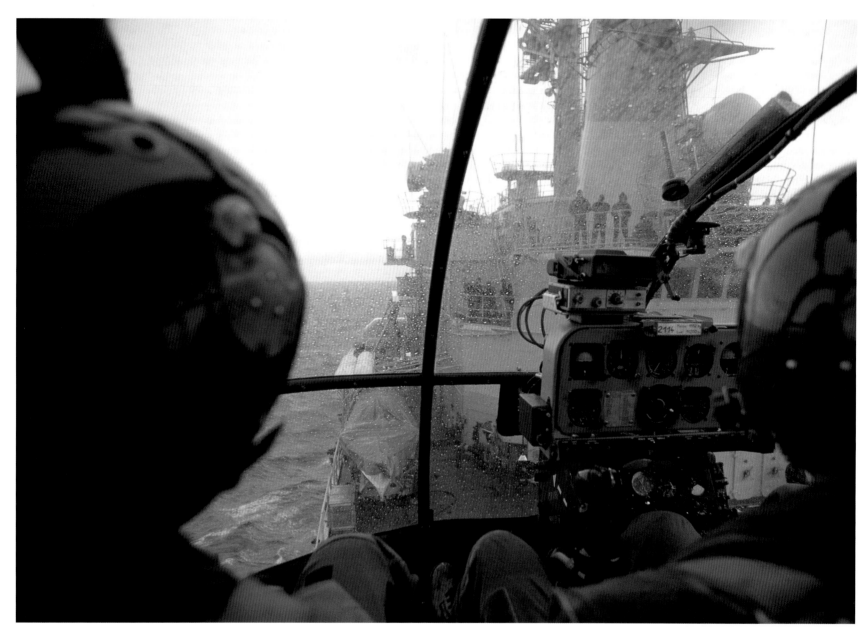

THE HELICOPTER CARRIER JEANNE D'ARC. AN ALOUETTE III HAS JUST LEFT THE BRIDGE
ON A RECONNAISSANCE MISSION OFF THE ARGENTINE COAST. THE CADETS OF THE NAVAL ACADEMY
COMPLETE THEIR TRAINING WITH AN AROUND-THE-WORLD TOUR ABOARD THE JEANNE D'ARC.

The *Jeanne d'Arc*, pictured here, is the French Navy's sixth ship of this name. Both a forty-two-gun and fifty-two-gun frigate bore the name between 1828 and 1865, as did an armored corvette between 1867 and 1934, then an armored cruiser. A training cruiser that made twenty-seven world field tours for the Naval Officers' School had the name until this helicopter carrier inherited it. The warship, which came out of the naval dockyards of Brest in 1961, was launched with the provisional name *La Résolue*, but was renamed the *Jeanne d'Arc* in 1964, upon its going into active service. During periods of military conflict, it participates in combat missions as an assault and antisubmarine combat vessel. The ship carries about ten helicopters, has a displacement of 12,000 tons, and runs at 28 knots. In peacetime, it serves as a training ship for the Naval Officers' School. It is one of the flagships of the naval fleet—everyone knows *La Jeanne*.

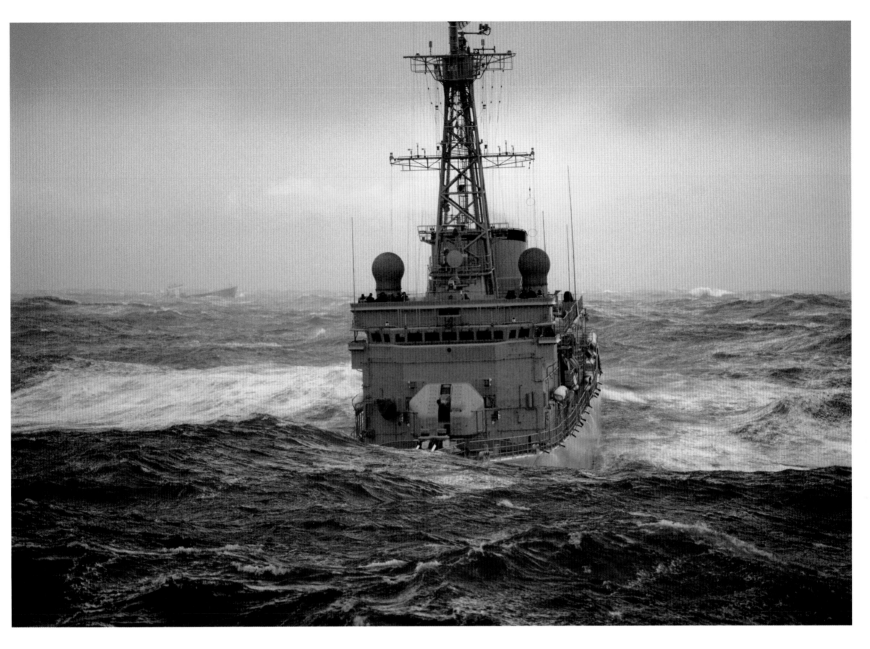

LYING TO. THE FRIGATE *LATOUCHE-TRÉVILLE* HEAVES TO OFF OF BREST IN BAD WEATHER.

To protect itself from the billowing breakers knocking it every which way in rough weather, a ship may come to a stop by letting the engine idle (a sailboat will trim or haul down the sails, and put the helm alee), as the captain of the warship *Latouche-Tréville* elected to do this day off Île d'Ouessant. This is one of France's seven antisubmarine frigates, which escort vessels such as submarines and aircraft carriers, protect naval forces, and engage in antisubmarine missions. With its crew of 230, this ship, weighing some 4,000 tons, usually travels at an average speed of 30 knots if it is using its gas turbines, or 21 knots with its diesel engines. Today, however, the sea has decided differently. Monumental waves on the order of 39 feet (12 m) high are tossing the frigate around like a cork, despite its 455-foot (140-m) length and 45 1/2-foot (14-m) width. In the distance, a second ship confirms the state of the sea.

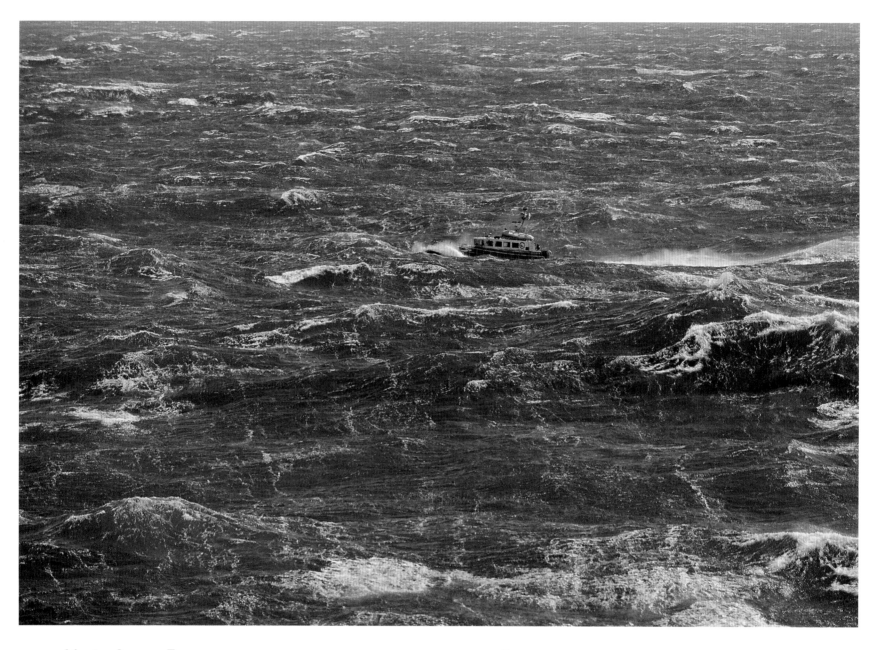

MOLÈNE ISLAND. THE ALL-WEATHER CRAFT RETURNS TO PORT THROUGH THE FROMVEUR PASSAGE
ON A STORMY AFTERNOON.

Returning from a rescue in winds of more than 60 miles per hour (100 kph), Molène Island's coastal lifeboat takes the Fromveur
passage, which roils in the powerful currents and bristles with reefs. The fact that the hull is invisible at the bottom of a trough
in a choppy sea gives an idea as to how difficult the conditions are in such an outing. Along the French coasts, 3,500 volunteer
rescuers—experienced and altruistic sailors—regularly risk their own lives to save the lives of others. In addition, throughout the
summer, seasonal volunteers act as lifeguards on the beaches. Every year, an average of six hundred people owe their lives to the
dedication and courage of these rescuers. In 1925, when fifteen rescuers disappeared during a mission in the open sea off Penmarc'h
in southern Finistère, the victims' relatives replaced the lifeboats' equipment. Today, 80 percent of lifeboats go out to help dis-
abled pleasure boats. In their distraction, the rescued sometimes forget to thank their rescuers. An unfortunate blunder indeed in
the world of the seafarers, who traditionally always display humility and solidarity.

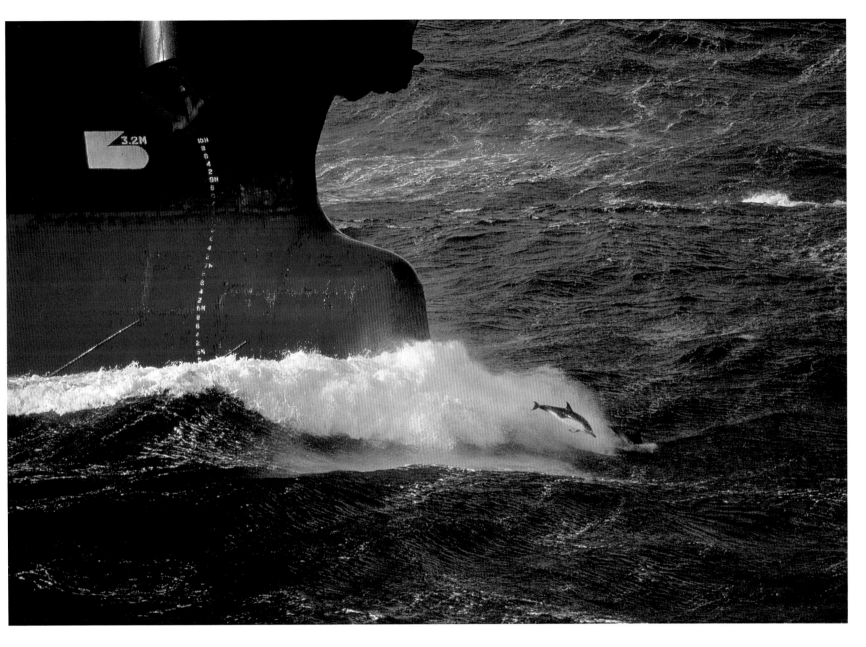

A PILOT DOLPHIN. THE PROW'S FOND GAZE SEEMS AMUSED BY THIS DOLPHIN'S AQUATIC ANTICS.

Dolphins seem to occupy a very special place in the human heart. Is it that mischievous smile of theirs? Is it because they are marine mammals, and the females nurse their young, or because the whistles and squeals with which they communicate resemble human language? Is it because they are playful and friendly to boats of every size? This dolphin, for example, has decided to pilot this freighter. The ship—an old hand at the shipping lanes—finds this devotion very moving. At least fifty thousand ships a year pass along the Île d'Ouessant lane, the busiest passage in Europe. The lanes are needed to control traffic in certain areas. For example, ships coming from the Atlantic into the Channel must take the up lane—on the French side—while vessels coming from the North Sea follow the British coast on the down lane. Right of way in the rail crossings is very precisely regulated.

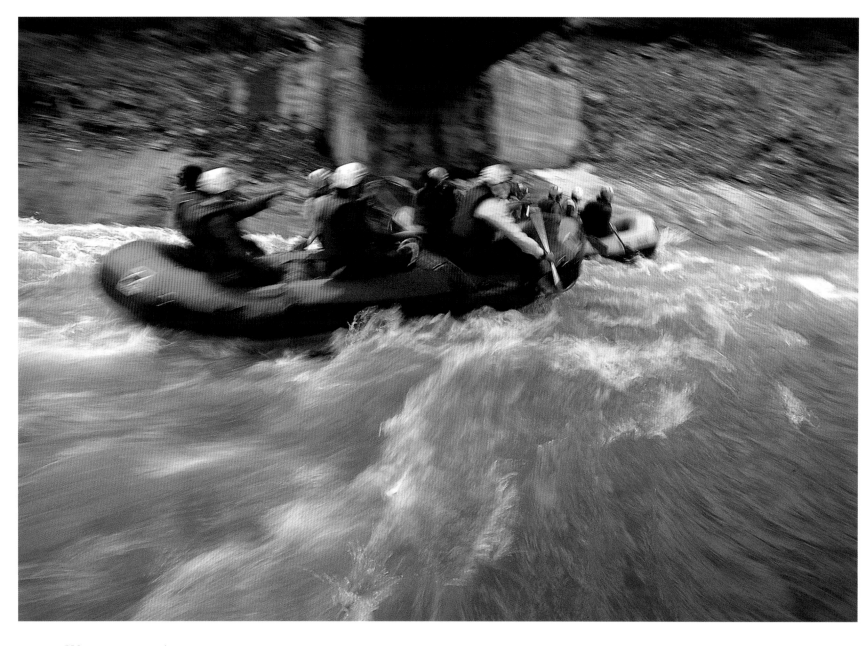

WATER SPORTS. ALL RIVERS LEAD TO THE SEA.

The crews of these rafts are surfing on a river in the Alps. If they were to follow its course, they would end up in the sea. Everywhere, whether on the plains, in the forests, or on the oceans, water is evaporating. It accumulates in the clouds until jettisoned to earth. Mountains, like man-made seawalls, inhibit the flow, forcing the water to accumulate. Altitude furthers condensation, with droplets growing heavier until the air can no longer support them, when they fall to the ground. In keeping with the laws of nature, up to 75 percent of precipitation drains into the river systems. Mountain water floods down the slopes, running into streams, forming rivers that eventually empty into the sea. Sometimes the journey is very long. The Nile measures more than 4,000 miles (almost 6,500 km), and the Amazon has some 15,000 tributaries culminating in a flow rate of almost 16 million gallons (60 million L) of water per second at the mouth of the river.

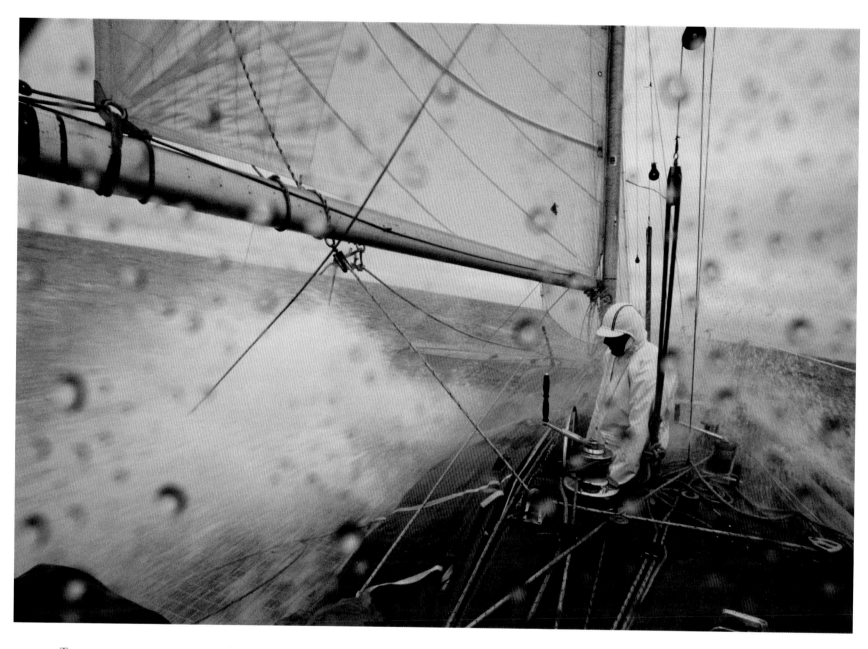

THE ULTIMATE EXPERIENCE. CROSSING THE ATLANTIC ON A MULTIHULL FROM
LA ROCHELLE TO NEW ORLEANS GUARANTEES THIRTY DAYS OF SALTWATER SHOWERS.

A ship equipped with several hulls, or pontoons, is well balanced. Thanks to the stability this system pro-
vides, boats have been able to employ ever greater expanses of sails, and so reach extraordinary speeds. This has
made the multihulled sailboats, requiring delicate handling, the jewels of ocean racing. The family includes tri-
marans, catamarans, and praus. The term "catamaran" derives from the Tamil word for the fishing boats on the
Coromandel coast, in southern India—*kattu* means "connection," and *maram* means "wood." The prau, which
originated in Malaysia and Indonesia but is also used by the Vezo fishing people of Madagascar, has a main hull
with an additional hull beside it for balance, which must always lie alee. A prau came in third in the 1982
transatlantic La Rochelle–New Orleans race, just ten minutes behind Marc Pajot on *Elf Aquitaine*, with Guy
Delage, François Girod, and Philip Plisson aboard.

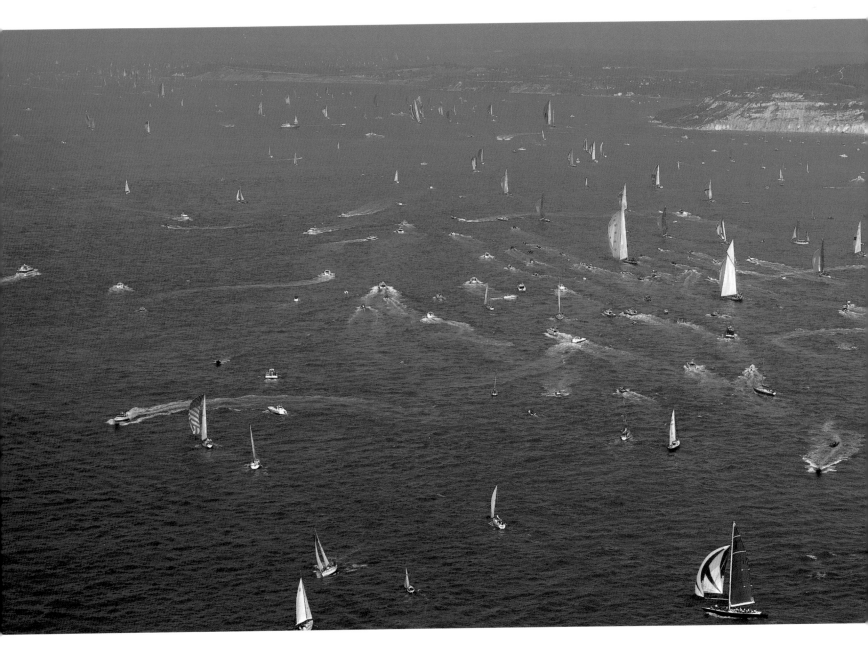

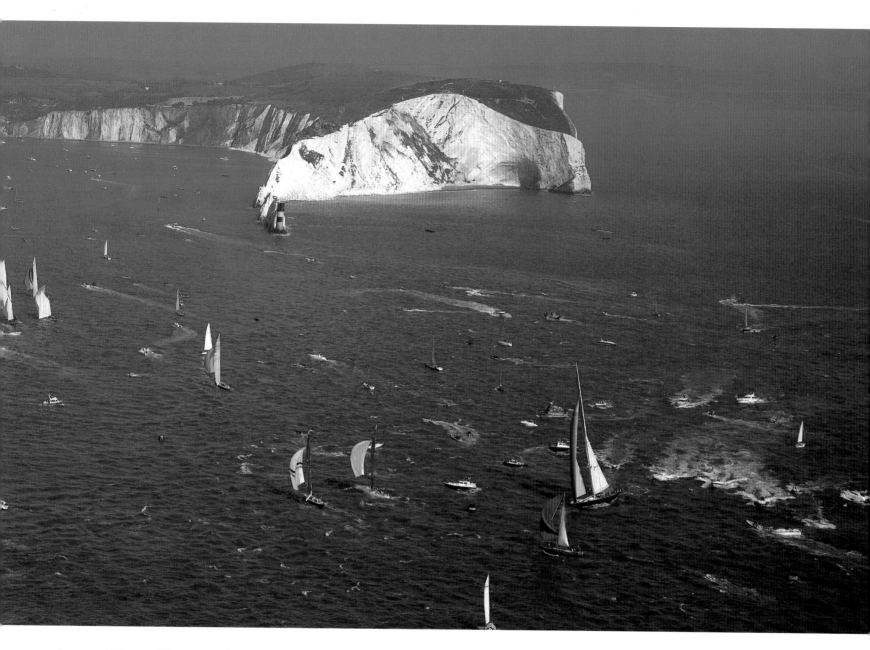

ISLE OF WIGHT. THE FIRST AMERICA'S CUP WAS RACED AROUND THIS ISLAND IN 1851. IN AUGUST 2002, IT WAS THE SITE OF THE MOST MAGNIFICENT CELEBRATION IN THE HISTORY OF MODERN SAILING, ORGANIZED BY THE PRESTIGIOUS ROYAL YACHT SQUADRON IN ASSOCIATION WITH LOUIS VUITTON, ON THE OCCASION OF THE RACE'S JUBILEE.

The America's Cup is named for the schooner-yacht *America*, which crossed the Atlantic in 1851 to take on the Royal Yacht Squadron in a race around the Isle of Wight. The outcome of the contest shattered the British naval might, believed at the time to rule the seas. As it approached the coast, *America* crossed the cutter *Laverock*, one of England's fastest ships, which the *America* easily passed. The news quickly reached the contestants, planting seeds of doubt. Ships hesitated to measure themselves against the powerful schooner from across the "pond," but outraged public opinion decided them. *America* finished first, carrying off the silver urn put up as a trophy. The victory elicited a legendary rejoinder. Appalled by what she had just witnessed from Osborne House, Queen Victoria asked who had come in second. The reply: "Majesty, there is no second place." The saga of the America's Cup—the pursuit of the trophy lost on August 22, 1851—was about to begin.

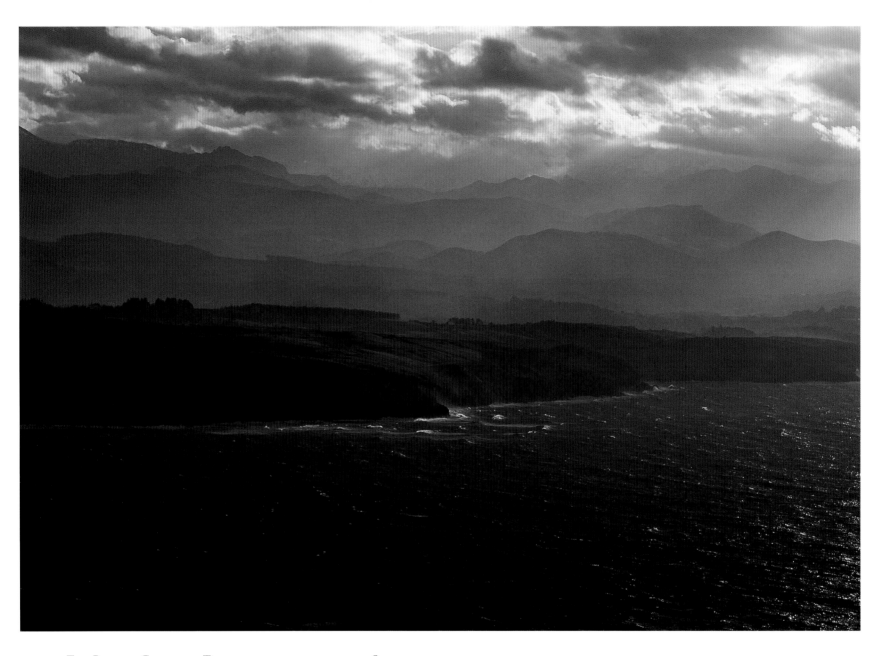

THE BASQUE COUNTRY. THE LAST FOOTHILLS ON THE SPANISH SIDE
OF THE PYRENEES SLOPE GENTLY DOWN INTO THE BAY OF BISCAY.

The Pyrenees, the natural border between France and Spain, rose out of a staggering collision between continental plates. In addition to the formations we can see, mountains also have underwater counterparts, where tectonic activity is in full swing. Sounders and satellites have revealed the existence of the ocean ridge—an undersea chain of mountains that range in height from 6,500 feet (2,000 m) to 9,750 feet (3,000 m), and the same across, extending a network of more than 37,500 miles (60,000 km) along the edges of the great plates that make up Earth's crust. Magma comes up through these fissures and spreads its basaltic lava on either side of the ridges. As the lava cools it thrusts aside the older rocks, and so the ocean floor rises from 1/2 inch (1 cm) to 7 1/2 inches (19 cm) per year. The discovery of the expansion of the ocean floor in the late 1960s solved the mystery of how the continents were formed, made possible the development of the theory of plate tectonics, and confirmed the continental drift that the German scientist Alfred Wegener had suspected a half century before.

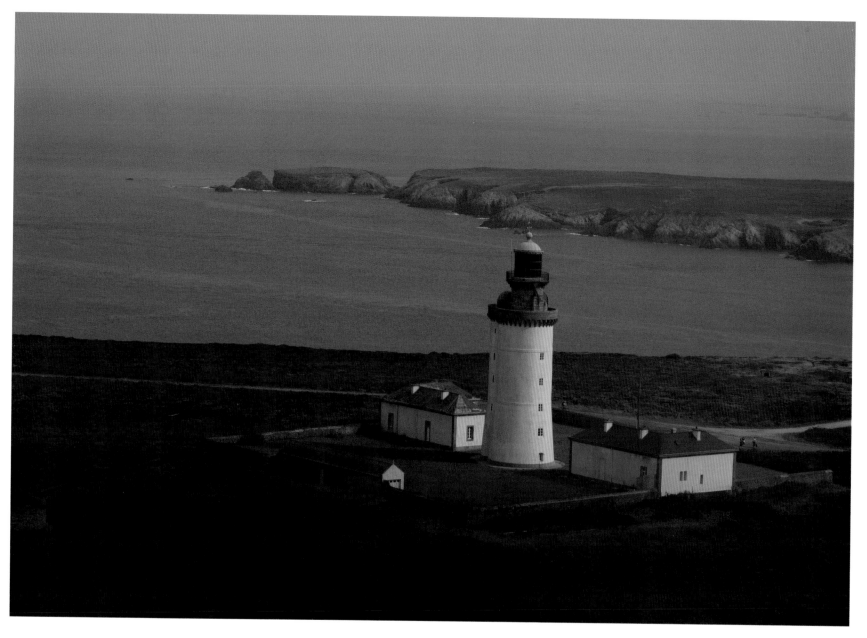

THE STIFF LIGHTHOUSE, OUESSANT. TWO RED FLASHES EVERY TWENTY SECONDS. ONE OF
FRANCE'S OLDEST LIGHTHOUSES HAS STOOD THE TEST OF TIME—AND THE TEST OF WIND.

When Vauban decided to construct the Ouessant lighthouse in 1695, there existed only one other in France, at Cordouan. He deemed it time to install a signaling system that would allow the royal fleet to return to its base ports during the night. In 1700, the double tower at Stiff was erected and its beacon illuminated. For the first twenty years of its existence it functioned only during the bad weather, from October to March. The staircase leading to the light was used by the keepers when the hearth needed stoking. Laden with sacks of coal, they had to climb three stories before reaching the balcony and the lantern room. When the lighting system was converted at the end of the eighteenth century, they had to hoist casks of olive and fish oils all the way to the summit of the tower, more than 100 feet (30 m) tall. In 1831, a Fresnel lens was installed and in 1957, to the great relief of the keepers, the beacon was electrified.

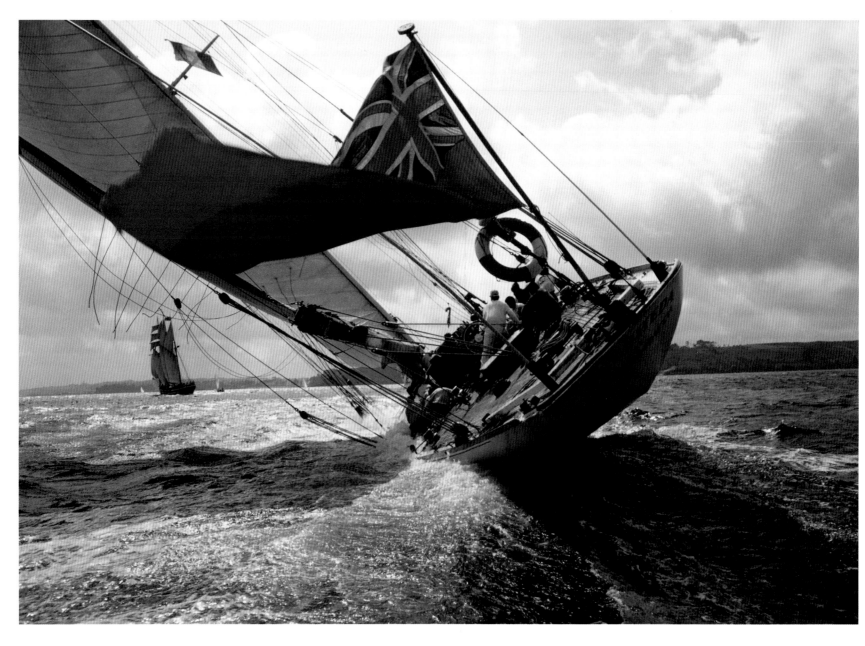

J-CLASS. VELSHEDA, WHICH CAME OUT OF HAMBLE AFTER TWENTY-FIVE YEARS OF INACTIVITY AND NEGLECT, MAKES THE FIRST OUTING OF ITS NEW LIFE IN THE BAY OF DOUARNENEZ IN JULY 1988. THESE BIG YACHTS ARE SPECTACULAR SIGHTS AS THEY TURN INTO THE WIND.

Jewels of the history of yachting, the J-Classes have numbered such famous names as *Britannia*, *Enterprise*, and *Rainbow*. Ten in all have sailed since 1930, six of them in the United States—all now dismantled or destroyed—and four in England. Three of the British yachts have survived the decades and, several times restored, are still sailing. *Endeavour*, *Shamrock V*, and *Velsheda*, the last of a line of graceful, sophisticated princes of the sea, vied in elegance and speed on the water from 1930 to 1937, the year of the last race organized for the J-Class (before the 12-meter JI appeared in the 1958 America's Cup). The second J-Class, born after *Shamrock V* and, like its predecessor, designed by Charles Nicholson, was *Velsheda*, launched in 1932 to compete in the 1934 America's Cup. This steel, 128-foot (39.5-m) racer, very distinguished despite its 168 tons, spreads 7,527 square feet (700 m²) of sails, thanks to a 163-foot (50-m) mast. The owner of this wonder had three daughters: Velma, Sheila, and Daphne.

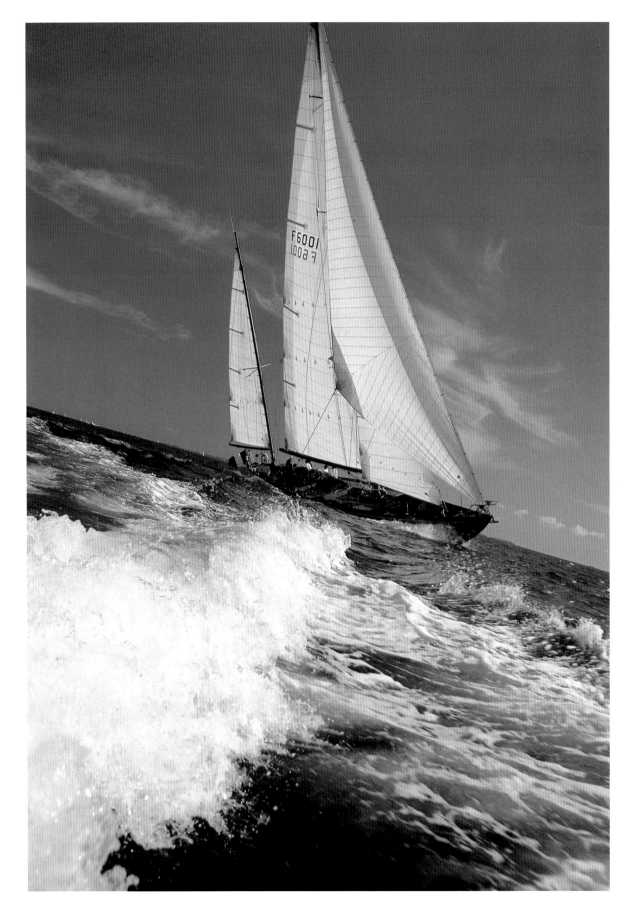

PASSION. WONDERFUL YACHTS LIKE *Oiseau-de-Feu* ARE ONE OF THE PHOTOGRAPHER'S PASSIONS. Born in a Southampton boatyard in 1936, *Oiseau-de-Feu* is one of Nicholson's most beautiful sailboats. It spent a long time in France—where its original name, *Firebird*, was changed to the French version—but continued to be placed in its native country's regattas until around 1970. Seized in the 1980s, then abandoned, it was pulled out of the Bono River, beside the Morbihan Gulf, in 1990 by an enthusiast. The rescuer then put it in the capable hands of the architect Guy Ribadeau Dumas and the marine joiner Raymond Labbe, who together in 1992 would resurrect the pirate cutter *Le Renard*. Thanks to the exact original plans, provided by the National Maritime Museum in London, *Oiseau-de-Feu* is very close to the 1936 original. Most of the original teak and mahogany of the long, narrow, 67-foot-3-inch (20.7-m) hull was able to be restored. As fast, easy to handle, and high-performing as ever, *Oiseau-de-Feu* is once again flying in the blue sky of La Trinité-sur-Mer, its home port, majestically unfurling its 263 square yards (220 m²) of white wings.

SAINT PETERSBURG. A RUSSIAN HODGEPODGE.
CONTAINERSHIPS, CRANES, AND SHIPS LEAVING PORT.

Along with Karelia and Kaliningrad, Saint Petersburg is one of three Russian ports on European seas and one of the only ports connecting the world's largest country to sea-lanes. Because the exportation of raw materials is the principal source of revenue for this port, its efficiency and overall appeal are of primary importance to Russia. The coming entry of Latvia, Lithuania, Estonia, and Poland into the European Union will facilitate the circulation of goods and merchandise through the Baltic Sea. The Baltic—with fifty cities with populations of over 100,000 and eighty ports—serves an internal market of potentially more than 230 million consumers, and the region promises to become a trade area of the first order. Saint Petersburg has taken up the challenge, modernizing its port equipment and doing its best to remain open all year long, so as to secure its place on the great merry-go-round of Baltic riches.

SAINT PETERSBURG IN THE WEE HOURS. THE GLISTENING GOLD OF THIS VENICE OF THE NORTH.

Far off, the spire of the Admiralty shimmers along with its dome of red, blue, and gold. In 1703, when Peter the Great decided to make Saint Petersburg his imperial capital, the region was nothing more than swamplands infested with mosquitoes. He ordered the construction of the first fortress to be on Zayachy Island at the mouth of the Neva River, then oversaw the draining of the swamp and commissioned Europe's best architects to build palaces and barracks. Twenty-five years later, the river delta was tamed and forty thousand people lived in the city that controlled 90 percent of the country's international trade. A radiant city modeled on Western courts was born, and the czar had attained his dream of transforming Saint Petersburg into a cultured, elegant European metropolis. Three hundred years later, the former Leningrad is home to 5 million people. With its six bridges, nineteen islands, hundreds of canals, lakes, and countless palaces, Saint Petersburg retains both the charm and splendor of Peter the Great's vision, and the access to the sea he sought.

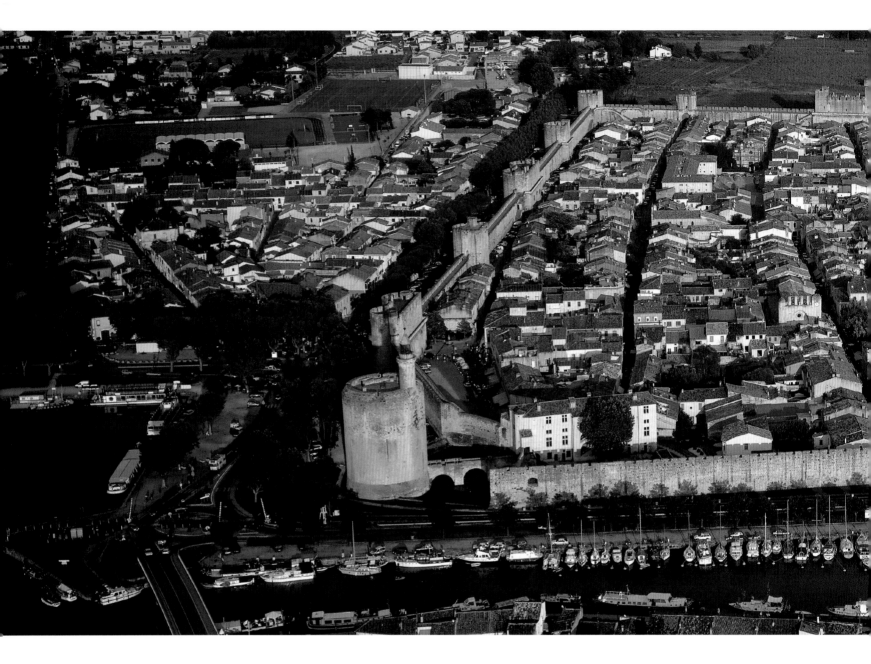

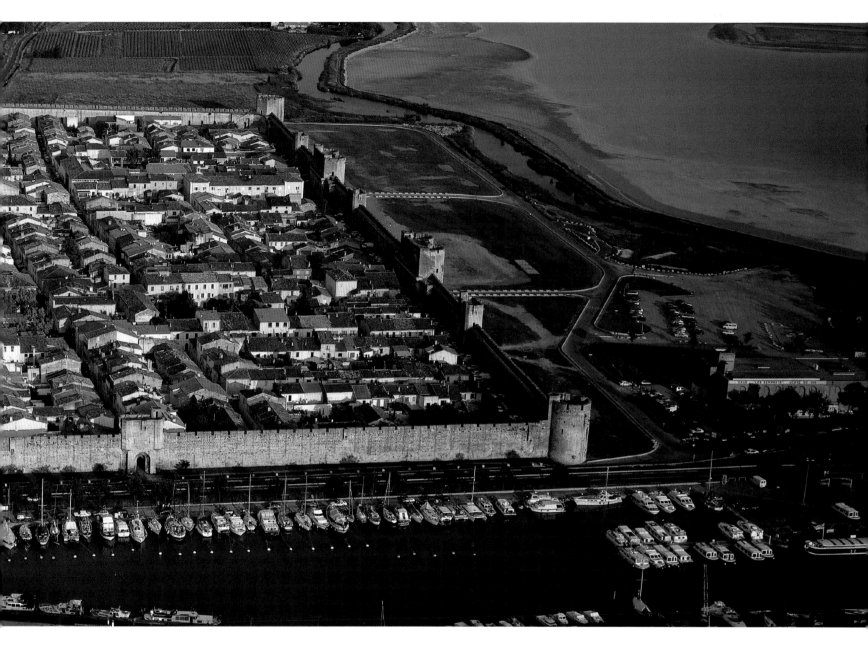

AIGUES-MORTES. THE CITADEL DEEP IN THE CAMARGUE REFLECTS THE LIGHT OF ITS GLORIOUS PAST.

This fortified quadrangle that seems to want to escape from the land has had a troubled past. Aigues-Mortes, the beautiful citadel, draws its name from the "dead waters," the lagoons and marshlands that surround it. In the thirteenth century, the city of Saint Louis, near the southern coast of France, decided to construct a port in this area in order to open a route to the Mediterranean, as Marseille was then in enemy hands. The salt from the salt marshes, a great source of wealth during that period, led to the settling of these fairly inhospitable lands. Canals and seawalls were built in order to create access to the Mediterranean, which did not touch this region. Today, Aigues-Mortes retains a certain elegance and grandeur and is eternally anchored in the Mediterranean, that sea it adopted as its own. The Constance Tower stands out in the foreground, which in other times was home to the misery of illustrious prisoners—notably Protestant women—whose dungeons were rife with disease, humidity, and cold. Embedded in the earth of the Camargue, it breathes the salty sea winds and its boats lie in perfect alignment, further proof of this town's desire to leave behind its swamps and search for open waters.

MIAMI BEACH, FLORIDA, UNITED STATES. A FLOTILLA OF COLORED SAILS
COMPETES WITH THE SERENE LINE OF THE HORIZON.

Under the unchanging skies of Florida, where the coconut palms sway in the breeze, the white-hot sand of
Miami Beach welcomes vacationers and those who devote themselves to beach sports. This is the middle of
winter. Miami the city and Miami Beach are quite different places. The first, located inland, is a cosmopolitan
city with a Latin-American accent. The second, located on the coast, is filled with hotels and vacation apart-
ments. Its famous Art-Déco quarter, which has been largely restored, gives one an idea of what the city had
been at the beginning of the twentieth century. The mauve, yellow, and light-green facades complement the
deep blue of the ocean, just as the brightly colored sails of the windsurfer flotilla contrast with the dark blue
of the horizon.

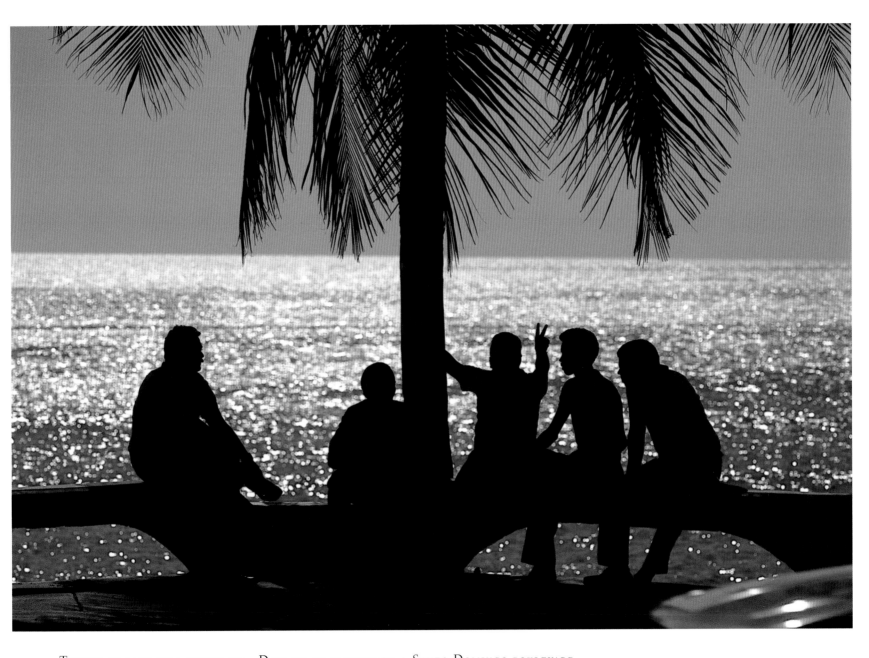

Taking it easy on a silver sea. Days go by slowly on a Santo Domingo boulevard.

Every evening, Santo Domingo's seashore comes to life. Groups gather beneath the palms, and dance music and Spanish-accented laughter ricochet over the Caribbean Sea. This expression of joie de vivre continues every night until two or three in the morning. Guitars appear from cars and couples sway to the rhythms of the merengues. On the island of Hispaniola, this Caribbean giant "discovered" by Christopher Columbus in 1492, both the culture and physical characteristics have been passed down from European conquistadores and African slaves alike. The Arawaks, who were native to the island, were killed off by the Spanish who founded their first colony in the New World on this fertile land rich with reserves of nickel, gold, and silver. Since 1697, this island neighbor of Cuba and Puerto Rico has been divided into two sectors: Haiti and the Dominican Republic, which, after an extended period of French rule, gained its independence in 1844.

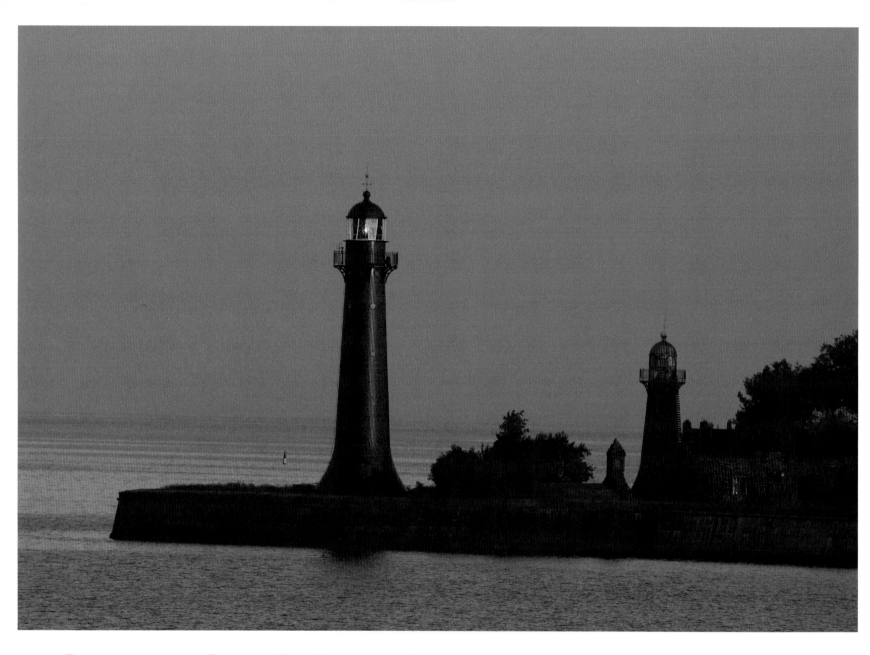

THE LIGHTHOUSE OF THE FORBIDDEN CITY. RED ON RED, IN RUSSIA, EVERYTHING MOVES.

This small lighthouse watching over the Gulf of Finland is not far from a somewhat unusual port—Kronshtadt on the island of Kotlin. Situated some 12.5 miles (20 km) west of Saint Petersburg, this city was closed off to foreigners until 1996. A strategic base under tight surveillance, the vanguard of the Soviet fleet, Kronshtadt was a part of the military system inaugurated by Czar Peter the Great at the beginning of the eighteenth century. To protect the banks of the Neva River from the clutches of Sweden, he fortified the small island and barred entry to the bay with a ring of forts. Placed at a distance dictated by cannonball range, these forts were erected on small, artificial islands that were then equipped with artillery. Today, a dike links the abandoned ring, rejoining it with Kronshtadt, and while the harbor of Saint Petersburg is practically closed, the secret city is open to all.

THE SUN SETTING OVER JAPAN. A ZEN MOMENT.

Since the sixteenth century, the country of the Land of the Rising Sun has used the primary star as its emblem.
The flag of contemporary Japan contrasts a blood-red sun upon a white background. This symbol of sincerity and
passion is also a reflection of the privileged position of the Japanese archipelago, one of the first lands on Earth
to be touched each morning by the sun. The photographer created this image as an homage to this symbolism.
Purified to the extreme, it expresses the wonder of the traveler. The Japanese aesthetic—its gardens, houses,
martial arts, visual arts, cuisine—is deeply influenced by Zen thinking. It gives its due to absence and the purity
of line. "The search for knowledge is a daily accumulation; wisdom, a subtraction," states this philosophy born
of Indian Buddhism and Chinese Taoism. An invitation to simplicity and meditation.

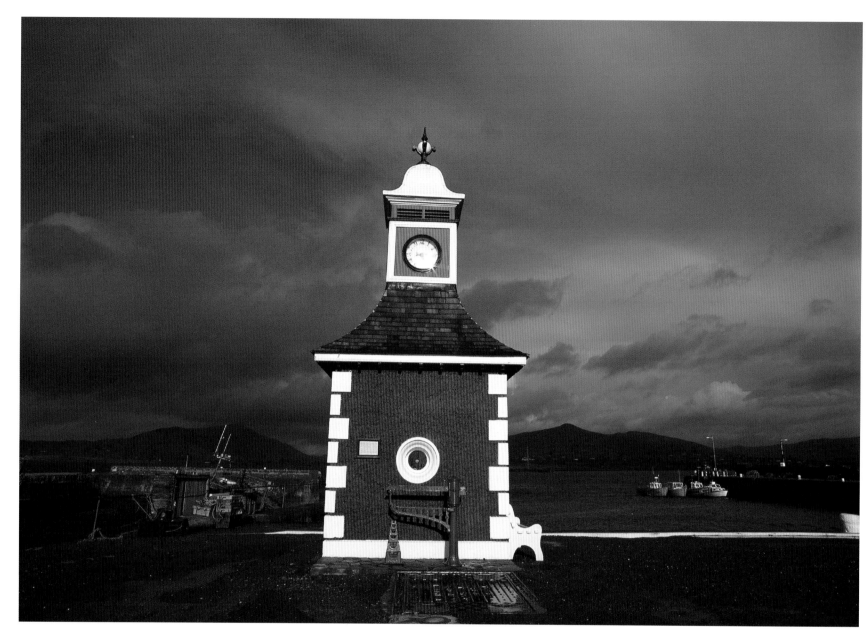

IRELAND. A SMALL PORT ON VALENCIA ISLAND.
THE HEAVY SKY SUMMONS THE BOATS BACK BEHIND THE JETTY.

The colors of the boats lined up in the shelter of the port are reflected in the facades of the adjacent houses—white, red, green, orange. The birds turn silent and seek the same calm waters as the sailors, the last of the light illuminates the stones—the storm is not far off. Here on Valencia Island, the animals live side by side with the people, and it is not unusual to have to wait for a flock of sheep to cross some narrow road because they are determined to graze on the other side. The landscape is rocky and sparse, and it's easy to imagine the difficulties people endured in the past. This little temple built on the dock and dedicated to sailors, is a testament to the fervor of those who conquered these hills scarred by the elements, these hopelessly steep, verdant spaces, and this terribly harsh climate.

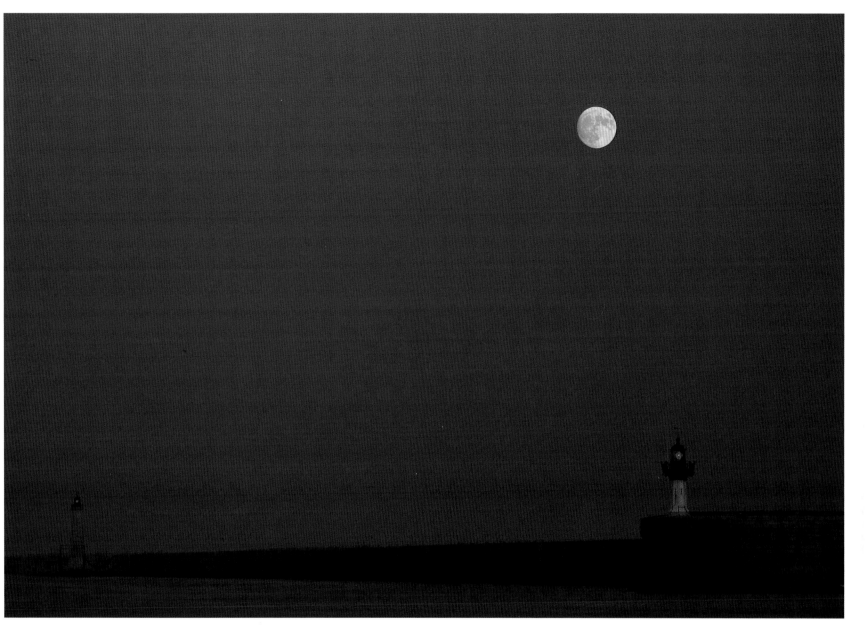

THE ENTRY OF THE PORT OF SÈTE. FIRST FOLLOW THE LIGHTS, THEN THE MOON.

The beacons compete with the bright light of the moon during this captivating night in the port of Sète. Between the marshes of Thau and the *Mare Nostrum*, this city appears to have been born from the wrath of Neptune. The original town, built on the banks of the "gulf" of Thau, would have been subsumed by the floodtides during a storm without some sort of protection. Perhaps this explains the odd mountain at the mouth of the bay, a giant cetacean seemingly placed there by the sea god. Closed off by this odd mountain, the gulf would have transformed itself into a lake. In the shadow of the new hillside first baptized Mount Setius, then called Cette and finally Sète, a village was founded. Today, it is the second most important French Mediterranean port, and the place from where ferries leave for the Moroccan port of Tangier. Merchant ships make it a port of call and fishermen are loyal visitors, even at night, when they go after lampreys. During these long watches, occasionally a "moon sardine" is caught having surfaced from the depths on a moonlit night, which shines an incomparable green.

JAPAN. FISHING IN TOKYO BAY.

On this volcanic black sand beach on the stretch between Tokyo and Chiba, all eyes look toward the blue sea. A cluster of pigeons arrives to ponder the ocean. A woman in a straw hat—her two gray dogs, still as statues, at her side—observe the comings and goings of the waves as they lap onto the beach. At any rate, she is not looking at the man fishing a little farther down on the shore; this fisherman dressed all in white who casts his line with the hopes of reeling it in just as fast. One thing is certain, the impatient spectators are wondering what will come from the fishing, as this bay abounds in fish. *Haze* (goby), *suzuki* (bass), and *shako* (slipper lob-sters) fill these seas, not to mention *anago*, the eels that are so popular here. But to catch those, the fishermen must use many lures and traps as the eels only venture out of their refuges at night. This simple scene of rod-fishing contrasts sharply with the enormous Japanese ship-factories that cut across the Pacific Ocean.

ON THE BEACHES OF BRITTANY, A GRIM CATCH AFTER THE *ERIKA*.
THE WORLD HAS GONE MAD, THE BIRDS ARE DYING.

December 12, 1999. At six o'clock in the morning, the regional rescue and maritime safety center (CROSS) in Etel received a distress call from the Maltese cargo vessel *Erika*. It was 30 miles (50 km) off the point of Penmarc'h, south of Finistère, in a violent storm. The twenty-six crew members were evacuated, the tug *Abeille Flandre* was dispatched to the area, but nothing could be done to prevent the 590-foot (180-m) oil tanker from splitting in two, sinking, and spewing some 20,000 tons of fuel oil. It was the start of a black winter for the Atlantic coast. How could such an accident occur despite all the precautions taken following the dozens of ship-wrecks and black tides of the previous thirty years? The worst of these incidents occur because 40 percent of the commercial vessels sailing the oceans are dilapidated, poorly maintained, overloaded, or managed by over-worked or poorly trained crews.

LIGHT BREEZE. CORMORANT FLYING OVERHEAD AT CLOSE OF DAY.

This is how birds see from above as they glide effortlessly on the ocean breezes. They study the surface of the water, spotting in the glints of the ripples the silver flash of the fish that will inspire a nosedive. The cormorant, like all sea birds, is an excellent fisher. An accomplished deep-sea diver, it can pursue its prey underwater for more than two minutes, and dive several dozen yards beneath the surface to catch it. In fishing villages in Asia, the people take advantage of this great bird, with its wingspan of 31 ¹/₂ in. (80 cm) and its coal-gray plumage, sometimes domesticating it. When the cormorant resurfaces after its dive, the fisherman—having taken care earlier to tie a loop around its neck to keep it from swallowing its catch—brings the bird back by means of a cord, and takes the quivering booty from its beak.

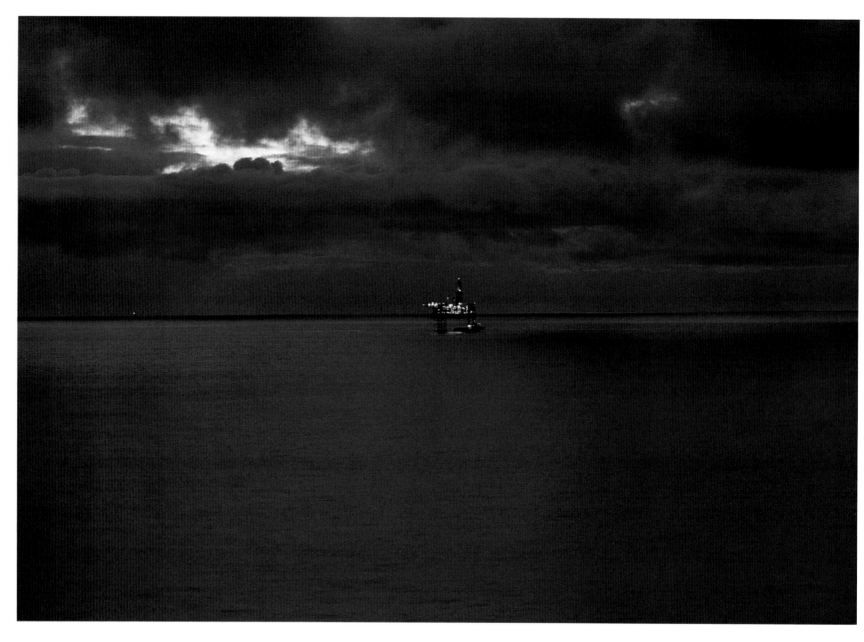

The North Sea. An unusually calm winter day
on a drilling platform halfway between Norway and Scotland.

The first offshore drilling platforms, the marine descendants of the derricks on land that were erected beginning
in 1859 in Pennsylvania, appeared a century later. In 1947, the first borehole—sunk to a depth of 16 feet (5 m)
just off the Louisiana coast—launched the age of offshore oil drilling in order to meet humanity's growing needs,
which has since increased sevenfold. The so-called black gold is found in subterranean layers that spread off
the shores of California, Venezuela, and Alaska, in the Gulf of Mexico, the Caspian Sea, the North Sea, and
especially in the Persian Gulf, which contains more than 60 percent of the known underwater reserves. Some
two hundred platforms directly above these deposits presently supply 30 percent of the world's oil production.
A deposit can be exploited for about twenty years, during which time the pumping ceases only in the case of a
violent storm. Since 1988, all installations in the northeast Atlantic are required to be dismantled once opera-
tions have closed down.

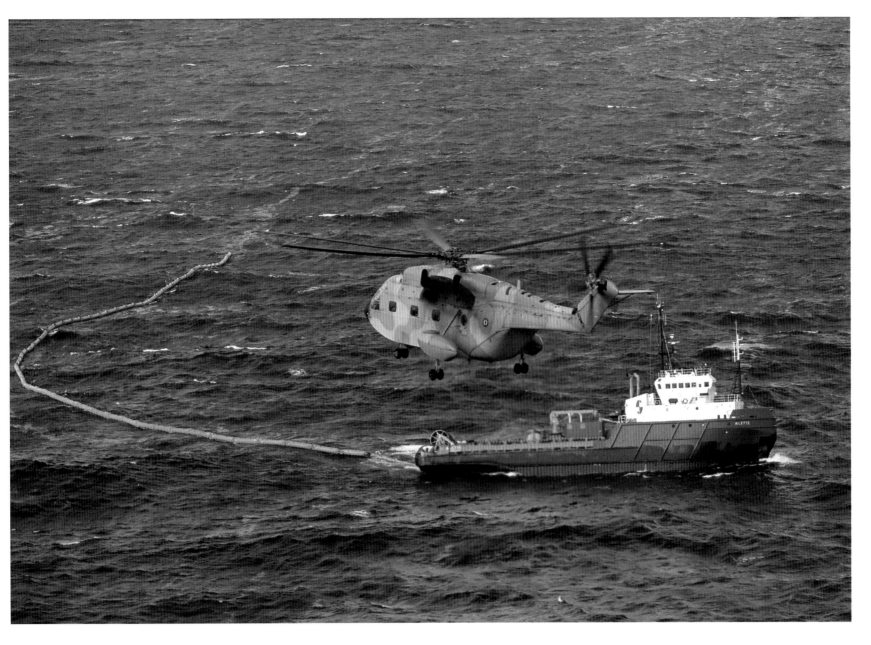

BRITTANY. A SUPER FRELON HELICOPTER ASSISTS IN THE PLACING
OF A FILTRATION BARRIER AFTER THE SINKING OF THE ERIKA.

On December 12, 1999, having left port in Dunkirk and headed to Liguria in Italy, the oil tanker *Erika* became shipwrecked off
the coast of Finistère. On December 13, this 395-foot (120-m) vessel carrying 50,000 tons of heavy fuel oil, sailing under the
Maltese flag and leased by Total, broke in two and sank to the 395-foot (120-m) depths of the ocean 35 nautical miles (40 mi/
65 km) off the Penmarc'h point. In the interim, the crew was evacuated thanks to the French Naval Air Corps and its Lynx and
Super Frelon helicopters, and two Sea King helicopters from the United Kingdom's Royal Navy. With the wind gusting from
45 to 55 miles per hour (70 to 90 kph), the mission was not simple; *Erika* rose and fell perilously with the waves and its crew
of twenty-six grew impatient with the diver responsible for the winch. All the men were rescued. The high-seas tugboat *Abeille
Flandre* arrived on the scene and attempted to tow the wreck to shore, but despite all its efforts to keep the aft portion of the
tanker level, it went under. Filtration barriers were then set in place to try to limit the pollution. Despite these efforts a storm
dispersed the chain of oil slick that had leaked from the hull, and the blanket of fuel eventually came to rest along the coast.

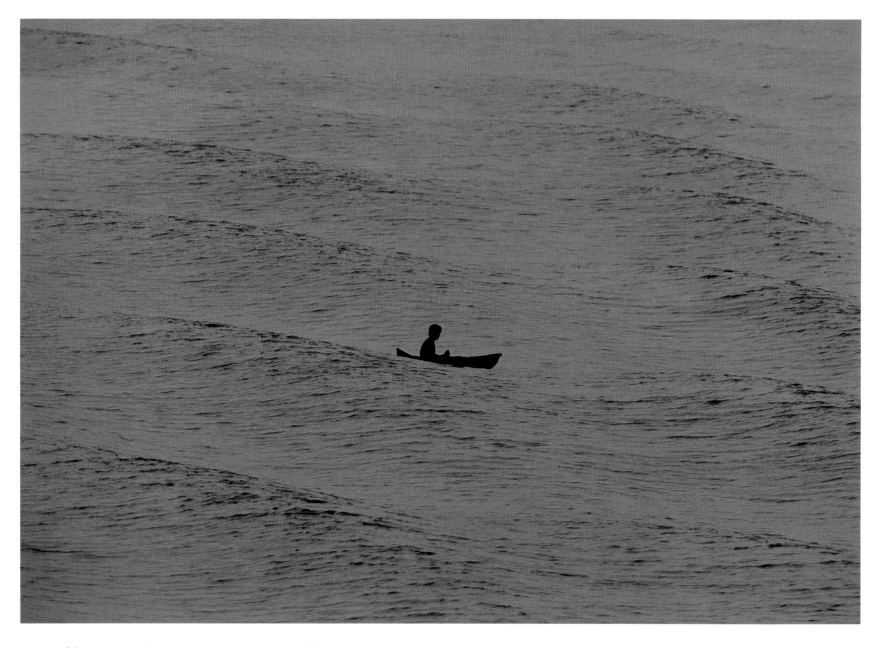

VENEZUELA. A YOUNG FISHERMAN IN THE ORINOCO DELTA.

The Orinoco crosses Venezuela for 1,250 miles (2,000 km) before pouring into the Atlantic Ocean, where it sprawls over some 220 miles (350 km) of coastline in the vast Amacuro delta. This landscape of swamps, mangroves, and lush forests covers almost 10,000 square miles (25,000 km²), and conceals a tracery of canals along which live almost twenty thousand Waraos Indians, masters of the pirogue. These low, small, delicate boats slip into the crowded labyrinth of the canals; handling them is child's play for the Waraos who, from earliest age, spend time in the waves created by the wake of the freighters that sail upriver. The appearance of the river deltas depends upon the continental plateau—the transitional zone between the land above the water's surface and the deep-sea bottoms. When the plateau is narrow and sheer, the rivers cannot deposit the sediment they carry downstream. In this case, the sea moves inland, in a deep, wide-mouthed gulf like the estuary of the Loire or the St. Lawrence. When the continental plateau is wide and gently sloped, the sediment accumulates, so that the river flows out in branches, forming a delta, such as the Ganges, Mekong, and Orinoco.

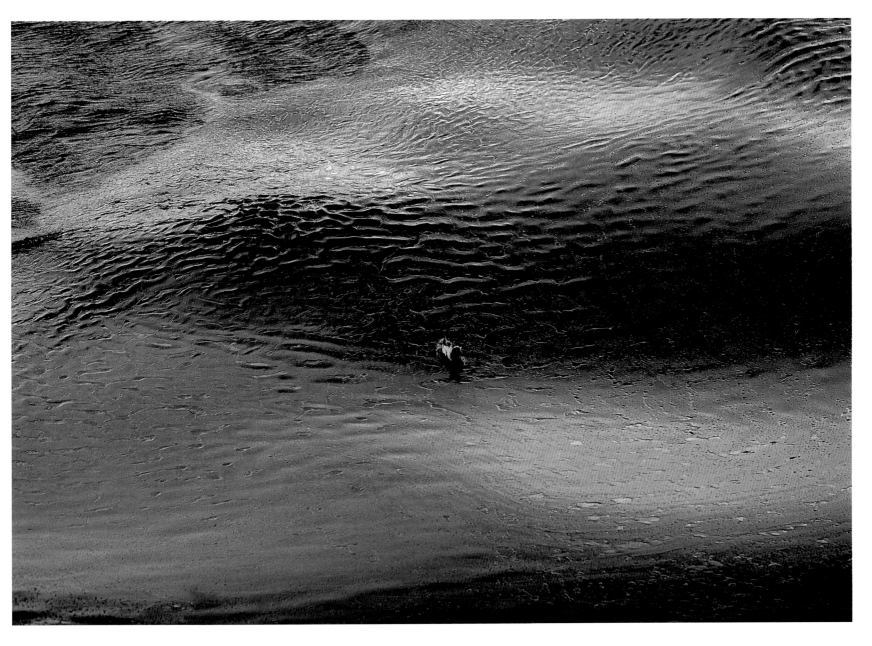

OIL SPILL. ON DECEMBER 20, 1999, THE FIRST SHEETS OF OIL LEAKING FROM THE *ERIKA'S*
TANKS WASHED TOWARD BELLE-ÎLE. THIS GANNET'S EYES ARE SENDING OUT AN SOS.

On December 12, 1999, the *Erika* broke in half and sank off Penmarc'h. Its 20,000 tons of heavy fuel oil covered
250 miles (400 km) of coastline, from southern Finstère to Charente-Maritime. A few months later, TotalFinaElf
spent more than $86.25 million (75 million euros) to pump out the 15,000 tons remaining in the *Erika's* hold,
650 feet (200 m) down; but the damage was done. The largest of the some 7,000 ocean-going tankers carry
300,000 tons of crude. In order to avoid such catastrophic oil spills in the future, these ships will—or are sup-
posed to—be equipped with double hulls beginning in 2015. This measure is also supposed to limit the number
of substandard and dangerous vessels, but perhaps the issue of flags of convenience should be addressed, along
with the negligence they license. After the *Erika's* damaging flood, 64,000 oil-covered birds were handled on
French beaches, while estimates put the number of birds affected at between 100,000 and 300,000. This gannet
must be wondering if human beings really are the most evolved of species.

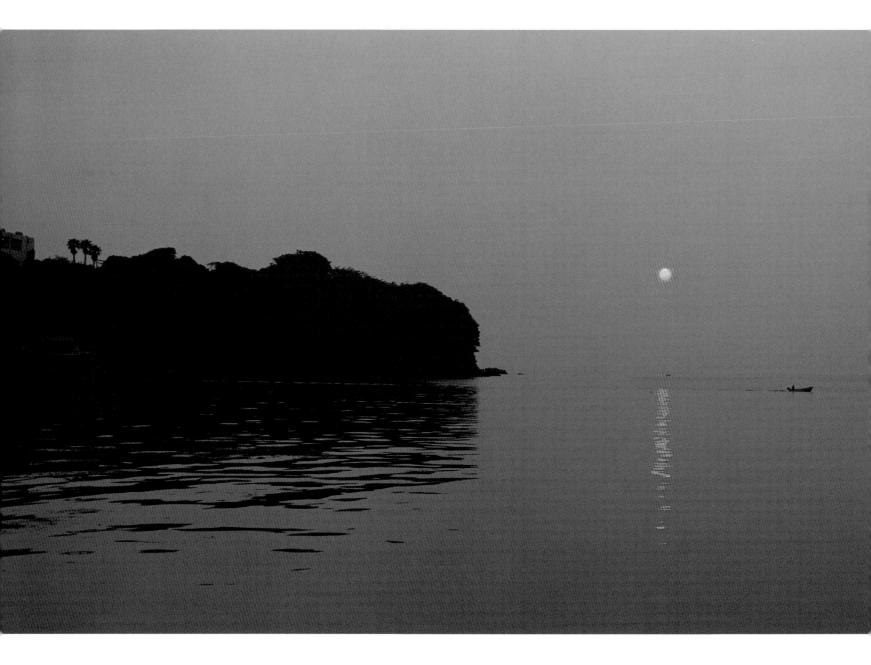

JAPAN. SUNSET IN THE LAND OF THE RISING SUN.

The sun frozen over Tokyo Bay. The sea is slack, its smooth surface merging with that of the sky. Nothing seems to disturb this timeless seascape. In the distance, the silhouette of a tiny fishing boat glides in the calm waters. Tokyo Bay, also called Tokyo-Wan, is extremely sheltered. A small, interior sea, it is almost closed off by the Boso and Miura peninsulas, but does open onto the vast Pacific Ocean. Thanks to this privileged geographical circumstance, the bay is protected from the tsunamis that hit Japan's coasts from time to time. Three large cities have been built on the coast of this bay: Tokyo, the capital, Kawasaki, and Yokohama. Today, these urban centers essentially form one vast city. The intense traffic of these three ports also merges into one, making this bay the largest industrial zone in the world. What an extraordinary contrast to this solitary red sun suspended over an immaculate seascape, which recalls both a Japanese print and the flag of the Land of the Rising Sun.

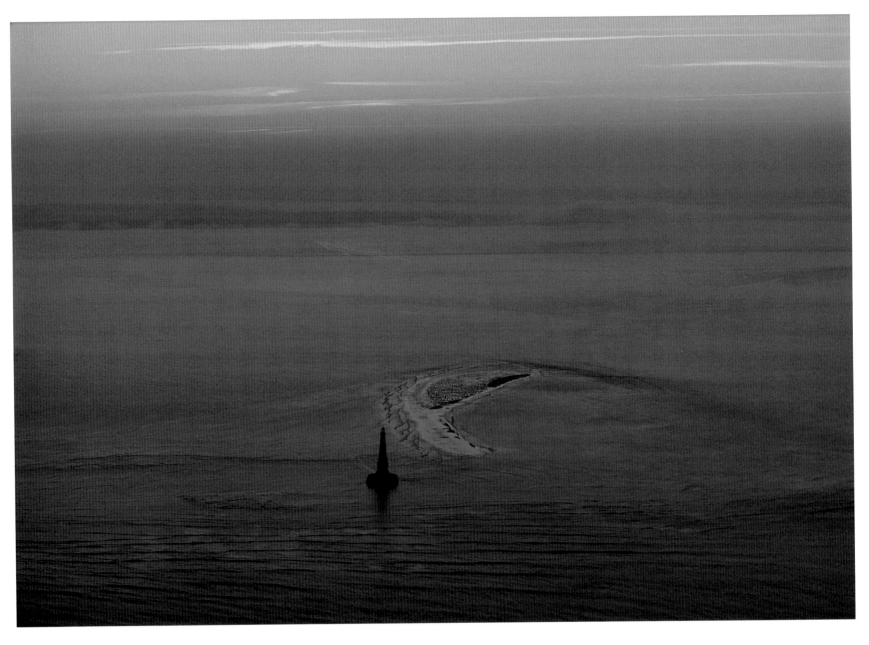

THE KING OF LIGHTHOUSES. CORDOUAN, AT THE MOUTH OF THE GIRONDE.

Dry land poses a greater threat to sailors than the sea. Attempts have always been made to avoid the dangers of sandbars, currents, and rocks. For example, a hermit once maintained a flame atop a precarious tower that was built beginning in 1360 on orders of the Black Prince, so as to guide ships as they entered the shallow mouth of the Gironde. In 1584, Louis de Foix began rebuilding the original Cordouan tower, which was gradually transformed into an elaborate Baroque monument. The addition of a lighthouse in 1789, crowning a third story built in 1611, raised the tower to some 220 feet (68 m). Cordouan, symbolizing the authority of king and church, comprises royal apartments and a chapel. But the presence of a keeper is not enough to check the deterioration of the sumptuous decorations and marquetries that cover the building's interior. France's oldest functioning lighthouse is also the only one to be classified a historical monument, in 1862 (the same year as the Notre-Dame de Paris). Even though it never actually housed any royalty, it is still known as the king of lighthouses.

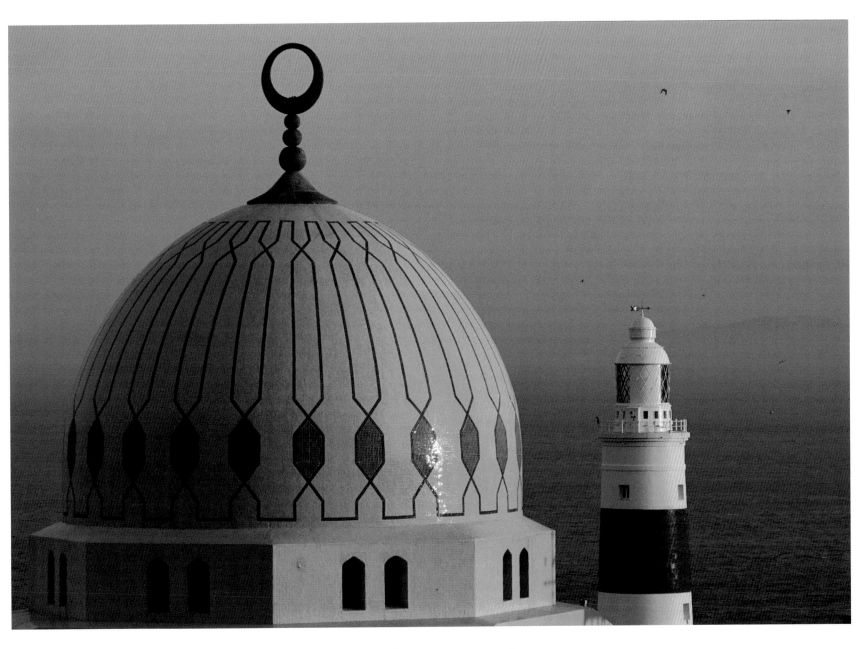

GIBRALTAR. THE EUROPA POINT LIGHTHOUSE, BUILT IN 1841, IS TODAY IN A BRITISH COLONY.

The Europa Point lighthouse is the last of the 250 lighthouses that make up the Atlantic arc. Europe's shining shield against the storms rising on the American coasts, the line of lighthouses extends over 1,750 miles (2,800 km), from Scotland's Shetland Islands in the north to the Rock of Gibraltar at Spain's southernmost point. Gibraltar's 27,000 residents, subjects of the British crown since 1713, are crowded into 2.25 square miles (6 km²) at the foot of the famous stone sentry that watches over the 9 miles (15 km) of the Strait of Gibraltar. This is where the Mediterranean, an almost inland sea 3,125 miles (5,000 km) long, ends, opening to the Atlantic at this narrow neck. This is where Europe ends, too, as this mosque reminds us. Across the strait, just a short distance away, is Africa. And it's getting nearer: beneath the Mediterranean, the plate that carries the African continent plunges below the Eurasian plate, bringing Africa about an inch (2 cm) closer to Europe every year. In 50 million years, the Mediterranean will be gone.

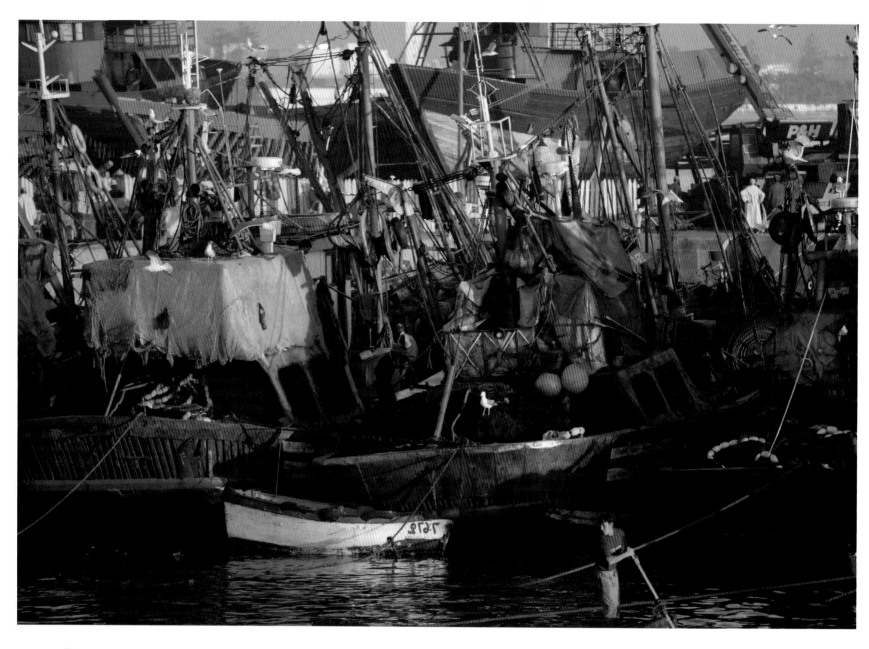

THE MAGIC OF A PORT—A MYSTERIOUS BEEHIVE OF ACTIVITY AND CHAOS TO THE UNINITIATED.

The boats are dry-docked; new ones being built, old ones repaired. And typical of all ports the world over, a tight crowd gathers. Here in Morocco, the commercial fishing industry is rather developed, comprising some twelve thousand boats that sail the Atlantic and Mediterranean coasts. Each day, the ports are replenished with conger eel, dorado, pollack, and whiting. Crabs and other crustaceans are also sold (through fierce bargaining) to the fishmongers waiting on the docks. The large-volume trawlers and seining vessels supply the fresh markets, the processing factories, and the canneries. The largest producer of fish in Africa, Morocco is also the world's principal exporter of sardines. Four hundred thousand people work in its fishing industry, which is responsible for 56 percent of the country's food exports.

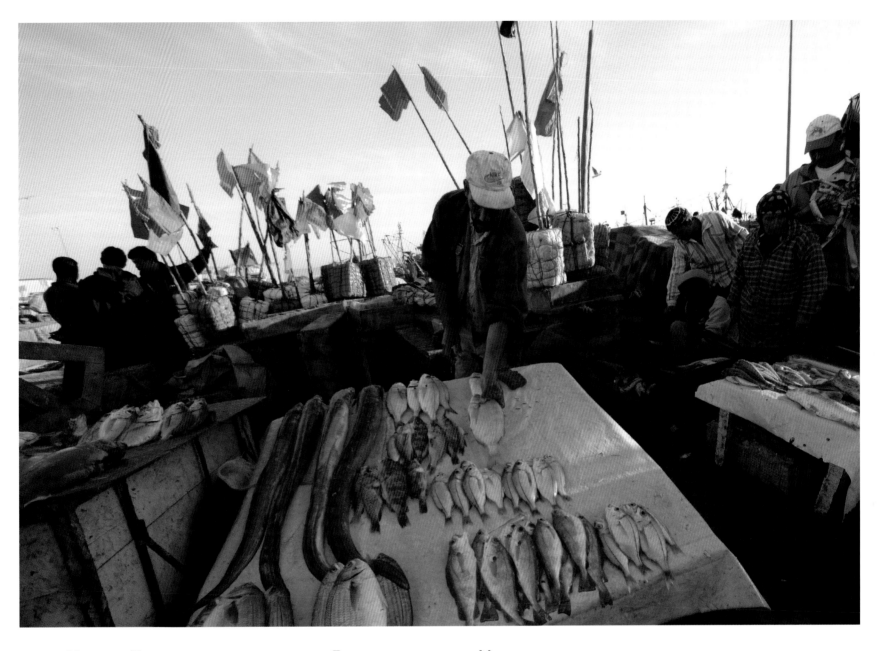

Morocco. The fish market in the port of Essaouira, the former Mogador.

With the early morning arrival of the fish, the fortified port of Essaouira awakens and its souk comes to life.
Regulars crowd around the stalls bargaining over the doradoes, bass, and sardines that have just been off-loaded
from the boats. With its 93 miles (150 km) of coastline, its cold currents, and its waters filled with fish, the
province of Essaouira has become the third-largest fishing region in Morocco. While Essaouira's two jetties are
home to many trawlers, sardine fishing boats, and long-liners, the port remains, by and large, a landing for small
fisherman, with room for over five hundred boats to tie up. For a number of years, the area has ranked first in
the world for sardine production, but in recent years the fishing fleet (primarily small-scale) has been unable to
broaden its scope and its production. Once night falls, the fishermen venture out into the sea. Sometimes, it is
the phosphorescence of the plankton that leads them to those coveted schools of fish, because they know that
starting at dawn, when they might want to start fishing, the docks will be bustling.

CASABLANCA THE WHITE. BENEATH THE TALLEST MINARET IN AFRICA,
SATELLITE DISHES CAPTURE THE VOICES OF THE STARS.

Every morning, the residents of Casablanca awaken to the muezzin's call to prayer. The praises to Allah and
Mohammed, the prophet of the medina, rain down upon this beacon city of Morocco. A little later, televisions
will be turned on in the block houses. The dish antennae that have flourished at the feet of the mosques will
capture the voices of the stars and sing in the thousand languages of the world. Indigenous Moroccan culture,
Islamic tradition, and modernity speak in familiar terms with one another on the streets of "Casa." The most
prosperous city in the country, it is home to 60 percent of the Morocco's private enterprise and is responsible
for 30 percent of its electricity consumption. Its port, protected by the seemingly interminable 1 3/4-mile
(3-km) Mouley Youssef seawall, is the fourth-largest in Africa, and its airport one of the busiest.

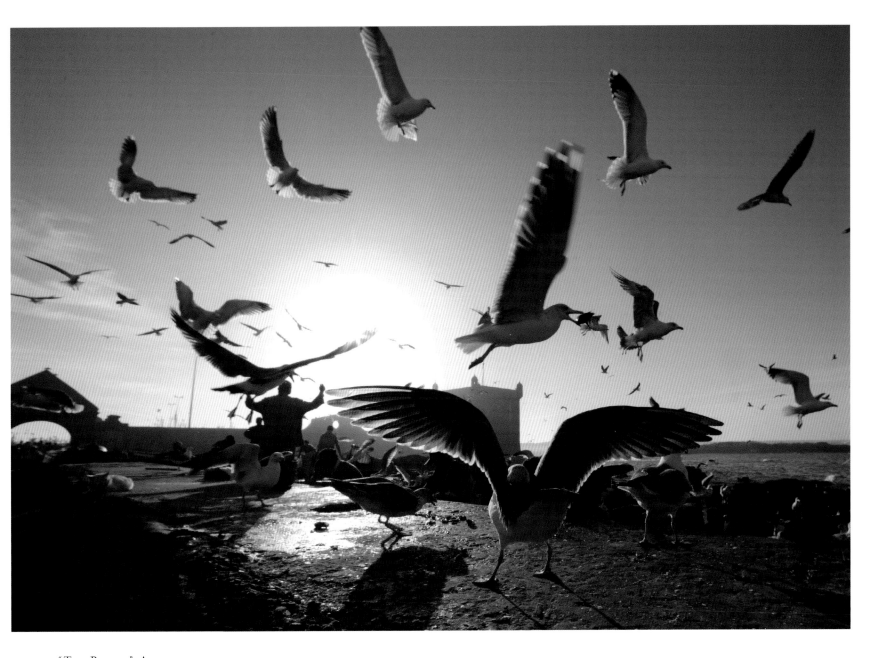

"THE BIRDS." A HURLY-BURLY OF FEATHERS AND SCALES AT THE FEET OF A FORTIFIED CITY.

Every evening, except for Sundays, this scene repeats itself beneath the ramparts of Essaouira. Gutting the fish, the fishermen serve the gulls a feast. To appreciate this squealing ballet, one must first walk through the medina, greeting the friendly artisans. In shops measuring about 3 feet by 6 feet (1 m by 2 m), under the watchful eye of an insect-eating lizard, they sell musk, amber, spices, and wholesome herbs. A perfumed blend that abuts the odors of the tanners' and carpet merchants' stalls. All calling to mind the atmosphere of ancient Mogador, that Portuguese colony through which convoys from sub-Saharan Africa laden with gold, salt, ivory, and ostrich feathers passed. The fortress that the sultan Sidi Mohammed ibn Abdallah commissioned in 1765 from a French architect accents the exoticism of the picturesque seaside Babel.

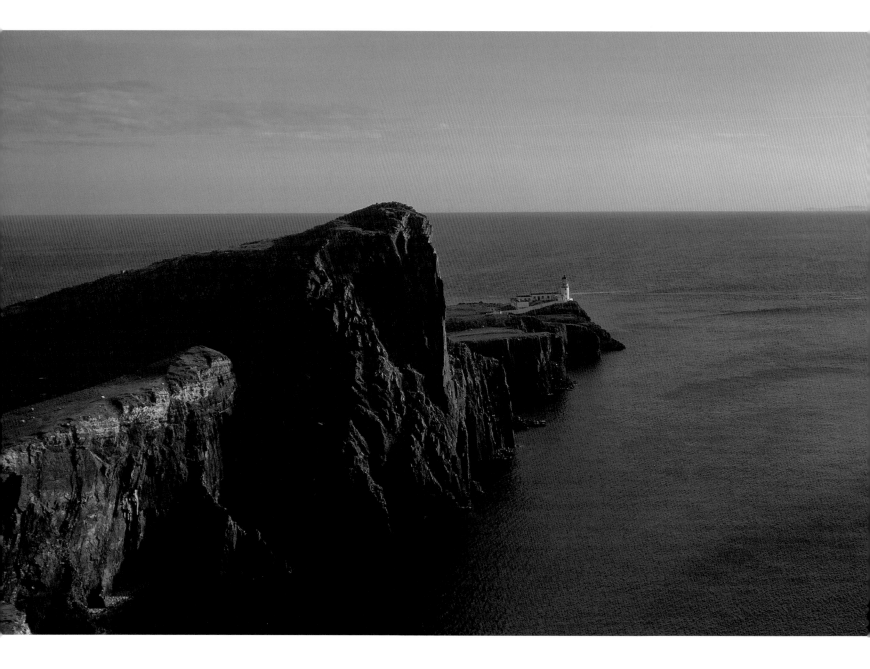

MEETING OF THE FIFTIETH PARALLELS. LIGHT, ROCK, AND HORIZON VIBRATE IN UNISON.

Earth often replicates its most beautiful scenery. With a little more open space, this peninsula stretching toward the distance, dotted with a white tower and dizzying rocks, could be the Cape of Good Hope. Or even Cape Reinga at the northern tip of New Zealand, or some points in Patagonia. It is, in fact, Neist Point, Scotland, and its lighthouse guards the straits separating the Inner and Outer Hebrides. Erected on the Isle of Skye, between the fifty-seventh and fifty-eighth parallels and charmingly named Northern Lights, it is one of sixty lighthouses on Scotland's Atlantic coast. The office in charge of the construction and maintenance of Scottish lighthouses and beacons has a difficult task keeping one of the least traveled sea-lanes in Europe lit.

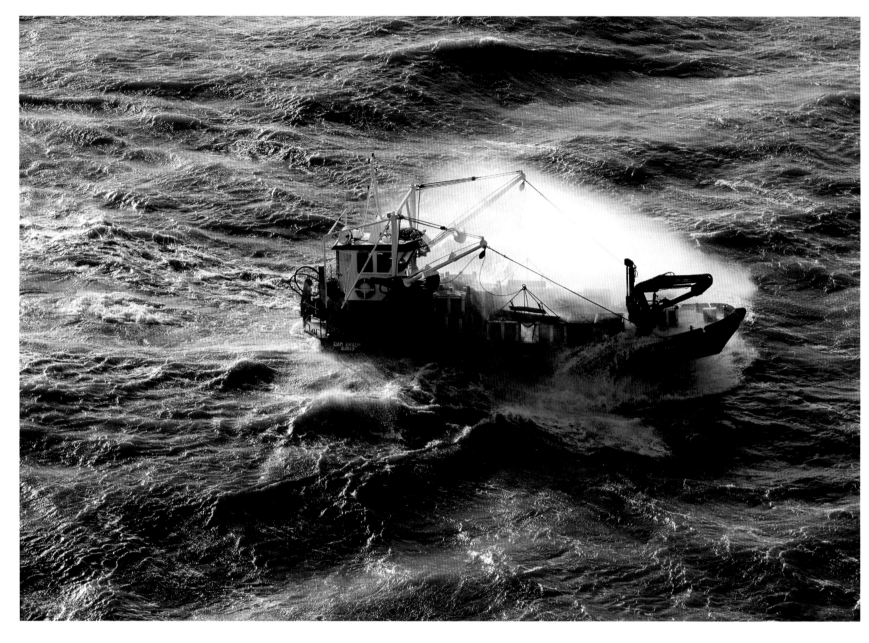

QUIBERON BAY. HERE, OYSTERS ARE RAISED UNDERWATER, WHICH MEANS OYSTER FARMERS HAVE
TO GO OVER THEIR OYSTER BEDS NO MATTER WHAT THE WEATHER.

Restrictive oyster farming requires as many people as in agriculture. A collection of spats, followed by the
growth and processing represents four years of painstaking care. Although well protected in their shell, oysters
aren't less sensitive to pollution, viruses, and parasites, and need close monitoring. These constraints are the same
in different areas of production: flat farming (on the ground) or raised (in a sack on 19 1/2-inch [50-centimeter]
tables), on floating rafts or again, like on Quiberon Bay, in the open seas. The oysters are then strewn directly
into depths between 33 and 49 feet (10 and 15 meters) and then brought back by dragnet. The sale of oysters
has a distinctive feature: 70 percent of the production is sold between December 20 and January 5. So the oyster
farmers of Quiberon must go drag anchor, depending on the water conditions, to respond to this peak in con-
sumption. On average a person in France takes great delight in 6 1/2 pounds (3 kilograms) of oysters a year
(13 pounds [6 kilograms] in oyster-farming areas).

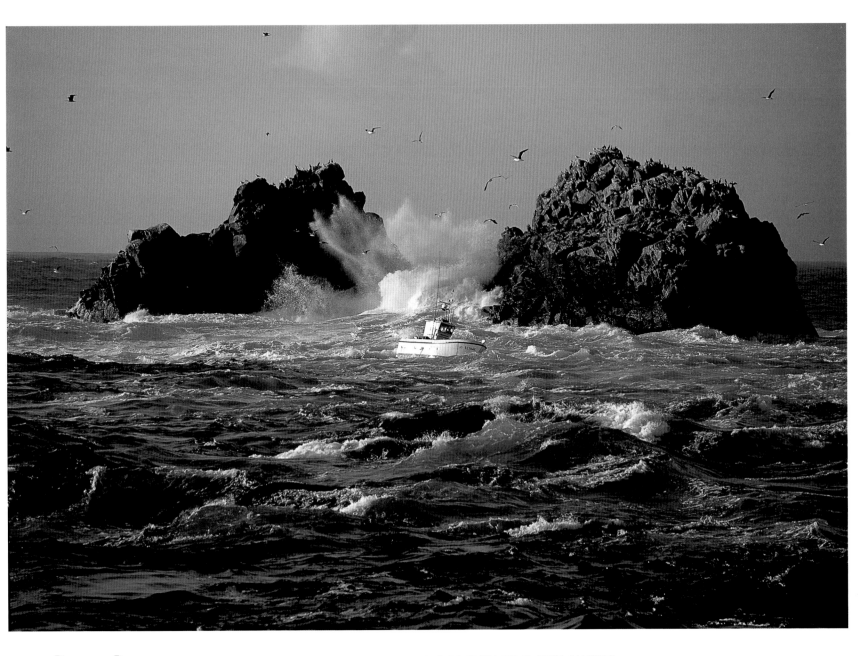

PLOGOFF. BASS FISHERMEN BRAVE THE MOST DANGEROUS CONDITIONS TO MAKE THEIR BEST CATCHES.

This brave fisherman's small boat is thrashing about in the eddies, a favorite place for wild bass. A few yards away, atop the merciless rocks, a group of cormorants and gulls watches, no doubt critical of the ways humans catch fish. With their variety, their weightless flight and acrobatic dives, strident cries and squawks, these birds fill seascapes with life and sound. Gannets, puffins, gulls, and cormorants exercise their talent for fishing from rocks and cliffs. Egrets, black-tailed godwits, oyster-catchers, and other long-legged shorebirds poke their long beaks into the mud of shores and marshes. The albatross, emblematic flier of the high seas, is an indefatigable long-distance traveler. It lands only to reproduce, then spreads its wings—whose span can reach 1 3 feet (4 m)— gliding for months at a time, skimming the water, and sleeping in the waves' troughs, undisturbed by storms.

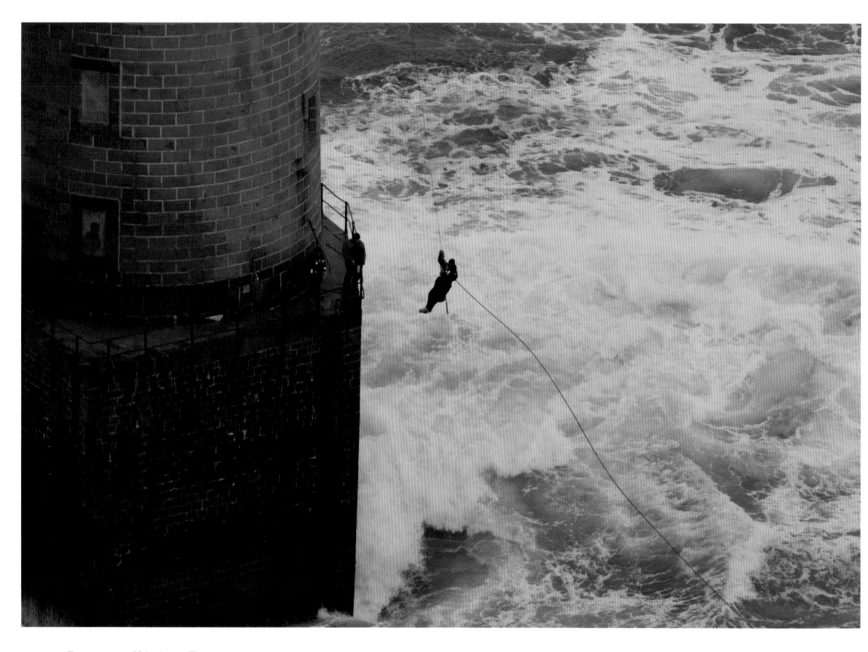

RELIEF AT KÉRÉON. FUNAMBULIST GUARDS TAKE FLIGHT.

In 1907, work began on the construction of a lighthouse on the fierce rocky coast of Finistère. Despite the difficulty and cost, the authorities decided to erect a tower on the reef, which could dispatch countless ships into the open waters. Hit by a wave when it was half finished, the structure was saved by a bequest. The descendant of a martyr of the French Revolution offered 600,000 francs to build the lighthouse on the condition that it would be named for Charles-Marie Le Dall de Kéréon, who had been guillotined in 1794. The beacon of these fierce rocks, baptized Kéréon, was first lit on October 25, 1916. Since then, the shoals of the beautiful region of Fromveur—the "great torrent," that mad current surrounding Ouessant—have been illuminated and overseen by two keepers of the high seas who are relieved every two weeks. No ship will crash against the rocks, the keepers make certain of that. Kéréon, nicknamed the "Palace" because of its magnificent interiors, is the last French lighthouse whose keepers are relieved "by winch" and one of the last lighthouses of the high seas that remains inhabited.

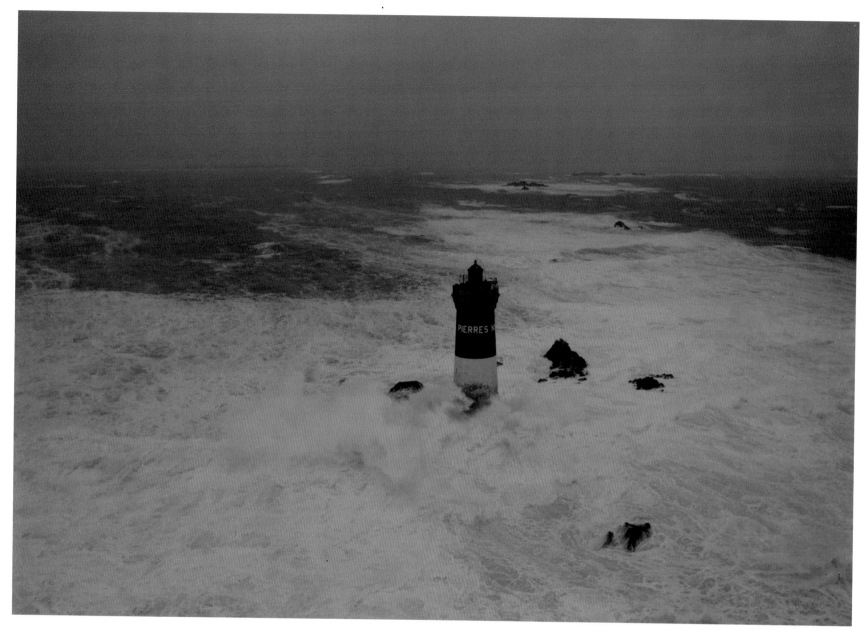

WHITE RAGE ON THE BLACK ROCKS. BETTER TO NAVIGATE FAR, FAR OFFSHORE.

To reach the Molène archipelago from the Pierres Noires channels in the south is not an easy thing. Even in fair weather, one must tack among the rocks, constantly making sure of one's points of reference—a white house with the Molène clock tower, a seamark with a buoy—and always keeping a close eye on the crosscurrents, some of which emerge from between the small islands, and can carry off a boat in the blink of an eye. Passing through here on a day when the sea is high is a dangerous proposition. Here, the swells rise over the base of the lighthouse and the surrounding embankment, breaking in thunderous crashes. It takes an extreme familiarity with one's boat to make it through this temperamental region. When the wind twists and turns, as in this photograph, navigating through the seaweed-ridden channel is out of the question. Calculating the red flashes from the lighthouse, the captain takes a fix on its blood-red tower, noting how it emerges from the waves, and then makes a wide tack off the turret.

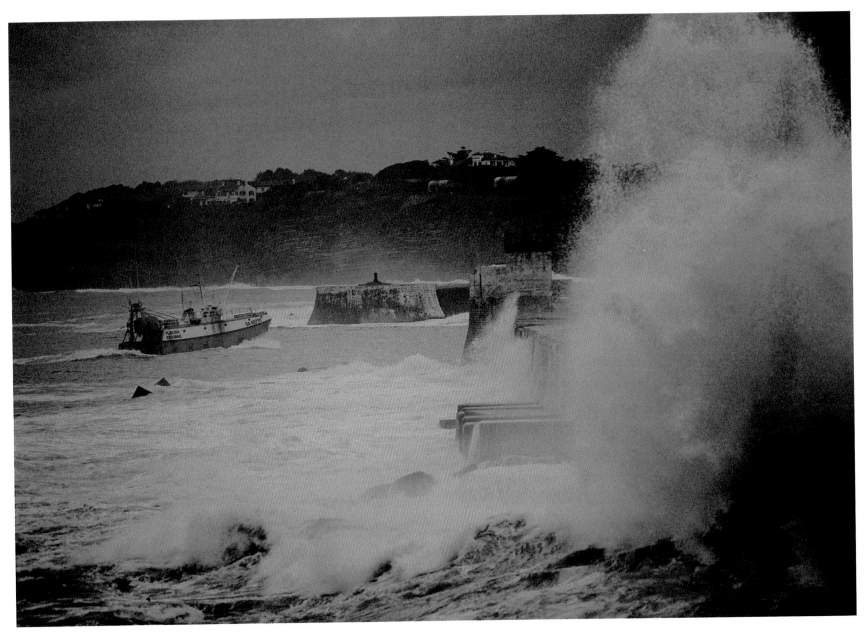

SAINT-JEAN-DE-LUZ. ON STORMY DAYS, THIS PASSAGE SEEMS NARROW
EVEN FOR THESE EXPERIENCED BASQUE SAILORS.

Fishing takes place in all kinds of weather. Day or night, calm or storm, the fishermen go out to fill their nets. Tossed about on the churning waters just before the passage, the master of a fishing boat skillfully takes his trawler back to safe harbor, beyond the breakwater where waves shatter in geysers of spray. On a day like this, the barometer, the instrument that measures the variation in atmospheric pressure—the weight of the air—is at its lowest point. When air pressure is low, the air rises and becomes colder, which creates clouds. A depression settles in, and bad weather with it. High pressure means that the air comes down and becomes warmer, and this chases the clouds away: if such an "anticyclone" appears, the weather will be fine. A barometer is an indispensable part of any sailor's toolkit. Nevertheless, no true sea dog would use one of these instruments without going, nose to the wind, to scan sea and sky to confirm its predictions.

UNITED KINGDOM. THE NEW EDDYSTONE LIGHTHOUSE OFF PLYMOUTH.

The most violent storm ever to strike Europe hit England during the night of December 7, 1703, and the Eddystone lighthouse, situated on an isolated rock off the coast of Plymouth, was literally swept away by the surging tides, becoming one of the first lighthouses to be lost at sea. In those days, the architecture of lighthouses was extremely intricate, replete with balconies, balustrades, turrets, and even inscriptions carved into the stone. *Pax in bello* (Peace in War) was inscribed on the walls of the Eddystone lighthouse. At the time of its construction, Louis XIV, who was then at war with England, had the opportunity to respond to these words engraved into the granite. In an act of great arrogance, a French corsair took the architects and builders of the lighthouse prisoner and presented them to the king, who duly punished them severely. Louis XIV then returned the prisoners, along with an array of offerings, declaring that he was not at war with humanity. Today, the appearance of the lighthouse is rather different from the past, as its summit is used as a landing pad for refueling helicopters.

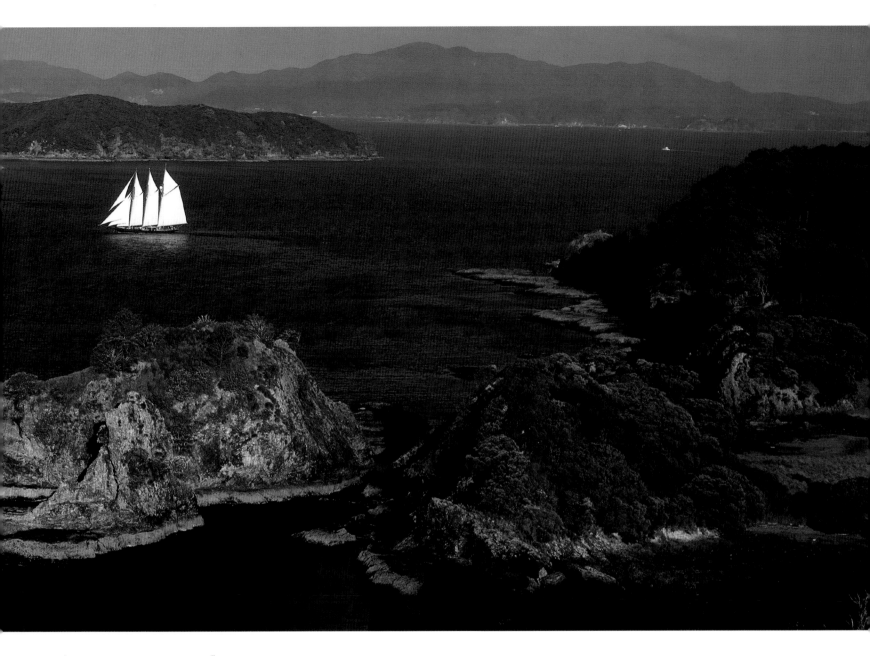

A VOYAGE BACK IN TIME. SAILING AROUND THE FORGOTTEN WORLD.

New Zealand was one of the last large, habitable landmasses to be colonized by man. First reached by Polynesian pirogues only a thousand years ago, it is among the most isolated areas in the temperate and subtropical zones of the world. Situated on a particularly active geological zone, this archipelago became detached from the Gondwana 80 million years ago, during the Age of Dinosaurs. This separation created a new territory containing a vast array of flora and fauna. The self-sufficiency protected species that were slowly becoming extinct on the rest of the planet. Their evolution progressing without outside influences, some of these species have survived to modern times. Thus, the kiwi, that astounding bird with no wings, along with parrots, plovers, insects, amphibians, freshwater fish, reptiles, and numerous endemic plant species make this territory a Noah's ark of a forgotten world.

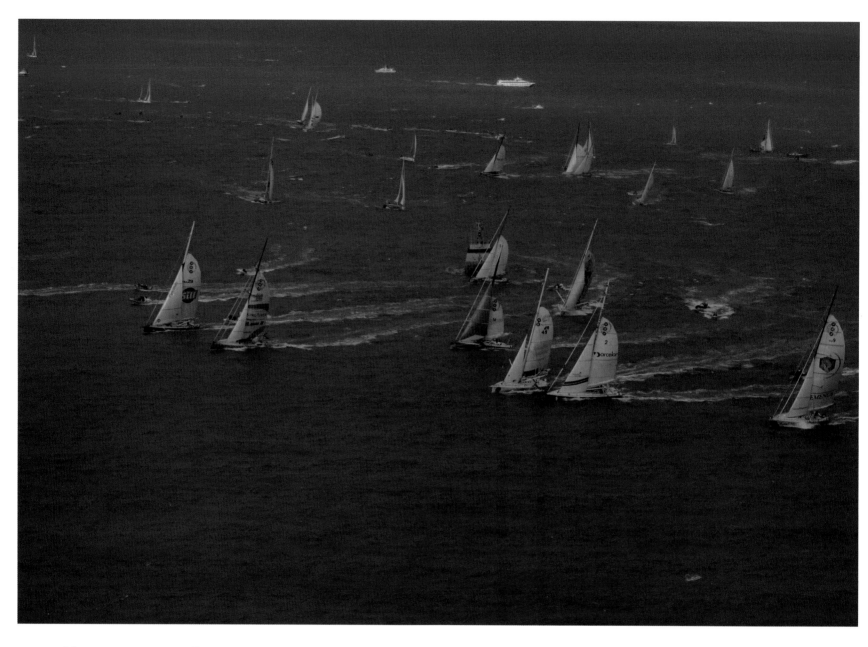

NOVEMBER 9, 2002: GREAT FANFARE AT THE SENDOFF OF THE ROUTE DU RHUM 2002.
THE ATLANTIC SETS UP RESISTANCE.

The mainsails are reefed and the jibs are furled. The wind blows, the forecasts are forbidding. Right from the start, the seventh running of the Route du Rhum lived up to its reputation—this exacting solo transatlantic race has, over the past thirty years, attracted the greatest sailors. It consecrated Laurent Bourgnon, Philippe Poupon, and Florence Arthaud, and saw the demise of Alain Colas (1978) and Loïc Caradec (1986). In 2002, only thirty-seven of the fifty-eight participants weathered the storms and crossed the finish line at Pointe-à-Pitre. In the lead of the 60-foot monohulls was Ellen MacArthur, with a winning time of thirteen days, thirteen hours, thirty-one minutes, and forty-seven seconds. Two years after having come in second in the Vendée Globe Challenge, this young Englishwoman finished the race a mere six hours after the first multihull skippered by Michel Desjoyaux. And once again, the Route du Rhum made history.

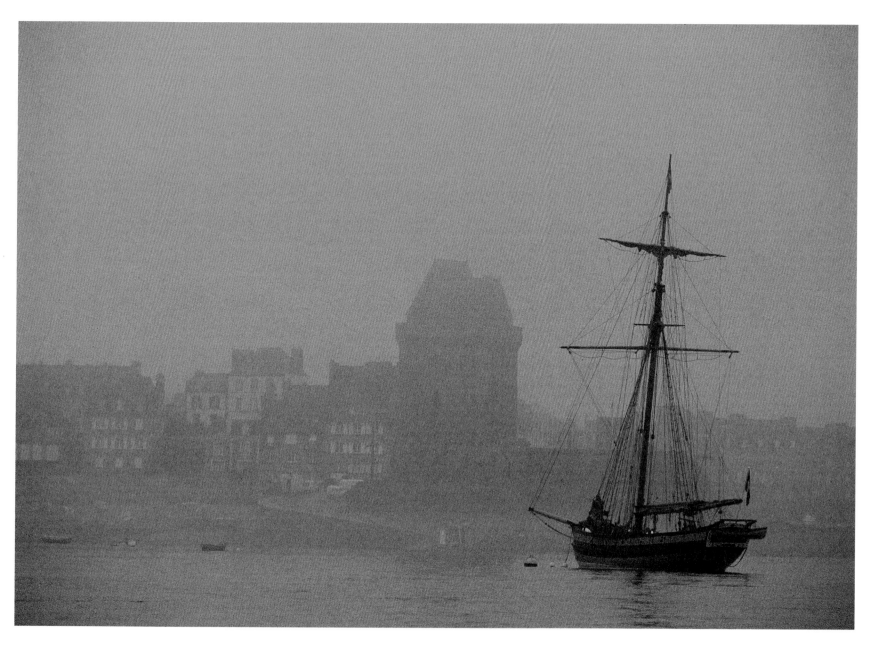

SURCOUF. THE PRIVATEER CUTTER *LE RENARD* AT ANCHOR
BELOW THE SOLIDOR TOWER IN SAINT-MALO.

In the late 1980s, a movement to rediscover the nautical heritage of the French coast inspired the construction of a traditional sailing ship in Saint-Malo. The Association du Cotre Corsair was founded in 1988. The following year, the *Renard*'s shipyard was inaugurated and the keel set in place. Launched in 1991 in front of 80,000 spectators, the ship received its rigging in early 1992. Its overall length—that is, from the stern to the tip of the bowsprit—is 97 1/2 feet (30 m). A few months after its launch, the privateer was all ready to take its place in the armada of tall ships in Brest, where it won accolades from the jury. This topsail cutter, so called for the square sail set above the mainsail, is a reconstruction of an 1812 ship commissioned by Robert Surcouf, a pirate from Saint-Malo who became a legend in the Indian Ocean because of his heroic battles against the British merchant fleet. The *Renard* can be seen anywhere between the bay of Saint-Malo and the Anglo-Norman islands, but also at home, just as it is here, at the foot of the Solidor tower.

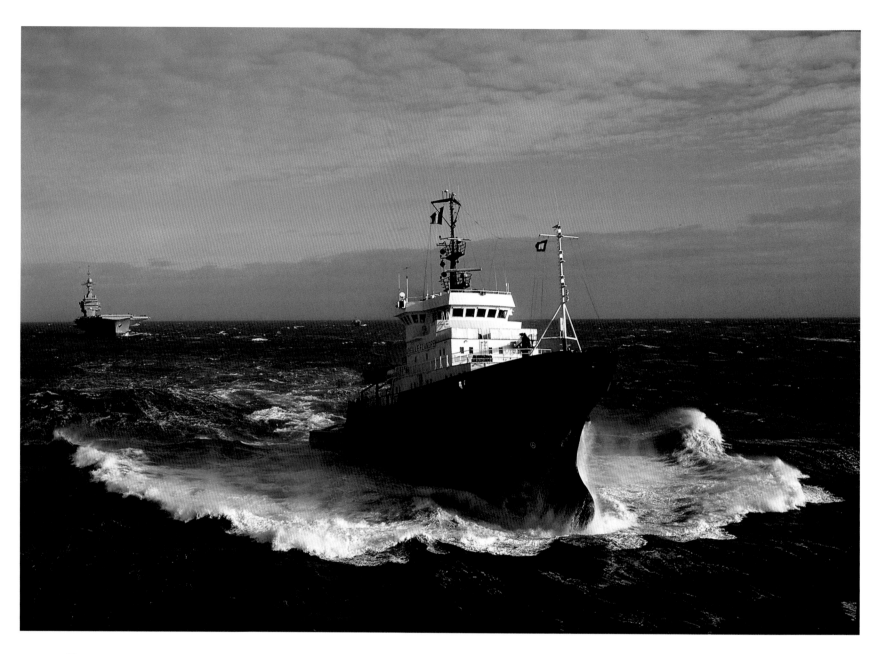

THE *ABEILLE FLANDRE* AND THE *CHARLES DE GAULLE* AIRCRAFT CARRIER: DAVID TUGS GOLIATH.

It is the ship of missions impossible, the Saint Bernard of the Brittany coast. People have lost count of how many shipwrecked sailors it has saved. In service since 1979 under the aegis of the French navy, the rescue tug *Abeille Flandre* measures only some 195 feet (60 m), but its twelve 800-horsepower engines enable it to tug even the largest vessels in the world, as is shown here with the *Charles de Gaulle* aircraft carrier. Based in Brest, the tug is on permanent alert, with two captains and two crews working in rotation. As a precautionary measure, the *Abeille Flandre* goes to sea whenever the wind reaches more than 25 knots in the Ouessant Corridor. Recently, the tug distinguished itself during the shipwrecks of the *Erika* in 1999 and the *Levoli Sun* in 2000. But as oil tankers and container ships are becoming larger and larger, the French navy has requisitioned two new, more powerful tugs that will be operational in 2005. The *Abeille Flandre* will then depart the Atlantic for the Mediterranean.

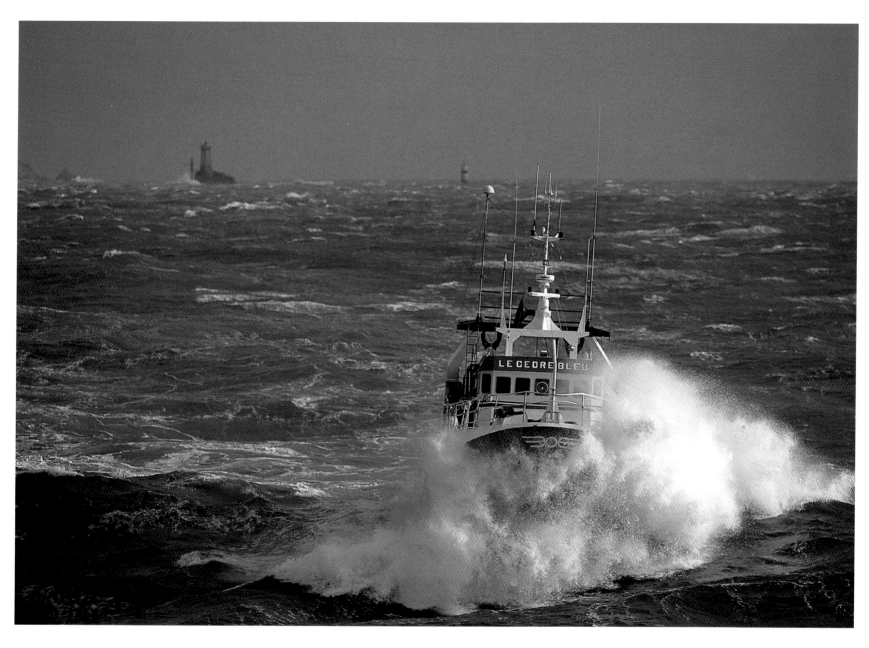

A FRESH WIND ON THE RAZ. THE *CÈDRE BLEU* IS NOT FOOLED,
AND TAKES ADVANTAGE OF THE TIDE.

If there is one spot where you do not venture without consulting the tide tables, it is the Raz de Sein, at the far
western end of Brittany. The current surges between La Vieille lighthouse and the Île de Sein across from the
Point du Raz with such violence that even when the sea is calm, on days of particularly high tides the waves
can reach heights of almost 6 feet (2 m). Thus, it is worth waiting for the lull between the flood and ebb tides,
and then surfing through the pass. This is the choice the *Cèdre Bleu* took, making a fine run and offering up a wall
of spray. Here, when the sea and the wind are at odds, attempting a pass is out of the question. On those days,
the Raz resembles a burbling caldron. Even line fishermen, who know how to hook a bass in the breakers, wait
for good weather to catch this temperamental fish that loves white waters.

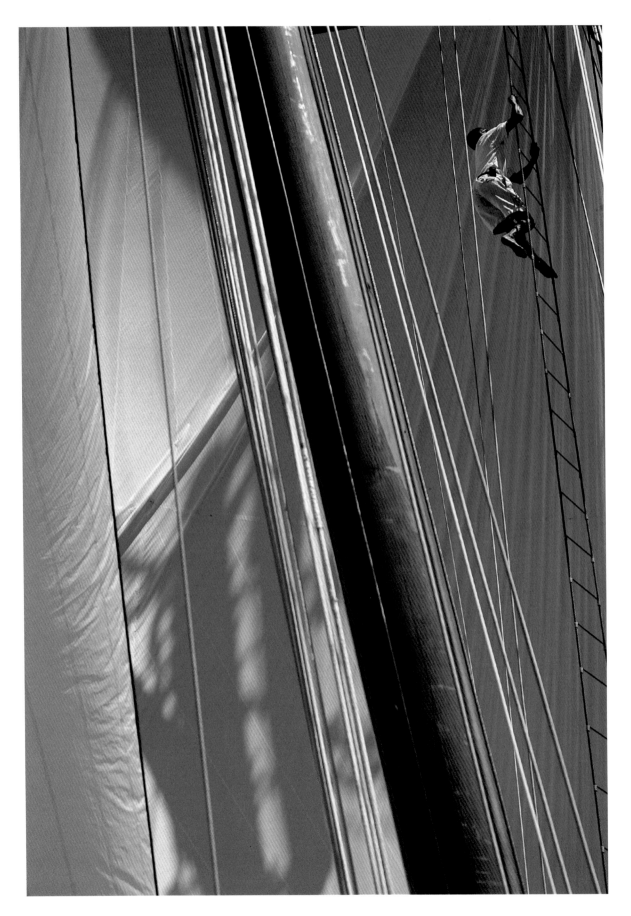

THE THREE-MASTER
SHENANDOAH. A CREW-
MEMBER CLIMBING THROUGH
THE SHROUDS. ITS FLIMSY
ROPE LADDER TAKES HIM
TO THE TOP OF THE SAILS,
AND THE MAN DRAWS NEAR
TO THE WIND.

In the year 1902, somewhere
off the American coast, the
Shenandoah, this magnificent
schooner, left the Towsend &
Downey shipyards and set sail
for the first time. On that day,
under the watchful eye of the
architect Theodore E. Ferris,
the boat met up with the ocean,
causing a hush to fall over the
crowd. But the craft gently
came to rest in the middle of
the basin, waiting to face the
elements. For a hundred years
now, men have climbed the ele-
gant masts of this craft. They
scale its shrouds and adjust the
halyards while suspended over
the void. One hundred fifteen
feet (35 m) separate them from
the deck when they are on
high, and nothing separates
them from the sea when they
reach the flags. The sails,
reflecting the blue, hold the
sky captive in their shadows.
The barefoot man catches his
breath and goes through a few
contortions in order to readjust
the sails, waiting patiently for
the wind to blow.

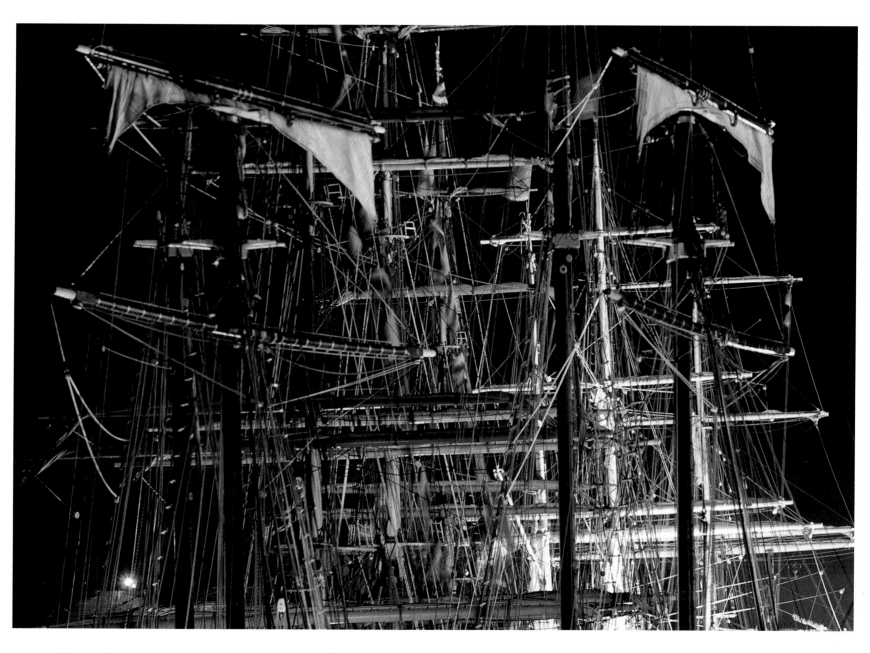

BREST. A CONFUSION OF MASTS LIT UP IN THE FINISTÈRE NIGHT.

Over the years, Brest has become one of the greatest venues for old rigs. It is here, on the front of Finistère (which means "end of the Earth") that ships that have escaped the clutches of time regularly meet. These vessels enjoy a respite in the calm of a vast harbor, as well as the admiring gaze of onlookers, before sailing off again to other seas. Before reaching the docks overflowing with visitors, these ships must first pass through the narrows that lead to the harbor. The three-masters then coexist with an arsenal of warships, current-day steel-and-iron machines, taking refuge under the Recouvrance Bridge. Yards, halyards, masts, and shrouds become superimposed, creating an image of inextricable confusion. Flags wave in the wind and the crowd shuffles off the docks, taking away a taste of those far-off seas.

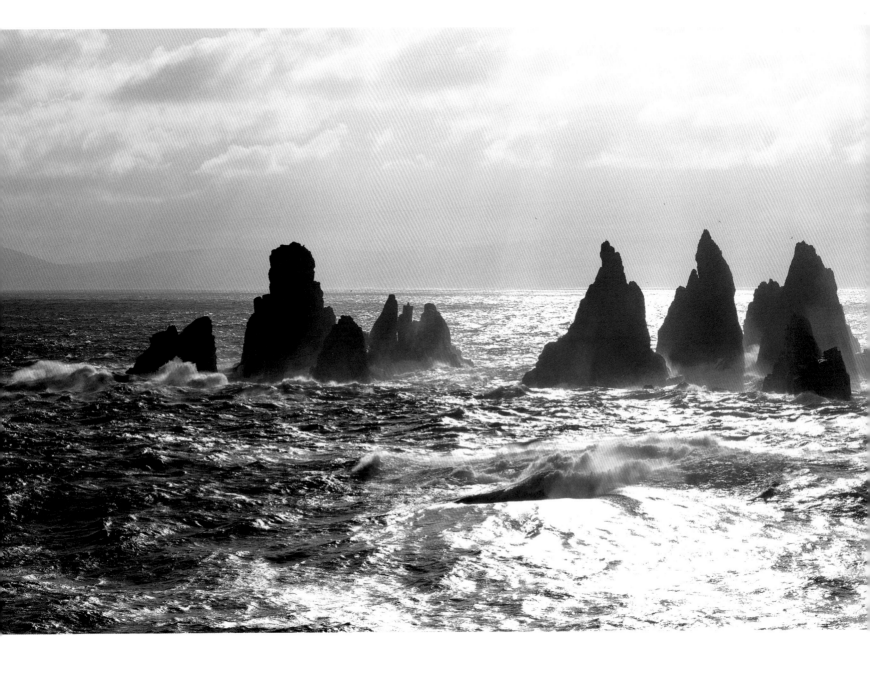

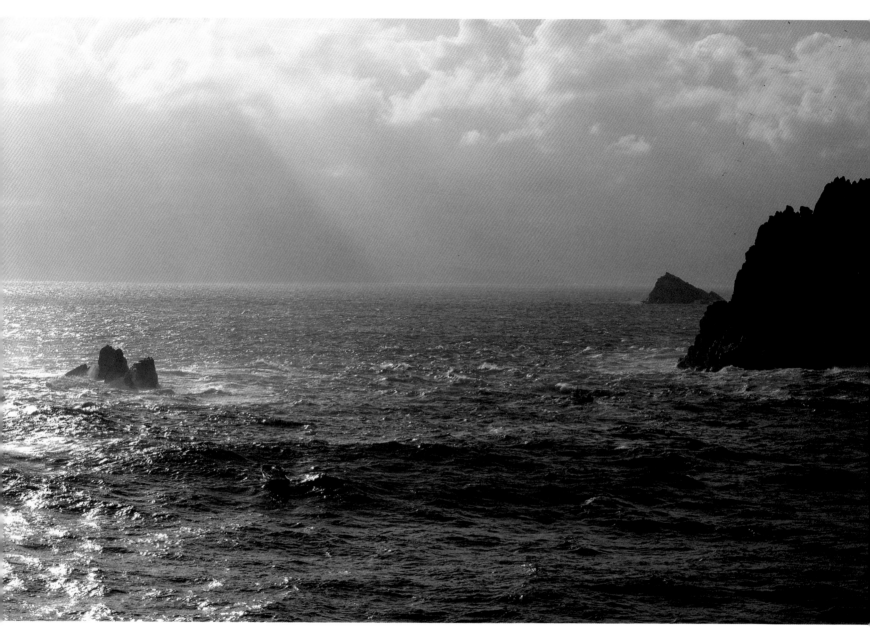

THE SEA'S TEETH. IN GALICIA, IN NORTHWEST SPAIN,
THE BEST FISHING IS AMONG THE BREAKERS AND AT THE BASE OF THE ROCKS.

The series of precipitous headlands along Galicia's indented coastline provides an area rich in fish, and sheltered
rias good for mussel farming. The disastrous wreck of the *Prestige* in November 2002, which covered the shore
with a thick, viscous layer of oil, hit the region hard—it was the fourth oil spill since 1976. Towed some
170 miles (270 km) from the coast soon after the wreck, the *Prestige* was sunk to 11,375 feet (3,500 m), so that
time and the intense cold might neutralize its dangerous cargo of 77 tons of crude oil. Despite the oft-cited
proverb "Out of sight, out of mind," the *Prestige* has not yet been forgotten: the oil continues to ooze up to the
surface, where it washes onto the beaches of the Atlantic coast in small cakes. Because it is impossible to pump
the oil out at such a depth, it will continue to pose a diffuse threat for many months to come. Other time bombs
also lurk in the ocean depths. For example, in 1990 a film of oil that kept appearing in California was traced to
a freighter that was shipwrecked in 1953.

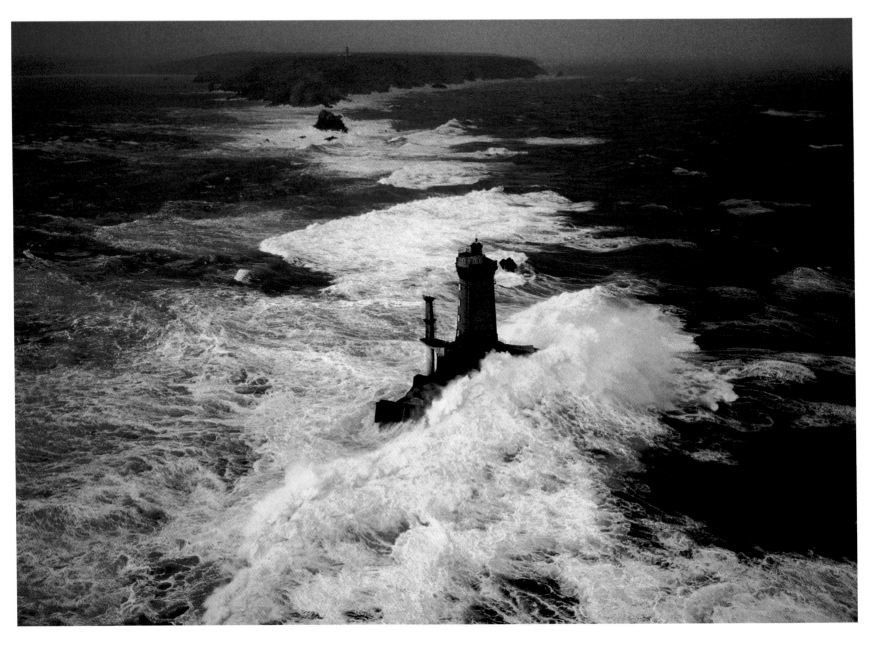

A BARE LIGHTHOUSE. LA VIEILLE FAITHFULLY MARKS THE PASSAGE OF THE SEIN RACE.

La Vieille has been stoically resisting the violent currents roiling across the Raz point in southwest Finistère since 1887. Behind its quadrangular silhouette looms the dark mass of a wind-whipped granite ridge. What perilous approaches it must have taken to resupply La Vieille's keepers! The daredevil act required a virtuoso maneuvering of small, solid, and dependable boats. The wave-tossed motorboat would go bravely right up to the lighthouse and catch the rope the keepers threw down from the top of their tower. The keepers would then lower themselves above the swells in a flimsy basket suspended by rope, finally reaching their ten days' respite on land. The new keepers took their places, prepared to spend at least two weeks in the lighthouse, though sometimes much longer, according to the sea's whim. When La Vieille was automated, on the morning of September 5, 1995, a helicopter picked up the keeper for the first and last time. La Vieille is still there, but the reassuring presence that had been associated with the night of the Sein race for more than a century is gone.

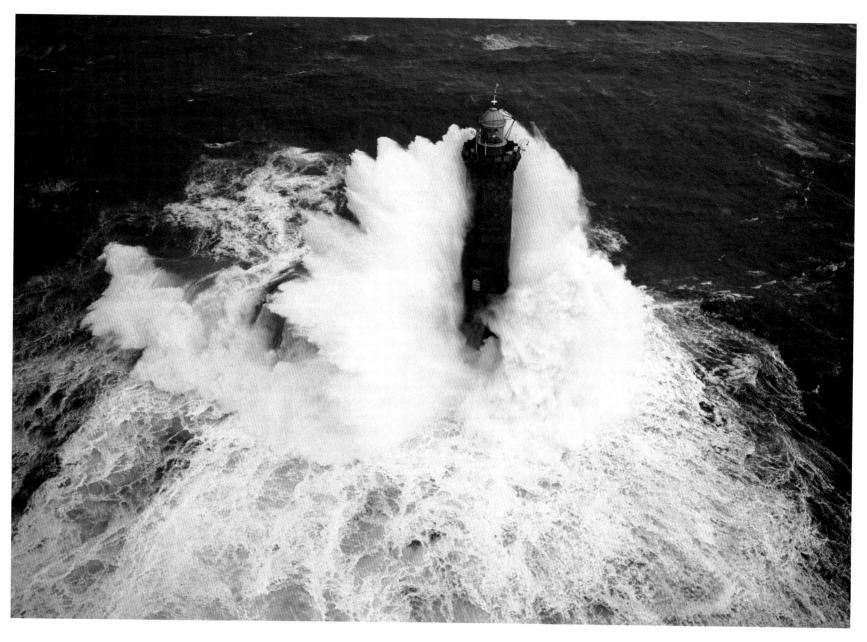

KÉRÉON, THE LAST INHABITED LIGHTHOUSE IN THE IROISE SEA,
HAS NOT BEEN AUTOMATED, MUCH TO ITS KEEPERS' DELIGHT.

A descendant of M. Le Dall of Kéréon, who was guillotined during the Terror, left a tidy sum to build a light-house in memory of her ancestor. Since 1916, Kéréon—stately despite the hammering of the waves against its 130-foot (40-m) shaft—has risen on the reef called Men-Tensel, "vicious rocks," where it marks the Fromveur passage, between the Molène islands and Île d'Ouessant. The paneled and inlaid living quarters concealed in this austere stone tower, with their sumptuous furnishings, stand in stark contrast to the sometimes terrible day-to-day trials faced by those who inhabit them. Kéréon is the last lighthouse in France where the dangerous changing of the guard, being suspended by ropes like vulnerable puppets, takes place at the end of a hoist. It is used as the staff training center, which is more worthwhile to them than being spared by automation. The replacement's know-how will always be indispensable for maintaining or repairing the lighthouses: even if they are automatic, they can't do without humans. At least, not for now!

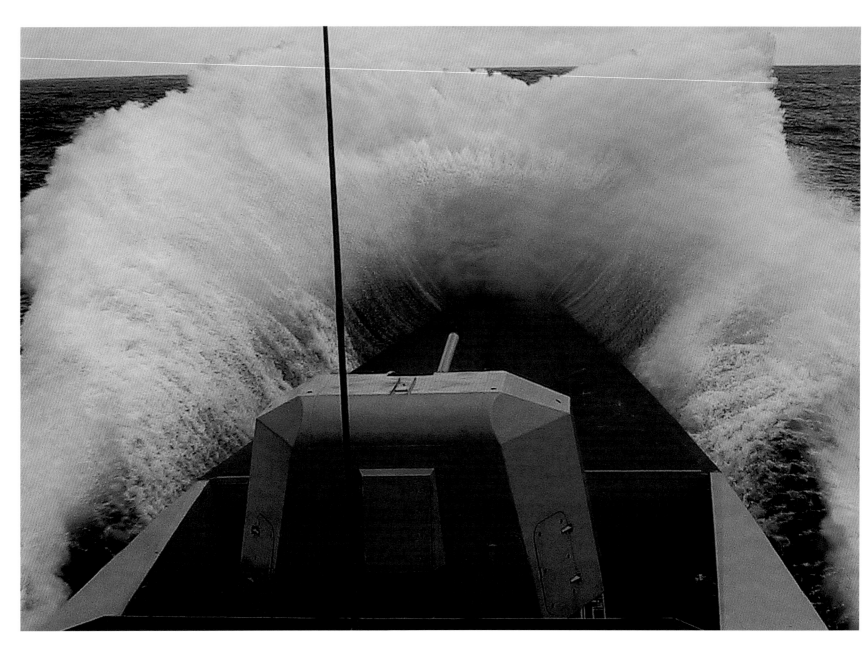

THE BOW IN THE FROTH. IN THE NORTH ATLANTIC.

The frigate *Surcouf* crosses a North Atlantic depression. The swell is long and the French navy makes its way head-on into the waves at reduced speed. This precaution does not prevent the 3,600-ton vessel from crashing through the waves. From the deck, where this photograph was taken, the scene is striking. The four diesel engines yield 21,000 horsepower, enabling a maximum speed of 25 knots (27 mph/44 kph) and a cruising speed of 15 knots. These remarkable crafts are equipped with a new active stabilization system, whose wings continually compensate for the vessel's movement and a rudder specifically designed to maintain its precision in high seas. A crew of one hundred and fifty can remain operational in weather conditions that would constrain conventional vessels.

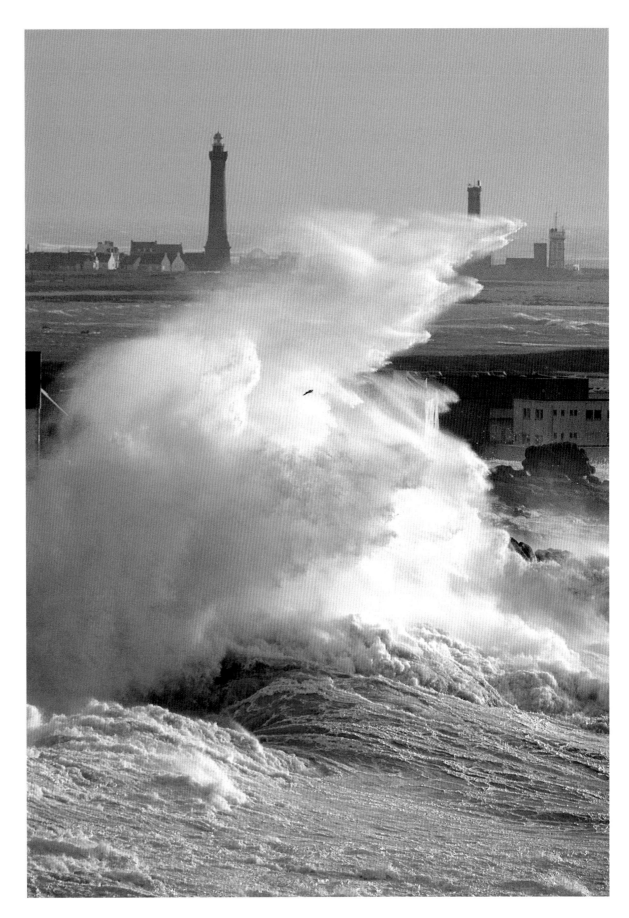

THE SEA TAKES FLIGHT.
PORT OF SAINT GUÉNOLÉ
AND THE LIGHTHOUSE AT
PENMARC'H.

There's not just one Brittany.
There is the inland Brittany,
with fog-wreathed mountains,
forests dense with legends,
rust-colored ferns wrapping
around granite outcroppings
thrusting from the Earth, and
a refreshing fine gray drizzle
that brings scents and washes
the green contours of the dells.
There is also the coastal Brittany,
with endless beaches, foaming
headlands where Penn ar bed—
the "head of the world"—ends;
white dunes edged with pines
that the ocean's winds have
blown to a slant; immense, pure
skies; and hosts of white-and-
blue houses clutching their
foundations to keep from being
carried away by the storms.
Their lives depend upon the
sea's moods, which may be
peaceful, rapacious, or even
playful when, stung to the
quick by a cocky cormorant's
daring, it flaps its own powerful
wings to take flight, even
higher and more free.

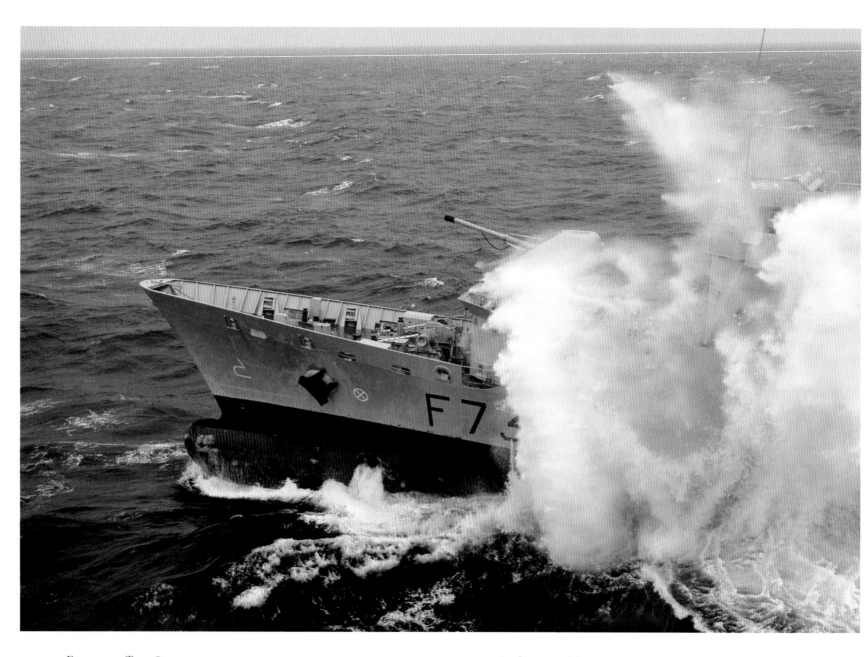

FRIGATE. THE GERMINAL PREPARES TO RESUPPLY THE HELICOPTER CARRIER LA JEANNE D'ARC.

The frigate of yesteryear was a three-masted sailboat. Its modern-day descendant is a missile-launching warship that weighs several thousand tons. The Marine Nationale Française numbers six observation frigates like the *Germinal*, which are charged with monitoring the French naval areas overseas that police navigation and supervise fishing grounds and that also evacuate French nationals. The *Germinal*, a 302-foot (93-m) ship, which carries its 120-man crew and 3,000 tons at a speed of 20 knots, also sees to the resupply of other ships, such as *La Jeanne d'Arc*. The provisioning frigate falls into line with the other ship and stays parallel with it. Cables are stretched between the two hulls and the fresh food, fuel, and equipment pass from one to the other. The operation may take as long as three hours. It is a delicate maneuver, to say the least, when the sea joins the crew on deck, and a task that becomes even more complex when water flies over the control room.

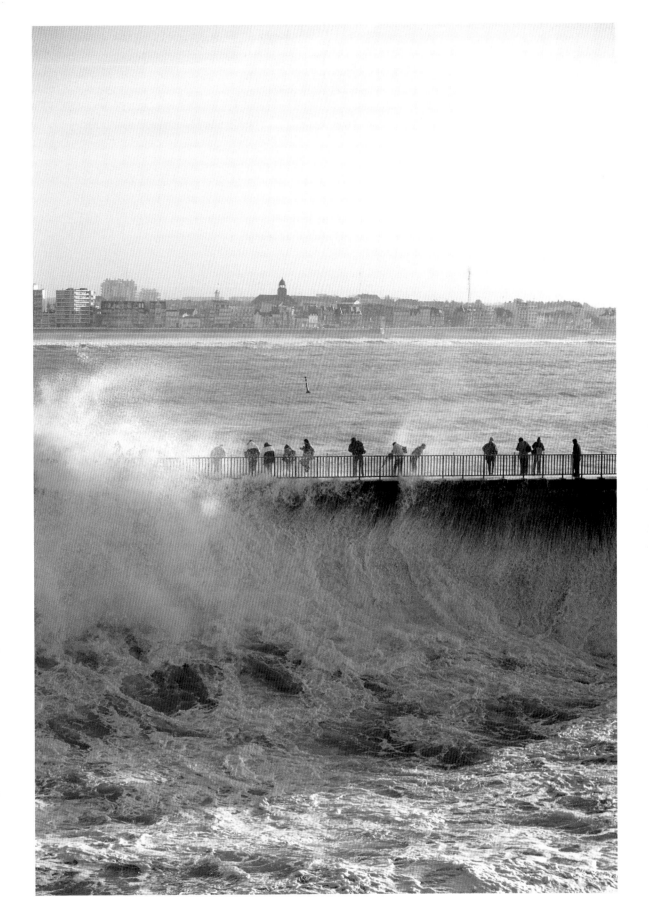

BREAKERS. WITH TIME
AND PRACTICE, PEOPLE
HAVE LEARNED HOW TO
BUILD STRUCTURES THAT
CAN WITHSTAND THE
REPEATED ATTACKS OF
THE WAVES.

The storms that beat down
upon the coasts cause damage
and other inevitable conse-
quences, including a precipi-
tate dash on the part of many
people toward the shore.
Whenever there is a storm at
sea, people are overcome by
an irresistible urge to go
watch the elements unchained.
Soaking wet, knocked about,
vulnerable, and insignificant
before the forces set loose
around them, they grip the
rail of a seawall, take shelter
in their cars, or press their
noses against a window.
Everyone follows the storm's
great performance with the
same uncontrollable fascina-
tion. What phenomenon
casts this spell? What strange
power unfailingly draws them,
scorning danger, to front-row
seats at the show? What
invisible physical energy,
intensified by this maritime
hullabaloo, acts on the human
body? Or is it that human
beings, bewitched by the sea
since the dawn of time, simply
allow themselves to be hypno-
tized by so much beauty?

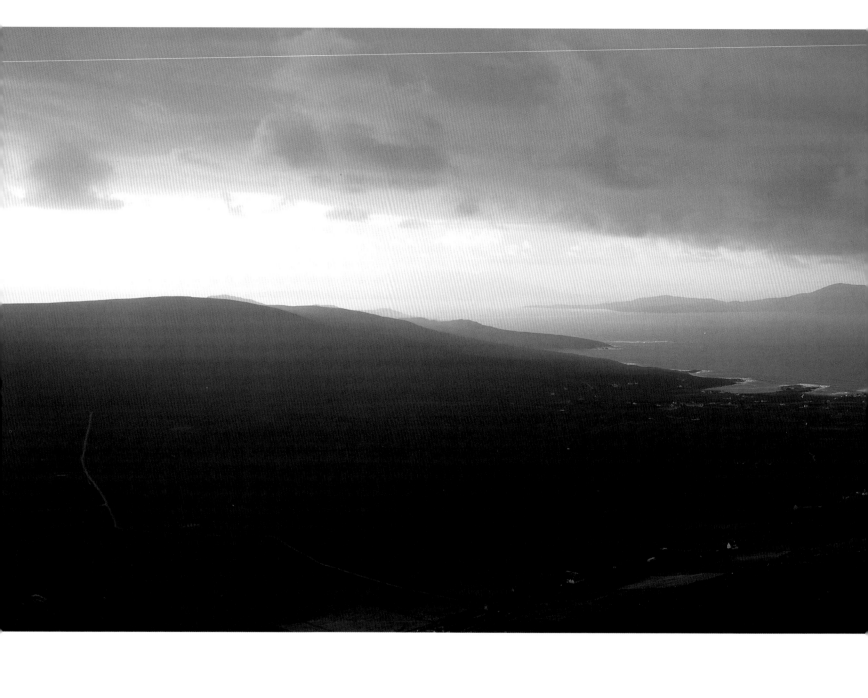

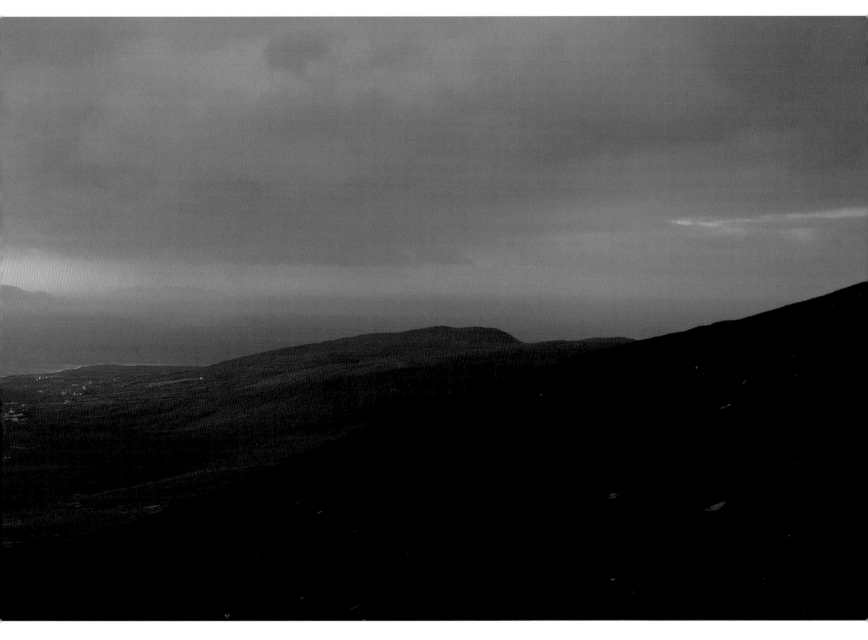

IRELAND. FROM THE COASTS OF CLARE ISLAND,
THE SUN GOES DOWN AND SETS ACHILL ISLAND AFLAME.

Even though a bridge connects it to County Mayo, when the sun sets here, on Ireland's largest island, people feel quite alone. This evening, just a stone's throw away from the westernmost island in Europe, the sky is ablaze and lights up the sea. Bald mountains, a background of moors, jagged coves, and cliffs battered by Atlantic waves slowly disappear into the night. When the moon is high in the sky, the lights of the small fishing villages are just barely visible. Keel is one of them, and it was an ancient, heroic port, nourished by whaling. Hidden away and scattered here and there are granite cottages and ruins of castles glistening with sea spray and legends. A few herds of sheep roam at the edge of the cliffs, while others linger below amid the storm of the surge. For these reasons the island has become the place of choice for a certain artistic elite—painters, writers, photographers—who come to relax and find inspiration.

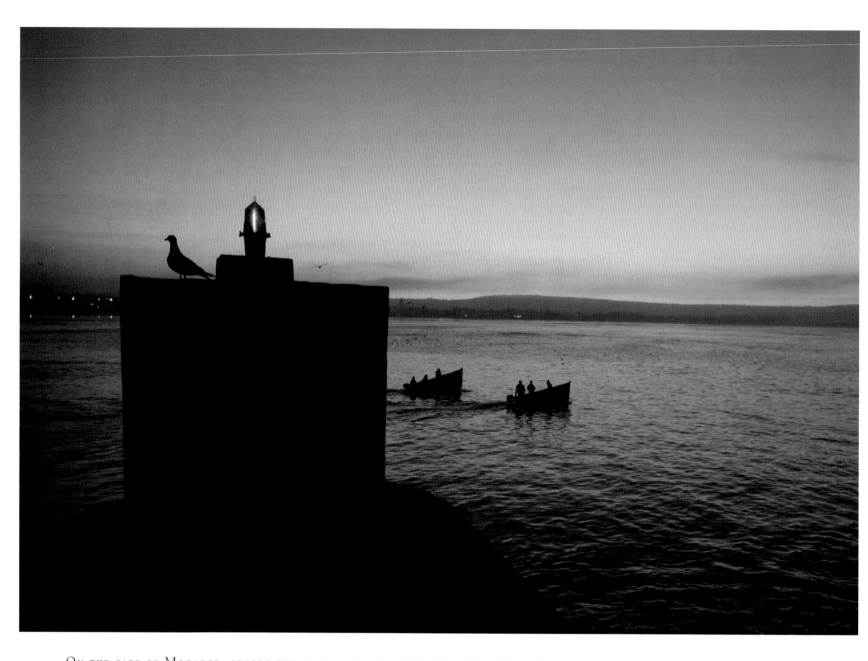

ON THE CAPE OF MOGADOR, BEFORE THE SUN GETS TOO HIGH AND THE WIND PICKS UP.

These two crews are the first to round the entry of the port of Essaouira. The dawn is young and the wind, which in the afternoon blows fiercely, has yet to pick up. The boats head off for the cape on the Isle of Mogador, a few nautical miles out to sea. Once there, the men will raise up the lobster pots, cast out some lines, and make two or three attempts at hauling. Out of the corner of their eyes, they will notice some Eleonora's falcons returning after having wintered on the islets. Today, no one disturbs their clutches. A few centuries ago, however, things were quite different. The *murex*, a species of mollusk, were everywhere to be found throughout the archipelago and from their shells a purple dye was derived. The Romans made great use of this pigment and when they retook the "Moroccan" coast from the Carthaginians, they embarked upon the exploitation of this precious deposit and baptized the islands "Les Purpines," or the "Crimson Isles."

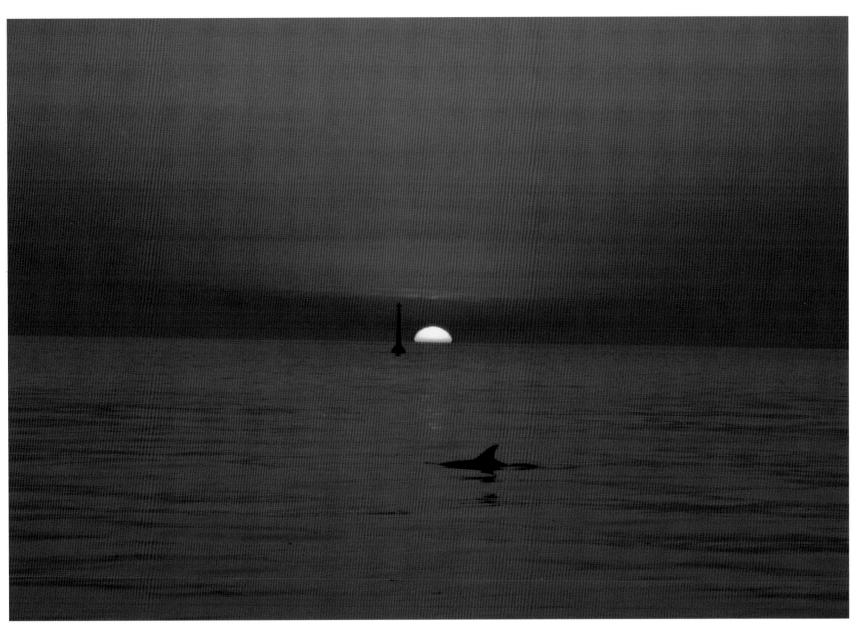

THE DAY SLIPS AWAY. A DOLPHIN GREETS LES POULAINS.

The regularity of the dolphins' breathing reaches far, and, with the engine cut, one can hear their singing as well. The one shown here deviated well off his course in order to greet the boat. He made a few appearances at the bow, casting an eye at the person leaning over the aft. The day was receding. Two worlds were meeting. This is a great joy for the sailor who travels the length of Brittany's coast where four species of dolphin pass through, as well as several kinds of other cetaceans and some seal colonies. The common dolphin, *Delphinus delphis*, is the most familiar of them. A little more than 6 ½ feet (2 m) in length, this sea mammal rarely visits European continental shores, preferring the open waters. Breezing by the *Poulain Nord* buoy off Belle Île, it keeps its distance from the Continent. The bottle-nosed dolphin (*Tursiops truncatus*), the striped dolphin (*Stenella coeruleoalba*), and the Risso's dolphin (*Grampus griseus*), along with several species of porpoises, also pass through the waters off Brittany.

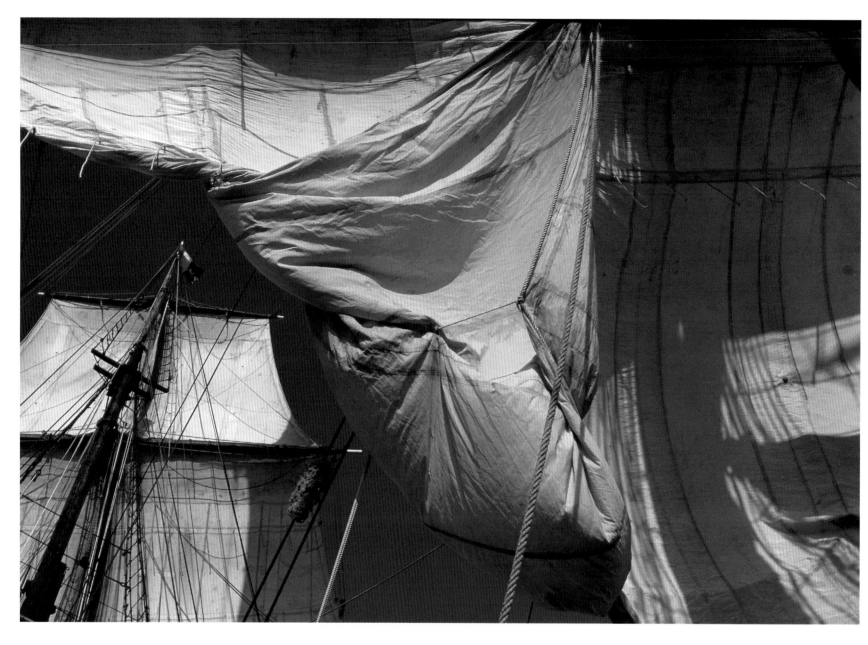

FURLING THE SAILS. A SECTION OF THE SAIL IS RAISED UP LIKE A CURTAIN,
OPENING UP A GLIMPSE OF BLUE SKY ON A FINE DAY.

The crews of these boats were large because to maneuver them often required rushing from the bow to the
mizzenmast (the stern section on a three-master). Today, crews continue to bring back the grandeur of these
glorious ships of the past, identically replicating the efforts of their predecessors. Many of these modern-day
sailors see their mission as a struggle against time; their sole desire is to prolong the life of these old rigs, and
they are not bothered by the difficulty of the task. One of the most demanding maneuvers in sailing is raising
the sails, which in nautical jargon is referred to as "brailing the canvas." The brail is a line that facilitates the
folding and then lashing of the sail to its yardarm, the horizontal piece of wood that is attached perpendicular
to the mast. With its sails refurled and its speed reduced, the three-master can prepare to enter port, here just
a stone's throw away.

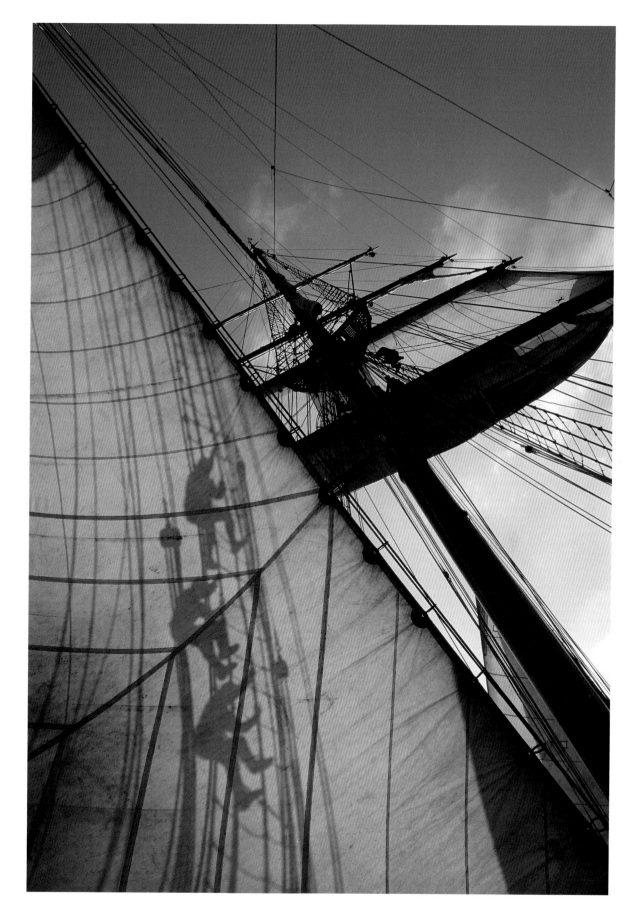

RIGGING. THE GREAT
REHEARSAL OF MANEUVERS
IN ALL WEATHER.

The rigging is the totality of a
tall ship's equipment—its
masts, spars, sails, cordages,
and blocks. The rigging is
what allows the ship to be
maneuvered and the sails to
be hoisted, set, taken in, and
furled on the yards. There is
no end to the possible ways the
rigging can be manipulated,
made all the more challenging
by the several different kinds
of sails. The fore-and-aft sail is
a trapezoid whose fore edge fol-
lows the mast. "Square rigging"
designates the totality of square
sails, spread by yards perpen-
dicular to the mast. Lateen sails
are triangular, while those on
today's yachts, hoisted by a
single halyard running along
the mast, are Bermuda rigged.
These sails make up the various
kinds of rigging that give their
names to the great sailing ships:
a square-rigged three-master
uses only square sails; a three-
masted bark is characterized
by a fore-and-aft sail on the
mizzenmast; and a three-masted
schooner is square-rigged on
the foremast with two fore-
and-aft sails.

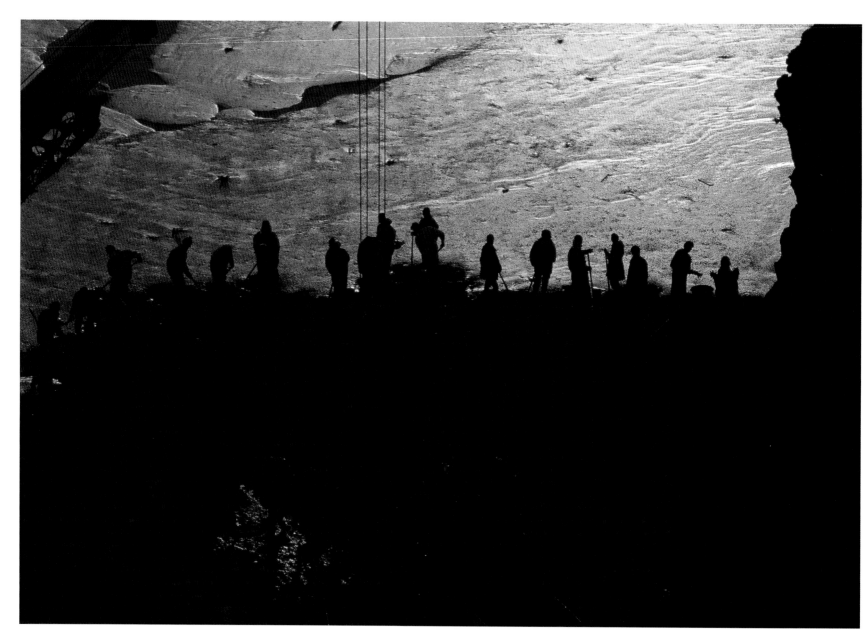

PORNICHET. CHRISTMAS 1999. FROM BELLE-ÎLE TO NOIRMOUTIER,
VOLUNTEERS SPONTANEOUSLY ORGANIZE TO BATTLE THE *ERIKA*'S GRIM, GREASY OIL SPILL.

An army of volunteers, boots sucked into the clinging mess oozing from the *Erika*, take on the oil spill. This is
just another in our collective memory, which is all too familiar, with coastlines and birds covered in oil from the
wrecks of the Exxon *Valdez*, the Amoco *Cadiz*, and the *Prestige*. But these disasters represent only a fraction of
the pollution that goes into the ocean. Of the 3 million tons of hydrocarbons that foul the globe's seas each year,
only 12 percent comes from catastrophes such as the *Erika*. Two-thirds of the pollution that goes into the oceans
comes from freighters emptying and cleaning out their tanks at sea, and from human activity on land. Less visi-
ble are the industrial, urban, and agricultural effluents that rivers and other waterways wash out to sea, and the
atmospheric pollution, the source of the very dangerous mercury and lead that the rain recycles into the oceans.

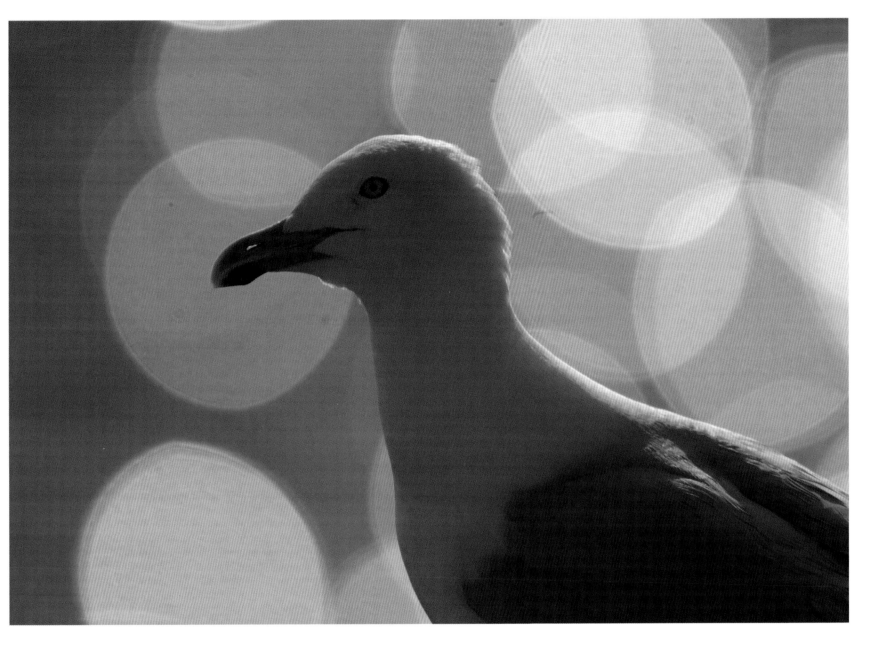

THE SILVERY HERRING GULL. A SWIFT EYE, A BEAK OF STEEL.

With a wingspan of 5 1/4 feet (1.6 m) and withers measuring 24 inches (60 cm), the *Larus argentatus* is one of the seabirds most commonly found on the European shores. Before maturing into the gray-and-white plumage the species is known for, the chicks will spend their first four years dressed in camouflage brown. Although they quickly grow to adult size, they continue to beg for food, making use of the red dot on the beak of their elders, which, when stimulated, instigates a regurgitation to feed the young. While some bird species have suffered from the presence of humans on the seaside, such is not the case with these opportunists. Above the hearts of cities with the most rugged of cliffs, they carve out a space in the air for themselves and supplant more fragile species such as the smaller seagull, with which it is often confused. One of the masters is the Great Black-backed Gull (*Larus marinus*). Larger and with black wings, it rules over the entire colony. It is less clever than its silvery cousin.

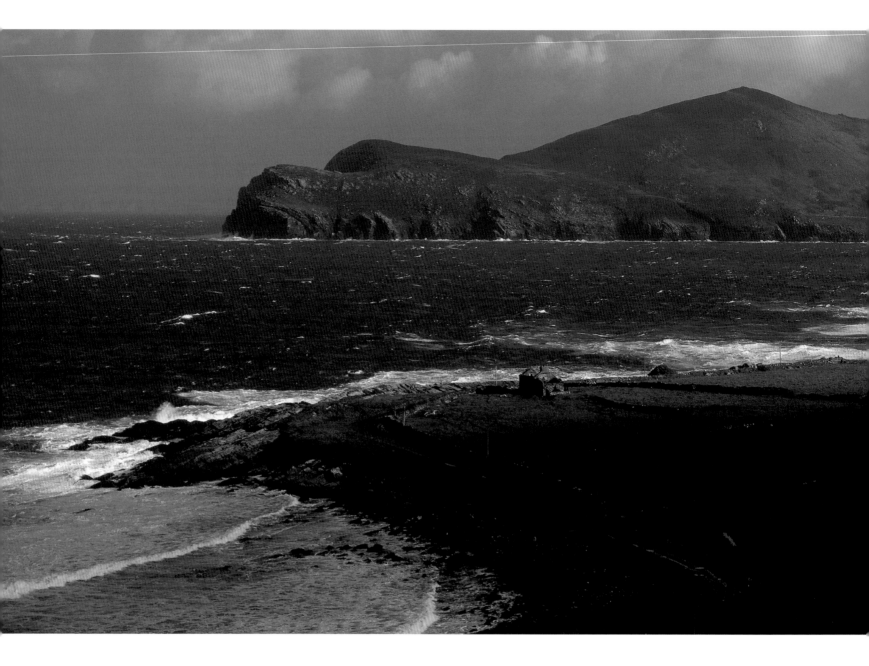

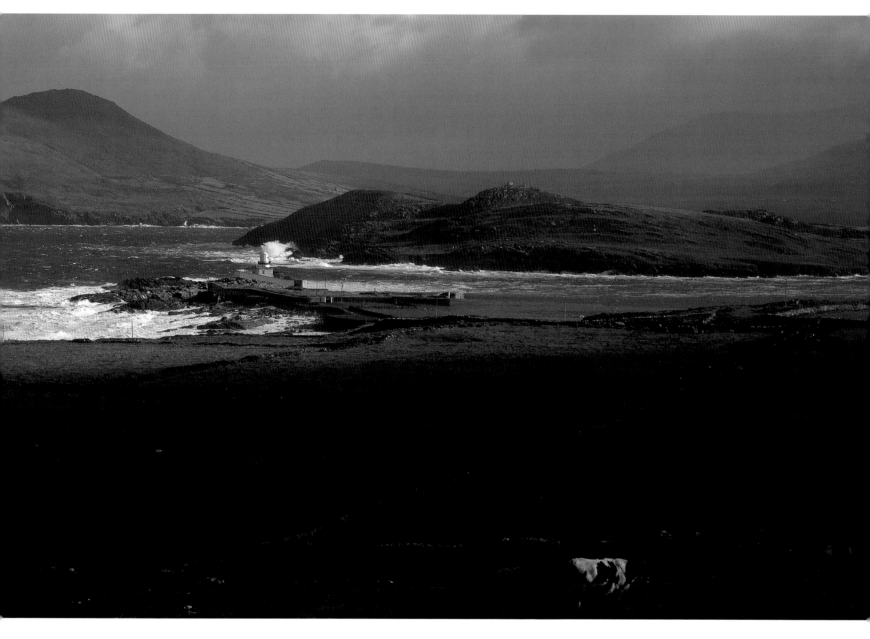

VALENCIA ISLAND AND ITS LIGHTHOUSE OVERSEE THE EXTREME TIP OF EUROPE.

Southwest of Ireland, this deforested moor sits beneath the tall granite cliffs that define the westernmost coast of Europe. Valencia Island is well known by North Atlantic sailors because the BBC habitually includes it in the shipping forecasts. The island of Skellig Michael just off shore from Valencia Island had for centuries been home to a small religious community founded by Saint Finian, and it is among the ruins of the monastery, perched on the peak of a narrow rock precipice 655 feet (200 m) above sea level, that the lighthouse was erected in 1820. With automation in 1987 came the exodus of the keepers and the last of a human presence on this wind-battered islet. Today, Skellig Michael is listed as a UNESCO World Heritage Site.

THE DUNE AT PYLA.

A sea of sand born of wind and ocean, the Pyla dune rises at the mouth of the Bassin d'Arcachon, the only indentation in the 156-mile (250-km) straight line of the Aquitaine coast. More than a mile and a half (2,700 m) long and almost a third of a mile (500 m) wide, it looks across at the Atlantic and the banks of Arguin, the large outcropping islet that gives its sand to the dune. The wind fashions the silhouette of the Great Dune according to its whim, raises undulating waves on its surface, and pushes it toward dry land. Advancing by 13 feet (4 m) a year, the dune is swallowing up the forest of Les Landes, the largest pinewoods in Europe, which edges the shore. In 1978, the Pyla dunes, at 338 feet (104 m) high—another European record—attained the honor of becoming one of France's Grands Sites Nationaux (Great National Places). More than 1 million visitors a year come to see this extraordinary natural site. In this region, where forests, beaches, and dunes all reach immense proportions, nature arouses the wonder of a solitary admirer, captivated by a dream of infinity.

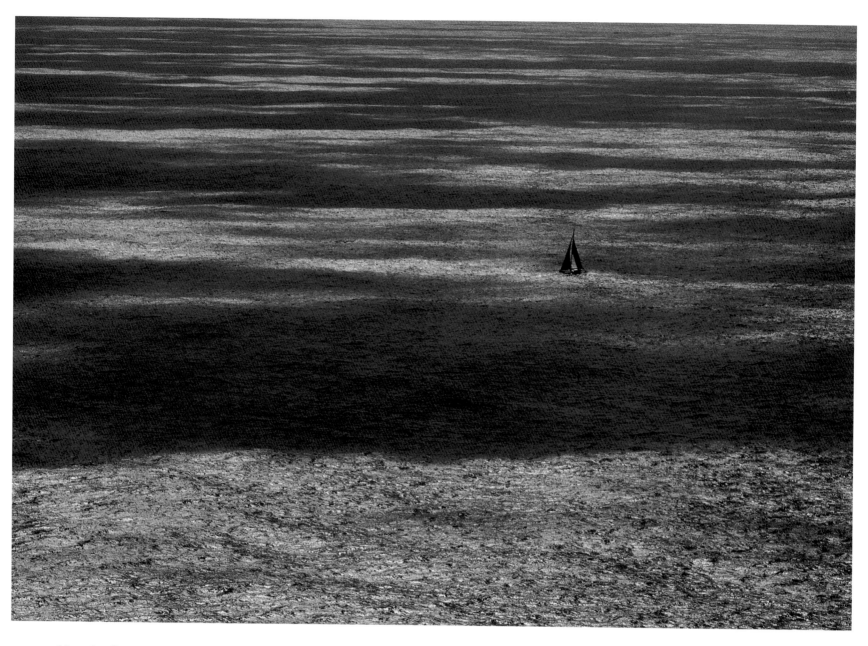

Vendée Globe. Tranquil skies over the Atlantic, following the start of the world's most grueling solo around-the-world yacht race.

The skippers of open-sea races handle vast expanses of canvas by themselves on their flying machines. In unpredictable conditions, from dead calm to gusty winds, they adjust their sails to control the boat's thrust, negotiate the troughs, and try to coax the crafty, powerful ocean. Lack of sleep and the need to remain constantly alert render the trials of sailing on the open water extremely harsh. This struggle, which can test the physical and emotional limits of human strength, is one that sailors confront by themselves, a challenge to their own courage. What inner harmony, what revelation do they seek by defying danger, setting sail again and again on the liquid world of the seas? Have they found a way to soothe their inner demons and free themselves from the chatter of our busy world, to seize the elusive and troubling sensation of simply being alive, on Earth, on this grain of sand in the universe?

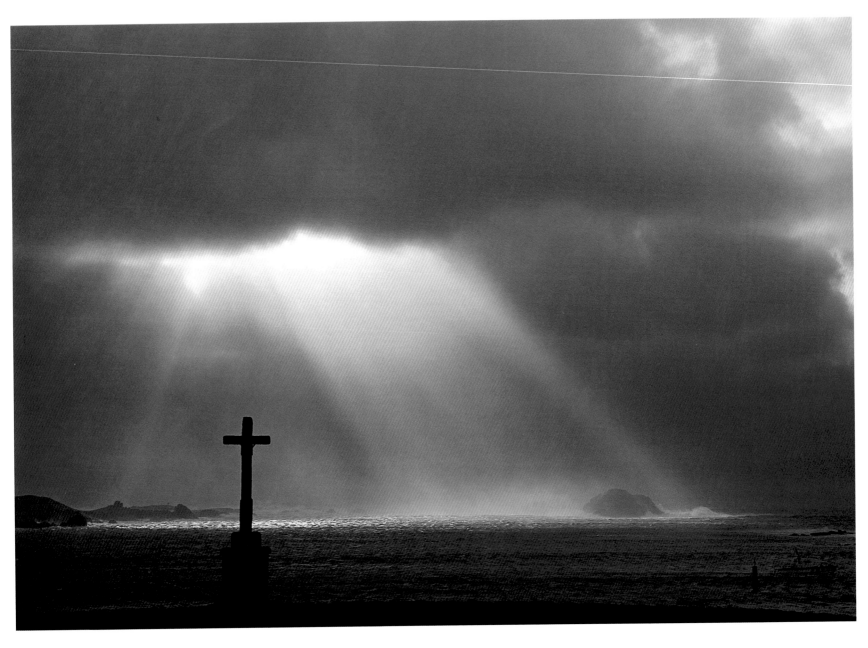

THE BAY OF LAMPAUL. THE CROSS OF THE CHAPEL OF SAINT NICHOLAS
ILLUMINATED BY A DIVINE LIGHT.

This unsettling scene is caused by a very ordinary natural phenomenon. After a low-pressure system passes, the wind becomes westerly and its gusts rip the thickest part of the cloud cover. The sun pours its gold through the gaps that pierce the overcast sky, and sweeps the sea with its warm rays—as in this moving moment, which occurred after a violent storm over Île d'Ouessant. When faced with the ocean's eternity and its unfathomable immensity, one realizes more than ever how fragile life is. "I didn't conquer the Pacific, it let me pass," Gérard d'Aboville stated humbly, after paddling across the ocean. Around the globe, like so many bulwarks raised against something greater than themselves, people raise stone crosses and chapels, wrap themselves in beliefs and superstitions, and beseech the all-powerful forces that can protect them and spare them the worst of the storms. This time, their timid request seems to have been heard.

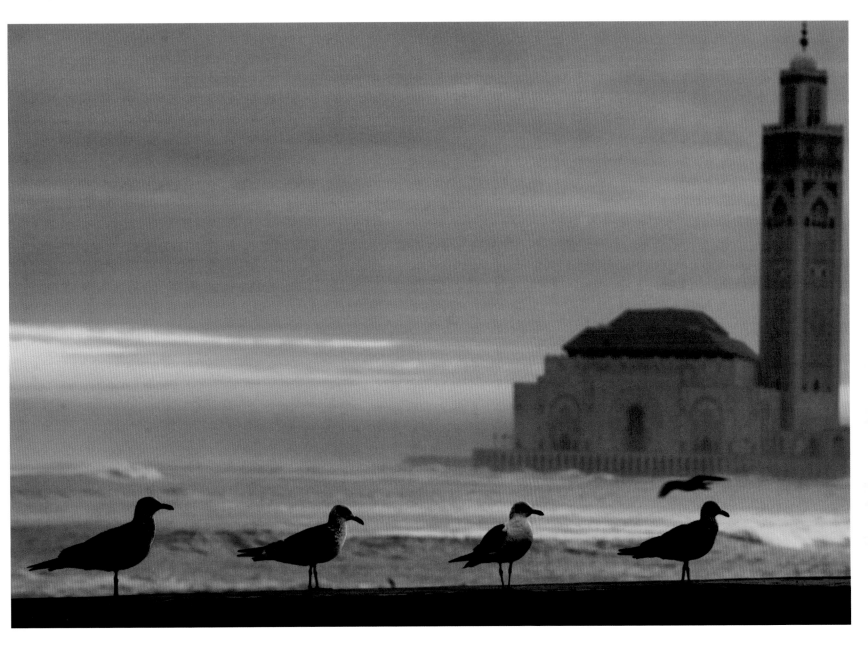

Changing of the guard at the Hassan II Mosque in Morocco.

The swell of a rolling wave. Guards with plumed helmets. Echoing the blue of the open sea is the blue of the
ceramic tiles designed in honor of the memory of King Hassan II. Constructed on piles, this largest mosque
in Africa covers 22 acres (9 ha), two-thirds of which were recouped from the ocean. Just as during the era of
cathedral building in Europe, thousands of artisans flocked here from throughout the kingdom. They sculpted
721,180 square feet (67,000 m²) of plaster and some 570,490 square feet (53,000 m²) of precious wood. For
this masterpiece, they conceived the most beautiful arabesques, and found from the vast legacy of Moorish art
the purest of tones and the most refined motifs. The square minaret is the tallest in the world, reaching 656 feet
(200 m) over the bay of Casablanca. The esplanade, a terrace that appears to be sitting on the Atlantic Ocean,
holds some 80,000 of the faithful. The prayer hall is covered by a retractable roof and can metamorphose into
a patio with room for 30,000. But the sea, which does not easily allow itself to be conquered, eroded the base
of the mosque, forcing the builders to rethink the foundations.

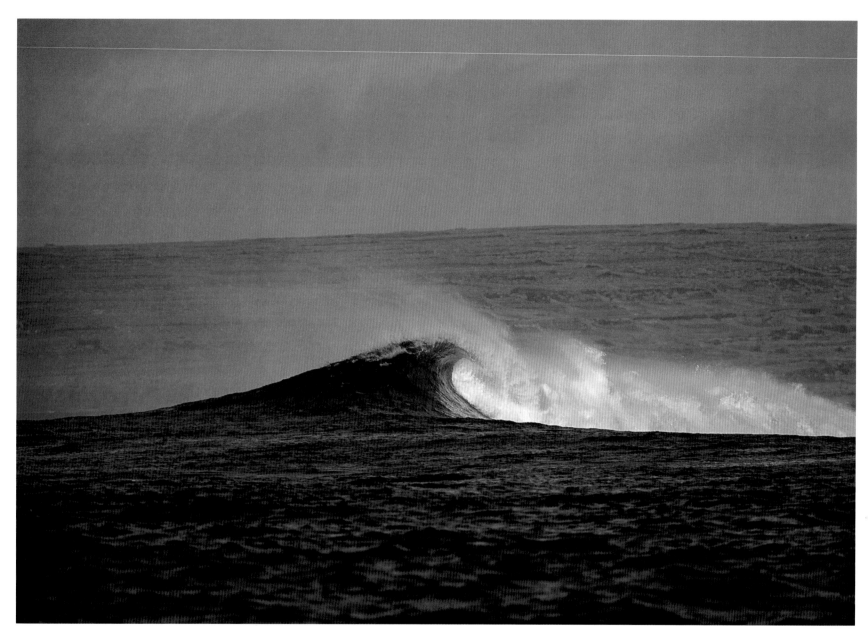

THE ARAN ISLANDS. IN CONNEMARA, THE PROCESSIONS
OF NORTH ATLANTIC WAVES WASH ASHORE AT INISHEER.

With no familiar object to convey the scale of this splendidly curling wave, the imagination is sorely tempted
to see it as a devastating tidal wave. In fact, it is just a great swell out at sea, ending its journey by rolling out
at the Aran Islands, west of Ireland. Other coasts, however, are subject to tidal waves, especially in Japan,
where they were named *tsunami*. These phenomena follow a volcanic eruption, a landslide, or an underwater
earthquake in an area of seismic activity. In cases such as these, the earth's tremors give rise to an extremely fast
surface wave that approaches land at a speed of almost 450 miles per hour (700 kph). The wave may be low
when it first appears, but grows as it nears the coast due to the water becoming more shallow and may become
65 to 100 feet (20 to 30 m) high. In 1883, the volcanic eruption on the Indonesian island of Krakatoa set off a
gigantic tsunami more than 110 feet (35 m) high, which ravaged the neighboring islands of Java and Sumatra
and was felt as far away as Yemen.

OCEAN ART.

Ocean water moving in the form of waves, tides, and currents represents a huge amount of energy. Human beings have figured out how to use tidal power stations to transform the tides' power into electricity. Now we are turning to the ocean currents. The best known is the mighty Gulf Stream. Rising in the warm waters of the Gulf of Mexico, it flows up the coast of North America before reaching the shores of Europe, which it follows as far north as the freezing waters of the Arctic at a speed of $2\frac{1}{2}$ miles (4 kilometers) per hour. Beyond this and other great ocean flows, the sea is alive with countless currents, more or less violent, that are generated by coastal indentations as well as by the underwater edges of land masses. Marine currents may prove to be an energy source: by simply placing underwater turbines in their path, they could become the submerged equivalent of windmills—watermills, perhaps. The big brains are already working on the problem.

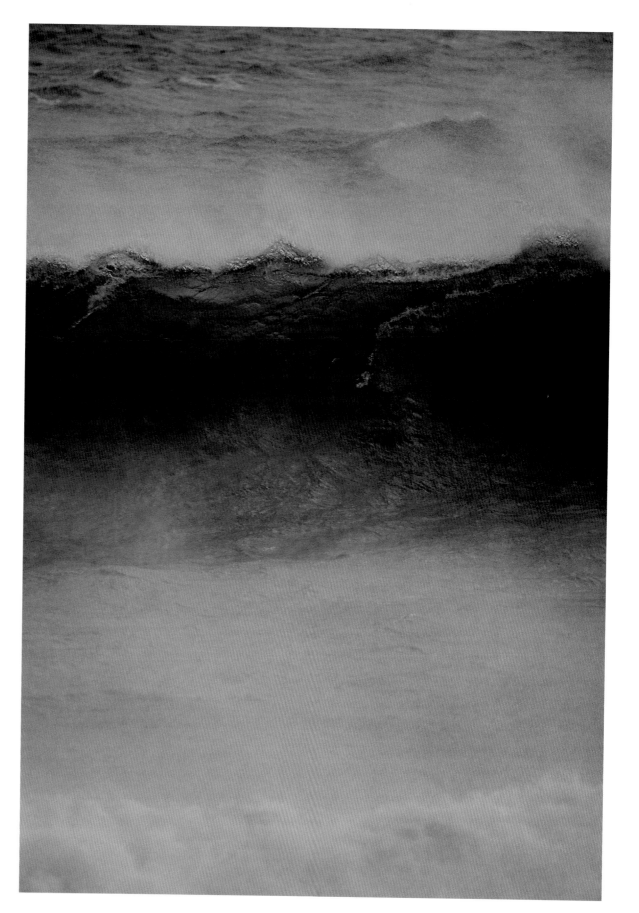

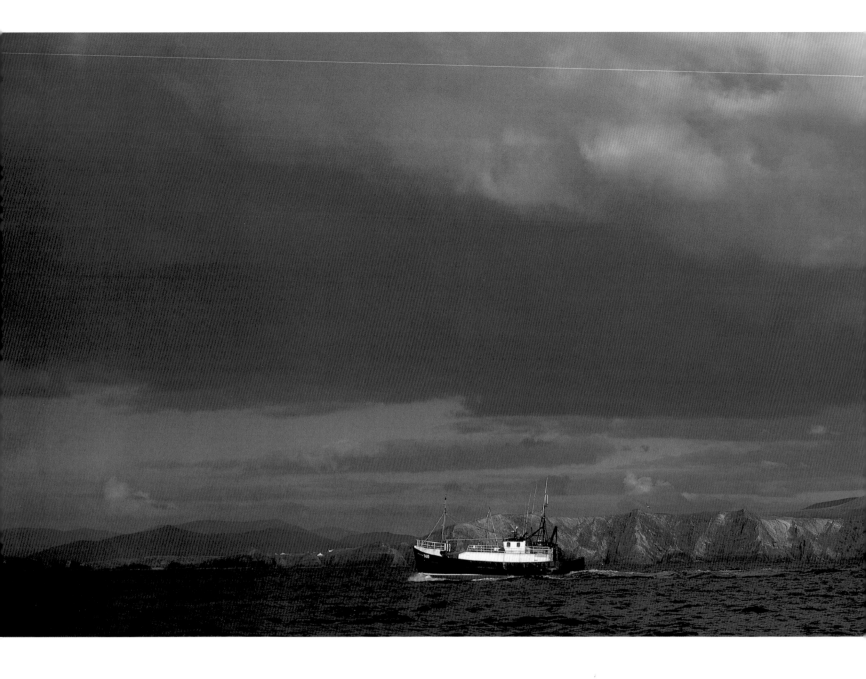

A calm sea and a rolling sky accentuated by the steep cliffs of Valencia Island that plunge into the Atlantic Ocean. Long known for its mackerels, the island, planted like a crow's-nest southwest of Ireland, remains a great region for deep-sea fishing. Because of its geographical location as an outpost of Western Europe, in 1886 the island became home to the first transatlantic telegraph cable, linking Ireland to the New World. Thanks to the wonders of the warm Gulf Stream currents, this austere island, with its wind-lashed and sea-beaten ravine coasts and its desertlike moors, flaunts stunning tropical gardens, which had been planted by Lord Monteagel, a local, wealthy aristocrat. Today, Valencia Island has become known for its underwater diving.

BIARRITZ. THE LIGHTS AND REEFS OF A BEAUTIFUL ADVENTURESS.

What a personality, that Biarritz! During the Middle Ages, the *Biarrots* took off in search of whales in uncharted waters. In the sixteenth century, the bays of the Old Port produced foolhardy sailors who settled in Canada, the New World, Greenland, and Spitsbergen. Those who succeeded at this high-risk fishing prospered until the hunt for leviathan ran dry. Gold fever touched even this small port. From 1820 to 1914, one hundred thousand people left the Basque country for America. At the same time, the spa craze was intoxicating Paris, and Biarritz became one of the most chic venues in all of Europe. Everyone on the Continent who considered themselves a star or a prince would be found in its surrounding hillsides. The cliffs were lit up by opulent villas and stylish manor houses, while the spas and casino drew great crowds. Napoleon III himself set up quarters here. Today, the small town retains the sheen of these opulent years and the maverick spirit of its ancestral adventurers.

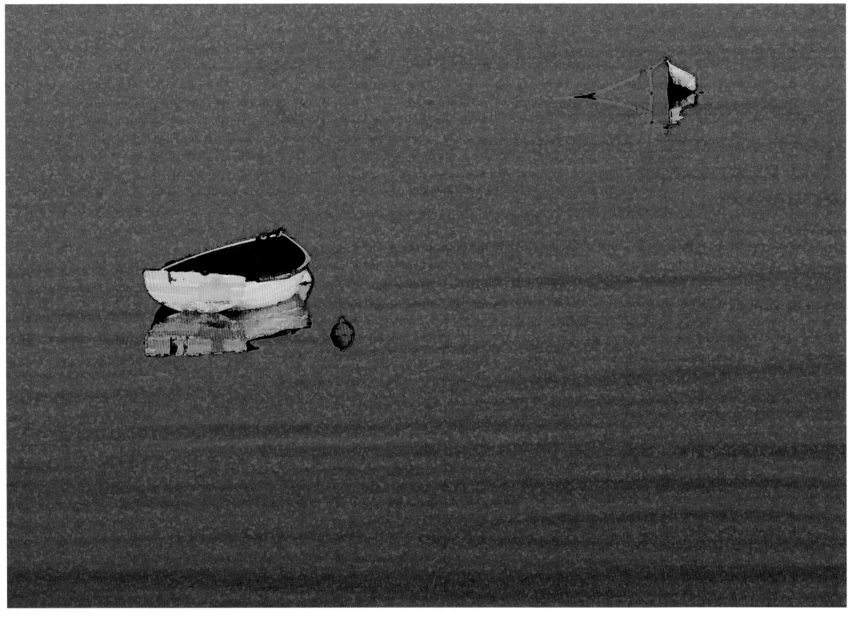

Tucked away in the Crac'h river, a small dinghy awaits its boat.

A simple tender, just one of tens of thousands found in Brittany. It was used to get to the buoy where the ship had been bobbing. The crew has already climbed over the ship's freeboard, stowed the oars, and set sail. Hours have passed and the dinghy still waits. The late-day sun, which remains unequaled for creating simple seascapes, illuminates the hull. Nearby the floating docks of Trinité-sur-Mer ring with the sound of lines against masts. One of France's largest pleasure ports—with more than 1,200 slips—it opens onto the bay of Gascony, the Belle Île archipelago, Houat, and Hoëdic. The preserve that originally belonged to Éric Tabarly abuts the Gulf of Morbihan. This small sea, dotted with hundreds of islets and measuring only about 30,000 acres (12,000 ha), is a dream destination for pleasure sailors. That is, if one knows how to navigate the fearsome currents that churn in these seemingly gentle waters.

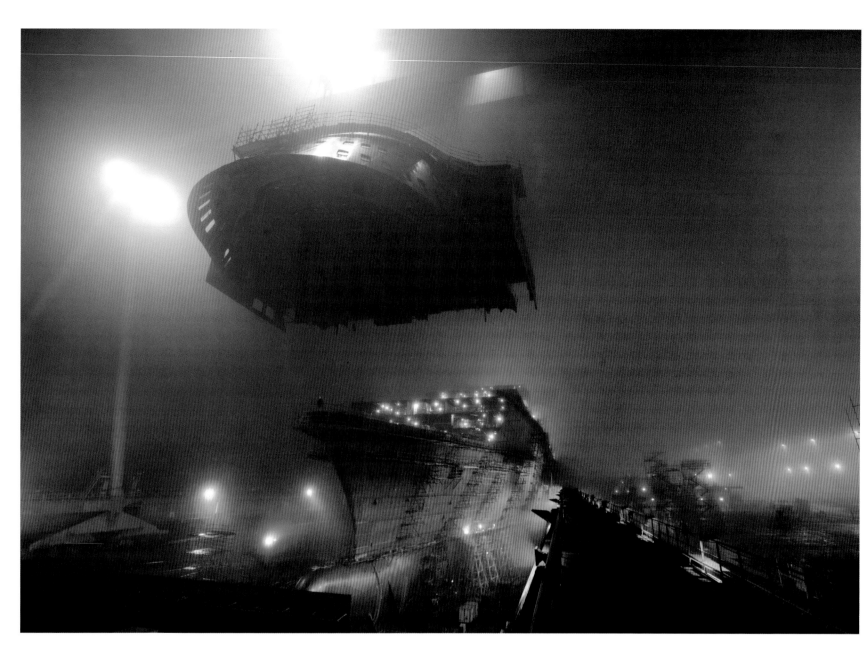

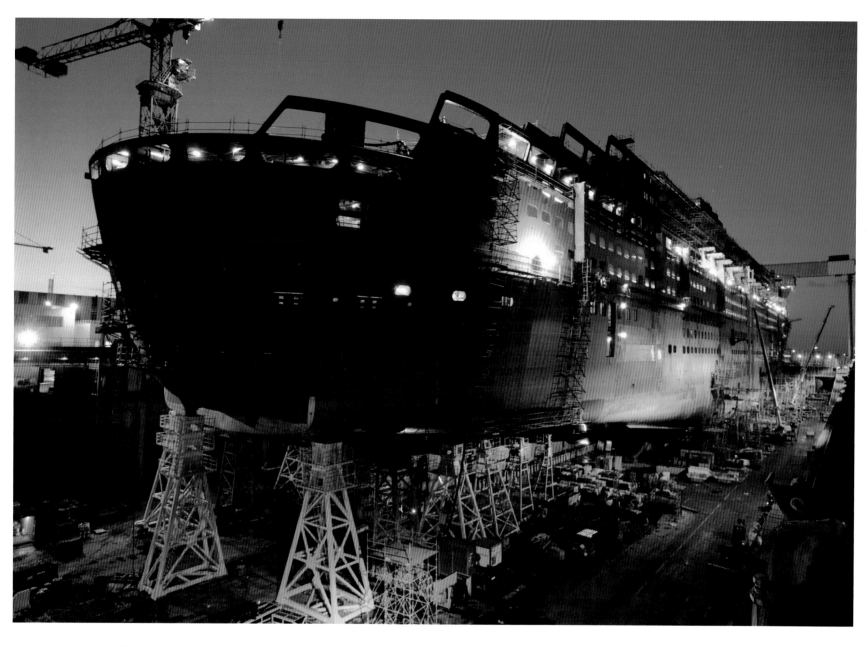

IN SAINT-NAZAIRE, THE LARGEST CRUISE SHIP IN THE WORLD TAKES SHAPE.

In the night of February 1, 2003, the stern of the *Queen Mary II* was endowed with its superstructure. On January 16, 2002, the date its construction began, the world's largest cruise ship began to take shape. Most of the twelve thousand employees and subcontractors working for the Alstom Shipyards of the Atlantic did not witness the spectacular workings of the operation, but in the morning, each could judge the evolution of the ship. The *Queen Mary II* has taken up a challenge: to rejoin Europe with America, despite the fact that no one has built a transatlantic cruise ship for more than thirty years. Its measurements presented a challenge for the shipyards of Saint-Nazaire. Its hull is 1,131 feet (345 m) long—148 feet (45 m) longer than the Eiffel Tower, about the same size as the Empire State Building—making it the longest and widest cruise ship ever built. It will also be the tallest, measuring 236 feet (72 m) from its keel to its stack, the equivalent of a twenty-three-story building.

A FISHERMAN WITH HIS "LADY OF AQUITAINE LACE."

They have a wild charm, these "ladies" of the rivers, deltas, and coasts of Aquitaine. Lopsided cabins balanced on graceful stilts, these huts that lean into the void, along with their meticulous fishermen, are peppered throughout the Vendée and Médoc regions of France. They have kept in use the finest of fishing nets—the *carrelet*, or square net. Mounted on a chestnut-wood frame measuring almost 10 feet (3 m) on each side, these nets used to be cast from the boat; a flat-bottomed boat would pull the fish in toward the boat. Later, fishermen found it more convenient to construct a lean-to over the water that was fitted with a hoist. Then elvers, mullet, and shrimp would have the bad fortune to get caught in the meshing of these highly efficient nets. Aficionados were well aware of the value of these nets and were willing to pay a high price for them.

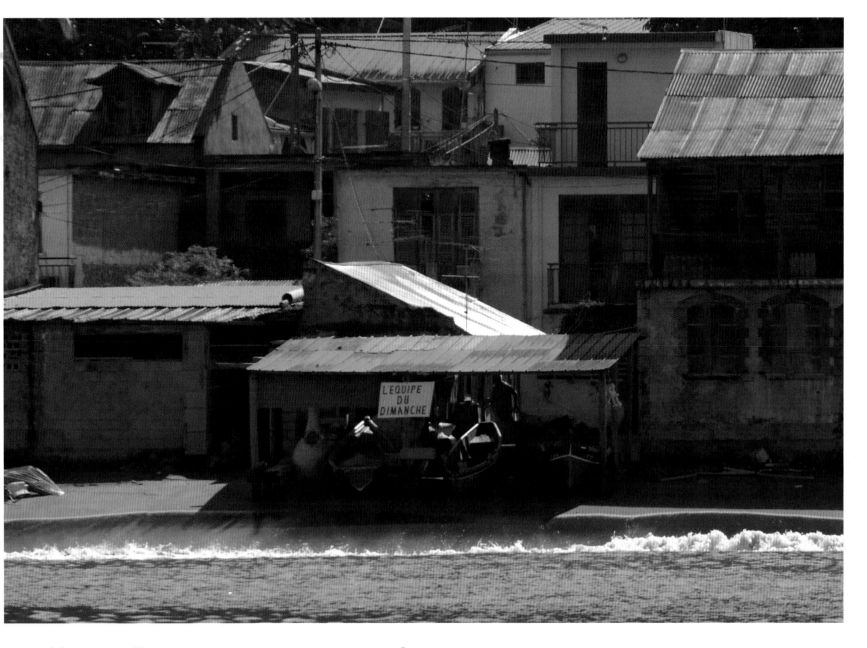

MARTINIQUE. THE BOATS SLEEP IN THE SHADE WAITING FOR SUNDAY.

The hot hours of the day burn on the horizon. Men, gathered under a roof of palms, mend a net torn during the morning catch. Jokes in Creole rain down. The radio surges dance rhythms and voices sound smooth as rum, an aged rum marinated with a branch of *bois bandé*, a few banana slices and lots of spices. "And if we baptize the place?" jokes someone. A few minutes later, a sign is hung up that will send smiles as far as the neighboring villages. This little group of friends is known as "Sunday's Team." When aboard one of the skiffs during the Sunday races, they are formidable sailors. In years past, the captain had built his own *gommiers*, carving them from a single piece of wood from the best tree for canoes—the *gomyé*, or gum tree. And thus, the origin of the name of these streamlined boats. Typically found throughout the Caribbean, these indigenous American boats have been around for more than 2,000 years.

THE GULF STREAM CREATES A TOUCH OF THE EXOTIC ON THE BEACHES OF THE COTENTIN.

Turquoise sea, transparent water, fine sand pink under the setting sun, this postcard could hearken from some island at the end of the world, but in fact, this is a beach in the Contentin peninsula in northeast Normandy. The miracle of the Gulf Stream, this hot current 77 °F (25 °C) born on the African coastline, passes off the shores of Brazil and travels the length of the New World before returning to French and British shores, displacing some 1,900 million cubic feet (55 million m³) of water per second. Warmed by this tropical current, at low tide when the English Channel recedes, an exotic beach emerges framed by the two cliffs. On dry land where the ancestral landscape is a blend of moors, woods, and marshlands, this exceptional climate also has its effect. In Flamanville, around the seventeenth-century chateau, conventional camellias and hydrangeas grow side by side with palm trees.

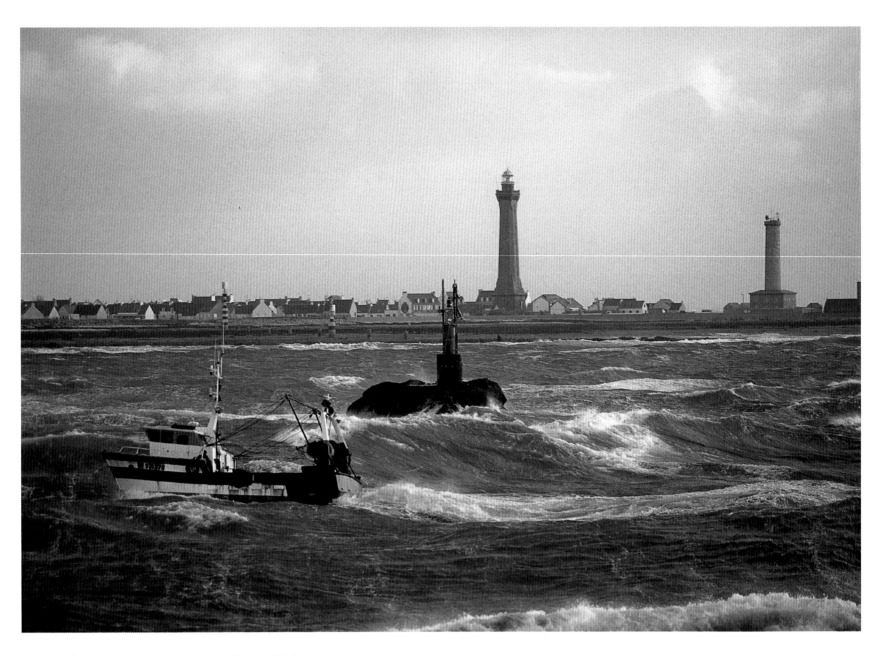

RETURNING TO THE PORT OF SAINT GUÉNOLÉ
UNDER THE WATCHFUL EYE OF THE PRINCE OF LIGHTHOUSES.

Six towers keep guard over the breakwaters of Penmarc'h, which goes to show that the point of Brittany needs its beacons. In the foreground, the perch indicates the way toward the port of Saint Guénolé. Just to its left, mixed in with the houses, the black-and-white-striped towers form a line that facilitates entry. To the right, in a wind-bleached sky, rises the Prince of Lighthouses. Built thanks to a bequest made in the memory of a marshal under Napoleon, Echmühl celebrated its centenary in 1997. At its sides, the old beacon and the navy's semaphore create a tableau from which one can deduce that these waters are not always calm. Seawalls protect the land from swells that can turn deadly here after gaining force in the Atlantic. Of Brittany's 1,100 miles (1,800 km) of coastline, the point of Penmarc'h is one of those spots least associated with southwesterly winds. Its port, however, is the site of a popular auction, and is one of France's most productive ports in terms of tonnage unloaded.

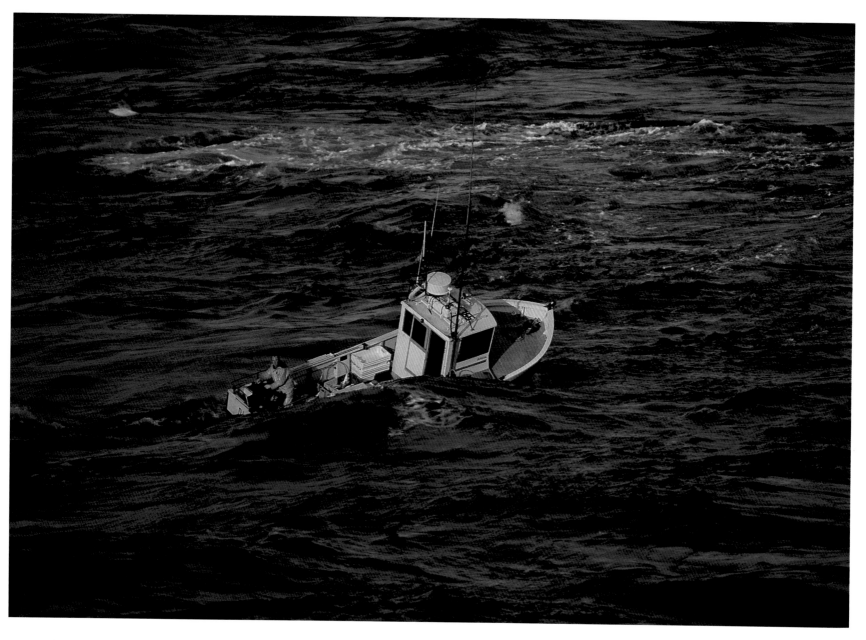

The fishing sector uses various approaches. Factory ships measuring more than 325 feet (100 m) long sometimes spend months at sea on intensive expeditions. As soon as the fish are caught, they are washed, gutted, sometimes filleted, and frozen on the spot. Deep-sea fishing uses industrial vessels 100 to 160 feet (30 to 50 m) long that stay out for two weeks at the most. Coastal fishing takes place within some 50 miles (90 km) from shore, on trawlers 40 to 80 feet (12 to 25 m) long. These fishermen, familiar sights in the seascape, usually go out only for the day, filling their nets with wriggling crustaceans and shellfish. Alongside this small-scale commercial activity is inshore fishing, which is done for just a few hours a day. This is what the bass fisherman and the gull are engaged in. The differences between the various fishing methods lie in the nature of the catches and the degree to which natural resources are affected. The range of methods makes it difficult to reconcile the area's various interests. It also increases the risk of mergers at the expense of small-scale fishing, which does very little environmental harm, while less sustainable activities are capable of doing a great deal of damage.

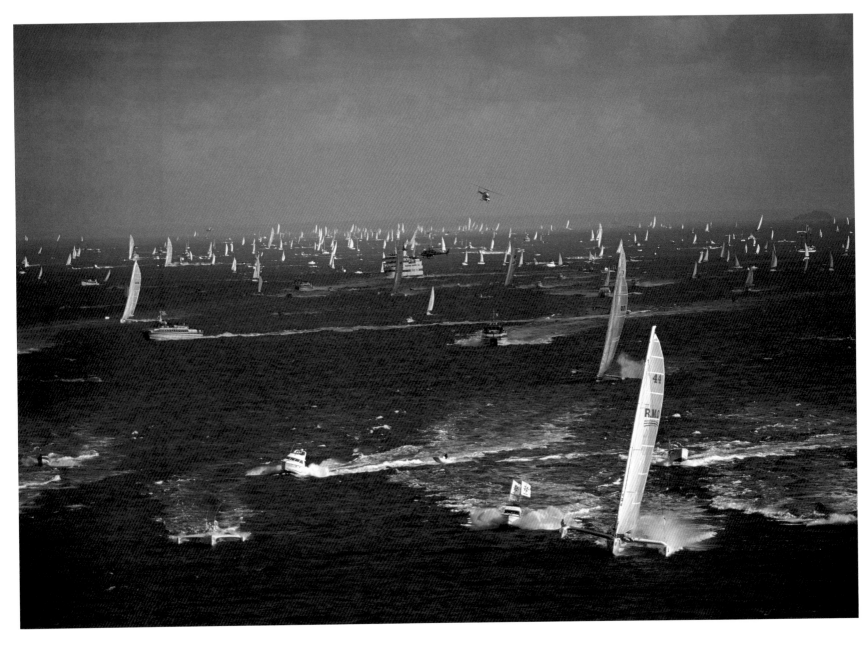

ROUTE DU RHUM. THIS SOLO TRANSATLANTIC RACE FROM SAINT-MALO TO POINT-à-PITRE,
FIRST RUN IN 1978, WAS THE BRAINCHILD OF COMMUNICATIONS EXPERT MICHEL ÉTEVENON.
IT HAS BECOME THE STANDARD BY WHICH ALL HIGH-SEA RACES ARE JUDGED—BUT AT WHAT A PRICE!

During the first Route du Rhum—"Rum Road"—race, Alain Colas, sailing *Manureva*, was lost at sea. In 1986, Loïc Caradec cap-
sized the *Royale* and was never found. Here, at the start of the 1989 race, Laurent Bourgnon, in the lead, is setting the pace, but it
will be Florence Arthaud who becomes legend when she arrives first in the French West Indies. Every four years, the trimarans
in the prestigious Route du Rhum, loaded with state-of-the-art equipment, outdo one another in sophistication. In the seventh
race, run in November 2002 (the first without Michel Étevenon), sixty entrants, including eighteen superpowered multihulls
with sails more than 58 feet (18 m) across and masts 98 feet (30 m) high, pranced at the starting line. Only three of the gigantic
new trimarans achieved the triple feat of going fast (30 knots at times), staying upright, and arriving in one piece. Are the
fragility of carbon fiber and the vehemence of the weather alone responsible for such a massacre? Trying to set a record, this time
"going for it" ended in "going under."

CALM WEATHER OVER THE RAMPARTS OF SAINT-MALO, THE TOWN OF PIRATES.

In the foreground stands the Solidor Tower that once controlled the mouth of the Rance. In the background, the Saint Vincent Cathedral's clock tower dominates the old city, and to its right the somber mass that is the chateau abuts the Quic-en-Groigne Tower. Even in calm weather and the gentle light of the setting sun, this ancient pirate town, a citadel on the northern Brittany coast, exudes a military austerity. Offspring of this granite city sheltered by ramparts include the adventurer Jacques Cartier who took off to discover Canada and the corsairs Duguay-Trouin and Surcouf, who sailed the seas of the world in the name of the king of France. Another of the city's heroes, the writer François-René de Chateaubriand, is buried on the Île du Grand Bé, a stone's throw from the walls he had seen erected. In Saint-Malo, the storms are spectacular and the sea, at high tide, comes crashing against the ramparts, drowning them in a deluge of spray.

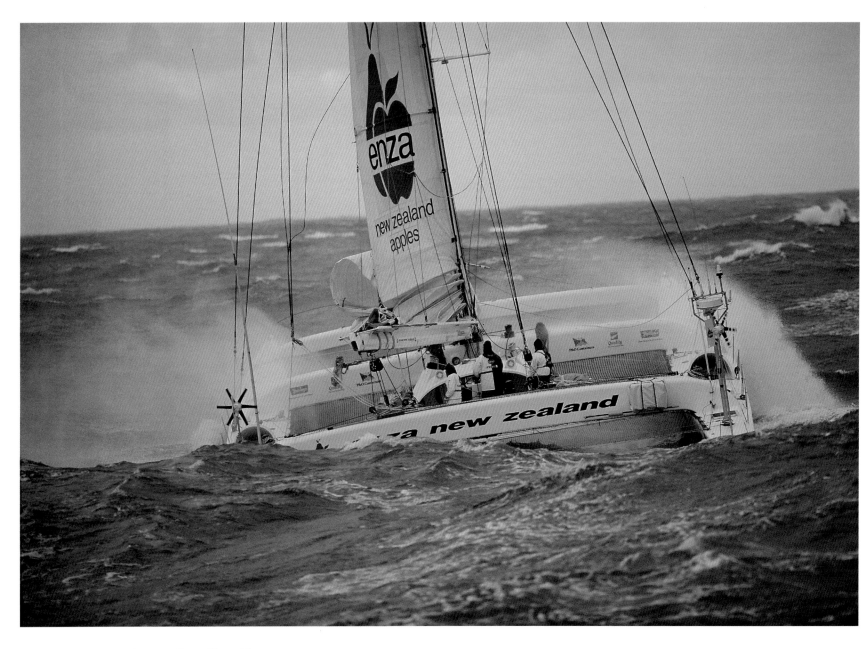

SIR PETER BLAKE. THIS NEW ZEALAND SAILOR
WON EVERY CREWED RACE ON EVERY OCEAN OF THE WORLD.

New Zealand junior champion at twenty years of age, Peter Blake made his real entrance into the sailing world
in 1979, when he won the tragic Fastnet of that year, in which seventeen competitors were lost at sea. An
extraordinary series of victories validated that success. He won the Fastnet again in 1989 and dominated the
Sydney–Hobart races of 1980 and 1984; the Around Australia in 1988 and in 1990; and the mythic nine-leg
Whitbread Round-the-World. In 1994, aboard *Enza*, he relieved Bruno Peyron of the Jules Verne Trophy. He
won the America's Cup again in 1995 and successfully defended it in 2000 before retiring from competitive
sailing. His brilliant sailing career was cut short by his premature death. Sir Peter Blake was murdered by pirates
in December 2001 as he was about to conduct an expedition up the Amazon aboard the *Antarctica*. His tragic
end closed a life devoted to the study and protection of the planet's marine environment.

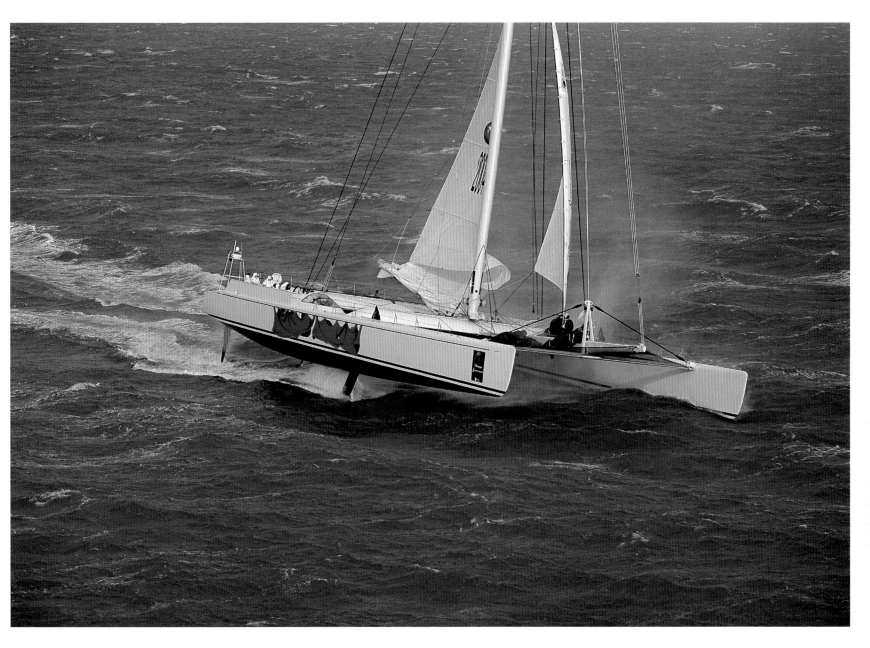

THE PEYRON BROTHERS. BRUNO WAS THE FIRST (1993) AND LAST (2002) TO WIN THE JULES VERNE TROPHY.
LOÏC RULES AS AN EXTRAORDINARY HELMSMAN IN THE WORLD OF OCEAN-GOING MULTIHULLS.
STÉPHANE ALSO GOES AROUND THE PLANET, TAKING PICTURES THAT SHOW THE WONDERS OF EARTH.

Conceived in 1990 by a handful of famous sailors who accepted Phileas Fogg's challenge, the Jules Verne Trophy is awarded in a contest that consists of sailing around the world, by way of the three capes, in fewer than eighty days. Bruno Peyron did it in 1993 (seventy-nine days), but he lost the trophy the next year to the New Zealander Peter Blake, who returned after seventy-four days. Olivier de Kersauson set the new record of seventy-one days in 1997, but Bruno Peyron made a comeback in 2002 (sixty-four days). These performances are light-years away from the time clocked by the first complete sailing trip around the world— Ferdinand Magellan's interminable, epic voyage. Magellan left Europe in September 1519 with five ships and a crew of 265, the first European navigator to cross the unexplored Pacific, but he died in the Philippines. His expedition, reduced to a single ship bearing eighteen men, returned in September 1522, having taken three years to complete the first trip around the globe.

The *Belem*, which emerged from the Dubigeon shipyards in Nantes in 1896, carried cacao beans from Belem, in Brazil, and took its name from that very active port at the mouth of the Amazon. From 1896 to 1914, the French three-masted bark made some thirty transatlantic crossings between Nantes, its permanent home port; French Guiana; and the French West Indies, on behalf of the famous chocolate makers Meunier. After its purchase by the duke of Westminster, who turned it into a luxurious yacht, it became in 1921 the property of the brewer Sir A. E. Guinness, who rechristened it the *Fantôme II*. Taken out of commission in 1939, the *Belem* lay almost forgotten in a river bend on the Isle of Wight. The Giorgio Cini Foundation rescued it in 1952, rigged it as a schooner-brig, and turned it into a training ship. In 1979, the Association for the Protection of Traditional French Ships made everything shipshape. The *Belem*, now eighty-three years old, got back its name, its original three-masted bark rigging, and its French flag—this after flying British colors for thirty-eight years and Italian ones for twenty-four. Since 1980, the bark, now owned by the Belem Foundation, has been a training school open to all.

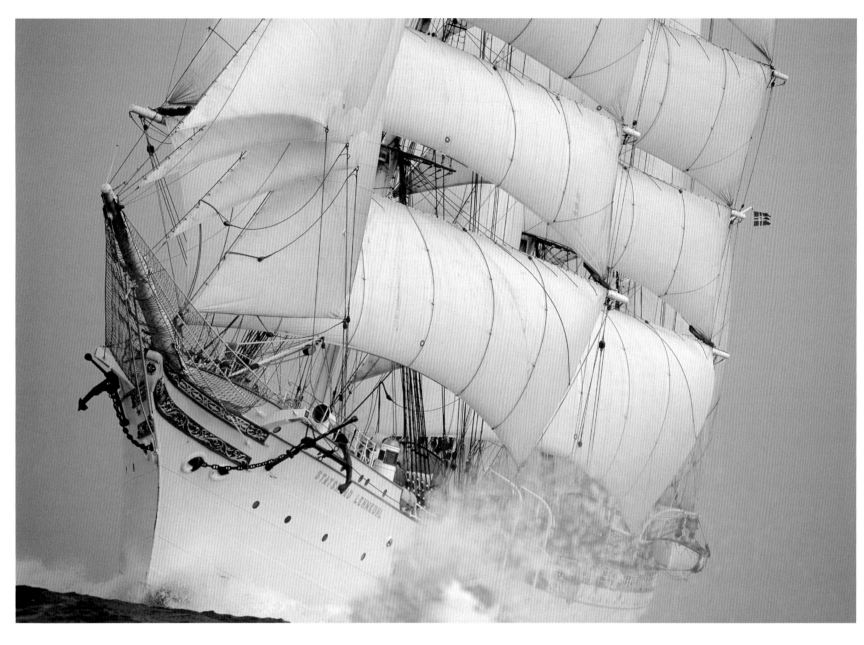

ALEE. TO BE PASSED ON THE WINDWARD SIDE BY A THREE-MASTED BARK
WITH ALL SAILS SET IS A WONDROUS AND MOVING SIGHT.

All dressed up, the *Statsraad Lehmkuhl* rushes to the armada of the century. The Norwegian three-masted bark is
an old hand at these gatherings of tall ships. Built in Germany in 1914, it first put its almost 320 feet (98 m) at
the service of the German merchant marine. At the end of World War I, the British seized it as a prize. In
1923, Norway acquired it and rechristened the great bird in honor of a former Norwegian minister, Kristoffer
Lehmkuhl. It survived World War II, when it was requisitioned by the Germans. Repatriated to Norway after
the end of the war to serve as a training ship, it was bought by the ship owner Hilmar Reksten, who restored
and sailed it. Operated today by a foundation of the same name, it pursues its career as a training ship; perched
on its yards like rows of sparrows are young people of every nationality who have come to learn to maneuver its
21,500 square feet (2,000 m²) of sails.

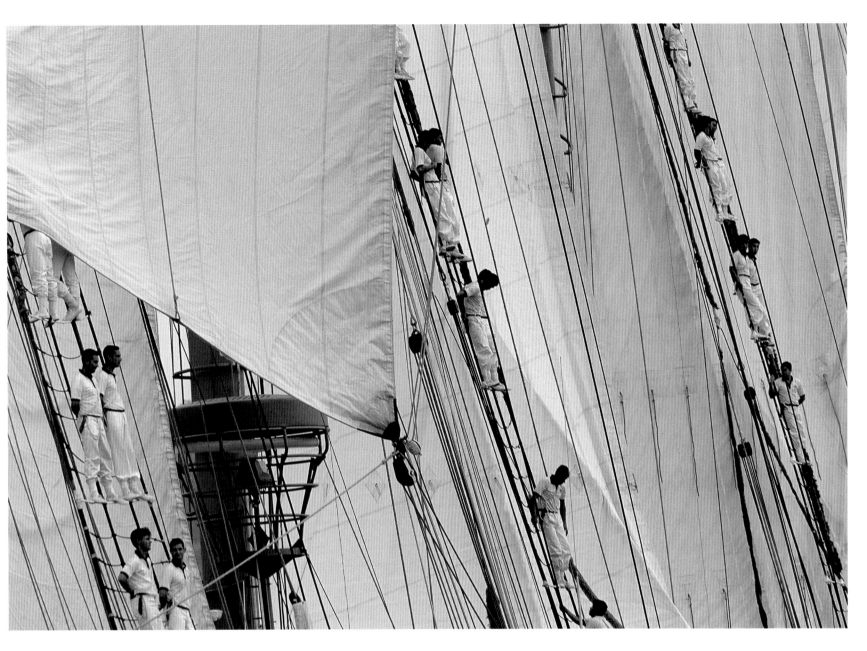

The Seine passes through Rouen, Normandy's sea and river port, then continues for 75 miles (120 km) before reaching the English Channel. In some years, when Rouen hosts an armada of the world's largest sailboats and warships, the river carries the dozens of boats and bears the great parade of traditional sailing ships to the sea. Standing acrobatically in the shrouds, Chilean navy cadets salute the moved, admiring spectators who crowd the riverbanks. These sailors were among the 8,000 crew members, representing more than thirty countries, who came to the event. Ships came from Turkey, Morocco, Argentina, Uruguay, Holland, Norway, and Poland, to name only a few of the participating countries, and every vessel tells a different history. Together, they touch the heartstrings of humanity's common history—so brief yet already so full.

THE BELEM. STOP KNOT.
The crew uses a stop knot to throw the hawsers of a large ship as they maneuver to dock it. This ball of rope is attached to the end of a line and tossed from the boat's bridge. The harbor pilots catch the knot and haul in the line, thus also pulling in the hawser attached to it. The maneuver is repeated for each of the hawsers, which are too heavy and too big to be thrown onto the dock like mooring lines. The miniature versions of this knot that adorn key chains have given it a certain celebrity outside nautical circles. The word "knot" turns up often in sailors' parlance in reference to more than cordage. For example, the wind also makes knots, as do boats; in this sense, "knot" expresses speed, specifically the number of nautical miles crossed per hour. A nautical mile, in turn, represents a minute of latitude, which is the equivalent of 6,076 feet (1,852 meters).

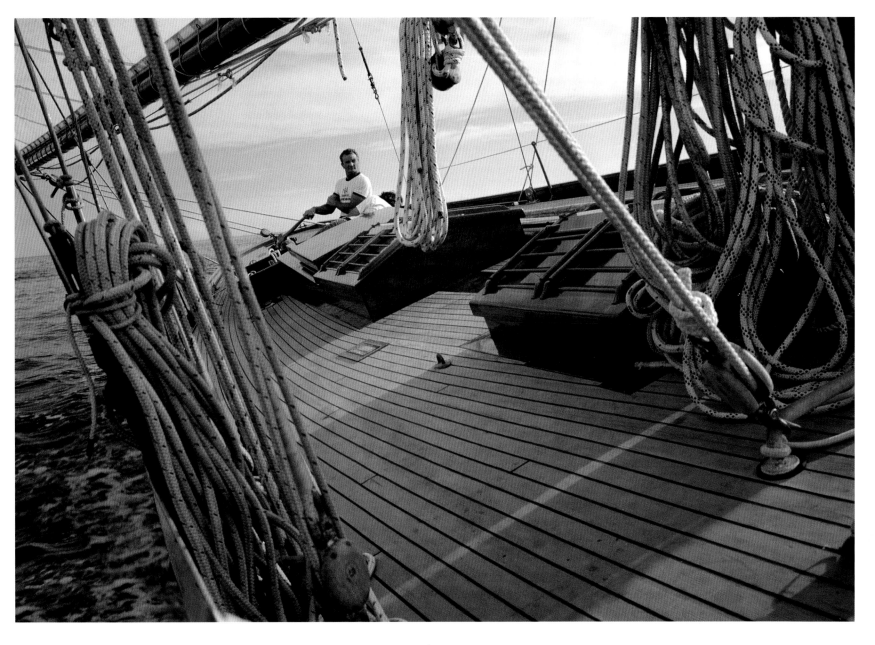

PEN DUICK—IN BRETON "THE LITTLE BLACK-CAPPED CHICKADEE"—
IS A FAMILIAR NAME TO ANYONE WHO LOVES THE SEA.

It has been borne by the various sailboats steered by the expert hand of Éric Tabarly, one of the century's great-est sailors and without a doubt the best-known French mariner. His first *Pen Duick* was the small family sail-boat, built in Ireland in 1898, which he bought from his father. Those that came after, born of his passion for classic sailboats and his interest in technical innovations, allowed him to win most of the important ocean-going races, beginning with the English Transatlantic of 1964. And it would be aboard his favorite, *Pen Duick I*, a majestic cutter that had just turned 100 years old, that he went down on a June night in 1998 off the Welsh coast, leaving behind the memory of an extraordinary sailor and man. In the words of Olivier de Kersauson: "He was a magnificent captain, and one of the good people."

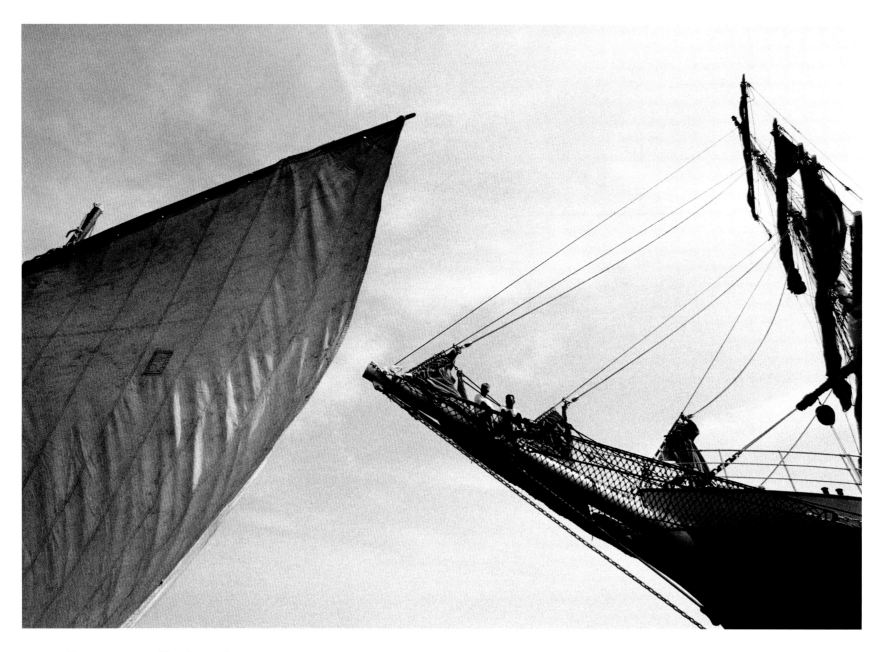

PASSING SHIPS. THE *BELEM*'S BOWSPRIT, BETWEEN SKY AND SEA, WATCHES ITS NEIGHBOR'S FORESAIL PASS BY.

Every year, more than a thousand sailors-in-training board the *Belem*, the flagship of the French sailing fleet, to be initiated into the customs and rules of old-time navigation, thereby discovering traditional sailing and honing their nautical skills. Every student receives the topman's manual, a guide for the sailors charged with maneuvering. Theory, however, is often different from the real—sometimes hard—life on board that awaits the crew. The fifty or so apprentice sailors assist the crew of five officers and eleven experienced sailors in all the tasks required for the ship to function: day and night watches, rudder, seamanship, security, maintenance, daily chores, and handling the rigging. It is a world made up of 13,000 square feet (1,200 m²) of canvas complicated by 200 lines and as many pulleys. No training would be complete without the chance, for those who so choose, to perform the most symbolic ritual of all on the ships of yesteryear—climbing the shrouds to the masts and spars and, once hoisted (and harnessed!) onto the yards, remaining cool enough to take in the sail—an unforgettable experience!

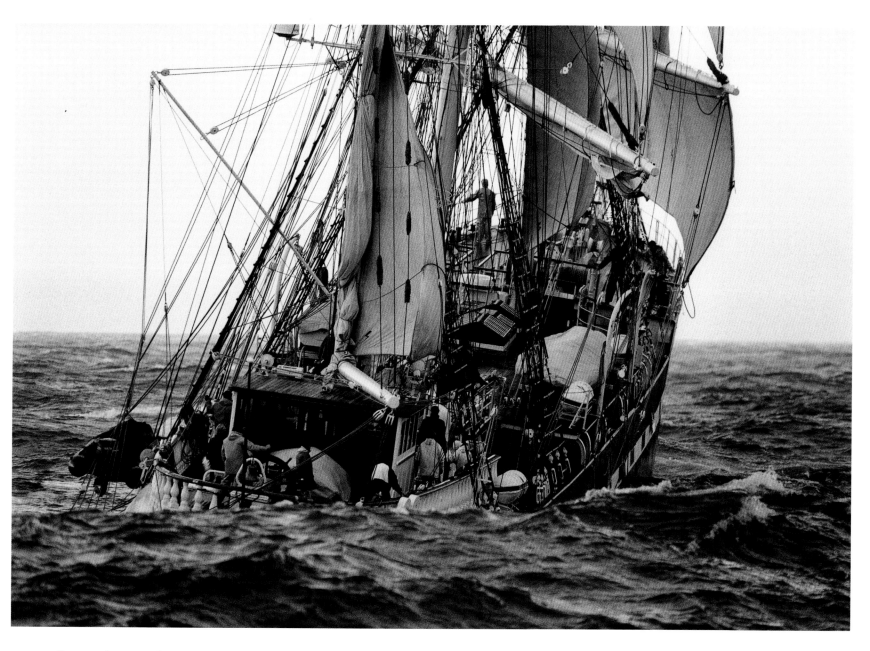

BELEM. IN LATE OCTOBER 1995, THE BELEM RETURNED TO THE ATLANTIC OCEAN AFTER SUMMER SCHOOL IN THE MEDITERRANEAN. RIDING HIGH AND STRONG AMID THE WAVES, IT RECALLS THE PRIDE OF ITS LONG JOURNEYS AT SEA.

The *Belem*'s stern, as it cruises off Belle-Île, reveals a network of lines, knots, and pulleys. These are the "hauling ends," a generic term that includes halyards, sheets, mooring lines, hawsers, gaskets, and many more. There is an entire glossary of words to be decoded to be able to hoist the sails, trim them, and moor the ship. The art of working with the cordage is called "seamanship." There are several thousand kinds of knots that serve as many specific purposes. Not all of them are used on today's yachts, but a handful are still indispensable. The knots' names, as poetic as a Jacques Prévert bestiary, are often better known than how to tie them: bowline hitch, capstan knot, granny knot, sheepshank, and so on. Synthetic materials, such as nylon, Tergal, and Kevlar, have replaced natural fibers, such as cotton, hemp, and Manilla hemp, used in yesterday's handling ends and lines. But this doesn't change the heart of the matter. Whatever the boat, there will always be a knot that must be tied—and tied well.

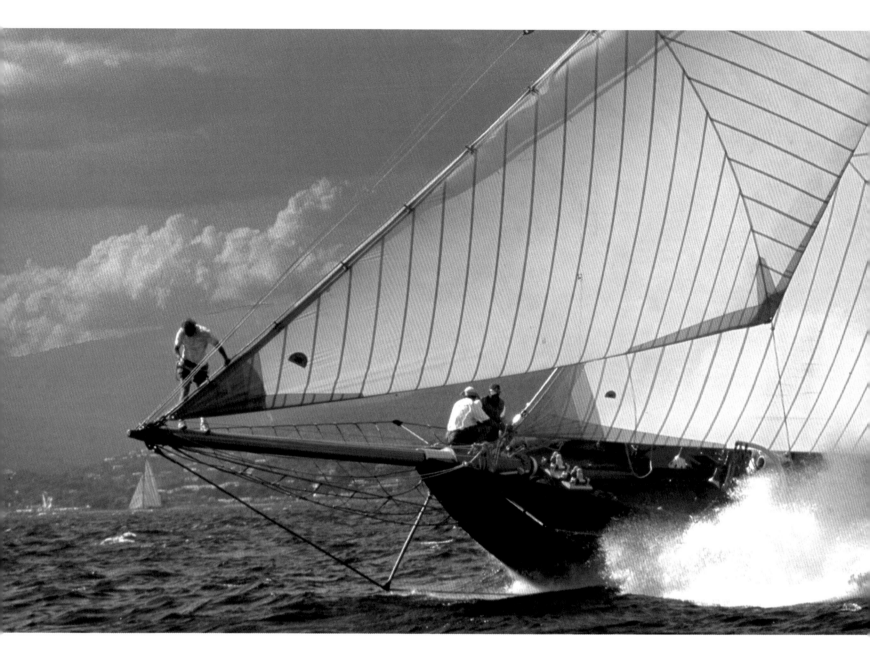

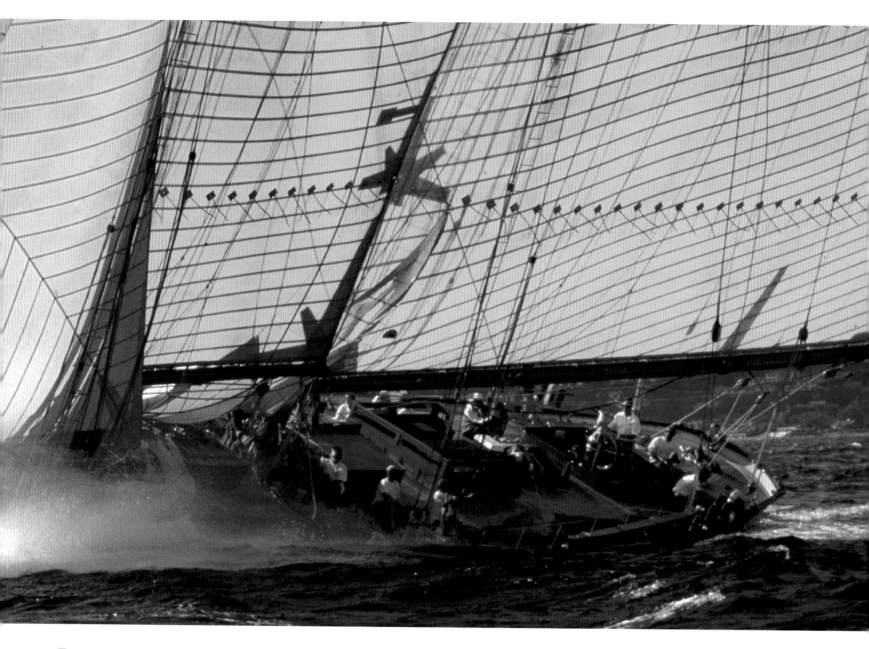

THE CREW AT THE BOW.

It was in 1915 that the *Mariette* left the shipyards of the "Wizards of Bristol," located in the United States. At the beginning of the twentieth century, Nathanael Herreshoff and his brother, the two architects of this boat, experienced a period of great repute in the world of yachting. Nathanael essentially designed these vessels without any plans, sculpting the half-hulls alone, and then his brother, who had gone blind, validated them by touch. This rather unusual method did not prevent them from constructing magnificent schooners such as the *Mariette*, the *Katoura*, the *Elena*, and the *Queen*. After having been appropriated during World War II, the *Mariette* experienced a protracted period of decline before being saved from a ship cemetery in the Caribbean. It was then rebuilt in Italy. Finally, in 1980, it set sail with all its interior fittings restored. However, despite its natural elegance, the deck-to-sail ratio was poorly designed. Since then, the vessel has regained its original magnificence; it can make long tacks, as pictured here in the Mediterranean handled by a crew that is among the most experienced in the world.

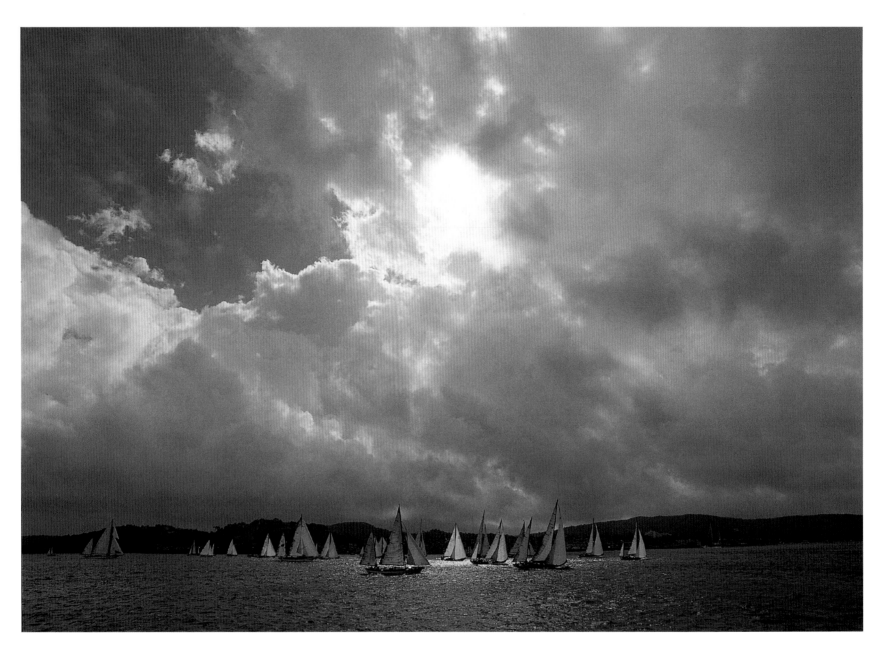

THE NIOULARGUE UNDER A "BRETON SKY." CLASSIC FROLICKING IN THE BAY OF SAINT-TROPEZ.

Born in 1981, the Nioulargue—"nest of the open sea" in Provençal and the name of a shoal—is the last stage of the Prada Challenge for Classic Yachts, a race circuit reserved for yachts of prestige. Products of nearby ship-yards such as the astonishing Wally, and flagships of the classic yachts, two hundred and fifty to three hundred sailboats participate in the regatta each season, sailing from Sardinia and passing through Cannes and Monaco. Renamed the "Sails of Saint-Tropez" in 1999, the event is set every autumn in front of the Pampelune beach in Saint-Tropez. Before the ecstatic lenses of the paparazzi, the crews in full regalia undertake several days of sail-ing in the pure yachting tradition. Born in the Netherlands, four centuries after the first pleasure sailboats, the Batavian *speeljachten*, the race continues to mix elegance with performance.

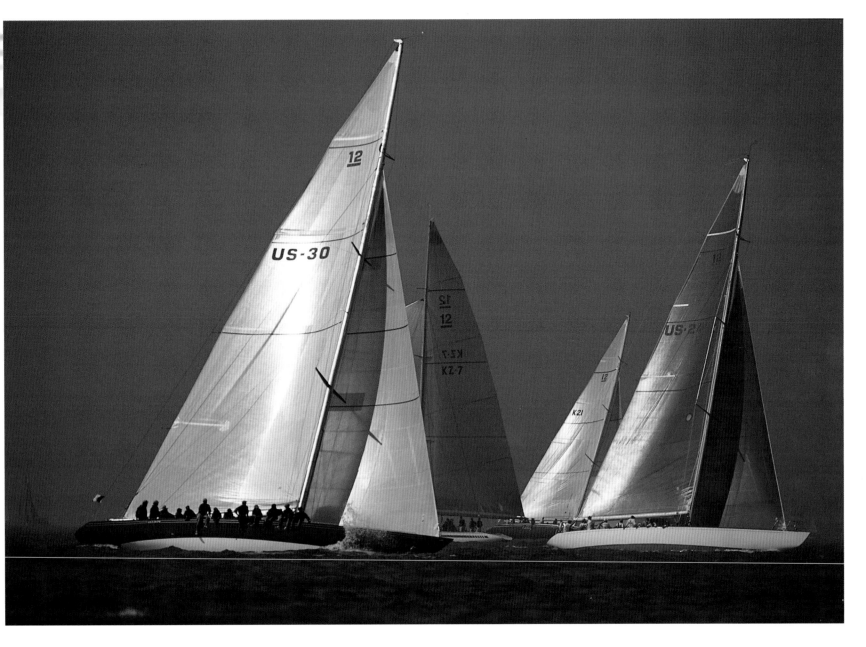

ISLE OF WIGHT. AN INTENSE CONFRONTATION IN THE BREEZES OF THE SOLENT
ON THE OCCASION OF THE 150TH JUBILEE OF THE AMERICA'S CUP.

The Solent is that pretty arm of the sea that separates the Isle of Wight from England and unites regatta sailors
of the world. It is home to charming little ports, one of the most famous of which is Cowes, on the north side
of the island. In 2001, the 150th jubilee of the America's Cup was held in Cowes, the birthplace of the cup
race. The two yacht clubs that had originally vied for the cup were none other than the New York Yacht Club
and the Royal Yacht Squadron of Cowes, a little more than one hundred and fifty years ago. And so for an entire
week that August, numerous 12-meter yachts competed under the British sun. Among the participants of this
friendly—though competitive—meet were several finalists of earlier America's Cups: *Shamrock* (1930), *Endeavor*
(1934), *Australia II* (1980), *Luna Rossa* (2000), and *New Zealand* (2001). Sir Peter Blake, Dennis Conner, and other
famous captains also took part. The winds responded favorably to the invitation.

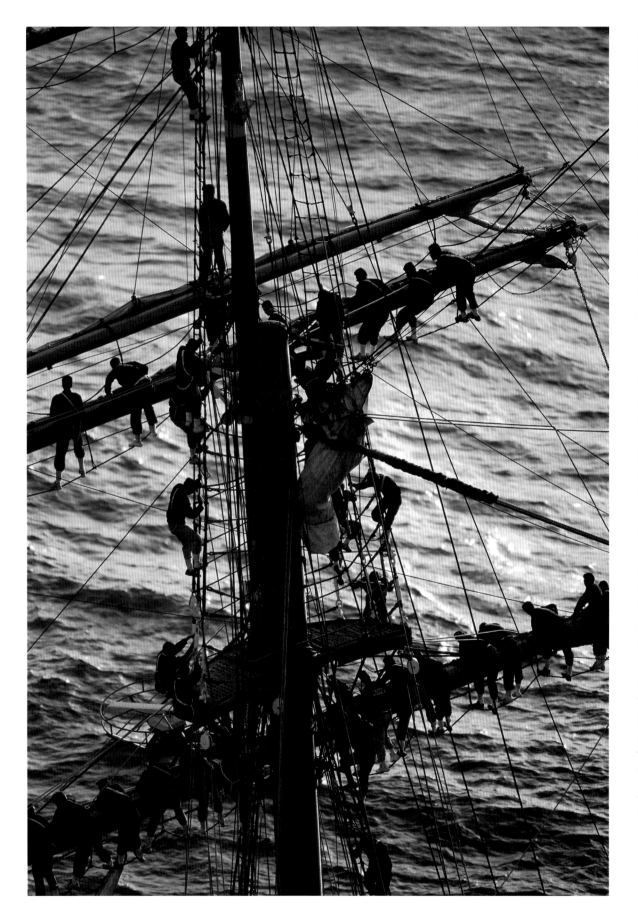

SAILING SHIP. TAKING IN
THE SAILS ABOARD THE
ESMERALDA, THE CHILEAN
NAVY'S TRAINING SHIP.

As the *Esmeralda* steers its
course, countless hands fold and
tie the sails onto the long yards.
Its sailors perch in the rigging,
as required by naval tradition.
The Chilean navy launched this
training ship in 1953; a four-
masted schooner, the *Esmeralda* is
one of the world's most beautiful
sailing ships. One of its fellows
in the legendary fleet of the
giant tall ships is the *Libertad*,
an Argentine three-master some
341 feet (105 meters) long; in
1966, the *Libertad* crossed the
North Atlantic by sail in eight
days. Other tall ships include
the *Sedov*, a Russian four-master
some 382 feet (117.5 meters)
long, with more than 43,000
square feet (4,000 square meters)
of sails; the *Belem*, a frisky French
three-masted centenarian; the
Belle-Poule and the *Étoile*, insepa-
rable twin French schooners
that have been cruising the
seas together since 1932; the
Cuauhtemoc, a Mexican three-
master that gobbled up
26,000 miles when it sailed
around the world in 180 days;
and the *Lord Nelson*, a three-
master launched in Great Britain
in 1985 and specially designed
to accommodate the disabled.
The great sailing ships of today,
be they training schools, cruising
ships, or movie stars, still have
the power to make us dream.

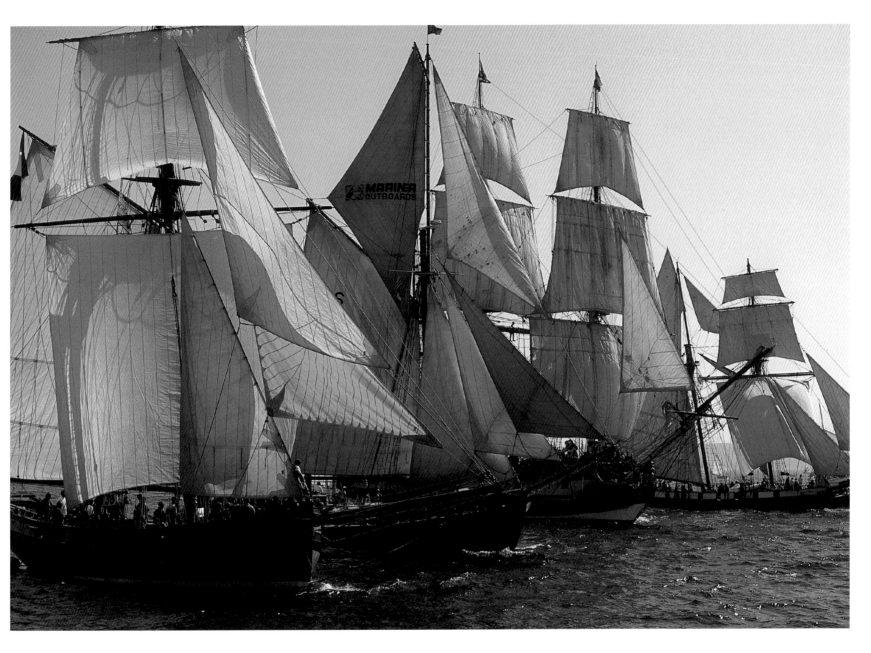

HAPHAZARDLY FOR THE ARMADA, A HAPPY MOMENT, BEYOND BORDERS AND THE AGES.

Brest. July 1996. Four years after the first International Festival of Sailing Boats, almost two thousand tradi-
tional ships—the largest, the oldest, the rarest, and the most famous that exist—gathered at Douarnenez,
37 miles (60 km) south of the Cité du Ponant, off the capes of Finistère. In the wake of the explorers of the
past, the tall ships the *Boussole* and the *Astrolabe* veer past the Goulet and bear down on the Tas de Pois, the
islets of Camaret. Around the sandstone cliffs, a flock of pleasure boats escorts the ancient rigs. In total, almost
three thousand boats performed in this unlikely ballet. Pictured here, the schooner *La Recouvrance*, the ambas-
sador of Brest, which left the Guip shipyards in 1992, sails in tandem with the *Rose*, which had crossed the
Atlantic for the occasion. In the foreground the *Renard*, a replica of the *Surcouf*.

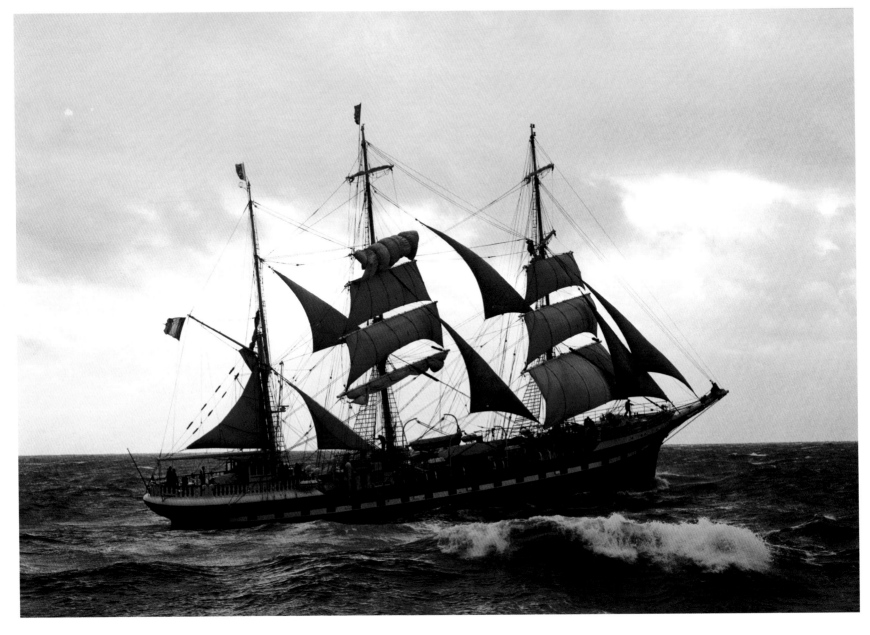

THE BELEM, PRESENTLY CLASSED AS AN HISTORIC MONUMENT, IS ENTITLED TO SPECIAL ATTENTION. THIS WAS ONLY ITS FIRST CENTURY—IT HAS MANY MORE MILES TO SAIL.

The last of the grand French three-masters is still fiery and responsive despite its great age! Built in Nantes in 1896, the *Belem* originally carried cocoa beans. A faithful attendee at gatherings of tall ships, it has honored all the festivities at Rouen and Brest with its presence. When not fulfilling its social engagements, it carries students who wish to practice traditional sailing aboard the last survivor of the fleet of great French merchant sailing vessels. The powerful three-master with its square steel sheet is 189 feet (58 m) long. Its rigging comprises twenty-two square sails and staysails, distributed among the foresail, the 111-foot (34-m) mainmast in the middle, and the mizzenmast aft. Under good weather conditions, it takes thirty to forty minutes to set all the sails and at least an hour to take them in. A complete going about—the maneuver necessary to change course—requires almost twenty minutes. To sign on as an apprentice sailor aboard the *Belem* means a lot of hard work!

CAULKING. THE BELEM
BEARS THE MARKS OF THE
WORK DONE ON HER EVERY
DAY TO KEEP THE RAVAGES
OF TIME AT BAY.

Crouching on the bridge,
curved over his meticulous,
laborious task, this man restores
the caulking of a wooden ship.
The operation consists of
stuffing oakum into the inter-
stices between the planks that
sheath the hull of a wooden
ship and its bridge to make sure
it is watertight. In the past, the
caulker—the crew member once
assigned to this specific job—
was generally considered a
poor sailor, relatively unapt at
maneuvering the rigging, and
so only good for this dirty
chore. Today, the caulker is a
sought-after artisan who main-
tains a traditional skill and
with his perfectionism. Manual
ability, the mastery of ancient
techniques, and the passion of
craftsmen who devote them-
selves to the restoration of
traditional ships have made it
possible both to preserve a mar-
itime and cultural heritage and
to return all the splendor and
nobility to the ancient trades.

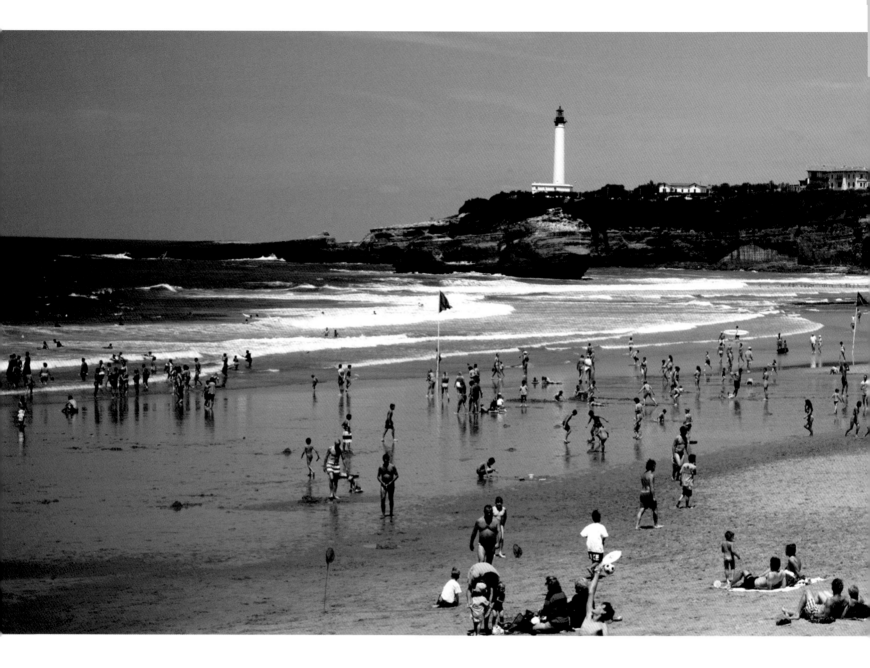

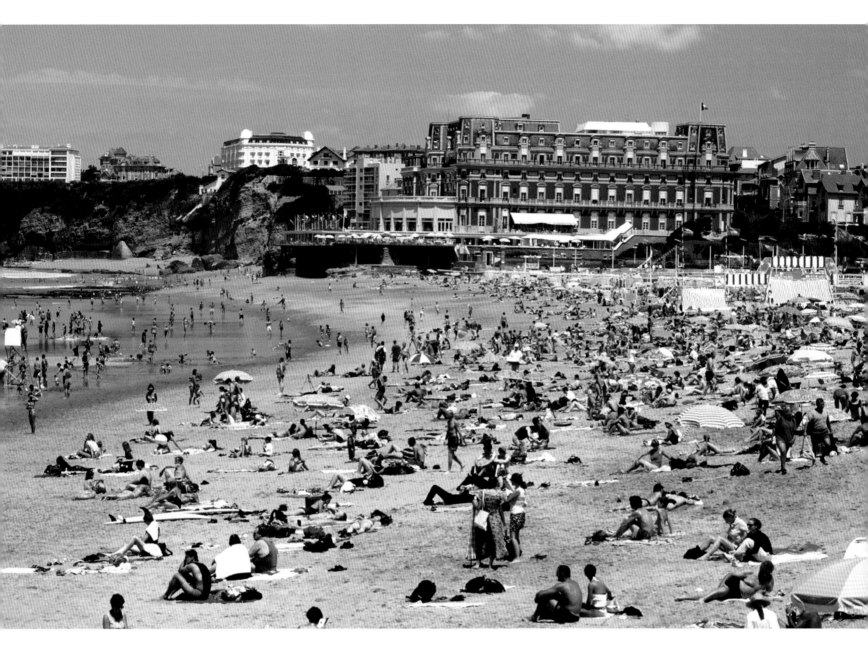

THE GREAT BEACH AT BIARRITZ—FROM IMPERIAL LUXE TO FAMILY HOLIDAYS.

The town's coat of arms stands as a reminder that Biarritz was originally a whaling port. This little village on the Basque coast owes its rapid expansion in the middle of the nineteenth century to the Empress Eugénie. Seduced by the temperate climate, she convinced her husband, Napoleon III, to build a summer residence here. The Villa Eugénia, now the Hôtel du Palais, set the ball rolling. During the *années folles* (1918–29), Biarritz and its beaches became *the* summer spot for European gentry, writers, and artists. But in the aftermath of World War II, society life lost its luster and the atmosphere became more family-oriented. With the arrival of the surfing craze in the 1950s, the town saw its second coming. Surfers were thrilled by those majestic rollers that the Atlantic Ocean cast with the regularity of a metronome onto the fine sand beaches. And from that point on, the old imperial spa has been known as the surfing capital of Europe.

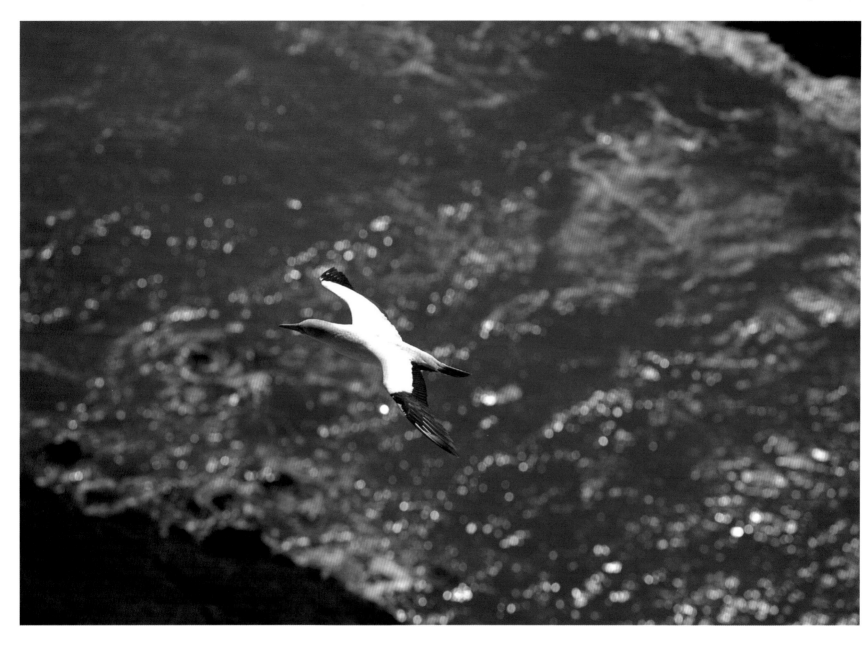

Scotland. A gannet, the ocean's acrobat, keeps watch over its prey.

The elegant gannet stretches out its 6 ¹/₂-foot (2-m) wingspan with such grace over the sea that one can almost forget how poorly adapted it is to fly. Its short, webbed feet give it a slow, waddling gait that is rather comical. But when the gannet wants to take off, it proudly raises its head toward the sky, half-opens its wings, and feebly hops to the edge of the cliff, encouraged by the other birds that prod it with their beaks. Then, after a few flaps of its wings, the gannet rises and takes off into the void, strength and power in flight enabling it to cover great distances. What's more, its fishing techniques are formidable. Flying some 65 to 95 feet (20 to 30 m) above the waves, the gannet spots its prey shimmering beneath the surface of the water and dives straight down to the fish. During descent, pockets of air gather in the bird's neck and body feathers, tempering the impact. It cuts through the water, and with the help of its large webbed feet and its wings, the gannet literally swims to its prey—a herring, a capelin, a sand eel, or a mackerel—all preferred dining. The victim is then swallowed as it surfaces, or even before it has the chance to do so.

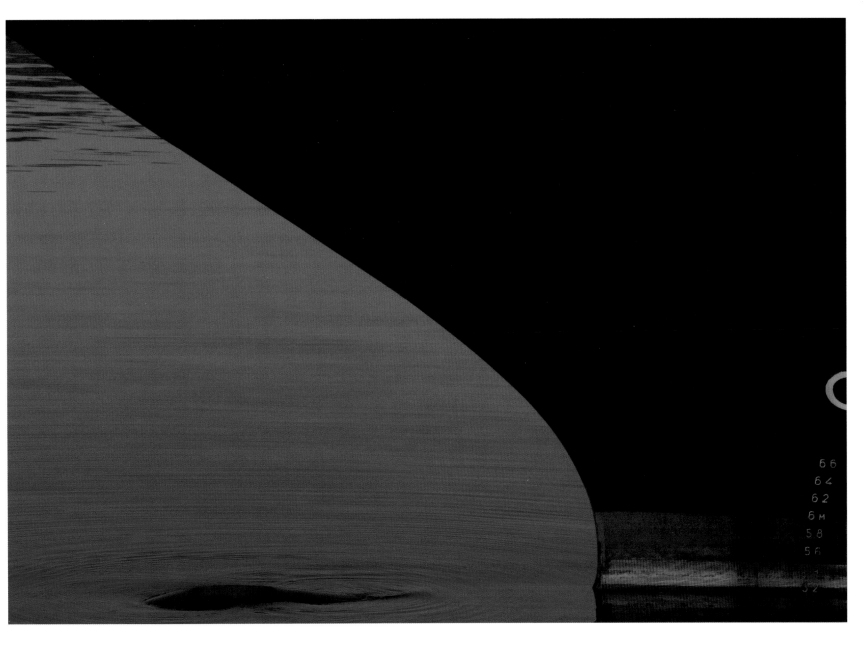

THE STEM, OR THE SECRETS OF A DEVOURER OF MILES.

There are perfect ones, just back at sea following a complete refitting. There are those that are brand new, skim-
ming through the ocean for the very first time. And then there are others that bear the scars from their oceanic
voyages: scratches, dents, and wounds that transcribe the history of the ship in mysterious runes. They recount
the collision with a buoy, a passage through glaciers, an encounter with a tugboat, or an entry into a port that
proved a little more difficult than projected. Always the magician, the stem carves out the ship's route, opening
up a path and plunging ahead 15 to 20 miles per hour (24 to 32 kph), or some 435 miles (700 km) every 24 hours,
13,670 miles (22,000 km) per month—the equivalent of a round-the-world voyage. Slender, curvaceous, sharp,
or inverted like the breastplate, the stem has gone through many transformations over the course of time. Captains,
carpenters, and architects have tried everything to make their vessel the most efficient, the fastest, most perfectly
formed to handle the waves.

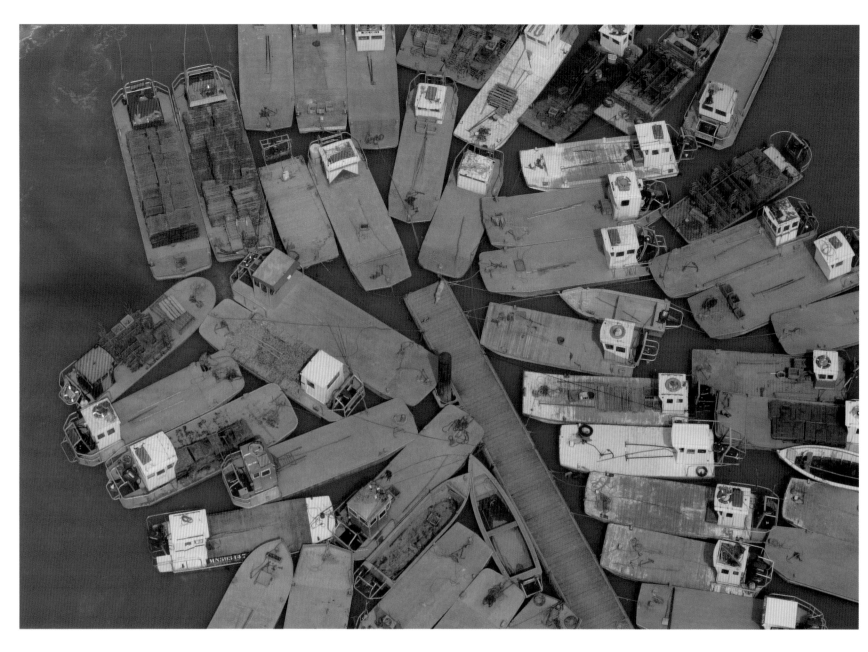

BOATS THE COLOR OF THE EARTH, SHELLFISH IN CLEAR WATERS.

To harvest the oysters from Oléron, the Atlantic, and the "flats," these working boats are painted the same dark brown. These rich waters produce one of the best crops of oysters in the world. These kings of fine dining have watery eyes, white flesh, and the insides of their shells are a deep blue. The treasures born of this sea have been classified as *Fines de Claire, Claire,* and *Marenne,* and some 40,000 tons—hundreds of thousands of dozens—of the oysters are produced each year in the Charente-Maritime region alone. This principal oyster-farming area of France extends over 8,650 acres (3,500 ha), the Marennes-Oléron basin comprising 6,180 acres (2,500 ha). More than four thousand people bustle about collecting the oysters that are abandoned by the sea at low tide. A whole world of boats and artisans in service to this mysterious beast, cultivated for its pearls elsewhere in the world.

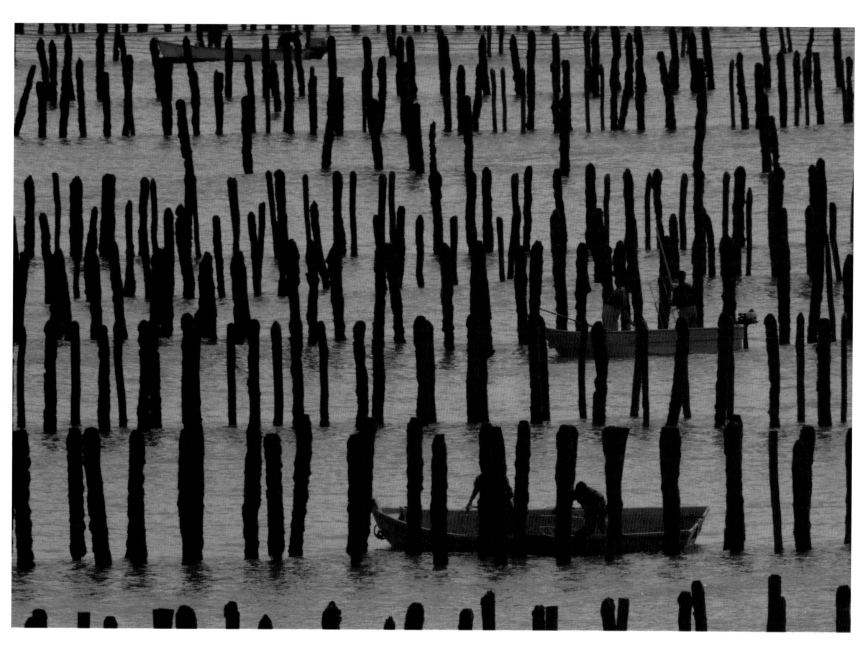

THE PECULIAR FOREST OF SHELLFISH FARMERS.

The stakes of black oak extend as far as the eye can see and the men putter about in the open avenues. In a little while, at high tide, the forest will disappear and the bay will regain its flat surface. Beneath the returning tide, the mussels will open their valves, activate their cilia, and treat themselves to a microscopic feast. Thanks to this fertile ebbing and waning, less than two years is required for large shellfish to fully develop. They grow out of the thousands of eggs that are haphazardly tossed about in the current and then, when spring arrives, they attach themselves to an extended line or net. A small percentage survives the foraging of fish, birds, and starfish. Three months later, the fishermen draw in the miles of line encrusted with tiny shellfish. They wind the line with the spats around the posts planted in the mussel beds. Eighteen moons and much care later, large violet shellfish adorn the mussel bed. Every year, France produces 60,000 tons of mussels and 140,000 tons of oysters.

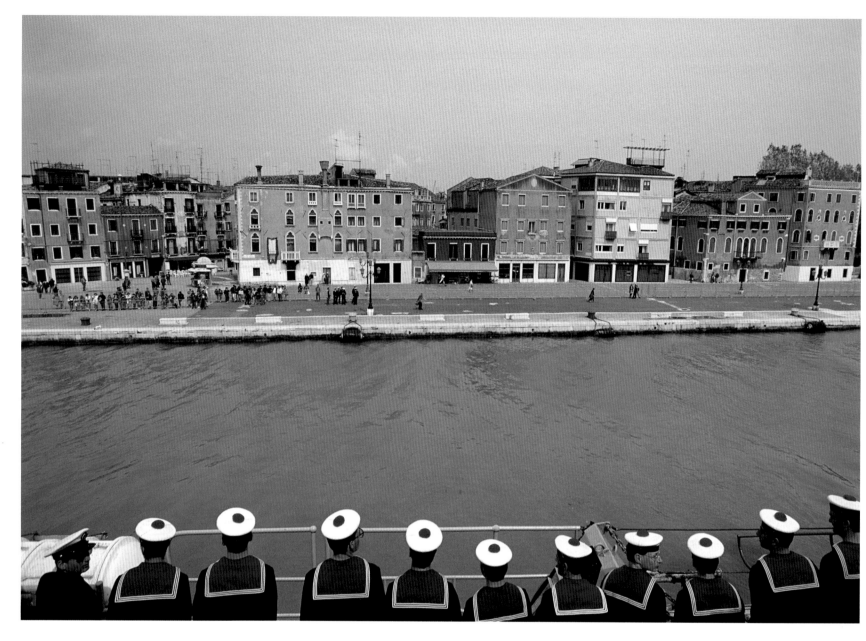

As the ship gets under way, a row of pompoms takes a last look at Venice, the celebrated pearl of the Adriatic and, unquestionably, of their tour. The sailors of the *Royale* have always worn the traditional white cap topped with its inseparable red pompom. The name *Royale*, hearking back to the time when the navy's ships were under the authority of the king of France, designates any military vessel, together with its crew, that is charged with defending France on all the seas of the world. In peacetime, the navy's ships monitor the sea-lanes and protect the territories. They may be assigned other missions as well: policing the seas, overseeing fishing, helping with navigation, rescuing, fighting to clean up oil slicks, or updating nautical charts. They also represent France when they visit foreign countries. Depending upon the circumstances—wartime or peacetime—the ships transport either sailor soldiers or soldier sailors.

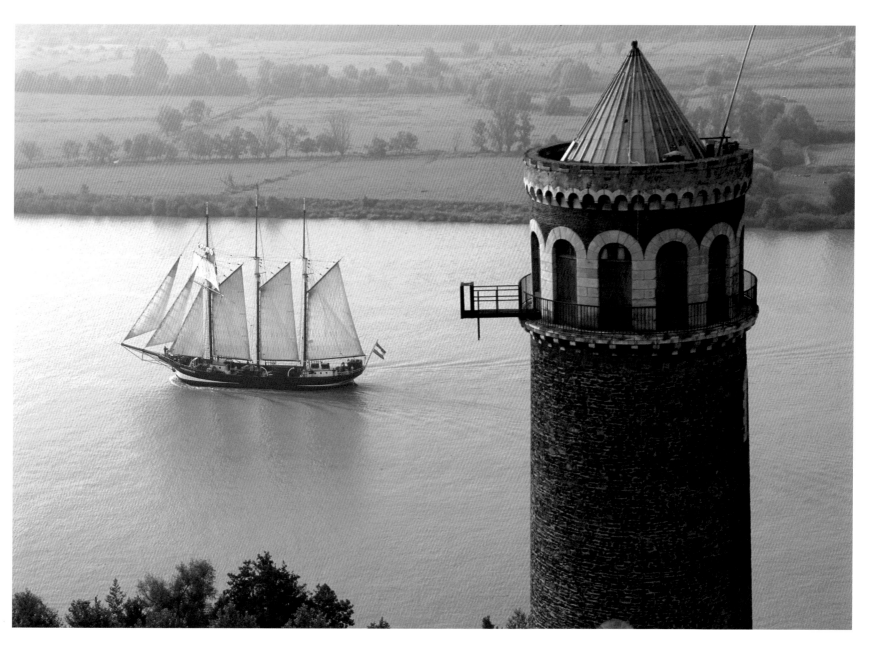

THE LOIRE. THE SCHOONER *OOSTERSCHELDE* GLIDES ON THE LOIRE RIVER,
ON THE PORT SIDE OF THE PLUMB TOWER IN THE VILLAGE OF COUËRON.

With its 165-foot (50-m) length and a draft of 10 ¹/₂ feet (3.2 m), the *Oosterschelde* carefully navigates the
shallow waters of the longest river in France. Built in 1918, this Dutch sailboat would, until 1939, transport
all manner of goods, including bricks, salted herrings, grains, vegetables, straw, and bananas. It was then
bought by the Danes. In 1992, after having been restored to its original state, the vessel made its way toward
its new roles. And from then on, it would cruise around the world for a rather wealthy client. Traveling the
Loire, it encounters not a chimney, nor a lighthouse, but rather the tower of lead in Couëron that was con-
structed at the end of the nineteenth century and where small lead pellets for rifles were manufactured. The
molten lead was transported in its liquid state to the top of the tower where it was then poured drop by drop.
As it fell, it solidified. All that remained was to gather up the metal pellets from the floor and load the rifles.
The *Oosterschelde* follows its course, passively. The schooner was never armed with a cannon.

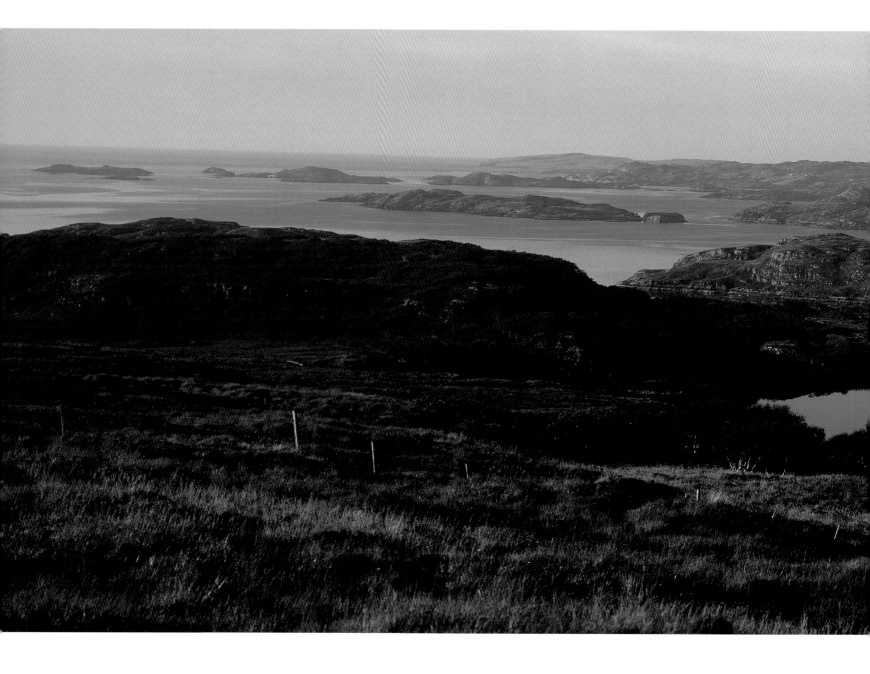

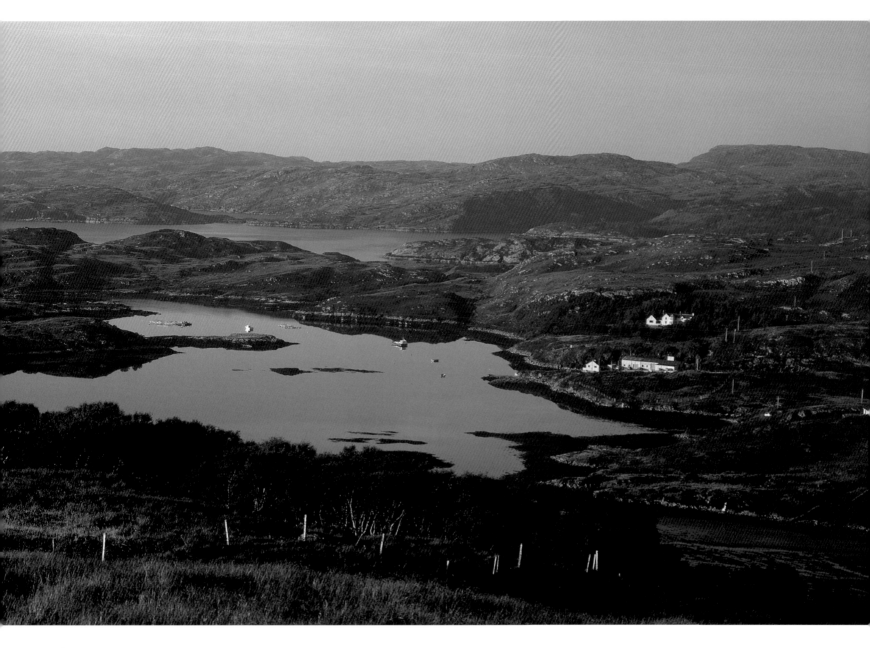

A LAND OF MOORS WHERE FRESH WATER AND SALT WATER BLEND TO INFINITY.

On a coastal prairie as intricately worked as lace, sheep take a rest in Scotland's endless moors. This land of water—it has thirty thousand lakes and five thousand streams and is filled with lochs, fjords, rivers, and water-falls—is surrounded on all sides by an incredibly jagged shore. This small land north of England has more than 3,860 miles (10,000 km) of coastline and covers a total of 30,900 square miles (80,000 km²), rocks and islets included. Its geography would make even the most patient mapmaker dizzy and, in places, he would have to trace the coastline with his finger in order to distinguish the mainland from one of the Inner Hebrides. The birds, however, are not tricked—there are more of them than people on this arid territory with a human popu-lation of 5.3 million. Six million sea birds come and nest here each spring and tens of thousands of banded shorebirds pass through each year during their migration between Africa and the Great North.

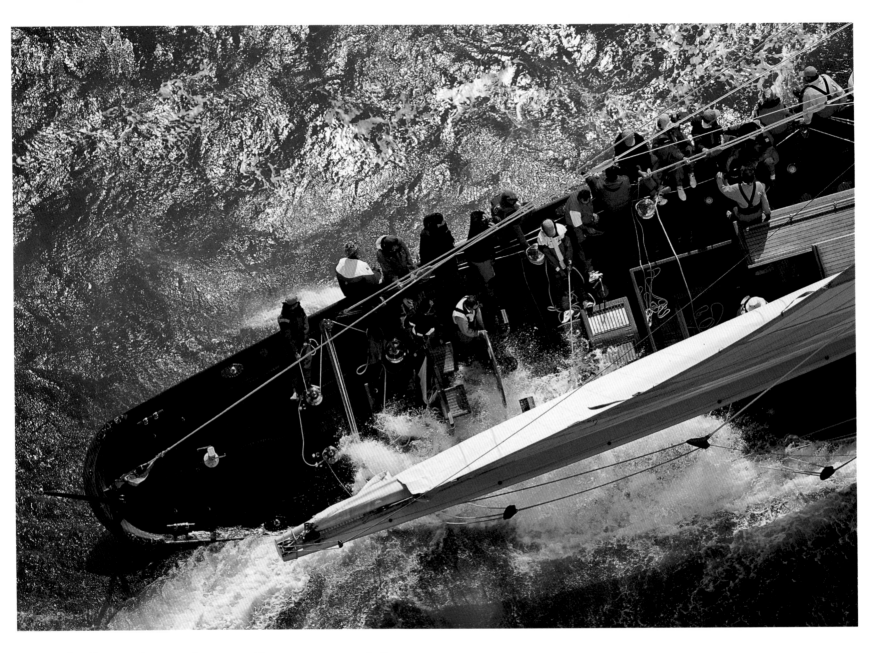

Sir Thomas Lipton. Shamrock V, the first true J-Class in history and the tea baron's last racing yacht, took part in the 1930 America's Cup off Newport.

In 1899, Sir Thomas Lipton's first *Shamrock* was a challenger in the America's Cup. Thirty-one years later, *Shamrock V* shot into the race, its owner's fifth and last, but the illustrious trophy remained in U.S. hands. Designed by Charles Nicholson in 1930, the nearly 119-foot (36.5-m) *Shamrock V* was the first English J-Class (as defined by the 1903 Jauge Universel, or "Universal Standard Measurement" regulation), and is the only all-wood yacht still afloat today. The boat's rigging and hull, designed in the earliest days of modern sailing, have undergone significant modifications dictated by the constant pursuit of improved performance. Over the course of its life, *Shamrock V* has scudded from owner to renovation, depending on the hearts and passions involved. It owes its most recent rehabilitation, in 1989, to Elisabeth Meyer. Today, this elegant prince of yachting is a star performer in the regattas of its youth. To see it together with *Endeavour* and *Velsheda*—the last three J-Classes— is to feel what the fabulous 1930s must have been.

TRAVELING LIGHT. BEGINNING IN THE 1970S, WITH THE INTRODUCTION OF NEW DESIGN CONCEPTS AND MATERIALS, SAILS HAVE UNDERGONE THE MOST DRAMATIC CHANGES IN THEIR HISTORY.

The family of water sports includes certain distinct crafts such as the centerboard dinghy. Whether sailed single-handed or by a crew of two or more, this small craft of slightly more than 13 feet (4 meters) never goes out of style. An excellent way to learn the fundamental principles of sailing, the centerboard dinghy is also a favorite of regattas, where the crew, after setting the asymmetrical spinnaker, sits on the trapeze to balance the craft. Another popular classic is the sport catamaran, which provides incomparable sensations of speed and glide. In the terrestrial version, the sailboard becomes a land sailer, a device that slips surprisingly quickly over the hard, damp sand of beaches. The sail can also be removed from the board. By holding the detached sail and letting it catch the wind, it can send you flying high in the sky. In this case, you are flysurfing, or kitesurfing—a technique that lets you soar 100 feet or more, performing a series of aerial figures. The sweetest of all sailing ships, however, is still the inimitable Optimist, the world's largest and fastest growing class of sailing craft. The crew sails crouched down in the 7 1/2-foot (2.3-meter), flat-bottomed aluminum hull, earning the craft its nickname, "the Soapbox."

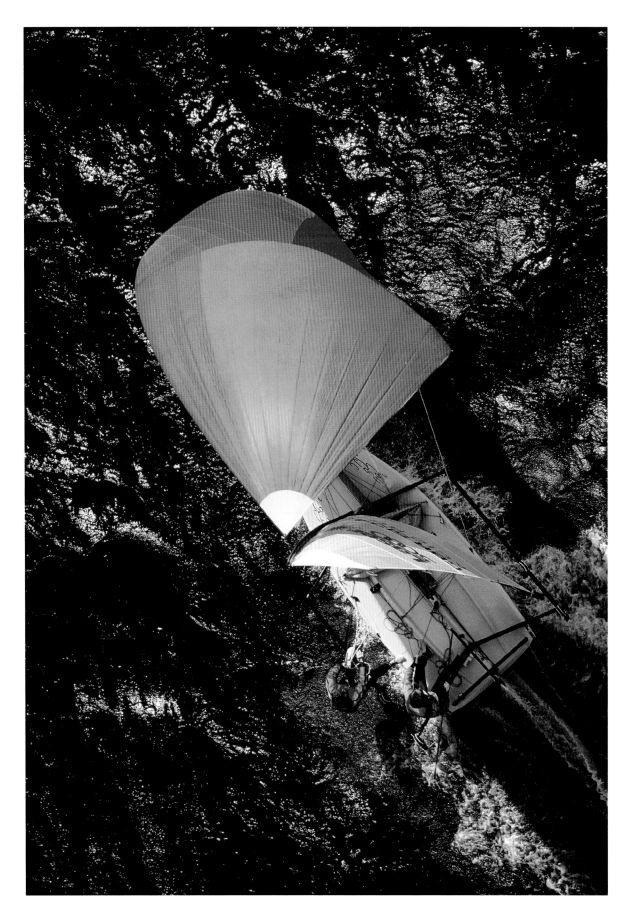

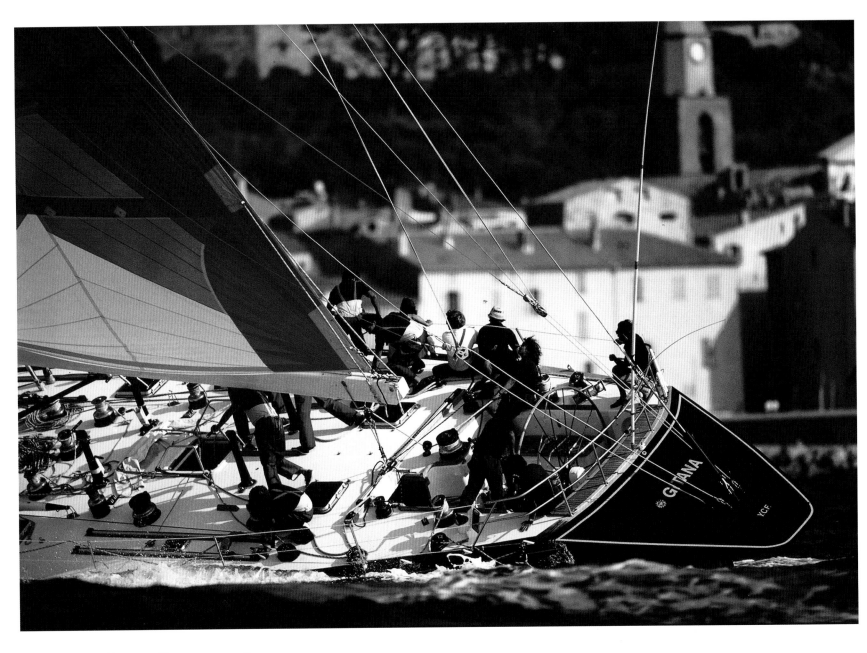

SAINT-TROPEZ. THE ELEGANT GITANA IN THE MIDST OF A MANEUVER
DURING A NEW EDITION OF THE NIOULARGUE RACE.

Since 1999, the nautical world of Saint-Tropez has organized one of the most beautiful assemblages of amateur
sailing. This meet, the Nioulargue, takes place the first week in October and gathers together on the same
stretch of water contemporary racing boats, schooners, and traditional yachts, all in a spirit of friendly competi-
tion. Pictured here off the Saint-Tropez coastline, the *Gitana* appears to be tacking. The *Gitana* competes in the
"maxi" category of precision-crafted vessels and carefully picked crews. The skipper at the wheel executes a
hard tack. The mainsail, enhanced with Kevlar (a highly water-resistant material), is being readied to switch to
the other side, or as the sailors say, "the other tack." In a matter of moments, the boat will reverse its direction
and the crew will regroup on the other side in a perfectly synchronized movement, giving the vague impression
that humans are capable of controlling the elements.

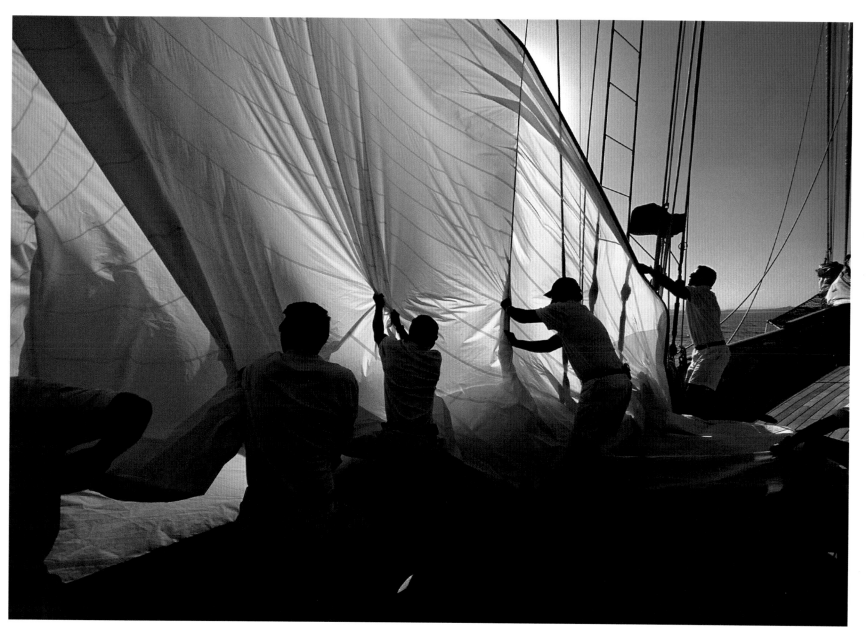

THE VILLE-DE-PARIS, THE FRENCH CLASS AMERICA CONTENDER IN SAN DIEGO.

In 1992, the monohull Class America, baptized the Ville-de-Paris, left the Multiplast shipyards in Vannes destined for the America's Cup race held off of San Diego, California. Despite its sporty appearance and the dedication of its crew, the Ville-de-Paris had only reached the semifinals in the Louis Vuitton Cup. The Team New Zealand, with Rod Davis at the helm, succeeded in ousting the French boat in the last regatta, with a score of 4–3. Marc Pajot and his crew were once again eliminated before reaching the finals. To that day, France had never reached the final stage of the America's Cup. The crew is gathered at the stern of the boat—the skipper, the helmsmen, and the two tacticians. With its spinnaker full, the Ville-de-Paris surfs the waves off San Diego. Flying, it leaves its wake behind. But in the wind, another wake cuts through the California waters, an unseen competitor gets a stone's throw ahead of the French tricolores, enough to cause the suntanned faces of the team to tense up.

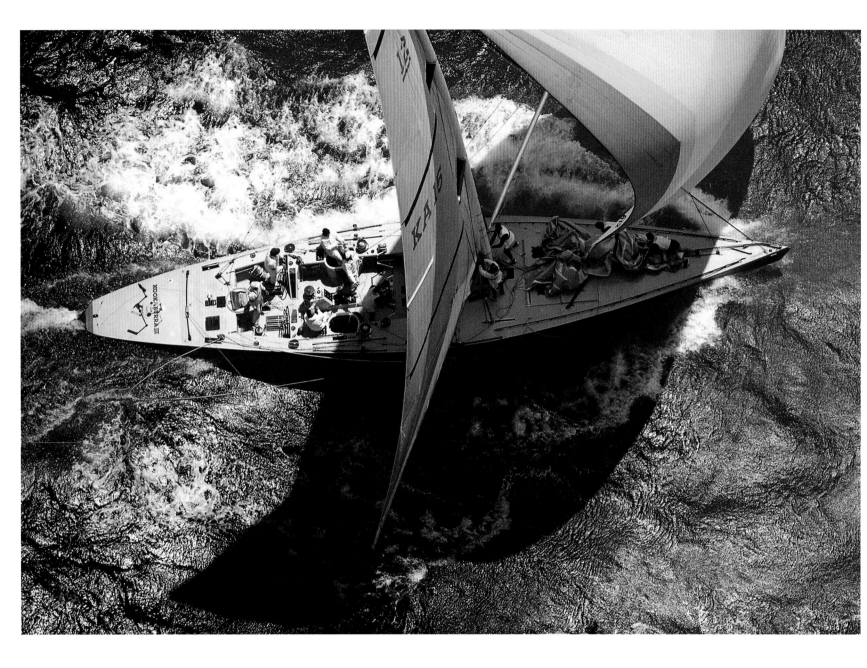

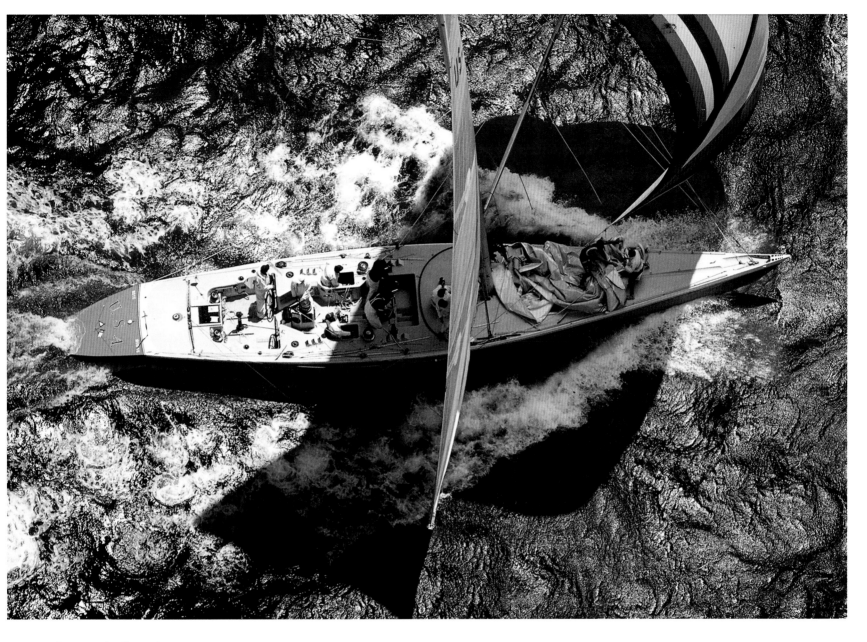

AMERICA'S CUP. A LONG RACE, OR THE GREAT BATTLE OF THE TWIN SAILBOATS.

Kookaburra III and *Stars and Stripes* in Fremantle, 1987. Looking at the color of the hulls, the spinnakers, and the
same tight tack, the two ships appear to be equal. But they were not. The America's Cup is not a race of identi-
cal boats. They must, however, conform to a set of rules that ensures parity. Created in 1907, the 12-meter
IMS (International Measurement System) is a class that comes from a mathematical formula based upon the length
of the hull, the freeboard (or water displacement), and the sail area. The stipulations impose general guidelines
for the architects of boats, but still allow for hundreds of variations. Thus, each team can give free rein to its
imagination and find the one detail that will win it glory. A wing-keel, the angle of the stem, subtle curves in
the design that are kept secret until just the last minute when the boat is launched.

TOBERMORY, ON THE ISLE OF MULL. SCOTLAND DRAWS IN ITS CLAWS.

Here is Scotland in its finest hour, when the ports look like villages of dollhouses. And the Hebrides is a wild and complicated paradise with thousands of great and small mysteries to discover—such as the mystery of the salmon. Five or six years following a first voyage into the Atlantic, the salmon, having reached maturity while in northern seas, will return to the river of its birth and swim against the current in order to reproduce at the exact place of its birth. This precision seems to be due to an exceptional olfactory memory, with each river possessing a particular taste or odor that the salmon remembers. The nature of the local water is also a determining factor in defining the signature taste of a given Scotch whiskey. A mysterious alchemy occurs in the depths of the moors, causing the peat to lend a smoky taste to the rainwater. And Scotland guards the secret.

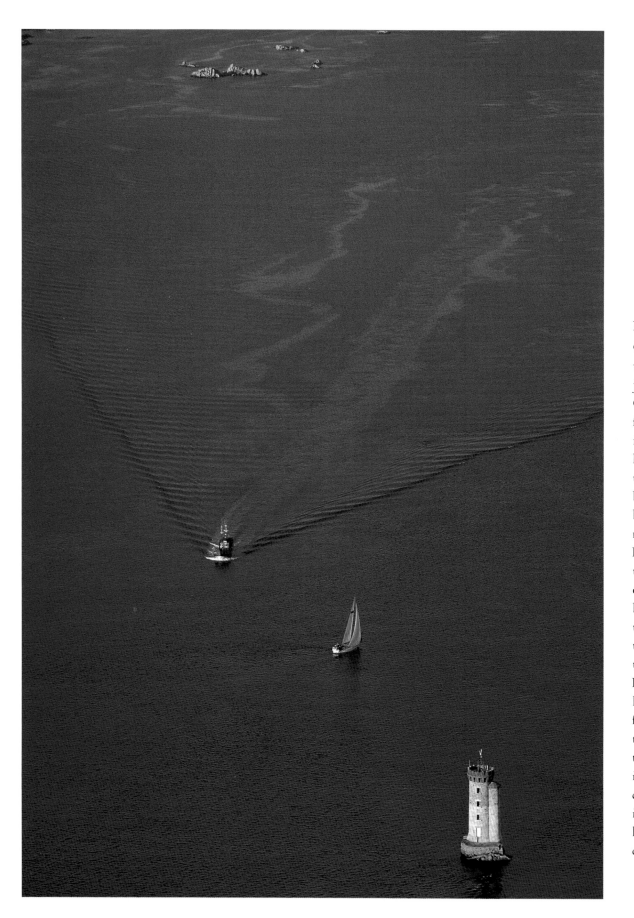

La Croix lighthouse.
On the Côtes-d'Armor shore,
where the waters of the Trieux
join those of the English
Channel, the river has scattered
forbidding rocks that in 1865
inspired construction of a light-
house at its mouth. From
trawlers to sailboats, everyone
benefits from this light that
bursts forth as regularly as a
metronome every four seconds.
Planted in the sea, the little
tower with its two faces—one
of plain stone, the other painted
bright white—stands out against
the horizon, and, together with
the Beuzec clock tower, shows
the way to enter the channel.
Perched on its pedestal, La Croix
lighthouse overlooks the sea
from its 75 feet (23 m). It was
torn down during World War II,
then rebuilt in 1949 exactly as
it had been. The war not only
created devastation on dry land,
it destroyed a number of light-
houses, plunging the affected
coastlines into endless night.

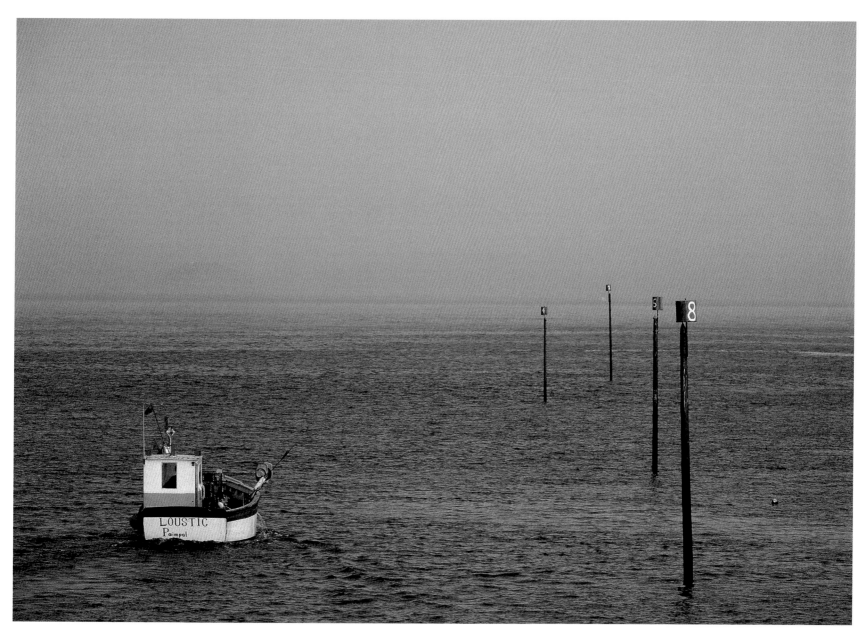

PLOUMANAC'H. THE LOUSTIC GOES FISHING,
FOLLOWING THE BUOYS MARKING THE SAFETY OF A CHANNEL.

Maybe just for fun, the *Loustic's* captain is singing the famous mnemonic "Un tricot vert et deux bas si rouges"—
"A green sweater and two very red stockings"—one of the first things a sailor must know how to decode. It is a
way of remembering that when heading inshore, the conical green odd-numbered buoys are on the starboard
(right) side, while the cylindrical red even-numbered buoys are on the port (left) side. These lateral points of
reference are only one of the many kinds of markers placed about the coastal landscape to complement the work
of the lighthouses in signaling dangers and organizing maritime traffic. There was a time when the only land-
marks sailors had were those provided by the land itself. This promontory, that lookout tower, or that rock
aligned with that unusual tree allowed them to identify their location on water. Today such landmarks are
sometimes officially listed; fixed and easily visible points on the coast remain invaluable.

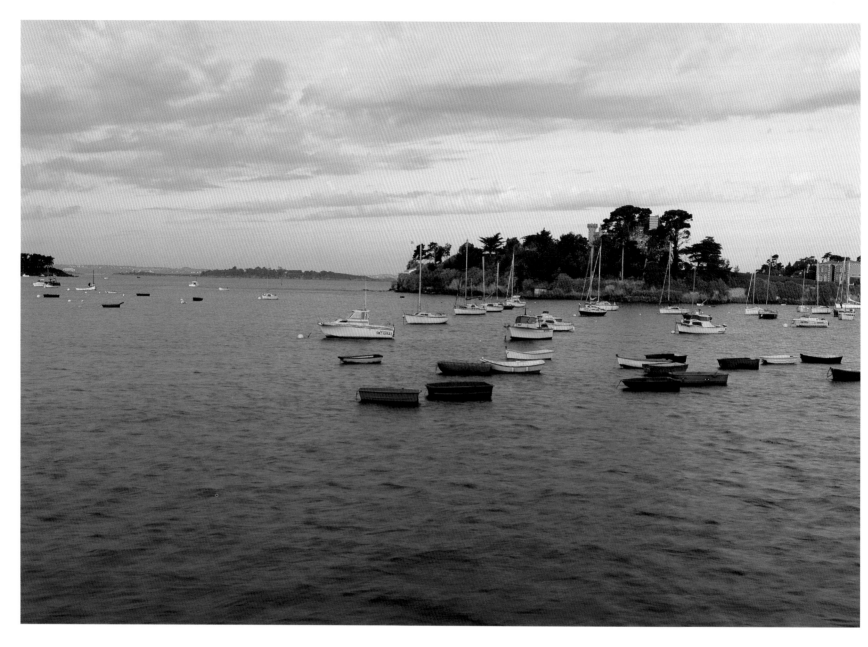

SAINT-BRIAC. THE JEWEL OF FRANCE'S "EMERALD COAST," THIS ANCIENT FISHING PORT
THAT LIVES WITH THE RHYTHM OF THE TIDES PUTS ON TWO SHOWS A DAY FOR US.

The white sandy bottom glinting with the hues of precious stones has earned this stretch of shoreline the appel-
lation "Emerald Coast." Between Saint-Malo and the Fréhel headland, Saint-Briac nestles in a sheltered bay
where the Côtes-d'Armor coast turns back on itself. An age-old home to fishermen and sailors, Saint-Briac's bay
also retains the sophisticated charm of the early-twentieth-century seaside resorts. It is always a pleasure to
moor at one of the marina's 700 buoys and let yourself be rocked by the sea's comings and goings. In the late nine-
teenth century, the entrancing mobile landscape of this peaceful harbor attracted a number of painters, inspiring
Pierre-Auguste Renoir and Paul Signac in particular. The scattered islets and rocks that adorn the bay emerge
and vanish, depending on the time of day. This dreamy part of the coastline is only still at slack tide—the inter-
val during which the sea level remains stationary, whether high or low. However calm, slack water is only a
temporary respite. Beware still waters.

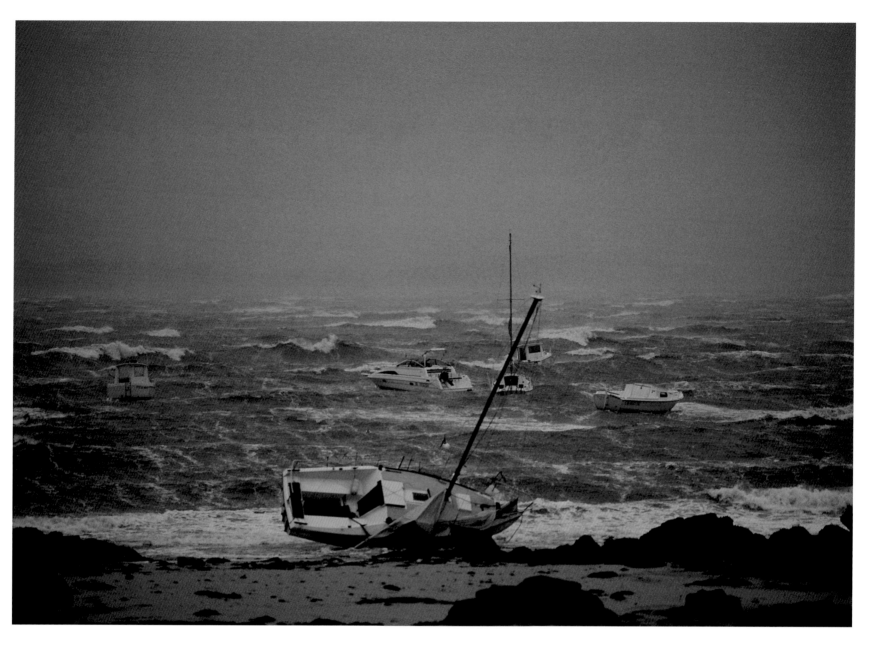

BEACHED. IN LATE AUGUST, WITH THE RETURN OF THE EQUINOCTIAL TIDES,
THE FIRST FRESH GALES ANNOUNCE THE COMING OF AUTUMN AND
THE WISDOM OF MOORING BOATS, OR EVEN PULLING THEM ASHORE.

At its most raging, when its surface is veined with lines of foam, the ocean tosses the few moored boats about like so many buoys. It is the end of August, and the string of winter depressions hurls its first gusts onto the Atlantic shore, pitifully stranding craft. In the tropics, when a devastating cyclone is expected, the safest place for a yacht is beneath the surface of the sand. Though less destructive, the Breton storms require secure mooring to resist the giant invisible hand that can make such a boat seem like a tiny plastic toy, yanking out the minuscule anchor hooked into the sea bottom. The instant the mooring gives, the boat will be thrown ashore like an old bottle or a piece of driftwood.

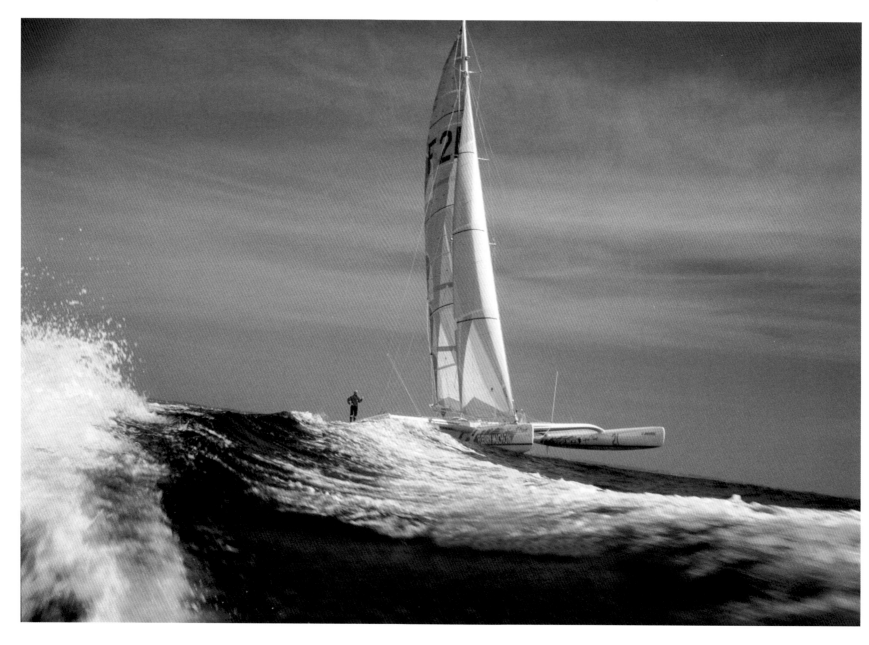

PHILIPPE POUPON. "A MAN, A BOAT, THE OCEAN"—THIS IS THE IDEA BEHIND THE ENGLISH TRANSATLANTIC RACE THAT HE WON IN 1988. THE MOST BRILLIANT HELMSMAN OF HIS GENERATION HAS NOW EMBARKED ON AN EXTENDED JOURNEY ABOARD THE *FLEUR AUSTRALE* FOR THE PURE JOY OF BEING AT SEA.

At this point, Philippe Poupon, a long-time veteran of ocean races, enjoys long sailing voyages more than competition. After crewing for Éric Tabarly, the Breton sailor began his brilliant career on a monohull and was preeminent in the Figaro single-handed race, which he won three times out of twenty-seven (in 1982, 1985, and 1995). Next, attracted by the multihulls' performances, he added to his trophy shelf by winning two legendary solo transatlantic races, the Route du Rhum in 1986, and the English Transatlantic (the Ostar, from Plymouth, England, to Newport, Rhode Island) in 1988. With his longtime sponsor, Fleury Michon, he had the advantage—an unusual one in the history of sponsoring—of an ongoing commitment, originally inked in 1982, that would provide a dozen or so boats flying the company's colors, from a 26-foot (8-m) monohull to a trimaran more than 65 feet (20 m) long. The inveterate ocean racer is here standing on one of them, casually holding onto a shroud. Either that or he has simply come to a stop in mid-ocean.

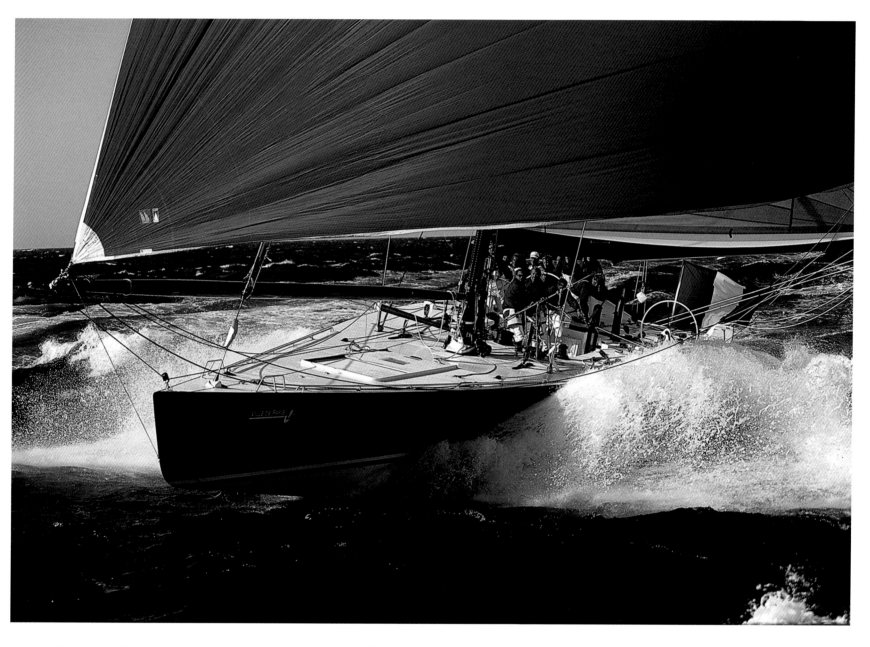

VILLE-DE-PARIS—A PRETTY NAME FOR A PROUD SHIP. FRANCE IN THE DANCE.

The year is 1992. A 30-knot wind whips the San Diego bay. It is the first wind-lashed voyage for *Ville-de-Paris*.
Marc Pajot, winner of the 1982 Route du Rhum, former crewmember with Éric Tabarly, and an Olympic
medalist, is taking part in his second America's Cup. In 1986, he was at the helm of *French Kiss* and, with his
brother, marked the return of France into the arena of the 12-meter IMS (International Measuring System). Not
since the various attempts of *Baron Bic* from 1970 to 1983 had the French flag flown in the skies of the cup. In
Perth in 1986, Pajot had led *French Kiss* into the semifinals. The funds he invested into the *Ville-de-Paris* were
small in comparison to those spent on the boats he was competing against. All the same, the crew maintained
the lead through the semifinals of the Louis Vuitton Cup, the preliminary test that decides the contenders for
the America's Cup. While the *Ville-de-Paris* lost to *Team New Zealand* that year, it finished an honorable second.

JAPAN. THE MODERN CONSTRUCTIONS COME UP ON THE HORIZON OF TOKYO BAY.

The city of Tokyo suffers from a terrible curse: itself. Its uncontrolled growth since 1900 has lead to its expansion out into Kawasaki and Yokohama. Little by little, the urban creations have overrun the coastline and gained ground in all of the bay since the mid-1950s with development projects near Funabashi, Chiba, and Kisarazu. During Japan's recovery after the terrible destruction from World War II, Tokyo Bay actually attracted millions of Japanese from the country. In search of new jobs, they therefore adapted to a new life, and so Tokyo experienced a development similar to a gold rush. This city today has enough to disorient its residents just by its sheer size. The last great challenge of Tokyo undeniably is its Aqua-line, a giant 9-mile (15-kilometer) long "bridge-tunnel" built to link up the East and West districts of the bay. Also, set in the heart of the bay, the aeration tower of the complex, with its huge conical construction coming out of the water, will probably not take a long time to become the new symbol of the city of Tokyo.

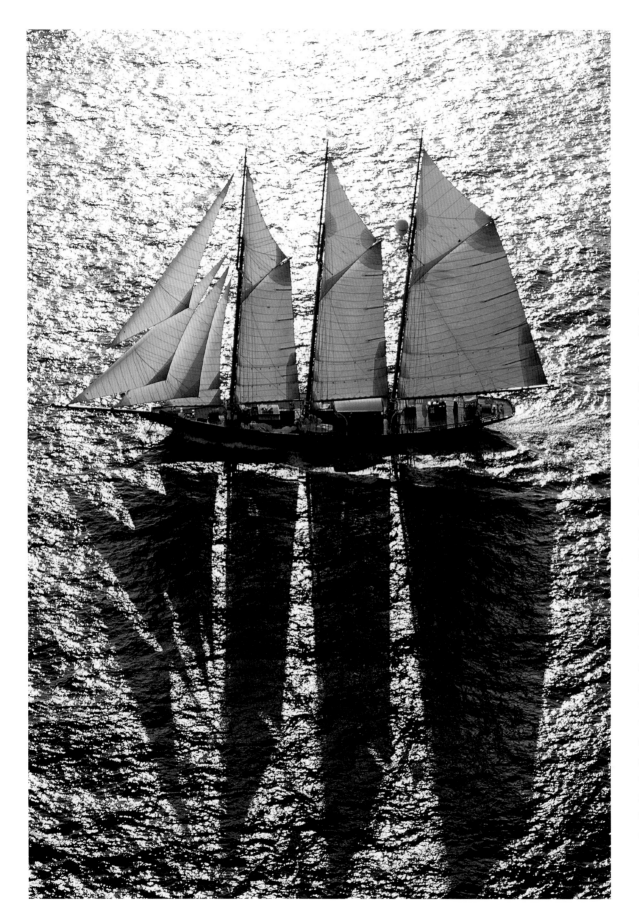

LIGHT AND SHADOW, THE
THREE-MASTED *SHENANDOAH*
SAILS IN THE SETTING SUN.
Measuring 118, 114.8, and
111.5 feet (36, 35, and 34 m),
the three slender masts of the
Shenandoah appear to grow in
length as the sun sinks toward
the horizon and the elongated
shadows create the impression
of another ship. Suddenly, the
three-master appears to have
doubled the quantity of its sails.
The glistening sea is white,
highlighted in a prism of colors
from the setting sun. And now
is the hour when flying-fish
follow the boat, seagulls swoop
at top speed, the sails are
hauled in, and the wind is on
the beam. The crew works to
maintain speed, making con-
stant changes, and thoughts of
the sun's shadows are relegated
to the background. In a matter
of moments, the *Shenandoah*'s
majestic double will fade into
the waves and there will
remain one single vessel, built
to cross the seas, the sun, and
the limits of time.

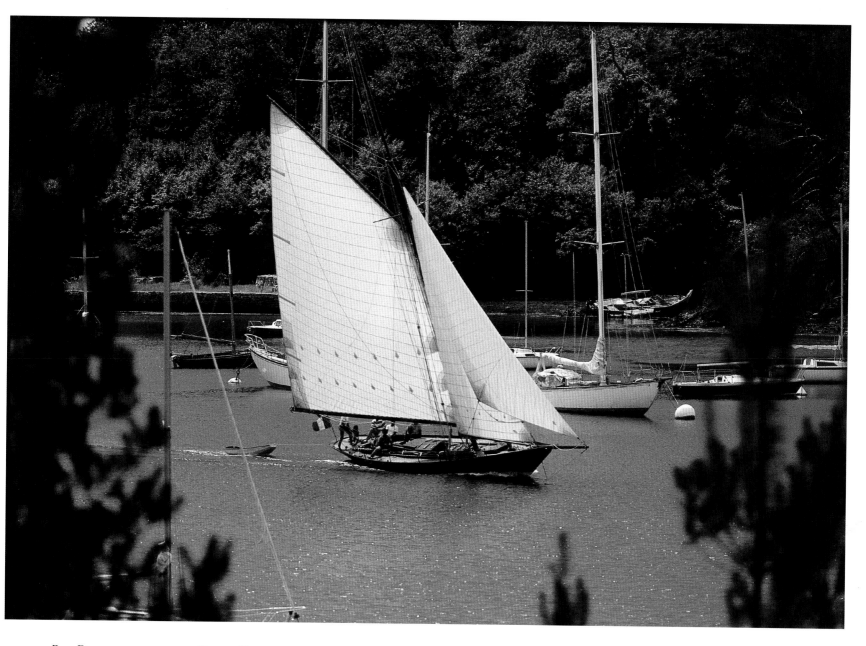

Pen Duick flits in the Odet. The river keeps its breeze.

Decks varnished, hull painted, and sails trimmed, the *Pen Duick* navigates back up the Odet. The river is not wide and its banks disrupt the light wind. At the helm, Éric Tabarly plays it tight. Designed by William Fife and launched in Ireland in 1898, this regatta cutter began its days in England before sailing under the French flag. Fifty feet (15 m) long, with a beam of almost 10 feet (3 m) and a keel of more than 6 $^1/_2$ feet (2 m), this elegant sailboat had for several years navigated under the name of *Butterfly*, an homage, one must imagine, to the 1,700 square feet (160 m²) of sails that are the wings to its gentle wooden curves. In 1938, Éric's father, Guy Tabarly, bought the *Butterfly* and renamed her *Pen Duick*—a black-headed titbird. In 1952, the younger Tabarly took charge of the yacht and restored her to grandeur. It was the start of an adventure that would lead him to refurbish six more boats. Each of these took the name of its forebear, aboard which he died in June 1998.

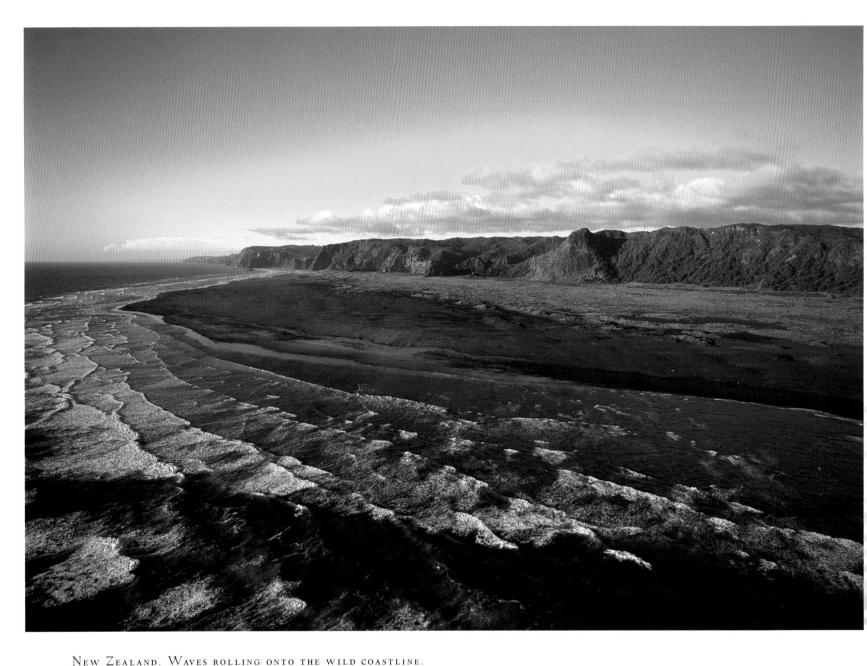

NEW ZEALAND. WAVES ROLLING ONTO THE WILD COASTLINE.
THE CLOUDS TAKE A SHORT BREAK INLAND BEFORE CONTINUING THEIR JOURNEY TO THE OCEAN.

In a country that has thirteen times more sheep than people, it goes without saying that this is a verdant land. For the most part, these peaceful ruminants occupy the western slopes of the North Island, a remote and sparsely populated region. The humid climate that results from the hovering, stagnant clouds (the Maoris call their island "Land of the Long White Cloud"), keeps New Zealand perpetually green. There are some areas in the west that receive an annual rainfall of 23 feet (7 m) of water over a period of more than three hundred days of rain, making it one of the wettest places on the planet. In addition to the sheep, the island's forests are home to the kea, or kiwi, the rare bird that inhabits the mountainous regions of South Island. Endowed with the beak of a bird of prey, it looks forbidding. It is said that it knows nothing of humans, but in fact the opposite is true. The habits of the nocturnal kiwi avoid humans. The aborigines are nonetheless very proud of these birds, which, through a quirk of nature, are unable to fly.

New Zealand. A long sky reflected on a deserted beach strand at low tide.

With its 375 miles (600 km) of coastline divided between two large islands and countless small ones, New Zealand maintains a privileged link with the Tasmanian Sea on one coast, and the Pacific Ocean on the other. In this rather temperate climate, New Zealand's sports and adventure enthusiasts have access to a land as impressive as it is varied. The followers of the Maori and English cultures often venture out into small, idyllic coves where the lush vegetation crosses paths with cliffs that plunge into the sea. Strange rivers empty into the ocean and the estuaries, their waters tinged an orange-yellow from the tannins leaching from the earth, which the Maoris have named "rivers of tea." Some of these are hot springs that either empty into the ocean or evaporate.

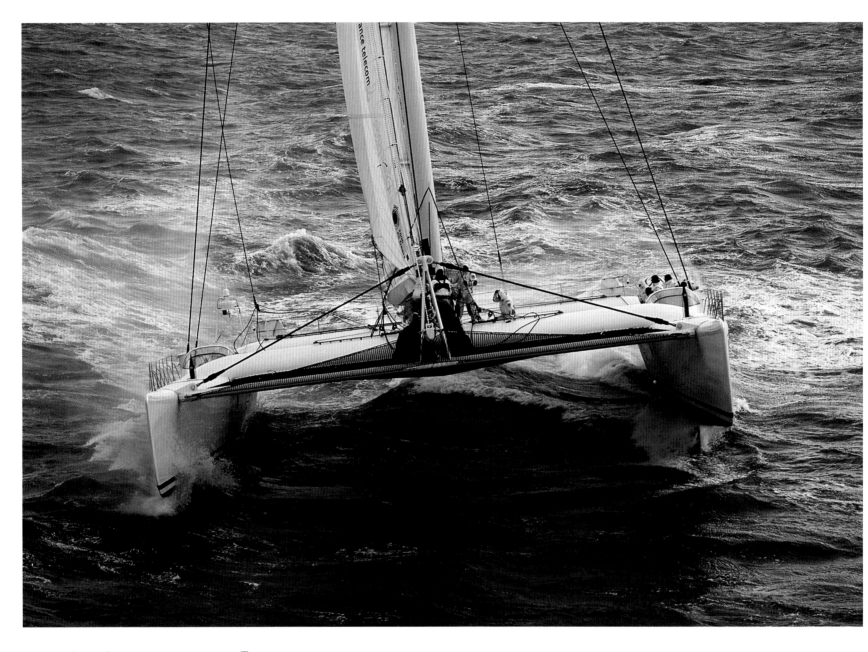

CODE ONE DURING PRACTICE. THE MAXI CATAMARAN,
PREPARED FOR THE RACE, SKIMS IN THE LATE AFTERNOON SUN.

Forty-five knots—*Code One*'s top speed. Since leaving the Multiplast shipyards in Vannes, this giant of the sea
has sailed far and wide. Renamed *Innovation Explorer* for its participation in "The Race," this racing beast gobbles
up distances at a prodigious rate. At 105 feet (32 m) long, a beam measuring 60 feet (18 m), the mast towering
to 145 feet (44 m), and weighing 20 tons, it adds up to a vessel that is able to sail at great speeds. Today, in
terms of speed, the maxi catamarans are in competition with *Yellow Pages*, a prototype based on the principle of
the hydrofoil, which continues to hold the record of 46.5 knots set in 1993. In the late afternoon light, *Code One*
makes a tack on the bay of Quiberon, a top French sailing venue where windsurfers often test their mettle
against these majestic machines.

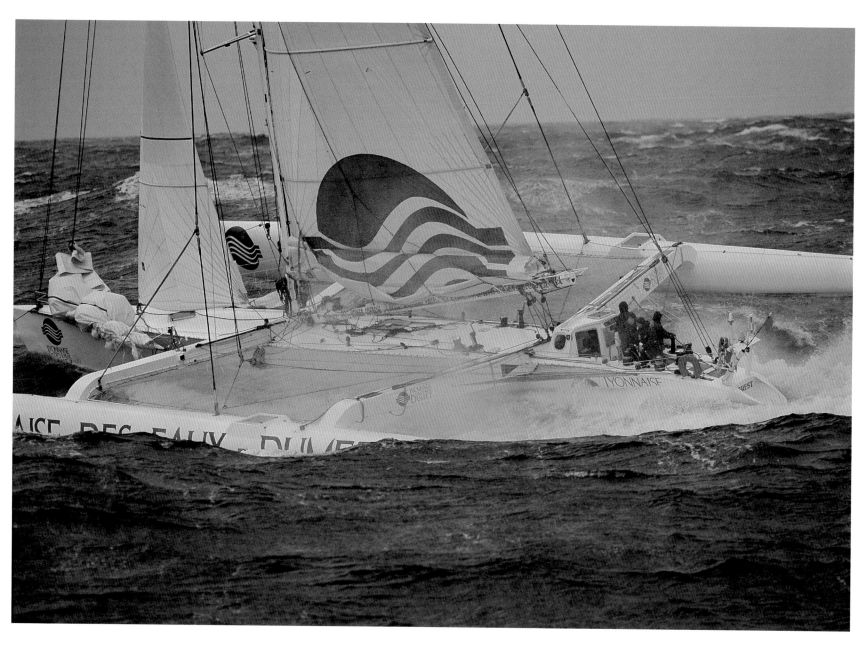

"ALL MY EMOTIONS ARE BOUND UP WITH THE SEA, AND MY SORROWS AS WELL."
OLIVIER DE KERSAUSON HAS A PASSION FOR THE SEA. HE HAS MADE IT HIS LIFE.

Like many French boys of his generation, Olivier de Kersauson first sailed out of La Trinité-sur-Mer. When he did his military service in 1964, he had the good luck, as he always says, to meet Éric Tabarly. For ten years, Kersauson was Tabarly's faithful mate aboard a series of *Pen Duicks* before beginning an extraordinary sailing career, dedicated to giant multihulls and feats of derring-do. His adventures with trimarans started with *Poulain*, which in 1989 broke the solo around-the-world record—125 days. He sailed on *Lyonnaise des Eaux-Dumez* then on *Sport-Elec*, with the latter winning the crewed Jules Verne Trophy (71 days and 4 hours). With *Géronimo*, launched in 2001, the world's largest trimaran—110 ½ feet (34 m) long; 71 ½ feet (22 m) wide; and a 130-foot (40 m) mast—and his fervid crew, he threw himself into a run of great sailing records on the planet's most prestigious ocean courses. For him, *Géronimo* "is a name that exemplifies struggle, nature, and will." A name in his own image.

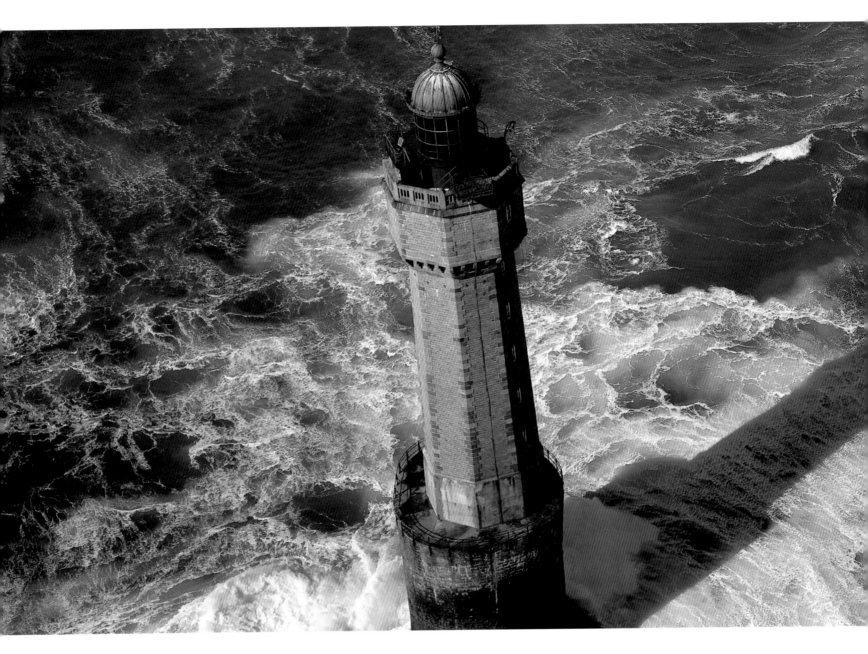

La Jument lighthouse, off Ouessant. Watch on the high seas.

At the beginning of the century, a certain Mr. Potron came back to life, having miraculously survived a shipwreck around Ouessant. As a gesture of gratitude, he offered 400,000 francs in gold to the French state to build a lighthouse southwest of the island. As their site, the engineers chose the rock called La Vieille Jument (The Old Mare) or Ar Gazek-Koz in the Breton language. The work was difficult and dangerous and the sea was perpetually turbulent. Begun in 1904, the project was finally finished in 1940 after multiple incidents. With a height of 155 ¹/₂ feet (47.4 m) and a beam that reaches 21 nautical miles (24 mi/39 km), the Jument lighthouse is a beacon planted in the open sea, an indispensable star that guides ships lost in the night. Living conditions were so harsh that the successive keepers classed it in the category of "Hell." The lighthouse has been automated since 1991.

THE SEIN CAUSEWAY. IT IS MARKED AT THE WESTERN END BY THE AR-MEN LIGHTHOUSE, NICKNAMED "THE HELL OF HELLS" BY THOSE OF THE BUREAU DES PHARES ET BALISES, THE GOVERNMENT OFFICE CHARGED WITH OVERSIGHT OF THE LIGHTHOUSES AND BEACONS OF METROPOLITAN FRANCE.

The lighthouse at Ar-Men—"the stone" in Breton—is the beacon for the Sein causeway, which lies west of Pointe du Raz, at the end of Finistère. This is where the mainland, after a few last rocky hesitations, one of which supports the lighthouse, finally plunges into the waves, only to emerge some 3,500 miles (5,500 km) later, when it reaches the shores of America. In 1867, it took seven perilous approaches to drill fifteen holes in the underwater rock. Thirty-four were made the following year, and the masonry was started. And so it went until 1881, when Ar-Men finally shot a beam from 100 feet (32 m) above sea level. It would require epic watches. Until the lighthouse was automated in 1990, the sea's unpredictability sometimes meant open-ended shifts: in 1923, the keeper Fouquet remained alone there for 101 days in a gale, cut off from the world and without receiving fresh supplies. The French lighthouse keepers speak of "Heaven," "Purgatory," and "Hell," depending upon whether a lighthouse rises out of land, an island, or the sea. Ar-Men was "the Hell of Hells."

A PHOTOGRAPHER'S
PASSIONS. AMAZING YACHTS
AND LIGHTHOUSES SUCH AS
LE FOUR AT SEA.

Ships going from the Channel
to the Iroise Sea or to Brest take
the Le Four channel, on the
northwest Breton coast. Since
1874, a fortresslike lighthouse
has guided them through this
dangerous and heavily traveled
passage, rife with reefs and
violent currents. Built upon a
granite rock some 80 feet (25 m)
across, the cylindrical tower of
Le Four is distinguished by the
five steady white flashes it
sends 100 feet (31 m) above the
waves—by remote control from
Île Vièrge since 1993. For
130 years, a grim chess game
has been played between this
medieval outpost and the queen
of this realm—the sea. When
it attacks, the waves, amplified
by the rocky shelf that supports
the lighthouse, submerge the
belfry. Then, only the small
light of the lamp in its glass cage
emerges, like a periscope, from
the foaming waters. The waves
slam the structure so hard that
the furniture inside jumps. But
when it is the tower's turn to
triumph, it steadfastly com-
mands Le Four channel, and
calls for the game to continue.

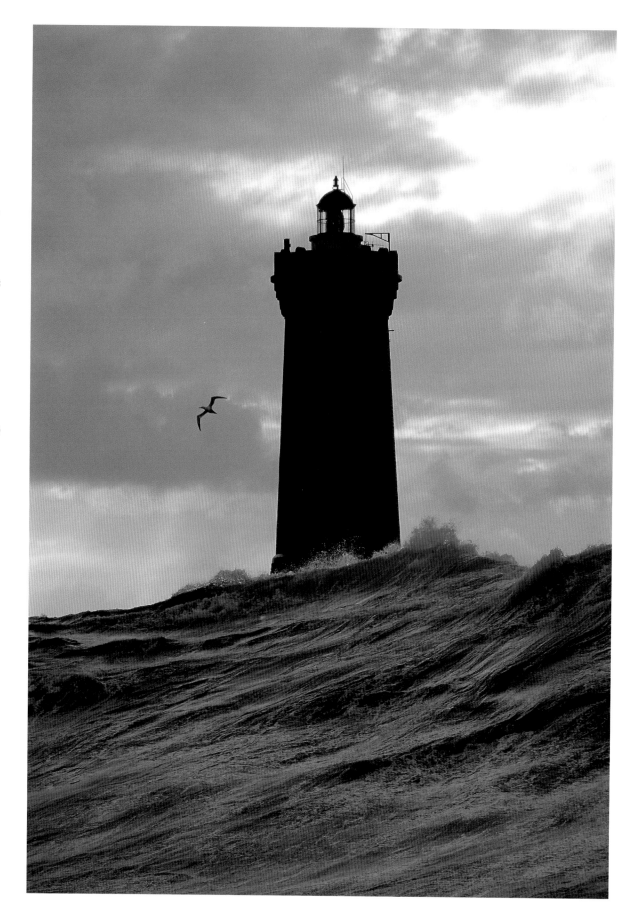

MORBIHAN. A BLANKET OF OIL ESCAPES FROM THE HULL OF THE ERIKA.

As the suns drops, the outline of a thick cloud is highlighted as it fragments the evening rays over the ocean off Morbihan. The sea is dark, awaiting the night. But not oily, thanks to the wind. Drifting with the currents, not surfacing under the setting sun, a layer of oil heads toward the coastline, pushed by the wind. This mass of hydrocarbons did not appear out of the blue. It came from the *Erika*, an oil tanker that had sunk further to the south, and whose toxic fuel would never reach the profitable coffers of its owner, Total. This oil spill would continue to navigate the ocean for a long time more, breaking up into many smaller slicks and washing up along the granite coastlines of the Atlantic. This blot floating on the water's surface under the evening sky would soon become an appalling anachronism of the seascape. The locals responded by donning their masks, gloves, and oil-skins, and taking out their shovels and rakes. All done in the simple hope that the use of these tools would not become a tradition in Brittany.

FINISTÈRE. THE SMALL CHAPEL OF SAINT-THEY ON THE POINTE DU VAN ACROSS FROM THE LIGHTHOUSE AT LA VIEILLE.

Here, during the fifteenth century, at the ends of the earth, on a barren, granite landscape, the small chapel of Saint-They was erected. Residents have claimed that the chapel's bell tolls on its own, alerting seamen in a storm to take harbor under the protection of Saint-They and to keep clear of the jagged cliffs lining the coast. As legend has it, one day a naval fleet of the Kingdom of France was being pursued by the enemy when the bell began to toll. The French captains headed for the shelter of the rather forbidding Trépassés Bay. The enemy ships, attempting to follow them, were suddenly swept away in the crosscurrents, many of their vessels sent smashing against the reefs, while the rest of the French fleet sailed out into the open waters. Here, where the saints and the birds reside, a single man is one too many. And so, one could say, the imposing Pointe du Van soberly heralded the direction of the wind.

THE ADRIATIC. MONTENEGRO'S "MOUTHS OF KOTOR" ARE EUROPE'S SOUTHERNMOST FJORDS.
THE GOSPA OF SKRPJELA AND SAINT GEORGE ISLETS, HOME TO ORTHODOX PRIESTS,
FLOAT LIKE SHIPS IN THE BAY OF KOTOR.

From the Montenegro shores, the waters of the Adriatic insinuate themselves deep inland. In the Mouths of
Kotor, a handful of tiny islands act as cloisters for Orthodox priests who have settled in this haven of peace.
Behind the natural port is the small, historic city of Kotor, an important commercial and artistic center during
the Middle Ages that was hit by an earthquake in 1979. Great peoples have ruled over different areas of the
Mediterranean, and the Christian and Muslim civilizations have met there over the course of centuries of his-
tory. In the Balkans, as all around the Mediterranean Basin, quakes, silted ports, and rising water levels have
swallowed up countless vestiges of the important chapter of humanity's history that were inscribed in this sea.
More than 1,250 archeological sites, from Byblos, in Lebanon, to Carthage, in Tunisia, have been identified as
lying under the waters of the Mediterranean.

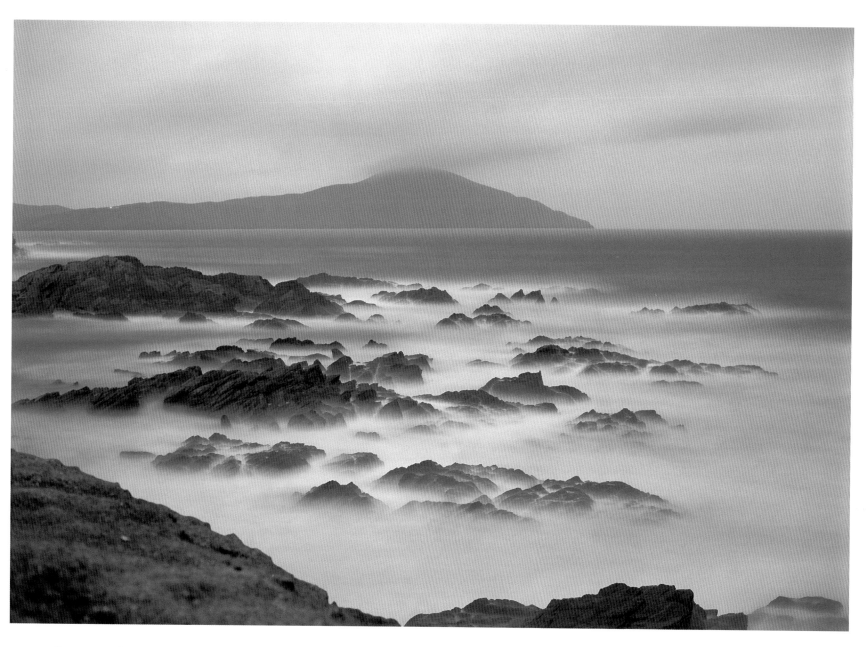

IRELAND. CLARE ISLAND, ITS TINY ILLUMINATED LIGHTHOUSE NOW OUT OF COMMISSION,
IS PRIZED BY CONNOISSEURS OF UNIQUE PLACES.

What fairy-tale mountains claim these peaks emerging from a layer of cottony clouds? None—this fluffy opalescence is a fluid image that choppy waves printed on film during a long exposure. These craggy summits are off Clare Island, in Ireland, and the delicate glimmer above is no Alpine refuge, but the island's lighthouse. After 140 years of service from atop its 420-foot (130-m) cliff, guiding ships during storms and preventing shipwrecks on the chain of reefs, the lighthouse was taken out of commission some thirty years ago. A couple of enthusiasts turned it into a hotel, bringing it back to life; it enchanted the lovers of vast spaces and untamed nature who came to contemplate these magnificent surroundings facing the Atlantic Ocean. It was recently sold again—now the former lighthouse is a former hotel. What new destiny awaits this magical turret?

BAY OF ISLANDS. THE *SHENANDOAH* CELEBRATES ITS FIRST CENTURY OF SAILING AROUND THE WORLD. AFTER MANY LONG MONTHS IN NEW ZEALAND WATERS, ITS OWNER, CAPTAIN, AND CREW HAVE MADE AN ENDURING IMPRESSION ON THE PEOPLE HERE.

The *Shenandoah* was born in a United States shipyard in 1902. This 175-foot (54-m) schooner has three masts and 21,500 square feet (2,000 m²) of sails to propel its 300 tons. The ship's name comes from a song of the Old West about an Indian chief from the Shenandoah Valley. A veteran of the 1980 America's Cup, this sailboat, which once belonged to Baron Bich, was recently sold to a German millionaire for more than $17 million (15 million euros). To celebrate its first century of sailing in style, the new owner offered the exquisite centenarian a trip around the world, from the chilly channels of Tierra del Fuego to Polynesia's idyllic atolls. The splendid yacht reveals none of the unparalleled luxury of its appointments, such as the elaborate woodwork, finished with bronze and brass. A fireplace holds pride of place in the main cabin of this deluxe residence, while the public bathrooms are covered in marble. The magnificent *Shenandoah* costs $1.7 million (1.5 million euros) a year to maintain. Who would suspect such opulence in an elegant vessel crossing a bay at dusk as discreetly as a whisper?

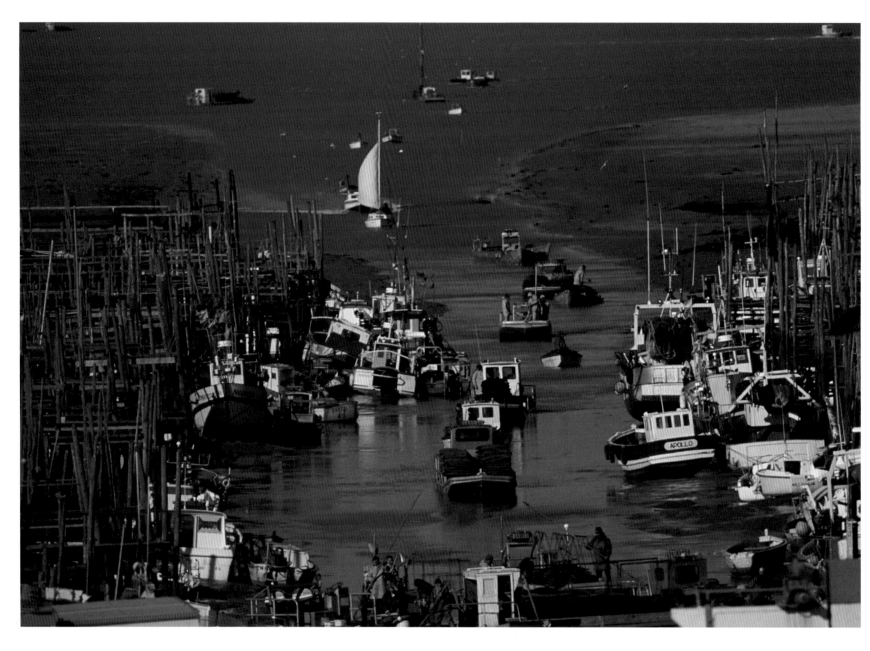

IN THE VENDÉE—THE BEAUTIFUL EYES OF THE OYSTER.

The oyster, that delicious "hollow stone," is one of the animals that humans like to eat raw. Cultivated by the
Chinese some two thousand years ago, they were also valued by the Romans, who tried to control their
"growth." In France, wild oysters have been gathered since the "age of fire," but the first farms date back only to
1830. Since then, oyster farming has developed both on the Atlantic and the Mediterranean coastlines. Spats—
immature oysters—are collected in open waters, put in sacks, and then spread out on racks that are regularly
checked by the oyster farmers. Protected from predators, the sacks are rotated, thus enabling all the creatures
to develop. After a few months' growth, the oysters are separated this time, according to size, and again placed
in sacks. Once planted in the farms, and depending upon the richness of the water, the oysters will remain there
for three to five years before being harvested. Refined in *claires*, or closed pools, they take on the deep color
desired by gourmets.

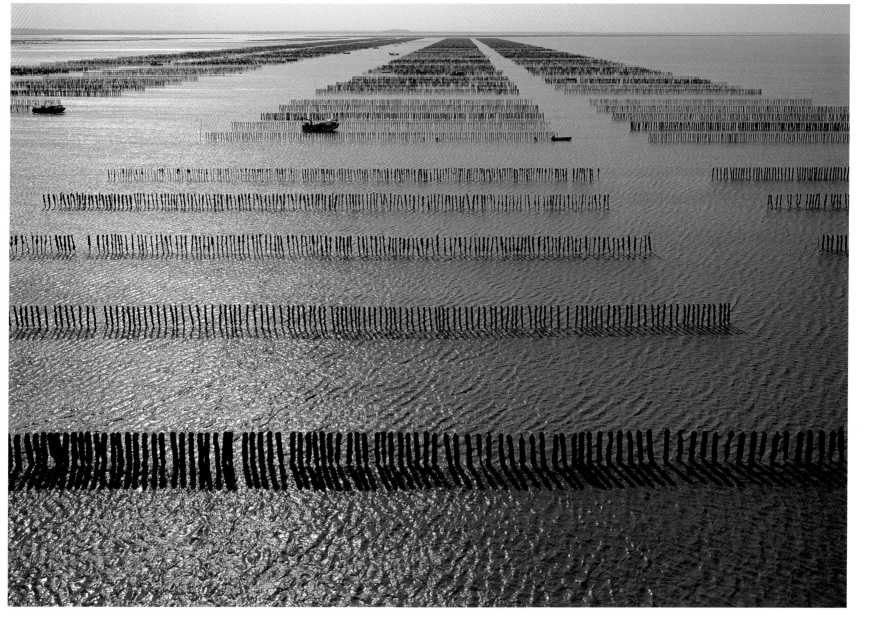

The bay at Mont-Saint-Michel is France's premier mussel-breeding ground.
With 187.5 miles (300 km) of mussel farms, the producers of Le Vivier-sur-Mer
gather and sell between 10,000 and 12,000 tons of mussels per year.

The significant differences in tide levels in the immense bay of Mont-Saint-Michel, which expose up to 3 3/4 miles (6 km) of shore at low tide, make it ideal for shellfish farming. The slender black strands tracing the lines of mussels add an Oriental note to the seashore in the mussel-growing regions. The story goes that an Irishman who ran aground not far from La Rochelle in 1035 was the first to discover the inclination of mussels to attach themselves to the wood stakes buried in the mud, which were used to trap birds. To these posts, which are about 6 feet (2 m) high, the mussel breeders attach the spats they collect in the spring, when the females lay their abundant brood. The mussels grow for about eighteen months, holding on to their support by their byssus. The mussel farms—rows of stakes some 163 feet (50 m) long—are adapted to the Atlantic's powerful tides. In the Mediterranean, the mussels hang in the water on ropes that are raised up at intervals. Every year, 1.5 million tons of mussels are grown worldwide; of these, France, the world's sixth-largest producer, raises 78,000 tons.

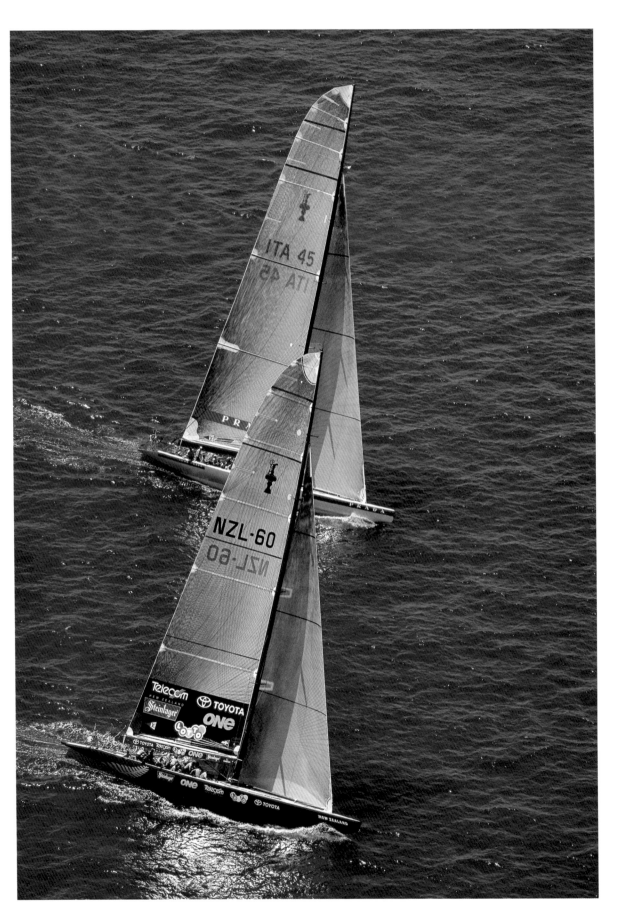

AMERICA'S CUP 2000.
In the first sixty seconds of the
first leg, *Black Magic*, the New
Zealand defender, showed
Italy's *Luna Rossa* the price of an
illusion. For the first time in its
history, the cup race remained
in Auckland, awaiting a more
challenging adversary. That
adversary appeared at the
thirty-first America's Cup: on
March 2, 2003, Team Alinghi,
the Swiss challengers, entered
the annals of the cup race.
With only a meager few sec-
onds' lead, they became the first
European challenger to win the
America's Cup, crushing the
defender with a 5–0 score.
Snatched from the hands of
Team New Zealand by Russel
Coutts and his crew, the trophy
made its way to Europe. Since
Switzerland has no seashore,
it will have to surrender the
privilege of organizing the
2007 race to a European coastal
city. Several cities have volun-
teered, including Cowes, on
the Isle of Wight, where the
legendary contest was born a
century and a half ago.

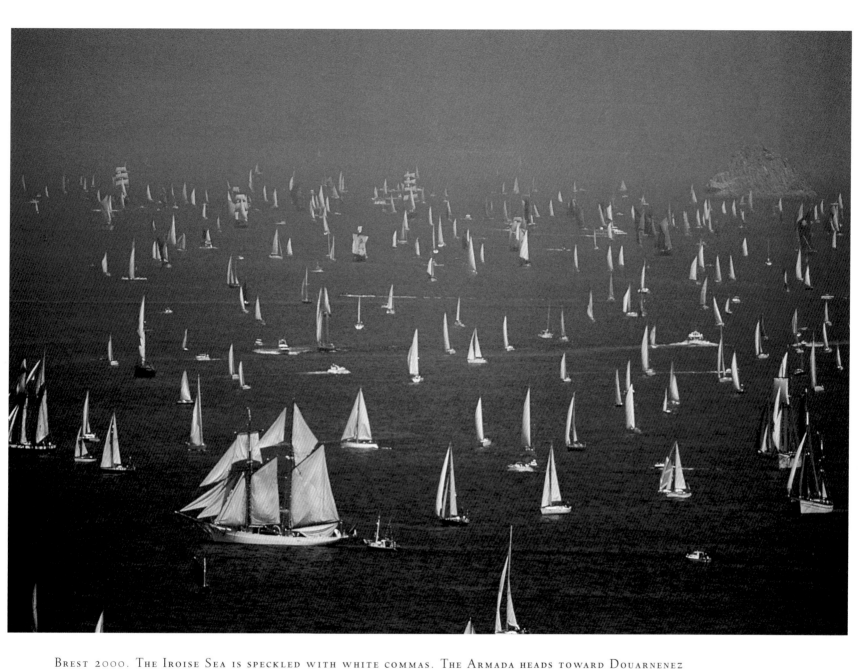

BREST 2000. THE IROISE SEA IS SPECKLED WITH WHITE COMMAS. THE ARMADA HEADS TOWARD DOUARNENEZ (PORT-RHU), THE FIRST PORT TO WELCOME THE GREAT GATHERINGS OF TRADITIONAL FRENCH WORKING SHIPS.

The year 2000 witnessed the third international festival dedicated to "the sea and seafarers," a quadrennial assembly first held in Brest in 1992. Taking part in this nautical and cultural event were some 2,500 sailing ships—among them fifty valiant centenarians—from some twenty countries, along with their 15,000 crew members, who met in the Brest roads and concluded their celebrations with a friendly race to Douarnenez. This consisted of the amazing procession heading into the Brest Channel and coming out into the Iroise Sea at the tip of Brittany. The flotilla then went around the Crozon Peninsula and doubled the Cap de la Chèvre, which marks the entrance to the bay of Douarnenez. This is an unparalleled collection of sails and hulls, enough to satisfy the most fanatical curiosities and passions. Luxurious cruising yachts and humble working boats bespeak a myriad stories and bring very different pasts to life. The Brest Armada, with its variety of riggings and age-old silhouettes, is a page from the great world-wide epic of the seas.

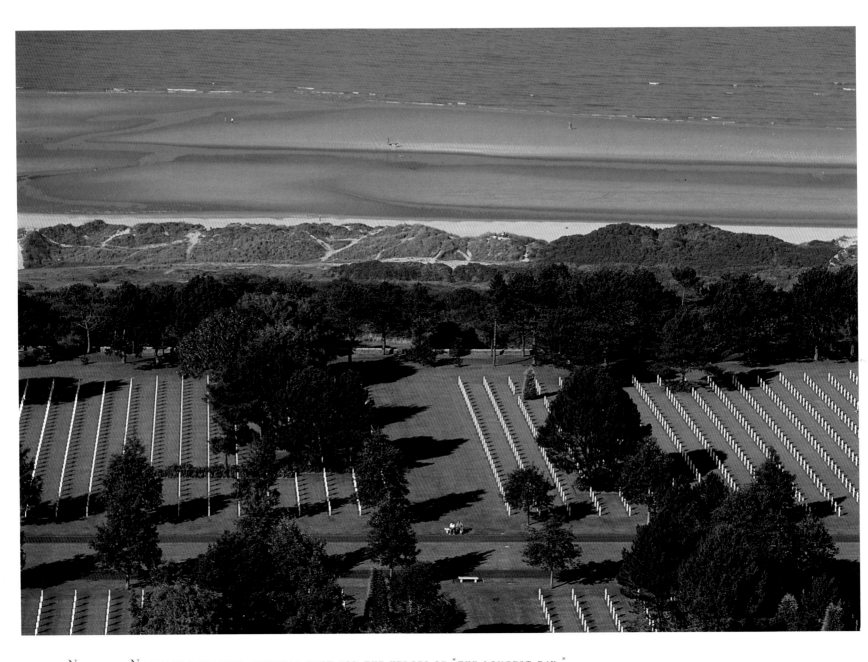

NEAR THE NORMANDY BEACHES, ETERNAL REST FOR THE HEROES OF "THE LONGEST DAY."
Utah Beach, Omaha Beach, Gold Beach, Juno Beach, and Sword Beach were the code names given by the American strategists who prepared the Normandy landing, which they dubbed *Operation Overlord*. Ever since June 6, 1944, these names have become a part of the French heritage. On that day, seven thousand allies—Americans, British, and Canadians—perished in battle with the German forces that controlled the coast and were bunkered in trenches along the Atlantic seaboard. Some having met death thousands of miles from their homeland, these soldiers were put to rest in six nearby military cemeteries—green oases marked with simple white crosses of Carrara marble. They are in formation, in a final parade, a few yards from the beaches where they spilled their blood for the liberation of France.

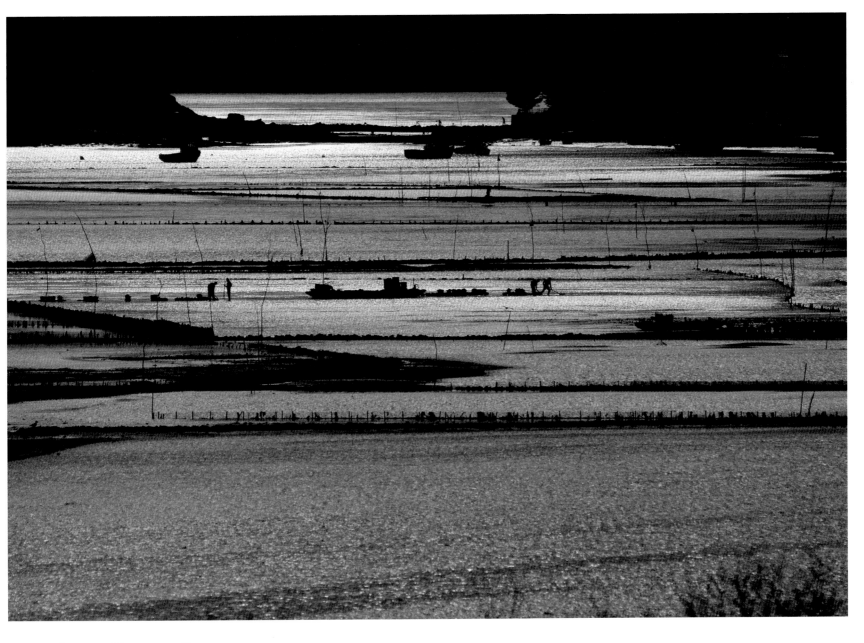

GULF OF MORBIHAN. BEFORE HIGH TIDE THE OYSTER FARMERS
ARE HARD AT WORK TURNING THE OYSTER BAGS AND MOVING THE TRAYS.

Shells unearthed in archeological digs reveal that even prehistoric people had discovered the rich flavor of oys-
ters, but they have only been farmed since the nineteenth century. In early summer, oysters lay from 1 million to
3 million eggs each. This seemingly excessive fertility is, in fact, prudent, since predators and merciless natural
conditions decimate their numerous progeny. The oyster farmers collect the seed-oysters and provide the young
survivors with an initial support to which they can attach themselves. They will stay there between six months
and a year, then spend two years in the oyster beds where they will grow in sacks of wire netting. At that
point the oysters are ready to travel, alive, to the gourmets' plates. Oyster farmers painstakingly labor over the
growth and health of their mollusks for an average of three years. Here, they prompt an extremely unusual com-
position, in which in a fleeting moment—awaited for months—are joined the right height of the tide, the
desired light, and the oyster farmers busy with the beds.

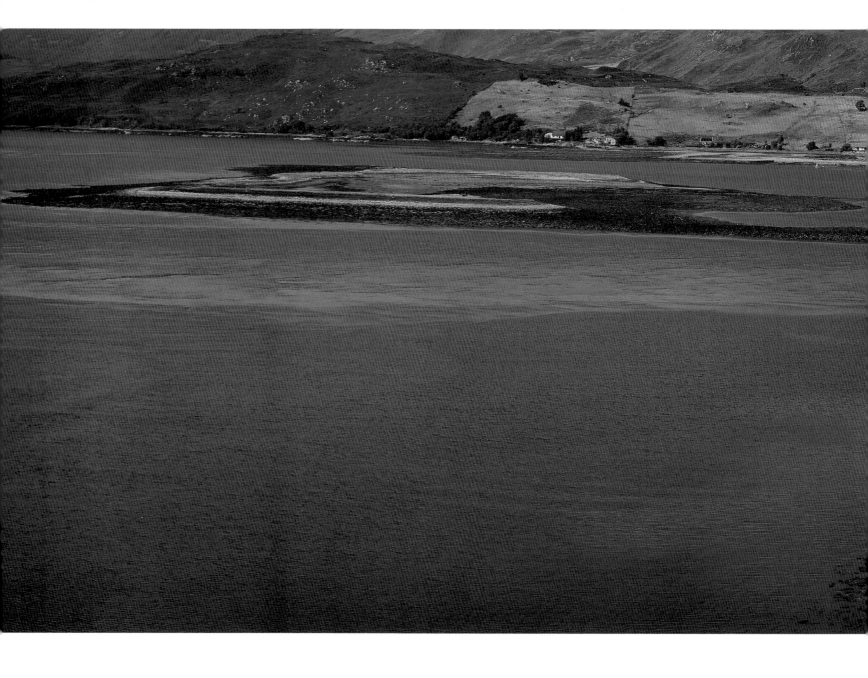

SCOTLAND. THE EILEAN DONAN CASTLE, SOLIDLY ANCHORED TO LAND,
IS REFLECTED IN THE SURROUNDING WATERS.

Located in western Scotland a few miles from the Kyle of Lochalsh, the fabulous Eilean Donan Castle sits atop
a rocky islet planted in the azure expanse of the Loch Duich. An elaborate stone bridge links the fortress to the
shore, where its dark silhouette merges with the mirror of the lake, while the surrounding verdant hills of the
village of Dornie thrive. Built in the thirteenth century by the Scottish king Alexander II, the castle was occu-
pied by the Spanish in 1719 and then partially destroyed in the same year by the English. Since then, the heirs
of the MacRae family have endlessly been restoring it. The Eilean Donan Castle has become renowned, thanks
to its serving as a setting for a number of films as well as to the legendary notoriety of its ghosts. Whispered
rumors state that a Spanish soldier killed in battle with the English appears within its walls from time to time.
It is said that the man has been seen in the room used for exhibitions, carrying his head in his arms. Do people
or ghosts have more active imaginations?

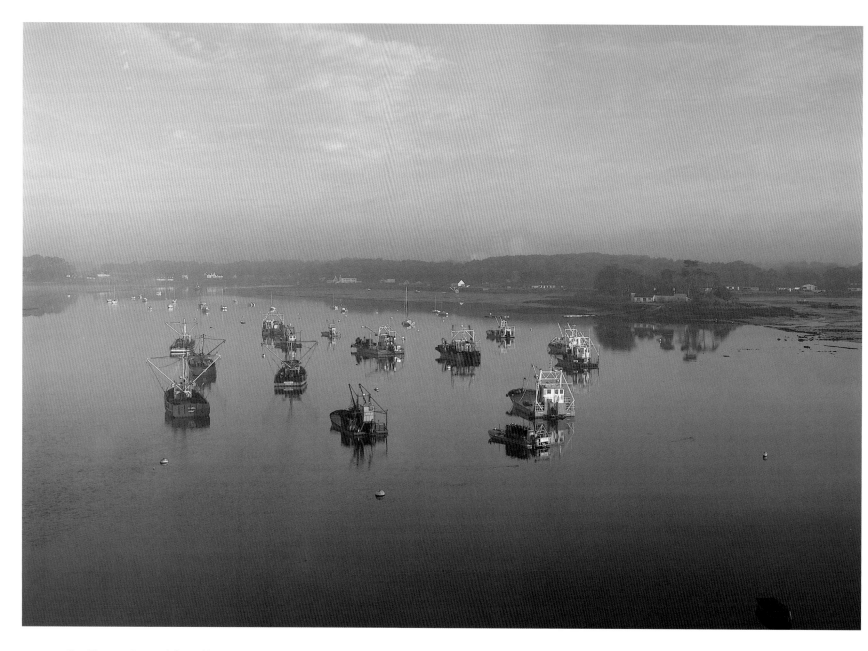

La Trinité-sur-Mer. For fifty years, the cradle of the flat oyster
has set an example: well-regulated oyster farming there has developed
in harmony with France's legendary sailing mecca.

At La Trinité-sur-Mer, small sailboats share the buoys of a peaceful cove with the boats of the oyster farmers
who work in Quiberon Bay. This traditional, time-honored activity of the French coasts is conducted princi-
pally in Brittany (Cancale, La Trinité-sur-Mer), Charente (Marennes), and Vendée (Bassin d'Arcachon). Oyster
farming represents a significant sector of the economy: France, with 130,000 tons of oysters per year, is the
world's fifth-largest producer, while global production is 4.3 million tons. There are mainly two genera of mol-
lusks that are raised: the flat oyster (*Ostrea edulis*) and the hollow oyster (*Crassostrea gigas* and *Crassostrea angulata*).
In other parts of the world, oysters serve as pearl factories rather than as a sophisticated dish. The Philippines
process 2.4 million tons per year, and Polynesia, whose valuable pearls are black, 850,000 tons.

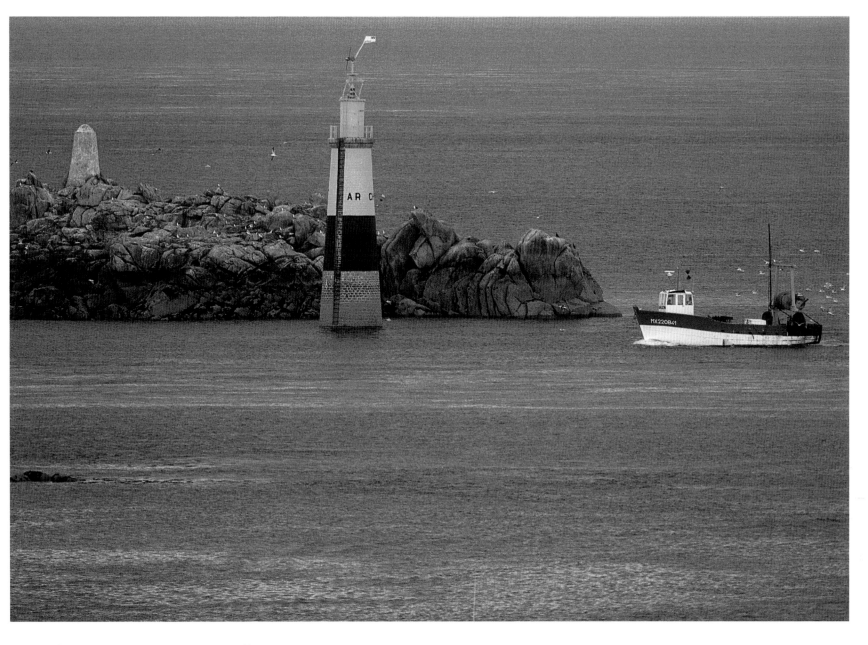

BEAUTIFUL SEA, GOOD FISHING. TIME TO MAKE FOR PORT.

The VHF radio crackles in the small cabin; the boss guts his last fish. It is a scramble for the spoils for the squawking seagulls ever-present off the stern. The fishing boat seems to know the Roscoff channel by heart. Without hesitation, it glides between the Ar Chaden beacon to the west—"Danger is to the east, I go west"— and the rocks. In foggy weather he would take a different route, but today the sea is calm, visibility good, and the route to port seems easy. Nearly two thousand fishing boats, one-third of all those in France, are registered in Brittany, the best region for fresh fishing in France. The Bigouden region, along with the hauls from Guilvinec, Lesconil, Saint Guénolé, and Loctudy, unloads almost 40,000 tons. In southern Brittany, Lorient (producing 35,000 tons) and Concarneau (producing 30,000 tons) are also in the top ranks.

MEN-DU BEACH AT LA TRINITÉ-SUR-MER.

When a primordial dawn like this one rises over Men-Du Beach, we might doubt the world was ever created.
At the end of a languorous stretch, a wave has left behind the scattered pearls of a necklace. This is the high-
water mark, the line the highest tide draws on the strand. This is where you gather the ocean's gifts—wreaths
of seaweed and colored pebbles, a collection of shells, and a few polished shards of beach glass. Perhaps one day
an ancient gold coin or a sapphire—why not? Over the centuries, thousands of vessels have foundered amid the
crash of storm or battle, taking ancient amphorae, gold ingots, cannon, and Chinese porcelain into the inaccessi-
ble depths with them. The world's richest museum is on the ocean floor, and the extraordinary wrecks fill the
dreams of historians, archeologists, and treasure-hunters—like the *Geldermalsen*, which sank with its cargo of
Chinese porcelains; the *Carnatic*, and its 40,000 sterling in gold; the wealth contained within the *Yongala*'s hull;
and the *Empress of Ireland*'s 250 bars of silver.

AN EVENING PALETTE ON THE COAST OF QUIBERON.
THE PAINTER TAKES HIS TIME TO CAPTURE THE SETTING SUN.

It takes only a fraction of a second for a photographer to capture this pensive silhouette and the dialogue of
ochers between sky and sea. The painter, however, lets the hours stream by, the tide turn, and the day come to
rest. Both strive after the same light that sheds its red tint as the sun sets. One, manipulating his lenses, finds
the rainbows in the evening sky; the other arranges colors, whose stories vanish in the night. In the past, artists
only had natural dyes at their access. Lapis lazuli, that blue stone from the mountains of Afghanistan, was trans-
ported by camels along thousands of miles of the Silk Route so that Chinese monks could enrich their palettes
with this precious blue-green pigment. In the cathedrals of Europe, stained-glass artisans used pure gold to lend
a reddish color to their windows.

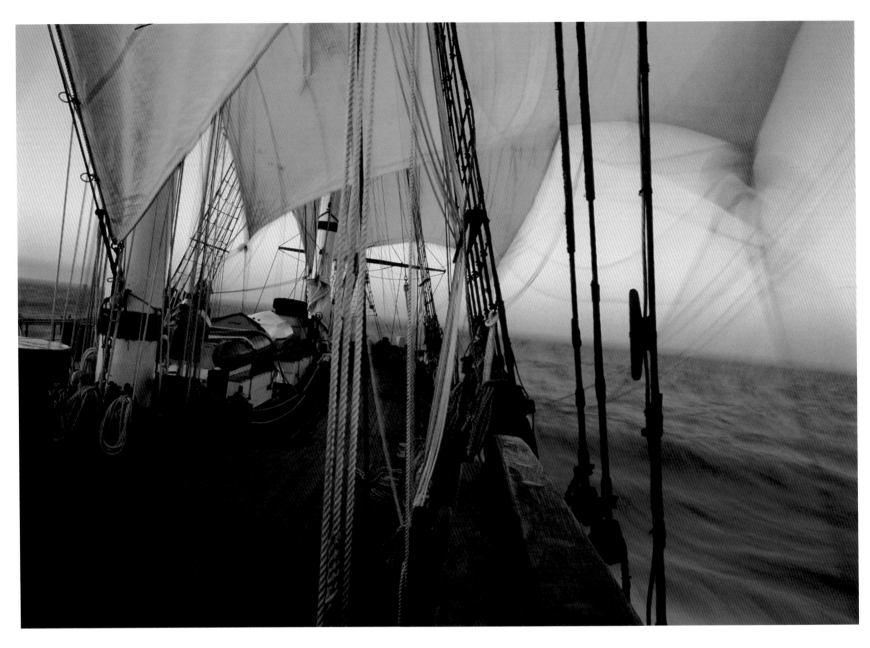

HMS Rose. A reproduction of an eighteenth-century British royal frigate
that played a part in the history of the United States.

The HMS *Rose*, a frigate built in England in 1757, was famous all down the coast of the colonies fighting for their independence.
The HMS *Rose* disappeared in Georgia in 1779. The British scuttled it across the Savannah river to keep the French, allies of the
Americans, and their fleet, from ousting the British from Savannah, which they were then occupying. The replica was built in
Canada in 1970 from plans that had been drawn up two centuries earlier, for the construction of its ancestor. Though it is a copy
of a British ship, the reproduction is an American vessel, and though its name is simply *Rose*, the initials HMS ("His Majesty's
Ship") often precede the name. Built for the bicentennial of the independence of the United States, in 1985 *Rose* became the prop-
erty of the HMS *Rose* Foundation. The restored ship appeared on the East Coast of the United States in 1991, with apprentice
hands unfurling its 13,000 square feet (1,200 m²) of sails. Succumbing to the glamour of Hollywood, this large, charming sailing
ship has been on sets since 2001. In its first role, it crossed the Pacific to San Diego, where it decks itself out behind the scenes.

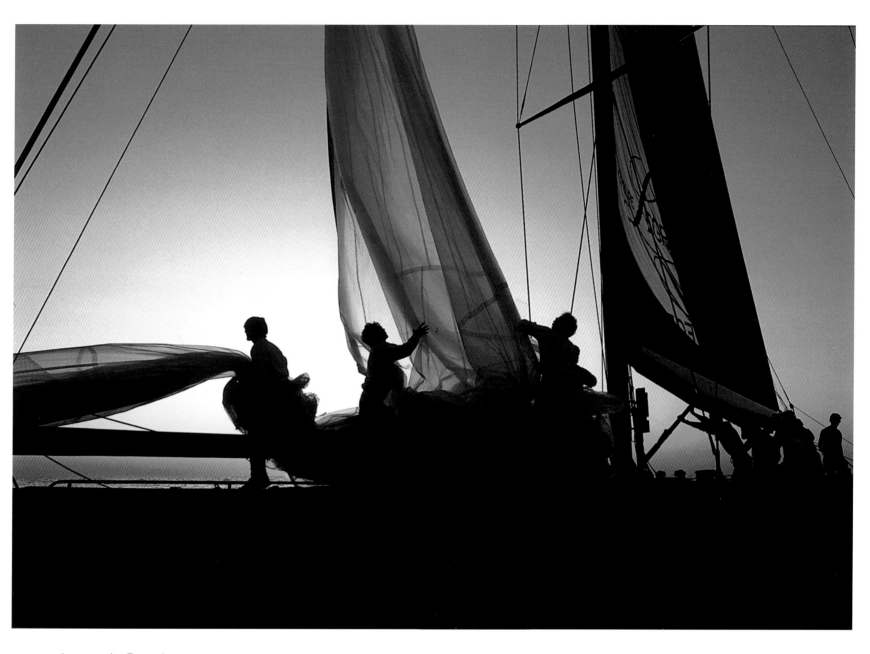

AMERICA'S CUP. AT THE END OF THE DAY, THE PLAY OF LIGHT ON THE SAILS.

The small joys of the America's Cup. Hauling in the sails in the evening after a fine day. The crew of the *Ville-de-Paris* is busy hauling in the spinnaker before sailing back close to the wind. It is the end of a day during the America's Cup. Arms are sore, eyes are burning a little, but fabulous visions of the race abound in the memory. Everyone could appreciate the ballet of boats—the endless maneuvering, the perfection of the tacks, and the passes around the buoys. The tension has subsided and the return to port, though requiring just as much precision, allows for a less intense tempo. With time slowed, one can finally savor the movements, the beauty of the moment, and the light touch of the spinnaker. To bring in this fickle sail, it must be grasped hand over hand. The mass resembles a cloud, both voluminous and lightweight and it takes more than a few armloads to stuff the 5,380-square-foot (500-square-meter) wing into a square bag.

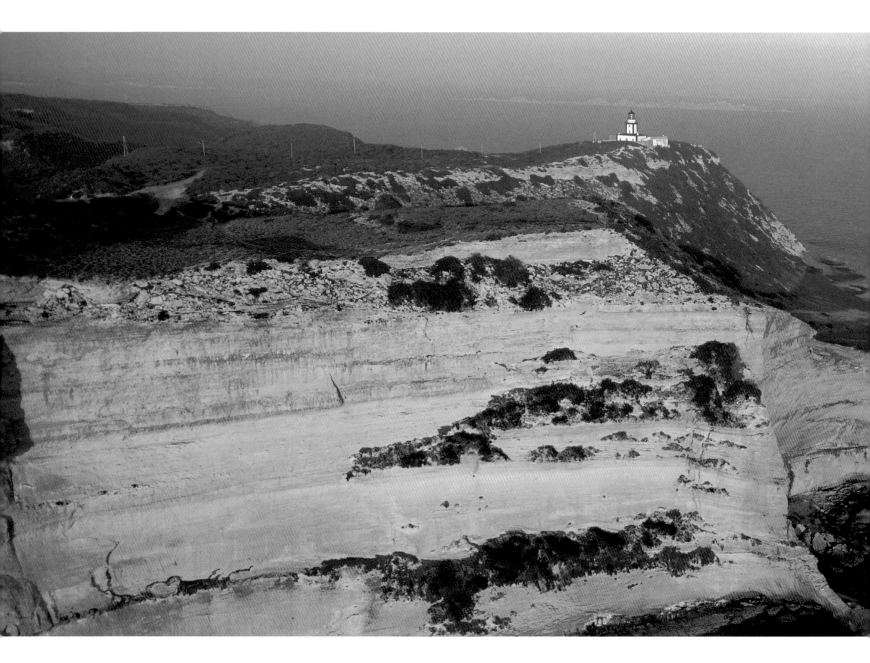

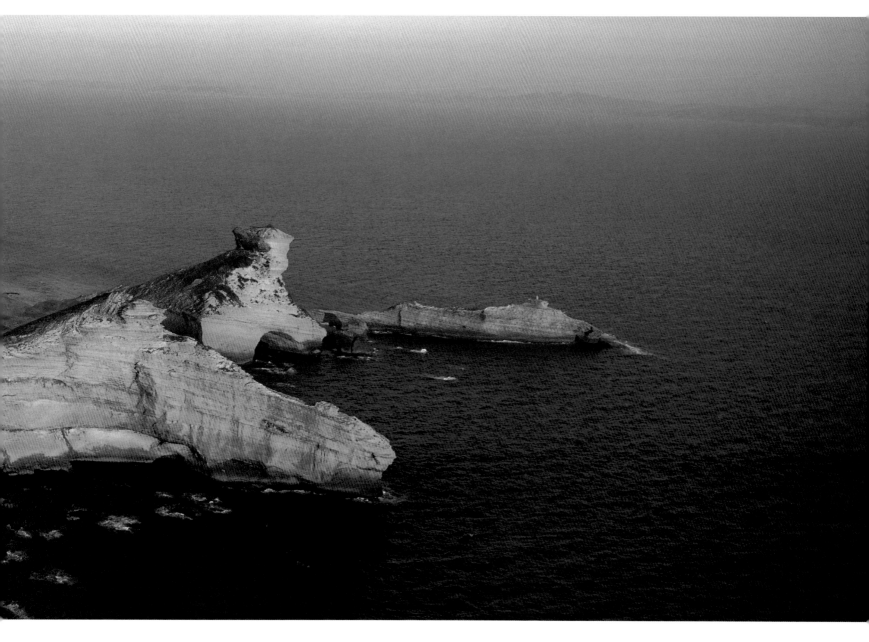

CAPO PERTUSATO AND ITS LIGHTHOUSE, SENTINELS OF SOUTHERN CORISCA.

A bleached white cliff turned pink with the rays of the setting sun, so ends the "Isle of Beauty" at Capo Pertusato, south of Bonifacio. Far off, the line before the horizon is a reminder that until the Mesozoic Era, Corsica and Sardinia were a single landmass. A veritable mountain jutting out of the sea, Corsica has more than 625 miles (1,000 km) of coastline. While the limestone cliffs of Bonifacio are as white as marble and the granite rocks of Sant'Ambroggio are beige, various reds dominate most of the other regions—the porphyritic volcanic rocks in Scandola, the deep purple of the Sanguinaire islands off Ajaccio, the pink granite of Calanches de Piana and Capo Rosso in the Gulf of Porto. All of these coastlines are reflected in the same blue waters that range in subtle degrees from turquoise to ultramarine.

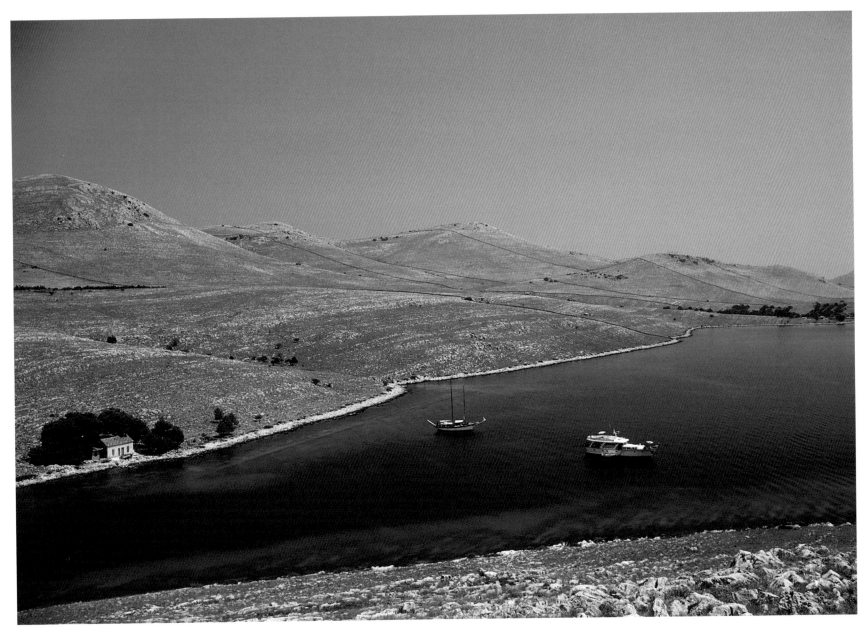

CROATIA. AT ANCHOR IN A SMALL BAY OFF THE KORNATI ISLANDS.

The archipelago of the Kornati Islands extends along the coast of northern Dalmatia and comprises hundreds upon hundreds of small islands and rocks that jut out of the Adriatic Sea. These rocky islands are, for the most part, quite arid and have even fewer trees than residents. They present a lunar setting of limestone boulders and low walls of dry stone, which in the past were used by cattle and sometimes even herds of sheep. To this day, shepherds migrate with their lambs to these unpopulated islands. Arriving from the coast and Murter Island, they are the sole (and temporary) residents who come to live in this inhospitable archipelago. They have built small houses, hidden away in the coves of the bay and near to the shore so they can easily go fishing. Their herds roam freely. These lairs, formerly beyond reach, are now slowly coming out of the shadows. In 1980, the Kornati Islands archipelago was declared a national park, and since then many tourists and sailboats have come and set anchor in these protected bays of deep azure water.

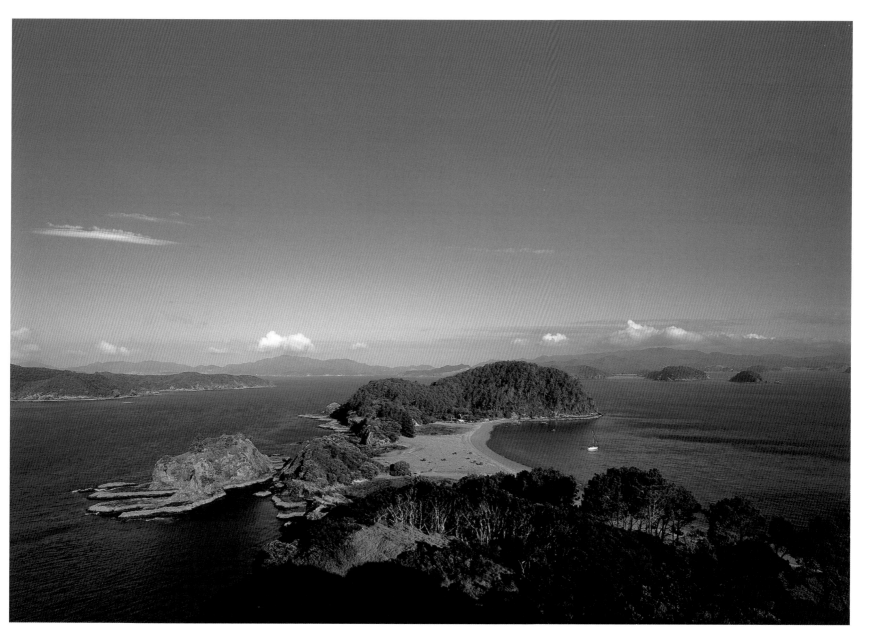

BAY OF ISLANDS, "PARADISE FOR PEOPLE FROM AROUND THE WORLD."

Hundreds of boats, registrations from every port on the planet, endlessly linger in New Zealand's Bay of Islands. Naturally, "kiwi" and Australian amateur yachtsmen are the first to take advantage of the innumerable moorings in this gulf where the promise of the world's ocean whispers. One-hundred-and-forty wooded and hilly islands, beaches, cliffs, hot springs, sumptuous flora, a subtropical climate, and magnificent underwater troves can be found here. The scene is idyllic and belies the original name of this elongated kingdom that is situated over a tectonic fault-line—Land of the Long White Cloud. Here, at the northern extremity of North Island, the sky is often blue and the temperatures mild (50 °F/10 °C in winter, 77 °F/25 °C in summer). This eden was chosen as the setting for one of the most significant historical events in the country's recent history—the signing of the Waitangi Treaty of 1840 that established British rule over the territory of the Maori.

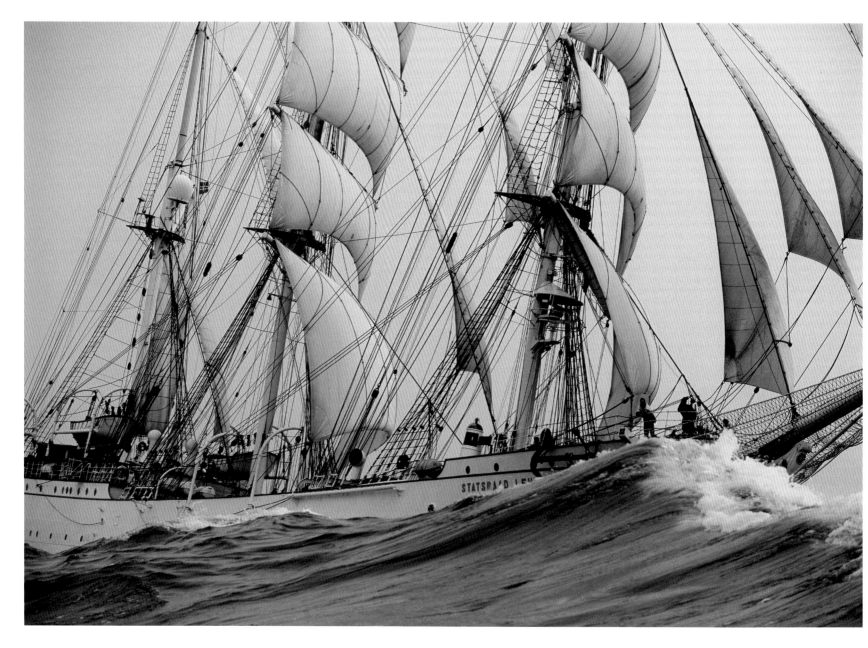

NORWAY. THE VERY ELEGANT THREE-MASTER *STATSRAAD LEHMKUHL*,
BUILT IN 1914, IS TODAY A PRIVATE SAILING SCHOOL.

Commerce has been the driving force behind many human advances. For example, in the nineteenth century, lighthouses began
their proliferation along the coasts in response to the growing traffic of ships transporting goods by sea, which in turn was
sparked by the progress in naval construction. The clipper ships, those majestic princes of the sea that appeared in the second half
of the nineteenth century, plied the waves on behalf of national merchant marines. Though large, the sailing ships were light and
airy and could sometimes do better than 20 knots (23 miles, or 37 kilometers, per hour). They took on coal and manufactured
products in Europe and brought back cotton, tea, and spices from Asia. The first steamships, in the early nineteenth century, were
not yet a threat to the clipper ships—the quantities of coal it took to propel them left too little room in the holds for cargo. The
technology advanced so quickly that before the end of the same century, steam-powered freighters and ocean liners were beginning
to replace the sailing ships. Some clippers—which have lost none of their presence—are today available for cruises; those nostal-
gic for the great days of sailing may embark on the *Statsraad Lehmkuhl* to spend a few days outside of time.

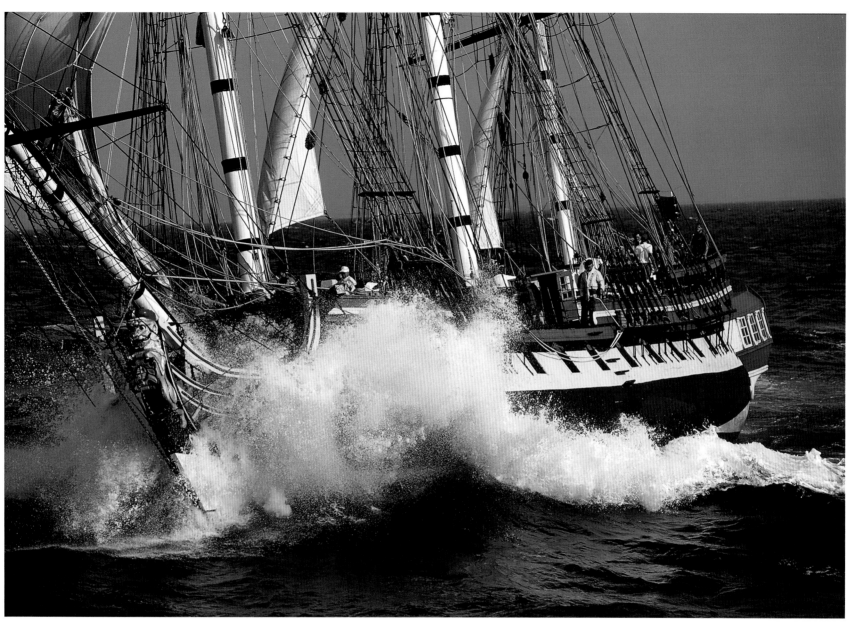

A THREE-MASTER ASEA. A WAVE CRASHES HEADLONG AGAINST THE STEM
OF THE FRIGATE HMS Rose AS IT SAILS AMAIN UNDER A CLEAR SKY.

The smiling lion on the bowsprit of the HMS *Rose* endures the assaults of the waves, while the passengers
aboard escape the spray. The pot-bellied boat heels under the force of the wind, and the small openings in its
hull are evidence of a double-rowed battery. In bygone days, its twenty-four cannons had served to escort more
vulnerable boats. When the sky is clear and the sea relatively calm, the pretty frigate will glide along with all
its sails hoisted. Here, the HMS *Rose* sails on a port tack, meaning that the wind is coming from the left side of
the ship, when viewing from behind. One hundred and sixty-five feet (50 m) long and weighing almost 500 tons,
the eighteenth-century vessel may not be the most imposing when compared to others, such as the *Belem*, but its
sails and the quality of its overall restoration make it perfectly seaworthy and full of style.

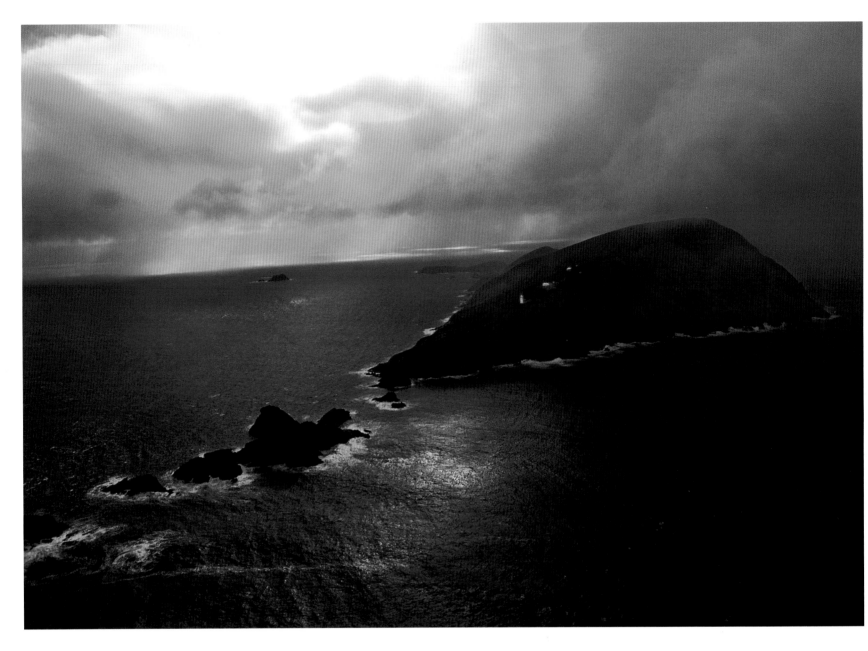

THE ENDS OF THE EARTH. A KEEPER STILL OCCUPIES THE LIGHTHOUSE ON MAATSUYKER ISLAND, A PEBBLE TEN MILES SOUTH OF THE AUSTRALIAN MAINLAND.

Tasmania, a triangular spur of land between the Indian Ocean and the Tasman Sea, rises southeast of Australia. Four hours south of Hobart by helicopter is Maatsuyker Island. Here on this tiny rocky world, at the same dramatic latitude as Cape Horn, lives the last lighthouse keeper in the Southern Hemisphere, an exile above a remote liquid world. Candidates for the job of lighthouse keeper—voluntary prisoners several miles from any coast—must demonstrate not only technical competence but unusual strength of character. Besides facing solitude and isolation, they must be able to overcome fear and to exercise self-denial, dedication, and solidarity. These values, which give the profession its nobility and specificity, inspire the esteem of sailors, who recognize them as of their own kind and lend them their vocabulary. Thus, for instance, the keepers "fit out" the lighthouse and "come on watch." With the automation of the lighthouses and satellite navigation, however, the days of these watchful sentinels are numbered.

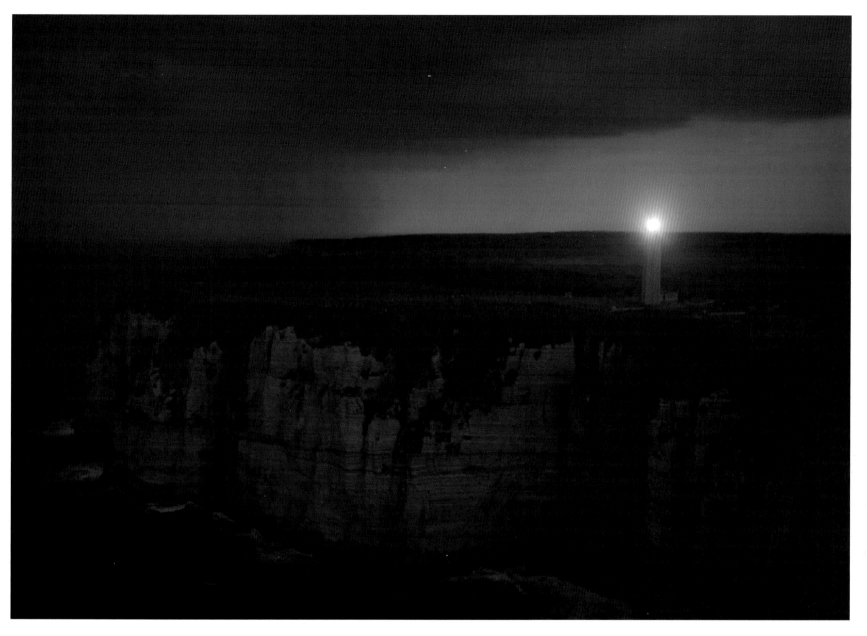

EARLY MORNING IN ÉTRETAT. THE LIGHT ON THE CLIFFS AS NIGHT EBBS.

"The weather was bad. The squalls were coming one after another and we were flying over the coast in a heli-copter. We were fishing for images, but did not hold out much hope. Suddenly, a streak of light shot through the chalk with fine, hair-like rays. Night was lifting, the beacon light still shone. The moment was dazzling, and I took the shot. Miraculously, it remained true to our vision," recalls Philip Plisson. Here, very close to Étretat and a stone's throw away from the gigantic oil terminal at Antifer, the landing lighthouse is no luxury. Its range is 28 nautical miles (32 mi/52 km), and it towers more than 330 feet (100 m) over the sea. But this great white eye, first illuminated in 1995, is under threat. Vegetation is consuming the cliffs from above, the sea is eroding from below, and the coastline is dangerously receding. The ground holding the tower could soon crumble because of these factors. Saving the lighthouse would require dissembling it stone by stone and then reconstructing it farther inland, as was done on Cape Hatteras, off North Carolina.

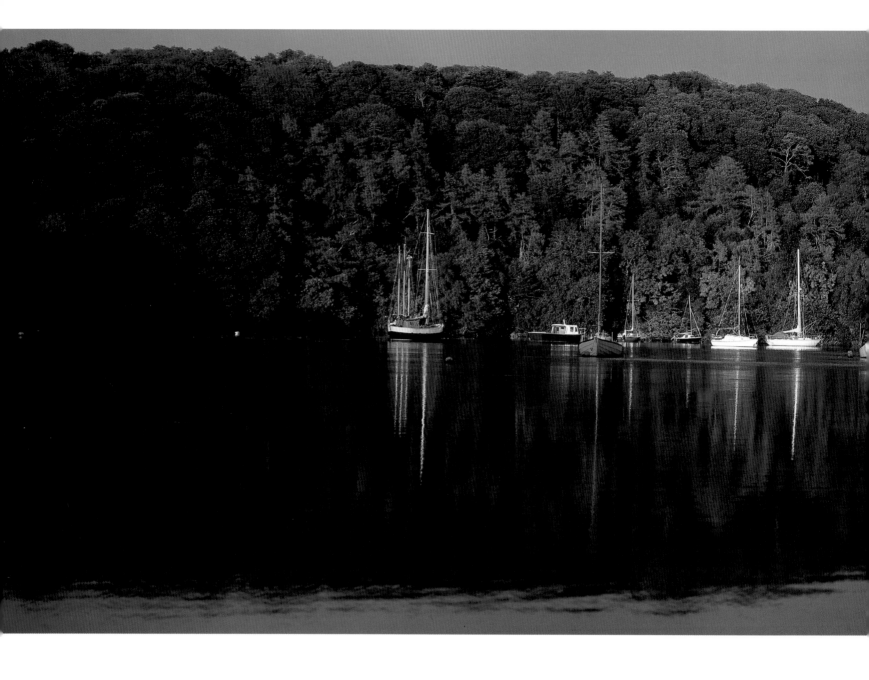

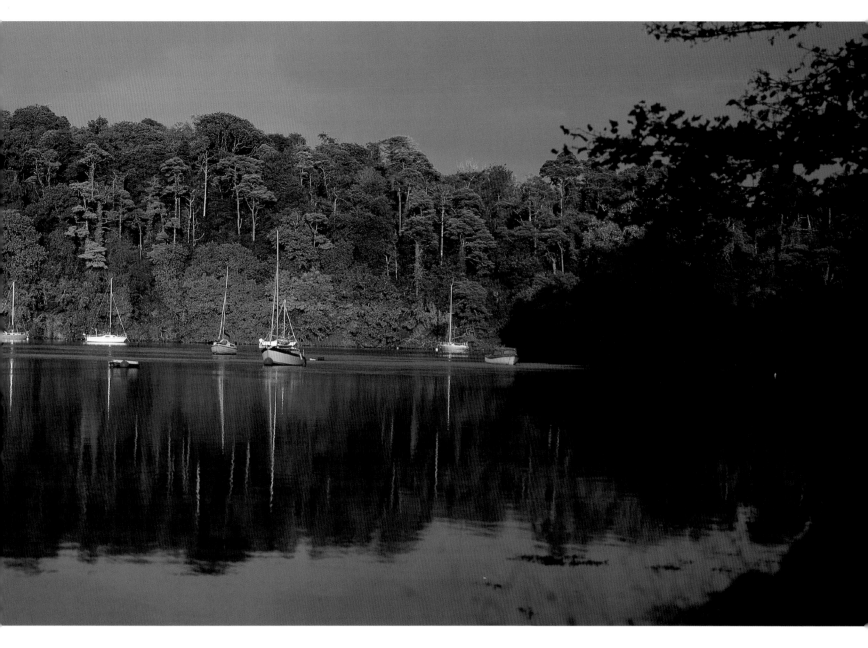

A STONE'S THROW FROM THE OCEAN, A DREAM ANCHORAGE ON THE OWENABUE RIVER.

The Owenabue river lolls between moors and forests before expanding to form the bay of Cork on the south coast of Ireland. This tranquil river, with its heavenly banks, has long been a preferred anchorage for pleasure sailors, and the small port of Crosshaven, located in the harbor, is home to the Cork Yacht Club. Crosshaven is also renowned for its shipyards, and it is here that the *Gypsy Moth V*, on which the famous British navigator Sir Francis Chichester sailed around the world in 1971, was built. This is also where, in 1976, Tim Severin built his *Brendan*, a replica of a sixth-century vessel, with which he proved that Irish seamen had reached the shores of America before Christopher Columbus.

BIG SMILES AND FRESH FISH. PASSING THROUGH GRENADA.

The island of Grenada's principal resource is farming, but the fishing is also an important activity. The return of boats into the port of Saint George at the end of each day is a central moment in the life of the country. Fish have taken the volcanic and wooded valleys by storm. Amid orchards of lemon trees or coconut palms, within the banana plantations and teak groves, are strewn myriads of small, colorful houses where people hang fish to dry on laundry lines and odd hooks. And here the children all rush over to get in the picture. One hundred thousand people share the 115 square miles (300 km²) of this island in the Grenadines, which for a time was under French and then British rule before it gained independence in 1974. The years under the authority of the British crown have left their mark: very British bobbies guard the traffic circles, and schoolchildren always wear smart uniforms with short pants.

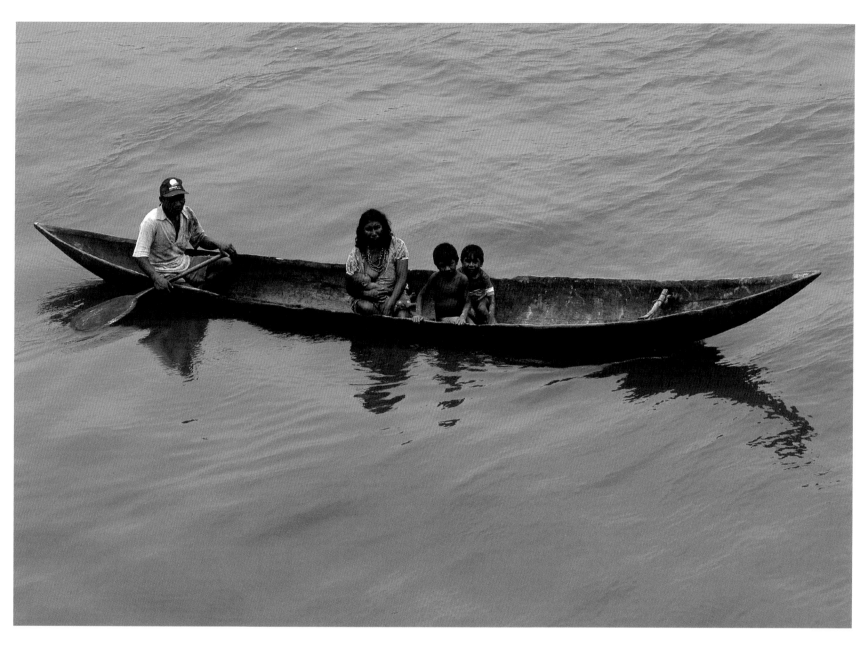

BETWEEN THE RIVER AND THE FOREST IN THE MOUTH OF VENEZUELA'S ORINOCO DELTA,
A WARAOS FAMILY PADDLES IN THE CURRENT.

Life together, on the water—the fresh, silty water of one of Latin America's largest rivers—such is the tradition
of the Waraos Indians. Their population of about twenty thousand lives in the labyrinth of canals, forests, and
backwaters of the Orinoco Delta. This amphibious region comprises more than 11,580 square miles (30,000 km²),
roughly equivalent in size to Belgium. More than 1,245 miles (2,000 km) long, the Orinoco empties into a basin
of some 366,700 square miles (950,000 km²), the largest on the continent. At its delta, the waters are so silty
that the land along the Atlantic expands by almost 165 feet (50 m) every year. Farther north, on Lake Maracaibo,
the Caribe and Arawak Indians lived in homes built on stilts. When the Spanish conquerors discovered these
lakeside villages, they called this region the Little Venice of Venezuela.

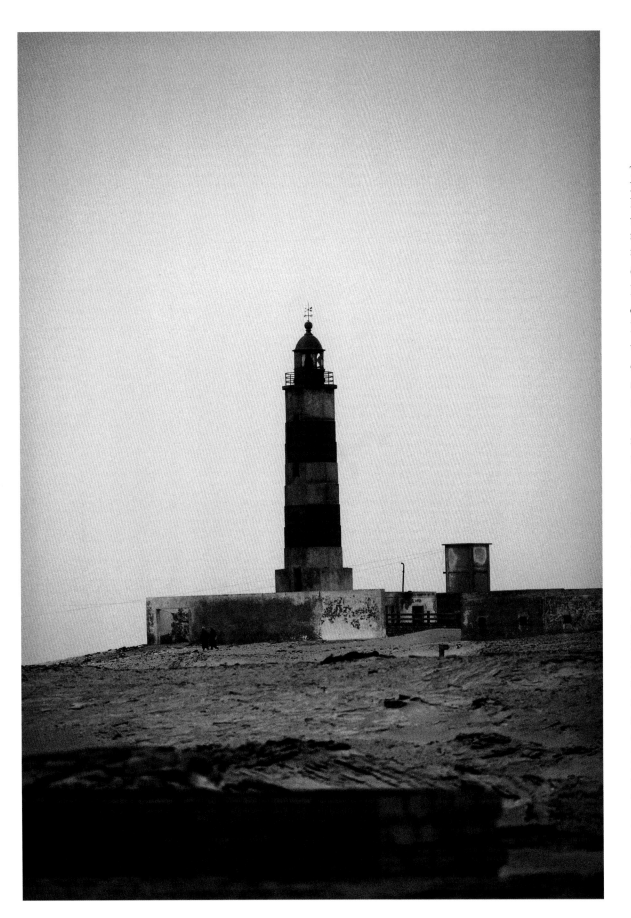

On this low and straight coast-
line bordered by a row of
dunes, the small Nouadhibou
lighthouse perseveres. The
vaguely lunar landscape is a
consequence of devastating
assaults by wind and sand
that raze, level, and polish the
ambitions of both man and
nature. A few groves of
tamarisk indefatigably struggle
against the wind erosion,
while the camels have adapted
to this arid land. The tradi-
tional Nouadhibouan fishing
boats take to the seas regardless
of the conditions. The raging
breakers of the Atlantic are no
deterrent for these flimsy skiffs,
often piloted by Senegalese
fisherman. Business activities
involved with fishing generate
more than half of export rev-
enues. The Mauritanian coastal
area is reputed for its richness,
to the degree that today some
European maritime companies
have ventured into this well-
stocked fishing zone. Men in
turbans go forth under a
bristling sun, and all the while
the small abandoned lighthouse
stands up to the wind.

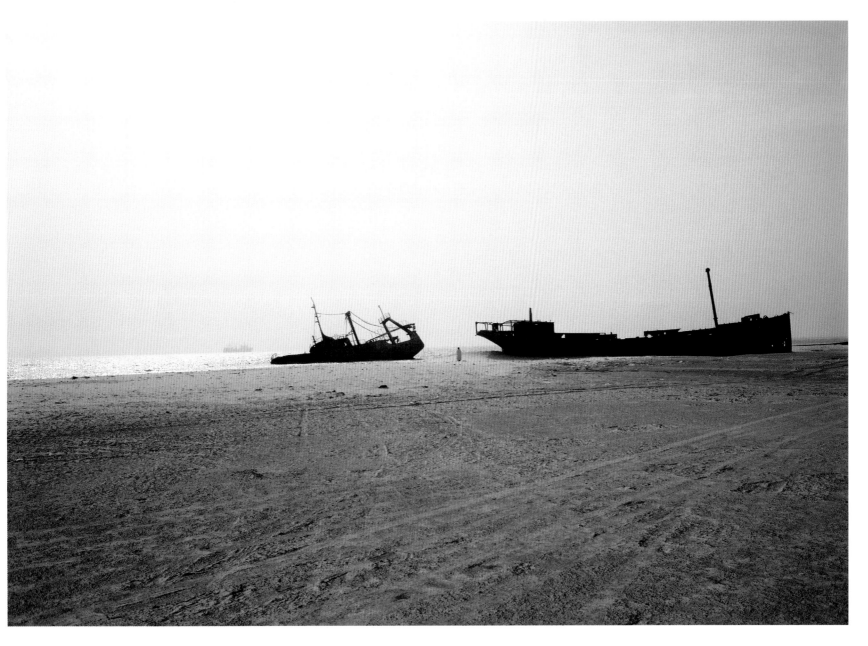

MAURITANIA. LITTLE BY LITTLE, THE SEA IS WITHDRAWING FROM NOUADHIBOU,
LEAVING THE ANCIENT FISHING FLEET OF THE ARGUIN BANK TO SINK INTO THE SAND.

In certain parts of the world, the coasts struggle in vain to resist the battering of the waves and gradually sur-
render the land to the sea. In other places, it is the sea that is abandoning its possessions. North of the Mauritanian
shore that forms the western edge of the Sahara, the Atlantic is withdrawing before the sands blown by the
dominant winds, slowly sinking the wrecks that become utterly incongruous with their new surroundings. Nor
is this instance unique. During the Middle Ages, Aigues-Mortes, in southern France, was a major embarkation
point for the Crusades; today it is more than a mile from the Mediterranean coast. Seville is another former sea-
port whose bay was silted up by alluvial deposits from its rivers, especially the Guadalquivir. Cadiz became
the area's port, as Seville withdrew inland. In the 1960s, in Kazakhstan, the two principal rivers that flowed
into the Aral Sea were diverted to irrigate the cotton fields. The banks of the Aral shrank some 50 miles (80 km),
stranding the carcasses of the trawlers that once fished its waters.

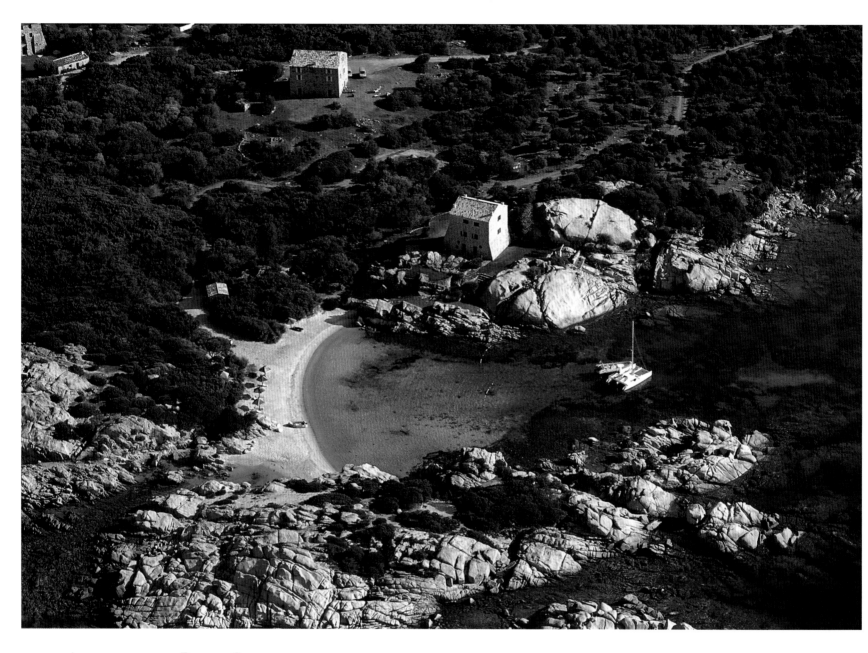

A SMALL BAY NEAR FIGARI. CORSICA, THE ISLAND WHERE BEAUTY REIGNS.

There are almost eight hundred pleasure boats registered in France, and the ports can no longer answer the ever-growing needs of present-day Robinson Crusoes. In this small bay near Figari, two boats seem anchored in paradise. The innumerable coves on the Corsican coast are protected by dense scrub, making them difficult to reach from land. This explains, in part, why the residents have had difficulty defending their island. From the Iron Age to the seventh century BC, the Iberians, the Ligurians, and then the Phoenicians landed on this island of beauty. A victim of its geographical location at a crossing of ancient sea routes, the island would be subjected to the successive yokes of the Etruscans, Carthaginians, Byzantines, Saracens, Pisans, Genovese.

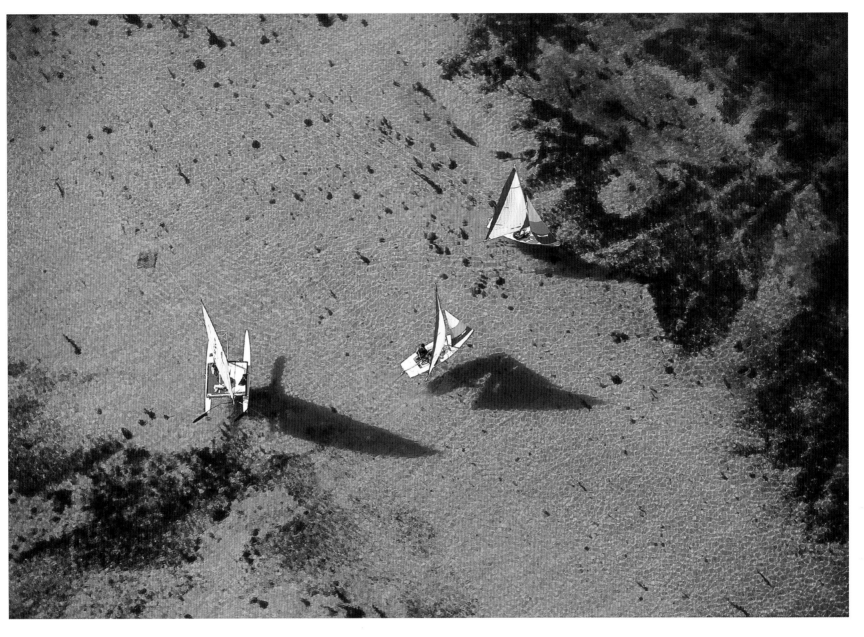

THE GLÉNANS. THE FIRST BOATS LUXURIATING IN EMERALD JOY.

These smaller boats could be meandering through the Seychelles or in the Caribbean, but it is the light southern winds of Brittany that guide them through the Glénans. Protected from open swells, these clear waters of the archipelago make for a calm marine setting that is perfect for water sports. Divers and windsurfers show up at Glénan every season, as do sailing novices, who have done so for almost fifty years to learn the rudiments of sailing in ideal conditions. The Glénan school has become an institution, having trained more than two hundred thousand people. Many sailors learned the ropes from these coaches and skippers whose reputations have made their way around Europe. The *Cours des Glénans*, an indispensable manual written by experts from the school, has sold more than 600,000 copies since 1961 and is a must-have aboard French ships.

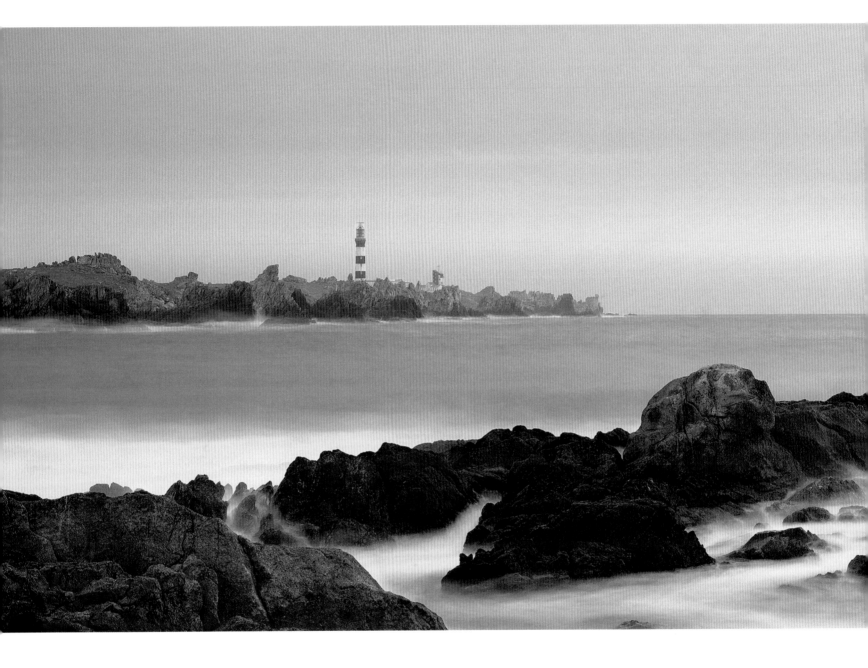

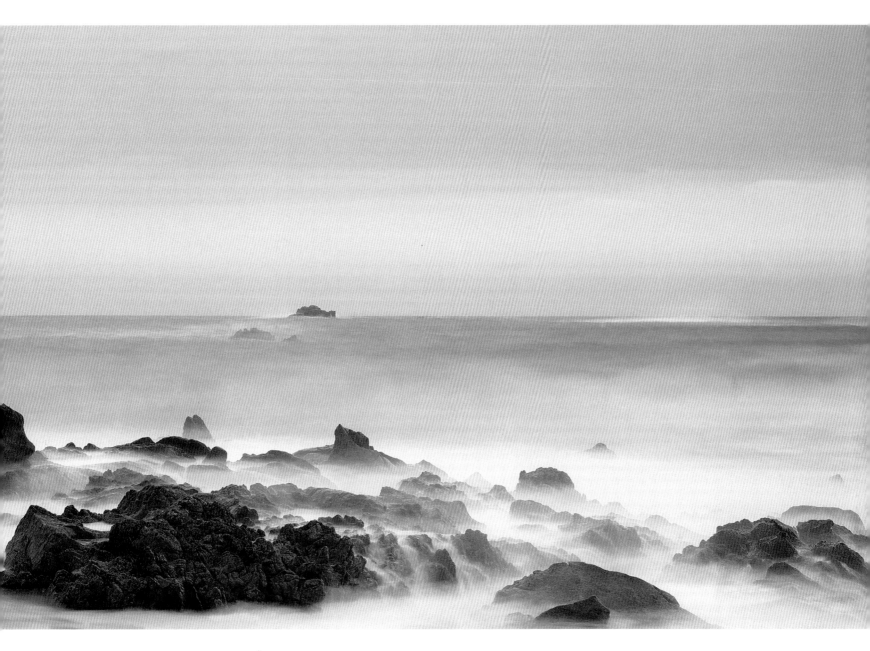

THE CRÉAC'H LIGHTHOUSE ON THE ÎLE D'OUESSANT, THE SENTINEL AT THE END OF THE WORLD.
Here is the western terminus of France. Beyond stretches the Atlantic Ocean and the coasts of the New World.
Anchored just a few miles off the point of Finistère, Ouessant is subjected to the combined assaults of the ocean
and the English Channel. During bad weather, the island is enveloped by the *boucaille*, a thick white fog, neces-
sitating no less than six lighthouses to guarantee the safety of ships passing through the area. As an old saying
goes, "He who sees Ouessant, sees his own blood." And the many ships that over the centuries have run aground
on its rocks serve as testament. Today, more than 150 cargo vessels pass through the Ouessant corridor each day,
of which a dozen or so are transporting hazardous materials. Since the catastrophic sinking of the Amoco *Cadiz*
oil tanker in March 1978, the passage of these vessels has been strictly regulated.

A BEAUTIFUL VISTA FROM THE WINDOW OF A LONG-HAUL AIRCRAFT.
THE DREAM BEGINS LONG BEFORE ARRIVING.

Plane flights can offer astonishing vistas. This jet flew at an altitude of just over 6 miles (10 km) over the Atlantic, heading toward the Caribbean. Under its wings, the cumulus clouds bloom and float in the sea air. Formed by the difference in air temperatures between latitudes and enhanced by the rotation of the earth, a light wind pushed these thick tufts toward the coast. Provoked by this wind, whitecaps form and will continue to mount over the course of many hours. The breeze will soon grow. The clouds will gather. The waves will travel as far as the coasts where they will sculpt the coves. Sea currents, born of these changes, will blow hot and cold over the continents. Such are the subtle climate changes that play out before the eyes of the observant traveler.

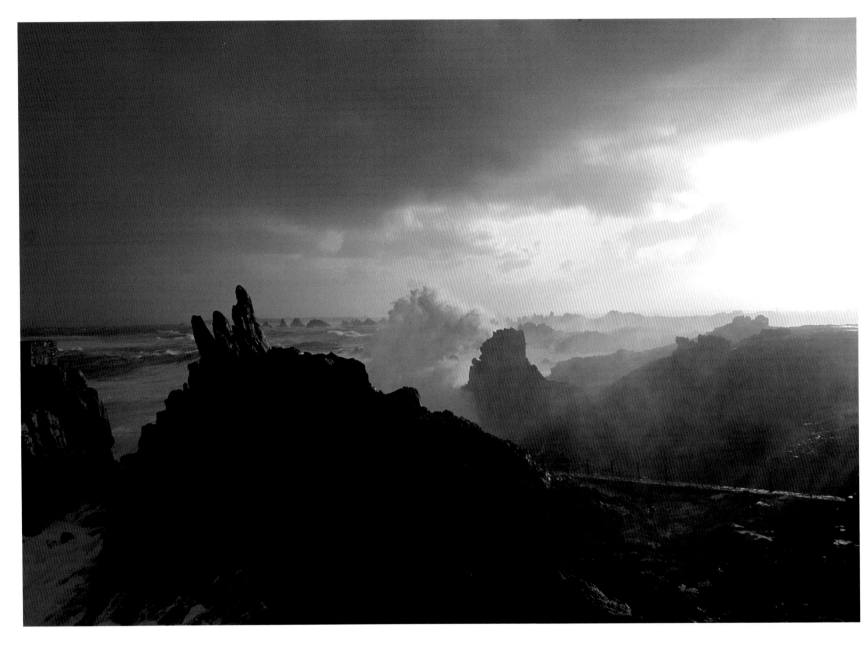

ÎLE D'OUESSANT. THE STORM BLEW ALL NIGHT.
THE FIRST RAYS OF THE SUN ILLUMINATE THE SCENE AT CRÉAC'H POINT.

Night is leaving Île d'Ouessant, taking with it an armada of overburdened clouds and a few gusts of an abating
wind. The storm raged all night, raising 65-foot (20-m) breakers out at sea, stumbling over the first rocks of the
mainland, shamelessly ripping roofs off nearby houses. Île d'Ouessant, off western Brittany, is the first landfall
for the barometric depressions that circle the North Atlantic and crash against the island. In 1806, the British
admiral Sir Francis Beaufort devised a scale to describe the force of the wind. The wind's speed is expressed in
knots—that is, nautical miles per hour (a nautical mile is equal to 6,076 feet [1,852 m])—using a scale ranging
from 0 to 12. A force 4 wind, for example, is a moderate breeze, blowing 11 to 18 knots (13 to 18 miles per
hour [20 to 28 kph]). On the Beaufort scale, 8 describes a "gale" or "fresh gale" (34 to 40 knots [39 to 46 miles
per hour (62 to 74 kph)]); 10 a "whole gale" or "storm"; and 12 a "hurricane." The many moods of this natural
force are revealed through the variety of words used to describe it.

Europe's largest shipyard is in Saint-Nazaire, on the Loire estuary. Founded in 1861, the Atlantique-Alstom yards today employ 13,000 people. They cover more than 267 acres (108 hectares), including 54 acres (22 hectares) of sheds. Atlantique-Alstom is one of the very few yards in the world equipped to build large, sophisticated ships. In 140 years, more than 600 civilian and military ships have come out of these yards. Battleships, aircraft carriers, frigates, container ships, methane tankers, supertankers, and ferries have come to life here, but it is the ocean liners especially that represent the yard's quality. The first ocean liner that the shipyard was contracted to build, in 1864, was the *Impératrice Eugénie*. In its wake, more than 100 liners and cruise ships have gone to sea, including the illustrious *Normandie*, launched in 1936, and the *France*, launched in 1962, after more than five years' work. The construction of the largest ocean liner of all time, the *Queen Mary II*, which will be completed in late 2003, was also awarded to the Atlantique-Alstom yards.

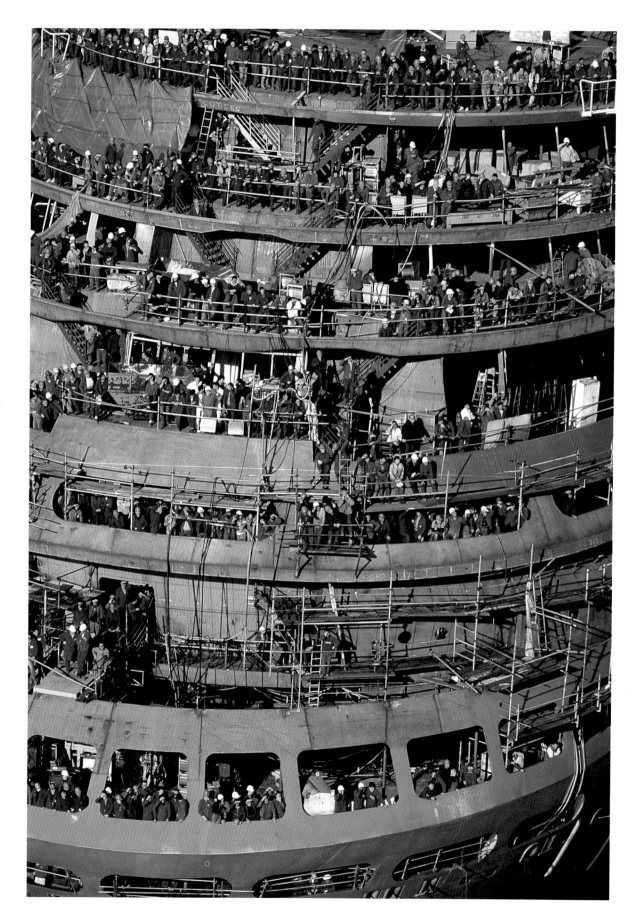

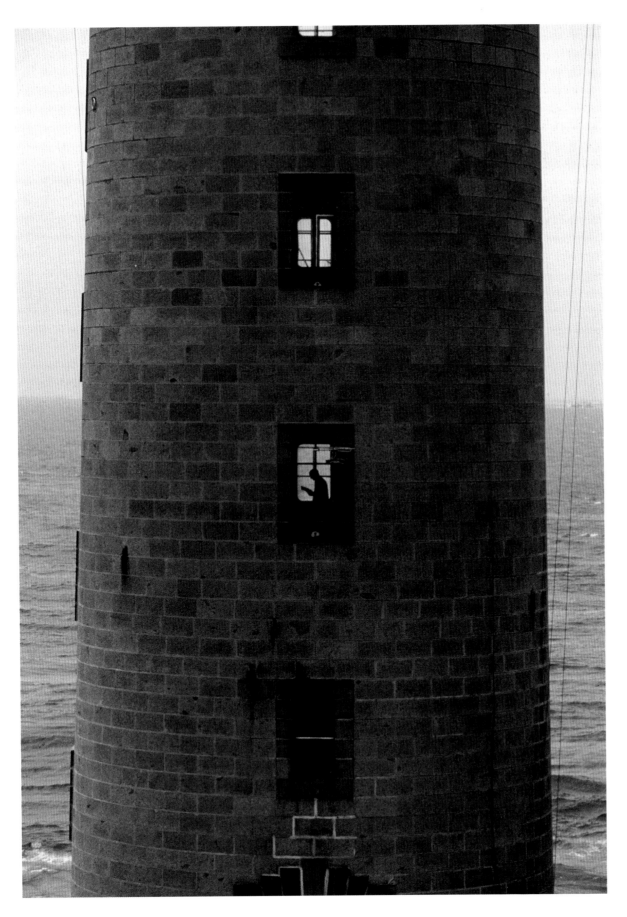

KÉRÉON LIGHTHOUSE.
THE KEEPER IS ABSORBED
IN HIS READING.

In the last three inhabited
lighthouses at sea in France, the
keepers—there are always
two—have almost unlimited
free time, once they have seen
to the lamp. To keep busy, they
talk, cook, tend to a faithful
pet, make or fix things—some
even haul a bicycle up to repair
it. At Kéréon, they play happy
homemaker, polishing the surre-
ally luxurious furnishings. The
best pastime, however, the one
that allows them to leave their
cramped stone dungeon for
expansive worlds and thrilling
adventures, is reading. In this
extraordinary instant, the pho-
tographer, flying at eye level
past the Kéréon lighthouse, had
the helicopter stop in order to
say hello to the keeper, spotted
at a window. Absorbed in his
reading, he was seemingly
unaware of the roar of the
rotors of the big, curious bum-
blebee watching him.

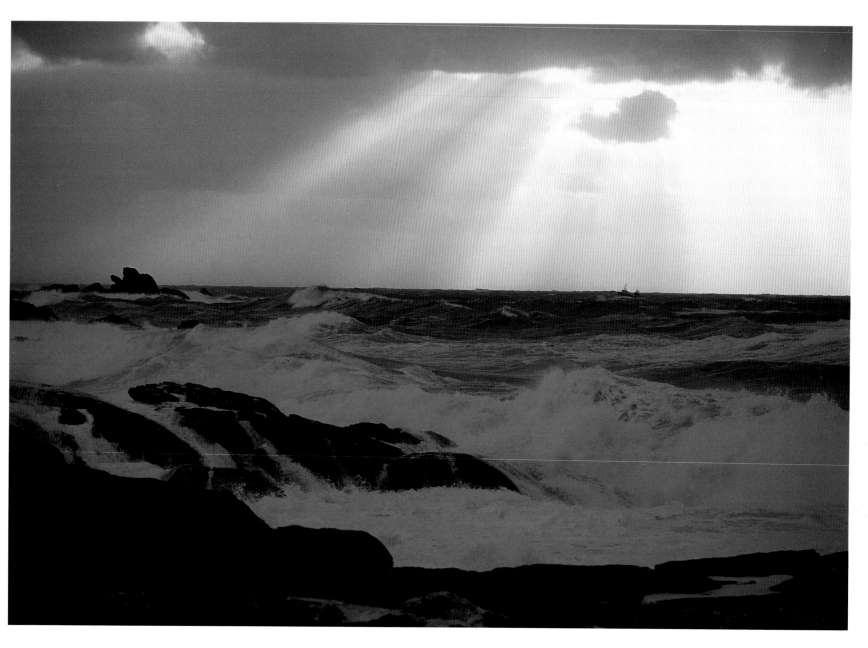

STORMY WEATHER. DAY OR NIGHT, THE SKIPPERS OF SMALL FISHING BOATS
MUST FIND THE WAY AMONG THE ROCKS THAT WILL LEAD THEM SAFELY HOME.

This tiny sea-tossed ship is returning with the tide to its home port of Saint-Guénolé, in southern Finistère. Its
silhouette is typical of the trawlers that are the standard vessels of both commercial and small-scale fishing
fleets. The ship's stern ends in an inclined plane bridged by a gantry. This rig allows the fishermen to maneuver
the trawl—the vast, conical net that the fishermen drag underwater or along the sea bottom, using frames to
keep it wide open. The trawl is lowered into the water from the stern by means of a winch and brought back
aboard the same way when it is full. These mesh funnels, the largest of which have maws nearly 500 feet (150 m)
across, are hauled by trawlers flying every flag, and account for more than half the world's catches. They differ
from the tangle nets that are stretched perpendicularly to the surface over several miles, in which the fish are
stuck, and which are controversial because they capture fish indiscriminately.

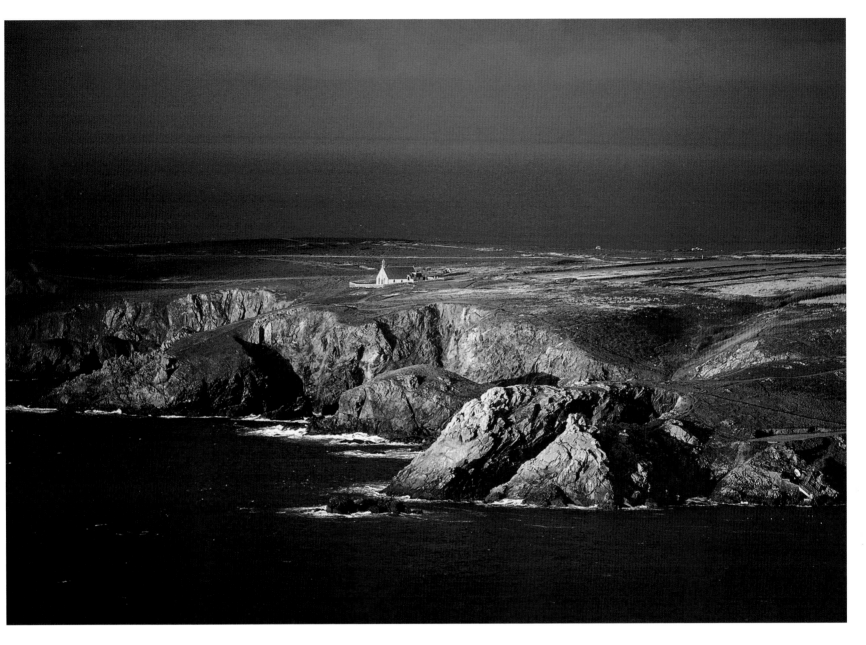

THE POINTE DU VAN AND ITS CHAPEL, PLANTED LIKE A CHALLENGE
TO MEN BEFORE THE VASTNESS OF THE OCEAN.

Millennia of storms, furious winds, and waves coming from the deep Atlantic have eroded the headland and
polished the hillsides. The Pointe du Van and its famous neighbor, the Pointe du Raz, mark the western
extremity of the Cornouaille. Its bald moor, without a single tree, plunges into the sea amid a chaos of rocks
showered with sea spray. The only sign of humanity on this desolate land is the Saint-They chapel, its squat
silhouette defining the terrain since the fifteenth century. It looks toward the horizon and the far-off Île de Sein
and La Vieille lighthouse. The nearby Cap Sizun Reserve is a stopover for an extraordinary colony of marine
birds—auks, crested cormorants, kittiwakes, stormy petrels, choughs, and herring gulls—that come each spring
to breed on the wild cliffs.

SCOTLAND. LATE-AFTERNOON FOG ENVELOPS THE COAST.

The Isle of Mull, which is part of the Hebrides, is the esssence of Scotland. The colorful houses of the quaint
city of Tobermory are lined up along the length of its port. Mull's bays are expansive and the solitude of the sea
unequaled. Gliding among the rocks that just break the surface of the water, discovering beaches that sparkle
beneath pink granite cliffs, contemplating a sky speckled with white clouds … nothing is too pressing on the
Isle of Mull. What appears to be a whale keeps company with the sailboats for a few miles until it submerges,
but the yachtsmen are well aware that it was in fact one of the many submarines that crisscross the area.
Stopping in a cove and then climbing the emerald green cliffs to discover, in the middle of a field, packs of sheep
peacefully grazing, carefully avoiding the bitter irises … It is difficult to extricate oneself from the magic of the
place. Lingering one more time on the loch, coming upon the small salmon farm that twists through zone and
then returning to the boat, any sadness is quickly erased by the breathtaking memories. Anyone who visits
Mull, returns to Mull.

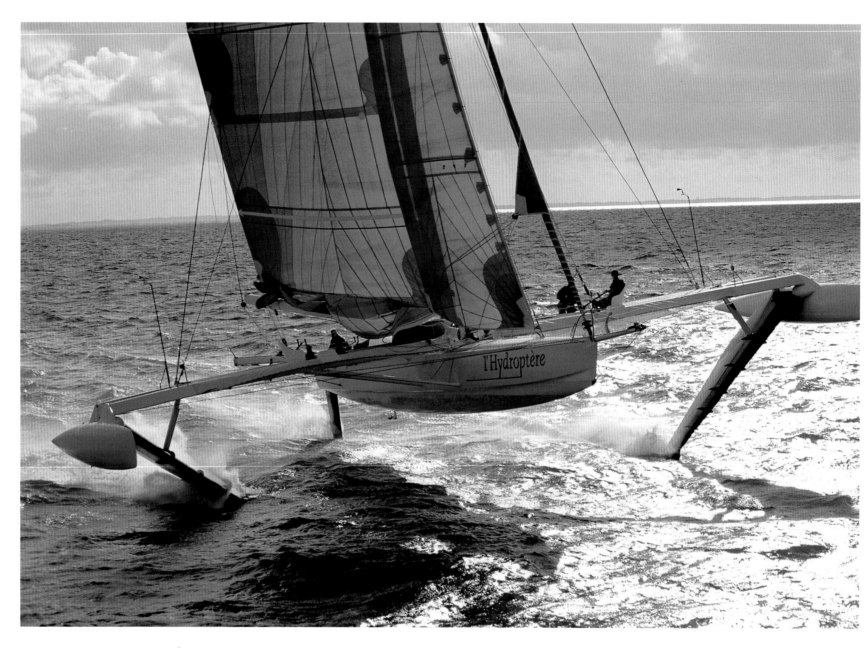

THE *HYDROPTÈRE*. ÉRIC TABARLY ENVISIONED IT, ALAIN THÉBAULT BUILT IT.

Hydrofoils do not float—they overcome the water's resistance by flying above it. As enthusiastic about tall ships as about technological innovations, Éric Tabarly was interested in hydrofoils (devices lifted on diagonal planes). In 1985, he told Alain Thébault about his idea for a "sea wing." In 1989, the mock-up became a prototype, corrected after a series of tests and calculations by naval architects and aeronautical engineers. In 1994, the *Hydroptère* was launched—and flew at 39 knots. Its designers are aiming for 45 knots (56 miles, or 90 kilometers, per hour), because the world record is 46.5 knots in a sailboat. This five-ton dragonfly is 59 feet, 5 inches (18.28 m) long and 78 feet (24 m) wide, with an 87-foot, 9-inch mast spreading some 1,796 square feet (167 m²) of sails. At 10 knots, it rises on its foils to reach its cruising height of between 6 feet, 6 inches and 9 feet, 9 inches. At that point, the helmsman becomes a pilot. In both vocabulary and appearance, this technological and sporting challenger, principally sponsored by Alstom Marine and EADS Airbus, is a creature as much of the air as of the sea. So—ship or airplane?

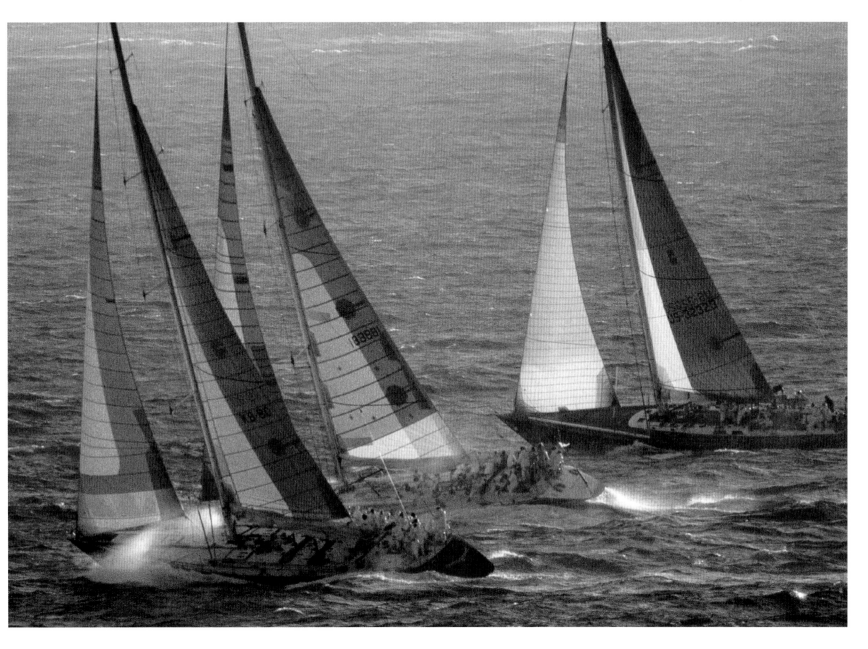

AUGUST 1985. THE SIXTIETH START OF THE FASTNET RACE.

In 1925, a handful of sailboats were at the starting line of the first open-water race in history. The race covered 605 nautical miles (600 mi/975 km) from the Isle of Wight, passing by the Fastnet lighthouse off southwest Ireland at its midway point and terminating at Plymouth. Six days after the starting gun, *Jolie Brise*, a cutter pilot from Le Havre, took the trophy. This new type of regatta that necessitated several days of uninterrupted navigation would give birth to the ocean challenges of today. Staged during the month of August of every odd year, the Fastnet race remains an important nautical event. The teams from the Admiral's Cup circuit confront changeable weather conditions that can become dangerous. The 1979 event was swept away by a hurricane. Of the 303 participating boats, five sank, nineteen were abandoned, and fifteen sailors were lost.

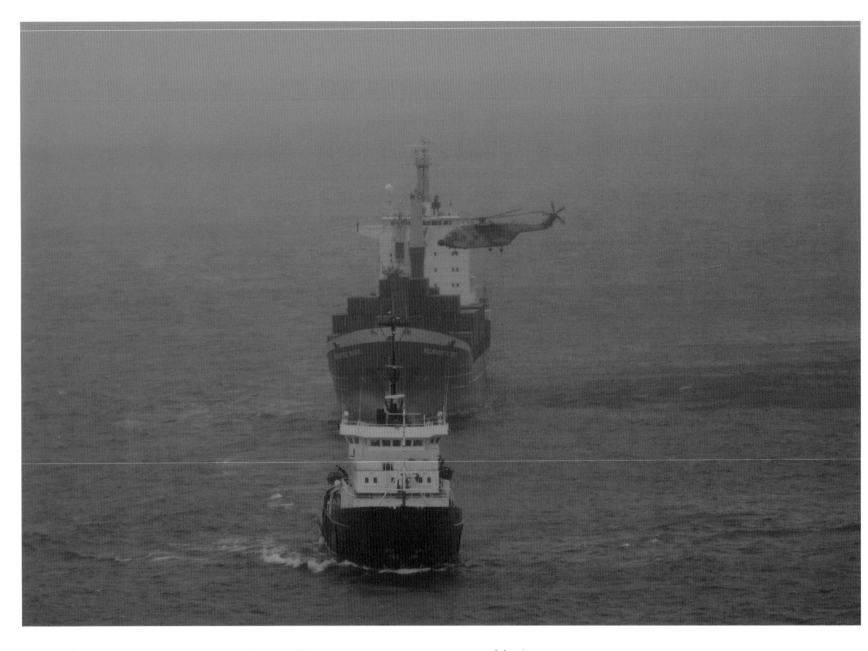

A DIFFICULT SECTION FOR THE *ABEILLE FLANDRE*, TUGGING THROUGH THE MOLÈNE CHANNEL.

How did the *Melbridge Bilbao* run aground without incident? Neither the people of Molène who, on November 12, 2001, discovered this container ship on their beach, nor the maritime professionals could conclude anything other than that it was a stroke of extraordinarily good luck. On board, the watchmen were asleep, exhausted from many days of work without a break. The alarm system had been shut off. The radio, over which controllers at Ouessant repeatedly tried in vain to make contact, had also been turned off. The vessel had been flying at 15 knots solely on an automatic pilot that was misprogrammed. Instead of entering into the North Sea maritime highway, the vessel headed toward the Molène archipelago and at 7:30 in the morning, ran aground 655 feet (200 m) from the village, coming to rest on a sandy shoal. The volunteers of the Société Nationale de Sauvetage en Mer (SNSM, or the French national organization of rescuers), who know even the smallest channels in this complicated zone, assisted crews from the French navy in getting the cargo ship out of this difficult waterway.

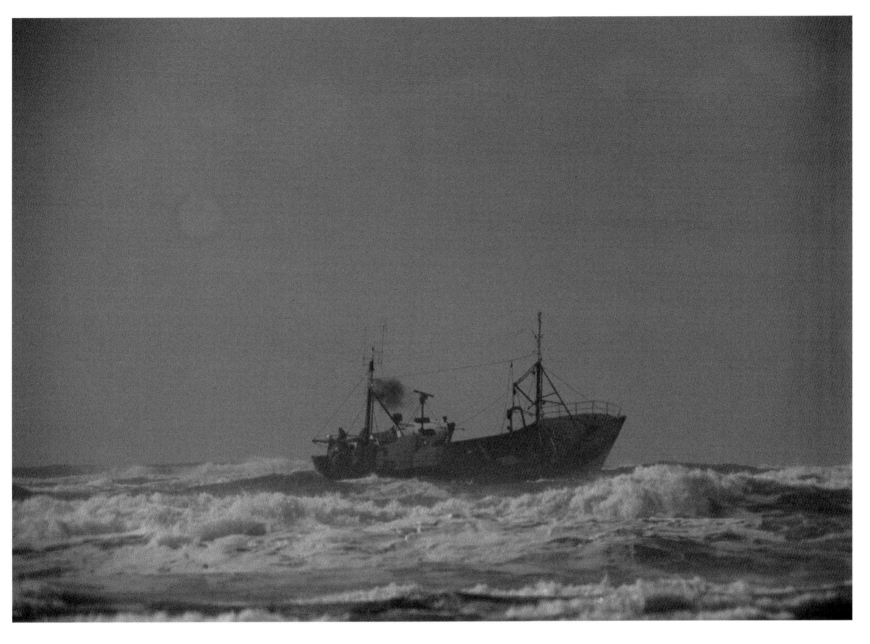

FISHING IN THE FOAM. A TRAWLER IN THE BLUE BEFORE NIGHTFALL.

In Brittany, eight thousand individuals make their living from fishing. Some, like the line fisherman and those going after shellfish, manage their boats solo, but for the most part there are many hired hands. In fact, since the mid-twentieth century, trawl fishing from huge ships has replaced the seasonal cod and sardine fishing that was traditional. Today, although these small coastal ships still exist, the deep-sea fishing vessels prevail. The seamen go out for periods of several weeks and as soon as they arrive at the right location, work day and night, often in violent seas. Fatigue only adds to the difficulty of the work, which is one of the most dangerous in the realm of the sea. Every winter, both men and ships are lost to the night waters.

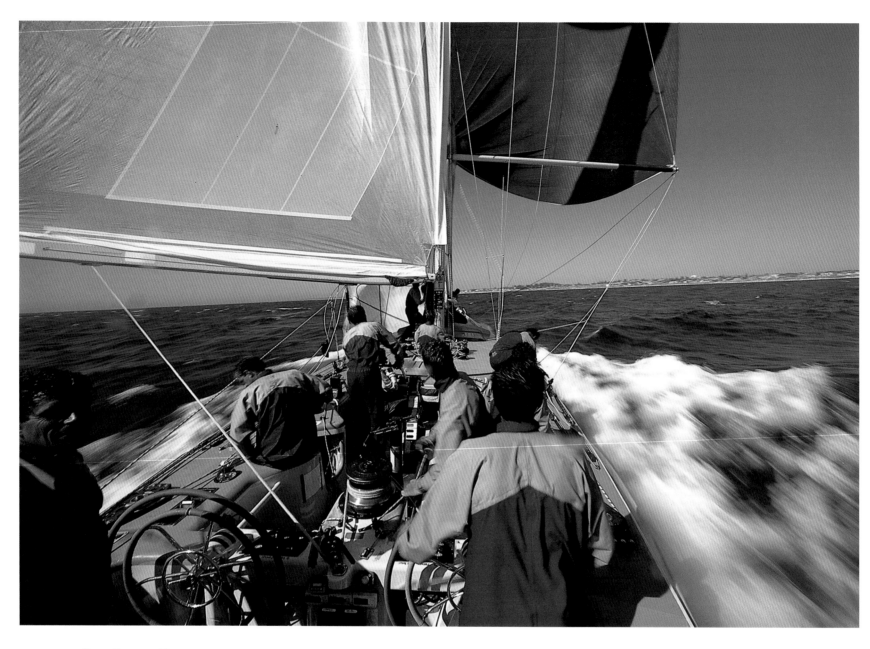

1987—FRENCH KISS AMAIN.

In 1851, on the occasion of the London World's Fair, England opened its very select Isle of Wight Regatta to foreigners. Contrary to all expectations, the schooner *America*, the New York Yacht Club entry, ran off with the race. The winners offered to put the title back up for grabs at the next race in New York, and thus a tradition was born. British enthusiasts were more than ready to reclaim their honor. Some builders transformed it into a personal quest, and expended fortunes on boats measuring 130 feet (40 m) that sported 10,765 square feet (1,000 m²) of sails and required sixty-men crews. Following World War I, the race was put in jeopardy due to lack of funds, thus leading to the advent of the J-Class. Less grand, the 12-meter IMS classification, measuring 44 feet (13.5 m) in length, replaced the huge boats of earlier days. *French Kiss* was of this generation. In 1992, the new standard of "America Class" was adopted. With hulls reaching 82 feet (25 m) and sail areas of 7,535 square feet (700 m²), the cup race has taken up with former loves again.

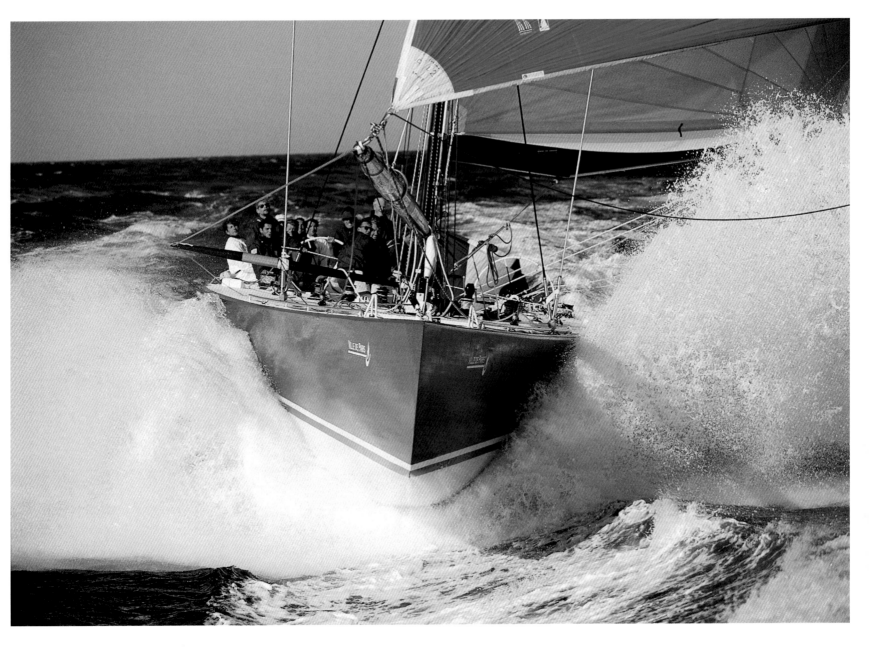

SAN DIEGO, 1992. THANKSGIVING; THE WIND IS BLOWING AT MORE THAN THIRTY KNOTS.

Marc Pajot and Philippe Briand, the architect of *Ville-de-Paris*, hesitate to go out. After an hour's discussion, persuaded by the photographer that the conditions are exceptional, they agree to make a single trip out to sea from Mission Bay. Thanks to Marc and his crew—this one's for them. For more than a century, the British fiercely but unsuccessfully attempted to take back the trophy that *America* had won from them in 1851. Beginning in 1962, other countries began to take an interest in the famous cup, and they dreamed of knocking the silver vase off its U.S. pedestal. Soon, it became necessary to organize elimination rounds to determine who would be the challenger authorized to go up against the representative of the yacht club holding the cup. For 132 years, the challengers went away empty-handed, with the elusive trophy remaining in American hands. Unexpectedly, in 1983, *Australia II* finally triumphed, carrying the cup off to Australia, in the face of a stunned United States. In 1987, the U.S. helmsman Dennis Conner recovered what he had let get away from him. From San Diego, California, the cup in 1995 went to New Zealand, represented by Peter Blake and his Team New Zealand. In 2003, with the victory of the Swiss challenger *Alinghi* in the thirty-first America's Cup, the Old World got its turn at capturing the trophy.

THE ECREHOU ARCHIPELAGO. PLAYING ROBINSON CRUSOE IN THE TIDES.

At high tide, these islets turn hostile, surrounded as they are by a seething sea and sharp teethlike rocks. But when the English Channel recedes, the Ecrehou archipelago displays its long, sandy beaches dotted with protected coves where sailboats can anchor. The Minquiers, Dirouilles, Casquets, and Paternosters reefs, far off the west coast of Cotentin, are part of the Anglo-Norman Channel Islands, the most famous of which are Jersey and Guernsey. Far from regular sea links, the Ecrehou archipelago gives the adventurer the chance to play Robinson Crusoe. Along with the splendid landscapes and the unexpected crystalline waters, the happily "shipwrecked" will discover its plentiful shellfish that the changing tide deposits on the beaches and rocks.

IMPRINT. THIS OYSTER FARMER'S MOORED BARGE HAS MARKED ON THE MUD THE RADIUS
OF ITS SWING.

The tide lends life ashore the rhythms of its perpetual comings and goings. Along sandy beaches and rocky
coasts, we see the waves ebb farther and farther out toward the horizon, then promptly return after changing
their mind. In the muddy ground of the estuaries, the sea evaporates as if by magic and flows back just as mirac-
ulously, with neither sound nor eddies. The sand acts like a sponge. Once it is saturated, the sea gradually
emerges from the wet sand, floating the small craft once again. The boats move at the end of their ropes, accord-
ing to the currents, the direction of the wind, and its intensity. This change in the direction of a moored ship is
called its swing. At the end of the ebb tide, when the last film of water has vanished into the silt, the boat
rests delicately where the day's wind places it. The imprint of its hull in the sand adds another line to the col-
lective work of art.

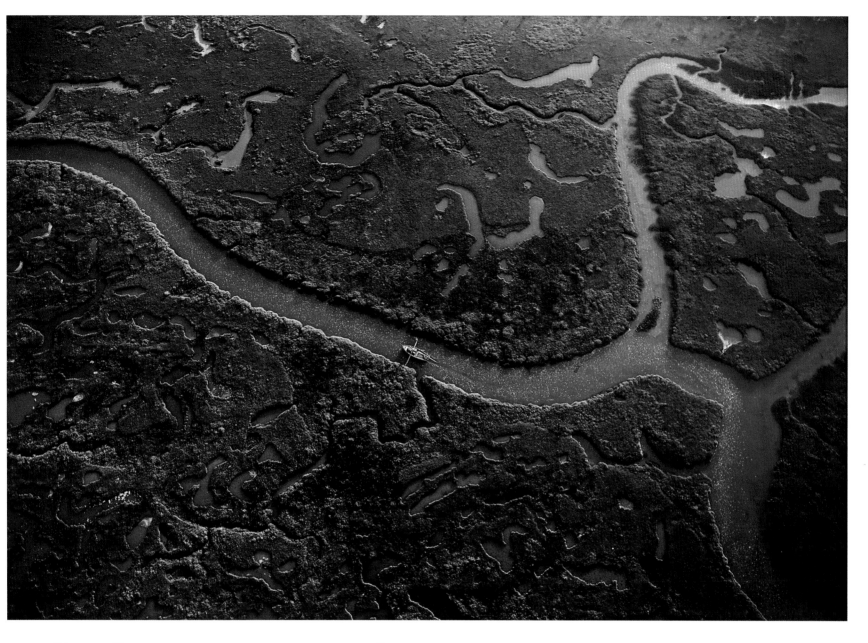

BÉNODET. TWO MEN ABOARD A CANOE GOING DOWN THE LETTY RIVER.

The little sister of the Odet river, the Letty finds its source only a few miles from the coast of southern Finistère via some spectacular meanderings. Through a flat, deforested land, the sinuous river makes for the heart of the Finistère countryside, endlessly twisting and turning. In this landscape of peat and marshlands, smaller branches of the river seem to disappear while the Letty nonchalantly follows its course. And if once in a while a canoe ventures through this barren setting, it will arrive at points where the Letty has become so narrow that oars become useless and the only way to continue is by sculling. Once through the bottleneck, the river will flow to its mouth. In truth, this territory is the property of the birds, and to cross it is a privilege. The river opens onto the "White Sea," also called the "Letty Lagoon." One of the most striking areas of Bénodet, it is a small internal sea with tides and currents. And so the poetry of the Letty fades away.

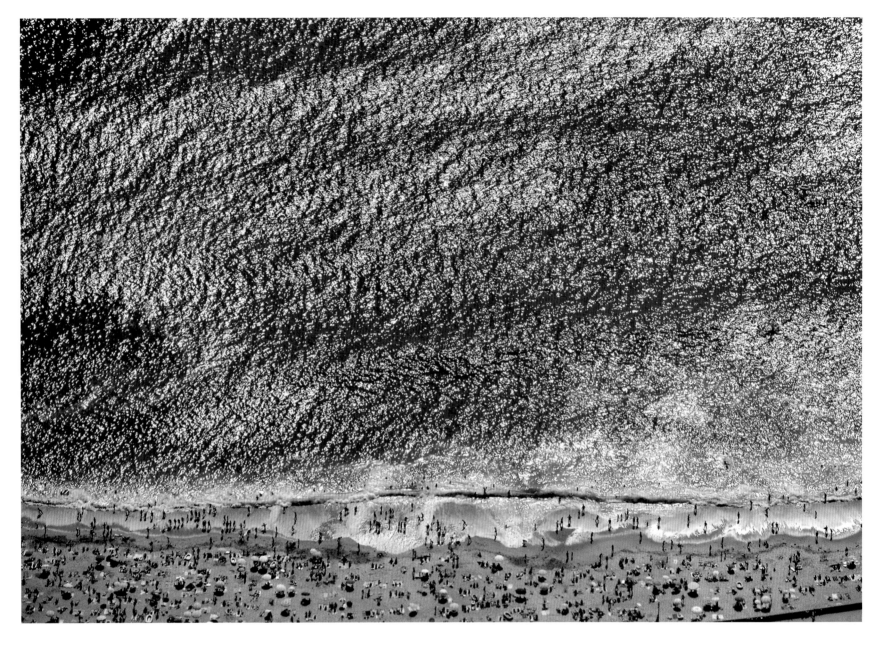

LA BAULE. OCEAN SWIMMING IS A LOCAL SPECIALTY THAT HAS GROWN SIGNIFICANTLY
SINCE THE 1950S, WITH THE ADVENT OF PAID VACATIONS.

After World War II, the French were able to take vacations, thanks to the institution of paid time off. They
began escaping to the seaside for a month, and a half-century later their infatuation with beach holidays is as
intense as ever. In fact, the majority of the French (75 percent) take their vacations in metropolitan France, and
for half of them the long summer break is inseparable from the sea. After this most popular of destinations comes
the countryside, the big cities, and, in last place, the mountains. Those devoted to the Mediterranean beaches
are the most numerous (30 percent of vacationers), but more and more people are flocking to the Atlantic and
Breton coasts. If the seashore continues to be the summer place of choice, it is because its attractions appeal to
the minds of vacationers: sunlight and warm sand, leisure and rest—this is what the French love about the sea.

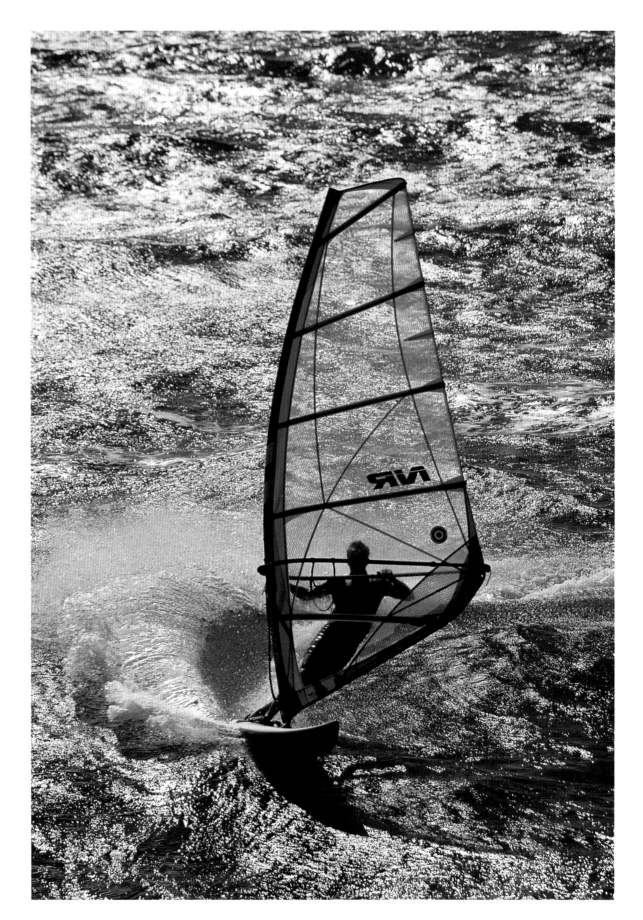

WINDSURFING.
THE GLIDE.

Windsurfers get a fast
beach start. Secure in their
foot straps, they alternate
beating windward and
leeward on a starboard tack
then step forward and lee-
ward to prepare to jibe. If
they wipe out, they take off
again from a water start.
After a few backsides and
bottom turns at the foot of
the waves, they will care-
fully compensate for the list
in order to complete the
jibe. More than daunting,
the vocabulary of windsurf-
ing is absolute nonsense to
the neophyte. It includes
terminology from the sailing
world but borrows from
surfers as well. In windsurf-
ing, a banana is not a fruit
but a description of the way
a board curves; carrots are
equipment, not things to
eat; "spatula" describes the
front of the board, not some-
thing to cook with; and the
twist refers to trimming the
sail—not a dance!

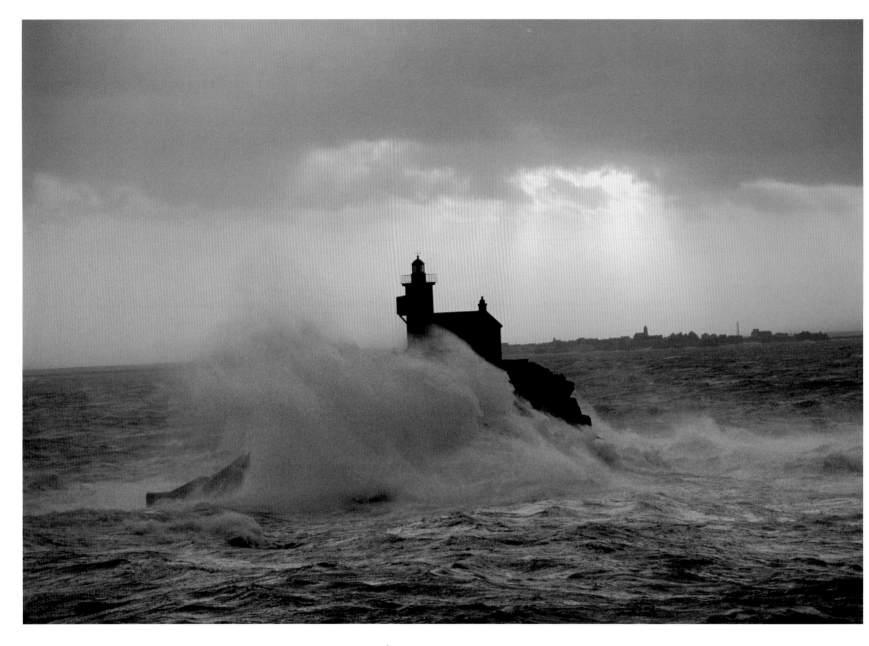

Seen from the Sein race, in southwest Finistère, Tévennec lighthouse and its narrow base, which the Seinans call *tavenok*, or "little cliff," stand out against the Île de Sein. Even before the lighthouse was built here, the shipwrecks caused by this rock—said to be haunted by those who died at sea—gave it an evil reputation. And despite its resemblance to a benevolent chapel resting upon the waves, Tévennec has witnessed a string of doleful occurrences from the moment it was first lit, in 1875. So many tragic accidents have happened here, so many keepers lost their lives or their minds, that the administration, to put a stop to the dismal litany, installed a permanent gas flame in 1910. In the end, it was the rock's curse that caused it to be automated so much earlier than others. The Eilan Mor lighthouse, perched on a cliff on Scotland's Flannan Islands, is another with a chilling history: in the night of December 15, 1900, its three keepers mysteriously disappeared, an event that remains unexplained to this day.

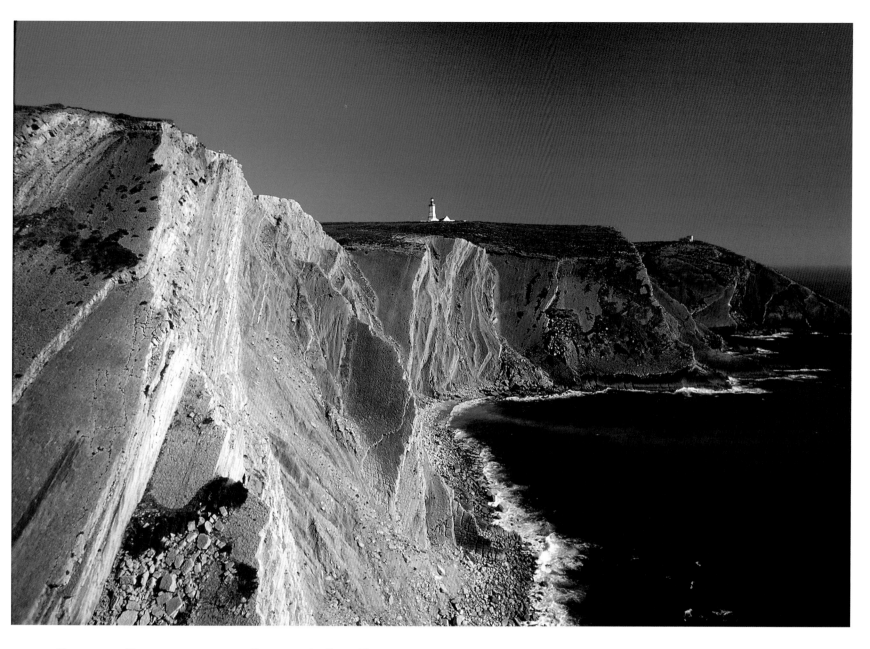

PORTUGAL. THE HARSH CLIFFS OF PORTUGAL'S CAPE ESPICHEL, TRULY AT THE ENDS OF THE EARTH.

The harmonious contour of the Cape Espichel cliffs forms small coves that only the Atlantic Ocean can reach and violently inundate with surges. These chalky white limestone cliffs crash down into the blue of the sea, while up above the scrub fights a continuous battle with the wind and sea spray. It is not surprising that this desertlike region has inspired scores of filmmakers, and has even been used for shooting westerns. At the end of this jagged and windswept land there stands a small white lighthouse that is one of Portugal's most astonishing sanctuaries, Our Lady of the Cape (*Nossa Senhora do Cabo*). According to legend, the Virgin, *Nossa Grassa*, was to have appeared to two sailors on these steep cliffs back in the thirteenth century, and ever since this has continued to be an important site of holy pilgrimage. On the other slope, one discovers another white point. At the edge of an abyss, a very small chapel adorned with *azulejos* (blue tiles) clings to the land facing the ocean, while below, a small cove struggles under the onslaught of the Atlantic.

CONNEMARA. IN GORUNNA ISLAND'S TINY PORT, IT'S THE END OF THE SEASON
FOR THE TRADITIONAL "HOOKERS". THE FLEET WAITS TO BE DRY-DOCKED FOR THE WINTER.

The preservation of maritime heritage can stimulate interest and restore the collective memory. Some groups
organize regattas in which the traditional Irish "hookers" meet in a relaxed, festive atmosphere. But these small
sailboats racing for the finish line tell a different tale than they once did. Before it was a leisure-time activity,
sailing was strenuous work. "Hookers" would transport the cattle and common people of the Connemara region,
especially between Galway and the Aran Islands. Until the early twentieth century, many of the county's
inhabitants still led the harsh, often impoverished, life of farmer-fishermen. Today, these traditional craft are
one of many varieties of pleasure sailboats. These noble, pristine vessels compete for the folklore in Galway Bay.
In their new incarnations, the "hookers" no longer work during the winter. After the regatta season is over,
they wait to be housed safe from the elements in the stormy months.

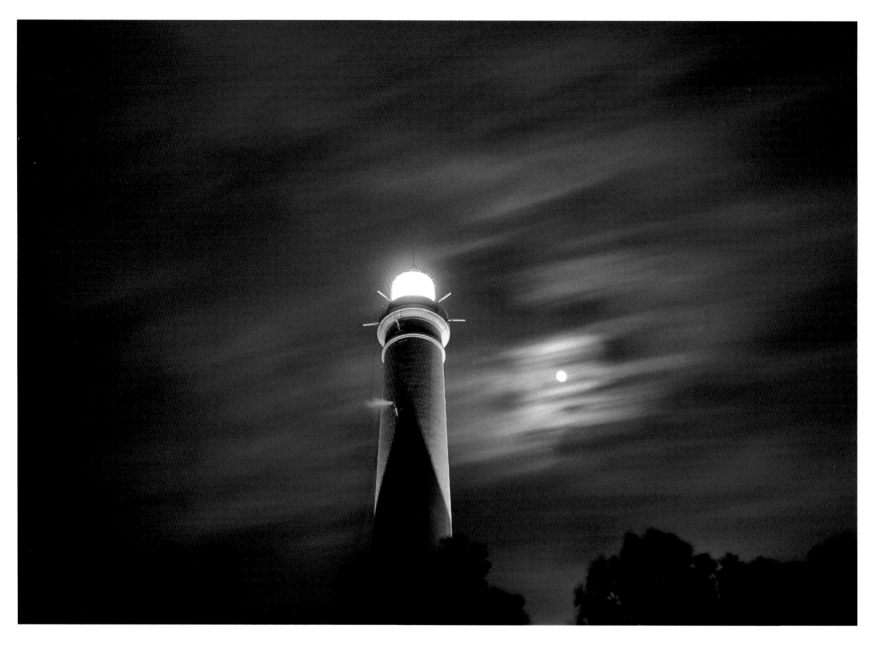

SAINT-MARTIN. THIS LIGHTHOUSE WAS BUILT IN BIARRITZ IN 1834—
BEFORE IT WAS DECREED THAT FRENCH LIGHTHOUSES SHOULD LOOK LIKE FORTRESSES.

Long before they looked up to lighthouses, in the earliest seagoing times, sailors looked up at the skies, studying the night and its billions of stars in order to correct their course. In the late sixteenth century, the compass revolutionized navigation on the high seas. Today, a ship's position still comes from on high, but seafarers no longer use a sextant to ascertain it. Instead, they watch their Global Positioning System (GPS) screen, which uses data transmitted from navigation satellites hovering in space to calculate the ship's speed and position to within about 30 feet (10 m). Hoisted some 237 feet (73 m) above the sea, this light waltzing with the enveloping clouds also keeps its head among the stars. Since 1834, the lighthouse on Saint-Martin point has raised its sober, refined, 150-foot (47-m) tower on this rocky hill, which thrusts into the bay of Biscay, across from the beach resort of Biarritz.

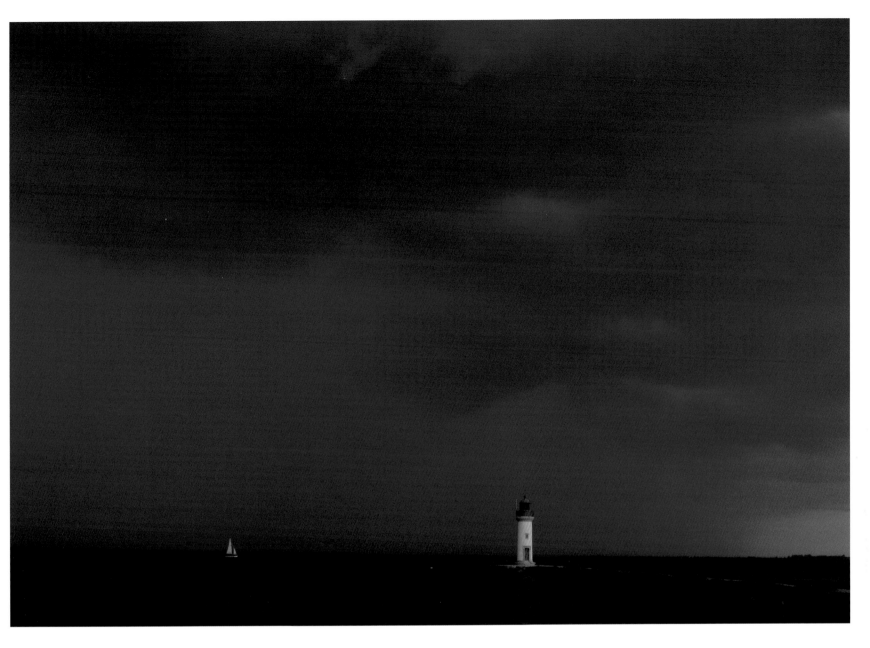

ALONE IN THE WORLD, AROUND MARSEILLE.

At the tiller of a sailboat, everyone is alone as he enters an unknown port. Every captain, even those at the helm of the smallest vessels, has experienced an indefinable exhilaration when passing a foreign seawall. They sense a slight tightening of the heart at the thought of the maneuvers to come. Catching the pontoon or anchor buoy will be the final test before setting the boat to rest and taking a moment to relax before exploring the new world, replete with fantasies of the unknown. This pleasure yacht is approaching Marseille along the banks of the Thau wetlands. Thau's port was founded in the sixth century BC, and just like this captain, the Phoenicians, those Ancient Greeks talented in commerce and navigation, disembarked here and established one of their many trading centers that were interspersed between the Aegean Sea and the ports of Scandinavia.

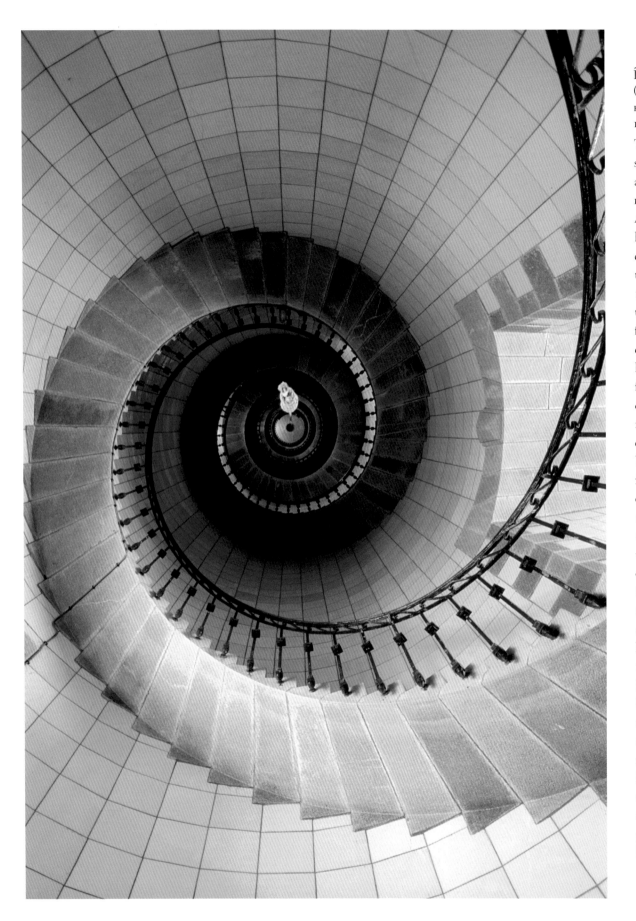

ÎLE VIÈRGE. AT 266 ½ FEET
(82 M) HIGH, THIS LIGHT-
HOUSE, FIRST LIT IN 1902,
IS EUROPE'S TALLEST.

The reefs around Île Vièrge are
scattered throughout the strait,
about 1 mile (1.5 km) from the
northern Finistère coast, in the
Aber Vrac'h estuary. The first
light to signal this danger
dates to 1845. Today, the "lit-
tle lighthouse," a square tower
107 feet (33 m) high, houses
the keepers—and a piercing
foghorn. In 1882, it was
decided to build a taller light-
house, which would be visible
from farther out—a necessity
due to the extensiveness of the
reefs in the area. The structure,
construction of which was
begun in 1897 and continued
for five years, celebrated its
one-hundredth anniversary in
2002. Île Vièrge lighthouse,
266 ½ feet (82 m) high and
with a diameter on the ground
of 42 feet (13 m), is the tallest
in Europe, and the world's
tallest lighthouse made out of
stone. At first fueled with
kerosene, then, beginning in
1956, with electricity supplied
by two nearby windmills, its
beam carries for more than 30
miles (50 km). It is reached by
an interminable stairway of
nearly four hundred steps. The
interior of the stairwell is splen-
didly lined with 12,500 sheets
of light-blue opalescent glass,
perhaps to make the climb seem
less arduous.

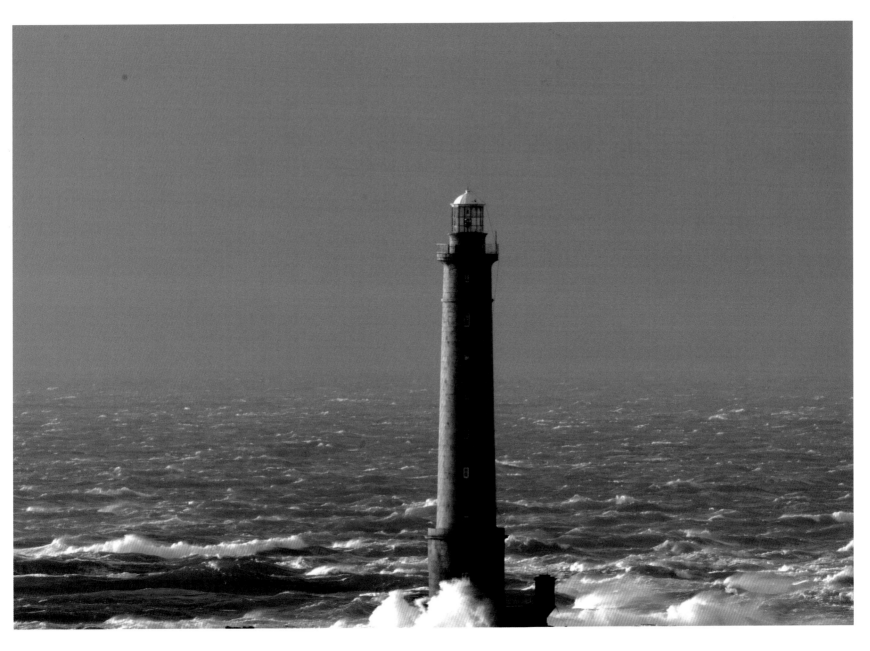

France. The lighthouse of La Hague, battling with the elements.

So often, the raging English Channel batters the coastline of Normandy. Alone, in the middle of the uproar, some 2,625 feet (800 m) off the cape of La Hague in an area known as the Raz Blanchard, the lighthouse of La Hague perseveres. At a height of 170 feet (52 m) above the sea, the lantern room glistens in a storm, pulsing its white light approximately every five seconds. The beam is visible for 23 nautical miles (26.5 mi/42.5 km), enabling the crews aboard the oil tankers, gas tankers, cargo ships, and deep-sea trawlers navigating through the zone to rely upon this precise fix. Since 1823, twenty-seven boats have gone down in this region, one of which was the cruise ship *Paris*, which sank along with many of its passengers. Work on the construction of the lighthouse did not begin until 1934, and it would take another three years until it was finally erected atop its rock islet. During extremely high tides, the water level rises to spill into its interior staircase. Having been automated in 1990 and controlled from Cherbourg, the lighthouse is no longer inhabited. So the people who have chosen to keep their distance from the lighthouse of La Hague continue to make sure that others, men of the sea, also do not get too close.

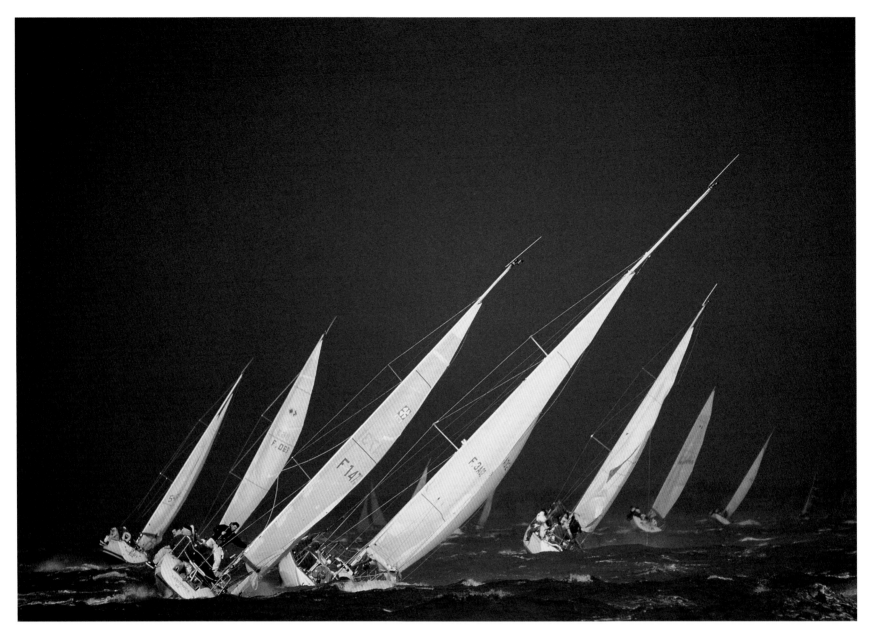

PASSION. THEY ARE OUT ON THE WATER IN FAIR WEATHER AND FOUL,
EVEN IF IT MEANS SUFFERING FROSTBITE, WINTER SQUALLS, AND STORMS IN THE COLD.

When weather conditions get bad enough to discourage the dilettantes, the real enthusiasts take over, prepared to sacrifice anything for their passion. These are the devotees, who discover that what they lose in comfort they gain in pleasure from the intoxicating sensations they get from the elements. The real aficionados—the racing zealots—never miss even one of the winter training sessions that take place every two weeks at La Trinité-sur-Mer, crossing the white blades of their sharp sails like sabers. They show up just as fervently when the wind is high and the temperature low, ready to mix it up in the waves and catch frostbite in the lashing gusts of the squalls, all in the name of logging a few more knots. And when they come in from that ordeal—smiling radiantly, eyes sparkling with satisfaction—that's when their dedication looks craziest to the uninitiated landlubber.

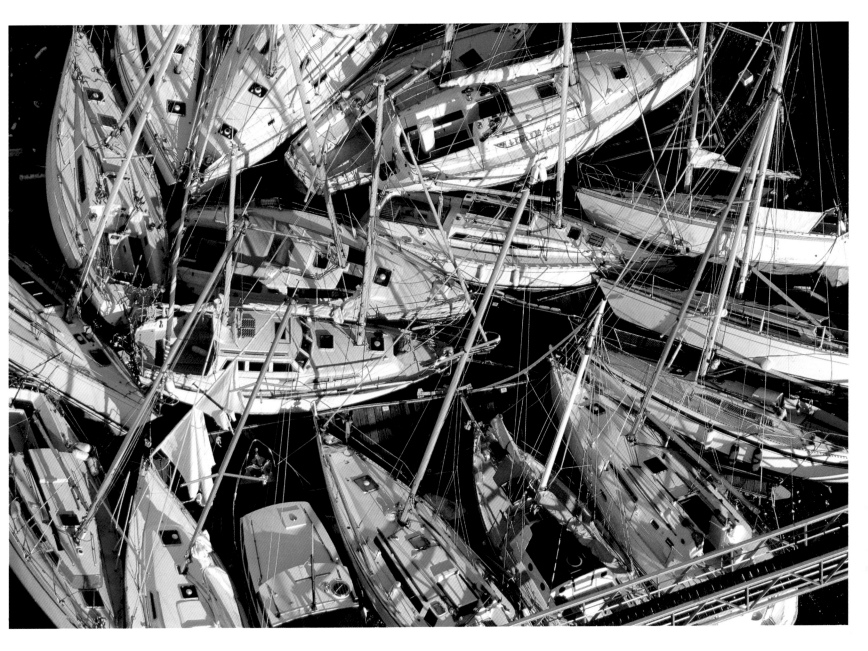

La Rochelle. A rare photograph: December 24, 1999.
A historic storm strikes the port of Minimes.

The violent storm that blew across France in December 1999 attacked the coast as well. At La Rochelle, it ransacked the yacht marina, tearing off pontoons and piling sailboats on the strand in a heartbreaking spectacle. Did this tumble of hulls happen because too many boats were crowded into the same area of coast? Luckily, congestion is not yet a problem in the 370 or so French ports hosting pleasure craft, despite the extraordinary increase in the popularity of yachting over the last thirty years, a result of the expansion of leisure time and the introduction of molded plastic, which greatly reduced the costs of marine construction. Out of the more than seven hundred thousand pleasure craft flying French colors, 70 percent are motorboats. These are especially popular in the Mediterranean, while sailboats are more common in the north of France. The Atlantic coast, and Brittany in particular, is still sailors' heaven.

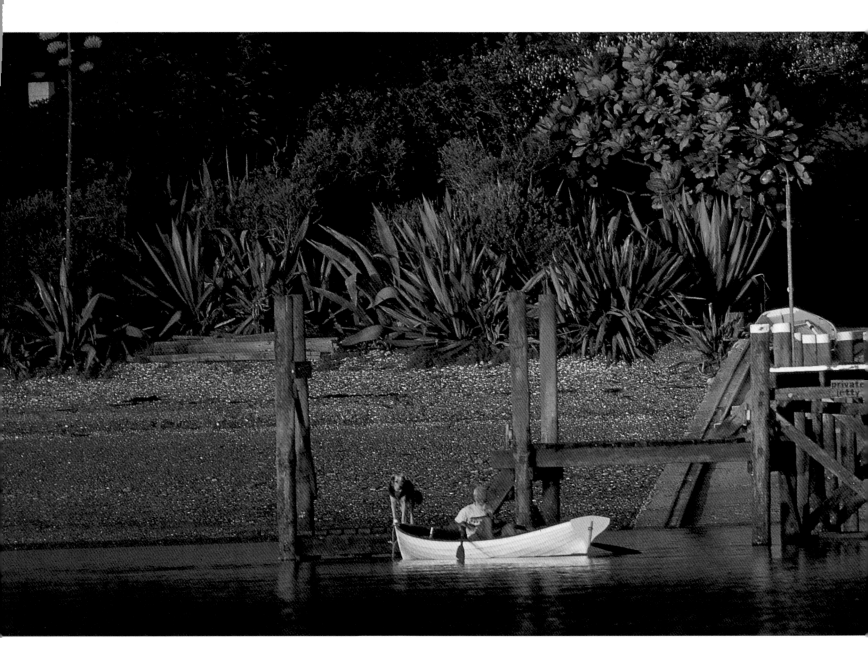

New Zealand. Life at the water's edge, in rhythm with the sun, the tides, and the fish.

This rugged country ravaged by the "bumps and holes," as its residents say, has not discouraged its vegetation, which has progressively appropriated the majority of New Zealand's land and led to a coastline where green lands abut the ocean. Reaching the beach after a hike that can require both courage and determination—believing no one has done it before—one finds that people have taken the same route for a long time. Settling there where nature had led them, they live peaceably on its offerings, somewhat as people had at the beginning of time. Signs of civilization slowly appear and those living in this hidden paradise have returned to simplicity without fully abandoning the technology of their past lives. Carrying the netting in their hands, they envision the world differently. Constructing a platform from wood, painting the boards, feeding the dog, and, when night falls, resetting the fire while listening to the crackling branches in the forest of oak, kowhai, and kanuka as the nocturnal world comes to life—this is the existence of those who have isolated themselves on the wild islands along the New Zealand coast.

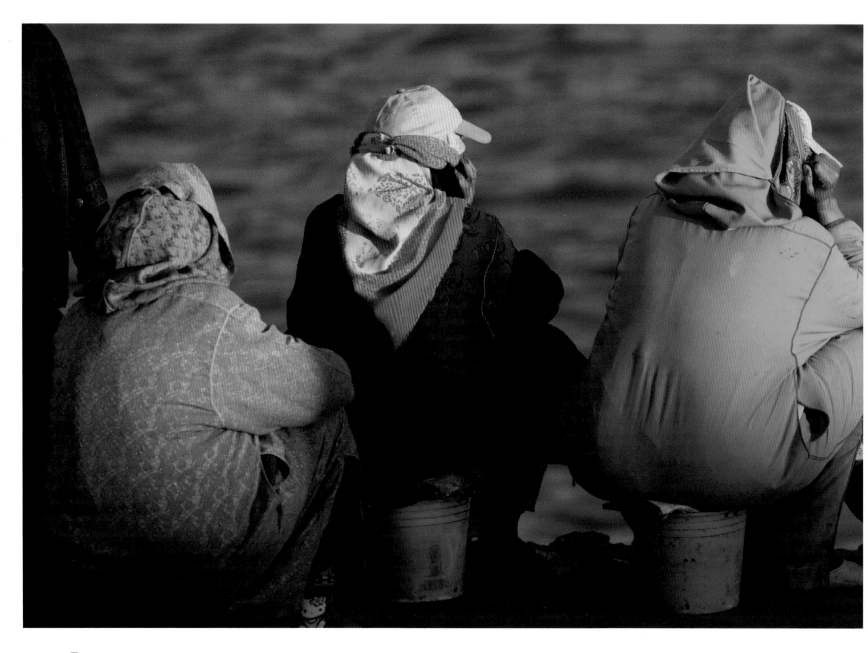

THE WOMEN WHO ARE MARRIED TO THE SEA.

Every evening, having passed through the narrow Moroccan streets of Essaouira, this cheerful and colorful band of women arrives. Emerging from the passageways, each armed with the same blue pail, they cross the large square, pass through the ramparts and meet at the docks. They then sit and cast kohl-lined eyes toward the port's entry. One can only hope that something comes to those who wait—a husband, a father, a brother. If all goes well, when the boats return, the fishermen will join the women and fill the buckets with fresh fish for dinner. "To marry a man of the sea is to marry the sea, absence, and fear," as the women who have linked their fate to men of the open seas will confirm. "To be the wife of a fisherman means to wait. Always to wait. Sometimes for a long time. I remember spending hours on the seawall staring off into the horizon," recounts Marie-Louise, the wife of Fanch, a fisherman from the Brittany port of Conquet. Here, there, everywhere, every day, they wait.

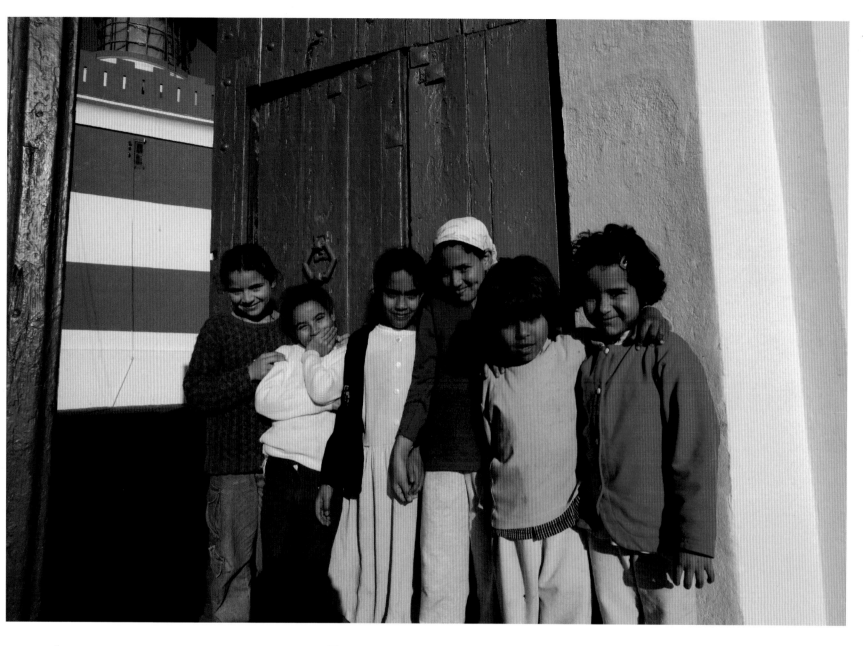

Six maidens for a green-and-white tower. The lighthouse at Cape Sim is well guarded.
The keepers of lighthouses (the only "land" seamen consider their own) have the privilege of housing their
families in the beacon's outbuildings. This became the norm starting in the middle of the nineteenth century,
when it was "noted that the structures were better maintained" when men were joined by their spouses.
The administration even saw fit to construct separate buildings for each family so as "to help avoid arguments
between the keepers' wives." At Cape Sim, between Essaouira and Casablanca, a green-and-white tower catches
the eye. Made by the hand of a master, it is the pride of its three keepers and their six daughters, who were
thrilled to pose for Philip Plisson (and also to see the image on the screen of his digital camera). "A moment of
grace," recalls the photographer.

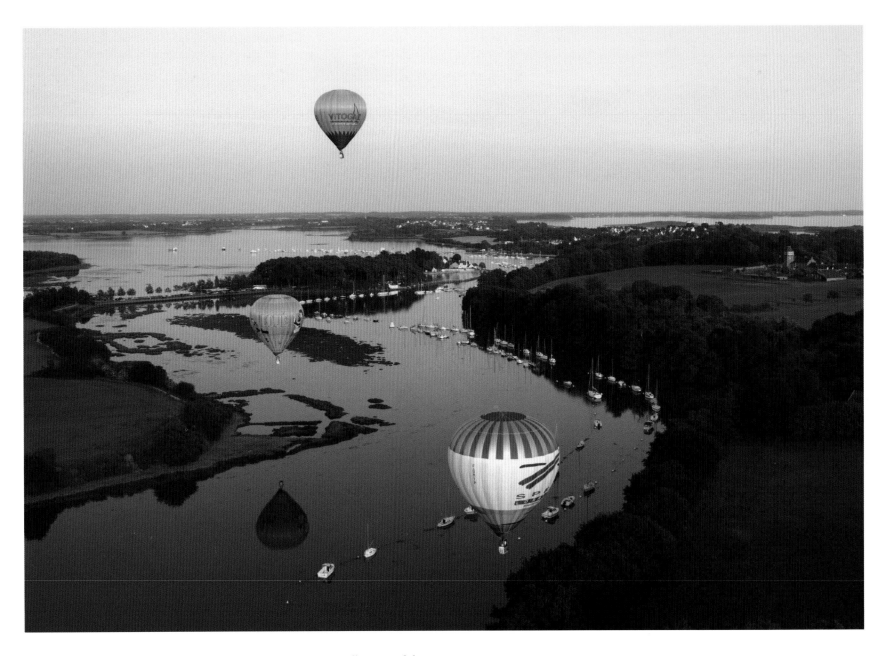

VANNES. HOT-AIR BALLON SUSPENDED OVER THE GULF OF MORBIHAN.

The flame bursts out of the lighter and up into the sphere filled with air. The passengers, nestled in their wicker basket, can look at the magnificent Gulf of Morbihan with its islands of green coppice, ships, and currents. The fifteen aircraft of Gulf Week 2003 soar slowly, guided simply by the wind. Farther below, on the water, the reflections and colors of these peaceful flying machines are everywhere. The crowds gathered to watch them diminish in the evening while flotilla with old rigging and new sails return to the banks of the port in Vannes. More than a thousand of these ships of another era were reunited during the event in 2003. They navigated across the gulf, spreading memories around the islands, the ports, and the most remote inlets of the "little sea," or "Morbihan" in Breton. The breeze carried them to the edges of Île d'Artz and Île aux Moines whose residents seemed divided between the sight of the sky and that of the sea, but both united over there, toward the horizon, only to form a unique and sublime vision.

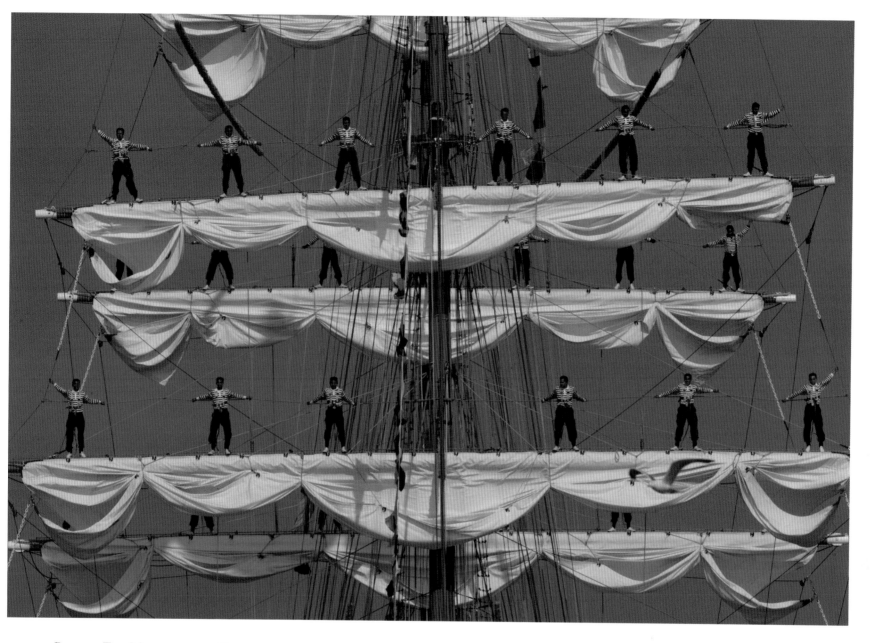

ROUEN. THE MEXICAN SHIP *CUAUHTEMOC* DISEMBARKS FROM THE
SEINE DURING THE ARMADA 2003.

Although the city of Rouen is certainly far from the sea, it doesn't mean its citizens aren't good sailors.
So, during the Armada 2003, there are more than fifty ships and six thousand sailors of twenty different
nationalities who gathered together in the capital of Haute-Normandie. Three-masters, schooners, cruisers,
and even helicopter carriers, the most beautiful boats in the world, traditionally sail up the Seine to dock in
the heart of Rouen. The crowds stretch out over the wharf, admire these magnificent ships, and then let them
set off again. The ships then embark to the estuary and return to the sea. So, for the Parade, the prestigious
craft pass by other ports, other countries, they slip under towering bridges, and finally stream into the English
Channel. The crew of the *Cuauhtemoc*, a 299-foot (91-meter) three-master, greets the crowds gathered in front of
Honfleur. The ninety cadets of this training ship daringly hoist themselves in the yards, but they are discreetly
rigged out every time so the illusion is perfect.

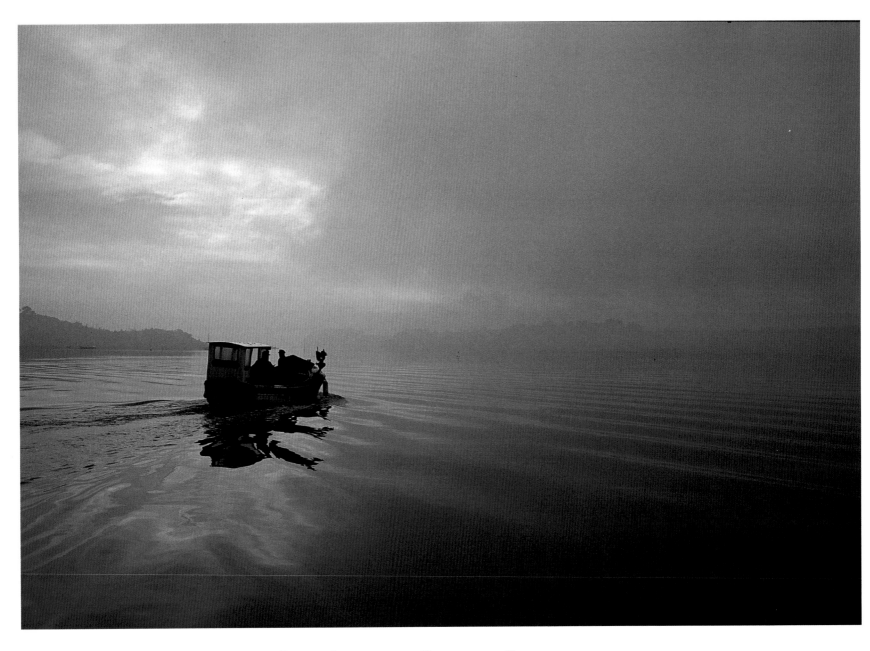

MORNING AND A *CASEILLEUR* ON THE RANCE. AN HOMAGE TO COMMANDANT CHARCOT.

Between Dinard and Saint-Malo, a few miles from the tidal power station, the Rance follows its course in a
timeless light. The *caseilleur* traces a perfect wake on the glass surface of the river, a stone's throw from the house
where Commandant Charcot loved to relax between his two polar expeditions. This is where his adventure
boat, *Pourquoi Pas?*, came in careenage from the Lemarchand shipyards. By the time Charcot built his three-master,
he had already explored Antarctica two times, recognized the Shetland coasts, and made landfall at Graham.
Aboard this boat, specifically designed for extreme latitudes, the man who adopted Saint-Malo as his home
returned, in 1908, to the Antarctic for a third time. He became interested in northern seas and after several voyages
to the Arctic Ocean, he was lost at sea on the *Pourquoi Pas?*, which sank on July 14, 1936, off the coast of Iceland.

MIST. THE SAILOR'S NIGHTMARE. WHEN THE SUN PIERCES THE CLOUD COVER,
IT RAISES HOPES OF SEEING THE HORIZON AGAIN.

Mist, the suspension of very small drops of water in the air, limits visibility to 3 miles (5 km). When everything beyond just half a mile (1 km) goes out of sight, the phenomenon is fog, formed by the condensation of water vapor that results from a mass of warm, humid air passing over the cool surface of the sea. In this unseeing universe, which swallows up the features of the shoreline and extinguishes lighthouses, it is the audible signals that speak to the sailors. They follow with focused attention the low call of a foghorn, which may spell out letters of the alphabet in Morse code; the penetrating cry of a siren; or a beacon's warning, whether it's a whistle or ringing bell. These loud signals do the best they can to guide boats, but the cottony mist distorts and muffles sounds and so makes it impossible to locate them precisely. Radio-sent directions and the Global Positioning System (GPS) can refine a sailor's approximations. When a ship is closer to shore, soundings can measure the water's depth, which in turn makes it possible to identify location on a map.

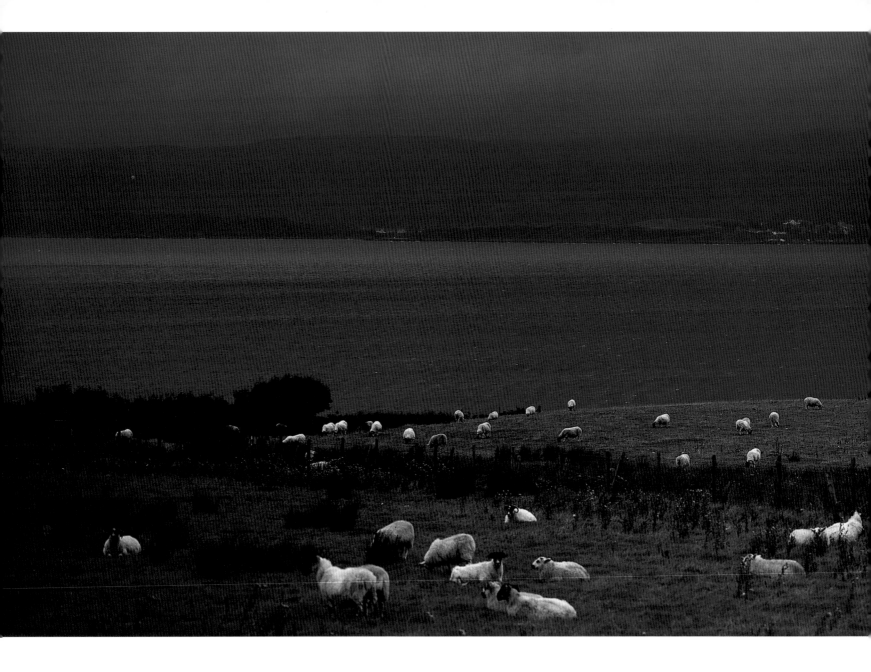

IRELAND. IN GALWAY BAY, THE SHEEP OF THE ARAN ISLANDS WATCH THE CLOUDS GO BY.

The port of Galway is the entry to Connemara, but farther to the west toward the open sea, a chain of wild lands juts up—the Aran Islands. There, the landscape changes to the whim of the light. In just a few minutes, a sunny prairie can be plunged into darkness. In these parts, it is often said that each day cycles through the four seasons. The clouds and squalls coming off the sea beat down on these stark fields without affecting them; to the contrary, they become highlighted. The little white spots are sheep grazing in the hills, while a checkerboard of enclosures and low stone walls protects each parcel of land from the assaults of the wind. The road gets lost in its own meanderings, a few hamlets light up the moor, and along the length of the walls bricks of peat try to dry out in the storm. Later, when night falls—the real night, the one with stars—the bricks will be used for making fires in the hearths.

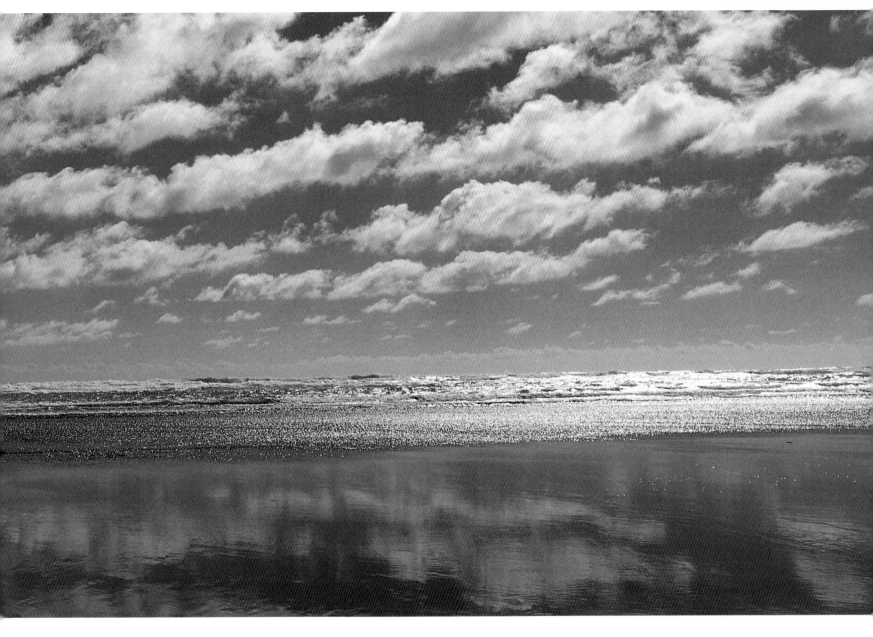

NEW ZEALAND. THE BEACH WHERE JANE CAMPION FILMED
THE LANDING SCENES IN HER MOVIE *THE PIANO*.

When Jane Campion set her cameras on Kare Kare Beach in 1993, it was battered by wind and rain and the sky was gray, as if this New Zealand beach were permanently closed. This stunning panorama gives a distinctively wild impression, but in reality the beach is only an hour's drive from the center of Auckland, the North Island's main city. The forests continue one after another, stretching down to the shore, tracing coves of great beauty. Moreover, this rich ecosystem comprises forty-seven islands and is a popular place for people to go whale watching. The grandiose seascape also attracts countless surfers who challenge the green and turbulent seas of the Pacific Ocean. New Zealanders are avid about their natural splendors. The coasts around Auckland are sanctuaries for marine birds, which, as soon as they leave the nest, fly off to the sunny slopes and play in the wind without fear of any human presence.

ACKNOWLEDGMENTS

Many thanks to:

The Sea.

Hervé de La Martinière, who suggested this work.

Michel Buntz, my friend and accomplice, who has supported me in this venture.

Benoit Nacci, artistic director, who chose 365 images from the 1,500 that I offered him.

The French navy, its general officers, officers, mariner officers, and crews,
who so warmly welcomed me aboard their craft, to keep the memory of our traditions alive.

Daniel Manoury and Éric Oger, my helicopter pilots, who have skillfully flown me
in all weathers into the heart of the elements.

Didier Blaque-Belaire, communications director of the Caisse nationale du Crédit Agricole,
who, since the 1980s, has provided me with the means to go after my dreams.

Le Govic, my printer and publisher, who was the first to believe in my images
and allowed us to create this collection.

Christophe Le Potier, my assistant, who managed the unmanageable with skill and ease.

The entire staff at Éditions Pêcheur d'Images, who have been taking care of the distribution
of my images and the management of my photographic collection from La Trinité.

Éditions de La Martinière, Céline, Barbara, Sophie, Isabelle, Cécile,
all the talented women who worked closely on this project.

Thalassa, Georges Pernoud and his entire team who, every week for twenty-five years,
have kept our dreams of the sea alive.

Météo France, the team of shipping forecast meteorologists, who, from Toulouse,
help me to prepare for my encounters with nature.

Guillaume, my son, who has shared the same passion for ten years.

Marie-Brigitte, my wife, without whom none of this would be.

My sincere apologies to:

All those whom I have forgotten, but deserved to be named.

Philip Plisson's images are distributed by Éditions Pêcheur d'Images and
online at www.plisson.com.
Contact: philip@plisson.com.

All the photographs reproduced in this book are by Philip Plisson with the
exception of those for March 25, April 13, April 19, June 2, September 16,
October 2, December 13, and December 21, which are by Guillaume Plisson.

For twenty years, all of Philip Plisson's photographs have been taken with
Canon equipment, EOS body and lenses, and the panoramic images with a
Fuji 6 x 17 chamber, mostly using Fuji Velvia film (ISO 50).

Project Manager, English-language edition: Susan Richmond
Editor, English-language edition: Virginia Beck and Libby Hruska
Jacket design, English-language edition: Michael Walsh and Rita Jules
Design Coordinator, English-language edition: Rita Jules and Christine Knorr
Editorial assistance by Sarah Mann

LIBRARY OF CONGRESS CONTROL NUMBER: 2003109924

ISBN 0–8109–4802–8

Printed and bound in Thailand
10 9 8 7 6 5 4 3

Harry N. Abrams, Inc.
100 Fifth Avenue
New York, N.Y. 10011
www.abramsbooks.com

Abrams is a subsidiary of

LA MARTINIÈRE
GROUPE